Langford's Basic Photography

The guide for serious photographers

Ninth edition

Michael Langford FBIPP, HonFRPS
Formerly Photography Course Director
Royal College of Art, London

Anna Fox
Professor of Photography
University for the Creative Arts, Farnham

Richard Sawdon Smith
Reader in Photography
Associate Dean Postgraduate
University for the Creative Arts, Epsom & Farnham

Contributors
Peter Renn
Senior Lecturer
University for the Creative Arts, Farnham

Christian Nolle
Freelance Photographer and Designer

ELSEVIER

AMSTERDAM • BOSTON • HEIDELBERG • LONDON • NEW YORK • OXFORD
PARIS • SAN DIEGO • SAN FRANCISCO • SINGAPORE • SYDNEY • TOKYO
Focal Press is an imprint of Elsevier

Focal Press

Focal Press is an imprint of Elsevier
The Boulevard, Langford Lane, Kidlington, Oxford, OX5 1GB, UK
30 Corporate Drive, Suite 400, Burlington, MA 01803, USA

First edition 1965
Second edition 1971; Third edition 1973
Fourth edition 1977; Fifth edition 1986; Sixth edition 1997
[Reprinted 1998 (twice), 1999]; Seventh edition 2000
Eighth edition 2007
Ninth edition 2010
Reprinted 2012

Notices
Knowledge and best practice in this field are constantly changing. As new research and experience broaden our understanding, changes in research methods, professional practices, or medical treatment may become necessary.

Practitioners and researchers must always rely on their own experience and knowledge in evaluating and using any information, methods, compounds, or experiments described herein. In using such information or methods they should be mindful of their own safety and the safety of others, including parties for whom they have a professional responsibility.

To the fullest extent of the law, neither the Publisher nor the authors, contributors, or editors, assume any liability for any injury and/or damage to persons or property as a matter of products liability, negligence or otherwise, or from any use or operation of any methods, products, instructions, or ideas contained in the material herein.

British Library Cataloguing in Publication Data
A catalogue record for this book is available from the British Library

Library of Congress Control Number: 2010924052

ISBN: 978-0-240-52168-8

For information on all Focal Press publications
visit our website at focalpress.com

Printed and bound in China

12 11 10 9 8 7 6 5 4 3 2

**Working together to grow
libraries in developing countries**

www.elsevier.com | www.bookaid.org | www.sabre.org

ELSEVIER **BOOK AID International** **Sabre Foundation**

Contents

Appendices 396

Glossary 429
Index 457

The first edition of this book, in 1965, was Michael Langford's first published title. In its ninth edition Anna Fox and Richard Sawdon Smith have brought his coverage of photography right up to date with contributions from Peter Renn and Christian Nolle. This is a classic text and every photographer's bible.

Much of Michael's original text remains and the spirit of the new texts ensure that his influence lives on, providing guidance to everyone who shares a great passion for photography and wants to learn more.

Picture credits

C over image: Shiho Kito. Picture research: Natasha Caruana

Figure 1.2 Vic Muniz. Courtesy of Sikkema Jenkins & Co. 1.7 Brian Griffin. 1.8 Gareth McConnell. 1.9 Henri Cartier-Bresson/Magnum Photos. 1.10 © 1984 The estate of Gary Winogrand, Courtesy Fraenkl Gallery, San Francisco. 1.11 Joel Meyerowitz. 1.12 Christopher Stewart. 1.13 Joan Fontcuberta. 1.14 Sir Francis Galton, UCL (University College London), Special Collections. 1.15 Jason Evans. 1.16, 13.16, 13.17, 13.18, 13.19, 13.20, 13.21, 13.23, 13.27, 13.28 Richard Sawdon Smith. 1.18 Eadweard Muybridge. Gift of the Sid and Diana Avery Trust. 1.19 Robert Demachy. 1.24 Stephen Dalton (DHPA). 1.28 Uta Barth. Courtesy of the artist; Tanya Bonakdar Gallery. New York; and ACME, Los Angeles. 1.29 Hiroshi Sugimoto. 2.1 Science & Technology Picture Library. 2.10(a), 3.7, 3.15, 3.19, 4.11, 5.2, 5.6, 5.8, 5.9, 5.11, 5.16, 5.18(bottom), 5.20, 7.4, 7.7, 9.25, 9.27, 9.34, 9.36, 11.1, 11.5, 12.20 Peter Renn. 5.7 Walker Evans. 6.4, 8.6, 8.29, 14.34, 14.20, 14.29, 14.30, 14.21, 14.41, 14.35, 14.25b, 15.8, 15.9 Christian Nolle. 7.21 Robert Freson, Sunday Times Magazine. 8.1 Elliott Erwitt Magnum. 8.2, 8.7, 8.8, 8.27 Library of Congress. 8.3, 8.15, 8.25, 8.30, 8.37, 15.7(d) Anna Fox. 8.4 Mark Bolland. 3.12, 8.5(b), 8.35, 15.7(b) Natasha Caruana. 8.9 Paul Seawright. 8.10 Edward Weston ©1981 Arizona Board of Regents. 8.11 Bill Brandt © Bill Brandt Archive Ltd at www.billbrandt.com. 8.13 Susan Lipper. 8.14 Martin Parr/Magnum Photos. 8.16 Hunter Kennedy. Shot after a full day of rain at the end of October. Canon equipment, Fuji Film. 8.17, 8.36 Roger Bool. 8.20 Pierre Stoffel. 8.21 Bruce Gilden/ Magnum Photos. 8.22 Daniel Meadows from the exhibition 'The Free Photographic Omnibus, National Portraits: Now & Then'. 8.32 Collections/Fay Godwin. 8.28 Anthony Haughey. 8.31 Paul Reas from the book *I Can Help* published by Cornerhouse Publications. 8.38(a), 8.40 Jason Evans. Styling by Simon Foxton. 8.38(b) Martin Salter. 8.42 Benjamin Stone. Courtesy of Birmingham City Library. 8.43 Trish Morrisey. 8.44 Jo Spence Collection, Jo Spence Archive London. 9.1 Courtesy Eastman Kodak Company. 13.22 © Man Ray Trust/ADAGP, Paris and DACS, London 2010. 13.24 Melanie Manchot, Courtesy Fred (London) and Goff & Rosenthal, New York. 14.1 Jeff Wall. 14.41 Pedro Vincente. 15.7(a) Maya Oklund. 15.10 © Masumi Hayashi. B.4 ©National Trust Photographic Library/John Bethell. All other pictures by Michael Langford. Special thanks to Val Williams.

Foreword

A book like Langford's *Basic Photography* is a fantastic introduction to a wonderful subject. I can't see how my life could have been anywhere near as full or as rich as it has been without photography. It's been everything to me, the electricity in my life, the way to communicate with people, to fall in love, to vent my displeasure at the world, to articulate every fibre of my feeling. Photographing has allowed me to express all of this and to make some sense of it.

Photography's power is as a passport: it gives you permission to participate in a whole series of situations in life that you wouldn't be allowed in normally. Whether it's a car crash or a presidential election, society immediately accepts you into this event because you are a photographer. If you take away the camera you are just like everybody else. Photography, like poetry or philosophy, enables you spend a lot of time scrutinizing the little details of life. It becomes a reason to live in a broader way.

Other people's pictures are enormously important as a way of solving problems: how someone else dealt with expressing great energy in their work, perhaps, or profound sadness. Photography is so accessible that it's very easy to produce images that seem to look as good as or similar in style or structure to existing work. What's slightly dangerous about this is that people quickly achieve these more or less adequate results, and think 'I can do this' and then remain at that level, aping others' styles. This is a false way of rationalizing your own work, however. Photography is about yourself, how you feel about what you see. Trying to express your perspective through somebody else's feelings is a twisted way of communicating.

Equipment or image-manipulation don't matter in themselves; which camera or software I use is no more interesting than which pen a writer uses or microphone a rock star sings from. But you need to know the scope of the technology. Without full knowledge of your equipment's ability to articulate what you are trying to express, it's like trying to speak with a limited vocabulary. Experimenting with photographic imagery is age-old. Look at the work of Erwin Blumenfeld, the man who put his film in the freezer in order to expose it through ice crystals during the 1940s, or Man Ray, who toiled away in the darkroom during the 1930s, solarizing his prints. A huge amount of historical imagery suggests that many photographers – past and present – do not regard the point of image capture as the only creative moment in image-making. The entire process – right from conception, through construction and post-production to the moment of completion – is important.

I can't believe that anybody can claim to be aware of every single square centimetre of their photographs. My earliest pictures, done with a 35 mm camera and black and white film, were reportage shots of skinheads and potentially violent events as they unfolded in front of me. I remember taking pictures of two girls that I liked the look of, who were standing against a wall in a dance hall. Only afterwards, when I looked at the contact sheets, did I notice that whilst one of them was holding a handbag, the other was holding a broken bottle.

Contrary to the principle of the 'decisive moment' that has dominated the understanding of photography, a photographer just isn't aware of the full image as it is taken. To describe the process, you force yourself into a situation in order to get the shot; you're experiencing

a crescendo of heightened awareness, pushing and manipulating, doing whatever is necessary to balance circumstances: lighting, relationships with the sitter, whatever it is. Finally, you sense a whole bunch of energy flows converging, which is almost like a melody becoming pitch perfect. You respond much quicker than you ever thought you could, but the shutter goes down and the flash goes off in response to the moment prior to capture. The moment documented is not the moment that you see; therefore, it is the moment that you *don't see*.

Unfortunately photography has recently been held to trial for its lack of representation of reality. My own view is that photography never lied but neither did it set out to tell the truth. It said, 'You know nothing of this situation. I'll give you some of my thoughts on it.' A far more crucial issue is that photographers have some moral responsibility for what they show us. Visual imagery is a very powerful medium of expression and some image-makers are guilty of firing it recklessly, like a gun, without looking at the impact of what they are doing. In a culture that can be so rich, we are so poor with our imagery. There is a whole range of people that just aren't included in our visual representation of beauty – excluded for their size, individuality, health, ethnicity or sexuality. I believe it is our duty to use our images to acknowledge that the parametres we set for our image of society are too narrow and reflect that these people have every right to be held up in adoration along with everybody else.

It is useful for all photographers to be shown that they are completely capable of screwing up. On any shoot, the first pictures that come out are almost certainly going to be a failure. Standing in front of someone who is supposedly meant to be the most beautiful woman in the world and then the initial Polaroids aren't very good at all – that's a reasonably humbling experience. It tends to force photographers into repeated patterns of behaviour, like: 'Last time I did it this way, or that works; so by playing this music and using this lens, talking a particular way to the model or using that light, etcetera, will achieve the same results'. Those confidence tricks aren't ways of understanding what is happening in front of you; they are ways of reassuring yourself. You should be metaphorically naked in front of your subject, out of your comfort zone and fighting for a new vision that you've never previously imagined. If you can see it already there is no point in taking the picture.

Nick Knight
Photographer

Introduction

'The camera is my tool. Through it I give reason to everything around me.'

André Kertész

Basic Photography is an introductory textbook, covering the varied skills that lie behind photographic practice. It is intended for students of all ages and, beginning at square one, and assumes that you have no theoretical knowledge of photography, or any scientific background. The book explains equipment and techniques, provides information on both analogue and digital photography: materials and processes, shooting and image manipulation. At the same time, the importance of visual content and meaning in photographs is also discussed with reference to many significant contemporary and historical photographers. In short, *Basic Photography* is planned as a primer to interest and inform professionals, students and amateurs alike.

'Photography' (literally translated as 'drawing with light') is essentially a combination of technique and visual observation: it is a magical invention that creates 2D illusions of the 3D world. In order to make successful photographs you need to combine the development of your technical skills together with exploring your creative visual style – you learn a lot from looking at the history of photography and finding photographers whose work you admire to start developing your own way of seeing. Learning the technical aspects of photography takes time and should be done step by step: once you have achieved a certain level you are ready to put these skills into use creatively. Interesting photographs need ideas behind them as well as having strong visual content and technical flair, and looking at other photographers' work is an excellent way of thinking about ideas for photographs. Technical knowledge to the photographer is a means to a visual end, something that allows better control and self-confidence in achieving what you want to say.

Basic Photography opens with a broad look at photography – putting it in context as a versatile and important medium. Then it goes on to show how photography's components, procedures and chemical processes fit together. The chapters are laid out in the same order as image production, starting with chapters on light and lenses, and proceeding through cameras, subject lighting, and composition. (These 'front end' aspects remain valid whether you use traditional photographic materials, or newer electronic methods of image capture.) The book continues with films, exposure, processing, printing, and finishing.

Many students may begin photography using digital cameras, to build up confidence in camera-handling and picture composition before progressing to more technical aspects of darkroom work. Others begin with black and white photography, processing the results themselves and learning the analogue craft skills right from the start. Reflecting both approaches, *Basic Photography* covers camera aspects of digital and analogue photography as well as the use of both colour and black and white materials, colour film processing, and black and white processing and printing. (Colour printing will be found in the companion volume, *Advanced Photography*; the history of technical and stylistic movements in photography is described in *Story of Photography*, also published by Focal Press.)

This ninth edition of *Basic Photography* will include extended information on recent developments in digital photography. Digital imagery has gone a long way towards taking over from traditional chemical-based procedures, especially in amateur photography and in the developing world. But the older processes will still be practised for their own particular qualities, just as black and white continues to be used alongside colour. Chapter 6 explains how digital cameras work, and their advantages and limitations. Research and development are still moving rapidly ahead and industry standards are being constantly updated. The use of computers to digitally manipulate pictures is now well established and many photographers never go near a darkroom, preferring digital printing techniques even when using film. This is covered in Chapter 14.

The text remains in a form that we hope is the most useful for students – either for 'dip-in' study, or sequential reading. You will find the summaries at the end of each chapter a good way of checking contents, and revising. The Glossary and Appendices at the back of the book are also very useful.

<div align="right">A.F. and R.S.S.</div>

Special thanks from Focal Press go to Michael Stern who technically checked the manuscript of this edition.

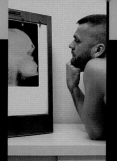

'What is photography?' may sound like an easy question to answer but the potential replies could fill this book alone. The fact that photography can mean different things to different people is part of its enduring appeal. Photography is such a part of our lives now that it would be incomprehensible to think of a world without it. We probably couldn't contemplate the fact of a wedding, watching the children grow up, or going on holiday without the camera. We are bombarded and saturated by images constantly, newspapers, magazines, advertisements, as well as the television and internet, yet we have an insatiable desire for more.

So why take photographs? What roles do photographs play in our life and relative to other forms of expression or communication? Does a photographer have responsibilities? What is actually involved? And what makes a result successful anyway? We will explore these issues and some of photography's possibilities over the course of this book, with the understanding that photography is a combination of subjective thought, creative imagination, visual design, technical skills, and practical organizing ability. Begin by taking a broad look at what making photographs is about, to put in to context and perspective your thoughts. On the one hand there is the machinery and the techniques themselves, although try not to become obsessed with the latest bit of equipment or absorbed in the craft detail too soon (Figure 1.1). On the other you have the variety of approaches to picture making – aiming for results ranging from documenting an event, or communicating ideas to a particular audience, to work which is self-expressive, socially or politically or commercially informed for the family album or perhaps more ambiguous and open to interpretation.

Why photography?

Perhaps you are drawn into photography mainly because it appears to be a quick, convenient and seemingly truthful way of *recording* something. All the importance lies in the subject itself, and you want to show objectively what it is, or what is going on (a child's first steps or a scratch on a car for insurance purposes). In this instance photography is thought of as evidence, identification, a kind of diagram of a happening. The camera is your visual notebook.

The opposite attribute of photography is where it is used to manipulate or interpret reality, so that pictures push some 'angle', belief or attitude of your own. You set up situations (as in advertising) or choose to photograph some aspect of an event but not others (as in politically biased news reporting). Photography is a powerful medium of persuasion and propaganda. It has that ring of truth when all the time it can make any statement the photographer chooses. Consider the family album for a moment: what pictures are represented here – all of family life or just the good moments?

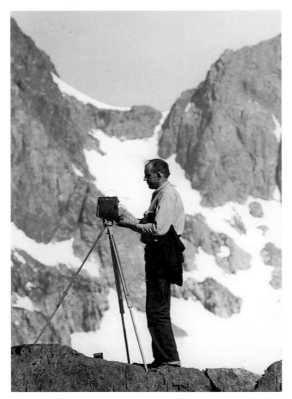

Figure 1.1 This photograph by Roland Partridge captures the great photographer Ansel Adams in the wilderness with his large format camera. Adams was at the forefront of using his technical understanding and skills to create pictures of wonder of the American landscape

Another reason for taking up photography is that you want a means of personal self-expression to explore your own ideas, concerns or issue-based themes. It seems odd that something so apparently objective as photography can be used to express, say, issues of desire, identity, race or gender, or metaphor and fantasy. We have all probably seen images 'in' other things, like reading meanings into cloud formations (Figure 1.2), shadows or peeling paint. A photograph can intrigue through its posing of questions, keeping the viewer returning to read new things from the image. The way it is presented too may be just as important as the subject matter. Other photographers simply seek out beauty, which they express in their own 'picturesque' style, as a conscious work of art.

One of the first attractions of photography for many people is the lure of the equipment itself. All that ingenious modern technology designed to fit hand and eye – there is great appeal in pressing buttons, clicking precision components into place, and collecting and wearing cameras. Tools are vital, of course, and detailed knowledge about them is absorbing and important, but don't end up shooting photographs just to test out the machinery. We must not forget either that being a photographer can be seen as a very glamorous job as well – some of the most well-known photographers are those who have taken images of famous people and become famous themselves by association.

Another attractive element is the actual *process* of photography – the challenge of care and control, and the way this is rewarded by technical excellence and a final object produced by you. Results can be judged and enjoyed for their own intrinsic photographic 'qualities', such as superb detail, rich tones and colours. The process gives you the means of 'capturing your seeing', making pictures from things around you without having to laboriously draw. The camera is a kind of time machine, which freezes any person, place or situation you choose. It seems to give the user power and purpose.

Yet another characteristic is the simple enjoyment of the visual structuring of photographs. There is real pleasure to be had from designing pictures as such – the 'geometry' of lines and shapes, balance of tone, the cropping and framing of scenes – whatever the subject content actually happens to be (Figure 1.3). So much can be done by a quick change of viewpoint, or choice of a different moment in time.

These are only some of the diverse activities and interests covered by the umbrella term 'photography'. Several will be blended together in the work of a photographer, or any one market for professional photography. Your present enjoyment in producing pictures may be mainly based on technology, art or communication. And what begins as one area of interest can easily develop into another. As a beginner it is helpful to keep an open mind. Provide yourself with a well-rounded 'foundation course' by trying to learn something of *all* these elements, preferably through practice but also by looking and reading about the work of other photographers.

Figure 1.2 Vic Muniz has made a deceptively simple photograph, a cloud in the sky. We then notice a man rowing a boat; the image was constructed in the studio from cotton wool. With reference to Alfred Stieglitz, Muniz wrote that 'the objective of a photograph is not merely a portrayal of a subject but the image of symbolic and emotional associations the formal treatment of a subject will bring to the viewer'

How photography works

Photography is to do with light forming an image, normally by means of a lens. The image is then permanently recorded either by:

- *chemical* means, using film, liquid chemicals and darkroom processes, or
- *digital* means, using an electronic sensor, data storage and processing, and print-out via a computer.

As digital methods have become readily accessible, cheaper and more ecologically sound, photographers readily combine the two – shooting on film and then transferring results into digital form for retouching and print-out. In many cases now, such as news photography, for simple quickness of use the digital route is taken.

You don't need to understand either chemistry or electronics to take good photographs of course, but it is important to have sufficient practical skills to control results and so work with confidence. The following is an outline of the key technical stages you will meet in chemical and in digital forms of photography. Each stage is discussed in detail in later chapters.

Forming and exposing an image

Most aspects of forming an optical image of your subject (in other words concerning the 'front end' of the camera) apply to both film and digital photography. Light from the subject

Figure 1.3 Terri Weifenbach's photographs are careful observations of overlooked spaces and stolen moments – backyard gardens, a bee suspended in midair, the house across the street, open fields. Through her use of saturated colour and selective focus we rediscover the wonder and lushness of nature

of your picture passes through a glass lens, which bends it into a focused (normally miniaturized) image. The lens is at the front of a light-tight box or camera with a light-sensitive surface such as film facing it at the other end. Light is prevented from reaching the film by a shutter until your chosen moment of exposure. The amount of exposure to light is most often controlled by a combination of the time the shutter is open and the diameter of the light beam passing through-the-lens. The latter is altered by an aperture, like the iris of the eye. Both these controls have a farther influence on visual results. Shutter time alters the way movement is recorded, blurred or frozen; lens aperture alters the depth of subject that is shown in focus at one time (depth of field).

You need a viewfinder, focusing screen or electronic viewing screen for aiming the camera and composing, and a light-measuring device, usually built in, to meter the brightness of each subject. The meter takes into account the light sensitivity of the material on which you are recording the image and reads out or automatically sets an appropriate combination of lens aperture and shutter speed. With knowledge and skill you can override these settings to achieve chosen effects or compensate for conditions which will fool the meter.

The chemical route

Processing. If you have used a film camera the next stage will be to process your film. A correctly exposed film differs from an unexposed film only at the atomic level – minute chemical changes forming an invisible or 'latent' image. Developing chemicals must then act on your film in darkness to amplify the latent image into something much more substantial and permanent in normal light. You apply these chemicals in the form of liquids; each solution has a particular function when used on the appropriate film. With most black and white films, for example, the first chemical solution develops light-struck areas into black silver grains. You follow it with a solution which dissolves ('fixes') away the unexposed parts, leaving these areas as clear film. So the result, after washing out by-products and drying, is a black and white *negative* representing the brightest parts of your subject as dark and darkest parts pale grey or transparent.

A similar routine, but with chemically more complex solutions, is used to process colour film into colour negatives. Colour slide film needs more processing stages. First a black and white

negative developer is used; then the rest of the film, instead of being normally fixed, is colour-developed to create a positive image in black silver and dyes. You are finally left with a positive, dye-image colour slide (Figure 1.4).

Printing negatives. The next stage of production is printing, or, more often, enlarging. Your picture on film is set up in a vertical projector called an *enlarger*. The enlarger lens forms an image, of almost any size you choose, on light-sensitive photographic paper. During exposure the paper receives more light through the clear areas of your film than through the denser parts. The latent image your paper now carries is next processed in chemical solutions broadly similar to the stages needed for film. For example, a sheet of black and white paper is exposed to the black and white film negative, and then developed, fixed and washed so it shows a 'negative of the negative', which is a positive image – a black and white print. Colour paper after exposure goes through a sequence of colour developing, bleaching and fixing to form a colour negative of a colour negative. Other materials and processes give colour prints from slides.

An important feature of printing (apart from allowing change of image size and running off many copies) is that you can adjust and correct your shot. Unwanted parts near the edges can be cropped off, changing the proportions of the picture. Chosen areas can be made lighter or darker. Working in colour you can use a wide range of enlarger colour filters to 'fine-tune' the colour balance of your print, or to create effects. With experience you can even combine parts from several film images into one print, form pictures which are part-positive, part-negative, and so on.

Colour and black and white. You have to choose between different types of film for photography in colour or black and white (monochrome). Visually it is much easier to shoot colour than black and white, because the result more closely resembles the way the subject looked in the viewfinder. You must allow for differences between how something looks and how it comes out in a colour photograph, of course (see Chapter 9). But this is generally less difficult than forecasting how subject colours will translate into tones of monochrome. Black and white is seen as less lifelike, creating a distance between the 'real' and its representation, and for this reason appeals to a number of beginners and advanced photographers alike, wrongly or rightly being considered more interpretative and subtle.

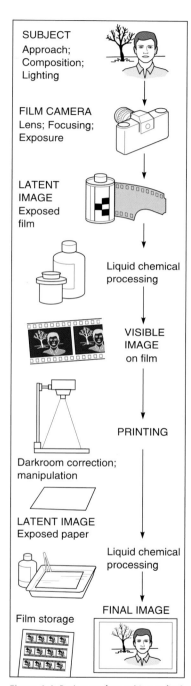

Figure 1.4 Basic route from subject to final photographic image, using film. This calls for liquid chemicals and darkroom facilities

Figure 1.5 William Eggleston is one of the early pioneers of colour photography as an art form. Before his 1976 groundbreaking and controversial show at New York's Museum of Modern Art (MoMA) colour photography was confined to advertising and product catalogues. His work has been described as 'ordinary and loaded with meaning, utterly simple and yet endlessly complex'

Colour films, papers and chemical processes are more complex than black and white. This is why it was almost a hundred years after the invention of photography before reliable colour print processes appeared. Even then they were expensive and laborious to use, so that until the 1970s photographers mostly learnt their craft in black and white and worked up to colour; there are of course exceptions to the rule such as William Eggleston (Figure 1.5). Today practically everyone takes their first pictures in colour. Most of the chemical complexity of colour photography is locked up in the manufacturers' films, papers, ready-mixed solutions and standardized processing routines. It is mainly in printing that colour remains more demanding than black and white, because of the extra requirements of judging and controlling colour balance (see *Advanced Photography*). So in the darkroom at least you will find that photography by the chemical route is still best begun in black and white.

The digital route

Capturing and storing. If you are using a digital camera, whether an SLR or a cameraphone, the exposed image is recorded on a grid of millions of microscopic-size light-sensitive elements, which is normally smaller than one frame of 35 mm film. This is known as a CCD (charge-coupled device) and is located in a similar position to film within a film camera. Immediately following exposure, the CCD reads out its captured picture as a chain of electronic signals called an image file, usually into a small digital memory card slotted into the camera body, or else directly onto the 'hard disk' of the camera, or even to a CD or DVD. (For more detailed information on the sequence of digital capture as well as the alternative CMOS sensor, refer to Chapter 6.) Images can then be viewed on a small screen on the camera and any unwanted shots can be erased. Image files are later downloaded from the card or direct from the camera into a computer, where they appear on a monitor screen or directly to a television screen. Or they can be downloaded directly to a printer without first being viewed on a computer. A rough guide to the quality and size of prints possible from a digital camera will partly depend upon the number of megapixels available. The bigger the print you want to make, the higher the number of megapixels needs to be. If you are only looking to view images on screen or email to friends and family then a 1 or 2 megapixel camera is adequate. To provide 'photo' quality prints up to 10 × 8 inches you need a 3 or 4 megapixel camera. To produce images bigger than 10 × 8 inches you need to have at least a 5 megapixel camera or higher. If selling your photographs to an image library you will need to check the minimum megapixels required as this can vary between different libraries. After downloading or

erasures you can re-use the card indefinitely for capturing new pictures (Figure 1.6).

Various image manipulation programs can be loaded into your computer, providing you with 'tools' and controls alongside the picture to crop, and alter brightness, contrast or colour, and make many other adjustments, effects and graphics. Each one is selected and activated by moving and clicking the computer mouse or by a keyboard shortcut – changes to the image appear immediately on the monitor display. Image files can be 'saved' (stored) within the computer's internal hard disk memory or on a removable disk.

Output. When you are happy with the on-screen picture, the digital file can be fed to a desktop printer – typically an inkjet or laser printer – for full colour print-out on paper of your choice. Or else, you can take your removable disk to a photo lab or machine in a shop for lightjet prints onto photographic paper.

It is possible to have digital files transferred to film and then printed in the usual way, or have prints made by commercially available print processes such as Lambda and Lightjet that are printed on traditional photographic colour paper.

Practical comparisons between making photographs by the chemical (film) route and the digital route appear in detail in Chapter 6. You will see that each offers different advantages, and there are good reasons for combining the best features of each.

Technical routines and creative choices

With technical knowledge plus practical experience (which comes out of shooting lots of photographs under different conditions) you gradually build up skills that become second nature. It's like learning to drive. First you have to consciously learn the mechanical handling of a car. Then this side of things becomes so familiar you concentrate more and more on what you want to *achieve* with the machinery, getting from A to B. Whether you work by chemical or digital means, photography involves you in a range of complementary skills. Being able to communicate your ideas to an audience is like getting from A to B and there are a few skills you need to acquire to do this in an interesting and successful way.

There are set routines where consistency is all important, for example film processing or paper processing,

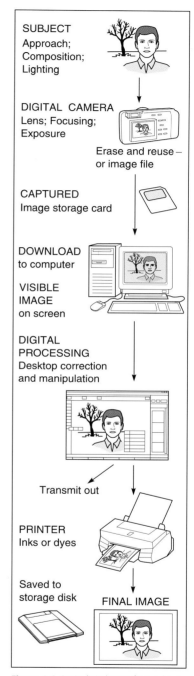

Figure 1.6 Basic digital route from subject to final image. No chemicals or darkroom are needed, and camera cards for image storage can be re-used. Images may also be digitalized from results shot on film, via a film scanner or from prints, via a flat-bed scanner

Figure 1.7 Pictures for business magazines don't have to be dull. Care over camera and figure positioning gives an eye-catching image of great simplicity. Much of Brian Griffin's work was for *Management Today* magazine

especially in colour, and the disciplines of inputting and saving digital image files. A consistency to your image-making, both technically and conceptually, will help in developing your own style. There are also those stages at which creative decisions must be made, and where a great deal of choice and variation is possible. These include organization of your subject, lighting and camera handling, as well as editing and printing the work. As a photographer you will need to handle and make these decisions yourself, or at least closely direct them.

Having more confidence about getting results, you will find that you can spend most time on developing the ideas and content as well as improving creative picture making problems such as composition, and capturing expressions and actions which differ with every shot and that have no routine solutions. However, you should still keep yourself up-to-date by looking at the work of other new and contemporary photographers, and finding out about new processes and equipment as they come along. You need to discover what new visual opportunities they offer that could help your photography, but not by slavishly following fashion for the sake of it.

Technical routines and creative choices give a good foundation for what is perhaps the biggest challenge in photography – how to produce pictures which have interesting content and meaning. Can you communicate to other people through what you 'say' visually (getting from A to B) by simple humour as in Figure 1.7 (picture by Brian Griffin) that replaces the boring corporate portrait with a more interesting use of composition and pose or by some serious comment on the human condition like that shown in Figure 1.8.

Figure 1.8 This documentary shot by Gareth McConnell was taken from a series of portraits of people living on what some might call the borders of society. It relies greatly on the photographer's ability to gain the trust of his sitter, and, by providing a non-judgemental response to communicate about their life, he accords them a dignified value and concern

Picture structuring

Composition is to do with showing things in the strongest, most effective way, whatever your subject. Often this means avoiding clutter and confusion between the various elements present (unless this very confusion contributes to the mood you want to create).

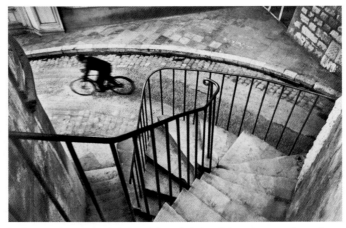

Figure 1.9 A Henri Cartier-Bresson picture strongly designed through choice of viewpoint to use line and tone, together with moment in time

The way you visually compose your pictures is as important as their technical quality. But this skill is acquired with experience as much as learnt. It involves you in the use of lines, shapes and areas of tone within your picture, irrespective of what the items actually *are*, so that they relate together effectively, with a satisfying kind of geometry (see Figure 1.9).

Composition is therefore something photography has in common with drawing, painting and the fine arts generally. The main difference is that you have to get most of it right while the subject is still in front of you, and make the best use of what is present at the time. The camera works fast, although the darkroom and computer do allow for alternative compositions. Often good composition is just about looking more carefully through the viewfinder. How many times have you seen a photograph with people's feet cut off or a flowerpot growing out of someone's head?

We have all heard that 'rules are there to be broken', as they encourage results which slavishly follow them but offer nothing else besides. As Edward Weston once wrote: 'Consulting rules of composition before shooting is like consulting laws of gravity before going for a walk.' Of course it is easy to say this when you already have an experienced eye for picture making, but guides are helpful if you are just beginning (see Chapter 8). Practise making critical comparisons between pictures that structurally 'work' and those that do not. Discuss these aspects with other people, both photographers and non-photographers.

Where a subject permits, it is always good advice to shoot several photographs – perhaps the obvious versions first, then others with small changes in the way items are juxtaposed, etc., increasingly simplifying and strengthening what your image expresses or shows. You need to get used to moving your body more when taking a photograph; all too often people will simply stand in front of a subject and shoot from eye level. Get down low, move to the side, hang from a tree! You will be surprised how much small movements can dramatically change the composition. It's your eye that counts here more than the camera (although some cameras get far less in the way between you and the subject than others).

Composition can contribute greatly to the style and originality of your pictures. Some photographers (Garry Winogrand, for example: Figure 1.10) go for offbeat constructions which

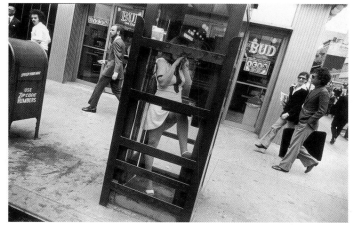

Figure 1.10 Garry Winogrand's street scene (*Woman in a Phone Booth*, New York, 1968) appears spontaneous and dramatic in composition and timing. However, it purposely expresses an offbeat strangeness, capturing the atmosphere of the city, demanding repeated viewings

add to the weirdness of picture contents. Others, like Arnold Newman and Henri Cartier-Bresson, are remembered for their more formal approach to picture composition.

Composition in photography is almost as varied as composition in music or words and can enhance subject, theme, and style. Good composition will help the audience to 'read' the photograph in the way you intended, communicating your ideas in a successful way. Every photograph you take involves you in some compositional decision, even if this is simply where to set up the camera or when to press the button.

The roles photographs play

There is little point in being technically confident and having an eye for composition, if you do not also understand *why* you are taking the photograph. An example of bringing together the technical understanding of photography and the power of photography to move people can be found in the work of photographer Joel Meyerowitz, Figure 1.11. However, the purpose may be simpler – a record of something or somebody for identification. It may be more ambiguous – a subjective picture putting over the concept of security (Figure 1.12), happiness or menace, for example. No writer would pick up a pen without knowing whether the task is to produce a data sheet or a poem. Yet there is a terrible danger with photography that you set up your equipment, busy yourself with focus, exposure and composition, but think hardly at all about the meaning of your picture and why you should show the subject in that particular way.

People take photographs for all sorts of reasons of course. Most are as reminders of vacations, or family and loved ones. These fulfil one of photography's most valuable social functions, freezing moments in our own history for recall in years to come.

Sometimes photographs are taken to show tough human conditions and so appeal to the consciences of others. Here you may have to investigate the subject in a way which in other circumstances would be called prying or voyeurism. This difficult relationship with the *subject*

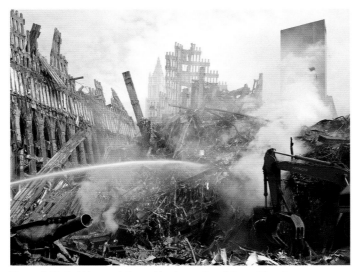

Figure 1.11 Joel Meyerowitz's considered recording of Ground Zero demonstrates the changing role of photography in reporting the news, which is now dominated by constant rolling 24-hour news broadcast on television and the internet. Photography often offers us a post-event contemplation of the action

Figure 1.12 Christopher Stewart photographs people working in the security industry for his series *Insecurities*, using traditional documentary practice, but at the same time, through the careful selection and editing of images, appropriates the codes and conventions of the staged photograph

has to be overcome if your final picture is to win a positive response from the *viewer*.

Understanding the best approach to the subject to create the right reaction from your target audience is also vital in photographs that advertise and sell. Every detail in a set-up situation must be considered with the message in mind. Is the location or background of a kind with which consumers positively identify? Are the models and the clothes they are wearing too up- (or down-) market? Props and accessories must suit the lifestyle and atmosphere you are trying to convey. Generally viewers must be offered an image of themselves made more attractive by the product or service you are trying to sell. In the middle of all this fantasy you must produce a picture structured to attract attention; show the product; perhaps leave room for lettering; and suit the proportions of the showcard or magazine page on which it will finally be printed.

News pictures are different again. Here you must often encapsulate an event in what will be one final published shot. The moment of expression or action should sum up the situation, although you can colour your report by choosing what, when, and from where you shoot. Until recently there was a long-held assumption that photographers are impartial observers, documenting events as they unfold. Reality is somewhat different, for no-one can be completely impartial. Photographers have their own beliefs (social, cultural, political or religious) and prejudices.

Photograph a demonstration from behind a police line and you may show menacing crowds; photograph from the front of the crowd and you show suppressive authorities. You have a similar power when portraying the face of, say, a politician or a sportsperson. Someone's expression can change between sadness, joy, boredom, concern, arrogance, etc., all within the space of a few minutes. By photographing just one of those moments and labelling it with a caption reporting the event, it is not difficult to tinker with the truth; therefore the photographer has a responsibility of acknowledging their own beliefs and bias.

These subtle distinctions demonstrate how photographers have always manipulated the viewer. The ease by which digital manipulation can now add or remove picture elements seamlessly, described in Chapter

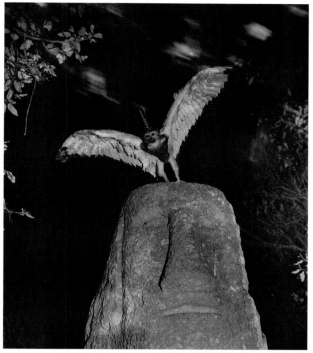

Figure 1.13 Joan Fontcuberta plays with the codes and conventions of different institutions of photography to make his 'Fictions'. From the series *Fauna*, this photograph of a constructed animal is shot as if caught in flight, suggested by the blurring movement of the tree, to replicate the photography of early explorers bringing their trophies back for the museum

14, has farther put to rest the old adage, which was never true in the first place, of 'photographic truth' and 'the camera cannot lie' (Figure 1.13).

Photography can provide information in the kind of pictures used for training, medicine, and various forms of scientific evidence. Here you can really make use of the medium's superb detail and clarity, and the way pictures communicate internationally, without the language barrier of the written word. However, again the history of photography is full of examples of 'scientific' images manipulated to provide evidence of the photographer's beliefs. Certain photography in the late nineteenth and early twentieth century, for example, was used to provide evidence that human traits were defined in the facial features of individuals, and the criminal, homosexual, diseased and mentally ill were subjected to the controlling gaze of the photographic lens (see Figure 1.14). The purpose of this was that they could be easily identified and removed from society to one form of institution or another, and you would then be left with a 'pure' race.

Today there are still certain types of photography that are based on difference, often visitors photographing in exotic places on holiday – the cute little Indian beggar boy or an African tribesperson – or even closer to home, the homeless. These and a number of other subject matters, such as windows and doors, forms of decay such as graveyards, scrapyards and even graffiti, enthral the photographer for one reason or another. As someone new to photography you will have to negotiate your way through the obvious and understand how you can define why you are taking photographs.

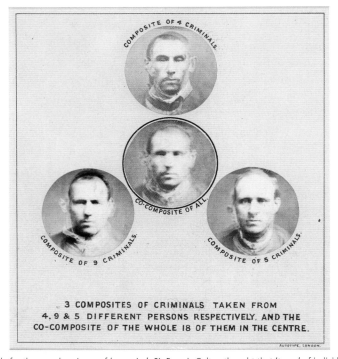

Figure 1.14 Responsible for the pseudo-science of 'eugenics', Sir Francis Galton thought that 'types' of individuals could be predetermined through facial characteristics. Composites are made by the layering of underexposed negatives on top of each other, as in this 1882 example of 'criminals', so that the resulting image would show the strongest common features. Therefore we do not have a photograph of a 'real' person but the composite of different people

At another level, entirely decorative photographs for calendars or editorial illustration (pictures which accompany magazine articles) can communicate beauty for its own sake – beauty of landscape, human beauty, and natural form or beauty seen in ordinary, everyday things (Figure 1.15). Beauty is a very subjective quality, influenced by attitudes and experience. But there is scope here for your own way of seeing and responding to be shown through a photograph that produces a similar response in others. Overdone, it easily becomes 'cute' and cloying, overmannered, clichéd and self-conscious.

Photographs are not always intended to communicate with other people, however; you might be looking for self-fulfilment and self-expression, and it may be a matter of indifference to you whether others read information or messages into your results – or indeed see them at all. Some of the most original images in photography have been produced in this way, totally free of commercial or artistic conventions, often the result of someone's private and personal obsession. You will find examples in the photography of Jo Spence, Diane Arbus, Nan Goldin, Wolfgang Tillmans, Joel-Peter Witkin, Hans Bellmer or Bernd and Hilla Becher.

There are many other roles photographs can play: mixtures of fact and fiction, art and science (Figure 1.16), communication and non-communication. Photography has played a major role in defining some artist movements such as surrealism (see Figure 1.17) where a play on the real or presumed objective nature of photography is used to startling effect. Remember too that a photograph is not necessarily the last link in the chain between subject and viewer. Editors,

Figure 1.15 Fashion shoot for *i-D* magazine by Jason Evans of a Helmut Lang tie. The basic graphic quality of a simple composition and the detail and tone range offered by 'straight' photography strengthen the subject's own qualities of pattern and form

art editors and exhibition organisers all like to impose their own will on the final presentation. Pictures are cropped, captions are written and added, layouts place one picture where it relates to others. Any of these acts can strengthen, weaken or distort what a photographer is trying to show. You are at the mercy of people 'farther down the line'. They can even sabotage you years later, by taking an old picture and making it do new tricks.

Changing attitudes towards photography

Today, photography is more popular in art than ever before, but an awareness and acceptance of photography as a creative medium by other artists, galleries, publishers, collectors and the general public has not been won easily. People's views as to what photography can and can't do or for and against photography as art have varied enormously in the past, according to the fashions and attitudes of the times, and photography has had different roles since its invention. For a great deal of the nineteenth century (photography was officially invented in 1839: See Appendix G for a timeline of events leading up to the invention of photography and important dates), photographers were often seen as a threat by painters, who never failed to point out in public that these apparently crass interlopers had no artistic ability or knowledge. To some extent this was true – you needed to be something of a chemist to get results at all; but a knowledge of art also helped with composition, lighting and so on.

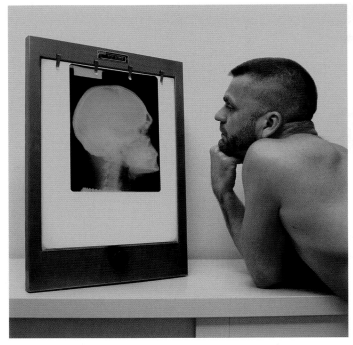

Figure 1.16 The Thinker. This double self-portrait uses the material of medical examination but re-presents it to the audience as an art object, questioning the relationship between doctor and patient

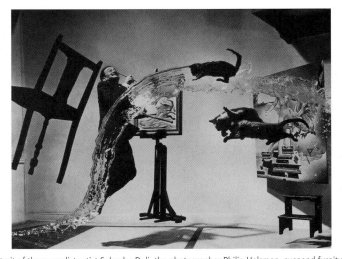

Figure 1.17 In this portrait of the surrealist artist Salvador Dali, the photographer Philip Halsman, suspend furniture on wires then threw cats and water into the air while Dali jumped into the mix. The shot required over 20 'takes' before Halsman was satisfied with the result. The wires were then retouched out and Dali painted cat legs and water out the canvas to match the composition of the photograph

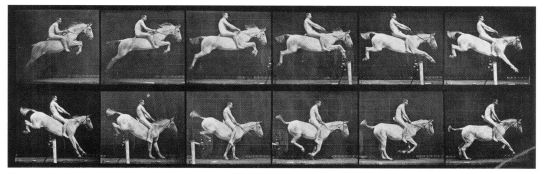

Figure 1.18 Frozen action. Eadweard Muybridge uses the camera for his motion studies (1886) as a form of scientific discovery to reveal something too brief for the human eye alone to see

Art and documentation

In the first half of the nineteenth century several people tried to perfect photography, inventing different processes and techniques, but all had similar goals: to produce the most realistic and detailed pictures by fixing the image created inside a camera, and by making what are now called 'photograms' (see Chapter 13). The first photographs were regarded as miraculous and praised for their beauty and detail; they also required lots of skill and knowledge to produce (see Figure 1.18).

By the end of the nineteenth century, equipment and materials had become somewhat easier to handle, and photography had spread all around the world and was being put to use for artistic purposes and to document people, places and things. Early in the twentieth century, snapshot cameras and developing and printing services for amateurs, made black and white photography an amusement for the masses. Some 'serious' photographers felt the need to distance themselves from all this and gain acceptance as artists, so they tried to force the medium closer to the appearance and functions of paintings of the day. These photographers were also attempting to recapture the 'hand-made' feel of early photographs at a time when photographs were becoming mass-produced machine products. They called themselves 'pictorial' photographers, shooting picturesque subjects, often through soft-focus camera attachments, and printing on textured paper by processes which eliminated most of photography's 'horrid detail' (see Figure 1.19).

Other photographers were more interested in photography as a new and modern way of producing images, and focused on what they thought photography could do better than other, traditional, forms of representation. They utilized new techniques for mechanically reproducing photographs on the printed page and were influenced by new popular culture (such as film and picture magazines) and by modern art as it became increasingly abstract. Photographers saw painters concentrating on the particular qualities of painting (surface, texture, and so on) and decided to concentrate on what photography could do, instead of trying to make pictures that looked like paintings. As a reaction to pictorialism, 'straight' photography came into vogue early in the twentieth century in Europe and America with the work of photographers such as Walker Evans, Paul Strand (see Figure 1.20) and Albert Renger-Patzsch. They made maximum use of the qualities of black and white photography that were previously condemned as artless: pin-sharp focus throughout, rich tonal scale and the ability to shoot simple everyday subjects using natural lighting and transform them into

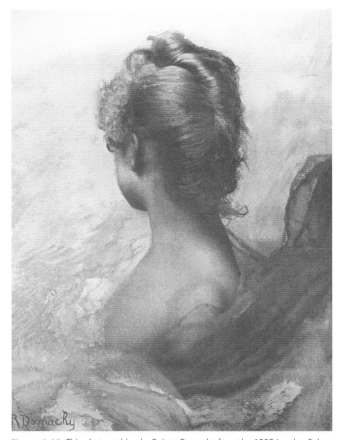

Figure 1.19 This photo etching by Robert Demachy from the 1895 London Salon is an example of pictorial (or 'picturesque') subject and style. Demachy made his prints by the gum bichromate chemical process, which gives an appearance superficially more like an impressionist painting than a photograph

beautiful pictures. Technical excellence was all important and strictly applied. Photography had developed an aesthetic of its own, something quite separate from painting and other forms of fine art. This aesthetic was pursued by photographers such as Edward Weston, Ansel Adams and Imogen Cunningham (see Figure 1.21) and their sharply focused studies of details and textures set the standards for art photography until the 1960s.

The advent of photographs mechanically printed into newspapers and magazines opened up the market for press and candid photography. Pictures were taken for their action and content rather than any greatly considered treatment. This and the freedom given by precision hand-held cameras led to a break with age-old painterly rules of composition.

The 1930s and 1940s were the great expansion period for picture magazines and photo-reporting, before the emergence of television. They also saw a steady growth in professional aspects of photography: advertising; commercial and industrial; portraiture; medical; scientific and aerial applications. Most of this was still in black and white. Use of colour gradually grew during the 1950s but it was still difficult and expensive to reproduce well in publications.

New approaches in the 1960s and onwards

Rapid, far-reaching changes took place during the 1960s. From something which a previous generation had regarded as an old-fashioned, fuddy-duddy trade and would-be artistic occupation, photography became very much part of the pop culture and consumerism that had boomed since the Second World War. New small format precision SLR cameras, electronic flash, machines and custom laboratories to hive off boring processing routines, not to mention an explosion of fashion photography, all had their effect. Photography captured the public imagination.

Figure 1.20 Pin-sharp focus throughout, rich tonal scale and the ability to shoot simple everyday subjects using natural lighting and transform them into beautiful pictures were the aesthetics of modernist photographers such as Paul Strand

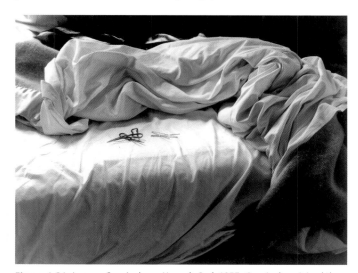

Figure 1.21 Imogen Cunningham, *Unmade Bed*, 1957. Cunningham joined the band of enthusiastic photographers founded by Ansel Adams and Willard Van Dyke in 1934 under the name of 'Group f/64'. Ansel Adams said that the group should be made up of 'those workers who are striving to define photography as an art form by a simple and direct presentation through purely photographic methods'

Young people suddenly wanted to own a camera, and use it to express themselves and depict the world around them. The new photographers were interested in contemporary artists, but neither knew nor cared about the established photographic clubs and societies with their stultifying 'rules' and narrow outlook on the possibilities of photography. As photographs had become so universal in people's contemporary lifestyle they became integrated with modern painting, printmaking, even sculpture, and a generation of young artists that included Bruce Nauman, Robert Smithson and Ed Ruscha (see Figure 1.22) began using photography as just another of the tools available to them. They saw photography very differently from the art photographers that had come before them and were less interested in the crafts of photography, enjoying its quickness, its ability to capture events and performances, and the fact that it seemed to be part of the everyday world of popular culture, not art.

Photography began to be taught in schools and colleges, especially art colleges, where it had been previously downgraded as a technical subject. America led the way in setting up photographic university degree courses, and included it in art and design, social studies and

RIMMY JIM'S CHEVRON, RIMMY JIM'S, ARIZONA

ENCO, TUCUMCARI, NEW MEXICO

HUDSON, AMARILLO, TEXAS

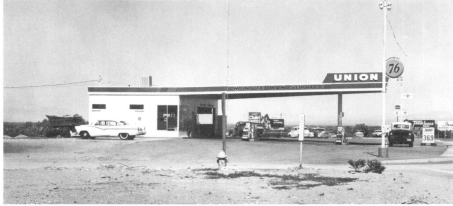

UNION, NEEDLES, CALIFORNIA

Figure 1.22 These images are taken from Ed Ruscha's seminal book *Twenty Six Gasoline Stations*, which was a milestone in the history of photography and pop art. He said about the photographs 'I was after that kind of blank reality that the subject matter would present. I was met with a little scepticism from some people and usually those people were more intellectual... but someone who worked in a gasoline station would say "Hey, this is great!"

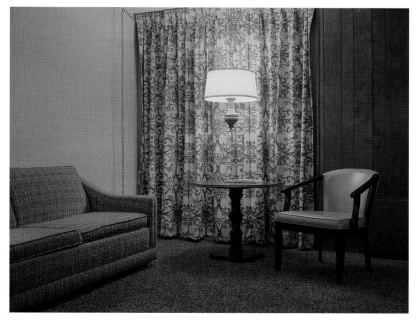

Figure 1.23 Stephen Shore was one of the earliest photographers to use colour photography as an art form with exhibitions in major museums and is known for a series of cross-country trips, making 'on the road' photographs of American and Canadian landscapes

communications. Nevertheless, few one-person portfolios of photographs had been published with high quality reproduction in books. It was also extremely rare for an established art gallery to sell or even hang photographs, let alone public galleries to be devoted to photography. As a result it was difficult for the work of individuals to be seen and become well known. Even magazines and newspapers sometimes failed to credit the photographer alongside his or her work, whereas writers always had a published credit.

By the 1970s, though, all this had changed. Adventurous galleries put on photography shows which were increasingly well attended. Demand from the public and from students on courses encouraged publishers to produce a wide range of books showcasing the work of individual photographers. Creative work began to be sold as 'fine prints' in galleries to people who bought them as investments. Older photographers such as Bill Brandt, Minor White and Andre Kertesz were rediscovered by art curators, brought out of semi-obscurity, and their work exhibited in international art centres, whilst photographers such as William Eggleston (see Figure 1.5) and Stephen Shore (see Figure 1.23) became the first to exhibit colour photographs in major museums.

The 1980s brought colour materials which gave better quality results and were cheaper than before. Colour labs began to appear, offering everyone better processing and printing, plus quicker turnaround. The general public wanted to shoot in colour rather than black and white, and gradually colour was taken up by artist photographers too. Colour became cheaper to reproduce on the printed page; even newspapers started to use colour photography. Around this time it also became possible to produce large-scale colour photographs, prompting a new generation of artist photographers to create images that were closer to the size of Old Master paintings, billboard adverts and cinema screens than to the book or magazine pages and small

prints more commonly associated with photography.

Today the availability of less daunting, user-friendly camera equipment combined with a much bigger public audience for photography encourages a broad flow of pictures. Galleries, books and education have brought greater critical discussion of photographs – how they communicate meanings through a visual language of their own. There are now so many ways photography is used by different individuals that it is becoming almost as varied and profound as any other art. In fact, today, photography is everywhere and it is part of almost every aspect of our contemporary lives. Digital cameras, scanners and the internet have made it possible to distribute photographs more widely and faster than ever before, and photography continues to expand as technologies and ideas change. A greater understanding of the languages of photography and the advent of new technologies has encouraged a wider appreciation of photography as a medium that documents the world and is expressive at the same time.

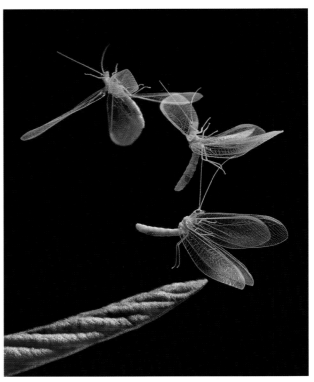

Figure 1.24 Lacewing taking off. A rapid sequence of three ultra-fast flash exposures made on one frame and shot in a specially devised laboratory set-up, by Stephen Dalton. Time-and-action record photography provides unique subject information for natural history and education, see also Figure 1.18

Personal styles and approaches

The 'style' of your photography will develop out of your own interests and attitudes, and the opportunities that come your way. For example, are you mostly interested in people or in objects and things you can work on without concern for human relationships? Do you enjoy the split-second timing needed for action photography (see Figure 1.24), or prefer the slower, more soul-searching approach possible with landscape or still life subjects?

If you aim to be a professional photographer you may see yourself as a generalist, handling most photographic needs in your locality. Or you might work in some more specialised area, such as natural history, police forensics, scientific research or medical photography, combining photography with other skills and knowledge. Some of these applications give very little scope for personal interpretation, especially when you must present information clearly and accurately

to fulfil certain needs. There is greatest freedom in pictures taken by and for yourself. Here you can best develop your own visual style, provided you are able to motivate and drive yourself without the pressures and clear-cut aims present in most professional assignments. However, by building your own distinctive portfolio of photographs the aim is that you will become more successful, in the long run, as you are able to provide new and interesting ideas for clients rather than rehash what is already available in the marketplace.

Style is difficult to define, but recognizable when you see it. Pictures have some characteristic mix of subject matter: mood (humour, drama, romance, etc.), treatment (factual or abstract), use of tone or colour, composition ... even the picture proportions. Technique is important too, from choice of lens to form of print presentation. But more than anything else style is to do with a particular way of *seeing*.

A word of caution; style over content is never advisable in any professional assignment, whether as a commercial or a fine art photographer. Many photographers have found themselves trapped by being defined as 'such-and-such' a photographer and lose the initial enjoyment that brought them to photography in the first place, when forced to repeat the work they are best known for by yet another client.

Content and meaning

Your approach to photography can be enhanced by looking at the work of others but it comes out of doing, refined down over a long period to ways of working which best support the things *you* see as important and want to show others. It must not become a formula, a mould which makes everything you photograph turn out looking the same. The secret is to coax out the essence of each and every subject, without repeating yourself. People should be able to recognize your touch in a photograph but still discover things unique to each particular subject or situation by the way you show them.

In personal work the content and meaning of photographs can be enormously varied. A major project, '21st Century Types' by Grace Lau, explores identity and how people in one part of the world view people in another. Lau set up a studio in Hastings, South East England, to photograph passers by and explore connections between China and Europe by using found props. Regarding Figure 1.25 Lau says she is '*making an oblique comment on Imperialist visions of the "exotic" Chinese and by reversing roles, I have become the Imperialist photographer documenting my exotic subjects in the "Port" of Hastings.*'

Katy Grannan's striking portraits examine the desire of her subjects to offer themselves up to the camera lens. Her early series (see Figure 1.26) are portraits of strangers Grannan met through newspaper advertisements. Her pictures are not documentary but staged. Her people are posed, and content and meaning are based on acute observation and meticulous planning. The landscapes and neighbourhoods of her photographs were informed by her own experience living in the American Northwest, and when photographing models in their own surroundings Grannan pays meticulous attention to the elements of each domestic setting, highlighting the mundane but often telling details. The subjects choose to remain clothed or model nude, working with Grannan to arrive at a pose resulting in an image that maintains a delicate, yet increasingly charged, sense of intimacy.

Many other contemporary photographers have gone to extremes to create staged images that look real, such as Jeff Wall (see Figure 14.1), Hannah Starkey or Gregory Crewdson,

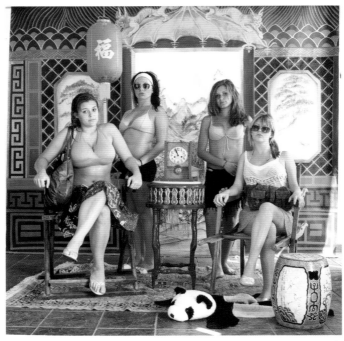

Figure 1.25 Photographer Grace Lau draws upon research looking at photographs taken in China between the decades from the Opium Wars to the Boxer Rebellion in which Victorian colonialists recorded the Chinese in studio portraits, and missionaries and scientists documented their subjects and categorised 'types'. In a role-reversal, she constructed a Chinese portrait studio in Hastings and photographed twenty-first century 'types' of exotic tourists and locals

creating tableaux (pictures of constructed events), where the subject has been replaced with actors or whole sets (re)created to look as if real locations. Although the tableau has a long history, the constructed photograph has existed since the invention of photography.

Victorians like Julia Margaret Cameron (see Figure 1.27) and H. P. Robinson produced many photographs narrating stories. This 'staged' approach has always of course been present in movies, and in most fashion and advertising still photography.

Sometimes the content of personal work is based on semi-abstract images in which elements such as colour, line and tone are more important than what the subject actually *is*. Meaning gives way to design and the photographer picks subjects for their basic graphic content which he or she can mould into interesting compositions, although in other hands even the simplest images of shape and form can carry meaning, as in Figure 1.28 where the image doesn't show any detail but suggests a relationship between photography and memory.

Look at collections of work by well-known photographers (single pictures, shown in this book for example, cannot do them justice): Henri Cartier-Bresson's love of humanity, gentle humour and brilliant use of composition (see Figure 1.9); Hiroshi Sugimoto's austere and highly refined presentation of seascape (see Figure 1.29); or Robert Demachy's romantic pictorialism (see Figure 1.19). Cindy Sherman, Jeff Wall, Martin Parr, Keith Arnatt and Mari Mahr are photographers who each have dramatically different approaches to content and meaning. Their work is distinctive, original, and often obsessional.

Figure 1.26 Katy Grannan photographs strangers but, for a brief time, she and they become intimate strangers, mirroring each other's motivations and creating a drama that draws us in as the viewer and gives us a prominent role to play. These are encounters that supersede the so-called documentary impulse in photography

In the fields of scientific and technical illustration the factual requirements of photography make it less simple to detect individuals' work. But even here high-speed photography by Dr Harold Edgerton (see Figure 1.30), the motion studies of Eadweard Muybridge (Figure 1.18) and medical photography by Prof. Dr Killian stand out, thanks to these experts' concern for basic visual qualities too.

Measuring success

There is no formula that can judge the success of a photograph. We are all in danger of 'wishful seeing' in our own work, reading into pictures the things we *want* to discover, and recalling the difficulties overcome when shooting rather than assessing the result as it stands. Perhaps the easiest thing to judge is technical quality, although even here 'good' or 'bad' may depend on what best serves the mood and atmosphere of your picture.

Most commercial photographs can be judged against how well they fulfil their purpose, since they are in the communications business. A poster or magazine cover image, for example, must be striking and give its message fast. But many such pictures, although clever, are shallow

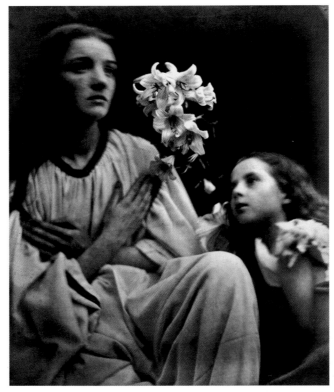

Figure 1.27 Portrait of Mary Ryan 'Study after the manner of Francia' 1865 by Julia Margaret Cameron. Who was particularly adept in using long exposures, soft focus and atmospheric lighting conditions to create powerful portraits and allegories. She is recognised as one of the most experimental and influential photographers of the nineteenth century

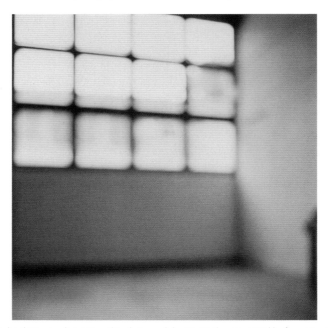

Figure 1.28 Ground #70: bordering on abstraction, this photograph by Uta Barth was created by focusing at a close distance, leaving the background as an ambiguous blur, to foreground the activity of looking and question how we look at familiar spaces. While not addressing the literal subject matter of the image but rather vision itself, Barth's photography can have the effect of making the overlooked and everyday beautiful

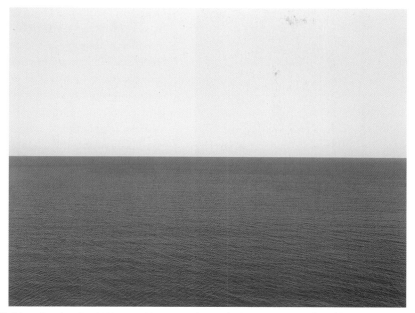

Figure 1.29 *Caribbean Sea, Jamaica*, 1980, a graphic seascape by Hiroshi Sugimoto, ignores the golden rules of composition but offers a black and white interpretative image of great simplicity. It was seen and photographed straight but printed with very careful control of tonal values

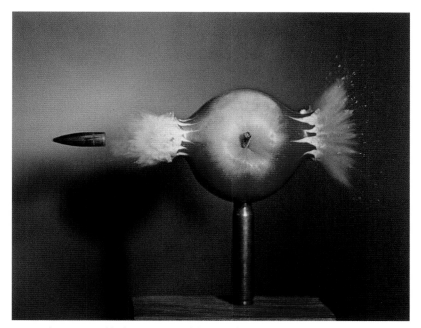

Figure 1.30 Inventor and artist Dr Harold Edgerton pioneered the strobe flash, stop-action photography and a method of taking super-fast images called Rapatronic. His image *Bullet Through Apple* was taken in 1964 with flash duration of about a millionth of a second

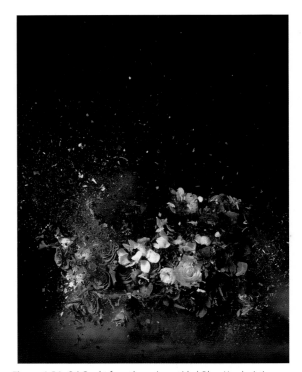

Figure 1.31 Ori Gersht from the series entitled *Blow Up*, depicting elaborate floral arrangements, based upon a nineteenth century still life painting, at the moment of exploding using a digital process, which captures each shattering still life at a speed of 1/6000th of a second. Gersht explores questions concerning optical perception, the conception of time and the relationships between the photographic image and objective reality

and soon forgotten. There is much to be said for other kinds of photography in which ambiguity and strangeness challenge you, allowing you to keep discovering something new. This does not mean you have to like everything which is offbeat and obscure but by looking you should be able to develop your ability for critical analysis.

Reactions to photographs change with time too. Live with your picture for a while (have a pinboard wall display at home), otherwise you will keep thinking your latest work is always the best. Similarly it is a mistake to surrender to today's popular trend; it is better to develop the strength of your own outlook and skills until they gain attention for what they are. Just remember that although people say they want to see new ideas and approaches, they still tend to judge them in terms of yesterday's accepted standards.

A great deal of professional photography is sponsored, commercialized art in which success can be measured financially. Personal projects allow most adventurous, avant-garde picture making – typically to express preoccupations and concerns. Another route is that of the academic who is enabled by his or her institution to pursue their own practice, normally termed as research, alongside their teaching and administrative duties (see Figure 1.31). They like other artists may also be supported by grants and funding from a diverse range of awarding bodies, which is another way of measuring success. Artistic success is then measured in terms of the enjoyment and stimulus of making the picture, and satisfaction with the result. Rewards come as work published in its own right or exhibited on a gallery wall. Extending yourself in this way often feeds commercial assignments too. So the measure of true success could be said to be when you do your own self-expressive thing, but also find that people flock to your door to commission and buy this very photography.

SUMMARY

■ Photography is a *medium* – a vehicle for communicating facts or fictions, and for expressing ideas. It requires craftsmanship and artistic ability in varying proportions.

■ Technical knowledge is necessary if you want to make full use of your tools and so work with confidence. Knowing 'how' frees you to concentrate on 'what' and 'why' (the photograph's content and meaning).

■ Always explore new processes and equipment as they come along. Discover what kinds of image they allow you to make.

■ Traditionally in photography the image of your subject formed by the camera lens is recorded on silver halide coated film. Processing is by liquid chemicals, working in darkness.

■ Technological developments allow us the option of capturing the lens image by electronic digital means. Results can also be manipulated digitally, using a computer. You don't need chemicals or a darkroom.

■ Visually, camera work in colour is easier than black and white. Colour is more complex in the darkroom.

■ Photography records with immense detail, and in the past had a reputation for being essentially objective and truthful. But you can use it in all sorts of other ways, from propaganda to 'fine art' self-expression.

■ Taking photographs calls for a mixture of: (a) carefully followed routines and craft skills, to control results, and (b) creative decisions about subject matter and the intention of your picture.

■ Photographs can be enjoyed/criticized for their *subject content*, or their *structure*, or their *technical qualities*, or their *meaning*, individually or together.

■ The public once viewed photography as a stuffy, narrow pseudo-art, but it has since broadened into both a lively occupation and a creative medium, exhibited everywhere.

■ Developing an eye for composition helps to simplify and strengthen the point of your picture. Learn from other photographers' pictures but don't let their ways of seeing get in the way of your own response to subjects. Avoid slavishly copying their style.

■ Success might be gauged from how well your picture fulfils its intended purpose. It might be measured in technical, financial or purely artistic terms, or in how effectively it communicates to other people. In an ideal world all these aspects come together.

When you are working on projects it is helpful to maintain your own visual notebook. This might be a mixture of scrapbook and diary containing written or sketched ideas for future pictures, plus quotes and work by other photographers, writers or artists which you want to remember (add notes of your own). It can also log technical data, lighting diagrams and contact prints relating to shots planned or already taken.

The projects below can be completed in either written or verbal (discursive) form, but they must include visual material such as prints, photocopies or slides.

1 Find and compare examples of *people photographs* which differ greatly in their function and approach. Some suggested photographers: Cecil Beaton, Diane Arbus, Yousuf Karsh, Dorothea Lange, Elliott Erwitt, Julia Margaret Cameron, August Sander, Martin Parr, Cindy Sherman, Nan Goldin, Bettina von Zwehl.

2 Compare the landscape work of three of the following photographers, in terms of their content and style: Ansel Adams, Franco Fontana, Bill Brandt, Alexander Keighley, Joel Meyerowitz, Fay Godwin, John Blakemore, John Davies, Dan Holdsworth, Hiroshi Sugimoto, Joel Sternfeld.

3 Looking through newspapers, magazines, books, etc., find examples of photographs: (a) which purport to provide objective, strictly factual information; and (b) which strongly express a particular point of view, either for sales promotion or social or political purposes. Comment on their effectiveness.

4 Shoot four examples of photographs in which picture *structure* is more important than actual subject content. In preparation for this project look at work by some of the following photographers: Ralph Gibson, André Kertesz, Lee Friedlander, Paul Strand, Laszlo Moholy Nagy, Barbara Kasten, Karl Blossfeldt.

5 Find published photographs which are *either*: (a) changed in meaning because of adjacent text or caption, or by juxtaposition with other illustrations; *or* (b) changed in significance by the passing of time.

6 Find, compare and analyse how different artists have used photography, looking at surrealism, constructivism and performance art as a starting point.

PROJECTS

2 Light: how images are formed

You don't have to understand physics to take good photographs, but understanding how light behaves and how lenses form it into images gives you a broader view of the possibilities of photography. The principles involved are very simple and easily demonstrated.

We start with light as it is the very essence, the basic substance of photography. What precisely is light, and which of its basic features are helpful to know when you are illuminating a subject, using lenses and learning about colour? From light and colour we go on to discuss how surfaces and subjects look the way they do, and how light can be bent (refracted) with glass to create a usable image.

The lens is the heart of any camera or enlarger. Starting with a simple magnifying-glass lens you can begin to see how photographic lenses form images. Later this will lead us on to other key components of camera equipment and allow us to understand what is important in making high quality photographs.

Light itself

Light is fundamental to seeing and making images. The word 'photography' itself means 'drawing with light'. Yet we are so familiar with light we almost take it for granted. Light is something your eyes are sensitive to, just as your ears relate to sound and your tongue to taste. Light translates the world for us to view through our eyes. Using light selectively you can show up selected aspects of a subject in front of the camera, and suppress others. Visual information is transmitted as modulated light via the camera lens onto photographic material, and light reflected from the final result, (the print), allows us to see and appreciate it. At this moment light reflected off this page carries the shape of words to your eyes, just as sound would form the link if we were talking. But what exactly *is* light?

Visible light is a stream of energy radiating away from the sun or similar radiant source. It has four important characteristics:

Figure 2.1 Light travels on a straight-line path but as if in waves, like the outward movement of ripples when a smooth water surface is disturbed

1 Light behaves as if it moves in waves, like ripples crossing the surface of water (Figure 2.1). Variations in wavelengths give our eyes the sensation of different colours.

Figure 2.2 Light travels in straight lines, shown clearly in this picture of a late summer evening, the light shining through the people makes its direction very visible

2 Light travels in a straight line (within a uniform substance or medium). You can see this in light 'beams' and 'shafts' of sunlight, (Figure 2.2), and the way that shadows fall.

3 Light moves at great speed (approximately 300,000 kilometres or 186,000 miles per second through the vacuum of space). It moves less fast in air, and slightly slower still in denser substances such as water or glass.

4 Light also behaves as if it consists of energy particles or 'photons'. These bleach dyes, cause chemical changes in films and electronic response in digital camera sensors, etc. The more intense the light, the more photons it contains.

Wavelengths and colours

What we see as light is just part of an enormous range of 'electromagnetic radiations'. As shown in Figure 2.3, this includes radio waves with wavelengths of hundreds of metres through to gamma and cosmic rays with wavelengths of less than ten thousand-millionths of a millimetre. Each band of electromagnetic radiation merges into the next, but has its own special characteristics. Some, such as radio, can be transmitted over vast distances. Others, such as X-rays, will penetrate thick steel, or destroy human tissue. Most of this radiation cannot be 'seen' directly by the human eye, however. Our eyes are only sensitive to a narrow band between wavelengths 400 nm and 700 nm approximately. (A nanometre or nm is one millionth of a millimetre.) This limited span of wavelengths is therefore known as the *visible spectrum*.

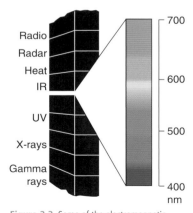

Figure 2.3 Some of the electromagnetic spectrum (left), and the small part of it forming the visible spectrum of light (enlarged, right). Mixed in roughly the proportions shown in colour here, the light appears 'white'

When a relatively even mixture of all the visible wavelengths is produced by a light source the illumination looks 'white' and colourless. But if only some wavelengths are present the light appears coloured. For example, in Figure 2.3, wavelengths between about 400 nm and 450 nm are seen as dark purple-violet. This alters to blue if wavelengths are changed to 450–500 nm. Between 500 nm and 580 nm the light appears to be more blue-green, and from about 580 nm to 600 nm we see yellow. The yellow grows more orange if the light wavelengths become longer; at 650 nm it looks red, becoming darker as the limit of response is reached at 700 nm. So the colours of the spectrum – violet, blue, green, yellow and red – are really all present in different kinds of white light (sunlight, flash or studio lamps for example) (Figure 2.4).

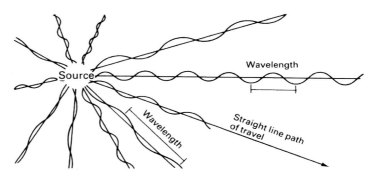

Figure 2.4 Most sources of light produce a mixture of wavelengths, differing in colour and expressed here in very simplified form

The human eye seems to contain three kinds of light receptors, responding to broad overlapping bands of blue, green and red wavelengths. When all three receptors are stimulated equally by something you see, you tend to experience it as white, or neutral grey. If there is a great imbalance of wavelengths – perhaps the light contains far more red (long) waves than blue (short) waves – stimulus is uneven. Light in this case may look orange tinted, just as happens every day around sunrise or sunset.

Try to remember the sequence of colours of the visible spectrum. It's useful when you need to understand the response to colours of black and white films, or choose colour filters (see Chapter 9) and darkroom safelights. Later you will see how the concept of three human visual receptors together responding to the full colour spectrum is adapted to make photographic colour films and digital sensors work too.

Shadows

Light radiates in all directions from a small or point source and travels outwards in straight lines. A small light source such as a bare light bulb or a candle produces harsh looking light with deep, sharp-edged shadows. The sun (or indeed the moon) in a clear sky has a similar effect as its great distance makes it appear as a small source. Small flash units or torches can also produce similar effects. It's a useful exercise to try this yourself using a small desk lamp or similar. Figure 2.5 shows how having all the light issuing from one spot must give a sudden and complete shut-off of illumination at the shadow edge. Only the parts of the subject directly in the light's path are illuminated. Everywhere else remains in darkness.

But look what happens when you place tracing paper in the light beam (or block the direct light and reflect the remainder off a matt white wall; Figure 2.6). The tracing paper passes light but also *diffuses* it. The light passed through the paper scatters into new straight lines

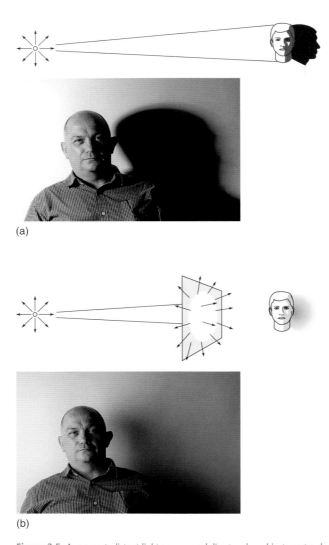

(a)

(b)

Figure 2.5 A compact, distant light source used direct makes objects cast a sharply defined shadow (a). A larger source – simply formed here by inserting a large sheet of tracing paper – gives a soft, graduated shadow (b).

proceeding in all directions from every part of its large surface area. The object you were illuminating now casts a softer-edged, graduated shadow, and the larger and closer your diffusing material the less harsh and contrasty the shadow becomes. This is because light from a large area cannot be completely blocked out by the subject; most of the parts previously in shadow now receive at least some illumination. The same happens with sunlight on an overcast day; clouds act as diffusers, spreading the light source over a wider area.

It's very important in practical photography to recognize the difference between direct, harsh lighting and soft, diffused lighting, and all the stages in between. Shadow qualities greatly influence the way subjects and scenes look. Bear in mind this is not something you can alter in a photograph by some change of camera setting or later manipulation, though some digital post-production programmes do now offer a range of lighting effects you can add (the effects are not necessarily the same as when created in camera). Understanding and controlling lighting is discussed in detail in Chapter 7.

Figure 2.6 A lamp, sunlight or flashgun directed entirely onto a matt white surface such as a wall or large card will reflect to also give soft, diffused shadows

When light reaches a surface

When light strikes a surface – maybe a building, or a landscape or face – what happens next depends upon the texture, tone and colour of the material, and the angle and colour content of the light itself.

Opaque materials

If the material is completely opaque to light – metal or brick for example – some light is reflected and some absorbed (turned into heat). The darker the material the smaller the proportion of light reflected. This is why a black camera case left out in the sun gets warmer than a shiny silver one.

If the material is also coloured it reflects wavelengths of this colour and absorbs most of the other wavelengths present in the light. For example blue paint reflects blue, and absorbs red and green from white light. But if your light is already lacking some wavelengths this will alter subject appearance. To take an extreme case, when lit by deep red illumination, a rich blue will look and photograph almost black (see Figure 2.7). You need to know about such effects in order to use colour filters (Chapter 9). Colour alteration can also be done at a later stage (Figure 2.8); if you are scanning the negative and digitally printing, then work can be done using various post-production software (see Chapter 14).

Surface finish also greatly affects the way light is reflected. A matt surface such as an eggshell, drawing paper or dry skin scatters the light evenly. The angle from which light strikes it makes very little difference. However, if the surface is smooth and shiny such as glass or gloss paint it acts more like a mirror, and reflects most of the light back in one direction. This is called *specular reflection*.

If your light strikes the shiny surface at right angles it is reflected backward along its original path. You get a patch of glare, for example, when flash-on-camera shots are taken flat on towards a glass window or gloss-painted wall. But if the light is angled it reflects off such surfaces at the same angle from which it arrived (Figure 2.7). So, if it is vital to avoid glare spots, try to arrange your lighting direction or camera viewpoint to bounce glare light away when photographing a highly reflective surface. (If you are using built-in flash, angle your camera viewpoint.)

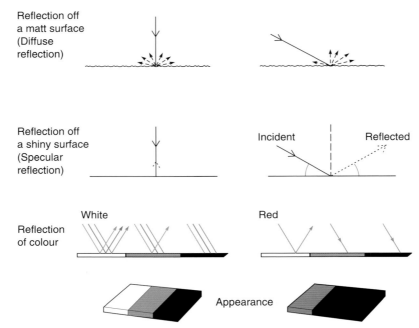

Figure 2.7 Light reflection. Top: Light reflected from a matt surface scatters relatively evenly. Centre: From a shiny surface light at 90° is returned direct. Oblique light directly reflects off at the same angle as it arrived (incident). Bottom: Coloured materials selectively reflect and absorb different wavelengths from white light. However, appearance changes when the viewing light is coloured

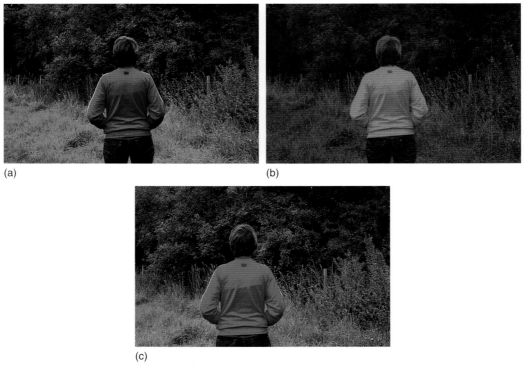

Figure 2.8 Different colour filters applied to colour film produce different colour effects: (a) green; (b) red; (c) yellow.

Transparent or translucent materials

Not every material is opaque to light, of course. Clear glass, plastic and water for example are *transparent* and transmit light directly, while tracing paper, clouds and ground glass diffuse the light they transmit and are called *translucent*. In both cases if the material is coloured it will allow more light of these wavelengths to pass through it than other kinds. Deep red stained glass transmits red wavelengths but may be almost opaque to blue light (see Figure 2.9).

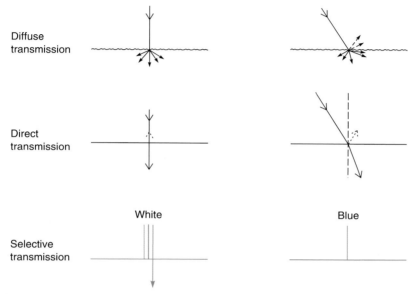

Figure 2.9 Light transmission. Top: Diffusely transmitting materials (milky plastic, ground glass) scatter light fairly evenly. Centre: Clear materials pass most of the light directly. Angled light is partly reflected, mostly refracted. Bottom: Coloured materials pass only selected wavelengths from white light. When the viewing light is a colour different from the material, no light may get through

Since translucent materials scatter illumination they seem milky when held up to the light and look much more evenly illuminated than clearer materials, even when the light source is not lined up directly behind. Slide viewers and light boxes work on this principle. The quality of the light is similar to that reflected from a white diffused surface.

Refraction

Interesting things happen when direct light passes obliquely from air into some other transparent material. As was said earlier, light travels slightly slower when passing through a denser medium. When light passes at an angle from air into glass, for example, its wavefront (remember the ripples on the water, Figure 2.1) becomes slowed unevenly. This is because one part reaches the denser material first and skews the light direction, like driving a car at an angle into sand (Figure 2.10). A new straight-line path forms, slightly steeper into the glass. The change of light path when light travels obliquely from one transparent medium into another is known as *refraction* (Figure 2.11).

You can see refraction at work when you poke a straight stick into clear water; it looks bent at the water surface. Thick window glass can cause similar distortions. This is significant because by using refraction, lenses bend light and so form images, as we will see.

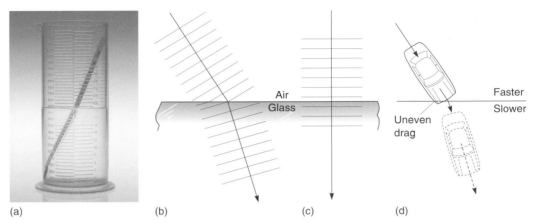

(a) (b) (c) (d)

Figure 2.10 Refraction. Light slows when passing from air into glass. Wavefronts slow unevenly if light reaches the denser medium obliquely (b). The effect is like driving at an angle from the highway onto sand (d). Uneven drag causes change of direction. Light striking the boundary at right angles (c) slows but does not alter direction

Figure 2.11 Imagine you are standing looking at this scene in reality. Light would be communicating information about its different parts to you in a mixture of ways. The water jets *transmit* and *refract* light. Glittering parts of the lake surface *specularly reflect*, while the grey stone *diffusely reflects* light. What little light there is from the sky reaching the shadowed areas beneath the fountain is mostly absorbed by the blackened stone. Your eyes and brain turn all this into information about the objects before you. This photograph re-presents the information to anyone who views it

Remember that refraction only bends *oblique* light. Light that strikes the boundary of two transparent materials at right angles slows minutely but does not change direction. And most light reaching the boundary at a very low angle (very oblique) is reflected back off the surface.

The whole picture

Everything we see in the world around us appears the way it does because of the mixture of effects it has on light – diffuse and specular reflection, some absorption, often transmission and refraction too. An apple side-lit by direct sunlight for example reflects coloured wavelengths strongly from its illuminated half. Most of this is diffusely reflected, but part of its smooth skin reflects a bright specular highlight, just where the angle of the sun to the surface matches the angle from this point to your eye. The shape and relative darkness of the shadow to one side of the apple gives you farther clues to its form. From experience your eyes and brain recognize all these subtle light 'signals' to signify solidity and roundness, without you actually having to touch the apple to find out. This is essentially what 'seeing' is. Photography allows us to make the image permanent and portable so others can experience it. Film cannot translate exactly how we see light with our eyes and different film types record light and colour in different ways. As you become familiar with the type of film you use you will begin to understand how it responds to light and shade. With a high specification digital camera you can alter colour intensity and type in the controls; however, the camera still cannot record exactly as you see and this is part of the magic of photography: that it transforms the world we see into an image.

Light intensity and distance

The closer a small light source is to a subject the brighter it will be illuminated. Halving the distance from light to subject makes the illumination four times brighter. This is because the light is concentrated into an area one quarter the size (see Figure 2.12). For example, if you are using a small flashgun or studio lamp to light a portrait, halving its distance from the subject gives you four times the light. Similarly moving the light away to twice the distance causes a fall off in illumination to one quarter the brightness. A similar effect applies to printing exposures when you alter enlarger height (Chapter 13), and in close-up situations (p. 248).

In practice this 'inverse square law' (twice the light source distance = one quarter the illumination) means that you must be especially careful when lighting a number of items at different distances in a small studio, especially using a harsh compact light source. It may then be difficult to achieve good lighting for items nearest and farthest from the light at any one exposure setting. A solution is to move the light source much farther away, so the ratio of nearest to farthest distance becomes less (p. 137), or change to multiple light sources or diffusers which will give you much less illumination 'fall-off' effect.

The same problem does not arise with direct sunlight outdoors. The sun is so far away that any two places on earth – be they seashore or mountain peak – are almost equal in distance from the sun. Brightness variations in landscape photography may be created by local atmospheric conditions but not by the sun's distance. If you are photographing indoors, however, using sunlight entering through a small window, the window itself can act like a compact light source. Intensity will then alter with distance in much the same way as if you had a lamp this size in the same position.

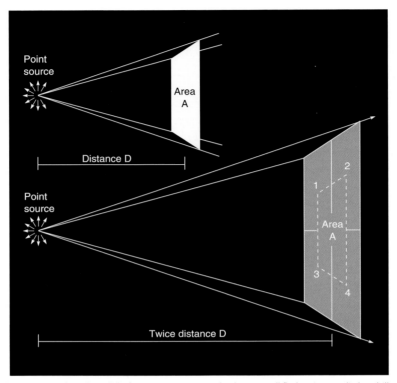

Figure 2.12 The inverse square law: direct light from a compact source (such as a small flash unit or studio lamp) illuminates your subject at greater intensity when you double the lamp-to-subject distance. The same light spreads over four times the area

Making light form images

Suppose you set up and illuminate a subject, and just face a piece of tracing paper (or film) towards it. You will not of course see any image on the sheet. The trouble is that every part of your subject is reflecting some light towards every part of the paper surface. This jumble of light simply illuminates it generally.

One way to create order out of chaos is by restricting the light, placing a sheet of opaque material such as a sheet of card with a small hole in it between subject and paper. Since light travels in straight lines, those light rays from the top of the subject able to pass through the hole can only reach the *bottom* part of the paper. And light from lower parts of the subject only reaches the *top* of the paper (Figure 2.13). As a result your paper sheet shows a dim, rather fuzzy *upside-down* representation of the subject on the other side of the hole.

The best way to see a 'pinhole' image is to be in a totally darkened room, with foil or black paper over the window facing a sunlit scene outside. Make a drawing-pin-size hole in the foil and hold up tracing paper about 300 mm (12 inch) in front of it to receive the image. You are literally inside a camera. Move the tracing paper back and forth to see how the image is captured.

You can easily take colour photographs using a pinhole if your camera has a removable lens. (See Project at the end of this chapter.) So the business of actually forming an image is not particularly complicated or technical.

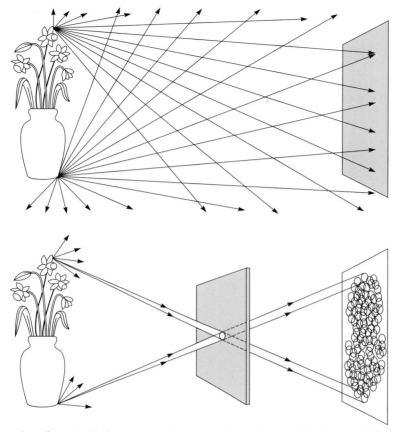

Figure 2.13 Top: A sheet of paper just held up towards an illuminated subject receives a jumble of uncontrolled light rays, reflected from all its parts. Bottom: A pinhole in an opaque screen restricts rays from each part of the subject to a different area of the paper, forming a crude upside-down image

Practical limitations to pinhole images

Pinhole-formed images lack clarity, and tend to have a soft, hazy feel to them (see Figure 2.14). None of the image detail is ever quite sharp and clear, no matter where you position the tracing paper. This is because the narrow 'bundle' of light rays reflected from any one part of the subject through the pinhole forms a beam that is *diverging* (gradually getting wider). As Figure 2.13 showed, the sharpest representation you can get of any one highlight or point of detail in the subject is a patch or *disc* of light. What should be details become many overlapping discs of light which give the image its fuzzy appearance; pinhole photographers use this quality to create their particular style of imagery. Figure 2.15 shows effects achieved by artist Roger Buchanon using a pinhole camera in the landscape.

You'll also have noticed that the pinhole-formed image is very *dark*. You can brighten it by enlarging the hole, but this makes image detail even less sharp and clear. (And if you make *two* holes you get *two* overlapping images, because light from any one part of the subject can then reach the paper in two places.)

Even if you accept a dimmer image and try to sharpen detail by using a still smaller hole, those discs of light can obviously never be smaller than the hole itself. And you quickly get to

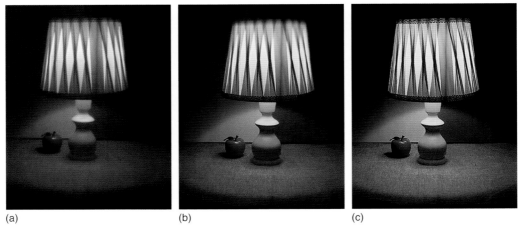

(a) (b) (c)

Figure 2.14 Pinhole versus lens. Pictures taken using a 35 mm SLR camera body fitted with (a) kitchen foil having a 0.25 mm diameter pinhole; (b) a simple plastic magnifying glass 'stopped down' to *f*/8 with a hole in black paper; and (c) the camera's standard 50 mm lens at *f*/11 (see Figure 3.6). Based on the camera's TTL light readings, the pinhole needed 20 seconds, the magnifier 1/60 s and the lens 1/30 s exposure. When focused for the centre, the magnifier gives the poorest definition of all near-picture edges. The pinhole gives slightly un-sharp detail everywhere

Figure 2.15 Roger Buchanon, Meathop Moss. An example of an artist using a pinhole camera to create an 'impressionistic' view of the landscape

a point where farther reduction actually makes results worse because of an optical effect known as *diffraction*. The smaller and rougher the hole the greater the percentage of light rays displaced by this effect, relative to others passing cleanly through the centre.

Using a lens instead

The best way to form a brighter, sharper image is to make the hole bigger (allowing more light through), then *bend* the broad beam of light you produce so that it narrows (*converges*) instead of continuing to expand. This is done by using refraction through a piece of clear glass. Figure 2.10 showed how light passing obliquely from air into glass bends at the point of entry to become slightly more perpendicular to the surface. The opposite happens when light travels from glass into air, as air is less dense. So if you use a block of glass (a 'prism') with sides that are non-parallel (Figure 2.16) the total effect of passing light through it is an overall change in direction.

In practice, a shaped piece of glass that is thicker in the centre than at its edges will accept quite a wide beam of diverging light and convert it into a converging beam. By grinding and polishing a disc of glass so it is this shape you make what is effectively an infinite series of

prisms, all bending light rays towards a common point. This is a simple *converging* lens. If you have such a lens (a magnifying glass is ideal) you can try it out.

When you make images using a lens instead of just a hole the upside-down picture on your tracing-paper screen appears much brighter, but details are only sharply resolved when the paper is at one 'best' distance from the lens. If you position it too close or too far away, the light rapidly broadens out (Figure 2.17) and points of detail turn into discs even larger than that given by a pinhole. The result is a very unclear 'out of focus' effect. So a lens has to be focused precisely; the correct image position will depend on the light-bending power of the lens, and the distance between lens and subject (Figure 2.18). Having tried a magnifying glass, compare it with your camera lens if it is detachable.

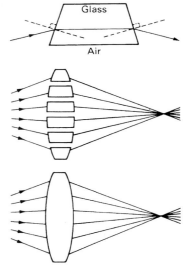

Figure 2.16 Lens evolution. Top: Using a non-parallel sided glass block (prism), refraction at each air/glass surface (compare with centre of Figure 2.9) causes an overall change of direction. Think of a lens shape as a series of blocks which bend many light rays to a common point of focus

Focal length and image size

The light-bending power of a lens is shown by its *focal length*. As shown in Figure 2.19, the focal length of a simple lens is the distance between the lens and a sharply focused image of an object at infinity. (In practice this generally means something on the horizon.) Focal length takes into account the type of glass (its *refractive index*) and its shape.

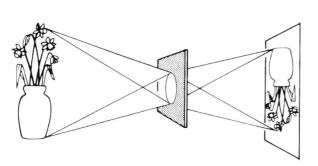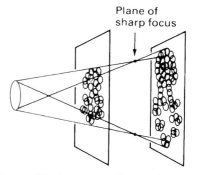

Figure 2.17 A converging lens bends diverging beams of light to a point of focus. However, if the lens-to-screen distance is incorrect, either too near or too far as shown right, images again consist of fuzzy 'circles of confusion'. (This is why out of focus highlights become discs – Figure 2.18)

A lens with a long focal length has relatively weak bending power – it needs a long distance to bend light rays to a point of focus. The *stronger* the power of the lens, the *shorter* its focal length. The picture detail is also smaller in size than the same subject imaged by a longer focal length lens (see Figure 2.20).

Figure 2.18 This image was made with a wide-diameter lens focused for one droplet on the barbed wire. Droplets closer (left) and farther away (right) become unsharp patches of light at this focus setting. Notice how each patch takes on the shape of the lens diaphragm

Imaging closer subjects

The lens-to-image distance you need for sharp focus changes as the subject gets closer. The rule is: the nearer your subject, the greater the distance required between lens and film plane (see Figure 2.21). This is why you often see camera lenses move *forwards* when set for close distances, and for really close work you may have to use a macro lens or fit an extension tube between body and lens (see p. 107). This is not a problem with simple single subjects but what about scenes with a mixture of both distant and close detail, all of which you want in focus? Luckily camera lenses allow this with aperture controls, as we will see in the next chapter.

Check out these focus effects for yourself, using your magnifying glass and piece of tracing paper. Use a single bright object such as a desk or table lamp in an otherwise darkened room. Notice how the focusing distance between lens and paper varies when you move nearer or further from the subject. It is always helpful to know (at least roughly) where and what size to expect a sharp image, especially when you are shooting close-ups, or printing unusual size enlargements. Ways of calculating detailed sizes and distances are shown in Appendix A.

Light from an object at infinity

Focal length

Axis

Principal focal point

Figure 2.19 Focal length. In the case of a simple lens, focal length is the distance between the lens and the position of a sharp image of an object at infinity

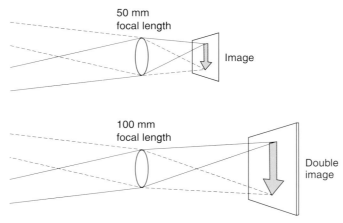

50 mm focal length

Image

100 mm focal length

Double image

Figure 2.20 Focal length and image size. The longer the focal length the larger the image. This is why cameras taking large format pictures need longer focal length lenses to include the same amount of your subject

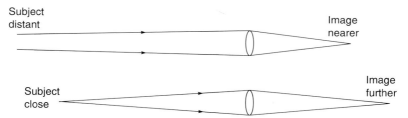

Figure 2.21 The closer the subject to a lens, the greater the distance it needs to bring the light into sharp focus. Light rays from a distant subject point are more parallel, so the same lens bending power brings them to focus nearer to the lens

SUMMARY

■ Light travels in straight lines, as if in wave motion. Wavelengths are measured in nanometres (nm). Visible light forms a small part of a much wider range of electromagnetic radiation. It transmits energy in the form of 'photons'.

■ Your eyes recognize wavelengths between 400 nm and 700 nm as progressively violet, blue, green, yellow, red – the visible spectrum. All colours if present together are seen as 'white' light.

■ Subjects illuminated by a relatively compact direct light source cast harsh, hard-edged shadows. Light from a large-area source (including hard light *diffused*) gives a much softer edge to shadows.

■ An opaque material absorbs some of the light striking it and reflects the rest.

■ Smooth, shiny surfaces give specular reflection – direct light is largely reflected all one way. Oblique illumination bounces off such a surface at an angle matching the light received. Matt surfaces scatter reflected light more evenly in all directions.

■ Transparent materials directly transmit light; translucent materials diffuse it. Light passing obliquely from one transparent material to another of different density is refracted (bent) more perpendicular to the surface in the denser medium.

■ Coloured materials absorb and reflect or transmit light *selectively* according to wavelength. Appearance varies with the colour of the light source illuminating them.

■ The amount of illumination received by a surface from a direct, compact light source is quartered each time the distance from the light is doubled.

■ Because light travels in straight lines, a pinhole in an opaque material forms a crude upside-down image of an illuminated subject.

■ A converging lens gives a brighter, sharper image than a pinhole, by bending a wide beam of diverging light from your subject so that it converges to a point of focus. The position of sharp focus depends on the refracting power of the lens, and subject distance. The brightness depends on the lens diameter.

■ Lens power is shown by focal length. In simple optics this is the distance between the lens and a sharp image of an object at infinity. The longer the focal length the larger the image produced.

■ Close subjects come to focus farther from the lens than distant subjects. A subject two focal lengths in front of the lens is imaged same-size two focal lengths behind the lens. Magnification is image height divided by subject height.

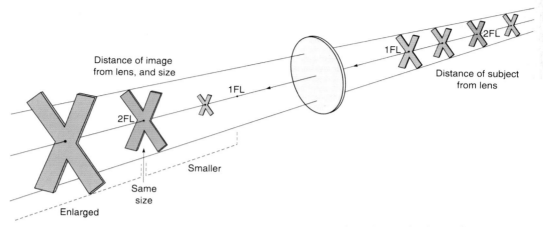

Figure 2.22 Conjugate distances. The positions where subjects at different distances from a lens are sharply imaged

1 Take pinhole colour slides. Remove the lens from a single-lens-reflex 35 mm camera and tape kitchen foil in its place (it is easiest to tape it across an extension ring which you then simply attach or detach from the body or make a small hole in a body cap and cover this with a small piece of foil). Pierce the foil with a needle to give a hole of about 0.3 mm diameter, free of bent or ragged edges. You should just be able to make out the image of a bright scene through your camera viewfinder. Set your internal exposure meter to manual mode. If the image is too dim to get readings, set the camera's ISO scale to its highest rating or the exposure compensation dial to the most extreme minus setting. Then multiply the exposure time shown either by the set ISO divided by the actual ISO, or the equivalent effect of the compensation setting. You may have to experiment with different settings if exposure times are longer than a few seconds.

2 Take pictures using a magnifying (reading) glass in place of your regular SLR camera lens. Fit a collar of black paper around the rim of the glass to prevent direct light entering the camera. Try some shots adding black paper with a hole in it over the lens to reduce its diameter by half. Compare the results, and also compare with the results of Project 1.

3 Practise forming images on tracing paper with a magnifying glass, or the lens detached from your camera. Work in a darkened room and use a lit desk or table lamp as your subject. Check out image size as well as position when the subject is in the various distance zones shown in Figure 2.22.

3 Lenses: controlling the image

Having been introduced to the fundamentals of how lenses create images, we can now explore the ways the controls on a camera lens allow you to alter the image. The principal control is the aperture (commonly referred to as *f*-number). The aperture adjusts image brightness and the range of subject distances you can focus sharply at one setting. It is very important in image-making to know when and how to create total sharpness, or to localize image detail. Some differences between cameras of different format (picture size) start to appear here too (Figure 3.1).

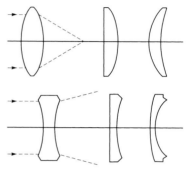

Figure 3.1 Single lens elements can be made in a great range of shapes and glass types. The top row here converge light. The bottom row, which are all thinnest in the centre, cause light to diverge. Diverging lens elements are combined with (stronger) converging elements in photographic lenses to help counteract optical defects

Photographic lenses

As we have seen, a simple glass lens creates a higher quality image (in terms of sharpness) than a pinhole. When you look closely at Figure 2.14 (p. 42), image sharpness is poor and not maintained equally over the whole picture, even when the subject is all at one distance. Simple single lenses often distort shapes, create odd colour fringes or give a general 'misty' appearance. Such results give a very particular impression that has sometimes been described as 'atmospheric' or 'romantic', in the sense that they are more removed from reality than the classic sharp detailed photograph and can seem 'other-worldly'. This is not always what one wants from an image so usually you will want to use a lens capable of producing high quality image clarity and detail. Some of the effects created by the pinhole camera or single lens can be achieved by adding diffusers or filters to the camera or by later manipulating results digitally (Chapter 14) or at the printing stage (Chapter 13). However, there are differences and you should explore all options before deciding on your approach.

The main principle of *photographic* equipment design and manufacture is to produce lenses that minimize optical defects (known as 'aberrations') while at the same time gaining the highest possible resolution of detail and image brightness. In order to achieve this, camera equipment manufacturers use a range of special optical glasses, each type of glass having different refraction and dispersion properties. A photographic lens has a 'compound' construction, containing a series of elements of different shapes and made from different glass types to help neutralize aberrations. In fact, a camera lens of normal focal length typically has 5–8 elements (Figures 3.2 and 3.3). Their centring and spacing within the lens barrel is critical,

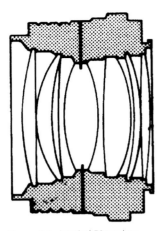

Figure 3.2 A typical 50 mm lens made as the normal focal length lens for a 35 mm camera. It combines seven lens elements, five converging and two diverging light, ensuring a distortion-free image which is equally sharp all over

Figure 3.3 Engraving around lenses here shows (top) name of lens, maximum aperture f/5.6 and focal length 180 mm and (bottom) name, f/1.7 maximum aperture and 50 mm focal length

and can be upset if the lens is dropped or roughly knocked. However, even the number of elements causes problems, as the tiny percentage of light reflected off every glass surface at the point of refraction multiplies as scattered light. If uncorrected, the result would be images that lack contrast and sparkle – like looking through a window with multiple double-glazing. The best lenses therefore have their elements surface-coated with one or more extremely thin layers of a transparent material that practically eliminates internal reflections under most conditions. However, light may still flare if you shoot towards a bright light source just outside the picture area and fail to use a lens hood, see Figure 5.21, p. 110 and also the section on lens care, p. 60.

Your camera or enlarging lens is therefore a relatively thick barrel of lens elements, all of them refracting light but together having an overall *converging* effect. Almost all photographic lenses have their focal length (usually in millimetres) clearly engraved around the lens barrel or front-element retaining ring.

Focal length and angle of view

Lenses can capture varying amounts of the scene before them from a very wide angle to an extremely narrow view. The natural field of view of the human eye covers approximately 45° and so a camera lens covering this angle is regarded as normal or 'standard'. It is approximately equal to the diagonal of the camera's picture format. In other words:

- For a 35 mm (24 × 36 mm) camera, a lens of around 50 mm focal length is standard.
- For a 60 × 70 mm in roll film camera, a standard lens is about 80–105 mm.
- For APS (17 × 30 mm) picture size cameras, the normal lens is 25 mm.
- Compact digital cameras have a tiny 4.8 × 6.4 mm sensor. A standard lens is typically only 6–10 mm.
- Professional digital SLRs have larger sensors at around 15 × 22.5 mm, meaning a standard lens is around 28 mm.
- A few very high-end professional digital SLRs have so-called full frame sensors of 24 × 36 mm, so using 50 mm as standard like a 35 mm film camera.
- For a 5 × 4 inch plate camera, a standard lens is 150 mm.

As Figure 2.20 showed, the shorter the focal length, the smaller the *image* the lens produces. But a lens of short focal length used with a small format camera gives the same *angle of view* as a lens of longer focal length used in a bigger camera. You are just scaling everything up or

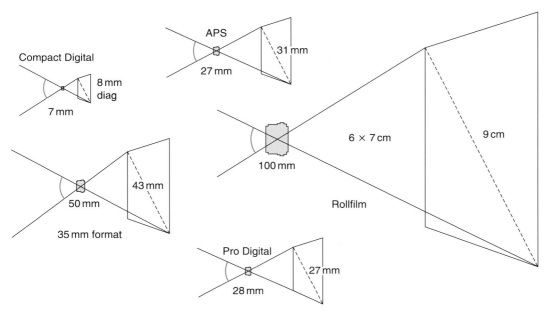

Figure 3.4 Angle of view. All four lenses here give a similar angle of view. They each differ in focal length but are used on different format cameras, maintaining a close ratio of focal length to picture format diagonal. Each combination will therefore include about the same amount of your subject in the picture. See also Figure 2.20

down. All the combinations above therefore give an angle of view of about 45°, and so each camera set up to photograph the same (distant) subject will include about the same amount of the scene (see Figure 3.4). The use of lenses giving a wider or narrower angle of view is discussed in Chapter 5.

Focusing movement

The cheapest simple cameras have lenses which are so-called focus-free. This means the lens is fixed in position pre-focused on subjects about 2.5 m from the camera. The assumption is that this is a typical situation for snapshots, and items slightly nearer or farther away will appear reasonably sharp due to depth of field (p. 52). This keeps costs down but is not ideal due to the limitations.

All manufactured camera lenses include some means of adjusting their position forwards or backwards for focusing subjects closer or more distant respectively. Typically the whole lens shifts smoothly by a centimetre or more within a sleeve (or internal elements alter position). Focus is manually adjusted by rotating the lens barrel, or via a motor under the control of an automatically controlled focus sensor that detects when the image is sharp (see *Auto-focus*, p. 79).

Often point-and-shoot auto-focus compact cameras show no distance markings on the lens. Lenses on cameras offering greater control (all single-lens reflexes for example) show a scale of subject distance which moves against a setting mark (see Figure 3.5). It is therefore possible to set the focus without looking through the viewfinder at all by estimating the subject distance or actually measuring with a tape (a method widely used in the movie industry). Normally this is unnecessary but it can be useful in very low lighting situations.

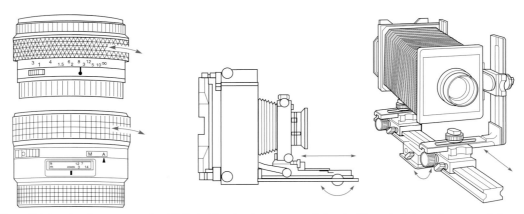

Figure 3.5 Lens focusing movement. Top left: Typical focusing ring on a manually focusing 35 mm single-lens reflex camera. Bottom left: Focusing ring on an auto-focus SLR, rotated by hand when switched to manual. Right: Two kinds of larger format sheet-film camera. Having longer focal length lenses which need greater physical focusing movement a focusing knob on the camera body shifts the whole lens-carrying front panel

All lenses can be set to focus for infinity (∞) for the most distant subjects. On most lenses this means anything more than a few tens of metres away. The closest subject distance offered depends on a number of factors. Mechanically it may be difficult to shift the lens farther forward. The longer the focal length, the greater the physical movement needed for adjusting focus settings. Close-up focusing may be purposely prevented because the lens is part of a camera with a separate direct viewfinder (p. 65). This grows increasingly inaccurate in framing up your picture the closer you work. Sometimes the lens may not maintain the same high image optical resolution at close distances (see macro lenses, p. 107).

Normal lenses for large format cameras need more focusing movement to cover a similar range of subject distances, owing to their longer focal length. The whole front unit of the camera moves independently of the back, the two being joined together by bellows. There is seldom any scale of distances on lens or camera body; focusing is done by checking the actual image on a ground glass screen at the back of the camera (see p. 65).

Aperture and *f*-numbers

Inside most photographic lenses you will see a roughly circular hole or 'aperture' located about midway between front and back elements. Usually a series of overlapping black metal blades called an iris diaphragm allows the size of this aperture to be narrowed continuously from full-lens diameter to just the centre part of the lens. It is adjusted with a setting ring or lever outside the lens barrel. On single-lens reflex cameras you may not see the aperture actually alter when you turn the ring, unless you first detach the lens from the camera (see p. 71). On these cameras the aperture usually stays wide open until the actual moment of exposure, when it closes down to the set value (Figure 3.6). There may be a 'preview' button on the camera or lens that allows you to close the aperture down in advance to check the effect.

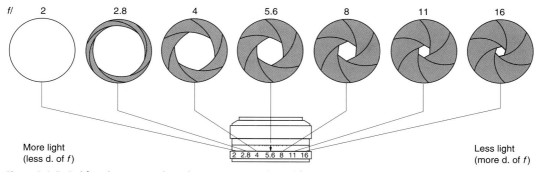

Figure 3.6 Typical *f*-number sequence (many lenses may open up beyond *f*/2, or stop down beyond *f*/16)

A series of relative aperture settings can be felt by 'click' and are shown on a scale of figures known as *f-numbers*. Notice that the *smaller* the relative aperture the *higher* the *f*-number. They typically run:

f/1.4 f/2 f/2.8 f/4 f/5.6 f/8 f/11 f/16 f/22

The *f*-numbers follow what is an internationally agreed standard sequence relating to the brightness of the image. In the sequence above, *f*/1.4 is the widest aperture, allowing the most light through for a bright image. *f*/22 is the smallest, letting only a fraction of the light through, allowing for a greater depth of field and most useful on very bright days. Note that the aperture scale extends beyond the example above with apertures wider than *f*/1.4 and smaller than *f*/22 often being possible on many lenses.

Each change to the next highest number halves the amount of light passing through-the-lens. And because the aperture is positioned in the lens centre it dims or brightens the entire image evenly.

The *f*-number system means that any lens set to the same number gives a standard image brightness, irrespective of the focal length or the camera size. You can change lenses or cameras, but as long as you set the same *f*-number the image brightness remains constant (provided your shutter speed and ISO film rating are also constant).

How *f*-numbers work

The actual *f*-numbers themselves denote the number of times the effective diameter of the aperture divides into the lens focal length. So *f*/2 means setting an aperture diameter one-half the focal length; *f*/4 is one-quarter, and so on. The system works because each *f*-number takes into account two main factors which control how bright an image is formed:

1 *Distance between lens and image.* For distant subject (lens focused on infinity) the image is formed at one focal length from the lens. The inverse square law of light (Figure 2.12) shows that doubling the distance of a surface from a light source quarters the light it receives. Therefore a lens of (say) 100 mm focal length basically forms an image only one-quarter as bright as a lens of 50 mm.

2 *Diameter of the light beam.* Doubling the diameter of a circle increases its area four times (Figure 3.7). So if the diaphragm of the first lens passes a beam of light 12 mm wide and the second only 6 mm wide, the first image is four times as bright as the second.

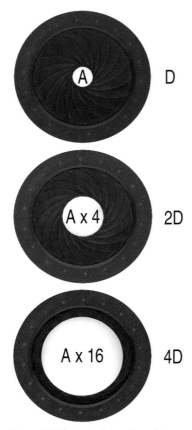

Figure 3.7 The basis of *f*-numbers. Each time the diameter (D) of a circle is doubled its area (A) increases four times

Now, in the example in Figure 3.8 you find that both lenses are working at near-enough relative apertures of *f*/8 (100 ÷ 12, and 50 ÷ 6), which is correct since their images match in brightness. So:

f-number = lens focal length ÷ effective aperture diameter

In practice the *f*-number relationship to brightness breaks down when working very close-up, because the lens-to-image distance will then differ greatly from one focal length (see Figure 5.17 on p. 106).

The *f*-number settings are also commonly referred to as 'stops'. In early photography, long before iris diaphragms, each stop was a thin piece of metal punched with a hole the required size which you slipped into a slot in the lens barrel. Hence photographers speak of 'stopping down' (changing to a smaller opening, higher *f*-number). The opposite action is 'opening up'.

You will find in practice that upper and lower limits of the *f*-number scale vary with different lenses. Most small format camera lenses stop down to *f*/16 or *f*/22. Larger, sheet-film camera lenses are designed to continue down to *f*/32 or *f*/45. Smaller apertures are useful for extra depth of field (see below), but if taken to extremes diffraction starts to destroy image detail. This is why no lens will stop down literally to pinhole size.

The *f*-number of your lens's maximum aperture, together with its focal length, name and individual reference number, are engraved on the lens rim (Figure 3.9). You may find that, of two lenses identical in make and focal length, one is almost twice the cost of the other because it has a maximum aperture one stop wider. This can be a high price to pay for the ability to shoot in poorer light or use faster shutter speeds, particularly when you can buy excellent ultra-fast film. The 'faster' lens is, however, likely to be of higher overall optical quality. As ever, it's a question of performance against price, but note that digital SLRs particularly benefit from high-quality optics.

Depth of field

Depth of field is the distance between the nearest and farthest parts of a subject that can be realised as a photographic image with reasonably sharp detail at one focus setting of the lens.

Widest aperture (smallest *f*-number) – opening of the lens – gives least depth of field, while smallest aperture (highest *f*-number) gives the greatest. There are two other significant effects: (1) depth of field becomes less when you are shooting close-ups and greater when all your subject matter is farther away; (2) the longer the focal length of your lens the less depth of field it gives, even with the same aperture and subject distance (Figures 3.10, 3.11, 3.12 and 5.4).

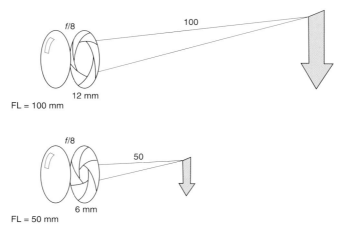

Figure 3.8 Image brightness. These lenses differ in focal length and therefore give different-size images of the same distant subject. But by having diaphragm diameter effectively one-eighth of focal length in each case, the images match in brightness. Both lenses are working at *f*/8

Figure 3.9 This collection of lenses – for large, medium and small format cameras – shows the variety of ways in which information on aperture, focal length, maker, and reference number appear

Practical significance

It is very important to be able to control depth of field and make it work *for* your pictures, not *against* them. By choosing shallow depth of field you can isolate one item from others at different distances. You can create emphasis, and 'suggest' surroundings without also showing them in such detail that they clutter and confuse. Such pictures are said to be 'differentially focused' (Figure 3.13). But remember that minimizing depth of field with a wide aperture also means you must be really accurate with your focusing – there is much less latitude for error. You may also have exposure problems if you choose to shoot at wide

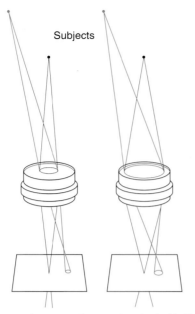

Subjects

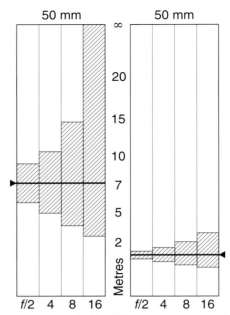

50 mm 50 mm

∞
20
15
10
7
5
2

Metres

f/2 4 8 16 f/2 4 8 16

Figure 3.10 Why aperture diameter alters depth of field. Right: When you focus a lens for a close subject it images each point on a more distant item as an un-sharp disc of light. Left: Stopping down to a smaller lens aperture narrows all cones of light. Although still not in critical focus other items begin to look sharp too

Figure 3.11 Depth of field at different apertures when a 50 mm lens is focused for 7 m (left) and for 1.5 m (right). The symbol ∞ denotes infinity. Depth of field is greatly reduced with close subjects

Figure 3.12 The practical effect of changing depth of field. The focus setting of the lens remained the same for both shots. (A slower shutter speed was needed for the right-hand version to maintain correct exposure because the aperture was smaller and so was letting in less light.) f/2.8 left and f/16 right

aperture in bright lighting, or with fast film, or want to create blur effects by means of a slow shutter speed.

On the other hand, by choosing greatest possible depth of field your picture will contain maximum information. An image that is sharp throughout allows the *viewer* to decide what to concentrate on rather than being directed by the photographer. Just be careful that you notice (and avoid) any unwanted clutter in the foreground or background.

Figure 3.13 Shallow depth of field. Using a wide aperture (f/2) limits detail, and concentrates interest on an element at one chosen distance – the pollen-covered flower tip

Nearly all SLR cameras show the image at wide-open aperture as this makes the image as bright and easy to focus as possible. The lens only stops down to the set aperture at the moment of exposure. Some cameras allow you to preview the stopped-down image by means of a lever or button on the lens or camera body. This is a very useful function as it allows you to check the extent of the focused zone. Alternatively there may be depth of field markings on the lens barrel (Figure 3.14).

Sometimes you cannot produce sufficient depth of field by stopping down (perhaps lighting conditions are so dim or film so slow that an unacceptably long exposure is needed). In such cases take any step that makes the image *smaller*. Either move back, or use a shorter focal length lens or smaller-format camera (Figure 3.15). Later you will have to enlarge and crop the image in printing, but you still gain on depth of field (see top left picture, Figure 5.2, p. 93).

You could use a tripod or monopod if the situation allows it (if there is any movement in the image then this will be blurred with a long exposure).

How depth of field works

To understand why the aperture affects depth of field, we need to look again at how a lens focuses an image point at one distance only, depending on how far the lens is from the subject. Other parts of the subject nearer or farther from the lens come to focus farther away or nearer, forming discs instead of points of light. They are known as *circles of confusion*. Large circles of confusion, overlapping (Figure 2.17) give a blurred image. However, provided the circles are relatively small they can appear sharp, since our eyes have limited resolving power.

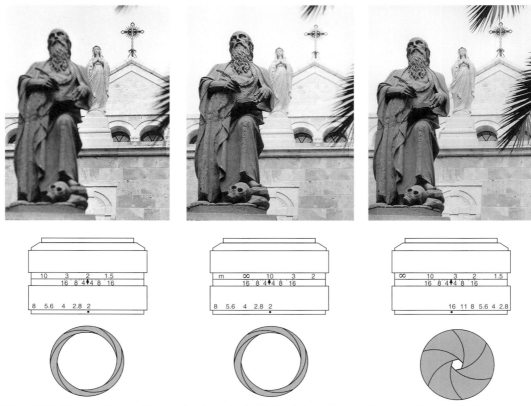

Figure 3.14 Using zone-focusing. The lens above has a depth of field scale located between focusing and *f*-number scales. To zone focus, first visually focus the nearest object you want sharp (left) noting the marked distance. Then do the same for the most distant part (centre). Using the depth of field scale, set the lens for a distance which places both near and far parts within the zone of sharp focus at a small aperture. Here *f*/16 is needed (right). Remember to set a slower shutter speed to maintain the same exposure

Figure 3.15 Maximum depth of field. This scene has important elements at several different distances and was shot at *f*/16 to produce sharp detail throughout

When viewing a final print you rate an image acceptably sharp even when tiny discs are present instead of dots. The upper limit to what most people accept as sharp is taken to be 0.25 mm diameter on the final print. (The same applies to the dot pitch on a computer screen.) Lens manufacturers for 35 mm format cameras assume that if 25×20 cm (10×8 inch) enlargements are made (film image magnified ×8) to this standard then the largest acceptable circle of confusion *on film* is 0.25 divided by 8 = 0.03 mm.

By accepting discs up to this size as sharp, subjects slightly nearer and farther away than the subject actually in focus start to look in focus too. And if the lens aperture is made smaller all the cones of light become narrower, so that images of subjects even nearer and farther are brought into the zone of acceptable sharp focus. Depth of field has increased.

Again if you move farther back from the subject or change to a shorter focal length lens, the positions of sharp focus for images of nearest and farthest subject parts bunch closer together. Their circles of confusion become smaller, again improving depth of field.

Remember that you produce greatest depth of field when:

- *f*-number is high (the lens is stopped down)
- subject is distant
- focal length is short.

With subjects beyond about ten focal lengths from the lens, depth of field extends farther behind the subject than towards the lens. Hence the photographer's saying: 'focus one third in', meaning focus on part of the scene one third inside the depth of field required. With close-up work, however, depth of field extends more equally before and behind the focused subject distance.

Using depth of field scales on lenses

You may find that your camera lens carries a depth of field scale, next to its scale of subject distances (Figure 3.14). The scale gives you a rough guide to the limits of depth of field and is useful if you are 'zone-focusing' – presetting distance when there is no time to judge focus and depth of field visually. Scales also show how you can gain bonus depth of field in shooting distant scenes. For example, if the lens is focused on infinity (losing half your depth of field 'over the horizon'), focus on the nearest part of the subject and read off the distance half way between this and infinity. This is called the 'hyperfocal distance' for the *f*-number you are using. Change your focus to this setting and depth of field will extend from half the distance through to the horizon (see Figures 3.16 and 3.17).

Depth of field is also exploited in some cheap cameras with simple symbols for setting lens focus. Typically a silhouette of mountains sets the lens to its hyperfocal distance; a 'group of people' symbol means 3.5 metres; while a 'single head' is 2 metres. Provided the lens has a small working aperture, these zones overlap in depth of field. So users stand a good chance of getting in-focus pictures as long as they make the correct choice of symbol.

Remember that depth of field limits don't occur as abruptly as the figures suggest – sharpness deteriorates gradually. Much depends too on what *you* regard as a permissible 'circle of confusion'. If you intend to make big enlargements, you will find that the level of sharpness is reduced and so the depth of field also appears reduced, though this can change depending on the viewing distance of the print. Even if your camera allows you to preview depth of field effects as previously described you should work well within the limits of what *looks* sharp, or you may

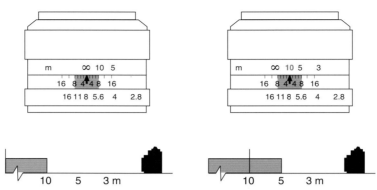

Figure 3.16 Using hyperfocal distance. For maximum depth of field with distant scenes, first set the lens to infinity. Note the nearest distance still within depth of field for the *f*-number you are using, here 10 m (left). Then refocus the lens for this 'hyperfocal' distance (right). Depth of field will extend from half this distance to infinity

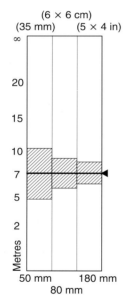

Figure 3.17 Depth of field when standard focal length lenses for different formats are used at an identical aperture (*f*/4 here). All were focused for 7 m. Larger format cameras produce less depth of field because they use longer focal length lenses

be disappointed with the final print. Some photographers will want to achieve grainy prints for deliberate effect. Different types of grain can be achieved in a variety of ways: high ISO films have a larger grain structure than low ISO films; making a large scale print from a small negative will create a grainy impression; harsh grain can be created through the method used to process the film (see Chapter 11).

Depth of focus

Depth of focus often gets confused with depth of field. But whereas depth of field is concerned with making light from different subject distances all come to focus at one lens setting, depth of focus refers to how much you can change the lens-to-image distance without the focused image becoming noticeably blurred. It is therefore concerned with tolerance in the lens-to-film/CCD distance in your camera or enlarger, and accuracy in focusing.

As Figure 3.18 shows, the two 'depths' have certain features in common. Depth of focus increases with small aperture and large permissible circle of confusion. However, depth of focus becomes greater the *closer* your subject and the *longer* the focal length of the lens. (Both changes cause light to come to focus farther from the lens, making the cones of light narrow.) These reversed features mean that in practice:

● A small format camera needs its lens more accurately positioned relative to the film than a large camera. This is due to its shorter focal length normal lens, as well as its smaller acceptable maximum circle of confusion. A large-format camera does not therefore need engineering with quite the same precision as a 35 mm camera, and its greater depth of focus also allows more use of 'camera movements'; see Appendix B.

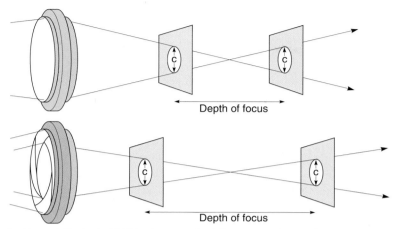

Figure 3.18 Depth of focus. Unlike depth of field this is concerned with focus accuracy between lens and image, e.g. in the camera or enlarger. The smaller the lens aperture and the larger the maximum permissible circle of confusion (C), the greater the depth of focus. (Think of this focusing latitude as the distance you could freely move a ring along two cones positioned apex to apex)

- When you visually focus the image given by a camera or enlarging lens, always have the lens at its widest aperture. This minimizes depth of focus, making it easier to see the sharpest point.
- When using your camera to photograph very close subjects (macro photography) it is easiest to alter lens focus to get the image roughly the correct size – then *move the whole camera* backwards or forwards to get the picture pinsharp. You will be focusing by exploiting the shallow depth of field under these conditions, rather than struggling with deep depth of focus which could keep you finely adjusting the lens focusing for a long time.

Image stabilization

A relatively recent development, image stabilization (also known as vibration reduction), is available on some 35 mm and digital camera lenses. A system of motion sensors detects movement of the camera and compensates for it by a moving optical element inside the lens, keeping the image steadily centred. The system reduces the effects of camera shake, allowing shutter speeds roughly two stops slower to be used. Stabilized lenses cost more than conventional ones but the increased sharpness, particularly on telephotos, is significant (see Figure 3.19).

Lenses for digital cameras

Some SLR camera lenses are sold as 'digital only'. This may mean that the design of the lens is biased towards high resolution at the expense of coverage area. This means that they do not cover the full 24 × 36 mm of a 35 mm frame and should therefore only be used on digital SLRs which have a smaller image size. Note that some digital SLR lenses may have extended rear elements which can foul the mirror if fitted to a 35 mm camera, causing permanent damage.

Figure 3.19 Image stabilization. Enlarged sections of photographs taken with the camera hand-held and using a long telephoto lens. Top: At 1/50 second the shutter speed is too slow to freeze the motion of the photographer's body. Bottom: With the stabilization system activated the moving optics correct for the motion allowing same shutter speed to be used

Lens care

Your lens is the most important part of the camera or enlarger. It is important to prevent damage to its glass surfaces. On a camera you can help to do this with some form of lens cap, or a clear glass UV filter (p. 223). Avoid carrying a camera over your shoulder or in a bag containing other loose items without some lens protection. A small speck on the glass is relatively unimportant – it just minutely reduces illumination – but a greasy finger mark, scratches, or a layer of dust will scatter and diffuse light, so your images have less contrast and detail.

Loose dust and debris is best puffed away with a blower brush or gently guided to the rim of the lens. Grease or marks left by spots of rain may have to be removed with a soft tissue moistened in lens-cleaning fluid. Serious dirt can be removed by specialist lens-cleaning solutions that dry to form a cling film-like material that is peeled off, taking deposits with it. A scratched lens may be able to be re-polished but the cost is likely to be prohibitive.

Don't become too obsessive about cleaning lenses. You will do far more harm than good if you rub away the top coating or inadvertently scratch the glass with a dirty cloth. Prevention is much better than cure. The internal elements of the lens should remain free from dirt but poor handling or storage can allow dust or moisture to find its way inside. There is a kind of fungus *Aureobasidium pullulans* that actually grows on glass, etching the surface with spidery lines and ruining lenses – look for this carefully when buying second-hand.

Lens hoods are useful for controlling stray light that can cause flare or lower image contrast, but they are also excellent for protecting the front element from rain, dust or odd knocks.

SUMMARY

■ Photographic lenses are assembled from multi-elements to help correct optical aberrations produced by single-elements. Glass surfaces are coated throughout to minimize reflections. Smallest and largest aperture settings are also restricted to help reduce aberration effects.

■ The image is not quite at its sharpest at either end of the aperture scale due to the aberrations mentioned above. The optimum setting for best performance is usually somewhere in the middle of the available range.

■ A typical 'normal' focal length lens for a camera has its focal length approximately the same as the diagonal of the picture format. It must also be designed to give an image of satisfactory quality over the whole of this area. The smaller the camera the shorter the focal length lens it uses.

■ The longer the lens focal length the greater the physical focusing movement needed to cover a range of subject distances.

■ An out of focus image of a point on the subject broadens into a 'circle of confusion'. Provided this is relatively small (typically 0.25 mm or smaller on the final result) it will still look acceptably sharp.

■ Focusing (manual or by autofocusing mechanism) ranges from infinity, setting down to a closest subject distance determined by whether the lens still maintains satisfactory image quality; and the accuracy of the camera's viewfinder.

■ Relative apertures are given f-numbers. Each number is focal length divided by diameter of effective aperture, so the *lowest* f-number denotes *widest* aperture setting.

Each f-number change either doubles or halves image brightness. Typically the scale runs f/1.4 f/2 f/2.8 f/4 f/5.6 f/8 f/11 f/16 f/22 f/32 f/45.

■ Depth of field is the zone between nearest and farthest subjects which are all acceptably in focus at one distance setting.

■ Depth of field is increased by 'stopping down' to a small aperture. It is also greater when you focus on distant subjects or use a lens of shorter focal length.

■ When shooting three-dimensional scenes, control over depth of field allows you either to isolate and emphasize, or to give maximum information by resolving detail throughout. Preview the effect visually by checking the image itself if the camera allows, or use a depth of field scale if you are zone-focusing.

■ As a guide, focus on an item one third inside the total depth of field you need. For distant shots, focusing for the hyperfocal distance will give you depth of field from half this distance to infinity.

■ Small format cameras give greater effective depth of field than large format cameras, assuming normal lenses are used under the same conditions of distance and f-number.

■ Depth of focus is the tolerance of focus movement before an originally focused part of the subject appears unsharp. It is greatest with close subjects and long focal length lenses.

■ Take care of your lenses by protecting them from scratches, finger marks and dust. Clean only when necessary. Learn to remove dust and slight marks safely, and leave the rest to experts.

1 Visually check depth of field. Use a single-lens reflex camera fitted with a preview button (or work with a large format camera). Arrange a scene containing well-lit objects at, say, 1 m, 2 m and beyond 3 m. Focus for 2 m and view the result at widest aperture. Next set the lens to *f*/8, press the preview button if using an SLR, and *ignoring the dimmer image* see how nearest and farthest objects have improved in sharpness. Test again at *f*/16. Also compare the effects of focusing on closer or more distant groups of objects.

2 Bright, out of focus highlights spread into approximately *circular* discs of light because lens and diaphragm are nearly circular. Cut out a star or cross shape from black paper and hold it against the front of your SLR camera lens, set to widest aperture. View a subject full of sparkling highlights (such as crumpled foil) rendered out of focus, and see the change of appearance your shape gives.

3 Using your camera on a tripod, compose a picture containing detailed objects over a wide range of distances, from about 0.5 m to the far horizon. Take a series of shots at: (1) widest aperture and (2) smallest aperture, with the lens set for: (a) infinity, (b) the hyperfocal distance for your aperture (read this off the depth of field scale), (c) a foreground object, (d) the same object as (c) but with the camera twice as far away and refocused. Compare results for depth of field changes. Remember to adjust exposure time for each change of aperture. It is useful to keep notes when doing a test like this.

4 Test your lenses for optimum aperture. Make a simple test target from a full sheet of broadsheet newspaper. Choose a page which has as much small print all over the page as possible (financial pages are good for this). Position the camera on a tripod so as to fill the frame with the page, with the camera square on to the paper. Having focused very carefully, take a series of photographs of the newspaper at each aperture on your lens using a fine-grained film (low ISO films have the finest grain). Note down the apertures used and as in no. 3 remember to adjust exposure time for each change of aperture. View the resulting negatives with a strong magnifier or project them in an enlarger. You will find the image is slightly less sharp at the extreme ends of the aperture scale and most crisp somewhere in the middle of the range. The *f*-stop which yields the best result is known as the *optimum aperture*.

PROJECTS

4 Cameras using film

This chapter takes you from the lens alone to the camera as a whole. It explains the main camera components, and shows how – put together in different combinations – they make up today's mainstream camera designs. It also compares the advantages and disadvantages of various camera types. This chapter and Chapter 5 concentrate on *film* cameras, and much of the information here is also valid when you are using a *digital* camera. Plenty of 'front end' components such as viewfinder, auto-focusing, zoom lens and built-in flash are common to both kinds of camera (Figure 4.1). (Chapter 6 discusses features unique to cameras recording by digital means.)

When you look at most modern equipment it's hard to believe that a camera is basically a box with a lens at the front and some form of light-sensitive surface at the back. Yet the first cameras were just that – wooden boxes put together by the local carpenter. A simple lens (often a telescope objective) was mounted over a hole at the front, and a holder for chemically coated material was arranged to fit into the other end (Figure 4.2).

During more than 160 years' evolution many different camera designs have been invented, improved or discarded. And yet today's camera equipment can be divided into four basic types: view cameras, compacts, twin-lens reflexes and single-lens reflexes. At the same time, camera picture sizes fall into three different groups: *large format* (sheet film, typically 5×4 inch), *medium format* (roll-film sizes giving 6×6 cm, etc.) and *small format* (principally 35 mm).

The essential components

Whatever its picture size or type of design, a camera should offer the following controls and adjustments, either manual or automated:

1. A means of accurately aiming the camera and composing the picture.
2. An ability to focus precisely.
3. A shutter to control the moment of exposure and how long light acts on the sensitive surface.
4. An aperture to control image brightness and depth of field.
5. A method of loading and removing film, without allowing unwanted light to affect it.
6. A meter to measure the light and indicate or set the exposure needed for each shot.

Composing and focusing

The oldest, and most awkward, way to accurately compose and focus your picture is still used in large format view cameras for professional photography. A ground glass screen at the back of the camera allows you to see and focus the actual image formed by the lens (Figure 4.3). Once you have placed the film into the 5×4 camera you can no longer see the image on the screen.

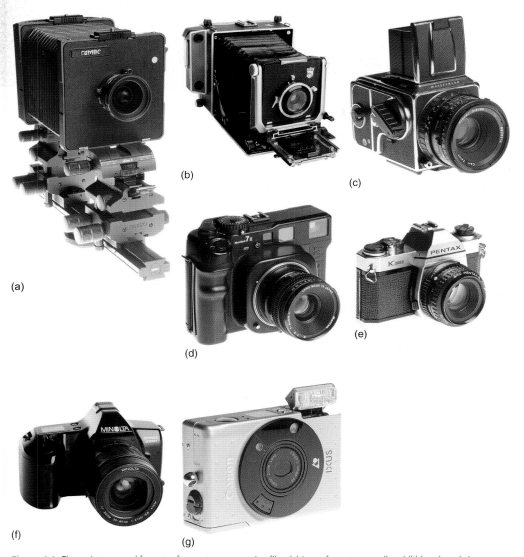

Figure 4.1 The main types and formats of current cameras using film. (a) Large format monorail and (b) baseboard view cameras. (c) Medium format rollfilm single-lens reflex and (d) direct viewfinder cameras. (e) Manual and (f) advanced small format 35 mm single-lens reflex cameras. Also (g) APS compact camera (now out of production)

Another arrangement, dating from early amateur cameras, is to have a line-of-sight viewfinder built into the body of the camera as found in today's compacts. It gives a separate direct view of the subject, and is masked to have the same angle of view and aspect ratio as the picture given by the camera lens. The trouble with this *direct vision viewfinder* is that although it exactly frames up distant subjects, as you photograph closer up what you see through the finder becomes increasingly displaced and inaccurate (see Figure 4.4). Since this fault is due to the separate, parallel viewpoints of camera lens and viewfinder it is known as 'parallax error'. Within the viewfinder window a correction line has to show the true top of your picture when shooting at your closest focusing distance.

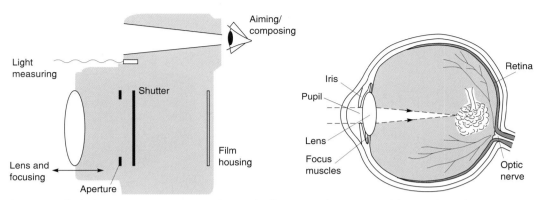

Figure 4.2 Left: The key components necessary in a photographic film camera, whatever its actual design or size. Right: Components with similar functions in our human camera, the eye. Muscles alter lens shape to focus. The iris varies its pupillary diameter like a camera aperture. The retina forms the (curved) light-sensitive surface, and the optic nerve communicates image information signals to the brain. Clear fluid fills the eyeball, maintaining the lens-to-retina distance

Figure 4.3 Photographing procedure with a view camera. (a) Composing and focusing on the ground glass screen. (b) Stopping down while visually checking depth of field. (c) Closing and setting the shutter. (d) After inserting a film holder, withdrawing the darkslide covering the film. (e) Firing the shutter

Figure 4.4 Direct viewfinding accuracy. The separate positioning of viewfinding (V) and taking lens (T) causes framing variations between what you see and what is photographed. This parallax error increases greatly at close subject distances (exaggerated here)

To focus the lens on a direct viewfinder camera, simple types may just have a lens positioning control you set to one of a series of subject symbols (distant views, middle distance groups or close-up portraits). A few high quality 35 mm or medium format direct viewfinder cameras have a precision, manual rangefinder system (Figure 4.5). As Figure 4.6 shows, you see your subject twice: once straight through the viewfinder, the other ducted (via a mirror and window) from a viewpoint farther along the camera body. This second view is superimposed over the central area of the first, and moves sideways as you alter camera lens focusing. When you see both versions coincide in their detail of items at a particular distance the lens is correctly focused for this part of your subject. Optics in the viewfinder may also tilt to help compensate for parallax error according to the lens focus setting.

The majority of direct viewfinder compact cameras now have an automated rangefinding system that gives full *auto-focus* (AF). As you begin to press the shutter release, the distance to the subject is measured by a form of electronic rangefinder (Figure 4.7), and lens focusing is automatically adjusted to the appropriate setting.

The above systems of composing and focusing your picture work reasonably satisfactorily for most general subjects. For real accuracy, however, you need to work viewing the image given by the camera lens. Single-lens reflex cameras allow this, without the slowness and inconvenience of a view camera, by having a mirror behind the lens to reflect the image up to a viewable focusing screen near the top of the camera body. This mirror lifts out of the way of the film just before exposure (Figure 4.33, see p. 88).

A focusing screen is the only film camera system offering 'what you see is what you get'. It accurately displays the visual effects of depth of field on your picture at different aperture

Picture area (close-ups)

Figure 4.5 Correction lines for parallax. The viewfinder in this compact camera suffers both horizontal and vertical parallax errors, due to its location relative to the lens. Extra lines in the viewfinder display show the top and sides of the picture limits (broken lines) at closest focusing distance

Out of focus

In focus

Figure 4.6 A manual rangefinder focusing system. This uses an optical rangefinder containing glass (S) with a semi-silvered spot, and a pivoting mirror (M) controlled by the camera lens focusing mechanism. In the viewfinder you see a second image centre-frame. The two coincide and merge when rangefinder (and lens) are set for the distance of this subject; see broken line at M

settings and lens focal lengths. Single-lens reflex cameras are designed to hold the lens at widest aperture (brightest image, least depth of field) while you are composing and checking focus. So you really need some way of snapping the aperture down to the setting which will come into use when the shutter fires, to preview exactly how much of your picture will be sharp. This is called depth of field preview (see p. 71). Most modern 35 mm single-lens reflexes have auto-focusing but allow you to focus manually too (Figure 4.8).

Shutter

A front or 'between-lens' shutter has several thin opaque blades which rapidly swing out of, and back into, the light beam to make the exposure when the release is pressed. In this central position the shutter has an even effect on the whole image, and only a small movement is needed to open and close the light path. It is also easy to synchronize this action with flash: contact is made to the (electronic) firing circuit the instant the blades are fully open. Often compact cameras combine the action of shutter and aperture (see p. 70).

Figure 4.7 Infrared AF system. When the shutter release is half-pressed a transmitter (T) scans centre of subject area. Detector (D) senses when the reflected signal is strongest. Processing circuit (P) relates this to the position of (T), halting the camera lens focusing motor at the step giving correct setting for the distance

A rear or focal plane (FP) shutter is more practical in cameras with interchangeable lenses. (Since it covers the film you can change lenses at any time.) Focal plane shutters in modern small format cameras often have sliding metal blades. Alternatively there are two roll-up fabric blinds. One blade or blind opens to start the exposure, the other follows to block out the light again. For short exposures the two follow each other across the film so closely they form a slit which actually exposes the picture. After each shot the blades or blinds are wound back, this time overlapped to avoid farther exposure, ready for the next picture.

Having a focal plane shutter also means that light can be allowed to pass through-the-lens and provide an image for viewfinding and focusing via a reflex system (Figure 4.9). And since one shutter will serve a range of lenses of different focal lengths you don't have to have a between-lens shutter in each.

The usual range of shutter speeds, on both types of shutter, is:

1, 1/2, 1/4, 1/8, 1/15, 1/30, 1/60, 1/125, 1/250, 1/500 s

Figure 4.8 Bladed, between-lens shutter. The lower drawing shows how the blades (simplified here to three) rapidly open or close when the ring is part-rotated

Advanced cameras with FP shutters may continue this series down to 1/8000 s. Most modern single-lens reflex cameras use electronically timed FP shutters offering settings up to 30 s, or B (see below). Large diameter between-lens shutters for view cameras have big, cumbersome blades to move and may not operate faster than 1/250 s.

The doubling/halving progression of shutter settings (figures rounded up or down in some instances) complements the aperture f-number scale in terms of exposure given to the film. In

Figure 4.9 For centuries before photography artists used the reflex 'camera obscura' to form a right-way-up image on glass, convenient for tracing

other words, 1/30 at *f*/8 is the same exposure as 1/60 at *f*/5.6 or 1/15 at *f*/11. Actual choice depends on the depth of field you want and whether movement should record frozen or blurred [see Figure 3.11 (p. 54) and Figure 4.11]. The shutter speeds listed above make a wide range of exposures possible. Combining this with a similar range of apertures on a lens means a very wide range of subject brightness conditions can be covered. Typically this means a range of 1:64,000 or more, which should encompass anything from candlelight to the brightest summer day.

If you want an exposure longer than offered by the scale of shutter speeds you may find that your camera has the setting 'B'. (B stands for 'brief' or 'bulb' after early photographers' use of an air bulb and tube system to hold the shutter open.) On B setting the shutter opens when you press the release button and remains open as long as you keep it pressed down, normally using a cable release.

Flash can be fired by a between-lens shutter at all marked speeds. FP shutters are slightly more difficult here because the flash must only fire when the entire film frame is uncovered (Figure 4.10). Otherwise only part of your picture will appear. Contact to fire the flash is made when the edge of the opening blind gets to the far end of the frame. Providing you use the speed marked on the camera for flash, *or any speed slower,* the second blind will not yet have started to travel and the full frame is uncovered for exposure. (Check your camera manual but in general don't exceed speeds of 1/125 with most 35 mm metal blade FP shutters; or 1/60 with large 6 × 7 cm blind FP shutters.)

$\frac{1}{60}$ sec (Resetting)

Figure 4.10 A focal plane shutter. One blade or blind follows the other horizontally. The sequence also shows how flash is usually triggered when the first blind has fully opened – at this point the film frame receives the full image

Between-lens and FP shutters that are electronically timed integrate easily with the metering, auto-focus and film wind-on circuits of small format cameras. They give 'stepless' settings – speeds between the marked times – when exposure is under the automatic control of the meter. Operating power is drawn from the camera's main battery supply. (An electronic between-lens shutter for view camera use has a battery compartment attached.) However, if the battery fails or your camera meter circuit is not switched on, many electronic shutters default to 1/60 second. Some shutters cease functioning altogether.

After a shot is taken, all focal plane and most between-lens shutters, mechanical or electronic, have to be re-tensioned before they can be fired to take the next picture. Often the cocking mechanism is set by winding on the film and so is hardly noticed. View cameras usually have a tensioning lever beside the shutter, and this must be activated before you fire the shutter with another lever or a cable release (Figure 4.12).

Figure 4.11 The effect of shutter speed on a moving subject. Top left: 1/1000 s renders the planes sharp but gives no sense of motion, making them look more like models than real aircraft. Top right: 1/8 s exaggerates movement at the expense of detail. Bottom left: 'Panning' the camera reduces the car's movement relative to the frame so it appears sharp even at a relatively slow shutter speed of 1/125 s. The background, however, is blurred in the direction of motion, adding to the sense of speed. Bottom right: A high shutter speed of 1/000 s freezes everything in the frame, but the essence of motion is retained by the spray being thrown up

Many modern SLR cameras feature intermediate shutter speeds. As well as the 'classical' settings listed above, you may find other numbers in between so the sequence looks (in part) like this:

... 1/8, 1/10, 1/13, 1/15, 1/20, 1/25, 1/30, 1/40, 1/50, 1/60, 1/80, 1/100, 1/125, 1/160, 1/200, 1/250 s ...

These interim numbers represent one third stop increments, allowing a wider range of options, but they are not essential for fine control of exposure since the lens aperture is usually adjustable to half or third stop accuracy. Alterations in shutter speed and ISO rating can also be used to fine tune exposure, particularly if you have decided on a specific aperture being necessary to achieve a certain depth of field.

Aperture

Physically, the diaphragm system used for lens aperture control differs little from camera to camera. As shown in Chapter 3, a series of overlapping sliding blades forms a

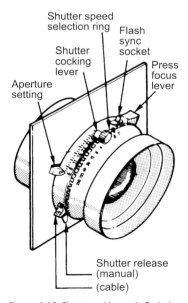

Figure 4.12 Shutter and lens unit. Typical view camera (5 × 4) lens unit with mechanical bladed shutter. The panel it is mounted on makes it interchangeable with other lens units

hole of continual variable diameter. Sometimes, however, when the camera has a between-lens shutter, shutter and diaphragm are combined. The shutter then has six suitably shaped blades designed to open only part way, temporarily forming a hexagonal aperture of the correct size according to the *f*-number preset. This reduces the mechanism needed and is very suitable for linkage to the exposure setting in fully automated compact cameras.

In cameras that allow you to compose and focus the actual lens image, the aperture can be preset. This means that you (or the camera's auto-exposure system) set the required *f*-number but the lens still stays fully open for brightest image viewing until just before the shutter is fired. On single-lens reflex cameras this last-minute stopping down is triggered automatically from the shutter release mechanism. On most view cameras you can stop down directly to a preset aperture by manually releasing a 'press-focus' lever.

In all cases you will probably want to check depth of field effects at different shooting apertures. On some 35 mm and most rollfilm SLR cameras there is a special aperture preview button on the camera body or lens; so long as you keep this pressed the diaphragm responds to any setting made on the *f*-number scale (see Figure 4.13). An aperture preview button is a desirable feature in any SLR camera intended for serious photography.

Light measurement

Practically all modern small and medium format cameras have some form of built-in system to measure the brightness of light from the subject and so assess correct exposure. This signals when you have manually set a suitable combination of *f*-number and shutter speed, or else it

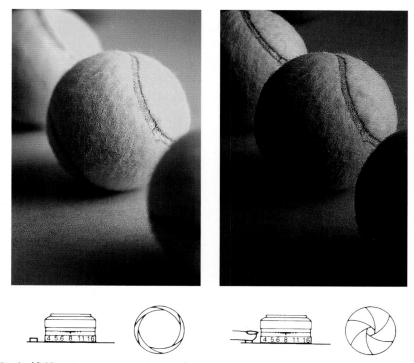

Figure 4.13 Depth of field preview. Lenses on single-lens reflex cameras have apertures which remain fully open before exposure for easiest focusing and view-finding (left). If the camera offers a preview button this will stop down the lens to the taking aperture. The image on the focusing screen now becomes darker (right) but shows you the actual depth of field you will record on film

automatically sets: (a) the correct shutter speed for an aperture you have set (known as aperture priority or Av mode); (b) or the correct aperture for a shutter speed you have set (shutter priority or Tv mode); or (c) a suitable combination of shutter and aperture settings chosen by the system from a built-in program. The practical advantages and disadvantages of each are compared on p. 242.

A tiny light-sensitive measuring sensor may be located on the front of the camera body pointing directly at the subject from close to the lens, or sensors can be positioned inside the camera, sampling the light which has come through the camera lens itself. In both positions the sensor should measure through any filter you may use over the lens. An internal sensor system is more accurate and works equally well with any change of lens.

All modern exposure-measuring systems need to be powered by a battery. This is usually tapped off the same power circuit for auto-focus, shutter timing and film drive. You may have to set the sensitivity of the film you are using (its ISO speed) although many 35 mm cameras do this automatically, reading a bar code on the cassette via electrical contacts in the film feed compartment. Large format cameras seldom have light-measuring arrangements built in, and you have to add a metering attachment or use a hand meter instead (see Chapter 10). (Alternatively, if you are working with a medium or large format camera without a meter, take readings with a small format internal-meter camera and then transfer the settings displayed.)

Film housing

Unlike digital cameras, a film camera must allow you to load and remove light-sensitive material without having it fogged by light. The oldest way to achieve this is to have separate sheets of film in a light-tight holder – a system still used for view cameras. The double-sided holder (Figure 4.3) slips into the back of the camera, displacing a focusing screen, and one side is then opened to face the (shuttered) lens. Smaller cameras, however, use film in lengths (35 mm wide, or 62 mm wide 120 rollfilm) to allow many exposures at one loading (Figure 4.14). The film passes from feed to take-up compartments behind a metal frame, flattened against it by a spring-loaded pressure plate. It is protected from light during loading and unloading because the film is contained in a

Figure 4.14 Three of the four main forms in which light-sensitive film is loaded into cameras of differing sizes. Left to right: 4 × 5 inch sheet film, part-inserted into a double-sided film holder; cassette of 35 mm film; 120 rollfilm. The film notch tells you which way up the sensitive surface is facing (see Figure 9.8). The cassette auto-sensing code sets the camera's exposure system for the film speed

cartridge, or a cassette having a velvet 'light-trapped' feed slot. Rollfilm is just tightly rolled up on a spool together with opaque backing paper.

Between exposures regular 35 mm cassette film is wound through the camera onto a permanently fitted open take-up spool. It must be rewound back into its light-proof cassette before you open the camera to remove the film for processing. Rollfilm does not need rewinding; it winds completely on to an identical, removable, take-up spool protected by the last few inches of backing paper. (You can also buy 35 mm bulk film for 250 or 500-exposure accessory backs, p. 110.) Once inside the camera the cartridge is automatically opened and film advanced; after the last exposure (or whenever you want to change film type) film is returned into the cartridge that closes again ready for removal.

Sheet film holders also allow you to change what is in your camera from one film type to another at any time. If you want to do the same with a 35 mm or rollfilm camera without wasting frames it is quickest either to use two bodies, changing the lens from one to the other, or use a camera designed with interchangeable film magazines. Most cameras with magazine backs also accept pack holders for instant picture film.

Lengths of film are shifted through the camera either by an electric motor triggered immediately the shutter closes after each exposure, or by hand using a wind-on lever. The wind-on, shutter-cocking and exposure release are normally interlocked, so that you cannot take another picture until the previous shot has been wound on, and vice versa. Some cameras offer a button to over-ride the system for special superimposition effects. Older medium format cameras do not wind on automatically: you have to remember to wind on after each shot – a small window in the film back shows you the number of the shot you have taken and you may have to put a darkslide back (as you do in a 5×4 camera) in between exposures to prevent light reaching the film. Cameras with built-in motor drive normally power-rewind the film back into its cassette after the end of the film has been reached.

Camera types – which is best?

So far we have looked at the basic components present in some form in *every* camera system – for aiming; focusing; controlling depth of field and exposure. Different camera types approach these tasks in a variety of ways, so how do you decide which is the right one? No one camera is *ideal*. Some are extremely versatile but something of a compromise, not matched to any one kind of photography. Others are specialist tools that enable you to tackle a narrow range of tasks in ways impossible with any other equipment.

Modern small format film cameras are internally very sophisticated, requiring least knowledge of photographic technicalities to get acceptable snapshots. Most medium and large format cameras have fewer automated aids so you must understand photographic principles more thoroughly to operate these cameras successfully. Another facet to consider is the rapidly improving performance of digital cameras (Chapter 6). However, since they retain most of the optics and mechanisms needed in film cameras, arguments for and against different camera designs raised here are largely common ground. Many photographers find the manual film cameras far more straightforward to use than some of the high end digital versions which have highly complex set up procedures with numerous details to fix in the menu settings before shooting.

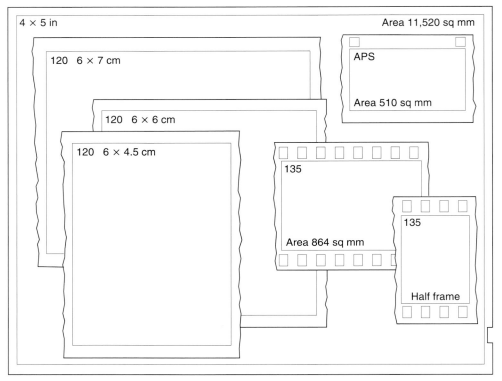

Figure 4.15 Picture formats. The picture areas given by large (4 × 5 inch), medium (120) and small (35 mm and APS) format cameras, drawn here life size. 120 rollfilm and 35 mm provide different formats according to the camera design

If possible try to get 'hands-on' experience of all four main camera types (view cameras; compacts; twin and single-lens reflexes). Compare convenience, toughness and reliability as well as image quality. Decide what sort of camera controls feel right for you, and consider whether the size and proportions of the picture a particular camera gives are best suited to your work (Figure 4.15).

Large, medium or small format?

1 The larger the format, the finer the quality your final image is likely to have – better definition, less grainy pattern, subtler tone and colour gradation. The 4 × 5 inch format, for example, has around 13 times the area of the regular 35 mm format; you can make enlargements to 16 × 20 inch before image quality becomes worse than an enlargement to only 4 × 6 inch from 35 mm. When you make large exhibition prints these differences become very noticeable.

2 Pictures shot on small format cameras have greater depth of field than pictures on large and medium format cameras (standard lenses, and same *f*-number) even when enlarged to the same size. In other words, you can shoot at a much wider aperture and still get the same depth of field.

3 The larger the camera, the more it physically intrudes between you and your subject. A small camera gives you greater freedom of viewpoint, is more mobile and much faster to set up and use, and allows you to shoot pictures in quicker succession. Note though that the slower set up and shooting rate of large format cameras are cited as an *advantage* by some users as it helps them make more 'considered' images; also to note is that a large format camera is often taken more seriously than a 35 mm camera and when photographing people this can be a huge advantage. Often people associate the 35 mm camera with the photojournalist or the paparazzi photographer and this can create problems for the photographer.

4 Small format cameras are often fitted with lenses that are 'faster', i.e. have larger maximum apertures. Among other advantages, the brighter image makes it possible to shoot at hand-held shutter speeds under dim lighting. 35 mm camera systems have a vastly greater range of lenses and accessories available too; see Chapter 5. Where equivalent items exist for medium or large format kits they are much more expensive. There are relatively few medium format zoom lenses for example.

5 Some specialised light-sensitive film materials are made only for large format cameras. Having sheet film holders allows you to change from one film to another with ease, and you can process pictures individually. However, a small format camera kit makes it easier to shoot and process a large *quantity* of pictures. 35 mm is ideal for making projection slides.

6 Large format cameras offer you a wide range of 'camera movements' (see Appendix B) for image control.

7 Enlargers and digital film scanners (Chapter 14) are more costly the larger the film format they accommodate.

The other important consideration is format *shape*. Height-to-width proportions have a strong influence on picture composition. Most formats are rectangular, 35 mm regular frame having a ratio of 2:3. At first sight a square format would seem the easiest to work with. You don't have to choose between vertical and horizontal shapes when framing a shot. But then you don't have the up/down or sideways (vertical or horizontal) push that they can add to your picture either. Conventionally, landscape photographers work with a horizontal frame while portrait photographers shoot vertically; hence the terms portrait or landscape referring to the shape of the frame – it is interesting to see what happens when you break these codes. The majority of pictures are rectangular, which says something about the way human beings view the world. Some photographers have tested out oval or round framing shapes, which can either be done at the printing or at the mounting stages of production.

Of course, during enlarging you can crop off unwanted image parts, but you will find that the original camera format still influences your picture making. Many photographers do not like the idea of cropping negatives and tend to print the full frame. Similarly, some shapes are definitely more 'comfortable' to compose subjects within than others. A few panorama wide-angle rollfilm cameras (Figure 4.16) offer ratios of 1:2 or even 1:3. These long thin negatives, up to 6 × 17 cm, must be enlarged using a large format enlarger. 35 mm and 6 × 9 cm negatives offer a picture ratio of 1:1.5, which is close to the 1:1.618 ratio claimed by Renaissance artists and architects to be 'the ideal format' (reference: the Golden Section). 5 × 4 inch and 10 × 8 inch negatives provide a picture ratio of 1:1.25.

There is no doubt that certain cameras fit certain jobs and, on top of this, different cameras can give varying impressions to your client or subject(s). You should try to select the most appropriate camera for the job you are doing, i.e. the one that will give you the best results – the way your subject(s) or client responds to your camera can affect the quality of the photographs; your choice of equipment may well be affected by this knowledge. When you use a

Figure 4.16 Specialist purpose direct viewfinder cameras. Top: A wide-angle 6 × 17 cm rollfilm camera (focus by distance scale only). Bottom: Architectural 'shift' camera accepting a roll or sheet film back

small format camera you may be seen as a press photographer or as an *amateur* – this may help or hinder your work. When you are commissioned for a commercial job and turn up with a 35 mm outfit not dissimilar to the client's own, the effect can be less impressive than medium or large specialist-looking equipment.

The review of how different camera types work that follows begins with view cameras. Although now less used because of improved medium and small format equipment, they are by no means obsolete, and their workings are deceptively simple. Little is hidden away inside, and it is easy to see how the basic components work together.

How view cameras work

This type of camera design relates back directly to the earliest form of photographic plate camera, as used by pioneers such as Louis Daguerre (Figure 4.17). Equipment then consisted of two boxes, one sliding inside the other for focusing, and having a lens at the front and a ground glass screen at the back. Today's view cameras are still large format, but designed for sheet film. The most usual size is 4 × 5 inch; others include 7 × 5 inch and 9 × 6.5 cm, even 8 × 10 inch. You can adapt *down* from any of these sizes by fitting an appropriate back or adaptor for smaller sheet film, 120 rollfilm, instant-picture material, or digital recording (Chapter 6).

The camera lens with its between-lens shutter is mounted on a clip on panel that fits over the camera front. You can quickly change to lenses of different focal lengths, also ready-mounted on panels. The front of the camera is connected to the back by an opaque concertina bellows that allows the lens and film to be placed at a wide range of angles and distances from each other. A finely etched glass screen at the back captures the lens image (upside-down) for focusing and composition. This back can be rotated from horizontal to vertical format. As the screen is spring-loaded, when you push in a film holder between glass and bellows the film surface becomes located in exactly the position previously occupied by the etched surface of the glass (Figure 4.3). It takes time to get accustomed to the upside-down image but if you use the camera enough you will stop noticing it eventually.

Figure 4.17 View cameras. Both monorail (centre), and baseboard (right) designs are derived from wooden sliding-box plate cameras (left) used by pioneer photographers in the 1840s

The lens-carrying front of the camera can be tilted, or offset sideways up or down independently from the back. These 'camera movements' are important for professional architectural and still life photography. They allow you extra control over depth of field and shape distortion, explained in detail in Appendix B.

There are two main types of view-camera design, monorail and baseboard. Monorail types are constructed as a pair of frames (called standards) attached to a bar. To focus you move either the front (lens) standard or rear (focusing screen) standard along the rail. Having such an open unit structure, a monorail offers the same camera movements front and back, allowing an enormous amount of offsetting. Monorails are virtually impossible to use hand-held and so are always used on a stand or tripod.

The baseboard type of view camera, also called a 'technical camera', is a box-like unit with a hinged front. Opening this flap you find you can pull the lens standard out onto it, on runners. Then by turning a milled knob at the edge of the board you move the runners, focusing the lens backwards or forwards while you check the image on the focusing screen. A baseboard camera is quicker to set up on its stand and use than a monorail type. However, it offers less comprehensive movements, especially on the back (Figure 4.18).

With all view cameras you need a fold out hood or an old-fashioned focusing cloth over your head and camera back to block out ambient light, so you can clearly see the image. Figure 4.13 shows the typical prolonged sequence needed to take a picture. Exposure is most often measured with a separate hand meter (Chapter 10).

View camera advantages

1 Cameras offer large format image quality (very apparent in really big exhibition prints) and an unrivalled range of camera movements.
2 You can take and process single exposures. When working in the studio this allows a check on each result as you go along.
3 Relatively simple construction. There's little to go wrong.

Figure 4.18 Left and centre: Monorail view cameras are unit constructed, allowing different lengths of bellows, rail, and size of back, as well as independent movements of lens and film. Some cameras have U-shaped standards, others L-shaped (Figure 4.17). Right: Baseboard type view camera folded, and open for use on a tripod. The lens pulls forward onto a focusing track; flaps which fold out at the back shade the ground glass focusing screen

4 The large format and static nature of the camera encourage you to build up carefully considered compositions, almost like drawing or painting.

5 Often chosen for architectural, landscape and still life photography; also for close-ups and copying because even the normal-length bellows allows considerable lens–film extension.

View camera disadvantages

1 Camera kit, film holders and tripod are bulky to carry and slow to set up and use (Figure 4.19). The dim, upside-down image is awkward to view (the field cameras are considerably lighter than a conventional studio camera).

2 It takes time to measure exposure, and with a hand meter there are exposure calculations needed when working close (see p. 250).

3 Impractical camera for fast moving subjects, e.g. sports.

4 Smaller choice of film types available in this format. Digital backs are possible but extremely expensive.

How direct viewfinder cameras work

This term covers cameras using direct vision (also known as *real image*) viewfinders, notably small format 'compacts'. Unlike view cameras or reflex cameras which allow you to see the actual image formed by the lens, they have a separate window set into the camera body through which you look at your subject directly (see Figures 4.4 and 4.5). Based on early user-friendly cameras invented to overcome the prolonged practical procedures that large-format view cameras demand, they are typically small, pocket sized, and fully self-contained.

Figure 4.19 Rising front. A view camera offering this camera movement is still often used for architectural subjects where most elements are well above the lens centre. Tilting a normal camera upwards would make vertical lines converge. Instead, the camera back here was kept upright and the front lens standard raised to include more arch top, less road (see also digital manipulation of perspective, p. 367)

Everything, including flash, is built-in. Technical settings are automated by sophisticated technology, making cameras instantly ready for shooting pictures hand-held.

Direct viewfinder cameras come in a huge range of compact point-and-shoot designs – mostly for 35 mm. There are also some more expensive versions having manually set exposure controls and rangefinders, which are designed more for professional work. These use either 35 mm or rollfilm.

Compact, point-and-shoot designs

The aim of these cameras is to make photography of 'typical' subjects simple. They achieve a high technical success rate, even under quite a wide range of shooting conditions. Photographers with little interest or skill in controlling results can expect to get clearly recorded images, provided they work within limitations such as not too close; holding the camera steady; and not trying to light a huge landscape with flash. The 'auto-almost-everything' features put compact cameras well ahead when you make a quick decision to take actuality pictures of an event. There's no delay over settings – you can even hold the camera up over your head in a crowd and get sharp, well-exposed results. Also you are more likely to always carry a camera with you when it is smaller and fits better in your pocket than a reflex type.

Features of typical compact cameras include the following.

Viewfinder. The direct vision viewfinder always shows your subject looking sharp even if too close since your eye is doing the focusing. Picture limits are often shown by a marked outline in a slightly larger viewing area (Figure 4.20). Short extra lines near the top show the true upper limit of your framing when shooting close-up (parallax correction, p. 65). A central zone is marked where the auto-focusing system is aimed. Information such as 'flash ready' or warning of 'too close for focusing range' may appear as light signals alongside the frame lines or beside the eyepiece of the viewfinder. It is important that your viewfinder has an eyepiece large enough to give you clear sight of all four corners of your picture at the same time – particularly if you wear glasses.

Figure 4.20 Information shown in a typical compact camera viewfinder. F: Suspended frameline, with parallax-correcting top lines for closest focusing distance. A: Auto-focusing area. S: Shake warning lamp (for when a slow speed is in use). R: 'Flash ready' indicator

Auto-focus (AF). Most auto-focusing systems are 'active', meaning that they use diodes transmitting and receiving infrared wavelengths (like those used for TV remote control). These operate through two windows in the camera body (Figure 4.21). The system works on the rangefinder principle (p. 67) but it sends out a beam of invisible IR rays from one window and has a narrow-angle sensor behind the other. First pressure on the shutter release button causes a motor to adjust the camera lens focusing and scan the beam across your subject (Figure 4.7), within the mid-frame target area. Both stop when a strong return signal is detected. In practice the lens is 'stepped' through a series of settings between infinity and closest focusing distance. Cheaper cameras may work using only seven setting stages. Others have 100 or more stages, which allows the auto-focusing to be much more precise.

An IR system will even focus in darkness, but it can be fooled sometimes if you are photographing through a window or shooting towards a bright source of light. Watch out too for situations when your main subject is not in the centre and the AF measuring area falls entirely on background or foreground (see Figure 4.22). Cameras have an 'AF lock' button to deal with this – you first aim the measuring area at your main subject, auto-focus

Figure 4.21 A typical direct viewfinder compact camera. (A) Shutter release and power wind-on. (B) LCD panel, displaying frame counter, battery state, etc. (C) Front window of viewfinder. (D) Windows for IR auto-focus system. (E) Light sensor for auto-exposure setting program. (F) Flip up or pull out flash. (G) Lens zooming control

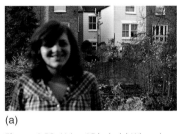
(a)
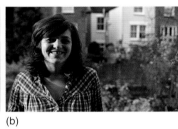
(b)
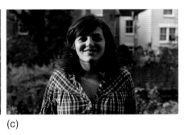
(c)

Figure 4.22 Using AF lock. (a) When the main subject is not positioned centre-frame the background becomes auto-focused instead. (b) Briefly recompose the picture, auto-focus and apply AF lock, and then return to your chosen picture composition (c) before exposing

with a half pressure on the shutter release, and then apply the lock and recompose your picture as you want it with main subject off-centre but now remaining sharply focused. However, the procedure takes time and it is tempting to shoot subjects centre-frame instead.

Zoom lens. Compact cameras don't have interchangeable lenses like SLRs or view cameras. Apart from the cheapest models it is usual to have a zoom (variable focal length) lens. Control buttons then provide you with a smooth optical adjustment that enlarges or reduces how much of your subject fills the frame – in other words, narrowing or widening angle of view. The direct viewfinder's optics must also move so it shows the same framing.

Auto-exposure (AE). Shutter speeds and aperture settings are determined and set internally by a program. This takes into account the light-sensitivity of the film you have loaded (read direct off the cassette or cartridge by modern cameras, p. 202) and the brightness of the subject you are photographing as measured by a light sensor facing it from the front of the camera (Figure 4.21). A good compact camera may make settings ranging from 1/8 s @ f/2.8 to 1/500 @ f/16, but not actually display what its choices are. If conditions demand speeds of 1/30 s or slower a signal warns you to use a tripod or change to flash; some cameras automatically switch the flash on.

Built-in flash. Flash built into a compact camera body is typically only powerful enough to give correct exposure at subject distances up to about 3 m. The closer and more reflective a subject is, the shorter the flash duration will be (see p. 255). The flash is triggered by the shutter

and is followed by a recharging delay of up to 10 seconds after each exposure. You have to wait for a 'flash ready' signal in or beside the viewfinder before taking the next shot.

An inherent problem with compacts is 'red-eye' caused by the closely positioned flash illuminating the retina pattern at the back of a subject's eyes (p. 66). To minimize red-eye, the flash is housed as far to one side of the camera lens as possible. Some designs use a fold-up or pull out arrangement to achieve this. Other systems fire a burst of several flashes in quick succession just *before* the actual exposure. The idea is to cause the subject's pupils to contract with the bright light, allowing less flash to be reflected from the retina.

Compacts using 35 mm film. The widest range of compact cameras is still of this type. A great variety of film types are available in 35 mm. Films can be user-processed if you so wish; and the image is big enough to enlarge to a 30 × 40 cm exhibition print without much deterioration (some photographers like the graininess of larger scale prints from these cameras – the viewing distance of a print affects the way it is read). The most common lens focal length is 38 mm but most have zoom lenses, typically 35–70 mm (×2 zoom range) or 35–105 mm (×3). However, the greater the zoom lens range, the more bulky the camera becomes, which is self-defeating. With such a wide range of 35 mm compacts, comparisons are difficult to make, but the best quality 35 mm types are capable of making high quality images (Figure 4.23).

Figure 4.23 The three picture formats offered by APS. In every case the full 30 × 7 mm frame is exposed, but you also record a magnetic signal on the film which later programs lab equipment to make either a 6 × 4 inch, 7 × 4 inch, or 10 × 4 inch print. Note APS cameras are no longer made.

Professional type direct viewfinder cameras

What are often referred to as 'rangefinder' cameras are intended mostly for the professional market and priced accordingly. They include some 35 mm format cameras such as the Leica and Contax, several for medium format rollfilm, and a few large format hand-held cameras (see Figure 4.24). Viewfinders are mostly 'parallax-corrected', meaning that optics slightly shift the frame lines downwards the closer you focus (Figure 4.25).

An attraction of these cameras is their quiet shutters, and reduced weight relative to single-lens reflexes offering the same picture format (Figure 4.26). They are also rugged and have high-precision optics. In the case of the Leica it has an almost soundless focal plane shutter (popular for photo-journalism) and a modest range of interchangeable lenses. The viewfinder automatically changes its frame lines according to the lens you fit. Exposure reading is made through the taking lens, by a hinged light sensor just in front of the shutter blind which moves out of the way immediately before you shoot.

Medium format direct viewfinder cameras often have the same features of interchangeable lenses and range-finding focusing, or have a zoom lens and auto-focusing. Everything of course is scaled up in size – if the format is 6 × 7 cm the standard lens is likely to be 80 mm, or a 55–90 mm zoom on a 6 × 4.5 cm camera. They are popular with some professionals for both editorial and studio based work where both formal groups and more spontaneous pictures will be needed. Wedding photographers used to regularly work with medium format cameras but more recently

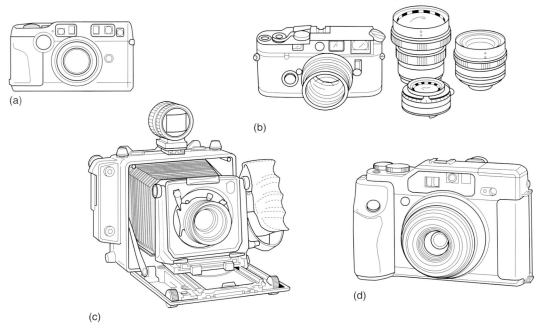

Figure 4.24 Direct viewfinder cameras for mainly professional usage. (a) Contax 35 mm compact, with manual/auto rangefinder. (b) Leica manual rangefinder 35 mm with some of its interchangeable lenses. (c) Baseboard 4 × 5 inch camera with coupled rangefinder. (d) Rollfilm 6 × 4.5 cm format camera with an auto-focus, zoom lens

Figure 4.25 Given time and a static subject you can correct both framing and viewpoint parallax error. Compose the picture, then raise the camera so the lens is exactly where the viewfinder was

most have converted to high end 35 mm digital cameras as these offer the vital preview facility and the safety of knowing you have got the shot!

Specials. A few direct viewfinder rollfilm cameras are designed for more limited, special applications. They include wide-angle cameras giving a panoramic-type format such as 6 × 17 cm, and highly portable 'shift' lens cameras for architectural photography which allow you to raise the lens to control perspective effects (see Appendix B). Some baseboard view cameras also accept a direct vision finder matching the lens in use, and have an optical rangefinder linked to the focusing track mechanism. You can then take hand-held pictures on 4 × 5 inch sheet film or change to medium format pictures by attaching a rollfilm back.

Direct viewfinder camera advantages

1 An all-in-one unit, mostly quick to activate and record things as they happen – getting a picture you would otherwise miss. Press photographers often carry an automatic compact as a back-up camera.
2 The viewfinder gives a sharp, bright image. You may also see part of your subject in the viewfinder before it enters the marked frame, good for sport and action.
3 Modern compacts pack in a wide range of practical features – motordrive, auto-focus, auto-exposure setting program, zoom lens, flash – yet remain small.
4 Medium format DV cameras may be designed for specialist roles, hand-held architectural photography, panoramas; or more general work where portability plus medium format results are required.

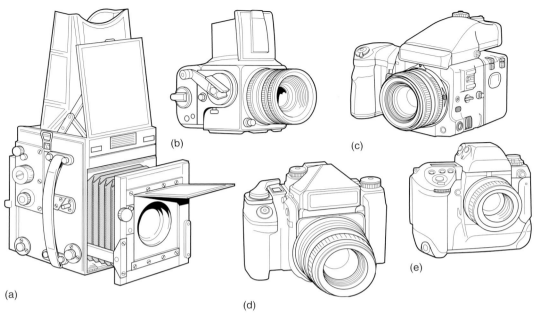

Figure 4.26 Single-lens reflexes, all based on 1920s plate camera design (a). Modern versions use formats 6 × 6 cm (b), 6 × 4.5 cm (c), 6 × 7 cm (d), 35 mm SLR cameras (e) are similarly related

Direct viewfinder camera disadvantages

1 Parallax error between viewfinder and lens is a real problem when working close. Even though 'parallax-corrected' cameras give accurate *framing*, the *viewpoint* difference still gives you a slightly different alignment of elements one behind another – sufficient to upset critical compositions.

2 There is no convenient way of visually checking depth of field.

3 It is easy to have a finger, or strap, accidentally blocking the lens, exposure sensor, or auto-focus rangefinding window. You will not see this looking through the separate viewfinder.

4 Inexpensive auto-focus compacts take a perceptible time to focus (typically 1/10 second). Delay between pressing and firing can mean you lose the key instant of a fast action shot.

5 The small flash built into compact cameras is not very powerful and gives only 'flat on' light. It cannot be bounced unless the camera has a shoe accepting an add-on flashgun.

6 Most small format compacts are totally reliant on battery power to function.

How reflex cameras work

Reflex cameras can be traced back to one of the earliest forms of camera obscura used for sketching views. With a mirror fixed at 45° behind the lens the image is reflected up to a horizontal surface and becomes *right way up*. Soon after the invention of photography this reflex arrangement was mounted on top of a basic plate camera to act as a full-size focusing viewfinder. The combination was called a twin-lens reflex (TLR). A few medium format versions of twin-lens reflexes are still made, but farther development resulted in single-lens reflex (SLR) cameras. These offer a much more accurate and informative image checking system.

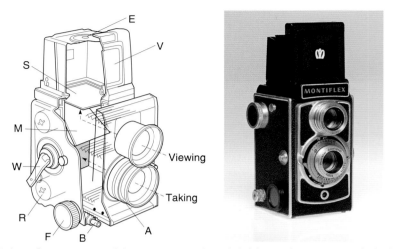

Figure 4.27 Twin-lens reflex. A: Aperture and shutter setting controls. B: Bladed shutter release. F: Focusing knob, shifts entire twin-lens panel. R: Rollfilm spool. W: Film wind-on handle (folds out). M: Fixed mirror. S: Focusing screen. E: Focusing magnifier. V: Push-in hood section, forms direct viewfinder with rear eyepiece

Twin-lens reflexes

The top lens has a fixed aperture, the same or wider than the maximum given by the diaphragm of the lower lens (Figure 4.27). This produces a bright image and minimal depth of field for easier visual focusing. The image on the screen is the right way up, but *reversed left to right,* a feature which makes it difficult to follow moving subject matter. There is therefore a simple fold-in direct viewfinder in the metal hood. However, since this viewpoint is 75 mm (3 inch) or more from the taking lens, parallax error is even more extreme.

TLR cameras are designed to give square format pictures. This is because the camera is awkward to use on its side – the image on screen goes upside-down. Some models have a built-in exposure meter, located behind a semi-silvered area of the mirror.

TLR advantages

1. A mechanically simple design is used, with a very quiet shutter.
2. You see the visual effect of focusing, on the full-size screen, even during the exposure itself.
3. The camera is easy to use over a wide range of viewpoints from floor level to high above your head (holding the camera upside-down).
4. A TLR costs less than a rollfilm SLR camera with similar lens quality. It is a cheap way into medium format photography, practical for weddings and portraits.

TLR disadvantages

1. Parallax error creates difficulties with close-up work.
2. The image on the screen is reversed left to right.
3. Depth of field is shown on a printed scale, but you cannot check its *visual* appearance.
4. The camera is relatively bulky for its format.
5. Few zoom or interchangeable lenses are available.

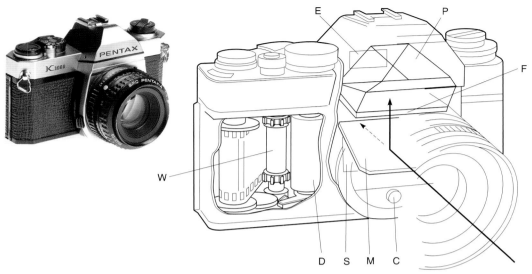

Figure 4.28 Typical manual 35 mm SLR showing basic internal structure. E: Eyepiece at rear of camera. P: Pentaprism. F: Focusing screen. M: Hinged mirror. S: Shutter (film behind). W: Film wind-on mechanism. D: Tensioning drum for shutter blinds. C: Typical sensor position behind the lens for exposure measuring. For external controls see Figure 4.32

Single-lens reflexes

The single-lens reflex (SLR) was developed to overcome most of the disadvantages of the twin-lens reflex camera. The design avoids parallax error completely as the image made by the lens is seen directly through the viewfinder eyepiece. A hinged 45° mirror reflects the image up to a horizontal focusing screen, but flips out of the way just before the shutter fires. The distance between lens and focusing screen, via the mirror, equals the lens-to-film distance. So what is sharp on the screen will be sharp on the film (Figure 4.28).

On all 35 mm SLRs a pentaprism above the screen corrects the image left to right and reflects it out through an eyepiece at the back of the camera, so you see the subject as it might be seen direct (Figure 4.29).

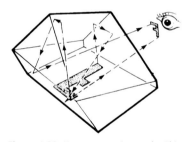

Figure 4.29 How a pentaprism works. This shaped block of glass reflects light across its 'roof' so that the (laterally reversed) image formed on the reflex camera's focusing screen is seen by the eye as the right way round and the right way up

The screen usually shows almost exactly (95–98 percent) of the full image area. Slightly more may be covered by the negative. If you wear glasses, buy an accessory dioptric corrector lens which fits over the camera eyepiece. Then you can remove your glasses and bring your eye close enough to view the entire screen, still seeing the image clearly. Some top-of-the-range cameras have some dioptric adjustment built into the eyepiece. Turning the dial slightly can make viewing more comfortable even if you don't wear glasses.

The focusing screen itself may be interchangeable. The most popular type for non-autofocus cameras has central 'crossed wedges' moulded into its surface, which shows a rangefinder-type double image of subjects not properly in focus (Figure 4.30). A surrounding ring of microprisms

4

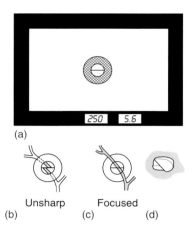

(a)

Unsharp Focused

(b) (c) (d)

Figure 4.30 (a) Focusing aids, and camera setting readout, as presented in the viewfinder of a manual-focus SLR. When the image is unsharp (b), prisms moulded into the focusing screen (d) give the image a split and offset appearance, while a correctly focused image (c) shows joined lines

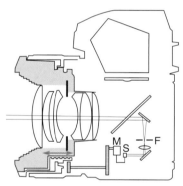

Figure 4.31 Typical auto-focus arrangement in an SLR camera. The system samples some of the lens-focused light passed through a semi-silvered part of the main mirror. Below aperture F (the same distance from the lens as the film) a pair of separator lenses bring the beam to two points of focus on a CCD sensor (S). The sensor's many segments detect the relative spacing of the two points of light, and control motor (M) to adjust the camera lens focusing position. The system works with a range of interchangeable lenses

breaks up an unsharp image into a shimmering dot pattern. Both focusing aids are designed to work with the lens at wide aperture; stopping down partly blacks out these areas.

Most auto-focusing SLRs use a *passive* electronic system to detect when the image is sharp. Some of the centre part of the picture is directed down onto a charge-coupled device (CCD) sensor (Figure 4.31). With unsharp images the system also detects whether the lens should be focused towards or away from the camera body. It may respond by signalling which way you must manually turn the lens, alongside the focusing screen ('focus confirmation'). More often it controls a motor within the camera body or lens which fast-shifts your focus setting by the required amount (full AF). Focus detection can be linked to the shutter release, so that you cannot shoot until the image has come into focus – useful in action photography (but sometimes a handicap too).

Exposure is read through-the-lens (TTL). The camera body contains light sensors which view subject brightness on the focusing screen, or else read it via light reflected off the shutter blind and film at the moment of exposure (Figure 10.9). The readings made are translated by the camera's circuitry to give semi-automatic, fully automatic, or manual exposure settings (see p. 242). Where light is measured off the film surface the system can control the duration of a flash unit. The flash may be a 'pop-up' built-in type or, more usefully, an add-on 'dedicated' unit which links into the camera circuitry, as described on p. 256.

The focal plane shutter, and reflex design, make this an ideal camera to use with a range of interchangeable lenses of fixed or variable (zoom) focal length, described in Chapter 5. You can change lenses quickly with a positive bayonet-fitting twist action, the focusing screen revealing every image alteration given by change of focal length, the use of close-up extension tubes, adjustment of special effects attachments, etc. Lenses have 'preset' apertures, meaning that the lens remains wide open until just before shooting, for clarity of viewfinding and focusing. If you need to see the appearance of depth of field you can press an aperture preview button (Figure 4.32), provided the camera offers one. (The meter reads the image at open aperture but is programmed by the *f*-number you have set on the scale.)

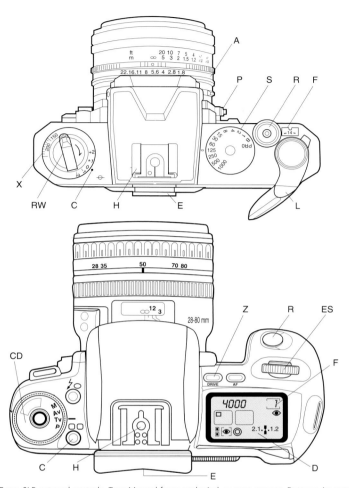

Figure 4.32 Typical 35 mm SLR external controls. Top: Manual focus and wind-on type camera. Bottom: An auto-focus multiprogrammed model. R: Release for shutter. S: Shutter speed control. P: Preview button. A: Aperture setting. X: ISO setting. RW: Rewind crank. C: Exposure compensation control. H: Hot shoe for clip-on flash unit. E: Eyepiece. L: Manual wind-on lever. F: Frame counter. Z: Power film rewind. With an advanced model, changes are made by selecting the mode or program you need on command dial CD, and then operating electronic input dial ES. Settings produced appear on body-top display panel (D), and are also presented to your eye alongside the focusing screen

When you press the shutter release on an SLR camera several things happen in very quick succession (Figure 4.33). Typically the mirror rises, the lens stops down, the focal plane shutter fires, the mirror returns, the lens opens fully, and the film is transported by motor or hand wind-on.

Manual or automatic?

All the major manufacturers of 35 mm SLRs – Pentax, Nikon, Canon, etc. – produced a *range* of camera bodies, from purely manual (including wind-on) to multimode automatic. A manually set camera is not only cheaper but having to select the three key controls – focus, aperture (with preview) and shutter speed – soon teaches you the technical principles which help enormously

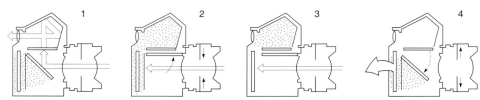

Figure 4.33 Sequence of exposing actions in a single-lens reflex camera. (1) Composing and focusing. (2) When you press the release the aperture first closes to its pre-setting and the mirror rises. (3) Shutter in front of the film fires. (4) Mirror returns, aperture re-opens, film winds on

in creative image-making. The manufacturer's range of lenses will fit all their SLR bodies so you can use the highest quality 'pro' optics on a relatively cheap body.

'Advanced' cameras still offer you a choice of program modes, giving settings the manufacturer considers best to cope with 'landscapes', 'portraits', 'action scenes', etc. Again you can customize such a camera to suit your preferred way of working, using a menu of twenty or more settings (from the length of the self-timer delay period to whether a new film advances when you close the camera or press the shutter button).

Although automatic SLRs are fast and reliable for set subject conditions, you may be buying a lot of modes which spend their time shut off once you have customized your camera. Again, if something does not perform as you expect, you may have to stop and thumb through a thick instruction book to discover what resettings to make.

Finally, don't overlook the fact that most automatic or semi-automatic SLR cameras, and certainly all professional models, give you the option of switching to fully manual mode for lens focusing, exposure settings, etc. You can therefore choose between complete control and varying degrees of programmed assistance, depending on circumstances.

Other SLR formats

A great many SLR cameras are made for 35 mm film, as this has been the most popular format for amateur and professional alike for several decades. Digital SLRs, similar in size and shape, are now more dominant in the professional market and they use the same lenses and accessories as the 35 mm range.

Larger cameras are also made, designed for 120 rollfilm (6 × 6, 6 × 4.5, 6 × 7 and 6 × 9 cm); see Figure 4.26. The medium format cameras mostly have interchangeable backs, so you can quickly change from colour to monochrome in mid-roll, or fit an instant picture back (p. 110) or even a digital back (Chapter 6). They are widely used for professional photography, due to the greater negative area yielding higher picture quality (p. 73).

Along with backs and lenses you can also change or remove the pentaprism, or switch to a special-purpose body for wide-angle or camera movement work (see Appendix B). Such flexibility means that these medium format 'systems' have largely taken over from large format view camera kits.

SLR advantages

1 You can *precisely* frame up the picture, focus, and (models with preview) observe depth of field, much faster than with a view camera.
2 35 mm types offer a choice of methods for setting correct exposure by using through-the-lens exposure measurement (including flash).

3 Key information such as correct exposure and focus, shutter speed and *f*-number, are signalled direct to your eye from alongside the focusing screen.

4 There is a wide range of lenses and accessories available. This makes SLR outfits versatile 'unit systems' – able to tackle most photography well.

5 Interchangeable backs on some medium format models allow quick changes from colour to black and white or Polaroid materials or even digital.

6 Fully AF models adjust the lens faster than you can focus it by hand – particularly useful with subjects on the move (sport, natural history, etc.)

SLR disadvantages

1 You cannot see through the viewfinder at the moment of exposure. This can be a nuisance during long exposures or when panning at slow shutter speeds (see Figure 4.11).

2 When you are viewing at open aperture (having set a small aperture) it is easy to forget the changes that increased depth of field will give to your picture.

3 The camera is electronically and mechanically more complex (and noisy) than other designs. Relative to a compact it is more bulky, heavier and tends to be more complicated to use.

4 The range of shutter speeds available for use with flash may be limited, especially with medium format models.

5 Use of passive auto-focus sharpness detection relies on sufficient ambient light and subject contrast. And some systems fail to work when a linear polarizing filter is over the lens (see p. 224).

- No one camera is the perfect tool for every job. You will probably need at least two cameras, complementing each other in format or design features.

- All cameras using a separate lens for view-finding suffer from parallax error. Even if there is parallax correction of framing, accurate alignment of objects in the frame is difficult, especially for close-ups.

- A rangefinder system allows accurate auto or manual focusing of subjects down to about 1 m. But where you have access to the camera lens image – on SLR and view cameras – you combine focus, framing, and visual check of depth of field, whatever lens is fitted.

- A focal plane shutter works with all lenses, permits lens change in mid-film, and allows reflex image viewing. But installed in cameras larger than 35 mm an FP shutter may not suit flash at fastest speeds (it can also be noisy).

- 35 mm or 120 rollfilm magazine backs, an additional 35 mm body, or separate film holders (sheet film cameras) all enable you to shoot a subject on more than one type of film.

- TTL metering systems accurately read image light from inside the camera and work with all lenses and attachments. Most compact cameras have a simple measuring sensor facing the subject direct. You need a separate hand-held meter for cameras without built-in exposure reading.

- The larger your camera format, the better the image detail and gradation in big enlargements, the less the depth of field, and the more camera movements that may be available. Smaller-format cameras are less obtrusive, more flexible, have 'faster' lenses and allow rapid sequences to be shot.

- View cameras are basically simple, offer large-screen composition and focusing, depth of field check and camera movements. But they are bulky and slow to use, need a tripod, and give a dim, upside-down image. They remain practical for architecture and still life because of movements and have features that encourage very considered compositions.

- Compact, all-in-one cameras offer complete exposure and focus (AE and AF) automation and can be brought into use quickly. Their direct view-finding system is bright, but has parallax inaccuracies and cannot show depth of field. The built-in lens is usually a zoom type. The camera's built-in flash tends to give 'red-eye' if there is no other means of positioning the flash unit. They are good for situations where you need to be unobtrusive as they are small, quick and quiet to use.

- Professional-type direct viewfinder cameras are mainly 120 rollfilm formats; lenses are either interchangeable or zoom types; and have a manual rangefinder or an auto-focusing system. Specialist designs include shift cameras and wide-angle types. Some large format baseboard cameras accept a viewfinder for hand-held work.

- Twin-lens medium format reflexes allow full-format image focusing and composition, up to and during exposure. But the finder shows images reversed left to right, suffers parallax error and normally cannot show depth of field.

- Single-lens reflexes provide critical focusing, accurate view-finding and (if pentaprism) correct-way-round composition. Most 35 mm types offer multi-option TTL exposure automation, plus auto-focus and auto-wind. A manual model is probably your best choice when first learning photography. With your cameras you can have an extensive range of interchangeable lenses and accessories.

- SLR cameras lose the viewfinder picture during exposure, and there are restrictions on flash shutter speeds and camera movements. But they tackle most subjects well, within limits of format size (35 mm or rollfilm).

- Remember, cameras are only a means to an end. They are tools to make photographs – learn to use them thoroughly, but concentrate on the photography.

1 Organise for yourself 'hands-on' experience of each of the four camera types described – view, compact, twin and single-lens reflexes. Compare practical features such as weight and balance (hand-held cameras) and the ease of working fingertip controls. Do you feel at home with their format proportions, the clarity of focusing and ability to frame-up shots? Check prices, including any extra lenses and accessories you will eventually need, plus film processing and enlarger equipment necessary for this format.

2 Decide the best *pair* of cameras together able to cover the widest range of work you expect to do. They are likely to complement rather than repeat each other's features, but don't leave gaps – tasks that neither camera can really tackle.

3 Make a comprehensive list of the technical features you consider: (1) essential, (2) useful but additional, and (3) unnecessary, in a 35 mm SLR camera. Obtain brochures on two or three competing models (similar price range) and compare them for each item on your list.

4 Set up a shot of a line of objects on a table top, using a 35 mm camera; take 7 different colour photographs using the different apertures of the camera. Keep notes on which aperture you have used on which shot. Do the same test with a 5 × 4 view camera and compare the differences in depth of field, colour and the actual form of the picture.

5 Photograph a moving activity using all the different shutter speeds on you camera; take notes recording the shutter speed used for each frame. Also try panning the camera with the movement of your subject at a number of different shutter speeds. Compare the results looking at how the different effects change the composition.

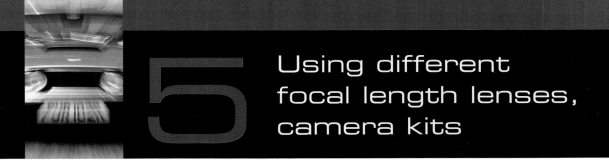

Whether you are using an SLR or view camera with interchangeable lenses, or a compact with a permanently attached zoom, you will soon want to explore the use of different focal lengths. Almost all camera types can be fitted with accessories – from tripods and other supports to flashguns and camera bags – many of which are worth considering as useful practical kit for your kind of photography.

Why change focal length?

Lenses of fixed focal length (i.e. not zoom), regarded as standard for cameras reviewed in the last chapter, are typically 50 mm for 35 mm, 28 mm for digital SLR, 100 mm for 60 × 70 mm format and 150 mm for 5 × 4 inch As Figure 3.4 showed, most of these combinations give an angle of view of about 45°.

To help understand why 45° is considered normal, try looking through a 35 mm SLR fitted with a standard 50 mm lens, holding the camera in upright format and *keeping both eyes open*. Compare picture detail on the focusing screen with the subject seen direct. Your naked eye sees a great deal more of your surroundings, of course. But within the area imaged by the standard lens and isolated by the picture format the relative sizes of things at different distances match normal eyesight.

If you keep to the same format camera but change or zoom the lens to a longer or shorter focal length you can:

1 alter angle of view (enlarge or reduce image detail and so get less or more subject in the frame);
2 disguise how far or how close you are from/to the subject and so suppress or exaggerate the effect of perspective in your picture.

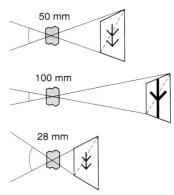

Figure 5.1 Changing focal length but keeping the same picture format alters the combination's angle of view; and hence the area recorded in the frame. Compare this with Figure 3.4

Each of these changes has an important influence on how your picture is structured.

Getting less, or more, subject in

Changing the lens in your camera to a longer focal length (or zooming to 'tele') makes the image detail bigger – so you no longer include as much of the scene and the angle of view becomes narrower (Figure 5.1). At first sight you seem closer to your subject but this is only an illusion due to enlargement (see Figure 5.2). Creating larger detail this way is handy if you cannot get close enough to your subject – for example, in sports and natural history work or press photography.

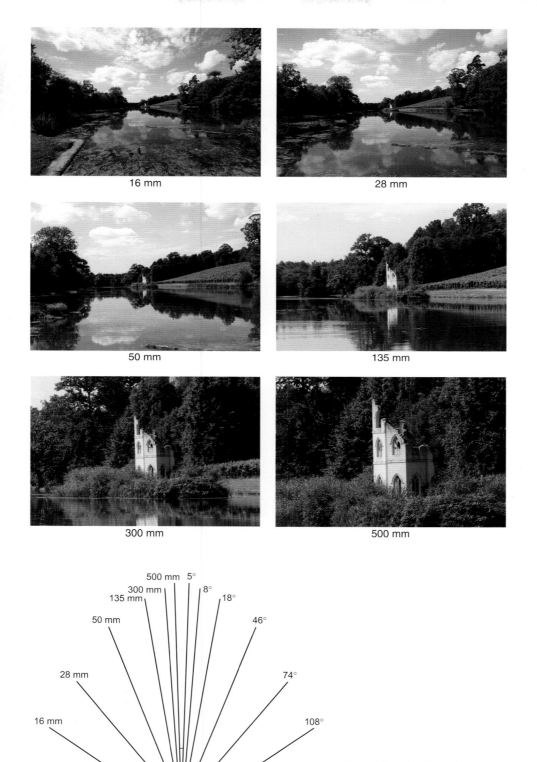

16 mm 28 mm

50 mm 135 mm

300 mm 500 mm

Figure 5.2 Angles of view given by lenses of different focal lengths used on a 35 mm format camera. Left: The same view photographed using different focal length lenses without changing the camera position

Any slight movement of the camera is also magnified, so if you are using it hand-held, consider picking a faster shutter speed to avoid blur. Other changes include less depth of field for the same *f*-number. A 100 mm lens gives half the angle and twice the image magnification of a 50 mm lens, assuming distant subjects.

Changing instead to a shorter focal length lens (or zooming to 'wide') gives all the opposite effects. You include more of the scene, noticeably foreground and surroundings, everything is imaged smaller, and there is greater depth of field. A wide-angle lens is particularly useful for cramped locations, especially building interiors where a standard lens seldom seems to show enough. Similarly, you can shoot views, groups, or any large subject where it is otherwise impossible to get back far enough to get everything in. The lens must be *designed* as a wide-angle for the camera you are using. Don't try to take a standard 50 mm lens from a 35 mm format camera and use it as a wide-angle in a large format camera – the picture will probably look unsharp and dark at the corners (see Figures 5.3 and 5.4).

28 mm

Altering perspective

It is important to remember that lenses themselves do not alter perspective, as this is only affected by your choice of

135 mm

Figure 5.3 Lens coverage. The total circular image patch formed by an 85 mm lens designed to cover 35 mm format. Used as a normal-angle lens on a 6 × 6 cm format camera, edges begin to darken. And attempting to use it as a wide-angle on 4 × 5 inch (outer frame lines) uneven illumination and corner 'cut off' becomes obvious, particularly when the lens is stopped down. See also Camera movements, Appendix B

Enlargement of centre of 28 mm shot

Figure 5.4 Enlarging part of the 28 mm lens image proves that lens change alters magnification, but not perspective. All shots were taken at the same aperture. Note the 28 mm blow-up has greater depth of field, but enlarged grain gives poorer detail than sharply imaged parts of the 135 mm lens version

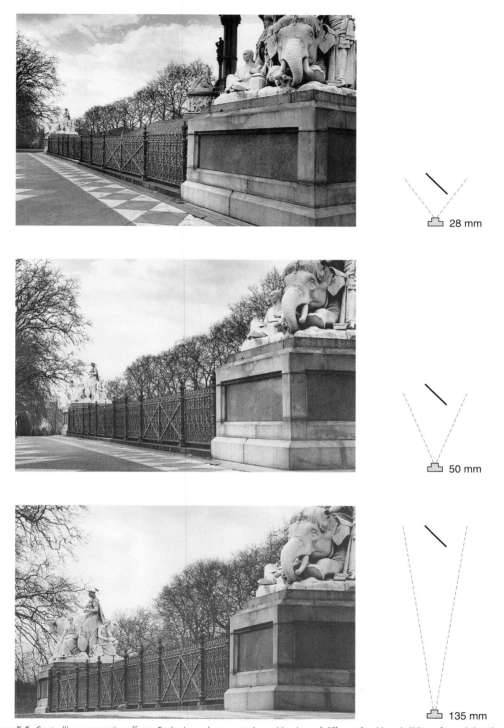

Figure 5.5 Controlling perspective effects. Each picture here was taken with a lens of different focal length (35 mm format), but the camera distance was altered each time. The near end of the monument remains about the same height but the scale of detail farthest away is dramatically different, changing your impression of depth and distance

viewpoint. By changing focal length *together with your distance from the subject*, you exert an important, powerful influence on the perspective of your pictures. Perspective itself is concerned with the way objects at different distances appear to relate in size, and how parallel lines seen from an oblique angle apparently converge towards some far-off point – all of which gives a strong sense of depth and distance in two-dimensional pictures of three-dimensional scenes.

As Figure 5.5 shows, if you look obliquely at an object of uniform height, the nearest end appears much taller than the far end. The difference between these two 'heights' is in direct ratio to their distances from you, so if the near end is 3 metres away and the far end 12 metres, ratio in height is 4:1. But move back until you are 10 metres from the near end and the far end will be 19 metres (10 m + 9 m) away. The ratio becomes only 1.9:1, and the wall's visual perspective is less steep.

Perspective therefore alters according to the distance of your viewpoint from the subject. But if you can change lens focal length you can include as little or as much of the subject as you need. Looking at Figure 5.5 you can see that when using a 50 mm lens, the nearer end of the monument appears larger than the farther end. Changing to a 135 mm lens and stepping back so as to keep the whole subject in the frame results in less difference between the near and far ends and less appearance of depth. On the other hand, using a 28 mm lens means the camera has to be brought closer to make the subject fill the frame. At this short distance the difference between the nearest and farthest points is exaggerated (Figure 5.6).

Use *steep perspective* (close viewpoint, plus wide-angle lens or shortest focal length zoom setting) whenever you want to exaggerate distance, caricature a face into a big nose

Figure 5.6 Exaggerated scale gives dramatic emphasis. 10 mm wide-angle on digital SLR elongates the motorway bridges and tilts the supporting columns to give an impression of movement and scale

and tiny ears, or dramatically emphasize some foreground item such as an aggressive fist, by exaggerating its relative size. Similarly use it to create a dynamic angle shot looking up at a building and exaggerating its height.

Use *flattened perspective* (distant viewpoint, plus telephoto lens or longest focal length zoom setting) to compress space, to make a series of items one behind the other appear 'stacked up', adding a claustrophobic effect to a traffic jam or a crowd. In landscapes it helps to make background features dominate over the middle distance, or merge both into flat pattern. Portraits tend to be more flattering, with nose and ears shown in proportions closer to true size, so use a slightly longer lens than standard (Figure 5.7).

Explore these controls over perspective and learn how they can help make the point of your picture. But if overdone (the two extremes of focal length giving either telescope or fishbowl effects) they easily become gimmicks that can overwhelm your subject matter. See also digital manipulation of perspective, Chapter 14.

The appearance of perspective in a photograph also depends finally on its finished size and the distance from which it is viewed. Strictly speaking, the image appears 'natural' in scale and

Figure 5.7 Walker Evans' choice of a long focal length lens and distant viewpoint made these industrial chimneys of Bethlehem, Pennsylvania, echo the stones in the workers' graveyard. Technique strengthens a powerful human statement

perspective if your ratio of *picture width to viewer distance* matches the ratio of *subject width to camera distance* when the shot was taken. This means that if something 4 metres wide is photographed from 8 metres (ratio 1:2) the print will look normal seen from a distance twice its width – perhaps a 12.5 cm wide print viewed from 25 cm, or a 50 cm print viewed from 100 cm. In practice you tend to look at all hand-size prints from a 'comfortable' reading distance of about 25–30 cm, which usually works out right for natural perspective appearance from normal angle lens photography. But reading wide-angle close shots and long focal length distant shots from the same viewing position makes their steepened or flattened perspective very apparent. If you want to exaggerate the illusion of compressed space and flattened perspective, print long-focal length (narrow-angle) shots big, and hang them in enclosed areas where the viewer has to stand close (see also Figure 5.8).

Figure 5.8 Top: Wide-angle distortion. Extreme wide-angle lenses (here 10 mm used on digital SLR) can give unacceptable distortion with a subject of known shape, especially at the edges of the frame unless you want a special effect. However, viewing this picture from 3.3 cm would make it appear normal. Bottom: Dealing with wide-angle distortion. Note how the lighthouse appears to lean over when on the edge of the frame (left). Recomposing the picture so it is more central makes it appear more upright (right)

(a)

(b)

(c)

Figure 5.9 (a) Using a wide-angle lens with a view camera, you risk including the front part of the rail or baseboard in your picture (only apparent when the lens is stopped down, see (b)). (c) Arrange that the monorail projects in front rather than behind, or use a drop baseboard. To focus the lens close enough to the film, change the monorail to compact bag bellows, or fit a recessed lens panel

Interchanging lenses in practice

On large format cameras the lenses have built-in shutters and are changed complete with mounting boards. When you fit a wide-angle, the lens has to be quite close to the focusing screen to give a sharp image. This may mean changing to a recessed lens panel, or removing the regular bellows from a monorail and using shorter, more flexible 'bag bellows' instead (Figure 5.9). On monorails and view cameras some parts project in front of the lens and care should be taken so they don't appear in the picture with a short lens. Longer lenses simply require more bellows extension. Some of these lenses are dual or even triple focal length. By removing, or changing, elements the focal length can be altered. These are identified by having two or three sets of focal length and aperture markings, usually in different colours, engraved on them.

The greatest variety of interchangeable lenses today are made for single-lens reflexes, especially 35 mm and digital formats (Figure 5.10). Originally their range was very restricted by the need for wide-angles to be placed close to the film, where they fouled mirror movement, and the awkward physical length of long focal length lenses. (This distancing problem is now solved optically by making long-focus lenses of *telephoto* construction and wide-angles of *inverted telephoto* construction.) Most small and medium format wide-angle optics today are of inverted-telephoto design, and virtually all long focal lengths intended as narrow-angle lenses are telephotos. This is why we tend to use the word 'telephoto' to mean the same as long focus.

Lens coverage. As Figure 5.3 shows, there are limits to the area a lens will cover with an image of acceptable quality. Designed for a 35 mm camera it will certainly perform well over a patch at least 43 mm diameter. But used on a 6 × 6 cm format picture corners show poorer definition, and on 4 × 5 inch the edges become dark. Any lens is designed to 'cover' a particular picture size. You could possibly use it in a *smaller* format camera, but not a larger one. In practice you cannot make mistakes on small and medium format cameras because their lens mounts prevent you attaching unsuitable optics.

The lens mounts for these camera sizes also differ depending on the brand – you cannot fit lenses from a Nikon to an Olympus body, and so on. Each maker also

Figure 5.10 New York from the top of the Empire State Building using a 35 mm camera with 150 mm lens. From such a distance perspective and scale change between foreground and background elements are minimized. This heightens the grid-like pattern

has different (patented) mechanical and electrical couplings between body and lens to convey information about the aperture set, to control autofocus, etc. Occasionally, when a maker develops a new body, lens mounts are changed – but this is done as rarely as possible to keep faith with previous purchasers of their equipment.

Independent lens makers produce optics to fit a range of cameras; you specify the type of body and the lens comes fitted with the appropriate coupling. The quality of the independent lenses varies more than for lenses supplied by the camera manufacturer. The latter have to reach a minimum optical standard common to an entire range. The best independent brands are consistently good too, but the cheapest lenses undergo less rigid quality control and may be anything from quite good to poor. Consult independent reviews for comparisons.

Lens kits

Wide-angles. There is no doubt that standard lenses (normal focal length) represent best value for money. Made in large quantities, they tend to be cheaper and have wider maximum apertures than wide-angles, longer focal length lenses and zooms. Most photographers however, soon wish to increase their range of options by having one or more additional lenses. Often the most useful second lens is a wide-angle, giving about 70–80° field of view. Focal length is 28 mm for 35 mm format (40 mm for 60×60 mm, or 90 mm for 4×5 inch). Using lenses wider than 80° (24 mm focal length on a 35 mm camera) begins to introduce 'wide-angle distortion', making objects near corners and farthest edges of your picture appear noticeably elongated and stretched (Figure 5.11). It is like having additionally steep perspective in these zones, although you can help to disguise the effect by composing plain areas of sky, ground or shadow here.

Figure 5.11 Using a wide-angle (45 mm on 60 × 70 mm rollfilm) lens allowed the tall light poles and lots of sky to be included and exaggerates the size of the foreground platform

Another feature of a wide-angle lens is that it gives greater depth of field than a standard lens at the same aperture. This can be an advantage, but also makes it more difficult to pick out items by differential focus. Extreme wide-angles need little focus adjustment and record almost everything in focus – from a few inches to infinity (Figure 5.12). Also they may no longer accurately image vertical and horizontal lines near picture edges as straight, becoming 'fish-eye' lenses (Figure 5.13).

Long focal lengths. While short lenses are useful for getting more into the picture, longer lenses allow you to select a smaller area of the scene than a standard lens. A moderately long focal

	Wide-angle							'Normal'		Long focal length								
	100°	94°	90°	80°	74°	62°	56°	50°	46°	28°	24°	21°	18°	14°	12°	8.5°	6°	2.5°
Digital SLR	12	13	14	16	22	24	26	28	37	55	65	70	85	120	135	180	300	550 mm
35 mm ▶	18	20	21	25	28	35	40	45	50	85	100	120	135	180	210	300	400	1000 mm
6 × 6 cm ▶			38	45	55	65	70	80	93	150	185	220	240 mm					
6 × 7 cm ▶			45	50	60	70	80	90	105	165	210	240	270 mm					
5 × 4 in ▶		75	90	105	130	140	165	180	300	370 mm								
10 × 8 in ▶				210	265	285	330	360	600	740 mm								

Figure 5.12 Angle of view given by different combinations of lens focal length and camera format diagonal. Lenses must be capable of fully covering the picture format

length, such as 100 mm on 35 mm format (24°), conventionally makes a good portrait lens. It will allow you to fill the frame with a face from a distance of about 1.5 metres, which avoids exaggerated perspective effects and a dominating camera presence. Longer lenses will be needed for any scene you want to shoot from a distance to show a compressed perspective effect (see Figure 5.7): subjects such as wildlife, fast moving activities or anything that you cannot approach closely.

Working in the studio on still life's, moderately long focal length lenses are again

Figure 5.13 Fish-eye lens distortion. Inside an antique British telephone box, taken with a 35 mm camera and an 8 mm fish-eye lens designed to give a 220° angle of view. This extreme lens forms a circular picture with vertical and horizontal lines increasingly bowed according to their distance from the centre

an asset. With food shots, for example, such a lens allows the camera to be kept back from the subject, avoiding any elliptical distortion of plates, tops of wine glasses, etc.

In general, lenses with angles of view of less than 18° begin to make you conscious of 'unnatural' scale relationships between nearest and farthest picture contents. This is more like looking through a telescope than seeing the scene direct. The longer the focal length, too, the more difficult it is to get sufficient depth of field and avoid camera shake when using the lens hand-held. As a general rule the longest safe shutter speed is the nearest fractional match to lens focal length, e.g. no slower than 1/250 second with a 200 mm lens, 1/500 with 500 mm, etc. Modern image-stabilized lenses will help overcome this problem (see p. 59).

On longer telephotos (over 300 mm on 35 mm format) the image contrast is frequently lower than with a standard lens, especially in landscape work where atmospheric conditions such as distance haze take their toll. Image definition is easily upset in pictures taken through window glass. Another problem is the size and weight of long focal length lenses. Beyond 500 mm it is usual to have to mount *the lens* on a tripod or monopod, with the camera body attached (Figure 5.14).

Wide-angle and telephoto 'converter' attachments are available for some SLR lenses. A wide-angle device fits over the front of the lens and typically reduces focal length by 40 percent. A tele attachment fits between lens and body and typically doubles the focal length. Provided the tele attachment is a multi-element unit designed for your particular lens, image quality should not fall off appreciably. A ×2 tele-converter has the effect of doubling the focal length but reduces the image brightness by two *f*-stops. Wide-angle attachments are more prone to upset the image definition near picture edges – always use them well stopped down for better definition.

Fixed focal lengths, or zooms?

A zoom is a lens of *variable* focal length – altered by shifting internal glass elements. They are built into most modern compact cameras where the lens cannot be removed. However, for cameras such as SLRs you can decide between a chosen set of 'prime' lenses (fixed focal length), or have one or more zoom lenses. The focal length is altered by moving a ring on the barrel on SLR lenses, or by a switch-operated servo-motor on compacts.

Good quality zooms are optically complex – the focusing point must not change when you alter focal length, and the aperture diaphragm must widen or narrow to keep the *f*-number constant. Also aberration corrections must adjust to maintain acceptable image quality throughout the entire range of subject distances and focal lengths. The best quality zooms compare very well with fixed focal length lenses but care must be taken at the ends of the zoom range. Limits to aberration correction at the extremes of zoom range typically show up as straight lines near frame edges bowing inwards or outwards, and edge sharpness may fall off slightly. As Figure 5.15 shows, the greatest choice of zoom lenses is to be found in the standard to telephoto (50–200 mm) range band. But increasingly you can also get wide-angle zooms spanning 24–70 mm, or tele-zooms 200–600 mm. Perhaps handiest of all are zooms which range more moderately either side of standard, such as 28–80 mm.

The practical *advantages* of a zoom lens are as follows:

1. A continuous change of image size is possible within the limits of the range – far more flexible than having several interchangeable fixed focal length lenses.
2. Ability to frame up action shots, wildlife and sports pictures where things can happen unexpectedly, and you may be too far away or too close with any regular lens.
3. No risk of losing a picture because you were changing lenses at the decisive moment.
4. Fewer items to carry.
5. Ability to zoom (or change image size in steps) during actual exposure, for special effects.
6. On many zooms, there is a 'macro mode' facility for ultra-close work (see p. 107).

A zoom's *disadvantages* are the following:

1. Widest aperture is about 1–1.5 stops smaller than a typical fixed focal length lens, e.g. *f*/3.5 instead of *f*/2.
2. It is more expensive and often bigger than any one fixed lens within its range.

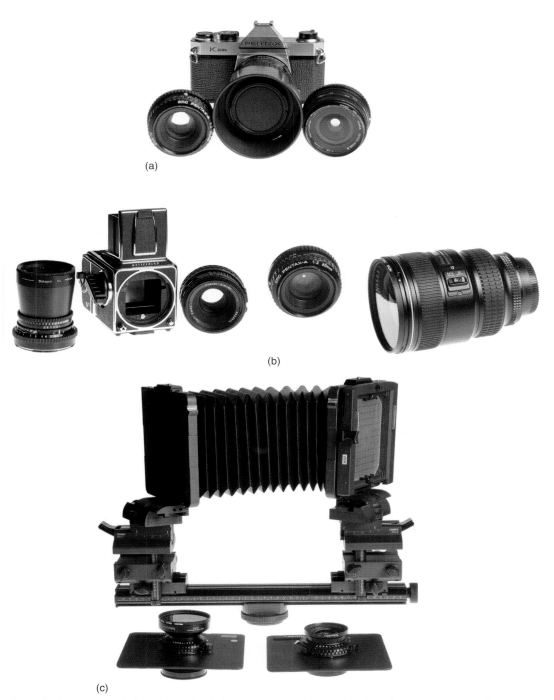

(a)

(b)

(c)

Figure 5.14 Some camera-body/lens kits. Each includes normal, wide-angle and long focal length types designed for the format: (a) 35 mm; (b) 6 × 6 cm and (c) 5 × 4 inch

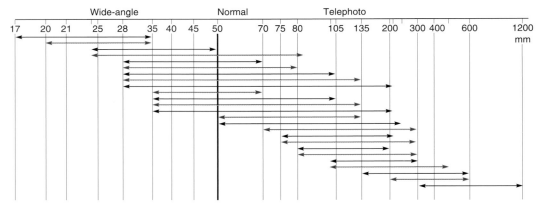

Figure 5.15 Zoom range. The focal length range of some commercial zoom lenses designed for 35 mm format. Zoom range is also given as the relationship of longest to shortest settings (×2 for 35–70 mm or 25–50 mm lenses; ×3 for 35–105 mm, etc.)

3 The continuous focusing scale does not usually go down to close subject distances.

4 Some cheaper types give poorer image contrast and definition, and distort shapes when used at either limit of their zoom range.

5 Zooms can make you lazy about using perspective well. It is tempting to just fill up the frame from wherever you happen to stand. Instead, always try to choose a viewpoint and distance to make best use of juxtapositions, or give steep or flattened perspective. Only *then* adjust focal length to exactly frame the area you want.

Even high quality zooms may change their maximum aperture between the extremes of zoom range, for example giving half or one stop less light at the longest focal length setting (maximum aperture is then engraved *f*/3.5/4.5, or similar). This is unimportant provided you are using a through-the-lens meter, but remember to allow for it if you are shooting at the lens's widest settable aperture and working with a separate meter, or a non-dedicated flashgun (p. 255).

Depth of field always changes throughout the range, unless you compensate by altering the *f*-number. It is greatest at shortest focal length, so whenever practical focus your zoom at its longest focal length setting, making critical sharpness easy to see – then change to whatever focal length you need.

Far fewer zoom lenses are designed to cover larger rollfilm formats such as 60 × 60 mm and 60 × 70 mm. Not only is the market smaller, but size and weight greatly increase if the lens is to have a usefully wide aperture. (A 100–200 mm *f*/4.8 zoom may easily weigh 2180 g, against 480 g for an 80 mm *f*/2 fixed focal length lens.)

Other lenses worth considering for a small or medium format camera kit are a shift lens (Appendix B, Figure B1) and a macro lens (see p. 107). Unless you are a specialist it is seldom worth buying lenses of extreme focal length. For example, a 600 mm *f*/4 lens for 35 mm can cost over thirty times the same maker's 50 mm standard lens! Instead, it is possible to hire them for unusual jobs, when optical distortion and unnatural perspective are perhaps an essential element in a picture. For most work such devices are a distraction, and become monotonous with overuse. You will often do better by moving either closer or farther back, and using more normal optics (Figure 5.16).

Figure 5.16 A 75–300 mm zoom used at its focal length extremes (top and centre) and when zoomed throughout a 0.5 s exposure (bottom)

Close-up equipment

The closest you can approach a subject and still focus a sharp image depends on how far the lens can be spaced from the film *relative to its focal length*. Typically this subject distance is about ten times the focal length. A 35 mm camera with standard 50 mm lens focused out to its closest subject distance gives an image about one-tenth life size. This can also be written as a ratio of 1:10, or magnification of 0.1.

Most 5 × 4 inch monorail view cameras have bellows which will stretch to at least 360 mm. Used with its standard (150–180 mm) lens, this allows you to approach close enough to get an image up to life size – a ratio of 1:1 or magnification of 31. Anything larger calls for cumbersome extra bellows (Figure 5.17). To shoot close-ups using a small or medium format camera you can expect to need some extra equipment. There are various options (Figure 5.18):

1 Adding one or more extension rings, or a set of bellows, between camera body and lens.
2 Changing to a 'macro' lens with its own built-in, extra-long focusing movement.
3 Using a zoom lens set to 'macro'.
4 Fitting an accessory close-up lens or adaptor over the front of the standard lens.

Bellows, or rings

Bellows allow maximum flexibility in focusing close subjects, although at *minimum* extension their bulk often prevents you getting a sharp image of anything farther away than about 30 metres. Rings or tubes are cheaper than bellows, and come in sets of three (typically 7, 14 and 25 mm for small format cameras). These can make up seven different lengths, used singly or in combinations. Together with your lens's own focusing adjustment, each gives an overlapping range of distances so you can achieve some continuity of focusing (see Figure 5.19).

Simplest bellows and tubes are 'non-automatic', meaning that the preset aperture of the camera lens no longer remains wide open until the moment of shooting. So you must be prepared to compose a dim image every time a small aperture is set. 'Automatic' extension units maintain a mechanical link between lens and body, so that the SLR aperture system still functions normally. Generally, autofocus systems don't work with bellows or rings as the necessary electrical connections are not present.

Figure 5.17 Bellows extension needed for close-ups. (a) View camera focused on distant subject. (b) Imaging the subject life size requires bellows twice the lens focal length. (c) The same lens needs two sets of these bellows and an extension rail, to image the subject three times life size. See also Figure 2.20

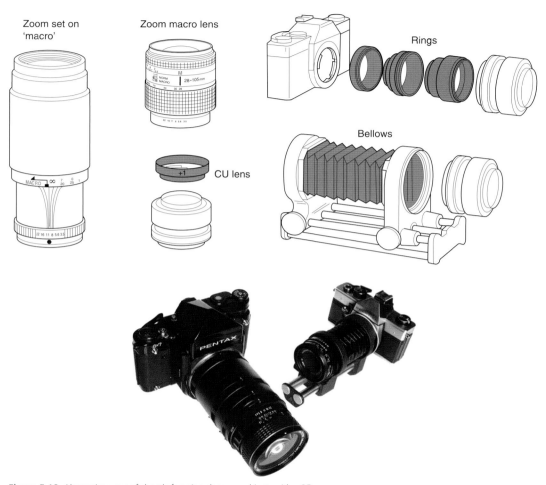

Figure 5.18 Alternative ways of sharply focusing close-up subjects with a 35 mm camera

In all instances, the camera's through-the-lens meter still gives an accurate exposure reading. However, with options 1–3 above, if you are using any *other* form of metering (such as a hand meter) the exposure shown must be increased to compensate for the effect of the unusual lens–film distance (see p. 249).

Macro lens

Macro lenses are designed for close-up purposes, computed to give best performance and maximum correction of optical aberrations when subject and image distances are similar. (The word 'photomacrography' refers to imaging at 1:1 scale or greater.) They cost more than regular lenses, and also stop down farther. Typical focal length, for 35 mm format, is either 50 mm or 100 mm, with an aperture range of f/2.8–32.

The focusing movement on a general macro lens takes it continuously from infinity setting to 1:1 ratio or beyond. This range, plus its aperture preset facility, makes it very convenient to

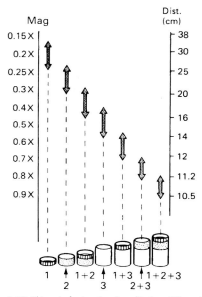

Figure 5.19 This set of extension rings (1, 2 and 3) can be used in seven different combinations. Added to the normal focusing adjustment of the 50 mm camera lens, they allow an overlapping sequence of sharply focused subject distances, from 38 cm (nearest focusing for the lens used alone) down to 10.5 cm

use. Such macro lenses give acceptable results with distant subjects too, but for close-ups offer better definition than a normal lens used in conjunction with bellows or rings. If you do a lot of extreme close-up photography then a dedicated macro lens is a good investment.

Macro zooms

Most zoom lenses, when set to shortest focal length, allow you to select a 'macro' setting that repositions internal elements. You can then sharply image subjects within a narrow range of close distances. Typical magnification ratios are around 1:4. Some zooms give quite poor quality close-ups, showing image softening towards corners of the frame.

Quite different in terms of performance, a few *zoom macro* lenses have recently been introduced for 35 mm cameras. Such a lens allows you to zoom around from, say, 70 mm to 170 mm while working just 150 cm from your subject, yet delivers high image quality. They are very expensive (but again may be hireable).

Close-up lens attachment

If you attach a converging 'close-up lens' over the front of your standard lens its focal length is changed. Or, to put it another way, the combination allows you to focus on a subject at a distance equal to the attachment's focal length, when the prime camera lens is set for infinity. Attachments are usually calibrated in dioptres such as 11, 12, etc. The higher the dioptre, the greater the magnification, and the shorter its focal length. A dioptre, or diopter, is a unit of measurement of the optical power (strength) of a lens (or curved mirror), which is equal to the reciprocal of the focal length measured in metres (that is, 1/metres). For example, a 3 dioptre lens brings parallel rays of light to focus at 1/3 metre.

Adding a close-up lens means you can work *without* having to extend the normal lens–film distance, or alter exposure. It therefore suits cameras with non-interchangeable lenses. Close-up lenses either clip over the front element or screw into the filter thread. They are often sold by filter manufacturers as well as the makers of camera lenses.

Attaching specialist optics

It is possible to attach the camera body to specialised optical equipment such as telescopes and microscopes. This is most widely done using 35 mm or digital bodies via a standardized adaptor known as a T mount. This mounting is a threaded collar which typically fits in place of the eyepiece of the telescope (or whatever) and is sold by the manufacturer of the equipment.

A T adaptor is then required which allows it to be joined to your camera's normal bayonet lens fitting. T mounts are available for Nikon, Canon, Pentax and all major camera manufacturers (see Figure 5.20). Small digital cameras can also be used with a 'Digiscope' attachment which allows them to be clamped direct to the eyepiece of a telescope or microscope, and photograph by means of eyepiece projection.

Figure 5.20 A T-type mount used to attach a 35 mm camera body to an astronomical telescope

Essentials and extras

Choosing other accessories for your camera kit is mostly a matter of personal selection. One of the most rewarding pieces of equipment you can buy, in terms of increased picture quality for its price, is a good tripod. Having the camera firmly attached to a fixed base has obvious effects on image sharpness but it often tends to make you focus and compose the image with greater care. Match the tripod to the camera's size and weight, and don't overlook the value of a small table tripod or clamp fitted with a ball and socket head. One of these will pack easily into a shoulder bag. For support in action photography – especially when you use a telephoto lens – try out a monopod, or a pistol grip camera support. These are all more portable and less obtrusive than a tripod.

If your camera has no built-in exposure meter you must have a hand meter (see p. 245). You may also need filters for black and white and colour photography (Chapter 9), plus some form of filter holder to suit the front diameter of your set of camera lenses. The holder can form part of a lens hood (Figure 5.21), an accessory always worth fitting to reduce flare when your subject is lit from the side or rear. It can also protect your lens. However, the hood must not be so deep that it protrudes into the field of view. Take care when using a zoom lens set too wide, and stopped down.

You will probably need a portable flashgun (speedlight is the US term) for use on location. This might be a powerful 'hammer-head' type sufficient to light fairly large architectural subjects, or a smaller dedicated gun that mounts on the camera (p. 253). See also studio flash, Chapter 7.

There are several worthwhile accessories for viewfinding and focusing. An SLR viewfinder eyecup helps to prevent reflections and stop sidelight entering the eyepiece, which can confuse the meter system on some models. A right-angle unit is helpful for low viewpoints and when the camera is rigged vertically for copying. A few 35 mm and most 120 SLR cameras allow the pentaprism to be interchanged. You can then fit a waist-level finder, a high-magnification finder, or an action finder that allows you to see the image from a range of distances and angles. You can also change focusing screens to suit the work you are doing – perhaps fit a cross-line grid screen for architectural work, to help you organise the lines of the building.

Figure 5.21 A selection of camera accessories. 1: Rubber lens hood. 2: Pistol grip hand-held camera support. 3: Pocket tripod. 4: Focusing screen viewing hood; replaces pentaprism on some models, for waist-level shooting. 5: Eyepiece cup. 6: Right-angle eyepiece. 7: Cable release. 8: Tripod carrying pan/tilt head; also monopod. 9: Bulk 35 mm film back. 10: Instant picture back for 6 × 6 cm. 11: Rollfilm back for view camera. 12: Changing bag. 13: Flashgun. 14: Travelling case for view camera kit. 15: Aluminium, foam-filled, general camera case. 16: Padded, compartmented shoulder bag

Provide yourself with plenty of film holders for a view camera, or film magazines for cameras that accept interchangeable backs. Instant picture (self-developing) film backs are used extensively for large and medium format professional work. They allow a final visual check on lighting, critical layout and exposure, and confirm the correct functioning of your flash and shutter equipment. Although instant Polaroid film is no longer produced, Fuji produce a similar range of products.

All the leading camera brands offer dozens of other accessories, ranging from backs which light-print words and numbers on every frame, to underwater camera housings, and radio or IR remote shutter releases. (See also digital backs, p. 128.) A changing bag is a useful standby if film jams inside any camera or magazine, or for reloading sheet film holders on location. Other 'back-up' includes a lens-cleaning blower brush, lens cloths or tissues, and spare batteries.

You will also need one or more cases for your camera kit. There are three main kinds. Large metal cases with padded compartments are good for the various components of a view camera outfit plus accessories. This kind of case has the advantage that you can stand on it – when, for example, you are focusing the camera at maximum tripod height. A smaller, foam filled metal attaché case suits a medium or small format kit and is designed for you to cut away lumps of foam to fit your own choice of components. (Avoid cases that make it obvious they contain

photographic equipment, and so encourage theft.) A tough waterproof canvas shoulder bag with pouches and adjustable compartments is one of the most convenient ways of carrying a comprehensive 35 mm or digital SLR outfit. There are several excellent companies that make numerous different types of bag including a vacuum sealed bag enabling totally safe transport via airline (in the hold).

Right for the job

No two photographers will agree on the contents of an 'ideal' camera kit. Your equipment collection is likely to build naturally as you expand the range of photographic subjects you cover. As such it is probably not a good idea to go out and buy a whole lot of gear in one go. The lists in Figure 5.22 are therefore only a generalised suggestion in order of usefulness. The three outfits listed are each reasonably versatile within the limits of a 4×5 inch view camera, 6×6 cm SLR, and 35 mm or digital SLR respectively. For more narrowly specialised subjects the equipment will vary; for example many professional sports or wildlife photographers would regard a long focal length zoom of 300–1200 as almost essential.

```
35 mm kit
Two bodies
28, 50, 105 mm lenses or zoom
    equivalents
Tele-converter
Extension tubes
Flashgun
```

```
6 × 6 cm kit
Body
Two magazines
Instant-picture back
50, 80, 200 mm lenses
Magnifying hood
Pentaprism finder
Extension tubes
Hand meter
Flashgun
```

```
5 × 4 in. kit
Camera with standard and wide-
    angle bellows
90, 180, 240 mm lenses
Six double sheet film holders
Instant-picture back
Focusing hood or cloth
Hand meter
```

Figure 5.22 Examples of camera kits. In addition each kit needs hoods for all lenses, cleaning equipment and a suitable storage/carrying case

■ Changing the focal length of a camera's lens alters image size and therefore angle of view.

■ A longer focal length concentrates on a small part of the scene; gives narrower angle of view and less depth of field; and exaggerates blur from camera shake.

■ A shorter focal length (wide-angle lens) includes more of the scene in the frame; makes image detail smaller; increases depth of field; and diminishes blur from camera shake. Extreme wide-angles begin to distort the apparent shapes of objects farthest from the picture centre.

■ Perspective in pictures depends on your camera's viewpoint and distance relative to different elements in a scene. Results are also influenced by final print size and viewing distance.

■ To exaggerate perspective effects, move closer *and* change to a wide-angle lens. To flatten perspective, move farther back *and* change to a longer focal length.

■ Extreme focal lengths give very 'unnatural' looking images. The most versatile kits contain moderately wide and telephoto lenses plus a normal lens, or (small format cameras) one or more zooms covering all these focal lengths.

■ Zooms provide a continuous focal length range, avoid wasted moments when lens changing, and offer zoom effects and macro focusing. But they have a smaller maximum aperture and tend to be bulkier than fixed focal length lenses.

■ You can focus very close subjects by increasing lens–film distance using rings, bellows, or a macro focusing lens. Recalculate exposure if you are not using TTL metering. Alternatively add a converging element close-up lens to an existing camera lens. Rings and bellows can affect image quality.

■ The most useful other camera accessories include a tripod, cable release, filters, hood, flash and separate meter. Also: extra film holders, magazines and spare bodies, viewfinder aids and carrying case.

SUMMARY

1 Get some practical experience of a range of lens types for your camera. Compare the size of image detail, the depth of field (at same *f*-number), the balance and weight of body plus lens, and degree of image movement produced by camera shake when hand-held. Check out the closest subject distance you can focus.

2 Prove that lenses alone do not have an effect on perspective. Select a subject containing several relatively distant objects such as people, animals and trees in a landscape. Take two photographs from the same viewpoint: one on a wide-angle lens, and another on a telephoto. Print both images, then enlarge the centre of the wide-angle frame until it is the same size as the telephoto shot. You will see that even though there may be differences in depth of field, the objects will be the same relative sizes as the viewpoint was unchanged.

3 Take full-face head shots of someone you know, using each of a range of lenses from wide-angle to telephoto or different settings of an equivalent zoom. For each focal length adjust your distance so that the subject's head is imaged the same size in every picture. Compare the perspective in your results. Also try one-shot from above and one from below. Compare the difference in these two portraits.

4 Test a zoom lens by imaging a squared-up modern building or grid-type subject.

Arrange horizontal and vertical lines to run parallel and close to all four picture edges. Check that these lines remain straight and in focus at longest and shortest focal length settings.

5 Try zooming during exposure. Use shutter speeds around ¼ second or longer. Have the camera on a tripod and either zoom smoothly throughout exposure or add a brief static movement at the start or finish. Make your centre of interest dead centre in the frame, and include patterned surroundings.

6 Check out the maximum magnification you can obtain with your equipment. Photograph a ruler and count how many millimetres fill the width of your frame. (With rings or bellows it is easiest to set the lens as far as possible from the film, and then focus by moving the whole camera forwards and backwards.)

7 Check to see what is the slowest shutter speed you can use holding the camera by hand, particularly with long lenses. Photograph a static subject at a variety of speeds and examine the results very closely. If your lens has image stabilization, try with the system both switched on and off. Some people are better at holding a camera steady than others and a heavy camera is often easier to hold steady than a lighter one. If you aren't very good, practise!

PROJECTS

6 Digital cameras

Digital cameras don't use film, otherwise many of their features – viewfinder, image-forming lens, aperture, flash – are the same or are closely related to film-based equipment. In fact most 'top-end' digital camera makers such as Nikon and Canon have made use of their host 35 mm SLR bodies for their range of digital cameras (Figure 6.1). Others take the form of a digital array sensor contained in a back replacing the detachable film magazine on a medium format SLR camera or the film holder on a view camera.

The basics covered in Chapters 3, 4 and 5 about camera and lens features, therefore, mostly still apply. This chapter concentrates on the practical differences between digital and film cameras – differences in cost and design; the way your picture is stored and retrieved; and what to expect in terms of image quality. Later, Chapter 14 discusses how images from digital cameras along with film or photo-print images turned into digital form can be manipulated, retouched and printed out.

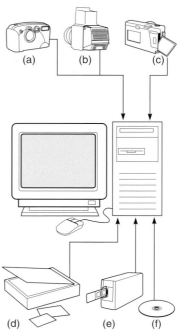

Figure 6.1 Digital image input. The main ways by which digital images are acquired by a computer system. Direct download via a USB cable from (a): Digital camera, (b): Digital back, (c): Card reader with memory card removed from camera, (d): Flatbed scanner for prints, (e): Film scanner for negatives and slides, and (f): From CD or DVD carrying scans from a photo-lab

How are digital images captured?

Instead of film a digital camera has a CCD (charge-couple device) (Figure 6.3) or a CMOS (complementary metal-oxide semiconductor) sensor, which consists of a grid of phototransistors to sense the intensity of the light across the plane of focus. CMOS sensors are slightly different from CCD sensors in that they generally use less power and have a different kind of light-sensing material.

On exposure, electrical charges are generated in proportion to how much light each pixel receives. A *colour filter array* is placed on top of the sensor to capture red, green and blue (RGB)

parts of the light and, via the built-in *analogue to digital converter* or ADC, changes these into a stream of digital signals – each picture creating a 'file'. The larger the number of pixels, the bigger the file size and the higher the resolution of detail in the image. Captured image files are the equivalent of exposed film frames.

Unlike analogue where you have a choice of colour or black and white film, digital cameras only take pictures in RGB. You can however on some use a black and white setting (on a number of cameras you have additional effects including sepia) but the image is converted to greyscale via built-in software after you have shot it. This is useful when you wish to see the immediate result of the effect (Figure 6.2) but you have far greater control over an eventual conversion in post-production. For more details see Chapter 14, Figure 14.36.

You can view the pictures before, while and after shooting on a small LCD (liquid crystal display) screen, located on the back of the camera body. At this time too, any shots you have taken but don't want may be deleted and their vacated file space used for new pictures, time and again. The quantity of pictures a full memory card can contain depends upon the size of each file (higher resolution images contain more pixels) and the capacity of the card you have in your camera. At any convenient time pictures can be downloaded from the camera or, more often, its memory card into a computer. You can then see them on a monitor, save your files prior to any necessary image manipulation, and print them out. Files can also be transmitted (e.g. by mobile phone or wirelessly from the camera itself) to a computer system located somewhere else, such as a newspaper picture editing desk.

The table below gives a comparison of analogue and digital cameras.

	Analogue	Digital
Speed of Response (Shutter lag)	Film cameras have a delay of some 10 milliseconds.	There may be a noticeable delay between pressing the shutter and taking the picture, but this differs greatly from camera to camera. You also have to factor in that you first have to turn your digital camera on.
Predictability	You don't know what you've got until you develop your film. You can shoot Polaroid film in parallel to make sure you get what you require.	Because you're given an almost instantaneous feedback you can therefore also adjust your picture and re-shoot your subject accordingly.
Cost of purchase	You can purchase a top of the range medium format camera that's capable of shooting both analogue and digital by using different backs.	Entry level compact cameras are very competitively priced but high-end digital cameras tend to be quite a bit more expensive than their analogue counterparts and you may need to buy new equipment every couple of years to stay up-to-date.
Viewfinder	Traditional cameras, especially 35 mm, will have a viewfinder you use with just one eye, while with a waist-level viewfinder, normally found with medium format cameras, you are still composing using both your eyes, but the image is laterally reversed.	Some compact digital cameras no longer have a viewfinder. You only have the LCD display to work with. Using the LCD screen you are composing your picture using both eyes, unlike a traditional viewfinder.
Costs of operation	Film stock, processing and associated darkroom expenditures.	After the initial investment in equipment there are very few costs involved. DVDs and/or external hard drives will be required for long-term archiving, although you may need to update the post-production software programs from time to time.

	Analogue	Digital
Sound	The sound of the shutter opening and closing and the film being forwarded.	Digital cameras are mostly silent as no film is in use and they have almost no moving parts. By default some are configured to play back the sound of a camera taking a picture, but this can in most cases be disabled in the camera menu. If you are using an SLR you still have the sound of the mirror going up and down.
Battery life	Some analogue cameras do not need a battery at all; others have just one to power the lightmeter, or for the motordrive and/or autofocus, etc.	Digital cameras are quite power hungry, with the LCD screen using the most – and they cannot function without a battery. Battery consumption tends to be much greater under extreme weather conditions, i.e. either very cold or very hot, so always carry a spare battery.
Output size	If you enlarge an image up high enough the grain will become apparent, but may still be acceptable.	If you enlarge a digital picture it will eventually turn pixelated and/or muddy in appearance, but may still be acceptable.
Long exposures	Film can handle exposures up to hours without any problems, but *reciprocity failure* can be an issue with long exposures.	The sensor in a digital camera sometimes has problems handling long exposures. *Noise* and loss of detail in shadow and highlight areas are common. Built-in noise algorithms help and a lot can be done in post-production. On some cameras the longest exposure you can make is fixed.
Storage	Under proper conditions, and if properly fixed, negatives and slides can potentially last hundreds of years.	The long term life of a DVD or hard drive can be problematic as any scratch or drop may render them unreadable, so make multiple copies and store these in separate locations. The hardware that you depend on may also be discontinued. Storing your work on external hard drives or online is a safer option.

The megapixel debate

The output size and to some degree the quality of a digital camera is measured in megapixels. A megapixel is 1 million pixels, and can be calculated as the number of horizontal pixels multiplied by the number of vertical pixels in an image – such as 4000×3000 pixels $= 12,000,000$ pixels or 12 megapixels (MP) (Figure 6.8).

Unlike film grain the pixels of a digital image are laid out in a rectangular grid. When you magnify a digital image you can see each individual pixel clearly, which is not like the magnification of film where grain appears irregular, unless you're shooting on a tabular grain film such as T-Max where the grain takes on a different shape. The human eye picks out regular patterns more readily than granular patterns, particularly since curved or diagonal lines in the image start to show jagged, staircase-like edges known as *aliasing*.

The number of megapixels your camera has dictates to a certain extent the output size of your final print. Prints carry a variety of output resolutions – a default of 300 dots per inch (dpi) is considered normal for a digital print to appear indistinguishable from prints from film. This assumes normal eyesight and average print viewing distance. It must be pointed out that 300 dpi is just a guideline and will vary on the type of printer you are using.

It should also be noted that the larger the image, the lower you can allow the resolution to go. For billboard-type prints, a dpi as low as 150 is often used. This has to do with the viewing

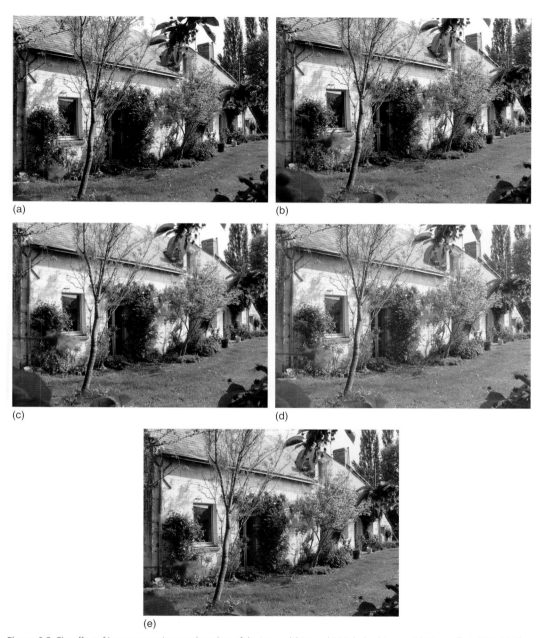

Figure 6.2 The effect of in camera settings on the colour of the image. (a) Normal RGB (colour) image. (b) Warm effect. (c) Cold effect. (d) Black and white. (e) Sepia

distance. You don't look at a billboard close-up; therefore it is not necessary to print it out with the same amount of detail per inch as say an A4 print – because on the billboard the detail is spread over a much bigger area.

One thing you must never lose sight of is that (for the same aspect ratio) you must quadruple your megapixel count to double the resolution. This means that a 12 megapixel sensor has more or less twice the resolution (horizontally or vertically) of a 3 megapixel sensor. As megapixel counts continue to climb, it is becoming harder and harder to demonstrate a significant resolution advantage. For instance, the megapixel count difference between a 10 MP camera and a 12 MP is minimal. Don't always go for the camera with the highest megapixel count; there are a lot of other factors to consider. To get an idea of how megapixels relate to print sizes it is important to make a couple of calculations. For this example we will be using the above 12 megapixel camera as the starting point.

At 4000×3000 pixels we can output the image on a printer at 300 dpi to 338×254 mm (13.3×10 inch). Dots in dpi refers to the density of 'dots' (how close together they are) that the printer can print within one square inch. A high-end medium format digital camera with a 22-megapixel back, with pixel dimensions of 5356×4056, can output a 300 dpi digital print at 17.8×13.5 inch. What's noteworthy here is the fact that even though we have almost doubled our megapixels, the size of our print is less than a third bigger.

We continue with a list of the essential features of digital photography and some differences to analogue cameras.

Grain, noise and pixel density

The digital equivalent of film grain is noise, and you will find noise in every image captured by a digital camera. Noise is generated when heat from the electronics free electrons from the image sensor; these are 'thermal electrons'. The smaller the CCD sensor in the camera or the higher the ISO, the more likely you are to have large amounts of noise.

When the size of the sensor remains the same but the megapixel count keeps climbing, with more and more transistors sitting side by side there is less room for excess heat to escape and this can result in increased noise being generated. This can be an issue with some compact digital cameras as some manufacturers try to keep their size small, while increasing megapixel count and adding features. The higher the sensitivity of the CCD (the ISO) the more noise it generates.

Lots of cameras have built-in noise reduction algorithms that generally are very capable of reducing the noise. You can also remove most noise

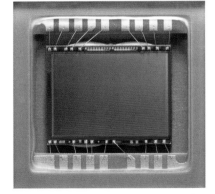

Figure 6.3 CCD image sensor. An image area of 23.7×15.6 mm containing a grid of 3008×2000 pixels (6 megapixels) sensor filtered red, green and blue

in post-production with built-in noise reduction functions or by using specialised plug-ins. The noise generated also differs greatly from camera to camera but as a general rule you will find more noise at high ISOs and with long exposures (Figure 6.4).

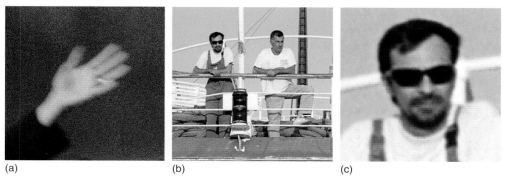

(a) (b) (c)

Figure 6.4 (a) An extreme crop of an analogue image clearly showing grain. (b) A similar crop of a digital image. (c) An extreme close-up of the same digital image where you can clearly see how the pixels are laid out

Optical and digital zoom

With optical zoom, the lens elements move around to zoom in or out by changing focal length. A digital zoom combines optical zoom with a technology called 'interpolation' or 're-sampling' to provide new levels of zoom. When you use digital zoom, and you hit the outer limit of the optical zoom area, the camera then starts its digital zoom software which crops in on the detail you're zooming in on. The end result is an image with a crop of the maximum optical zoom image, which has been 'interpolated' back to full size. This in most cases results in the degradation of the overall image quality by increased pixelation and muddiness. You should only use digital zoom under special circumstances, such as when it is impossible to move any closer to the subject. On most cameras you can disable this feature so you don't use it accidentally.

Image stabilizer

Another feature often mentioned when digital cameras are advertised is optical image stabilization (OIS). You may have seen its effects without realising it, as more and more cameras now come with image stabilization. If you are photographing in low light conditions and are unable to use flash, the resulting images may show signs of camera shake. Optical image stabilization is designed to counteract this, enabling you to take sharp pictures in low light. The camera achieves this by a moving element in the lens compensating for small movements (shake) detected by solid state positional devices. See Figure 3.19 for an example of optical image stabilization.

Bit depth

A bit is essentially the smallest unit of data: It is either 0 or 1, black or white, on or off. 8 bits is a byte and can therefore represent 256 different states, 2^8th. To make matters more complicated, 8 bits is sometimes also referred to as 24 bit, as it is a composite of red, green and blue (3×8).

Most of the digital world operates in 8 bit – your monitor and printer for instance. If you are shooting in the *RAW file* format newer cameras can produce images in either 12, 14 or 16 bit depending on the camera used.

Instead of using 8 bits, i.e. 256 levels, to represent a single colour newer cameras utilise 65,536 levels for 16 bit. What this gives you is a potentially amazing increase in colour detail throughout your image. Having this additional detail available to you in post-production allows you to adjust your image to display additional detail throughout. When done you can then convert the image to 8 bit for printing or web usage, as most printers and screen are unable to display the full colour range of a 16 bit image (Figure 6.5).

White balance

When you shoot on film you can choose between two different types: daylight or tungsten-balanced film. If you are shooting digitally the white balance (i.e. colour temperature) of your image is normally calculated automatically by the camera (Figure 6.6). It adjusts its colour temperature (set in Kelvin degrees) according to the kind of lighting you are shooting under. On most cameras you can also pre-select your white balance from a list, i.e. cloudy, sunny, flash, indoor, etc. It is also very common to be able to custom-set your white balance value. You simply take a picture of a 'neutral area', for instance a white wall and then let the camera calculate the white balance based on the neutral area.

Figure 6.5 In Photoshop you can convert between different bit depths. There is no point converting upwards as it's impossible to add 'new data' to an existing photograph

(a) (b)

Figure 6.6 (a) A scene shot using the auto white balance function. (b) The same scene shot with the camera while balance set to tungsten, i.e. indoor lighting conditions

Colour modes

On an increasing number of digital cameras, compacts as well as SLRs, you can now specify what colour space you wish to operate in, both of them RGB.

RGB is an additive colour model where red, green and blue are mixed together to reproduce a broad range of colours. Within the RGB spectrum there are two sub-modes you should be aware of: *sRGB* and *Adobe RGB (1998)*. sRGB was developed by HP and IBM and is best suited for images that are intended for screen use, such as in a website or a digital slideshow. For images aimed at printing you should use Adobe RGB. An image captured in the Adobe RGB mode is also better suited for conversion to CMYK (Cyan, Magenta, Yellow and Black), the colour space used for offset printing.

Sensor sizes

APS-sized sensors

The sensors found in most digital cameras are much smaller than a 35mm frame, some as tiny as 7×5mm. This is not a problem for cameras with fixed lenses. It raises, however, a couple of issues with digital SLRs. The sensors in most low-end and mid-end SLRs are comparable in size to the APS film format, 25.1×16.7mm. The sensors in these are called APS-C or APS-H and vary in size depending on manufacturer. Some are slightly smaller and others bigger than the APS format. To develop and manufacture high quality sensors with incredible precision is very costly and therefore they are often smaller than a 35mm frame. This difference in size between a 35mm frame and an APS frame is called *focal length multiplier* and is a ratio of either 1.5 or 1.6 depending on the size of the sensor. This results in a 'cropped field of view'. Say you are photographing an object with a 50mm lens on an APS sensor: the lens now acts as an 80mm lens but the object is still the same size it would have been had the photograph been taken with a 50mm lens on a full frame camera.

It should be noted that the aspect ratio of an APS sensor is the same as that of a 35mm frame (36×24mm vs 25×17mm). This difference in sensor size and lens size as a general rule produces a ratio difference of 1.5 or 1.6 (i.e. 35mm focal length×1.6).

Focal length on 35 mm camera	Equivalent focal length on D-SLR with APS sized sensor
24mm	38.4mm
28mm	44.8mm
35mm	56mm
50mm	80mm
90mm	144mm
18–55mm	28.8–88mm
18–70mm	28.8–112mm
18–135mm	28.8–216mm
24–105mm	38.4–168mm
28–135mm	38.4–216mm

The above table shows a variety of lenses and their focal lengths on a 35 mm camera compared with what they approximately would be if used on a digital SLR with an APS-sized sensor.

Due to the popularity and affordability of cameras in the low- to mid-end digital SLR market, manufacturers are increasingly producing lenses made for the APS format that do not suffer from the ratio issue – a 50 mm lens is a 50 mm lens. Generally these APS-lenses do not work properly on most full frame (see below) digital SLRs. Nikon, however, has developed a mode that allows you to use an APS lens with a reduction in the megapixel output.

Full frame sensors

Camera manufacturers have always produced digital SLRs with a full frame sensor, i.e. a sensor of the same size as a 35 mm frame, 36 × 24 mm. Traditionally these were reserved for the very high end models but prices and models are available making them far more affordable. With these you can use any compatible 35 mm lens without a cropped field of view.

File formats

TIFF (Tagged Image File Format)

TIF, as it is mostly referred to, is the industry standard for digital images. TIF files can be compressed or uncompressed and come in a PC and a Mac version, both of which can be accessed on either platform. You can view and manipulate TIF files on all computer platforms and in almost any image editing software.

RAW

RAW files come in many shapes and forms, but they all have some things in common:

- A RAW file is the 'raw' untouched file which comes straight from the camera's CCD or CMOS sensor.
- RAW files can be compressed or uncompressed.
- Each camera manufacturer has its own version of the RAW format. Canon digital cameras produce CRF (Canon Raw Files), Nikon cameras produce NEF (Nikon Electronic Files) and Adobe has been trying to establish an industry standard called DNG (Digital Negative).
- Headroom is the dynamic range that you can push in post-production either to show more details in the highlights or shadows.
- With a RAW file you can adjust your white balance and other properties in post production, which can otherwise be extremely difficult with TIF and JPEGs unless you use the newer version of, for instance, Photoshop.
- The RAW image file also contains metadata about the photograph, such as the camera used, lens, exposure, aperture and sometimes location data if the camera has GPS built-in. This information can be useful for cataloguing purposes and online presentations.

Image software such as Adobe Photoshop and Adobe Photoshop Elements is shipped with a plug-in called Camera Raw that can open almost all RAW file formats. RAW files are about 1/3 smaller than TIF files and you can therefore store more images on your card with RAW than with TIF.

Figure 6.7 Three different types of memory cards. Clockwise from top: a 2 GB compact flash card, 1 GB secure digital (SD) card and a 16 MB Sony memorystick

JPEG (Joint Photographic Experts Group)

The JPEG file format is the undisputed king of file formats for photographic images. It is a compressed file format. With JPEG you can generally achieve a file size a 1/10th the size of an equivalent TIFF file without a noticeable loss of quality.

The higher the quality – you set this in percentages or in steps (high, normal, low) – the more detail is retained in the image, but the file size is larger and it therefore takes longer to load. If you use a quality setting of 60 percent it means that the image has been compressed 40 percent. When you save a JPEG file you must make a compromise between image quality and image file size.

The catch is that the more you compress an image, the worse the quality, which is why most professional photographers choose to work exclusively in an uncompressed file format so as not to compromise the quality of their work. However, for most jobs the JPEG format is an excellent option if you are shooting lots. With the right setting you can achieve excellent results, but overall the RAW format is better. Some high-end digital cameras have the ability to simultaneously produce a RAW and JPEG file, which is useful if you want to quickly preview your images as JPEGs are quicker to access and view than RAW, since they don't have to go through a RAW converter first.

Storage cards

If you are a studio-based photographer you may not need a storage card in your camera (Figure 6.7). Instead you can connect your camera directly to a computer and download the photographs as you take them. On some cameras you can even transfer your photographs wirelessly, increasing your mobility around the studio or on location.

In any other scenario you need a memory card in your camera. The majority of digital cameras are sold with a storage card. These are usually of questionable quality and very small (the standard size seems to be around 32 MB). It is highly recommended that you invest in two more cards. This provides more storage space, and one can act as a back-up in case the other corrupts or stops working.

You can judge the quality of a card storage medium from the following:

Capacity	How big is it in megabytes MB/GB? The bigger the card, the more photographs you can store on it.
Speed	How fast does it write and read? The slower the card, the longer you have to wait between shots. This is indicated when you purchase a card. It may say: '133 SD-Card, 15.5/21 MB Write/Read'. This means that the camera can write or read pictures to the card at between 15.5 to 21 MB per second. 60 speed would translate as 6–9 MB per second. If you have an 8 MP camera producing a 16 MB RAW file, a 133 speed card is capable of writing 1–1.4 pictures per second. Most digital cameras have a built-in memory buffer, which allows you to continuously shoot without having to wait for the camera to save the files to your card. The photographs are saved to the card in the background, allowing you to shoot without having to wait for them to be saved.
Reliability	Is it stable or does it have a tendency to corrupt? If that happens you can lose all your pictures.
Price	Speed, not size, is the biggest contributor to price. Rule of thumb: the higher the megapixel, the bigger and faster the card you need.

Card types

Compact Flash (CF)	There are different types of CF cards: Type I, Type II, CF+ and CFast. The various versions do not differ in their physical size but may be incompatible with older cameras. The CF Card type is generally considered more robust and faster than its thinner and smaller competitors and it is available in a wealth of sizes up to 32 GB and with write speeds up to 300 MB/s.
SmartCards	Before XD cards were introduced, SmartCards were the smallest on the market. Now they are almost obsolete and only available in small sizes (128 MB, 256 MB).
SD (Secure Digital)	This is one of the smallest digital storage cards and is currently available in sizes up to 2 terabyte. Because of its size it is very popular with digital compact camera manufacturers. New versions of the SD card type are SDXC (Extended Capacity) and SDHC (High Capacity) offering increased storage capacity, reliability and speed.
MemoryStick, MemoryStick Duo (Sony)	This storage card type was invented by Sony and is not compatible with any other manufacturer. You can share a MemoryStick between a variety of Sony hardware. Most Sony cameras are also compatible with a second memory card type.
XD picture card (Olympus & Fuji)	XD cards are even smaller than SD cards, but only compatible with Olympus and Fuji cameras.
Microdrives	A microdrive is actually a miniature hard drive housed in a compact flash Type II casing. With a hard drive you have moving parts, unlike a flash-based card, which means that it is prone to corruption and is somewhat unreliable. It is also slower, but it is cheap, and multiple gigabyte versions are available. The microdrive is all but obsolete now.
Other systems	Some cameras from the birth of digital photography used 3.5 inch floppy disks; others now use writeable CDs/DVDs, and high-end cameras can have an external hard drive attached to the bottom with room for 250 GB or more of digital photographs.

Download

You can review your photographs at any time using the LCD screen at the back of the camera (see Figure 6.11). Here you can move between your photos, zoom in and pan around for a detailed look and decide which you want to keep, and delete unwanted ones. However, be aware that some LCD screens will not always give you a proper representation of your image. Some are

Megapixels	Pixels on camera CCD	File size (RAW)	File size (JPEG fine)	File size (JPEG normal)	Print size @ 300 DPI	Print size @ 200 DPI
2	1600 x 1200	N/A	600 KB (1706)	400 KB (2560)	13.5 x 10.1 cm	20.3 x 15.2 cm
3	2000 x 1312	3.9 MB (262)	1.1 MB (930)	700 KB (1462)	16.9 x 11.1 cm	25.4 x 16.6 cm
4	2272 x 1704	4.3 MB (238)	1.4 MB (730)	900 KB (1137)	19.2 x 14.4 cm	28.8 x 21.6 cm
5	2592 x 1944	4.8 MB (213)	2.1 MB (487)	2.5 MB (409)	22 x 16.4 cm	32.9 x 24.7 cm
6	3008 x 2000	5.4 MB (189)	2.5 MB (409)	1.5 MB (682)	25.5 x 16.9 cm	38.2 x 24.4 cm
7	3072 x 2304	6.8 MB (150)	2.6 MB (393)	1.5 MB (682)	26 x 19.5 cm	39 x 29.2 cm
8	3504 x 2336	7.5 MB (136)	2.7 MB (379)	1.6 MB (640)	29.7 x 19.8 cm	44.5 x 29.7 cm
10	3872 x 2592	8.6 MB (119)	4.4 MB (232)	2.5 MB (409)	32.8 x 22 cm	49 x 33 cm
12	4288 x 2848	11.6 MB (88)	7.1 MB (144)	4.5 MB (227)	36.2 x 24.1 cm	54.2 x 26.2 cm
16	4992 x 3328	14.7 MB (69)	9.8 MB (108)	5.2 MB (196)	42.2 x 28.2 cm	63.4 x 42.3 cm
21	5616 x 3744	21.5 MB (46)	3.5 MB	1.2 MB	47.5 x 31.7 cm	71.3 x 47.5 cm
25	6048 x 4032	25.5 MB (39)	6.8 MB	4.2 MB	51.2 x 34.1 cm	76.8 x 51.2 cm
31	6496 x 4872	35 MB (28)	N/A	N/A	55 x 41.2 cm	82.5 x 61.9 cm
39	7216 x 5412	112 MB (8)	N/A	N/A	61.1 x 45.8 cm	91.6 x 68.7 cm
84	10600 x 8000	402 MB (2)	N/A	N/A	89.7 x 67.7 cm	134.6 x 101.6 cm
191	15990 x 12000	852 MB (1)	N/A	N/A	135.4 x 101.6 cm	203 x 152.4 cm

Numbers in brackets indicate the maximum number of images that can be stored on a 1 GB card.
N/A = Not applicable.

Figure 6.8 This table lists different megapixels and their corresponding output. These are rough estimates and not based on any particular camera models, but they should give you an idea of the relationship between megapixel, file size and print output sizes at two different resolutions.

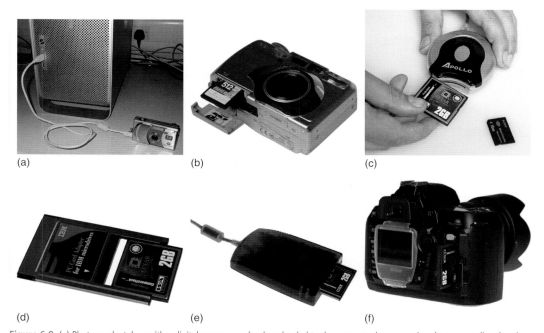

(a)　　　　　(b)　　　　　(c)

(d)　　　　　(e)　　　　　(f)

Figure 6.9 (a) Photographs taken with a digital camera can be downloaded to the computer by connecting the camera directly using a USB/firewire cable. (b) Memory cards are usually contained in the camera at the bottom or on the side. Remember to turn your camera off before inserting it or ejecting it. (c) You can also use an external card reader to download your photographs from your memory card. These can be connected to the computer via a USB/firewire cable. (d) With older card types (in this case a microdrive) you may have to insert your card into a card adapter before you insert into a card reader. (e) An external card reader with a memory card mounted in an adapter. (f) On this digital SLR the compact flash card is inserted at the back of the camera

Figure 6.10 Digital cameras including (top centre) digital SLR, (top left) video camcorder capable of shooting still images (bottom centre) camera phone and a variety of compact digital cameras

too dark, too light or have too much contrast. It is therefore always recommended that you make your final judgement on a computer screen. To do this you must first download your pictures:

- You can take the memory card out of your camera and insert it into a card reader that is connected to your computer (some computers have a built-in card reader). You can then download the photographs from your card into your computer for farther review and/or manipulation.
- Plug the cable that came with your camera into the camera and connect it to your computer. Normally this is a USB (Universal Serial Bus) cable. Your camera will then act as a card reader, downloading the images. Beware of battery life: use mains power in preference if possible.

You can also bypass this completely by using a high street photo outlet to have your images printed, or plug your card into a PictBridge-compatible printer (a printer with a built-in card reader) and print your photographs without the use of a computer.

Digital cameras

Camera phones

More people have cameras than ever before (Figure 6.10), taking more pictures than ever, which is largely due to the popularity of the mobile phone. Built right into most phones you will often find an increasingly sophisticated digital camera with up to 8 MP on the CCD chip, zoom functionality, ability to record video and much more. Some even come with a flash or light source. They are usually shipped with software and cables that enable you to download your photographs onto your computer or upload them wirelessly.

Compact cameras

Compact digital cameras are by far the most popular; there are literally hundreds of different models (Figure 6.11). They come in a variety of shapes and sizes, ranging from the very small pocket-sized camera to more bulky versions with features that are very close to digital SLRs. Generally they look and operate very much like a traditional film-based compact camera, but have an LCD screen in the back and a CCD sensor instead of film.

Figure 6.11 A typical compact digital camera. All digital cameras have an LCD screen at the back. The screen is used as a viewfinder and via the menu buttons you can adjust a variety of settings such as white balance, quality (RAW or JPEG) and ISO (sensitivity)

The viewfinder is in some cases almost a redundant leftover from the analogue era and generally of very poor quality especially at the lower end of the spectrum. With some models digital camera manufacturers have removed the viewfinder altogether leaving you only with the LCD screen to compose and review your pictures, as most people tend to work this way. This allows you to use both eyes but be aware that the LCD consumes quite a bit of battery and it may be somewhat difficult to view under certain light conditions.

The features offered on compact cameras vary considerably from the more 'point-and-shoot' models to those where you can manually adjust all variables from exposure compensation to focusing. As with any camera it is important to pick one with a good lens; for example, Carl Zeiss, Leica and Schneider Kreuznach lenses are used on many digital compact cameras.

Navigation buttons next to the screen allow you to bring up any picture you have taken, zoom in to ensure it is in focus, erase it or review tiny thumbnails of each of your images. Here you can also change all kinds of picture settings using the menus. You can set up modes specifically for portrait or night photography, etc. On more advanced models you have the ability to change the file type (RAW, JPEG) and colour space you're working in and review the histogram (more on that in Chapter 14). It is also worth noting that almost all compact digital cameras suffer from a brief delay between clicking the shutter and taking the picture.

Hybrid cameras

There are a number of digital cameras on the market that are neither compacts nor SLRs but a mixture of the two. It has been a problem that some digital SLRs are simply too big and bulky and that the features on some compacts are not good enough. One interesting development is, for instance, Kodak's EasyShare series, which instead of offering one lens to do it all has two; the advantage is that one lens can handle the extreme wide angle and the other is for zoom use, without compromising lens quality.

Digital SLRs (D-SLRs)

D-SLRs look and behave almost exactly like their film-based counterparts. Some descend directly from them and others are complete new builds (Figure 6.12). A range of models are offered, from entry-level to mid-range, to high-end D-SLRs aimed at the professional market. What sets them apart from the compact camera range is the ability to change lenses and speed of use. A D-SLR from Nikon for instance is also backwards-compatible with older Nikon lenses. This,

(a) (b)

Figure 6.12 (a) The layout of buttons and dials on a modern digital SLR. At the top you will find some with which to change the mode, ISO and quality settings (RAW, JPEG, etc). Most of the controls are very similar if not identical to its analogue counterparts. (b) At the back of the camera there is a built-in LCD screen where you can review your images that you have shot, delete unwanted ones and configure more advanced settings.

however, does not offer you the best integration between camera and lens. To achieve complete harmony between a D-SLR and its lens you need to purchase specially made digital lenses. These contain a digital chip that communicates with the camera, have improved resolution and better colour correction, etc. One of the main differences between D-SLRs and digital compact cameras is the lack of shutter delay (or noticeable delay; the delay is in milliseconds). To counteract the delay, D-SLRs have a built-in buffer, enabling you to shoot continuously for a set amount of frames. The buffer acts as temporary storage space between the CCD chip and the memory card.

Newer D-SLRs offer a host of features such as the ability to record High Definition video and Live View. Live View allows you to use the LCD screen as your viewfinder as one would with a compact. This allows you to for instance to take photographs under unusual circumstances, such as holding the camera above your head, while still keeping an eye on what you are photographing.

Medium and large format digital backs

High-end digital equipment is primarily aimed at the professional market with specification and a price to match (Figure 6.13). Manufacturers such as Leaf and PhaseOne produce a range of medium format digital backs that can be mounted on Hasselblads, Mamiyas or other host cameras just as one would a film back. This allows you to switch between shooting via digital or on film using the same camera body. They also produce completely integrated medium format digital solutions, where body and sensor are one unit.

The CCD/CMOS sensor in these cameras tends to be 60×45 mm in size, or thereabouts. To use one on a body of Hasselblad you place a little plastic frame inside the viewfinder to crop off the parts of what is not covered by the sensor.

Older models scan the image with a narrow sensor strip 'array' of CCDs like a flat-bed scanner, or even take a sequence of three exposures through changing red, green and blue filters. In these last two instances image capture times can be in minutes rather than seconds, so scanning or tri-exposure backs are restricted to still life-type subjects and archival use and require the use of nonflickering lights. These scanning backs offer a much greater resolution than any competing system with up to 384 MP.

(a)

(b)

Figure 6.13 (a) A 30 MP medium format digital back mounted on a Hasselblad camera. (b) The camera next to a digital and analogue back. The two are almost identical in size and shape.

Higher resolution chips produce bigger files. It is now possible to buy medium format digital systems where you can mount an external hard drive at the bottom of the camera, which offers you up to 250 GB of storage space, or you can shoot direct to computer if you're studio-based, giving what is called a tethered image.

In the end, medium and large format digital backs offer an amazing platform from which to work, but at a high cost. Not only do you need to invest in a digital back but also in appropriate production equipment to handle the big files. If you have already invested in a medium format or large format set-up it is always possible to use a digital back in parallel with the film back with relative ease.

SUMMARY

■ The CCD sensor in place of film carries a microscopic grid of pixels, to convert the image focused on it by the camera lens into a stream of digital electronic signals. The more pixels, the higher the resolution of the digital image and the greater its recorded 'file' size.

■ All cameras carry an LCD screen to display the picture before and after exposure. Unwanted shots can be deleted. Image files are stored on removable cards. Final image quality depends upon factors such as CCD pixel count (megapixels) and any compression made of the image file; for instance as a JPEG it will increase card storage capacity, but decrease quality of eventual output.

■ Advantages include immediate assurance of results, and no darkroom, chemicals or film or lab costs. In digital form images are easy to retouch, manipulate, and send elsewhere electronically.

■ Disadvantages relative to film are mainly higher capital costs, including computer and printer. LCD screens absorb battery power, and can be difficult to view.

■ To match the appearance of traditional photo-prints, digital images should be printed out at around 300 dots per inch (less for screen usage or newspaper reproduction).

■ Relatively large, very expensive multimillion-pixel CCD sensors are built into digital backs for medium- and large format cameras.

■ The higher the ISO the more noise you are likely to see in your image, which may degrade the quality of the image.

■ Compact flash cards rival secure digital cards as removable, re-usable image storage devices. SD cards are a lot smaller. Compact flash (CF) cards are generally more durable and faster than SD cards and mostly used on digital SLRs.

■ Digital camera equipment offering high quality image resolution is still expensive but it allows the professional photographer to review all pictures on the spot, and when necessary transmit them rapidly elsewhere. Results can be immediately edited on a computer.

PROJECTS

1 Try to output a photograph taken with various quality settings, such as RAW, JPEG (low, normal and fine) and compare them.

2 Photograph the same scene under different lighting conditions, first using the default automatic white balance setting and then intentionally setting it wrong; and lastly manually set the white balance.

3 If you are using a compact digital camera, experiment with the various built-in effects, such as black and white, sepia and others. Compare these later with what you can accomplish in post-production.

7 Lighting: principles and equipment

In this chapter we look at the six features of lighting; quality, direction, contrast, evenness, colour and intensity, and how lighting can be used to express (or repress) chosen aspects such as texture, form, depth, detail and mood. We will cover essential lighting equipment, working with available and mixed lighting as well as solving lighting problems.

The way you select and organise your lighting is highly creative and individualistic – in fact you will find lighting one of the most stimulating, exciting aspects of photography. Many photographers' individual styles can be identified through their use of lighting, and you have probably noticed how often a studio portrait or a movie can be 'dated' by the way it was lit, and there are always new things to discover, which happens when photographers explore things in a different way.

It is useful to read this chapter in conjunction with Chapter 2 as the characteristics of light discussed there – its straight-line travel, the effect of size of source, diffusion, reflection, colour content, etc. – can be used in various practical ways to alter the appearance of a subject, and they apply to any source, whether the sun, a flashgun, a studio lamp or even a candle.

One of the best places to learn lighting is in a space where you can control the lighting; however basic this may be, we call this a studio but it could be your front room. Try experimenting with a still life subject on a table in a room blacked-out as much as possible (see Figure 7.1), and have your camera fixed on a tripod. Make sure there is ample room to position lights or reflectors anywhere around all four sides of the table. Once you have experienced how lighting works with everything under your control, it is easier to deal with the many 'existing light' situations you will meet away from studio conditions.

Basic characteristics of lighting

Quality

The best way to describe the 'quality' of a light source is in terms of the type of shadow it makes objects cast. The shadows can be hard and clear-cut, soft and graduated or somewhere in between. As Figure 2.5 showed, this quality depends on the size of the source relative to its distance from your subject. Hardest light comes from direct use of the most compact, point-like source, such as a spotlight or projector bulb, a small flashgun, a torch, a lighted match or direct light from the sun or moon. (The sun and moon are vast in size, but because of their immense distances they form relatively small, intense sources in our sky.) All these light sources vary enormously in intensity and colour, but when used direct they all make sharp-edged shadows form (see Figure 7.2).

The softest light comes from a large, enveloping source. This might be totally overcast sky or a large frosted window. It could be a lamp or flashgun with a large-diameter matt

Figure 7.1 Olivier Richon approaches his compositions from a painterly direction. When he positions an object in a way that protrudes off a table, he is making reference to the way still life painters, such as Chardin, display their understanding of perspective

white reflector, or a cluster of fluorescent tubes. You can make any hard light source give soft lighting by placing a large sheet of diffusing material, such as tracing paper, between it and the subject. The larger and closer your diffuser is to the subject, the softer the lighting. Similarly, you can direct a hard source on to a large matt reflector such as a white-lined umbrella, card, or the ceiling or a nearby wall, and use only the light bounced from this for your subject illumination.

The opposite conversion is also possible. You can make a large, soft light source give hard illumination by blocking it off with black card, leaving only a small hole. Indoors, if you almost close opaque window blinds you can produce fairly hard light even when the sky outside is overcast (see Figure 7.3).

The way size and closeness of your light source alters lighting quality also changes the character of reflections from gloss-surfaced subjects. A hard light source gives a small, brilliant highlight. Typical of this is the little point of light ('catchlight') in the eyes of a portrait (see Figure 7.20). Remember that these highlights in glossy surfaces are essentially mirror reflections of the light itself and so take on the shape of the lamp. The highlight from a soft light is a reflection of the large, diffuse source giving a paler, spread highlight, which may sometimes dilute the underlying colour of an entire glossy surface, making it look less rich.

Direction

The direction of your light source determines where the shadows will fall on both the subject and its surroundings (Figure 7.4). This in turn affects the appearance of texture and form. Since a light can be placed anywhere around your subject, particularly when you have free movement of a light source in the studio, there are infinite variations in the lighting direction you employ. If you are using fixed, existing, light you may be able to move or rotate your subject instead, or perhaps plan out the right time of day to catch the direction of sunlight you need. The time of day can have an incredible impact on your photograph. If you are imaging a landscape with rolling fields and hedgerows, a photograph taken during midday when the light is from

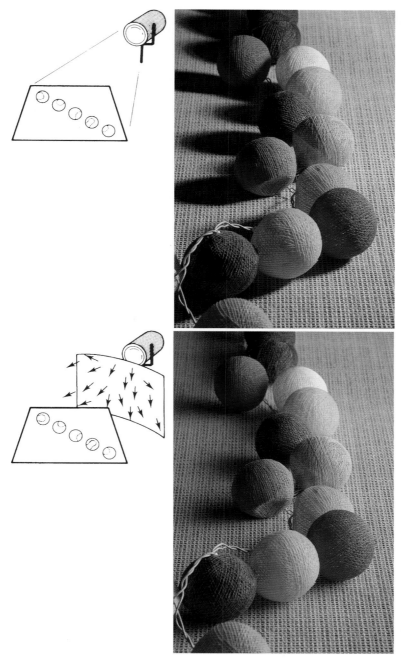

Figure 7.2 Lighting quality. Top: Illuminated by a distant, compact light source, these balls of wool cast dark, hard-edged shadows. Bottom: The light source is effectively enlarged by inserting tracing paper close to the subject. Softer edged shadows and more subtle modelling then appear. This 'soft, directional' lighting looks less dramatic to the eye, but often gives best results when photographed. (Outdoors the same differences in lighting quality are created by direct sunlight, and by cloudy conditions)

Figure 7.3 You can make a large soft light source give hard illumination, in this case by almost closing opaque window blinds even when the sky outside is overcast, creating dramatic lines to this composition

above will produce a rather flat and potentially dull image as everything is bathed in the same light. The same scene shot earlier on in the day with the sun just rising or later in the day with the sun setting creates a more directed light producing highlights and shadows revealing the texture so that potentially every blade of grass could stand out.

We tend to accept lighting as most natural when directed from somewhere above, mimicking the sun; after all, this is usually the situation in daylight. Lighting a subject from below tends to give a macabre, dramatic, even menacing effect. Compare (C) with (H) in Figure 7.4. Frontal light from next to the camera (G) illuminates detail, gives small shadows, minimizes texture and flattens form. Reflective surfaces seen flat on flare light straight back towards the lens. This effect can also be seen when you use direct flash from the camera (see, for example, Figure 7.5). Lighting from above or one side of the subject helps to emphasise texture in surfaces facing the camera, and shows the form of three-dimensional subjects. Backlighting can create a bold edge line and give you a strong shape (B), but most of the subject detail is lost in shadow which also flattens form. All these changes of direction work with both hard and soft light sources, but they are more marked with hard light because of its sharply edged shadows.

Contrast

Lighting contrast is the ratio between the brightness of the most strongly lit parts of your subject and the darkest (shadowed) areas. Photographic film and CCD sensors in digital cameras cannot accommodate as wide a range of brightness (luminance) in the same scene as can the eye. Often this means that when you expose to get detail in the lightest areas the shadows reproduce featureless black, even though you could see details there at the time. Alternatively, exposing to show detail in the shadows 'burns out' details in lighter areas.

The problem is greatest with hard side or top lighting: although the lit surfaces then show excellent form and texture there are often large very dark shadow areas. If you want to improve shadow detail you might be tempted to add an extra, direct, light source from the opposite direction, but this often forms an extra set of cross-shadows which can be confusing, 'stagey' and unnatural. Often a much better solution is to have some kind of matt reflector board on the shadow side to bounce back some of the spilt main light as soft, diffused illumination. This is known as shadow-filling. For relatively small subjects, portraits, etc., you can fill in using white card, cloth, newspaper or a nearby pale-surfaced wall. With large subjects in direct sunlight you may have to wait until there is cloud elsewhere in the sky to reflect back some soft light, or until the sun itself is diffused. With fairly close subjects you can use flash on the camera, preferably diffused with care to add a little soft frontal light, without overwhelming the main light (see p. 257).

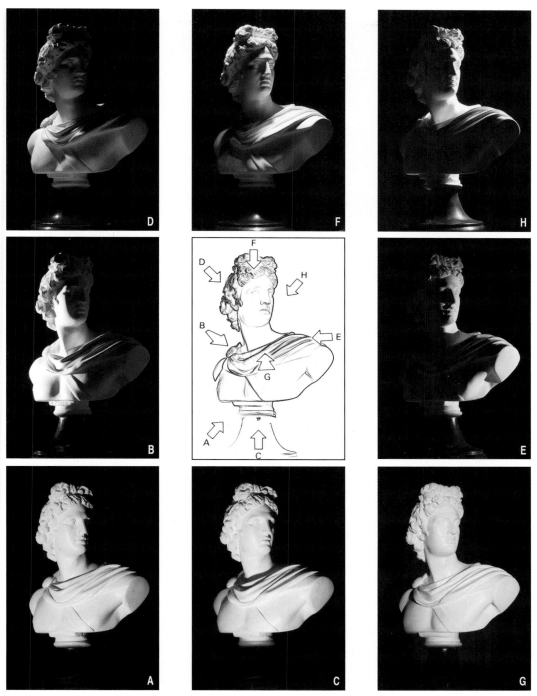

Figure 7.4 Lighting direction. The same object changes greatly in apparent shape and form according to the relative position of the light source. See central key

Figure 7.5 Flat-on frontal lighting given by flash from the camera illuminates all the subject detail, suppressing form and texture. Photograph by Martin Parr, Ireland, Roscommon Races, 1981

As a guide, an average subject with the most brightly lit parts lit ten times as bright as shadowed parts (a lighting contrast of 10:1) will just about record with detail throughout, in a black and white photograph. That represents 3.5 stops difference between exposure readings for the most illuminated and the most shaded subject areas of inherently equal tone. The equivalent for a colour shot is about 3:1 (see also p. 237). With experience you can judge how contrast will translate onto film; however, the problem is that the eye is more adept at dealing with contrast than is film so when starting out you should remember to use lower lighting contrast than might seem best to the naked eye (Figure 7.6).

Unevenness

Lighting unevenness most often happens when you use hard lighting from an undiffused spotlight or flashgun, too close to the subject, so that elements of the picture nearest the light source are much brighter than elements farther away. When you double the distance of what is almost a point source of light, the illumination at your subject drops to one-quarter the brightness. This means that if you have a still life setup 1 metre wide and then side-light it from a position 1 metre away the illumination across your subject will be four times (2 stops) brighter at one side than the other (see Figure 7.7). For an example of totally even lighting see the section on copying (Figure 7.28 and 7.29) where two lights of identical intensity are placed at equal distance on opposite sides of the subject.

If you want to avoid unevenness (with minimal effect on lighting quality) just pull the light source back farther, in a direct line from the set. At 2 metres the variation across the set becomes one-and-a-quarter stops, and at 3 metres only two thirds of a stop. Alternatively, add an additional light source, diffuse the light, narrow the set, or help yourself by positioning the darkest, least reflective objects nearest the light source.

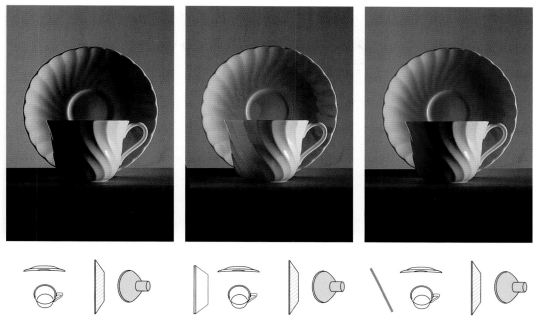

Figure 7.6 Controlling lighting contrast. All three pictures are lit by one diffused floodlight about 90° from one side. Left: No fill-in. Centre: A large matt white reflector is added left, directly facing the light. Right: Using red instead of white reflector board

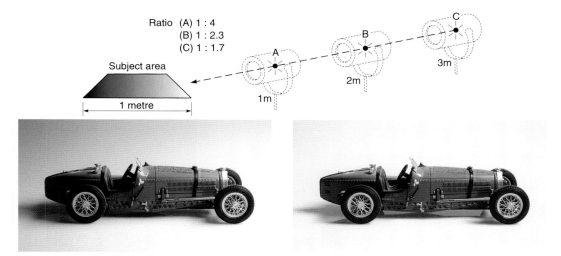

Figure 7.7 Distance and evenness. Left: A hard light source positioned obliquely at A is too close to the subject – the nearest part of this model car receives four times more light than the farthest end. Right: Pulled back to position C, three times the original distance, this ratio is reduced to 1.7 times. The subject is much more evenly lit and easier to expose correctly

Colour

Most light sources used for photography produce so-called 'white' light, a mixture of all colours. They are said to have a continuous spectrum, although its precise mixture may vary considerably from an ordinary domestic light bulb, which is rich in red and yellow but weak in blue, to electronic flash containing relatively more energy in blue wavelengths than red. As Figure 7.8

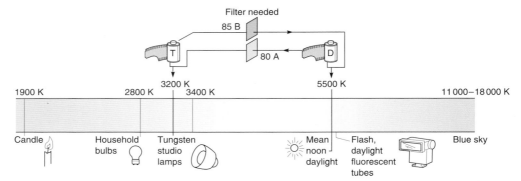

Figure 7.8 The colour – expressed as colour temperature kelvin (K) – of common 'white light' sources. Daylight-balanced film (D) needs a blue 80A filter for use with 3200 K lamps. Tungsten film (T) must be used with an 85B filter for daylight or flash, for correct colour rendering. See also Figure 9.30

shows, most sources can be given a 'colour temperature'; the higher the kelvin (K) value, the bluer the light.

When shooting colour, especially colour slides, you must be careful to match the colour temperature of your lighting to your film. Normally this is 5500 K (for 'daylight' film) or 3200 K ('tungsten light' film). Alternatively you can use a tinted correction filter to bring light source and film into alignment, such as an 85 B or 80 A (their effect is shown on p. 213). If all your subject lighting is the same colour temperature, the adjusting filter can be used over your camera lens. If it is mixed – daylight and studio lamps, for example – and you want even, consistent colour you can place a filter over one of these sources to make it match the other, as well as the film. Some light sources, such as sodium street lights and lasers for example, do not produce a full range of wavelengths and so cannot be filtered to give a white light result. In Figure 7.9 the colour cast from street lights is deliberately used to increase the mood of the photography.

This colour content of your light source is much less important when shooting black and white film, although strongly coloured light will make the colours of your subject record with distorted tone values (in red light, for example, blues look and record almost black, reds very light); see Chapter 9.

Most digital camera CCDs have colour sensitivity which can be varied. Each photosite has a red, green or blue filter in front it. Then special software calculates the image colour the pixel has received by referencing these filter clusters. Cameras often offer 'auto white balance' which works like a video camera, sampling the colour content of surrounding light and adjusting the CCD's colour sensitivity so that, say, a sheet of white paper always records white no

Figure 7.9 Typical cast created when subject shadows only receive light from a clear blue sky. The silvery coloured Chrysler Building appears almost the same colour as the background. The building would appear more neutrally coloured if shot when there was sufficient cloud around to reflect back 'white' light, or at a different angle or time of day

Figure 7.10 Tungsten lamp units which give hard lighting. Compact coiled-filament lamps (a) used in a focusing spotlight (b) or open-fronted reflector lamp (c). Lamphead attachments: barn doors (d), wire gauze 'scrim' (e), acetate filter holder (f), and snoot (g)

matter what the colour temperature of the lighting. Within limits you can make farther colour corrections later using digital manipulation software (Chapter 14).

The intensity of the light

Light intensity (brightness) is independent of contrast, evenness, etc. This is worth remembering as the human eye can often be fooled by extremely bright or very dim conditions. The camera's exposure settings, together with the sensitivity of your film or CCD, control the brightness of the image. With an auto-exposure camera, the light level indirectly affects depth of field and movement blur – bright illumination and fast film leading to small aperture and fast shutter speed, for example. Very dim lighting can require long exposure times, often giving distorted colours on colour films.

The light intensity of tungsten studio lamps can be quoted in watts, and electronic flash in joules or watt-seconds (see also 'Working from guide numbers', p. 253). High-wattage lamps – say 1 kilowatt and above – are so intense in brightness and heat that they are generally uncomfortable to use in the studio. However, high-intensity lighting is often necessary, either to use very small apertures for depth of field or to light a large area. This is where powerful studio flash offers a better alternative (see below).

Flash intensity can be reduced by selecting full, half, or quarter power settings without any change in the colour of the light. Most hand-held flashguns measure light reflected off the subject and control their own light duration; you can farther increase the effective light output of a flashgun by firing it several times during a time exposure (see Chapter 10). The best way to dim tungsten lighting is by fitting a grey neutral-density acetate or wire gauze 'scrim' (Figure 7.10), or just moving lamps farther away. It is possible to dim lamps by reducing the voltage of the supply with a variable resistor, but this is often unsuitable for colour photography because dimmed tungsten lamps have a lower colour temperature and give results with a reddish cast.

Lighting equipment

As already indicated, lighting kit divides into two main types – tungsten lamps and flash. Tungsten units allow you to see precisely how the light affects your subject's appearance. Flash (flashgun or studio flash units) avoids the heat and glare of tungsten lamps, and gives out more light but just for a brief instant. This allows you to work with the camera hand-held, and can give blur-free images of moving subjects. The colour of flash also matches that of daylight. Most forms of studio flash contain a built-in tungsten modelling lamp to help you to predict how lighting will look when the flash goes off. Flashguns, being battery powered, free you from the need for mains electricity supplies when working on location, outdoors, etc. although they use up traditional batteries very quickly and you would be advised, if you intend to do a lot of flash photography, to invest in a battery pack that is rechargeable and offers a longer-life supply of power.

Both tungsten and flash equipment will allow you to create hard or soft quality illumination. And unlike working with sunlight they offer you complete freedom to pick the height and direction of your subject lighting.

Tungsten lighting units

Tungsten lighting is so-called because the lamps contain a fine filament of tungsten metal which heats up, becomes incandescent and radiates light when an electric current passes through it. Ordinary household bulbs, as well as those in torches, car headlights, etc., usually have tungsten filaments. Units designed to give hard lighting (Figure 7.10) use bunched filaments to produce an effect as close as possible to a point of light. The filament is sealed into a sleeve of clear quartz glass filled with a halogen (often iodine) vapour and is therefore known as a tungsten-halogen or quartz-iodine type. Do not finger the quartz when fitting or replacing such lamps – handle them in the small plastic sleeve provided as grease from skin can burn when the lamp is switched on, causing it to crack.

Some lighting units can simply be a polished concave reflector with an open front. The lamp holder can often be moved backwards or forwards slightly within the reflector to give a narrower or broader beam. Alternatively the lamp can fit within an optical spotlight. This is an enclosed lamphouse with a curved reflector at the back and a large simple lens at the front to focus the light in a controllable beam. You shift the lamp using an external control to form either a wide beam or a concentrated pool of light (Figure 7.11).

Both these units accept fit-on accessories. Hinged 'barn doors' on a rotary fitting allow you to shade off any part of the light beam. A conical 'snoot' narrows the whole beam, limiting it to some local part of your subject. A 'scrim' reduces light intensity, usually by one stop, without altering its colour or

Figure 7.11 Focusing spotlight. Top: Shaped 'Fresnel lens' bends illumination like the fatter lens (left) but is less bulky, with larger cooling surface. Bottom: Shifting the lamp position in a focusing spotlight adjusts the beam width. Broadest beam gives hardest, most point-like lighting; see also Figure 2.5

quality, and a filter holder (spaced away from the unit to prevent overheating) accepts sheets of tough, theatre-type dyed acetate, also known as 'gels'.

You will find that each unit gives hardest quality light when the beam is at broadest beam setting. Focus a narrow beam when you want a graduated patch of illumination, say on a background behind a portrait. This focus setting will also give softer edges to the shadows. To light a small area evenly and with sharp-edged shadows, first focus a broad beam and then restrict this with barn doors or a snoot.

Note that tungsten lights get very hot in operation and so anything attached to them such as gels and diffusers should be capable of withstanding great heat. It can be tempting to use black paper or card for things like snoots but they can easily catch fire!

Units for soft lighting (Figure 7.12) use a large translucent glass lamp, usually with a 500 watt or even 1000 watt tungsten filament. This is housed in a wide, often matt white, dish reflector to form a floodlight (Figures 7.13). The lamp sometimes faces inwards, to turn the whole dish into a more even, large-area light source. You can also buy, or make up, a grid of floodlight bulbs

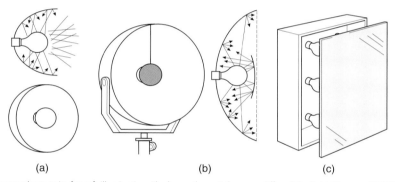

(a) (b) (c)

Figure 7.12 Tungsten lamp units for soft illumination. The larger the unit the more diffused the light. They use 3200 K diffuse-glass floodlamps in (a) matt white open-fronted reflector, (b) wider dish flood with direct light shield and (c) large opal plastic-fronted box giving lighting quality similar to overcast light from a window

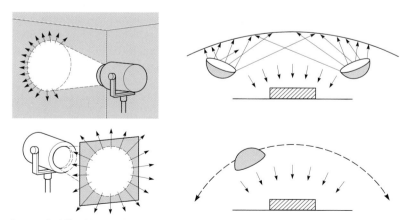

Figure 7.13 Producing soft, diffused lighting from a relatively hard source. Left: 'Bouncing' illumination from a spotlight off a large area of matt white wall, or (lower) directing it through tracing paper. Right: Spreading light from a small flood by reflection from a white overhead canopy, or (lower) by moving it in a wide arc over your subject during a time exposure of several seconds

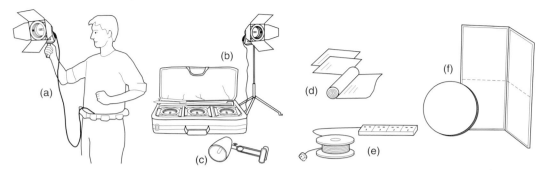

Figure 7.14 Tungsten lighting for use on location. (a) Battery-belt powered 'sun gun'. (b) Suitcase lighting kit containing three tungsten-halogen lampheads and stands. (c) Lightweight lamphead on clamp. (d) Dyed acetates. (e) Cable and multi-sockets. (f) Folding lightweight reflector surfaces

behind a diffusing sheet of opal plastic. The quality of illumination this gives is like overcast daylight through a large north-facing window – which is why it is often called a 'window light'.

Your lighting units should have stands which allow the head to be set at any angle or position, from floor level to above head height. For location work, (Figure 7.14) lightweight heads such as QI lamps can have clamps with ball and socket heads, so they will attach to doors, backs of chairs, etc. Consider too the use of a 'sun gun' – a totally mobile small, hard QI unit which can be hand-held by an assistant and powered from a belt of rechargeable batteries. Typically this gives up to 20 minutes of 300 W lighting.

When you use tungsten lighting for colour photography, if you want even colour illumination make sure you have lamps that all give the same colour temperature, preferably matching your film, and run them at their specified voltage. Over or under-running voltage by as little as 10 percent will give a noticeable blue or orange tint to results and might be something you want to try, to see the results for yourself. See the text below on power loadings and extension cables.

Flash units

Electronic flash produces its light when a relatively high voltage pulse is discharged through a gas-filled tube. The flash is typically 1/1000 second or less and matches the colour of 'daylight'. Otherwise it complies with the same optical principles as tungsten lighting. There are two forms of equipment – a flashgun either built into or mounted on the camera generally for hand-held use, and free-standing studio units that you can move around more like tungsten lamps (Figure 7.15).

Battery powered flashguns range from the tiny units built into camera bodies, attached to the lens (Figure 7.20) through clip-on accessory guns, Figure 7.15, (brighter, and capable of tilting), to still more powerful 'hammerhead' guns that attach alongside the camera. All these tend to have short flash tubes and highly polished reflectors that give hard quality light when used direct, unless some form of diffuser is fitted or illumination is bounced (Figures 7.19 and 10.36). A plastic 'beam-shaper' condenser lens over the flash window often allows you to narrow or widen the light beam, to match the different angles of view of tele or wide-angle camera lenses. Battery flashguns contain no modelling lamp.

(a)

(b)

(c)

(d)

Figure 7.15 Battery and powered flash units. (a b) Built into compact and SLR camera bodies. The SLR flash rises from the pentaprism housing to distance it from lens viewpoint. (c) Add-on unit with tilt-up head for bouncing light off the ceiling, etc. (d) Powerful 'hammerhead' type gun with rotatable head, bracket for camera, and separate power pack. All these units give hard light, unless bounced or diffused

There are all sorts of interesting effects that can be achieved with portable flash (Figure 7.16) and you can construct your own bounce card (or buy one) that needs to be attached at a 45° angle to the upright pointing flash head instead of simply bouncing light off a white ceiling. A bounce card can be used outside to help soften flash when used in daylight or at night. (See Figure 8.3 – this portrait was made by underexposing the background and flashing the face with a portable flashgun and bounce card at 45° to the upward pointing flash head.) A snoot could also be constructed over the head of your flashgun and the flash would be directed to specific small areas of the image. In Figure 7.17 (by David Moore from the series 'The Velvet Arena') you can see how the photographer used the smallest type of portable flashgun with a synchronized lead so that he could light up a small selected area of the image.

Studio flash is mains-operated, and of two types – monoheads and generator systems. All the electronics plus flash tube are combined in a monohead unit, supported on a lighting stand (see Figure 7.18). A generator (or 'power pack') system is more powerful and expensive, often hired rather than bought. Electronics and controls are contained in one unit that can feed

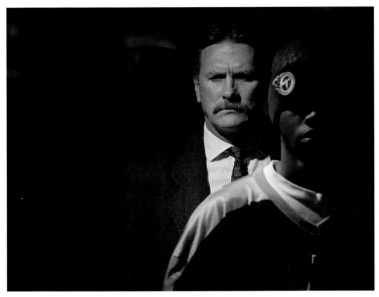

Figure 7.16 From Philip-lorca diCorcia's series 'Heads', where he took pictures of people walking in Times Square unbeknowns to them, rigging lights and focusing his lens on a spot 20 feet away from him

Figure 7.17 In this dramatic image by David Moore, from the series 'The Velvet Arena', he has used a portable flashgun on automatic setting with an extendable synch lead (so the flashgun is hand-held off the camera) so that he could light up small selected areas of his photographs of his choice

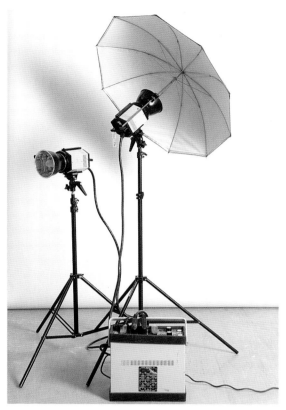

Figure 7.18 Studio/location flash units requiring an electricity supply. Each has a tungsten modelling lamp to forecast its lighting effect. Left: Monohead type unit, with both power pack and tube in the head. Right: More powerful, separate generator type, powering one of up to three heads. Both types give hard lighting if used as shown here

several flash-tube heads on separate stands. Both kinds of studio flash use a small tungsten modelling lamp in each head. To do its job properly and show you how the lighting will look when the flash fires, this lamp must match the size and position of the flash tube as closely as possible (see Figure 7.19). The modelling lamp is dimmed if you adjust the flash output of its particular head from full to fractional power. This is important when you are using several heads set to different outputs (Figure 7.21).

Lighting quality from studio flash is determined by the size and shape of tube and type of reflector or diffuser you fit to the head. Monoheads use one permanent flash tube and rear reflector, to which a variety of accessories fit. Generator systems allow you to choose from a range of designed heads, having tubes of various shapes as well as attachments ranging from a spotlight to a large fabric 'soft box' giving a very diffused window light effect. An umbrella, white-lined or made of translucent material, will act as a large reflector or diffuser respectively, yet it is easily transportable. Umbrellas fit to generator heads or monoheads (but be careful that stands are anchored, particularly with monoheads, in case draught or wind topples them over).

Bear in mind that the accessories, heads, or just the way flash is deployed (bounced off a wall or ceiling for example) can give you lighting matching the quality of a tungsten lamp of the same size and used in the same way. The lighting principles behind flash and tungsten light sources are not as different as they at first seem. (See also flash exposure, and practical techniques, pp. 250 and 258.)

Other artificial light sources

There is a wide range of tungsten lamps other than the 3200 K studio types which are standard for artificial light ('tungsten') colour film. You may come across over-run 'photo lamps' or 'photofloods' and QI movie lamps, which are high intensity but operate at a slightly bluer 3400 K designed for colour negative movie film stock. Results on 3200 K tungsten light film show a slightly bluish cast unless you shoot with a pale orange correction filter (p. 221).

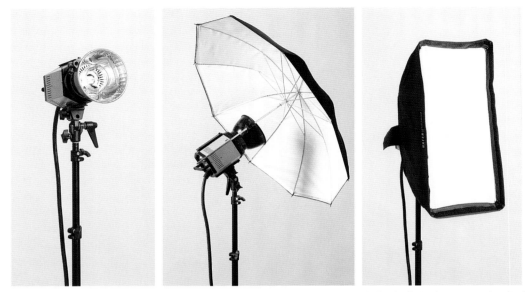

Figure 7.19 Head detail and fittings for studio flash. Left: Tungsten modelling lamp surrounded by the flash tube. Centre: White-lined umbrella reflector. Right: Fabric 'soft box' attachment. Both these heads give soft, diffused lighting

Figure 7.20 Ring flash unit with battery power pack. Right: The soft-edged rim shadow here is typical when using ring flash with the subject close to the background

Domestic lamps are less bright and give out light of a warmer colour than studio lights – the lower the wattage, the more orange the results will be. If you have to use such lighting, pick 100 watt lamps, have an 82A correction filter over the lens and shoot on colour film designed for artificial light.

Fluorescent tubes can form useful studio light sources for black and white photography. You can group them vertically, in clusters, to softly light standing figures, still life, etc. To shoot in colour pick 'colour matching' tubes and use daylight colour film. They are not recommended

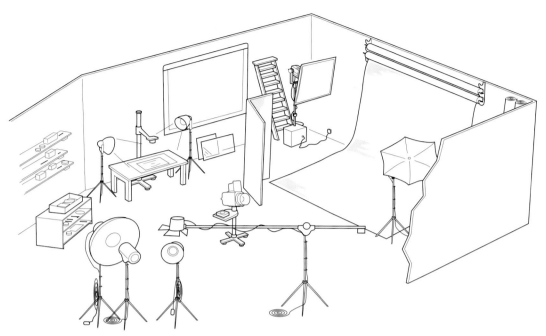

Figure 7.21 Layout of a typical general studio. Window has a removable blackout. Main set, using 3 m wide background paper, is equipped with a flash soft box (window light) head. A separate monohead unit has an umbrella. Two tungsten floods are in use for copying with a 35 mm camera on pillar stand. Other lighting, stored in the foreground, includes a boom stand with lamphead. The adjustable camera stand in the centre is an alternative to a tripod and easily supports even large cameras. Card, glass, blocks, clamps, tape and tools are all stored near to hand on shelves

for critically accurate results, but often on location you are forced to work with them – when they form the existing light in shops, for example.

In such cases a pale magenta fluorescent-daylight correction filter can be used if you do not like the colour cast caused by such lighting; sometimes it can be a very useful tool to create atmosphere in an image. If you find that you are shooting somewhere lit with a mixture of different tube types (or tubes and lamps), if possible you can try and swap them around to get greater uniformity. Alternatively, change to your own flood or portable tungsten lighting instead.

You may also encounter specialist lamps designed for TV studios. These typically consist of an array of small fluorescent tubes and give a good deal of daylight-balanced light while running very cool. They take several minutes to 'warm up' and reach full brightness.

Lastly, consider hand torches which use a number of white light LED (light-emitting diode) units. The light produced is actually quite blue but these units can be useful for black and white photographs of small set-ups.

Lighting accessories

As well as the attachments described on p. 140, back-up items for your lighting might include collapsible cloth reflectors or home-made ones made from white card with crumpled kitchen foil on one side to give alternative effects. Builders' merchants sell large sheets of polystyrene foam

Figure 7.22 Direct evening sunlight skim-lights a Cotswold cottage wall. Hard light directed so obliquely dramatically shows up texture, provided that the subject is all on one plane

designed for insulation which makes ideal large, lightweight studio reflectors. You may also need supports for paper backdrops, a boom light stand, clamps, sticky tape and both white and black card. 'Bulldog' or 'crocodile' clips are invaluable for attaching accessories to lights or sets, as are wooden clothes pegs which have the advantage of being highly resistant to heat. Blue acetate or blue-dyed 'daylight' lamps to make tungsten lighting match the colour of daylight when two kinds of light have to be combined on location can be useful. Similarly orange acetate, fitted over flash, can match it into a tungsten-lit environment.

Have sufficient cable to link your units to the nearest supply, and don't exceed its fuse rating. Remember:

Total amps drawn by lighting equipment = Total number of watts ÷ Voltage of the supply

So one 250 V socket fused at 13 A will power a maximum of 3250 W of lighting. When servicing the equipment check that your lighting units and plugs are all properly grounded (earthed). If you are using a drum of cable always unwind this fully before passing current through it, or the coils will overheat. If using very long extension cables remember that the voltage will drop due to the resistance of the wire. Consider using a portable generator instead but ensure it has sufficient power.

Check out the electrical hazards advice in Appendix E. Finally, don't jolt lamps while they are hot – especially tungsten-halogen types which easily short out their closely coiled filaments, and are expensive to replace.

Figure 7.23 The same principle of single-source skim light as in Figure 7.22, but using an overhead desk lamp in a darkened studio. Note the depth of the shadows

Practical lighting problems

Think carefully what your lighting should actually do for your subject, other than simply allow convenient exposure settings. Perhaps it must emphasize the form and surface textures of a building (Figure 7.22), or a small product in the studio. It might heighten features in a dramatic character portrait, or be kind to an ageing person's wrinkles (Figure 7.23). Your lighting will often be the best way to emphasize one element and suppress others, or reveal extreme detail throughout. It can 'set the scene' in terms of mood and atmosphere, and alter your composition by attracting the eye to a certain point of the image or simply solve a technical problem such as excessive contrast in an existing light situation.

Existing light

Learn to observe 'existing light', noticing what is causing the lighting effect you see, and how this will reproduce in a photograph. For example, look up from this book for a moment and observe how your own surroundings are lit. Is it hard illumination or soft? Even or uneven? Which areas are picked out by lighting direction and which suppressed? Are any textures or forms emphasized? Try narrowing your eyes and looking through your eyelashes – this makes shadows seem darker and contrast greater, a good guide to their appearance on a final print.

Daylight. The lighting quality of daylight ranges from intensely hard (direct sun in clear atmosphere conditions) to extremely soft (totally clouded sky in an open environment). Colour varies from an 18,000 K intense blue when your subject is in shadow and only lit from blue sky, to an orangey 3000 K around dawn or dusk; think of those popular sunset shots bathed in warm orange light. (Strictly 'daylight' colour film is balanced to give correct colour reproduction at 5500 K, this being a mixture of direct noon sun plus some skylight.) We barely notice these differences as our eyes and brains constantly compensate for them. You can see this most clearly by standing in an ordinary tungsten-lit room at dusk. Everything looks natural, but if you glance out of the window the world outside looks very blue indeed. If you step outside at this point your eyes quickly adjust to the prevailing light and looking back through the window from outside shows a very orange-looking interior. Through practice you will soon become used to understanding how light will affect your colour photographs, how flash, tungsten and daylight are linked through colour temperature measured in kelvin. Colour daylight film and flash units are balanced at 5500 K to match direct noon sun and tungsten film and lights are balanced to 3200 K that matches the orangey tone of dawn or dust.

The direction of daylight changes throughout the day as the sun tracks in an arc from east to west, being at its highest point at noon. This point is highest in summer and truly overhead only at the equator. Considered use of daylight for subject matter such as architecture and landscapes calls for planning, patience and the luck of getting all the aspects you need together at one time.

(a) (b)

(c)

Figure 7.24 Supplementing uneven existing light. (a) Correctly exposed for the daylight-lit parts of the room, using 1/60 at f/8. (b) Flash bounced off ceiling above the camera set to autoflash exposure. Result has overlit foreground. (c) Flash positioned as per (b) but set on manual mode and reduced to one-quarter the correct power. Exposure settings as per (a). Result shows realistic balance of 4.1 daylight/ flash

The varied character of natural daylight is often an important feature in pictures shot outdoors: the orange tint of a setting sun can add to the impression of an evening atmosphere if it is a realistic impression that you want to achieve.

Supplementary daylight. Often when you are working with existing light you will need to modify it in some way. When shooting a black and white portrait outdoors, you may find direct sunlight too harsh and contrasty, but the light changes completely if you move your subject into the shadow of a building. However, this can give an unacceptable blue cast with colour photography, so it may be better to remain in sunlight but work near a white wall, or have a reflector board (p. 153) or even just a newspaper to return light to the shadow side. Another way to soften harsh shadows with close subjects such as portraits is to use a diffused flashgun on the camera. Since the latter is likely to be a battery-operated flash unit you cannot see the effect created unless you are using a digital camera or shooting instant picture material (see 'Fill-in flash', p. 259), and results have to be worked out by careful calculation of exposure.

Supplementary light is often necessary when you shoot an architectural interior using existing daylight. There may be excessive contrast between views through and areas near windows, and the other parts of a room. You can solve this by bouncing a powerful light source off a ceiling or wall not actually included in the picture, to raise shadow-area illumination to a level where detail just records at the exposure given for brighter parts (Figure 7.24).

Figure 7.25 Mixed lighting. Mass celebrated at a tungsten-lit altar, with daylight illuminating the surrounding interior. In this instance the best compromise was to shoot through an 80A, blue filter onto daylight film (see p. 213) or use tungsten-balanced film if available. Either gives this result showing the key area in the correct colour, but an exaggerated blue cast elsewhere. On daylight film without a filter the central area would reproduce as orange, and the surroundings the correct colour

This artificial light source might be portable QI lamps or a flash unit. If you are shooting in colour, ensure any tungsten supplementary lighting is filtered to match the daylight, and be careful not to bounce off tinted surfaces such as coloured walls. Sometimes a dimly lit interior can be 'painted with light' to reduce contrast, by moving a lamp in a wide arc over the subject during a long exposure.

If you are looking for an even light source in your photograph, mixtures of existing light sources which have different colour temperatures can be a problem when shooting in colour. You may be able to switch off, or screen off, most of one type of illumination and use the correct film or filter for the other. Otherwise decide which of the two kinds of lighting will look least unpleasant if uncorrected. A scene lit partly by daylight and partly by existing tungsten lighting often looks best shot on daylight-balanced film. The warm cast this gives to tungsten-lit areas is more acceptable than the deep blue that daylight-lit parts will show on tungsten-balanced film. However, much depends on what you consider the key part of your picture (see Figure 7.25).

Fully controlled lighting

If you are working in the studio, or some other area where you have complete control, try to build up your subject lighting one source at a time – each unit should have a role to play. It is useful to keep the camera on a tripod so you can keep returning to it to check results from this viewpoint every time you alter the light.

Starting from darkness, switch on your main light (soft or hard) and seek out its best position. If you are just showing a single textured surface – such as a fabric sample, or weathered boarding – try a hard light source from an oblique direction. By 'skimming' the surface it will emphasize all the texture and undulations. But take care if this means that one end receives much more light than the other – move your light source farther away.

A single hard light will probably exaggerate dips in the surface into featureless cavities. Also, if the picture includes other surface planes at different angles, some of these may be totally lost or confused in shadows. One solution is to introduce a second or 'fill' light, but if this creates a second set of hard shadows the scene will tend to look 'staged' and theatrical, because we are rather conditioned by seeing the world lit by one sun, not two. To avoid this try adding very diffused light – perhaps just 'spill light' from the first source bounced off a white card reflector – sufficient to reveal detail in what still remain shadows. The reflector will have to be quite large, and probably set up near the camera to ensure it redirects some light into all shadows seen by the lens. If you cannot produce enough fill-in in this way, try illuminating your reflector card with a separate lighting unit. Another approach is to change your harsh main light to something of softer quality, perhaps by diffusing it.

Figure 7.26 Complex still life arrangements can be illuminated to reveal forms without confusing shadows by using a large diffused light source across the top and side of the set. Here, a window light from top left is used with a second diffused light from the right

If your picture contains a more distant background, you can light this independently with a third source (maybe limited by barn doors) so that the surface separates out from the main subject in front. Again, be careful not to spread direct light into other areas, if this creates confusing criss-cross shadows. In fact, when you have a great mixture of objects and separate planes to deal with in the same picture, there is a lot to be said for using one large, soft, directional light source (i.e. from one side and/or above). This can produce modelling without excessive contrast or complicated cast shadow lines, giving a natural effect like overcast daylight from a large window or doorway (see Figure 7.26).

Much the same kind of build-up can be applied to formal studio portraiture. Decide viewpoint and pose, then pick the direction of your main light, watching particularly for its effect on nose shadow and eyes. With a 'three-quarter' head shot (Figure 7.27) think carefully whether the larger or the smaller area of face should be the lighter part. Consider how much, if any, detail needs restoring in shadows by means of a reflector. If you want to stress an interesting outline you could light the background unevenly, so that darker parts of the sitter appear against

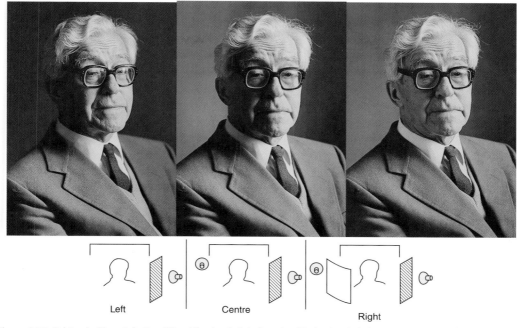

Figure 7.27 Lighting build-up. Left: One diffused flood main light from the side the sitter is facing. Centre: A second flood added to lighten one side of the background and pick out the head outline by 'tonal interchange'. Right: The farther addition of a large matt white reflector board softly fills in some shadow detail

the lightest area of background, and vice versa. It is often a good idea to light backgrounds completely independently as it allows you much greater control.

You could even add a farther low-powered or distant spot to rim-light hair, shoulders or hands from high at the rear. However, there is a danger of so-called overlighting which puts your sitter in a straitjacket. He or she cannot be allowed to move more than a few inches for fear of destroying your over-organised set-up, and this can result in wooden, self-conscious portraits. The more generalised and simple your lighting, too, the more freely you can concentrate on expressions and poses.

The build-up approach to lighting applies equally to tungsten units and flash sources. Studio-flash modelling lamps will show you exactly what is happening at a comfortable illumination level, changing only in intensity when the flash is fired. (See also flash exposure technique, p. 258.)

Special subjects

Copying

The main aim when copying flat-surfaced originals such as photographs and drawings, is to create totally even lighting free from reflections off the surface of the original. Figure 7.28 shows the best way to approach this, using two floodlights at about 30°, each directed towards the far edge of the subject. Black card around the camera will prevent its shiny parts reflecting and

Figure 7.28 Flat-on lighting set-ups. Left: Set-up for copying artwork, etc. Lamps are at 30° to subject's surface, distanced at least twice the width of the artwork and directed towards its opposite edge. Black card near camera blocks reflections. Centre: Coins on a black card photographed through (G) thin glass at 45° (see diagram, right). The camera lens (C) looks down the same path as the light from the lamp illuminating the subject (S)

Figure 7.29 Example of copy work by Gordon McDonald from the *Rat Archive, made in collaboration with artist Catherine Moriarty. Gordon used the copying technique to document all the materials that had been used by a rat to build its nest in Catherine's New York apartment*

showing up in your picture (Figure 7.29). With care even pictures framed under glass can be copied this way. (See also polarizing filters, p. 225.)

Note that this basic setup is also very useful for lighting backgrounds where you want good, even, flat illumination. Unless the background is highly reflective, you can increase the angle of the lights to about 45°.

Macro work

Sometimes in extreme close-up photography you want flat-on frontal illumination to light every tiny detail of a coin, etc., or some recessed item such as a watch mechanism or electronic layout. A ring flash is sometimes the answer, but you can also work with a piece of clean, thin, clear glass set at 45° between lens and subject. A snooted spotlight or similar hard light source

is directed at 90° from one side so that it reflects off the glass and is directed down on to your subject, sharing the same axis as the lens (see Figure 7.28).

Transparent/translucent subjects

Glassware, etc., is often best lit from the rear. Either use a large white background spaced behind the objects and direct your lighting evenly onto this, or direct lights onto the glass from the sides or rear so that the background remains dark. The former gives a dark outline to the glass against a predominantly light ground. The latter produces a white outline against dark. If the glass has a glossy surface you can suggest this quality by adding a rectangular-shaped light source from near the front, simply to appear as a window-like reflection.

Highly reflective surfaces

Subjects with mirror-like surfaces such as polished silver or chrome bowls, spoons or trays impose special problems (Figure 7.30). They tend to reflect the entire studio in great detail, confusing their own form. You can treat them with an aerosol dulling spray (either from specialist photographic suppliers such as Tetenal or use simple hairspray) but this may suggest a matt rather than a polished finish and can damage objects. Often the best approach is to enclose the subject in a large, preferably seamless, translucent 'tent' such as a white plastic garbage bag or sphere, or improvised from muslin or tracing paper. Cut a hole just wide enough for the camera lens to peer in, remembering that the longer its focal length the farther back it can be, giving a smaller and more easily hidden reflection. Illuminate the outside skin of the tent using several floodlights, or move a single lamp over this surface, painting it with light throughout an exposure time of several seconds (Figure 7.31).

Figure 7.30 Lighting simple glassware. Left: Using a separately lit white surface some distance behind the glasses to get a silhouette effect. A spotlight, shielded from the glasses direct, illuminates white card to reflect soft highlights, suggesting the roundness and sheen of the glasses. Right: The same set re-lit to give a more delicate, luminous look to the glass. Grey card covers the background seen by the camera, and soft lighting is directed through the glasses from side and rear. A frontal reflector board returns some light to help reveal form and surface

Figure 7.31 'Tent' lighting. For this shot of highly reflective silver tableware a large sheet of tracing paper formed a canopy over the set, and was evenly illuminated from above by floods. In this instance, to prevent dark reflections, the camera was shielded behind white card, leaving a hole for the lens

SUMMARY

■ The main ways lighting can alter subject appearance are through its quality, direction, contrast, evenness, colour and intensity. Of these *quality* and *direction* are often the most important – because neither can be adjusted later by some camera setting or printing technique.

■ Hardest quality lighting is given by a relatively compact and distant light source, used direct. Soft lighting is created by a large, close enveloping, diffused source.

■ The direction of the light controls which parts of your (three-dimensional) subject will be in light or shade. It strongly influences the appearance of form; also the direction and length of shadows.

■ Lighting contrast needs to be kept within bounds if you want to show detail from highlights through to shadows. It is often best controlled by using a reflector placed near the subject's shadow side, or the use of additional light sources.

■ To improve evenness, increase the distance from light source to subject, or diffuse or bounce the light so that it becomes spread and less of a 'point source' in character.

■ Lighting colour, often quoted as a colour temperature (kelvin), should suit the balance of your colour film, or be brought into line by using a colour filter over the light or lens.

■ Tungsten lighting units – QI lamps, focusing spotlamps, individual floods or larger window-light units – mostly operate at 3200 or 3400 K. Only the former suits tungsten-light colour film without filtration.

■ Electronic flash is equally versatile with hard direct light, soft bounce light, window light, focusing spotlight and ring-light units. Mains-operated studio units with modelling lamps allow you to preview their lighting effects. The colour of regular daylight and most flash suits 'daylight' colour film balanced for 5500 K. Try to avoid mixed colour– temperature lighting conditions, except for effect.

■ When lighting a subject, build the light by introducing one source at a time, and consider what each must do. It is good advice to keep things simple, aiming mostly for a natural daylight effect.

■ In the studio, consider lighting foreground and background with separate lights, as it is much easier to control the effect by the building method described above than to make one light do two jobs.

■ Learn to recognize the technical pitfalls of existing light – excessive contrast, unevenness, mixed colour. Be prepared to improvise to control contrast and colour, or to return at another time for the lighting quality and direction you need.

■ Certain lighting 'formulae' are helpful for special subjects: for example, 30° lighting for copying, ring-flash or 45° glass for maximum detail macro work, backlighting for transparent subjects, and a light-diffusing tent for polished objects.

1 Experiment using an ordinary desk lamp, tracing paper and card to light a simple three-dimensional still life subject such as an ornament, doll or toy car. See how much you can vary the illumination *quality*, from hard to very soft.

2 Photograph a white box in the studio on a white background, to show its top and two sides. Choose and arrange your lighting so that *each* of the three box surfaces photographs with a different tone.

3 Take two photographs of either tennis balls or eggs. In one they should strongly reveal their rounded three-dimensional form. In the other make them look like flat two-dimensional discs or ovals. The only change between each version should be in the lighting.

4 Check out the appearance of subjects when lit by direct or bounced flash, directed from various positions. If you have only a battery flashgun, tape a hand torch to it and work in a darkened room to preview results. Take pictures of the most interesting variations (see exposure, p. 258).

5 Set up a still life group consisting of two or three neutral or pale-coloured, matt-surfaced items, lit either by daylight or by tungsten lamps. Have the camera on a tripod. Take colour pictures in pairs, demonstrating radical differences due to *each* of the following changes in subject lighting: (a) quality, (b) direction, (c) contrast and (d) colour. Measure and set correct exposure for every picture, but make no other alteration. Compare results.

6 Collect examples of portraits from magazines or books which show different styles of lighting. Attempt to re-create them in the studio. Remember that careful study of the shadow of the nose and highlights in the eyes in particular can give you valuable clues.

PROJECTS

8 Organising the picture

This chapter is concerned with composing the image of your subject as a picture. It deals with recognizing and exploiting visual features of scenes and framing them up in the strongest possible way.

Sometimes a photograph has to be composed in an instant, as some fast-changing action is taking place, so that exactly what you include and how it looks is changing every fraction of a second. Or your picture may be constructed quite slowly, as with a still life shot painstakingly built up item by item. Most photography lies somewhere between these two extremes, but whatever the conditions there is always the need to make decisions on picture structuring. Basically you have to pick out, from a mixture of three-dimensional elements, an image that works in two dimensions (perhaps translated into black and white too) and enclosed by corners and edges. You need to develop a way of seeing the world through the camera.

A photograph can be successful on different levels and in different ways: if you want to make a picture that is strong enough to go on the wall (at home or in a public place) or on to the page of a magazine or book then you will want it to express or interpret more than if you were actually there – you should aim to transform the subject in some way. To achieve this you need to be a good organiser – being in the right place at the right time with suitable equipment, and perhaps an assistant/collaborator, props, models, lights, etc. You should also understand your technique – best use of perspective, lighting control, depth of field, exposure, etc. But perhaps above all you need the ability to know when all the visual elements look right and 'hold together' in a way that gives an outstanding visual result.

Often composition means simplifying from chaos, having a picture structure that is balanced and harmonious. Sometimes you may want the opposite, choosing imbalance and awkwardness, a kind of off-beat confusion which is the point of the picture or the way you decide to interpret the subject. Sometimes you might move things within the picture frame, or perhaps you will move around the subject with your camera until you have the right point of view. Picture structuring is very subjective – open to individual style and original interpretation – so there are strong arguments for *not* having rules of composition. However, long-established guidelines are still very valid and often used to make successful pictures – it is worthwhile trying to achieve taking a conventionally composed image before trying to invent your own rules (it is difficult to be a revolutionary until you know what you are revolting against).

Noticing subject features

We tend to take the things around us for granted. There is too little time to spare. It is easy to get into a state where we no longer really *look* at objects, but just accept them for what they are or do. Have you really examined that bowl of fruit, the arrangement

159

of your living room, or what goes on in your front garden? Imagine that you have just arrived from another planet and, having never experienced these items before, set out to evaluate them. Try jotting down the list of *basic visual qualities* you notice about the bowl of fruit, for example. It has its own particular shape; it may have texture, pattern, form, and colour and tone values. Think about the background story to the subject – the bowl may contain particular types of fruit, purposefully selected; some of it might be old or it may have only just been bought.

Every subject has individuality in this way and everybody can form their own analysis, deciding which are for them the strongest visual features, the ones they want to emphasize when taking the picture. There are no academic 'rights' and 'wrongs' about such an assessment. It is personal to *you* – an opening to express feeling as a photographer, not just pointing and clicking without thinking.

Like most people you are probably stimulated by a change of environment – a trip abroad, or just a visit to an unfamiliar building. Here you are seeing new things, therefore making new evaluations. After a while the environment becomes commonplace; objects are accepted and grow less interesting. A young child examines (looks, bites and presses) each new material it meets, naively making an analysis – hard or soft, rough or smooth. A good photographer retains this ability always to look freshly at the visual content of what is in front of their lens. A good photographer is also naturally inquisitive and will have discovered something about their subject that has inspired them to be interested in it. A good starting point for re-inventing your style of photographing is to take a new point of view; see Figure 8.1, for example.

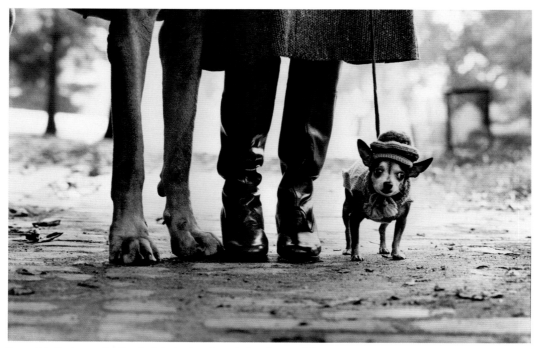

Figure 8.1 The humour in Elliott Erwitt's visual pun is partly the subject itself, but comes mostly from his clever use of viewpoint, which exploits shape, scale and cropping

Shape

A bold shape or outline is one of the strongest ways of singling out an object or person, giving it or them a sense of separation from their environment. This kind of separation can be done dramatically using a silhouette or a shadow. A shape can be just a single item, or formed collectively by a mixed group of objects. In Figure 8.2 it is the shape of the hat and wearer's face that gives this portrait its stark framework. Having several strong shapes in an image invites comparison, and may relate otherwise quite dissimilar elements, as in Figure 8.13.

One way of repeating shape is by hard, cast shadow. This can produce interesting variations, as when shadow falls on oblique or undulating surfaces. Hard sidelight may cast the shadow of one elevation of something alongside another (for example a face-on portrait with a profile shadow cast on a nearby wall). Shadow shapes also tell you about things outside your picture area (Figure 8.6).

The best way to stress shape is through your viewpoint and lighting. Use both to simplify and isolate subject outline against a contrasting, preferably plain, tone. Shallow depth of field will also help you disentangle shape from background details. If you are working digitally you will be able to add shadows and silhouettes in the post-production stage using photo manipulation programs.

Texture

Texture is concerned with surface – for example, the tight smooth skin of an apple, or the pitted surface of corroded

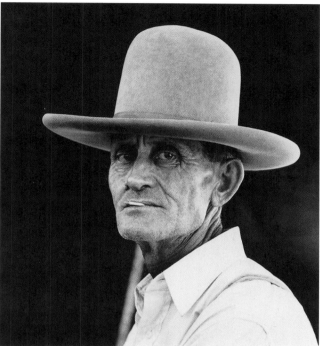

Figure 8.2 'An Eastern Texan', Russell Lee's documentary portrait, works strongly through its use of a bold, simple shape, and the subject's direct relationship to the camera

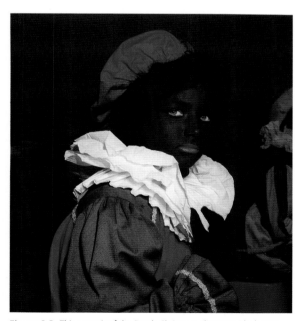

Figure 8.3 This portrait of the Dutch Christmas character Black Pete uses the square frame to help contain the subject in a dignified and painterly manner

metal. It can vary in scale from the rugged contours of a distant mountain range to a brick in close-up. The visual appearance of texture suggests the character of particular materials, and reminds you how they would feel to your touch. Skin and fabric textures can be highlighted if your photograph is very detailed; they can also be simplified and details removed especially with strong lighting. Subjects containing a rich mixture of textures are especially rewarding because of the ability to contrast one surface with another.

Figure 8.5 shows that textures are best revealed by oblique lighting from the side or rear. Unless you are dealing mainly with a single surface, try to work in lighting which is not excessively

Figure 8.4 Mark Bolland's photograph of a Sphinx might suggest ruination and decay, history and mythology

(a)

(b)

Figure 8.5 (a) The natural lighting on this close-up image highlights all the texture in the paint and on the wall surface. (b) Flashlight from the side helps to highlight the texture of the graffiti cut into the tree in this photograph by Natasha Caruana

contrasty, to avoid empty distracting shadows. To suppress texture use either predominantly frontal lighting, or backlight which throws the subject into total silhouette. Again you would be able to create some of these effects digitally after the photograph has been taken (see Chapter 14 where digital manipulation techniques are discussed).

Pattern

Pattern is appealing to the human eye, whether repetitive and formal, or irregular and off-beat (Figure 8.7). So by finding and exploiting a visual pattern in a scene you can create a point of interest. Using digital manipulation, patterns can be created out of almost any image by a simple process of copying and repeating (see Chapter 14).

Pattern can be created by a number of different things: shadows, textures, plant forms, multiples of shapes, or groups of people. Strong patterns, the kind you find in rows of houses or displays of goods, when photographed from the right angle can give you a very formal image where everything appears ordered and repetitive. You can experiment with viewpoint,

Figure 8.6 Shadows can be used to suggest and exaggerate an invisible presence as in this self-portrait by Christian Nolle

Figure 8.7 Pattern is often created by a mixture of actual forms and cast shadows. Light travelling through the window (behind this plant leaf) passes through a net curtain throwing a shadow of its pattern onto the leaf of the indoor plant

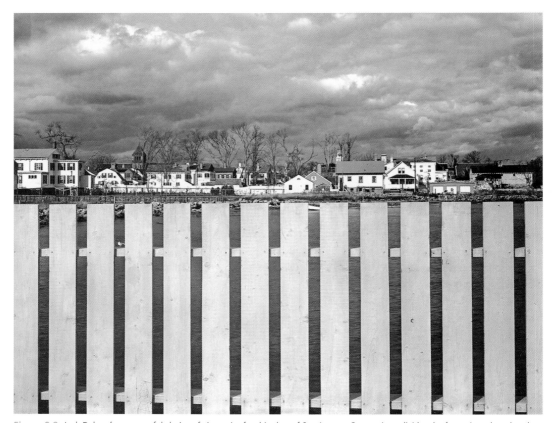

Figure 8.8 Jack Delano's very careful choice of viewpoint for this shot of Stonington, Connecticut, divides the frame into three bands of pattern. Flat-on lighting also contributes greatly in setting the relative values of fence and sky. Instead of receding, the picture seems all on one flat plane

focal length, lighting and use of filters to help exaggerate your pattern. There are no ground rules for lighting. Sometimes three-dimensional subjects, harshly side-lit, create a bold pattern of shadowed and lit areas. Sometimes shadow is cast all over your subject from an unseen patterned element, disguising true shapes. In other instances soft, frontal illumination is best to show detail and suppress confusing texture in what is turned into mainly two-dimensional pattern (Figure 8.8).

Patterns are like musical rhythms which you can use as either dominant or background features of your images. They can help organise, or disorganise (if disrupted), the formal aspect of your photograph. In a sense every photographic image has a pattern to it – colours or tones alone can create patterns (see Figure 8.9) and it is through this patterning that the viewer makes sense of the image.

Form

Form is to do with an object's volume and solidity. It can be shown in two-dimensional photographs through tone gradation (shading), although shape contributes greatly too. A photograph can include a single form, a number of forms or, occasionally, no forms at all

(as in the case of the empty landscape). Forms are everywhere: they include things as diverse as the human figure, the monumental form of a giant boulder, or the minute form of a grain of salt. Forms range from the everyday objects found in a kitchen, curvaceous and sharp, or the flowing curves of a simple vegetable (see Figure 8.10), to the more complex geometric structures of buildings. Some dramatic-looking forms are transient and not really solid at all: storm clouds, waves, or the briefly held form of wind-blown washing are all of this type.

Learn to recognize form in objects irrespective of their actual function. A pile of old oil drums or a simple crumpled ball of paper can be as interesting and inspiring to photograph as a beautiful horse or a superbly designed object. Often this is the challenge – to make something that seems ordinary and familiar to others take on a new intensity of appearance. It is handled through your use of camera angle, perspective, lighting and the qualities of your final print.

Colour and tone values

Thinking about colour and tone values is vital in order to develop an understanding of composition; colour and tone both contribute greatly to emphasis and to mood. Since the mid-1980s colour photography has been fully accepted as an artistic form alongside black

Figure 8.9 Colour from artificial street lighting reflected off trees helps to create a strong, menacing patterning effect with the branches against the night sky. From the series 'The Forest' by Paul Seawright

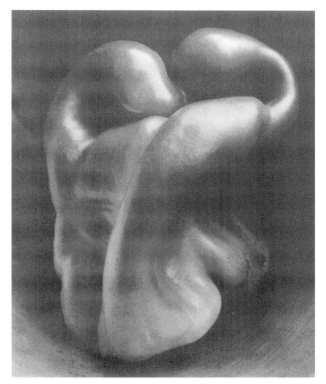

Figure 8.10 Form revealed by sympathetic lighting and richness of tone preserved in exposure, development and printing. Edward Weston took this famous photograph of a pepper softly lit by daylight

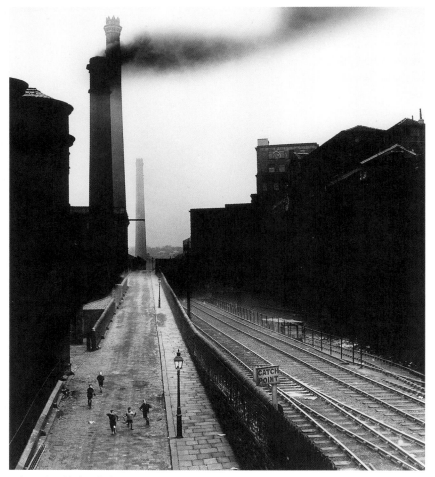

Figure 8.11 Dark, sombre, black and white tones set the low-key mood of Bill Brandt's 1930s view of Halifax. (This documentary shot is often printed as a fine-art image with the top half much darker, and road and railway highlights picked out with chemical reducer, p. 331)

and white photography. In the 1960s and 70s photographers such as the Italian, Luigi Ghirri and the Frenchman Francois Hers, pioneered the use of colour in their very modern looking images of everyday life. Prior to this most colour photography was made for commercial purposes only; the innovative commercial photographs made by the John Hinde studio in the 1950s and 60s have been very influential for contemporary photographers (Figure 8.12). The relationship of object colours themselves, plus any predominant colour in the lighting (due to surroundings or the light source itself) can assist in creating a particular atmosphere (Figure 8.16). Colours close to each other in the spectrum tend to blend, while widely separated colours contrast (Figure 9.24).

Colour scheme is important too. Muted colours give an overall feeling of flatness or softness, whereas high contrast colours are vivid and shocking (see Figures 8.43b and 8.14). Notice how any element with a contrasting colour, or forming a small area of intense colour among muted hues (see Figure 8.15), will appear with great prominence; remember it may lose this emphasis in black and white. Unwanted areas of colour can be subdued by cast shadow or shot against the light, or simply obscured by some close foreground object.

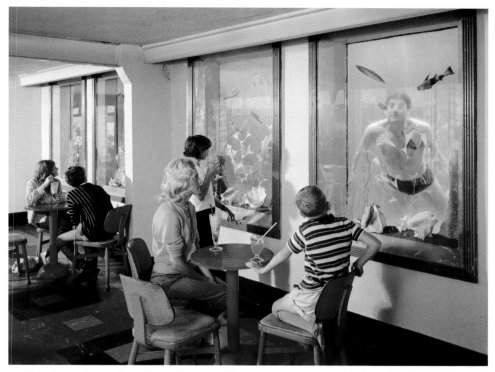

Figure 8.12 Butlin's Ayr Lounge Bar and Indoor Heated Pool (Ground Level) Elmar Ludwig © John Hinde Ltd (circa 1970)

Different types of film all have different colour balance and tone; for example high-speed colour films are grainy and have a soft or subtle colour range, slow-speed colour films give brighter colour with more contrast, while amateur colour films are quite different also from professional colour films and tend to be more vivid. Many colour photographers expose their colour film in their own personalized way in order to achieve the colour result that they want: over-exposure of colour negative film is common, particularly when working indoors or when wanting good shadow detail. Figure 8.43(a,b) (p. 192) shows different exposures used by different photographers to achieve their own particular desired affect. Different makes of film have different characteristics; for example some colour films are warm, some cool and some neutral. You should test different films until you find one that suits you. Most film manufacturers provide descriptions of each of their different films, giving suggested uses (you don't have to follow these, just use them as guides for what the film is like).

The range and distribution of tone values (scale of greys) contained in a scene has its own effect on mood. Large areas of dark are easily associated with strength, drama, mystery and even menace. Scenes that are predominantly light in tone suggest delicacy, space and softness. You can exaggerate tonal values in a picture, especially in black and white photography (because colours are not then distorted too). Use their influences to help set the scene constructively.

If the lighting is contrasty you have the option of showing your main subject in a small lighted area and setting exposure only for this (p. 248) to give the rest of the scene a 'low key' effect. Or, if the subject can be in a small area of shadow and you expose solely for this instead, lit parts become bleached out, helping to give 'high key'. Remember to choose a viewpoint or

Figure 8.13 The shapes in this photograph, by Susan Lipper, from the series 'Grapevine', echo one another – the lampshade, the oval photo mount and the cowboy hat all bounce off one another and encourage the viewer to make connections between the objects in a humouous way

Figure 8.14 Martin Parr's use of vivid colour in this photograph from the series 'Common Sense' is achieved through a combination of low speed amateur colour film and flash lighting

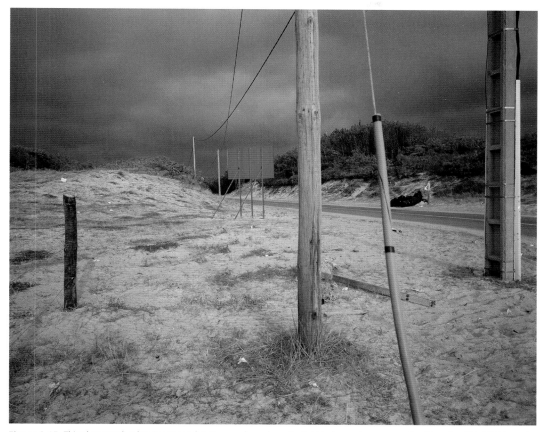

Figure 8.15 This photograph taken in Les Landes, France, shows how the light before a storm can really pick out and highlight certain colours, even when they are a really small element within the whole image

arrange the subject so that the main tone of background and foreground help along the scheme of your shot. Colour filters on black and white film can help too (Figure 9.27), by darkening chosen coloured areas, such as blue sky.

Notice how the distribution of tone values adds to your impression of depth and distance too, especially with landscape (see Figure 8.16). Atmospheric conditions often make objects look paler in both tone and colour with distance. Overlapping hill folds, trees, buildings, etc., at different distances appear like a series of cut-out shapes in different tones – an effect known as aerial perspective.

Movement

Movement is very apparent to the eye (even at the extremes of our field of vision we are highly sensitive to movements, probably for self-preservation). Fast movement makes subjects appear like streaky shapes, especially if they are close. Looking from the side of a moving vehicle, for example, close parts of the landscape whizz past while the horizon moves hardly at all. Movement seen against other movements in differing directions gives a sense of dynamic action, excitement or confusion.

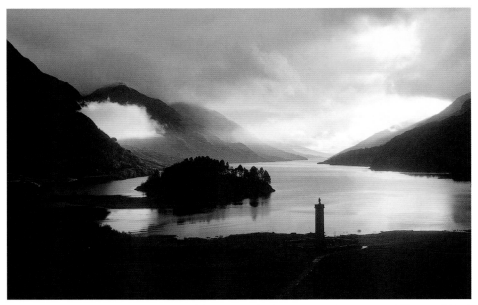

Figure 8.16 Aerial perspective. The visual impression of distance given by changing tone values is a powerful feature of this shot of Loch Shiel, Scotland, by Hunter Kennedy

In still photography, movement is highly *subjective*. Images on the move often record as unfamiliar forms and shapes, not as when you were watching the subject at the time. This is because the exposure onto film was much longer or shorter than the eye's own perception of events. Fast movement can be frozen, like the basketball player in Figure 8.17 or like the movement of a fairground wheel (Figure 8.18) can appear as if speeded-up. Eye and brain read such images of movement against our experience of the relationship of blur to speed. You can similarly deceive the viewer about speed and degree of movement by panning (Figure 8.19) or zooming. Since movement and time are so closely linked, a *sequence* of frozen images like frames from a movie or a comic strip also reads as action. Try making a series of closely related images which show changes only in the position of figures against the same background detail. Presented as a panel of matched prints they read as actions and movement happening over a period of time. Alternatively, a whole bunch of sharp or blurred images can be superimposed within just one frame. The more numerous the overlapped images, the more movement seems to be taking place. Bear in mind too that even though you shoot a picture to show frozen action it can later be digitally manipulated. The computer allows you to multi-superimpose, or add a controlled degree of blur to imply subject movement in any direction you choose (see p. 368).

Using flash lighting with a moving subject can also be interesting (see Figures 8.20 and 8.21); in the UK this is called *flash blur* and in the USA it is referred to as *shutter drag* or *second curtain sync*. *Flash blur/shutter drag* is created when your shutter speed is set fairly low and you are photographing a moving subject with flash. The effect is dependent on how fast your subject is moving and how slow the shutter speed is set. The flash freezes the subject for 125th of a second or less at the moment that it fires.

Note that different effects are created when the flash is fired at the beginning or the end of the exposure. Most cameras fire the flash as soon as the shutter opens, and any blur caused by a moving

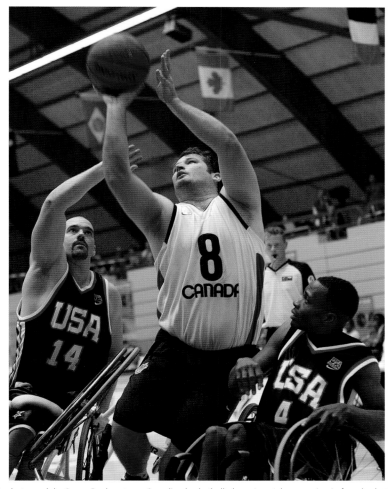

Figure 8.17 This photograph by Roger Bool captures Canadian basketball player Joey Johnson going in for a basket against the USA in the finals of the Wheelchair Basketball Gold Cup World Championships 2006. It was shot using a 70 mm, 2.8 L lens exposed at 1/200th of a second. The film speed was ISO 800

object will appear in front of its sharp flash-lit image. Some cameras allow you to set the flash off just before the exposure ends (so-called second curtain sync), which results in the flash exposure occurring after the blurred image has been formed. The result is a flash-lit image with motion blur behind it – a bit like the 'whizz lines' used by cartoonists to suggest motion (see Figure 10.3).

Content and meaning

Most of the subject features discussed so far have been concerned with narrow physical detail. Shape, texture, colour, etc., all have a combined effect on the appearance of things, to be stressed or suppressed according to their interest and importance. But these are only components of your photography's much wider content and meaning.

Meaning can be simple or highly complex: it is determined by content and how this content has been photographed. Meaning changes with time: straightforward portraits may appear

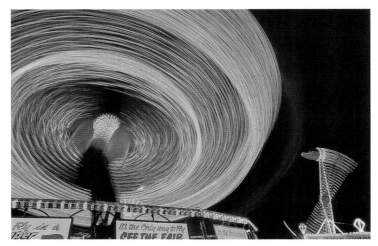

Figure 8.18 Moving fairground rides take on new dynamic forms when spread and blurred by an exposure several seconds long. Having the camera firmly supported records stationary objects sharp, to contrast the exaggerated movement and give a spectator's-eye view

relatively ordinary when they are taken but looked at twenty years later they can become a fascinating document on the style of the time and therefore valuable documents (see Figure 8.22). Meaning can be created in numerous ways: a simple juxtaposition of objects, in a single image, will create a narrative; equally, a meaningful story can be created through editing together a series of photographs. The classic documentary picture story is composed of a series of images that build upon one another, letting the story unfold; some of the photographs in a picture story will be powerful single images and some will be useful linking images.

Objects can have many meanings from obvious literal meanings through to more complex ones that may have been invested in them through historical stories, see Figure 8.4 for example. They can also have meanings that are personal to you. If you want your audience to understand the meaning of your picture you must make sure that you are photographing your subject in a way that conveys this meaning. Gestures and expressions can also give meaning to a picture: capturing

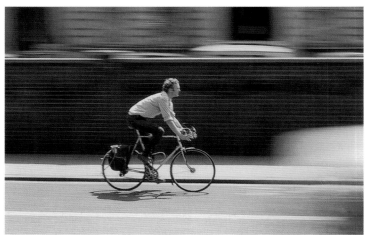

Figure 8.19 Panning a moving subject. The cyclist, right, had 1/15 s exposure while the camera was smoothly panned sideways as shown above. Start the pan early to achieve a swing of the right speed when the shutter is released (S) and then follow through. Notice how in the foreground and background vertical details disappear and horizontal highlights spread into lines. The picture gives an impression of moving with the cyclist. In bright light, shoot with slow film and stop down fully; you may also need a neutral density filter to avoid over-exposure at this slow shutter setting

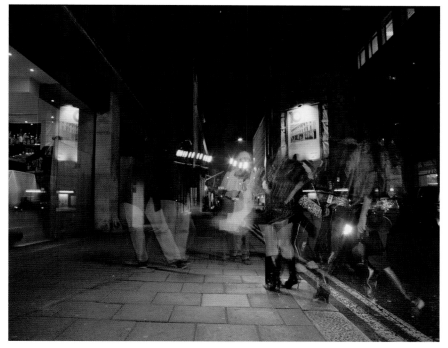

Figure 8.20 Pierre Stoffel made this photograph on a long exposure using a portable lighting kit. The photograph shows paparazzi photographers at work and their flashlights also help to light the image

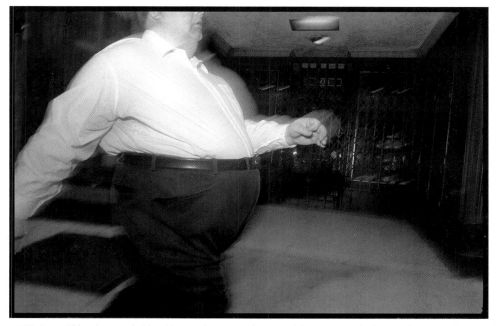

Figure 8.21 Bruce Gilden photographs his subjects as they move either towards him or across the frame in the streets of New York. The effect of flash blur reinforces the movement

Figure 8.22 Daniel Meadows' portraits were taken in 1974 (left) when he travelled around Britain in a double-decker bus. The portraits came to prominence when they were published in *National Portraits* in 1997. Later, in 1995 (right), he was commissioned by a national newspaper, to trace his '70s subjects and re-photograph them

a strong expression in a conversation reveals something about the relationship between people (see Figure 8.25). Often meaning can be communicated quite simply through a straightforward choice of viewpoint, like Figure 8.1 (Elliot Erwitt) and Figure 8.23 by O Zhang, who uses a low angled viewpoint to create an unusually powerful portrait of a child. Sometimes (and this is usually more challenging, for the photographer, and interesting for the final viewer) it operates through subtle use of symbols. For example the Sphinx in Figure 8.4 might suggest ruination and decay, history and mythology. Use of 'old against new' can say something about ageing, irrespective of your actual subject.

Choices of content are opportunities to express *concepts and emotions* and/or to impart information about something. Meaning is also invested in a photograph through its title or caption, or the story that accompanies it. Look at the difference between the captions used with photographs in magazines and the titles accompanying photographs on a gallery wall. Some artists have become known for using text in their images; this is generally referred to as 'image-text-based' work, you can find examples of this in the work of Canadian artist Ken Lum and the American artist Barbara Kruger.

Visual communication, whether based on symbol, metaphor, or simply 'gut reaction', is central to photography. Develop your ability firstly to notice and then select basic subject qualities that best help you to make statements – rather like choice of words.

Try creating meaning in single images (see Figure 14.1 by Jeff Wall) and then in a series of images (as in a classic photo-journalistic story). Pick something you feel strongly about, perhaps an environmental or social issue. Then build up a volume of work, with pictures that strengthen each other. The total can be a visual statement with powerful meaning. Look out for examples of the work of individualistic photographers such as Sally Mann, Martin Parr, Cindy Sherman or Phillip Jones Griffiths, who have each pursued (very different) obsessions through the content and meaning of their pictures.

Figure 8.23 O Zhang uses a low point of view to create power in her portrait of a child in *Horizon 22*

Structuring pictures through the camera

You can only go so far in looking at the subject direct. Picture composition must be done looking through the camera, because this brings in all kinds of other influences. Some are helpful, others less so. With digital cameras and Polaroid backs you can see what your chosen composition looks like before you click the shutter. This is very useful when dealing with commercial clients and art directors or if you are particularly unsure of what you want in the frame. Many photographers who use medium or large format will use a Polaroid back and test the composition and exposure with instant film first. Increasingly, digital cameras are taking over from the Polaroid backs.

The most obvious change is that you now have to work within a frame with distinct edges, corners and width-to-height ratio. The viewfinder or focusing screen is like a sheet of paper – you don't have to be able to draw on to it, but you must be able to see and structure pictures within its frame and give due thought to balance and proportions of tone or colour, the use of lines, best placing of your main feature, and so on. Some viewfinder systems make composition much easier than others. A poorly designed direct-vision finder, or the upside-down picture on

Figure 8.24 Use your hands, or a colour slide mount, to estimate how a scene will look – isolated and composed within a picture format. Position your eye the same distance from the slide mount as your camera lens's focal length to see how much is included. Alter this distance to preview other focal lengths

a view camera screen, takes more time and practice to 'compose through' than the view-finding optics of a modern SLR camera. A digital camera with viewing screen provides the clearest way of viewing your picture before it is shot; it also gives you the opportunity to shoot more photographs and so giving a greater chance of getting the picture you want, particularly in fast-moving situations. The digital camera viewing screen can also be used to show potential clients: it gives such a clear view of the image, but beware – it is usually one or two stops out in terms of exposure, so the final quality may be slightly different.

Using your camera as well as your eye means too that you add in all the techniques of photography, such as shallow or deep depth of field, blur, choice of focal length – usually to strengthen rather than detract from the points you want to make.

Proportions

Most cameras take rectangular pictures, so your first decision must be whether to shoot a vertical or a horizontal composition. Sometimes this choice is dictated by the proportions of the subject

Figure 8.25 The expressions on the faces of these women suggest how they are feeling while chatting with each other

Figure 8.26 Tajresh, Iran at night, a picture by Afshin Dehkordi 2007, is structured through its viewpoint and side lighting to give a strong horizontal flow linked to the blurred city lights in the background through colour

itself, or by how the result will be used (horizontal format for TV or computer screen, vertical to suit a show-card layout or magazine cover). Often, however, you have a choice.

Of the two formats, horizontal pictures tend to be easier to scan, possibly because of the relationship of our two eyes, or the familiarity of movie and monitor screen shapes. Horizontal framing seems to intensify horizontal movements and structural lines (Figure 8.26), especially when the format is long and narrow. In landscapes like that in Figure 8.16 it helps increase the importance of skyline, and in general gives a sense of panorama, and of stability.

Vertical pictures give more vertical 'pull' to their contents. There is less ground-hugging stability, and this can give a main subject a more imposing, dominant effect. Vertical lines are emphasized, probably because you tend to make comparisons between elements in the top and bottom of the frame rather than left and right, and so scan the picture vertically.

Square pictures are entirely different and conventionally the square is used as a portrait format. Each corner of the square format tends to pull away from the centre equally, giving a balanced, symmetrical effect. Many photographers will avoid the square format but when used successfully it is very effective. Movement is particularly difficult within the square but Figure 8.28 by Anthony Haughey shows how the square format can be used to create a dynamic effect and a sense of movement within the frame. Portraits such as that in Figure 8.3 really gain strength from the way that the format holds the head and shoulders tightly in the frame.

Figure 8.27 Frames within frames. Reflected in this mirror the family is grouped within one shape, placed beside the food on the sideboard like a picture in a frame. Mirrors, windows and doorways are all useful devices to relate one element to another

You are of course not always restricted to a particular picture shape by the height-to-width proportions of your subject. A predominantly vertical subject can be composed within a horizontal format, sometimes by means of a 'frame within the frame' – showing it within a vertical area naturally formed by space between trees or buildings, or through a vertical doorway, window or mirror. It is also possible to crop any picture to different proportions during enlarging, producing either a slimmer or a squarer shape. Digital images can be cropped both in camera using the crop function/mode (not all digital cameras, mostly lower end of the market models, do this) or in post-production.

For many years some leading photographers felt strongly against any such 'manipulation', even to the extent of printing a thin strip of the film rebate all round the frame to prove it remains exactly as composed in the camera. Today with the mass development of digital imaging and manipulation these ideas have largely been left behind and it is believed by many

Figure 8.28 Anthony Haughey really uses the whole space of the square frame for his vivid portrayal of Irish family life, and despite the hectic action he always contains everything within the frame

that keeping every picture to camera format proportions is monotonous and unnecessary. Professionally you may often have to produce results to proportions strictly imposed by a layout.

Balance

Your combination of subject and the camera's viewpoint and framing often divide up the picture area into distinctly different areas of tone, colour and detail. Frequently these are the shapes and proportions of objects themselves, but sometimes they are formed by the way edges of the frame 'cut into' things: a cropped building or person. Think of these 'parts' as areas or bands of tone, pattern, colour, etc., which to some extent you can alter to different proportions, move around, and make to fill large or small portions of your picture, all by change of viewpoint or angle; this in turn affects meaning too.

The main division in a scene might be the horizon line, or some foreground vertical wall or post which crosses the picture, or even the junction of wall and floor in an interior. With a distant landscape, for example, tilting the camera will shift the horizon, and might alter your picture content from the ratio one part sky:three parts land, to the reverse (see Figure 8.29). When most of your picture is filled with dark land detail there is an enclosed feeling, and the added foreground makes scale differences and therefore depth more apparent. With most of the picture area devoted to sky, the impression is more open and detached.

A central horizon, dividing the picture into two halves, splits the picture into areas of equal weight with neither predominating. Much depends on the range of shapes, colours and tones in each half. Complete symmetry is unusual in analogue photography and when used

Figure 8.29 This photograph of an aeroplane taking off from Heathrow airport is dependent on a low viewpoint to create the imposing relationship between the plane and the settee

Figure 8.30 Repeating an image using digital manipulation tools can create an interesting patterning effect

it creates a strong overall pattern, often surrounding and leading to a centralized main subject. Photographers who use digital manipulation are freer to create repetitive pattern through building up repetitions of symmetrical shapes. Figure 8.30 is an example of repetitive pattern created through digital manipulation: cutting, copying then pasting (the original image was a miniature section of a flower).

The best placing of divisions depends on the weight of tone, strength of colour, and pattern of detail they produce in different parts of the picture. One approach is to go for a *balanced* effect where weight of tone allows the centre of the picture to 'pivot' like a set of scales, but without being monotonous and over-symmetrical. On the other hand, a picture intentionally structured to appear imbalanced can add tension and will stand out amongst others. A slight movement of camera angle can create an extraordinary sense of chaos; in Paul Reas' photograph from the series *I Can Help* it seems like the world is slipping away from us (Figure 8.31).

Line

The use of strong lines in any photograph can help draw attention to certain subjects or features and this could improve the composition. They also have an effect on the atmosphere of a picture.

Lines need not be complete outlines but a whole chain of spaced or overlapping shapes – clouds, hedges, a blurred movement, a background shadow – which your camera's single viewpoint sees as attached or linked together. In fact lines occur wherever a clear boundary

occurs between tones or colours, with strongest lines where contrast is greatest. Subject lighting is therefore influential. Lines can help to hold things together or push them apart; they can affect the sense of movement or stillness in a landscape; connect a group of disparate still life objects; or relate/separate things in different parts of the frame (see Figure 8.32).

The general pattern of lines in a picture has an interesting influence. Well-spaced parallel lines and L shapes have the most tranquil, stable effect. Triangles, broad ovals or S shapes seem to offer more 'flow', encouraging you to view the picture more actively. Pictures with long, angled converging lines (formed by steep perspectives, for example) rapidly attract your eye to their point of convergence. A mass of short lines angled in all directions helps to suggest excitement, confusion and even chaos (Figure 8.33).

Why we experience these reactions probably has a scientific explanation. Use them constructively. If you want a dramatic, powerful image, shoot it from a high or low angle, with steep perspective and bold contrasts. If your intention is to create a soft, gentle picture the same approach would be destructive; instead, flowing open shapes and graduated tones will be more effective.

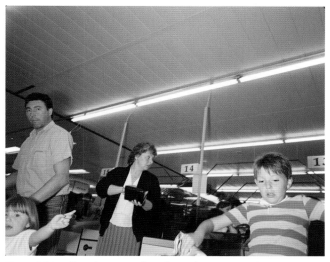

Figure 8.31 In his series *I Can Help* Paul Reas shoots at an angle to create a chaotic scene where shoppers appear to be slipping off the edge of the world

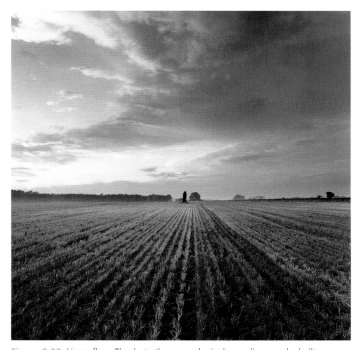

Figure 8.32 Linear flow. Thanks to the camera's single eye, lines can be built up within a composition from a whole chain of different objects at various distances. Fay Godwin shows this marker stone on the old Harlech road from a viewpoint, which links it into criss-cross stone walling spanning the Welsh hills

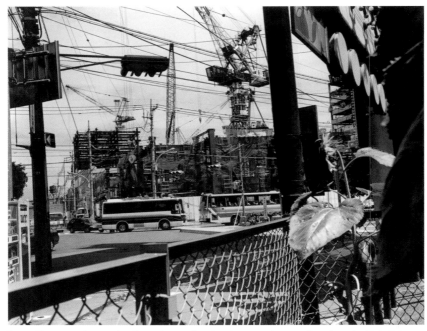

Figure 8.33 Osamu Kanemura observes the chaos of power lines in a Japanese city street from the series *Today's Japan*

Figure 8.34 Top: The so-called Rule of Thirds. Dividing each side of the frame by three and drawing intersecting lines forms four alternative locations for strongly placing the main subject. Bottom: The classic golden mean of ideal proportioning (for the format itself or composition of subject areas within). Starting with a square, a line drawn from the centre of one side to an opposite corner becomes the radius of an arc. This defines the base line of the final 5:8 ratio rectangle

Emphasis

Try to ensure that everything included in the frame in some way supplements and supports (rather than dilutes or confuses) your main theme. The trouble is that photography tends to record too much, so you must be able to stress your chosen main element (or elements) relative to the rest of the picture. There are several well-proven ways of doing this. One is to choose a viewpoint that makes lines within the picture 'lead in' to the main subject. You can also make your centre of interest prominent by showing it breaking the horizon or some other strong linear pattern.

Another method of emphasis is to show your main element against a background, or framed by foreground, which strongly contrasts in tone or colour. Choice of lighting is again important, and camera techniques help to untangle subjects from surroundings too. Use shallow depth of field if things are at different distances; if one is moving relative to the other try panning.

There is a guide to the strongest positioning of your main subject within the frame, known as the Rule of Thirds (see Figures 8.34 and 8.35). This places an imaginary grid over the picture area, creating four

off-centre intersections that tend to be strong locations. (A similar guide, much used in classical architecture and painting and called the Golden Mean, uses ratios of 5:8 instead of 1:2.) Other references which relate to emphasis include Roland Barthes' theory of the *punctum* in photographs (see *Camera Lucida* by Roland Barthes) and Cartier Bresson's ability to frame 'decisive moments' drawing the viewer's eye straight into a particular point of a picture.

Always remember such a guide but, like working only with a normal angle lens, don't let it restrict and cramp your style. Sometimes the formality, or the tension, of your image will be better served if the main element is placed centrally, or against one edge. A shot

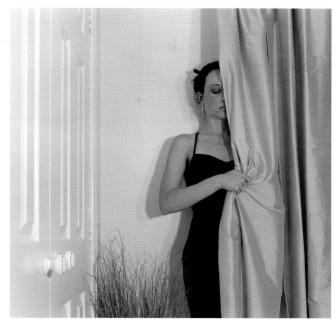

Figure 8.35 Natasha Caruana uses the Rule of Thirds to divide the structure of her images in her highly constructed photographs from the series *The Other Woman*

can also be given *two* points of emphasis, and you can attract attention by placing them at opposite extremes of the frame so that the viewer scans from one to the other, making comparisons, conscious of distance and space. Of course with digital manipulation objects within the photograph and whole areas can be cut out and moved or removed entirely: you will need to learn very precise blending skills in order to make these kinds of transition seamless.

Framing movement

You can alter your impression of active subjects by picture composition and choice of moment. Think of the frame as a stage. If the action is moving across the frame and you show the main subject at one side, facing inwards, the activity seems just to have started. But if the activity faces outwards with all the space behind it, the same subject seems to have completed the action.

You can make movement appear more dynamic and aggressive by composing it diagonally across the frame, angling vertical and horizontal subject lines, and if possible converging them too. Remember that even when no strong lines are present, a slow exposure (p. 105), plus zooming and panning if necessary, will draw out highlights into powerful blur lines. Digital manipulation allows you similar effects after shooting.

The moment chosen to photograph moving objects and rapidly changing situations can make or break a picture. Fast reaction may allow you to select and capture one brief decisive moment, summing up a whole event or situation. This could be a momentary expression, a key action (like breaking the winning tape in a race) or just two elements briefly included

in the same frame and signifying something by their juxtaposition. Shooting at four pictures per second would seemingly cover every eventuality. But the vital moment can still fall between frames. There is no substitute for split-second manual timing. Cropping as in Figure 8.36 can also help to highlight significant action or events. Most documentary photographers covering subjects that are moving very quickly, or events where a lot is happening, do tend to shoot a lot of film in order that they can get the moment that they need (see Figure 8.37); with digital you can see at a glance when it has been achieved, although there is something lost when selections are made this quickly. Frequently a photographer has considered an image worthless when shot, and then re-discovered it as a successful photograph years later. So don't erase your digital files too quickly.

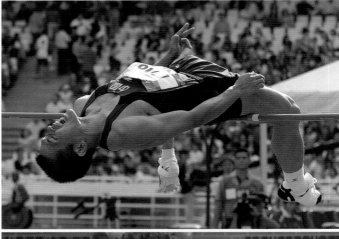

Figure 8.36 Both these photographs are made from the same negative by Roger Bool. Cropping highlights and exaggerates the action

Where photographs go

I f you are producing pictures purely for yourself there may be no one else's requirements to take into consideration. But if you are a professional photographer given a commercial assignment, producing an exhibition, portfolio or publication, it is vital to adapt your approach to the needs of the commission or job.

Photography is a very versatile medium and photographs are everywhere – we see them on billboards, on magazine and newspaper pages, in family albums, in medical and architectural journals, on mantelpieces, in museums and galleries and even in courtrooms. Where would we be without them? A photograph can be a record of an event, an exhibited artwork, a promotional shot or a passport identity portrait. One of the most astounding things about photographs is that they can be reproduced over and over again. In some contexts, such as

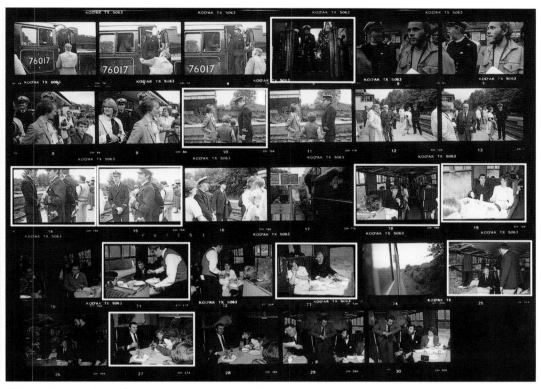

Figure 8.37 A contact sheet from a documentary shoot: many different images are shot but only one is used – the thick pen marker surrounding the image highlights the selected frame

the art marketplace, this reproducibility has had to be curtailed in order to give value to the photographs on sale. Photographers selling their work in large commercial art galleries limit the edition of their prints to give them a greater value.

Commercial photography

The world of commercial photography is massive and you really need to decide which areas that you want to work in before putting together a portfolio to take to show people.

When doing a commercial job you may be given a precise brief/assignment that could be considered as problem solving. The problem may be mostly technical – how to get a detailed informative picture under difficult conditions. Or it might be much more subjective, perhaps concerned with creating atmosphere, mood or particular style. On other occasions you may be freer to produce a body of work without a tight brief/assignment, and sometimes this can be more difficult as you really have to work this out for yourself. When you are given a brief/ assignment start off with a clear, accurate idea of all aspects of the problem via a consultation with the client, designer or editor. What is the subject, the purpose of the picture and its intended audience? You also need to know practical details such as final proportions and size, how the picture will be physically shown or reproduced, and what will appear around it. Commercial work covers a wide range of different types of photography from constructed imagery through to documentary both used in all commercial arenas from the music business

(a) (b)

Figure 8.38 (a) *Roxane in red skirt* was shot for *i-D* magazine in 2004 by Jason Evans. The styling is by Simon Foxton. The clothes were chosen for their emblematic quality and the photographer and stylist were interested in seemingly arbitrary fashion poses, and inventing their own. (b) *Pre-match drinks*. An editorial photograph by Martin Salter taken to illustrate a magazine story titled 'Behind the bar' – an article about bar staff

through to advertising. A large percentage of commercial photography briefs are commissioned by design groups and advertising agencies and many photographers seeking commercial work will join an agency to promote their work and help build their reputation (Figure 8.38).

Scaling down or up

If your picture is to fill a space with fixed height-to-width proportions it will be a great help to mark up the camera focusing screen accordingly, and compose within this shape. As Figure 8.39 shows, by drawing a frame with the necessary proportions on paper and adding a diagonal you can scale it down to fit within any camera format. This is where it helps to have a camera allowing easy access to the focusing screen (such as view cameras, medium format SLRs or 35 mm models with removable pentaprism).

Use a thin black grease pencil to trace the new outline accurately on to the viewing side of your screen. In the same way you can mark out the precise areas where type matter or other images must finally appear within the completed illustration. Digital camera viewing screens are not usually easy to draw on and they are usually easier to view proportions on anyway.

Pre-planned proportions are not practical with some types of documentary, or candid or press photography. Here they tend to follow on from picture contents rather than lead them. However, an art editor will usually be grateful if you cover the same subject in both vertical *and* horizontal formats. Ideally too, avoid tight framing, and leave sufficient content around the edges to allow cropping to slightly different proportions according to layout. (Of course you are then in the hands of the editor, who may have a very different idea about composition than you – some photographers purposely make pictures that cannot be cropped as they want complete control over how their image is used!)

Size

The smaller your final picture the simpler its image should be if you want it to be easily read and understood. If it is to be reproduced little larger than a postage stamp (or on coarse paper) aim for a bold, uncluttered composition, perhaps with a plain and contrasting background. The larger the reproduction and the better the paper, the more detail and tone graduation will be preserved. If you know

Figure 8.39 Scaling. Transferring picture proportions from a (larger) drawn layout to your camera focusing screen. (1 and 2) The page designer's specified picture shape is traced and a diagonal added. (3) Aligning this tracing with the bottom left corner of the camera's focusing screen, the diagonal now shows you the position for the top right corner of the format. (4) A wax pencil line drawn at this point gives you the scaled-down format needed

that your final result will be displayed as a large photographic enlargement, for example, it is probably worth changing to a larger-format camera, or at least finer-grain film – that is, if you want a fine-grain, fine-focus effect (sometimes a large-scale grainy image can look fantastic and it is possible to blow up 35 mm negatives to very large-scale prints). If you choose to use a small format camera and make big enlargements the result will be very rough, with coarse grain, and if you want the exposure and tonal values to remain good you may well need to over-expose your film when shooting (negative film on analogue cameras only). With digital photography the file size affects the size you can blow an image up to and you need to know right at the start of the shoot what the final possibilities will be. Take special care over limitations of size if you work with a *digital* image – whether it is shot by digital camera or scanned from film (see pp. 120 and 121). With analogue photography you are freer to leave the printing scale choice till later on.

Managing the job

Having established the needs of the job – the creative possibilities as well as specified layout, content and approach – you can get down to planning. If you are working in the studio, what are the most appropriate accessories to include? Will some form of set need building or hiring? If it is a location job the right place has to be found, and hired if necessary. Models can be shortlisted through an agency, interviewed and chosen; some photographers use their own selected models, often people they just meet on the street (Figure 8.40) and occasionally their friends. Assistants may well be required to work the lighting, find the locations or look after the models. A stylist will also be required, particularly for fashion or food shoots: stylists are rarely acknowledged but they have played a major role in the history of commercial and fashion photography.

Lighting has to be planned. If you have to rely on natural light, consult weather forecasts for your location. Existing artificial light needs checking for its technical suitability. Tungsten

Figure 8.40 *Mounir 2005*. Fashion photographers do not always look for models in model agencies – they often use friends or simply people they spot in the street. The photographer Jason Evans met Mounir in the street in Casablanca in 2005 and then made this photograph for *Hanatsubaki* magazine. The stylist was Simon Foxton

or flash-lighting units, and special equipment such as a wind machine, smoke machine or portable generator, may have to be hired. If you are shooting on film choose the most appropriate stock – colour or black and white, negative or transparency (transparency is rarely used today).

On the day of your shoot, with all necessary items brought together, you can start to build and work with your set and subjects to create the images you will finally use. There are numerous aspects that you will need to consider playing with and altering as you work: viewpoint, lighting, framing, the relationship between subjects, how to highlight one thing in the frame, and how all these technical aspects can affect the actual meaning of the image.

Working digitally on a commercial shoot is highly advantageous as the images can be checked and revised constantly. Photographers working with film will use a digital back or separate camera to check the results before shooting on film. Later one roll or sheet of film typical of the shot will be test-processed, and then the remainder put through, giving any modifications suggested by those first results.

Working as a commercial photographer is demanding and you need to be continuously investing in both updating your portfolio as well as taking it round to show art directors, designers and picture editors on a regular basis. You may need/want to use assistants and you will find it useful to be connected with professional organisations like the Association of Photographers (AOP) in London who give support and advice to photographers. There are a wealth of design groups and advertising agencies in particular who are always on the lookout for new talent. There are also numerous photo libraries who will hold your photographs on file and promote them to a range of commercial users at a designated price. The library would ask for a particular number of photographs, and themes vary according to the library; they will also take a percentage of the sale. With a photo library it is essential that you check the contract and make sure that you are happy with all the conditions within it. Agencies such as Magnum and Vu are world famous and difficult to join while other agencies such as Photoink (India), Drik (Bangladesh) and Autograph (UK) often operate in specific areas and with particular types of photography.

Publishing, books, magazines and the internet

Photography has always had a huge presence in books and magazines and more recently on pages of internet magazines and websites. There are numerous monographs about both contemporary and historical photographers. The first photographic monographs are considered to be the albums produced by Anna Atkins in 1843 followed by *The Pencil of Nature* (Fox Talbot) in 1844. Today the monograph is one of the most successful ways of getting photographs out into the world, and the marketplace for photographic books has expanded the world over. Specialist bookshops, predominantly in the USA and Europe but also in Japan, sell only photographic books and magazines, and a wide range of specialist photography publishers such as Aperture (NY), Oregon (OR), Photoworks (UK), Chris Boot Publishing (UK), Actes Sud (Fr.), Lunwerg Editores (Sp.) and Apeiron Photos (Gr.) regularly publish new titles. As well as this, some of the bigger publishing houses such as Phaidon, Thames & Hudson, Manchester University Press, Steidl and, more recently, Yoda Press do publish a number of photography monographs and history books. The printed page lends itself very successfully to the showing of photographs; unlike reproductions of paintings, reproductions of photographs can be extraordinarily faithful to the original print and there is a big market for collecting photography books. Photography magazines are published all over the world and some titles such as *Aperture* and *Portfolio* magazine have long histories dating back to the 1950s (*Aperture* 1st edition, April 1952). *Creative Camera* (UK 1964 to 1999) was hugely influential in the development of contemporary European photography and regularly published the work of young or emerging photographers. New magazines such as *Foto8* and *Camerawork Delhi* are beginning to reach larger audiences and photographs are published in the widest range of non-specialist magazines such as in weekend supplements, fashion magazines, and travel magazines; in fact most magazines use photographs to help tell their stories. The internet is also quickly becoming an easier and, at times, very interesting place to publish work. Looking at work on the screen is very different from turning the pages of a book or magazine and a number of publishers are creating on-line magazines and projects such as Foto 8 (www.foto8.co.uk) and www.5b4.blogspot.com.

The art marketplace

The marketplace for photography in the art world is a relatively recent phenomenon in Britain whereas in the USA, photography has been accepted as saleable art for many more years. New markets for the sale of photographs as art are opening up in India and China and are expected to expand in other parts of the world soon. Getting your work into this arena is not easy and there are different ways of approaching galleries:

- Send them a curriculum vitae together with a digitally printed set of images with introductory text – this could be bound simply with spiral binding or, better still, in a smarter folder.
- Make sure you send them updates on all new developments in your work – invitations to exhibitions, etc. Draw their attention to your website.
- A personal approach is feasible with some of the smaller galleries but the larger, better known galleries generally prefer to spot their own talent.
- A visit to Photo London or Paris Photo where all the galleries show and sell their work (both happen once a year) will allow you to take in the range of galleries and the type of artists and photographers that they represent. It is also a good idea to get your work seen at portfolio viewings. Several organisations do this and probably the best known are Rhubarb Rhubarb in Britain (www.rhubarb-rhubarb.net), Houston Fotofest in Texas (www.fotofest.org) and Rencontres de la Photographie in France (www.rencontres-arles.com); all of these have annual or bi-annual events where you can take your portfolio to show to a range of experts, get advice and get noticed. Figure 8.41 shows curators looking at portfolios at the Rencontres de la Photographie in Arles.

Figure 8.41 This photograph shows curators looking at portfolios at La Rencontres de la Photographie in Arles, France 2008

If you are successful in organising an exhibition of your work there are many things that you need to consider including size of images, how they will be presented and hung, publicity for the exhibition and organizing the opening night (preview or private view).

Size is particularly important when working towards an exhibition, as this is the one time and place where you really do have space to work with. You should really take time to examine the space and think about the colour of the walls (white cubes are not always the best!), leaving space around the images, and the importance of titles and information about the work, and how this should also look good on the wall. There are exhibiting trends and you should not necessarily follow these; most importantly, you should consider what is the best for your photographs in relation to the space you are exhibiting in (see Chapter 15, Finishing and presenting work).

Photography for museums, independent galleries and organisations

This is a distinct category of photographic work that, although it is paid, is not considered highly commercial in the sense that the financial rewards are not high and the work does not generally go out to a mass audience in the way that images made in advertising might. Museums, galleries and photography organisations (amongst others) can commission photographers to make new bodies of work, usually in response to a set theme. A commission is likely to be advertised, possibly in a photography magazine or in *Artists Newsletter* (UK) or on various websites, and to apply for a commission you would usually be asked to write a proposal based on information they have given you. Photographers are given details of the demands of the commission: the time limit set for creating the work and what form the work should ideally take at the end of the work. This type of project usually allows the photographer a considerable amount of time to develop their work and the commission may result in an exhibition or even a publication (see Figure 1.25). There are also a number of organisations, worldwide, that provide grants for artists and photographers. Applications are made by either the photographer or a gallery/museum wanting to exhibit their work; guidelines are clear and advice can usually be sought from the awarding body. In England the Arts Council England has supported a number of photographers to create new bodies of work or prepare the work for exhibition. In the UK, France and Germany, the British Council, L'Institut Français and their Goethe Institute respectively, have also been active in providing grants to promote their own photographers abroad.

Archives

An archive is a collection of photographs, usually based around a theme or a place or taken by a particular person or group of people. The collection is stored in a particular place and often looked after by a curator – that is, if it is a recognized and collected archive. An archive can be well-known and housed at a significant museum or company or it may be little known, in a small town museum for example or even unknown in somebody's attic. The Victoria and Albert Museum in London has a huge archive of photographs by well known photographers that can be viewed in the Print Room at the museum under archival conditions. An archive often includes photographs taken over a long period of time and will be of historic interest and importance. Large companies and most museums have archives of one sort or another and sometimes it is surprising to discover where things are. The Benjamin Stone Archive is stored at the Birmingham City Library and is a fascinating series of images documenting, amongst other things, rural customs from the late nineteenth century through to the early twentieth century (see Figure 8.42). All the major newspapers have their own archives (usually digital), and at the University of the Arts, London (UAL) there is a fascinating new initiative called Photography and the Archive Research Centre (PARC) that works with photography in a variety of archive

Figure 8.42 This image of Sherborne Pageant was made by the prolific photographer Benjamin Stone in the early 1900s. It commemorates an attack of the Danes in AD 845. Benjamin Stone documented many English customs and his work is archived in Birmingham City Library

contexts. A number of universities worldwide have active research centres that have collections and may commission new work from time to time.

Family albums and other domestic settings

Most of us take family snapshots and then place them on mantelpieces, in boxes and/or in family albums. Learning to take better photographs will improve the look of your family archive. Many artists and photographers have questioned the value of family albums and in particular explored

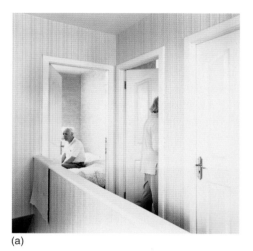 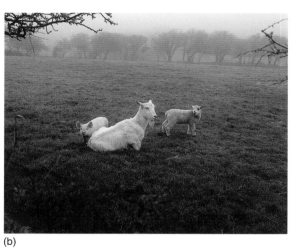

(a) (b)

Figure 8.43 (a) Trish Morrissey over-exposes her colour film by up to four stops and then processes as normal to achieve fine detail in these low-lit interiors. Her work concentrates on the re-presenting of the family; by staging her parents within their own home, fictional (yet very ordinary) narratives are constructed. (b) In this colour photograph from the series 'A Raft of Carrots', Jem Southam uses 1/2 to 1 stop under-exposure to decrease the colour contrast and achieve a level of tonal flatness. He always prints this work as C-type colour prints, preferring the subtle detail to the harsher contrast of digital printing

Figure 8.44 These photographs by Jo Spence come from a series of self-portraits in which Jo acted out roles that she remembered her mother playing in 'real-life' (she re-played these roles with her own response to them embedded in the performance)

new ways of picturing the family. In the early 1980s Jo Spence wrote a book titled *Beyond the Family Album* that included many of her ground-breaking images, all re-working memorable family moments. Figure 8.44 shows a photograph by Jo Spence from her series investigating family roles. This body of work was composed of a set of self-portraits in which Jo acted out roles that she remembered her mother

playing in 'real-life'. Jo was re-playing these roles with her own response to them embedded in the performance. More recently, Trish Morrissey became fascinated by documenting (all the images were re-staged documents) the lives of her mother and father in their home in Ireland and the very particular way in which they live (see Figure 8.43a). A family photograph represents a group of people at a certain time and in a certain place, and you can make these photographs at any time, not just at the predictable moments (on holiday or at family events). Family photographs are valuable documents/fictions and are usually archived in albums or boxes; wedding photographs too are usually placed in an album. (Figure 8.45 shows a contemporary wedding photograph done in a documentary style).

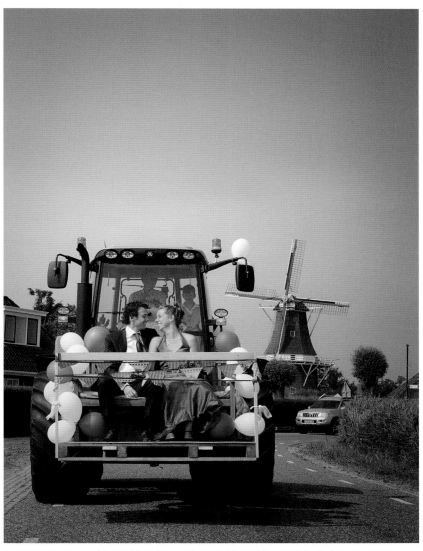

Figure 8.45 A contemporary approach to wedding photography: *A Dutch Wedding*, 2009, by Andy Fox

■ Picture building starts with recognising the basic visual qualities of your subject and needs of your picture, then emphasizing or suppressing, and composing the resulting image in the strongest possible way.

■ Look out for subject qualities such as *shape* (identification, framework), *texture* (feel and character of surface), *pattern* (harmony, rhythm), *form* (volume and solidity), *colour* and *tone* (mood, emphasis), and *movement* (time-based action).

■ Subject appearance must carry through the meaning and purpose of your picture. This brings in factors such as expressions and relationships, and the way we *read things into* objects and situations.

■ Using a camera means working within a frame. Consider picture shape and proportions, balance of tone and colour, the use of lines to give structure and emphasis, and the positioning of your main subject.

■ Seize every opportunity for a strong structural composition, even though you have to think and shoot fast. After a while composition becomes almost a reflex – but don't lapse into stereotyped pictures.

■ Most professional photography is visual problem solving. You need to: (1) understand the purpose of the picture, (2) evaluate subject qualities in the light of this purpose, (3) compose the subject into a meaningful image within the frame, (4) choose the right technical controls to carry through the idea, and (5) organise all aspects of the shooting session in a professional manner.

■ Photography is a medium with multiple applications.

■ The art marketplace is a place for artists and photographers to sell fine-art prints and exhibit their work.

■ Commercial photography is a massive world that includes advertising, fashion and editorial photography. Photographs made for the commercial sector may appear in company brochures, on billboards, on the internet, in photo libraries or on magazine pages.

■ Photographs are published in numerous books and magazines all over the world. Photography has illustrated editorial stories since the late 1800s and photographic monographs are popular collectable books. Publishing a book of photographs is an excellent way of promoting work to a wide audience.

■ A commission for a museum or gallery may enable you to develop a new body of work and can often be worked on for periods of time between 3 and 12 months.

■ An archive is a collection of photographs that might have been saved for many different reasons and uses. Archives can be found in all sorts of places from museums to attics.

■ Family photographs are most often taken at celebratory events such as parties and holidays and are then kept in albums or boxes.

1 Choosing an appropriate subject in each case, produce four photographs. One must communicate texture, one shape, one form and one colour – excluding the other visual qualities as far as possible.

2 Shafts of light – created by sunlight through leaves, slatted windows, half-open doors, etc. – have inspired work by photographers and artists. Look at some examples and produce photographs based on your own observations of *interiors* (naturally or artificially lit).

3 Photograph a mousetrap twice, each picture meeting one of the following briefings: (a) an objective illustration in a catalogue distributed to hardware shops. Final size reproduction 36 × 54 mm, horizontal format; (b) a poster advertising the play *The Mousetrap* (the picture should simply and dramatically draw attention to the title, and that the play is a thriller). Final poster A2 size, vertical format.

4 Produce four pictures which portray *one* of the following concepts: power, space, growth, action.

5 Take several pictures with the main element (or elements) composed close to the *sides or corners* of the frame. Make this unusual positioning contribute positively to meaning in your results.

6 Looking through books of photographs, find examples of pictures structured mostly through the considered use of: (1) lead-in lines, (2) divisions or compartments within the frame, (3) patterns or textures, (4) high key, (5) low key, and (6) shape.

7 Investigate your local museums and find out if they hold any type of photographic archive. Research the photographers who made the images and try to build a picture of the conditions that the photographs were made in. Make a dossier that collects your findings.

8 Write a proposal for a long term project that you would be interested to do in your local area. In the proposal include information on the subject that you want to photograph, how you might do it and the way that you envisage resolving the project: is it an exhibition or a series ready to be archived or even published?

9 Decide to photograph your family in an original way and try two new approaches to family snap shooting:

■ Carry your camera with you at all times and photograph as many different things that happen over one weekend. Tell your family to try to ignore the camera and to definitely avoid posing for the photograph. Don't always photograph everyone from the front and alter your viewpoint as well as your distance from your subjects. Print the photographs and present as a diary of the two days.

■ Find a painting of a group of people in a domestic setting. Use members of your family and try to re-stage the painting in your own home. Props and furniture cannot be identical but can have similarities. Encourage the group to look at the painting and to take up a pose in the spirit of the image, and try lighting the photograph (this is best done in black and white) to imitate the lighting in the painting.

PROJECTS

Having composed and formed the picture in the camera the next step is to make the image permanent. Digital image capture is increasingly used, recording images as electronic signals from a CCD panel (Chapter 6), but a huge amount of photography relies on chemically coated film as the image-recording medium because of its fine quality of results and lower equipment costs. Once film is exposed and processed it can be printed onto chemically coated papers or electronically scanned (Chapter 14), allowing more adjustments to be made to pictures than ever before.

Light-sensitive compounds of silver have been used from the earliest days of photography in the 1840s, becoming enormously improved in sophistication and performance since then. This chapter describes the various types of modern films, outlines how they work, their practical performance and their suitability for various types of work. The biggest distinction occurs between colour and black and white materials. *Colour* records the most information and the results relate more closely to what you saw through the camera. This means that images in colour are more immediate in their impact on the viewer, but need careful control to avoid variations in hue, etc., which would look odd. *Black and white* is more restrained, and much more of an interpretation of reality; it requires a different approach to composition and lighting and has more tolerance in exposure and processing.

Nevertheless, both kinds of film share important basic features. These include speed rating, the relationship of graininess and sharpness, response to colour values, contrast, and the various physical forms camera materials take. It is also relevant to look at lens filters here, because their use links up closely with the colour response of films and therefore can have a dramatic effect on both colour and black and white films.

Once film is exposed and processed it can be printed onto chemically coated papers (Chapter 13) or electronically scanned (Chapter 14), allowing a whole host of adjustments to be made to pictures.

Silver halide emulsions

Photographic materials carry one or several coatings of *silver halide emulsion* – crystals of a silver halide chemical, such as silver bromide suspended in gelatin. Light-sensitive compounds of silver have been used from the earliest days of photography in the 1840s, although they have greatly improved in sophistication and performance since then.

Changes begin to happen when these crystals are struck by light-energy particles ('photons', see p. 32). A few tiny deposits of silver accumulate at crystal imperfections (called 'sensitivity specks'). But given typical camera exposure they are far too small to see as any visible change, even

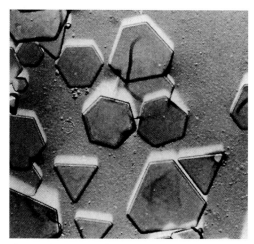

Figure 9.1 Silver halide crystals. An electron photomicrograph showing them here magnified approximately ×3000

if you were able to examine them through a microscope at this stage. However, this brief exposure to the relatively dim image accumulates just sufficient photons to give tiny build-ups of silver atoms.

Since most photons are received from bright parts of the scene, and least from where it is darkest, you have all the components of a photographic image but in an invisible or 'latent' form. Later, at the processing stage, chemicals go to work on the tiny silver deposits forming the latent image. They will be grown and amplified enormously to give a visible chemical image (see Chapter 11, Film Processing).

How film is made

Approximately half the world's production of silver is used by the photographic industry. Bars of the metal are dissolved in nitric acid to form silver nitrate, and this is reacted with a halogen element (typically iodine, bromine or chlorine in the form of alkali salts or *halides* such as potassium iodide, potassium bromide or potassium chloride). After by-products have been removed, the resulting compound consists of *silver halide* crystals, which are light-sensitive (Figure 9.1). In order that these finely divided silver halides can be coated evenly onto film base they are mixed with gelatin to form a creamy silver halide emulsion.

Gelatin is used because it is highly transparent and has no visible texture of its own. It becomes a liquid when heated – ideal for coating – but also sets ('gels') when chilled or dried. It holds the silver halides in a firm, even coating across the film surface, yet swells just sufficiently in processing solutions to allow chemicals to enter and affect the halide crystals, without disturbing their positions (Figure 9.2).

In detail, modern film manufacture is very complex and demanding. Mixed emulsions are given additives and held for fixed periods at controlled temperature to 'ripen'. This makes some crystals ('grains') grow larger, giving increased light sensitivity (greater 'speed') and producing less extreme contrast. Film contrast changes because, when first formed, crystals are all very small and not particularly sensitive. They are affected by light equally. When an emulsion contains a mixture of different-sized grains (mixed sensitivity), however, low-intensity light affects large crystals only, more light affects large and medium sizes, and brightest light affects

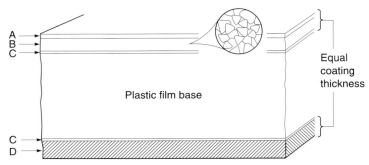

Plastic film base

Equal coating thickness

Figure 9.2 Cross-section of black and white film. (A) Scratch-resistant gelatin top coat. (B) One or more emulsion layers, containing silver halide crystals. (C) Foundation which improves adhesion to the plastic film base. (D) Gelatin anti-curl backing (may also contain anti-halation dye)

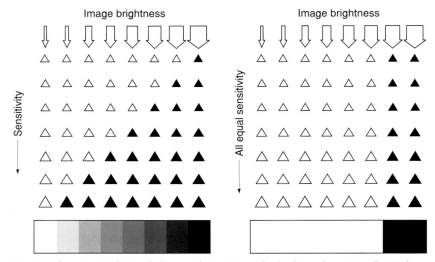

Image brightness

Image brightness

Sensitivity

All equal sensitivity

Figure 9.3 Grain size and contrast. Emulsion with slow, equal-size grains tend to be slow and contrasty. All grains become developable (right) at one triggering light level. Mixed large and small grains (left) can yield a range of tones related to light received. They are also faster

all crystals, even the smallest. When the film is developed, these variations in light intensity therefore record as various grey *tones* rather than simply extremes of black or white (Figure 9.3).

Farther additions to the emulsion alter its sensitivity to coloured light. In its raw state emulsion responds to blue and ultraviolet (UV) only, but this can be extended to farther bands or the whole visible spectrum. Meanwhile the film's base (most often polyester or tri-acetate) receives several preparatory coatings, including an anti-curl gelatin layer applied to the back to prevent the film shrinking or curling when the emulsion is coated on the front. Another layer of dark 'anti-halation' dye prevents light reflecting back from the base and forming 'halos' around the images of bright highlights. This layer may be between emulsion and base, or coated on the back of the film. In addition, 35 mm film has grey dye in the base to prevent light passing into the cassette, piped along the thickness of the film like a fibre-optic. Like the anti-halation material it disappears during processing and is sometimes seen as a darkening of the used chemicals.

Emulsion coating itself is extremely critical, and carried out in ultra-clean conditions. Black and white films may need between one and four layers, while most colour films have more than

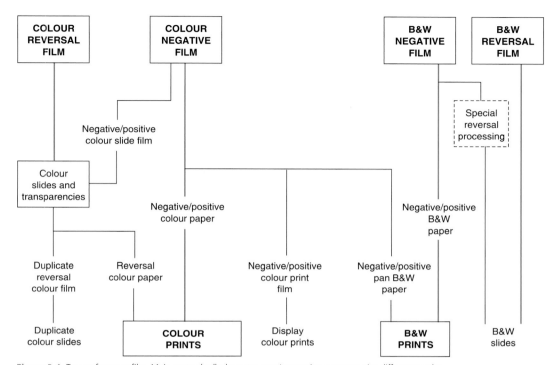

Figure 9.4 Types of camera film. Main routes (red) plus extra copy/processing stages to give different results

ten layers of several different colour sensitivities. The final layer is clear protective gelatin. (For details of the structure of instant-picture materials, see *Advanced Photography*.) Film is coated in large rolls, typically 1.5 m wide by 900 m long. After drying, this is cut down to the various standard film sizes, and edge printed with frame numbers and other information.

The flowchart in Figure 9.4 shows the main forms of colour and black and white camera material for general photography. Types are also made for X-ray, infrared, lithographic and other special purposes. You can often shoot on one film and end up with a form of result normally produced from another – black and white prints from colour negatives, for example. But the most regular route, with fewest stages, always gives best quality. This is why it is important to know in advance what is needed from a job, in order to shoot on the right materials in the first place.

Features common to all films

Sizes and packings

Figures 9.5 and 9.6 and 4.15 show the main types and sizes of film. The widest range of colour and black and white emulsions is made in 35 mm (135) size. Originally meant as movie film but adopted by photographers for its convenience and quality, 35 mm film is supplied in cassettes giving up to 36 exposures of standard 24×36 mm format. A few 35 mm films are available as 15 m and 30 m (or 50 ft and 100 ft) lengths in tins. This bulk film is for cameras with special film backs (p. 110), or you can cut it into short lengths to refill regular-size reloadable cassettes. Doing reloads (Figure 9.7) reduces film costs but risks scratches and dust. It is generally a false economy for professional work.

Figure 9.5 Packaged film materials. (Left) sheet film, 35 mm cassette and rollfilm, (Front, centre) instant-picture peel apart pack and an enveloped sheet, (Right) tin of bulk 35 mm

Film width	Maximum picture width (nominal)	Size coding	Notes
24 mm	17 mm	APS	Perforations on one edge; cartridge
35 mm	24 mm	135	Standard 35 mm; double-perforation; cassette
6.2 cm	6, 4.5 or 7 cm	120	Standard rollfilm, unperforated, rolled in backing paper; gives 12 frames 6 × 6 cm, 10 frames 6 × 7 cm or 15 frames 6 × 4.5 cm, etc.
		220	As 120 but double length
7 cm	6 cm	70 mm	Double perforation; bulk film for cassette loading
Camera sheet materials sizes*			
4 × 5 inch	Also instant-picture single peel apart units		
10 × 8 inch	Also instant-picture single peel apart units		
3.25 × 4.25 inch	Peel apart instant picture packs (fit special backs for rollfilm, e.g. 6 × 6 cm cameras)		

*The actual cut size of sheet film is minutely smaller, to slip into holders.

Figure 9.6 Film sizes – main camera materials

Figure 9.7 35 mm bulk-film loader. Once it has been loaded with up to 30 m of film in the dark, you can insert and fill 36-exposure reusable cassettes in normal room light

Figure 9.8 Typical sheet film notch codes. In the dark you can 'feel' the notch pattern to discover the film type. The emulsion is facing you when held as shown

Medium format film, usually called '120', is rolled in opaque backing paper on a spool, and is 62 mm wide. The number of pictures per film depends on your camera's picture format (see Figures 9.6 and 4.15). '220' film is on a thinner base, allowing twice the length and number of pictures on the same spool size as 120 but this is declining in popularity as it is more vulnerable to damage.

Sheet films packed 10, 25 or 50 per box come in several standard sizes such as 4 × 5 inch and 8 × 10 inch The edge-notching (Figure 9.8) helps you locate the emulsion surface when loading film holders in the dark, and has a shape code by which you can 'feel' film type, as well as identify it after processing. Rollfilms have farther type and batch identification data printed along their edges. Check the manufacturer's data sheet for the product to decode information.

Instant print sheet materials are mostly used as 8- or 10-exposure packs 3¼ × 4¼ inch and 4 × 5 inch, or individual sheets 4 × 5 inch and 8 × 10 inch special envelopes. They are of two main types (Figure 9.9), 'peel apart' and 'integral'. Each exposure on peel apart material is removed from the camera as a sandwich of two sheets you leave together for a timed period, and then peel to reveal a right-reading print on one sheet. It is most often used in a pack holder which attaches to 120 cameras with magazine backs, or 35 mm cameras with removable backs. Sheet instant film slots into a special film holder inserted into a view camera which also contains the roller mechanism used for squeezing out the chemical gel used when processing. These peel apart materials are still extensively used by professional photographers in the studio to produce a quick print confirming lighting, exposure, composition, etc. You have to remember though that colours may not exactly match your final results on conventional colour film. 'Integral' instant picture prints eject from the camera after exposure as a plain card which forms a picture as you watch. Its main use is in Polaroid point-and-shoot cameras which are designed with an internal mirror – otherwise pictures on integral material are reversed left to right. However, Polaroid announced in 2008 that it would cease manufacturing of instant film products and so they are hard to come by now although Fuji instant films are still available.

For APS cameras films are 24 mm wide and come in cartridges which open and self-load when dropped into the camera body. The picture format is 17 × 30 mm, but cropped by the

Figure 9.9 Instant-picture materials: Top: Integral type. Bottom: Peel apart type, showing pack attached to a rollfilm camera in place of its film magazine

camera at the shooting stage (see p. 81). There are 15, 25 or 40 exposures per cartridge, and film is returned from the lab with its processed negatives secured inside the container which is not designed to be opened. Mechanized printing machinery retrieves the film automatically for reprints, etc. Hand printing is possible, but you will have to break the cartridge open. APS never really caught on with professional photographers as they found the film area too small, just 56% of 35 mm and the point and shoot amateur camera market was soon dominated by digital cameras. Kodak, who introduced the format in 1996 ceased producing APS cameras in 2004 although it is possible still to buy a limited range of APS film.

Other formats are rarely encountered but the industry manufactures them for specialized applications, often in science and industry. For example, astronomers occasionally require extremely flat negatives, much more dimensionally stable than acetate film and so still use old-style glass plates although CCD arrays are now more commonly used.

Film speed rating

A film's sensitivity to light is denoted by the emulsion speed figure printed on the packaging. It follows strict test procedures laid down by standardizing authorities. Most manufacturers quote an ISO (International Standards Organisation) figure (see Figure 9.10). This combines previous US-based ASA ratings and European DIN ratings. The first part of the ISO figure doubles with each doubling of light sensitivity; the second number (marked with a degree sign) increases only by 3 with each doubling of sensitivity. Often the first ISO figure forms part of the film's brand name, for example Fujicolor 160. Specialist films such as infrared may display no ISO number, but instead give guides based on exposure index (EI) information (see Chapter 10).

The doubling of sensitivity is also equivalent, in terms of exposure, to changing the aperture or shutter speed by one stop. If the correct exposure for a subject using an ISO 100/21° film gives

ISO	25/15°	50/18°	100/21°	125/22°	160/23°	200/24°	400/27°	800/30°	1000/31°	1600/33°	3200/36°
Speed		Slow			Medium			Fast		Ultra-fast	
Grain			Fine				Medium		Coarse		
ASA	25	50	100	125	160	200	400	800	1000	1600	3200
DIN	15°	18°	21°	22°	23°	24°	27°	30°	31°	33°	36°

Figure 9.10 ISO film speed ratings. The ASA scale is linear – if the rating is doubled the film sensitivity is doubled. DIN ratings follow a logarithmic progression – an increase of 3 means double the speed. ISO combines both

a reading of *f*/5.6 at 1/250 then with an ISO 200/23° film the exposure would be *f*/8 at 1/250; if changing the *f*-stop or *f*/5.6 at 1/500 when changing the shutter speed, with an ISO 400/27° film the reading would be *f*11 at 1/250 or /*f*5.6 at 1/1000. From this you can see with the same lighting conditions on a faster film you can either increase the depth of field by stopping down the aperture or capture fast-moving subjects by increasing the shutter speed.

The speed rating figure is based on standard conditions of lighting, typical exposure times and the amount of development given during processing. The film will usually perform best if used according to this rating but it can be altered. If you intend to increase or decrease development from normal you can 'up-rate' or 'down-rate' film speed when exposing – this is also known as 'pushing' or 'pulling'; this may be helpful when you want to alter contrast, or simply get maximum possible speed out of a film in dim conditions. In general, fast films of ISO 800 and upwards are designed to best respond to up-rating and consequently require extra development, and if you down-rate or pull a film it will generally require less development (see p. 275). Exceptionally long or short exposures also influence film speed due to *reciprocity failure* (see Appendix C).

35 mm films have checkerboard codes printed on their cassettes. Most modern cameras have electrical contacts in the cassette compartment to 'read' this code and so set the internal exposure meter automatically. If you want to up-rate or down-rate the film's normal speed, you must do this with the camera's exposure compensation dial to override the electrical contacts that read the film code (Figures 4.32 and 10.20). On manual cameras you can up-rate by changing the speed dial; for example you would up-rate (or push) an ISO 400/27° film to 800 on the dial (one stop) or to, say, down-rate (pull) an ISO 100/21° film you would set the dial to 50 (one stop). As you now have to change the developing time this can only be done for the whole film and not just a few selected shots.

Speed, grain and sharpness

Reviews of film types, manufacturers' literature and technical material on films refer to a variety of terms:

- *Speed* is sensitivity to light as discussed above. Films of identical speed are equally responsive to the exposure they receive.
- *Grain* refers to the pattern of grain clumps in the processed image. If this is coarse it will show up as a mealy pattern and break up delicate tone values when enlarged.
- *Sharpness* or *'acutance'* in an emulsion is concerned with the degree of fine image detail the film can record. This brings in local contrast or edge sharpness, as well as grain, for an image can be fine-grained yet lack 'bite' because detail is flat and grey (Figure 9.11).

Figure 9.11 Typical examples of the image grain given by (left) ISO 125/22°, (centre) ISO 400/27°, and (right) ISO 3200/36° films. Each film was processed normally in its recommended developer and is reproduced here enlarged approx. ×32, equivalent to a print 45 × 30 inch from the whole of a 35 mm format image

Speed, graininess and sharpness are traditionally linked. As Figure 9.12 shows, the challenge to the manufacturer is to improve speed without increasing the size of silver halides and coarsening grain. If the emulsion is simply made thicker to obtain speed by containing more halides, there may be minute scatter of light ('irradiation') within this sensitive layer which worsens sharpness. Modern flat-shaped 'tabular' grains offer more speed with less sharpness loss, but your choice of film is still a trade-off between speed and image quality. Fast films are inherently grainier than slow films, and the more enlargement your film is to receive later, the more important this fact becomes.

Sometimes you may choose fast film intentionally to get a granular effect, such as in Figure 9.13. More often this choice is made because the subject is dimly lit, and perhaps you need to stop down for depth of field and freeze movement with a short exposure. One way to reduce the effect of grain and improve sharpness is to change to a larger-format camera, because the film image will need less enlarging, but you will then have to stop down farther for the same depth of field.

In general, graininess is increased and image sharpness reduced if you over-expose and/or over-develop. In black and white photography there are a number of fine-grain and high-resolution developers to choose from, but they may reduce film speed too (see Chapter 11).

Sensitivity to colours

Monochrome films. Film emulsions are sensitized during manufacture to some or all the colours of the spectrum. The vast majority of black and white films are given panchromatic colour sensitivity ('pan') see Figure 9.14. This means that they respond to light of all colours as well as to shorter UV wavelengths (Appendix C). In fact this response does not quite match the human eye's concept of light and dark colours. Pan film 'sees' (reproduces on the print) violet, blue and orange-red as somewhat lighter in tone and greens darker in tone than we would generally judge them to be. The difference is generally accepted, and is of some value in allowing slow pan materials to be handled under very deep green darkroom safelighting. For a more exact match you can shoot using a pale yellow camera filter.

A few black and white films are made insensitive to the red end of the spectrum beyond about 590 nm, and are known as orthochromatic ('ortho'). These films reproduce red as black

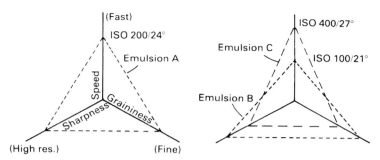

Figure 9.12 Relationship between film speed, sharpness and graininess. The faster the speed (emulsion C) the lower the resolution and the coarser the grain tends to be, relative to slower emulsions A or B. It is comparatively easy for manufacturers to make trade-offs between the three factors but difficult to increase the triangle area

Figure 9.13 Using a grainy film. A moody, low-key shot taken on ISO 3200/36° film, then given extended processing and enlarged onto contrasty paper to help emphasise the negative's grain pattern. Note it is important to print the grain perfectly sharp or the image will turn to 'mush'

on the final print, and orange as very dark. Ortho materials – mostly sheet film – are useful for copying black and white prints or drawings not involving colours. You can conveniently handle them in the darkroom under red safelight illumination. They are also used for some forms of medical, forensic and scientific photography. Ortho film speed rating is lower when the subject is lit by tungsten light rather than daylight or flash, because the former contains a higher proportion of red wavelengths.

One or two films, very slow and intended for the printing darkroom rather than camera purposes, are made with blue (and UV) sensitivity only. These are used for making copy

negatives, usually in large formats for special printing processes. You can also buy special films for camera use with special 'black' filters to become insensitive to almost the whole visual spectrum but respond to infrared and UV; see *Advanced Photography*.

Colour films, both negative and slide types, often have a stack of six or more emulsion layers. They use three different kinds of colour sensitization. The top emulsion is sensitive to blue only; others respond to blue and green; and the remainder primarily to red. A yellow filter may be incorporated below the blue-sensitive layer so that blue light cannot proceed farther into the film. Therefore you effectively have a multi-layered emulsion responding to blue only, green only, and red only – the three thirds of the spectrum. (Later each of these three emulsion types will form its image in a different coloured dye, to reproduce the final image in full colour; see Appendix C).

The relative sensitivity of the different layers (colour balance of the film) is carefully controlled during manufacture. Most colour films are balanced to give accurate colour reproduction when the subject is illuminated by daylight or flash (5000–6000 K). You can also buy a limited range of tungsten-balanced films which have slightly slower red-sensitive layers to give correct reproduction of subjects lit by red-rich 3200 K tungsten lamps. Apart from 'daylight' and 'tungsten' colour balance films, one or two exceptional materials are sensitized to infrared or laboratory light sources.

Choosing films for black and white

Negative types for general use

The majority of black and white films are designed to give you a negative image in black silver. In other words, the latent image recorded in the camera is strengthened into visible black silver during developing, and then the remaining creamy halides are removed, leaving the film with a negative image (subject highlights darkest, shadows lightest) in clear gelatin.

General-purpose pan films range from about ISO 25/15° to ISO 3200/36°. The slower the film is, the finer the grain and the better its ability to resolve detail. Contrast – the range of grey tones formed between darkest black and complete transparency – is slightly greater with slow films than fast films. This tendency is taken into account in the recommended developing times, which tend to be shorter for slow films.

Films between ISO 100/22° and ISO 400/27° offer a good compromise between speed and graininess. ISO 400/27° film gives prints with a just visible grain pattern (noticeable in areas of even grey tone, such as sky) when 35 mm is enlarged beyond 10 × 8 inch although this depends upon negative development and the type of enlarger light source used; see pp. 274 and 294.

In general it is best to use the slowest film that subject conditions sensibly allow, especially when working with small negatives such as 35 mm. For occasions when you want to give long exposures to create blur in moving objects, this too will be easier on slow film (see also neutral density filters, p. 223). However, slow film may prevent you from stopping down enough for depth of field, or necessitate a tripod in situations where it is impractical. Fast film is necessary for reportage photography under really dim conditions, and action subjects or hand-held telephoto lens shots which demand exceptionally short shutter speeds. Although reportage photographers might use flash for certain situations, and therefore can use a slower film, if they

Figure 9.14 The reproduction of the coloured pencils is shown when they are photographed on (centre) ortho, and (right) panchromatic monochrome films

were working under conditions where they do not wish to be conspicuous this obviously would not be appropriate. If you are working in well-lit conditions but deliberately want to use very fast film to give a grainy texture to the image you may have the problem of too much light. In this case, use a neutral density (ND) filter (see pp. 223, 224) to reduce exposure.

Chromogenic films. A few monochrome negative films, such as Ilford XP2 Super and Kodak T400CN, give their final image in a purple-brownish dye instead of silver. Extra components in the emulsion layers form tiny globules of dye wherever silver is developed. The processing you must give these films is known as 'chromogenic', and this finally bleaches away all silver, leaving your image in dye molecules alone. Since chemicals and processing stages are the same as for *colour negatives* (p. 278), it is easy to hand your exposed film in to a high street mini-lab anywhere for rapid black and white results.

Another advantage of chromogenic films is that they are more able to tolerate inaccurate exposure – especially over-exposure – than silver image types. You can choose to rate your film anywhere between ISO 125/22° and 1600/33°, provided you develop accordingly. However, although results are fine grain the grain is less 'crisp' and image sharpness slightly poorer than with silver image film. They also cost more for self-processing, and you don't have the choice of developers possible with the other films. Chromogenic films are popular with some news and documentary photographers because they suit a wide range of shooting conditions. They also have a different 'look' from silver halide films; which might attract some photographers.

Special-purpose monochrome films

Line film. Some materials are made with high contrast emulsions. Available mostly in sheet films but also 35 mm, they give negatives with few or no greys at all between dense black and clear white, when processed in the appropriate high contrast developer. Line films (and the more extreme 'lith' films) are intended for photographing documents, pen-and-ink drawings, etc., which contain only pure black and pure white and need to be reproduced in this form (Figure 9.15). Emulsions are very slow and fine-grain, and most often have ortho sensitivity for easy darkroom handling.

You can also use line film to simplify regular images of full tonal range scenes into stark, graphic black and white. Compare Figure 9.16 with Figure 10.17. Since this sort of material only has a speed of about EI 8, and its high contrast demands absolute exposure accuracy, it is best to

Figure 9.15 High contrast line film reproduces ink drawings (as here), diagrams, lettering, etc., in pure black and clean white only

Figure 9.16 Line films can also be used to copy and convert a normal contrast print into a stark graphic image. Original shown on, p. 247 (Figure 10.19)

shoot your picture first on normal film, then reproduce this onto line film by re-photographing or printing in the darkroom. (This effect can also be achieved by digital means using an image manipulation software program, Chapter 14.) Line negative film is also excellent for making slides of black-on-white line diagrams or text which then project as bold white-on-black images.

Films for monochrome slides. There are now few 'off the shelf' films yielding monochrome transparency images. Black and white positive slides can, however, still be made, using normal negative film processed in specialist chemistry kits from manufacturers such as Kodak. These can give excellent quality monochrome slides, with rich tone range, fine grain and extreme sharpness. But, as with all reversal-processed materials such as colour slides, you must get your exposure correct at the time of shooting because little adjustment is possible later.

Instant black and white print materials. There is a limited range of monochrome instant-print materials, mainly intended for professional use. They work on the 'peel apart' basis (Figure 9.9)

and come in pack form or as individual sheets in special envelopes. Speeds range from ISO 50 to ISO 400. These are used mostly as 'proofing' materials to make on-the-spot lighting, layout and colour-translation previews when shooting a black and white assignment using regular film. It is a reassuring check on all your equipment before (and after) an important job. Instant material is approximately three times the cost of normal film. It also requires special camera backs or film holders and separate processing devices in some cases. Lastly the prints tend to have a fairly limited life, although the monochrome negatives that were available on a couple of Polaroid films, have good life expectancy.

Films with extended sensitivity. Some materials have been made with abnormal properties for specialist purposes. For example, films designed for speed-trap traffic cameras have panchromatic sensitivity extended to include infrared wavelengths. Used with a deep red filter, subjects such as portraits record with darkened eyes, pale lips and a slight overall image softness. Kodak High Speed Infrared film was developed for aerial survey and medical purposes and has far less panchromatic response. It reproduces blue skies in landscapes as black, foliage white and skin tones ghostly pale when exposed through a very deep red filter (see *Advanced Photography*).

Films for colour photography

Negative types. Colour negative (or 'colour print') film has always been the biggest selling film type in the popular photography market; now there are companies who have started to discontinue a number of their films, particularly in the amateur ranges because of the popularity of digital cameras. High street labs were geared up to process and print from colour negative film at competitive prices, now you will find a predominance of printers to create prints from your digital files. In terms of quality, however it is possible to get as good if not better digital prints from your home printer, although it might cost more per print. It is also possible to make black and white prints from colour negatives by either using silver halide material or by scanning into and printing out from a computer (p. 330). Professional labs can also produce colour or monochrome slides (Figure 9.17).

Colour negative films carry in effect three types of black and white emulsion, recording blue, green and red respectively. They reproduce the image in negative tones and complementary colours (Figure 9.17). To understand this term 'complementary' colour, remember the colour spectrum of white light (Figure 2.3). If you remove all the red wavelengths from the spectrum, what remains appears not white but greeny-blue (called 'cyan'). Cyan is therefore said to be complementary to red – opposite or negative to it in terms of coloured light. In the same way removing green from white light produces a purply-red ('magenta'), and if you remove blue from white light you get a dominance of yellow. *Cyan, magenta* and *yellow* are said to be complementaries of *red, green* and *blue* light. (Note: these differ from the complementary colours in paints and pigments.)

The way that natural image colours formed by your lens in the camera are turned into their complementary colours in the processed film, is shown in Figure 9.18. Each emulsion layer in the film also contains a colour coupler chemical – a yellow dye former in the blue-sensitive layer, a magenta former in the green-sensitive layer, and a cyan former in the red-sensitive layer. Couplers only turn into their designated colour dye when and where the silver halides to which they are attached are affected by light, and so develop to black silver. When towards the end of

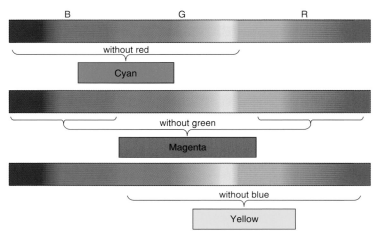

Figure 9.17 Complementary colours. When one third of the spectrum (one of the primary colours red, green or blue) is removed from white light, the remaining mix of wavelengths appears cyan, magenta or yellow respectively. So each of these colours is a combination of two primaries and can be said to be 'complementary' to the missing third. In a sense they are 'negative versions' of red, green and blue

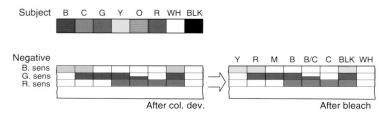

Figure 9.18 How colour negative films reproduce colours. Left: Black silver develops and complementary dye forms where each layer responds to subject colour (compare this G and R response with Figure 9.17). Right: Silver and remaining halides are removed, leaving negative image in dyes alone

this chromogenic processing the silver is removed, what was originally the blue-sensitive layer contains an image in which all parts of the picture containing blue record as yellow. Similarly, in other layers, parts of the image containing green record as magenta, and red parts as cyan. Wherever the scene was some other colour, the image is recorded in more than one layer, while white or grey records in all three. Viewed as one, the 'stack' of layers gives you the familiar colour negative image (plus a characteristic warm tint remaining in clear areas). Follow this through in the reproduction of the coloured pencils (Figure 9.19). During enlarging similar layers in colour paper give 'a colour negative of a colour negative', recreating subject colours and tones.

Colour negative films for general use

Colour balance. The vast majority of colour negative films are balanced for use with daylight or flash. If you shoot with them in tungsten lighting instead, results show a warm orange/yellow cast. It is possible to make colour correction during darkroom printing or digital manipulation, but this may create difficulties and restrictions owing to the amount of change required. It is better to shoot with a bluish conversion filter over the lens (p. 222). A very few roll and sheet

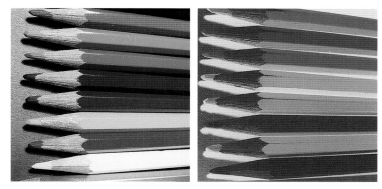

Figure 9.19 Colour negative image. Compare the original pencil colours (left) with the complementary colours in which they have been recorded on negative colour film

films are made colour balanced for 3200 K tungsten lighting – if used with daylight or flash an orange filter is necessary.

Film speeds, and colour contrast. You have greatest choice of film speeds in 35 mm and to a lesser extent rollfilm formats. Typically they run ISO 100, 160, 200, 400 and 800. These fast films are also designed to be up-rated when needed to double their box speed, then push-processed in the standard developing kit for all colour negatives known as C-41 (see p. 278). Sheet films differ very little in speed, typically around ISO 100. 35 mm colour negative film of ISO 200 or 400 gives good balance between speed, graininess and resolution for most situations apart from press photography.

The colour qualities of your final picture can range from natural or subtle to bold and vivid. Fine judgement of what looks best depends on you as the photographer and how you want your subject to appear – film types and makes are all very different and if you read the maker's specifications you can get an idea of what the nature of the particular film is, but you really need to test different makes of film as they all have slightly different colour bias. Adjustments can again be made in colour printing, but to minimize compensations at this stage (particularly if you use an outside lab for prints) some films for professional photography are made in a choice of colour strengths. So the same film name, whether fast or slow, may be followed by the suffix NC for 'natural colour' or VC for 'vivid colour'. The NC version usually gives a softer, more subtle colour; VC would enhance a subject with a rich predominant colour, especially in flat, existing light. Films with slower speed ratings tend to be more vivid whereas faster films are softer and grainier.

Slide and transparency films

Colour films designed to give positive images direct often include the suffix chrome in their brand name rather than colour, which is used for negative types (i.e. Fujichrome rather than Fujicolor). Chrome films are also collectively known as colour reversal films, because of the special reversal processing they must be given. Results from rollfilms and sheet films are normally referred to as transparencies, and 35 mm results as slides. Traditionally these materials were mainly used by the professional (although there were very particular amateur photographers who made all their holiday snaps on slide film in order to do holiday slide

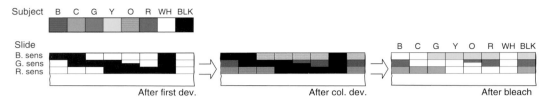

Figure 9.20 How slide films reproduce colours. Left: Black silver develops only where layers respond. Centre: Remaining emulsion is turned into black silver plus dyes. Right: All silver is removed, leaving positive image in dyes alone

shows!). The amateur market for slide film has completely died out and digital is fast replacing transparency in the commercial world also. Slide and transparency films have high image resolution (unlike most prints which have had to pass through a lens twice) and so traditionally were preferred for the printed page. Today, however, digital files are what the commercial magazines and newspapers use. Advances in digital imaging have meant that images can simply be transferred via the internet in suitable image files and then go straight to print.

All reversal films have a multi-layer structure, making use of blue-, green- and red-sensitive emulsions, and most have yellow, magenta and cyan dye-forming couplers, similar to those in colour negative film. However, results have stronger contrast and saturation of colour, plus a lack of 'masking' (see *Advanced Photography*), which means that there is none of the overall pinkish tint characteristic of colour negatives. Viewed on a light box or projected as slides, reversal film images show a wider range of colours than it is possible to achieve on paper prints.

During the first part of processing only black and white developer is used, forming black silver negatives in the various layers. Dyes are then formed where the unused halides remain so that when all silver is removed, a positive, correct-colour image remains. For example, referring to Figure 9.20, green (e.g. foliage) in your subject records on the green-sensitive layer and is developed as black silver there. The blue- and red-sensitive layers in this foliage area are not affected by the light and so form yellow and cyan, which together make the final image here look green.

All reversal colour films need chromogenic processing using developing kit E-6 and this, like C-41 for negatives, can be carried out by photographer or laboratory.

Colour balance. Colour balance must be more accurately matched to type of lighting than with negative materials, as corrections are more difficult. They can be corrected by digital means (see Chapter 14) or printing but if you are using slide film to project images this becomes more complicated. The majority of colour slide films are balanced for daylight and flash but there are also several films designed for 3200 K tungsten light. Daylight film needs a bluish filter if used with tungsten light; tungsten-balanced film needs an orange filter with daylight or flash (Figure 9.21). Image colour is easily 'burnt out' by accidentally over-exposing or darkened by under-exposing, so here again you have to be more accurate – little correction is possible later, apart from some speed-rating compensation of complete films during processing.

Film speeds and colour contrasts. Again, the widest range of reversal films is available in 35 mm format, from ISO 25 to ISO 1600. Most (up to ISO 1000) are also made as rollfilms. Sheet films range in speeds from ISO 64 to 160. Tungsten-balanced films are typically ISO 64 (many of these have been discontinued). Most reversal films of ISO 200 or faster can be up-rated and then push-processed to double their normal speed rating – either to correct overall exposure errors or help when you shoot in dim lighting. Some make a feature of their up-rating potential and

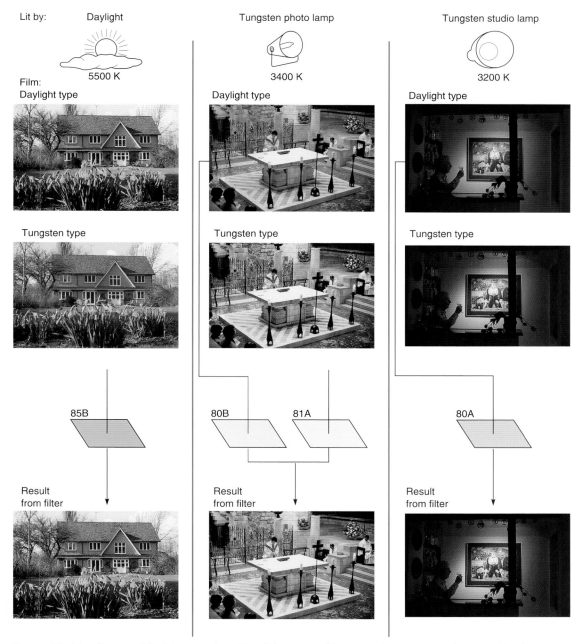

Lit by: Daylight

5500 K

Film:
Daylight type

Tungsten type

85B

Result
from filter

Tungsten photo lamp

3400 K

Daylight type

Tungsten type

80B 81A

Result
from filter

Tungsten studio lamp

3200 K

Daylight type

Tungsten type

80A

Result
from filter

Figure 9.21 Colour films, especially slides, exposed to subjects lit by a source of the wrong colour temperature show a cast. You shoot using an appropriate conversion filter. (Note: 3400 K tungsten lamps, regularly used for TV and movie lighting, require filtering on both daylight and tungsten type stills-photography film)

allow four times the speed rating shown on the box, although changes in image contrast and increased graininess become your limiting factors. (When you know in advance that light will be poor it is usually wisest to shoot on fastest film, rather than up-rate normal speed material.)

Processed results from reversal films are brighter and richer in hue than colour negatives. They must have the brilliance of appearance expected in a final image, as opposed to an intermediate tailored to match up with the characteristics of neg-pos-colour printing paper later. Different reversal films produce subtle differences in image colours owing to different image dyes used by the manufacturer. According to subject and mood you can shoot with a very saturated colour film; or one saturated but 'warm'; or one specially optimized for skin tones; or again film giving a slightly warm colour balance for outdoors in cloudy conditions. Take care though not to mix reversal films from various manufacturers when covering any one assignment. Shots showing differences in hue and contrast then stand out like a sore thumb.

Special reversal materials

Special low-contrast transparency films are designed for duplicating slides, while others with boosted contrast are used for copying coloured line drawings, or low-contrast specimens photographed through the microscope, etc. You can also obtain false-colour infrared Ektachrome for medical and aerial work, or special colour effects (see *Advanced Photography*).

Storing film – before and after exposure

'Professional' and 'amateur' films

All the main film manufacturers designate some of their range (negative and slide) as professional and include this word on the pack. The main difference between professional and 'non-pro' or amateur film is that the former is designed to give its best, exactly specified performance the moment it leaves the factory. So provided you give it immediate refrigerated storage at 13 °C or less, as suggested for the product, it will record with great film-to-film consistency. Professional film must be processed immediately after exposure too.

Amateur films are planned for a slightly different storage scenario – in which they remain at room (or shop) temperature for an average time after delivery, and there is a more variable time delay between exposure and processing. In practice, amateur films are about 25 percent cheaper than professional films of the same speed. They are in no way inferior for professional work, and some professional photographers prefer to use them, but it is advisable to make checks for possible batch-to-batch variations. Having done this, colour consistency is better maintained if you keep them in refrigerated storage as for professional films.

Length and type of storage

The main hazards to avoid – before and after exposure, and before processing – are damp, humid conditions, chemical fumes, and fogging due to exposure to light. Exposed films are more likely to react than unexposed ones; and fast film rather than slow.

Speed loss is the most common effect of overlong storage. Colour film is especially vulnerable to change because alterations to the finely adjusted relative speeds of its different emulsion layers upset colour balance. Remember that the expiry date stamped on the packaging

is only a guide – so much depends on storage conditions (including before you bought it). Stored in the general compartment of a domestic refrigerator, sealed film should remain usable beyond this date without changes.

However, allow time for your film to warm up, unopened, between removing it from the refrigerator and shooting. Unsealing too soon may cause condensation to form on the emulsion. Recommended periods are 1 hour for cassettes and sheet film, or 3 hours for cans of bulk film. Remember too that instant-picture materials only function at their expected speeds when at 18–30°C. Below about 10°C most will not work at all, so take care to warm up the pack under your coat when working outdoors in winter.

If you cannot process exposed film straight away, store it in a cool, dry, dark place. If it goes back into the refrigerator keep it in a taped-up foil bag or airtight box, as without this your film is no longer protected from humidity. If possible include a packet of desiccating crystals such as silica gel within its container to absorb any moisture.

So which film is 'best'?

Digital photography has undoubtedly taken over a large percentage of the amateur photography market, and it is generally believed that consumer photography will be virtually completely digital within a few years. Silver halide photography is still available to the high street shopper in most countries but generally tends to be used most often by photographers who have specifically chosen to use analogue materials – medium and large format digital equipment are still far more expensive than analogue equipment. Some photographers prefer the ease of using the analogue equipment and some also prefer the quality of film. Some film types have been discontinued so choice is less than it was five or ten years ago. If you choose to use film you will probably already own a film camera; it is a good idea to test a range of film types and makes to find out which one suits you/your camera/the job you are doing. It makes good sense to narrow your field: use as small a range of films as your work allows, and get to know them thoroughly. A good familiarity with a film's characteristics is most likely to give technically consistent, reliable results. Just remember the existence of other materials for special tasks.

The main factors to consider when choosing film are:

1 *What is to be the final result?* Print or slide/transparency; colour or black and white; a large print to hang on the wall, a set in an album, or for reproduction on the printed page or transmission via the internet? If your picture might be used now or in the future in a whole variety of ways, shoot colour negative. And if there is any likelihood that a large display or exhibition print will be the end product go for a film format larger than 35 mm if you want the finest quality (Figure 9.22). Illustrations for magazines or books are now mainly done digitally and most people make their slide presentations or talks using digital presentation programs. If you plan to scan your pictures into a desktop computer, colour negatives give better results because of their lower contrast. Remember too that colour negatives can be darkroom-printed in monochrome, or scanned-in 'grey-scale' (p. 370).

2 *Relate the film to type of subject and lighting conditions.* Will its contrast, colour brilliance and grain (if any) best suit the image quality and/or mood you want to achieve? Will the film's speed and colour balance link up with the strength and colour of the lighting? Remember likely depth of field and movement blur requirements too). Perhaps you will be working in changing lighting, and conditions where exposure may be difficult to measure accurately? If this is the case, pick a film that is most tolerant of over- or under-exposure.

Figure 9.22 Film types: (a) monochrome rollfilm negative, (b) 35 mm colour negative, (c) reversal colour (slide) film, and (d) reversal monochrome film

3 *Will you process and print it yourself, or use a lab?* For self-processing use a tried and tested combination of film and developing which gives excellent results on your enlarger (or through your computer's film scanner). Is there a reliable, caring lab able to handle the work for you and return it promptly – preferably knowing the kind of result you like, via personal contact?

4 *Personal preference.* Beyond a certain point colour, contrast, and 'crispness' or 'subtlety' of image quality is subjective. It can be useful to know one or two films that really suit your style, and help give a recognizable look to all your work; perhaps you might want to shoot different subjects in different styles.

5 *How expensive is film and processing?* If you are working professionally this comes lower down the list because your time, travel, studio and lighting hire, etc., are all more expensive elements.

Always test out a film you have never used before, prior to using it on an assignment. And where practical, buy your transparency film in batches with the same coating number (printed on the box). If most of your photography is 'constructed' – using models in the studio or on location, working to layouts, etc. – use instant-picture material in a suitable camera back as well to test exposure and image appearance. Here it helps to pick material with the same ISO speed as your regular colour film, so that camera settings (which affect depth of field, etc.) remain the same for test and shot. One of the major advantages of using digital is that you can alter the ISO for every shot that you take; so no longer does the professional photographer need to take out different cameras with different film types in them.

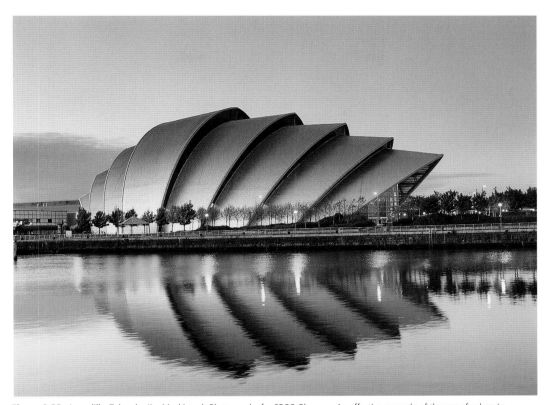

Figure 9.23 *Armadillo*. Taken by Jim Mackintosh Photography for SECC Glasgow. An effective example of the use of colour in architectural photography. A split filter tinted only in its upper half was used over the camera lens (see p. 227)

Filters – how they work

Deceptively simple pieces of coloured glass or plastic, filters are extremely versatile photographic tools, allowing us to change the tones of an image very subtly or by extreme amounts. To understand them fully, it is worth taking a moment to consider just what an optical filter does. Certain wavelengths of light are absorbed, while others pass through freely, allowing the photographer to use just the type of light to suit the subject and film and if necessary shift the emphasis.

The rule is that a filter passes light matching its own colour, and absorbs (darkens) other colours – particularly those farthest from it in the spectrum (see Figure 9.24). To check out filter effects, first find yourself a bold, multi-coloured design – a book jacket or cornflake packet perhaps, or a motif like that of Figure 9.24. View it through a strong red filter (even a sweet wrapping will do). The whole subject appears red, but check how light or dark the original colours now appear. Strong blue and green subject areas are relatively darker in tone, almost indistinguishable from black areas. This is because very little of their colours make it through the filter.

Red parts of the subject, however, look much paler than before, practically the same as white areas since they reflect as much red light as the white areas do (the other colours that

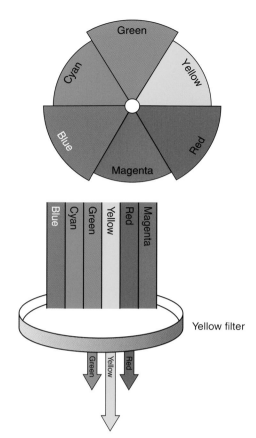

Figure 9.24 Top: Simplified colour wheel, based on the spectrum of light 'bent' into a circle. Oversize segments blue, green and red are the primary colours of light. Yellow, magenta and cyan are complementary colours, and (for filtering purposes) the most opposite to each primary. Bottom: A coloured filter absorbs most of the spectrum, allowing only certain wavelengths through

white reflects are absorbed by the red filter). The same tonal changes occur when the light source illuminating your subject is filtered instead of your eye or camera lens, so a red filter over your studio lights or flashgun will have the same effect.

Coloured filters help you to alter the relationship between the grey tones made by monochrome film (see Figures 9.25 and 9.26). Used with colour film they allow you to shoot using light sources for which the film is not balanced (e.g. daylight film in tungsten light) without getting an overall colour cast (Figure 9.21). By using paler filters you can gently 'warm up' or 'cool down' colour images when the subject or lighting colour is not ideal.

Filter types. Photographic filters are made in three main types. The simplest are very thin flexible squares of dyed gelatin or polyester which you either hold over the lens or fit into a filter holder. These are relatively cheap but soon pick up finger marks and scratches if used often. The majority of dyed filters are now manufactured in optical (CR 39) resin, square in shape to slip into a holder. Unlike the gelatin type these are not flexible and will crack if dropped but they resist scratching much better. The third type are made in glass and sold in circular mounts which screw into the front rim of the lens. These tend to be the most expensive as they are usually made from optical glass and frequently treated with anti-reflection coatings like camera

Figure 9.25 Filtering to enhance/change sky detail. The left picture was shot on pan film without any filter. A deep red filter was added for the right picture. Notice how filtering has darkened the mid-blue sky. The filter factor was 38 so the exposure was increased by three stops

lenses. Remember that the filter is the first thing the light passes through and therefore it needs to be as clean and free from damage as possible. A glass or resin filter may slightly alter the position of sharp focus, so always focus with your filter in place, especially if shooting at wide aperture. It's difficult to fit a filter over the front of a wide-angle lens without corners of the picture darkening ('cut-off'). Some extreme wide-angles therefore have 3 or 4 internal colour filters which a dial on the lens barrel will bring into use.

Because a coloured filter absorbs part of the light from the image, it reduces its brightness. This may be taken care of by a 'through-the-lens' exposure meter such as in SLR cameras because it reads through the filter. If using a separate hand-held meter you will have to increase exposure by a 'filter factor', shown in the table in Figure 9.27 (see also p. 249).

Using colour filters in black and white photography

Blue skies often record much paler grey than they seemed at the time, because film is more sensitive than the eye to blue. Clouds may therefore barely show up unless you photograph (on pan film) through an orange – red filter. Much of the blue sky light is then absorbed by the filter, making white clouds stand out boldly against what is now dark sky (Figure 9.27).

No change takes place if the whole sky is white with clouds, and there is little effect if the sky is only weak blue (containing a high proportion of white light too). You should also consider

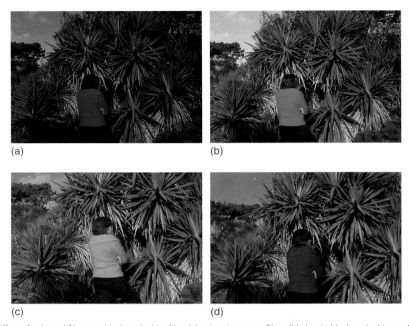

(a) (b)

(c) (d)

Figure 9.26 Effect of coloured filters on black and white film: (a) colour image no filter, (b) shot in black and white no filter, (c) same scene shot in black and white with red filter – notice how red now appears lighter against darker greens, and (d) shot with a green filter – see how the greens are now lighter and the red darker

any other colours present. If the sky is part of a landscape with green foliage, for example, the green darkens as well. If you use a deep green filter here instead this will darken sky tone almost as much, but lightens the foliage instead. The table in Figure 9.27 lists the typical uses of other filters.

Whereas deep coloured filters are known as 'contrast' filters, one or two paler types, normally yellow or pale yellow-green, are known as 'correction filters'. They make colours record in grey tones closer to their visual brightness instead of that given by unfiltered panchromatic film. This is really only important for critical technical photography – with most work the difference hardly shows. However, for landscapes with blue sky you could work with a yellow filter as standard.

Coloured filters are very useful in this regard to emphasize certain parts of the picture while suppressing others. Other examples are photographing autumn leaves through a yellow or orange filter to make them stand out more in a black and white print, or photographing portraits through a red one to lighten and reduce the appearance of skin blemishes such as spots.

Digital filter effects

Many digital cameras have options in their software to record black and white images, emphasizing certain colours over others, giving the effect of a red, green or blue filter over the lens. Depending on the recording format used these effects may not look as smooth as with an optical filter and should be used with caution (see Chapter 6).

Using colour filters with colour materials

Colour filters are used with colour films, either for correction or for special effects.

Correction filters. There are two kinds of colour correction filters. Firstly a small number of often quite strong 'colour conversion' filters (Figure 9.21) allow you to shoot film balanced for one colour temperature in lighting of another. The second group consists of a wide range of mostly paler 'colour compensating' (CC) filters in six colours and various

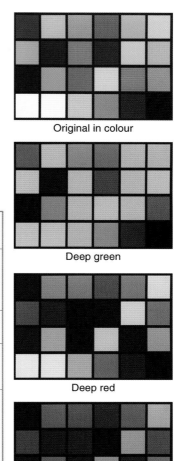

Original in colour

Deep green

Deep red

Deep blue

Uses of col. filters on B/W film	Exposure increase factors:	
	D/light	*Tungs.*
Deep red Darkens blue skies Turns red stains white Changes green against red into black against white	×8	×5
Orange Like red but less extreme	×4	×2
Yellow-green Tones down blue skies Compensates pan film oversensitivity to blues	×5	×4
Green Darkens blue skies Turns green stains white Changes green against red into white against black Helps reveal detail in landscape foliage	×8	×8
Blue Lightens blue skies Turns red stains black Changes blue against deep yellow into white against dark	×6	×12

Figure 9.27 Colour filters with black and white film. Colour chart photographed on panchromatic film through a deep green (top), deep red (middle), and deep blue filter (bottom)

strengths (Figure 9.28). These allow you to 'fine-tune' adjustments towards warmer or colder results due to batch variations, working conditions, non-standard light sources, etc. They are especially important with colour transparency materials, which, unlike colour negatives, cannot easily be adjusted at the printing stage.

Conversion filters with odd reference numbers are yellowish or orange, for lowering the colour temperature of the light (Figure 9.29). Filters with even numbers are bluish and raise the colour temperature. These set filters change a particular light source by the amount required for a particular film type. For example an 85B, which is orange, changes daylight to the colour equivalent of 3200 K tungsten lighting to suit tungsten-balanced film. An 81A,

Figure 9.28 Some gelatin sheet colour compensating(cc) filters. The numbers relate to their strength, the final letter to colour

Light source	Film type:	
	Daylight	**Tungsten**
Daylight	No filter	85B
Flash	CCY10*	85B + CC10Y*
Tungsten 3400 K	80B	81A
Tungsten 3200 K	80A	No filter
Tungsten 100 W lamp		82A
Fluorescent (basis of test)	CC40M	CC50R

*A few small flash units.

Figure 9.29 Colour conversion filters

much paler pink, changes the slightly too-blue light of 3400 K photolamps to 3200 K to suit the same film.

An 80A and an 80B filter (even numbers, and both blue) change 3200 K and 3400 K tungsten lighting respectively to match daylight and so suit daylight-balanced film. These are particularly useful filters because manufacturers offer so few films balanced for tungsten light. An 85B filter is always worth having in your camera case for roll, and 35 mm materials

if daylight scenes and tungsten-lit shots are likely to be recorded on the same film. If subject lighting is mixed (a tungsten lamp used to 'fill in' and reduce contrast in a daylight-lit interior, for example), you can use the filter in sheet acetate form over one source to match it to the other. (Avoid using a lighting acetate for the lens; its poor optical qualities will upset image definition.)

Colour compensating filters, on the other hand, are best bought as gelatins of various tints and strengths. The most useful ones are yellow, red and magenta, in CC10 and CC20 strength (used together these form a CC30). Filters are most often needed on the lens:

- When using light sources (such as some fluorescent tubes) for which no one colour conversion filter exists.
- To fine-tune your image colours, based on the appearance of processed slide film tests. If, for example, the test film shows a slight bluish shift, view it through yellow CC filters of different strengths until neutral midtone subject areas look neutral again. The rule then is to use a CC filter half this value over the lens when you reshoot.
- To help counter the effect of reflective coloured surroundings – green vegetation, room decorations, etc. – which may otherwise tint your subject.
- To give the scene an intentional slight all-over colour bias which strengthens mood, and helps blend and coordinate a colour scheme.

Colourless filters, used for both monochrome and colour films

Several important filters are equally useful whether you are shooting in black and white or colour.

Ultraviolet

UV-absorbing filters look like plain glass because they only absorb wavelengths our eyes cannot see. The sun's short-wavelength radiation is most readily scattered by particles in the atmosphere – a reason why distant haze in landscapes has a bluish appearance to the eye. On films, however, this scattered UV records as well, increasing the mistiness of haze and, on colour film, exaggerating its blueness. The effect is especially notable with landscapes at high altitude and near the sea. A UV absorbing filter therefore helps to record the subject appearance you actually *see*. Modern camera lenses often incorporate a UV absorber within their optics.

Better still, for colour films, use a 1A 'skylight' or 'haze' filter, which has a barely perceptible pink tint. It's worth having this filter on for all landscape work shot on reversal film, to prevent excess blue. (If you are using a warm-coloured filter this will also act as a UV absorber.)

Neutral density

These are grey, colourless filters which affect all wavelengths equally and just cut down the image brightness. They are made in various strengths in increments of one third of a stop (see Figure 9.30). An ND0.3 or ND0.6 filter is useful when you have fast film loaded but want to use a slow shutter speed (to create blur) or a wide aperture (for shallow depth of field), or just need to shoot in intense lighting without over-exposing. ND filters can be combined to increase their strength.

Ref. (density)	Allows you to increase		
	Aperture	or	Time
ND0.1	0.3 stop		×1.25
0.2	0.6		×1.5
0.3	1		×2
0.4	1.3		×2.5
0.5	1.6		×3
0.6	2		×4
0.7	2.3		×5
0.8	2.6		×6
0.9	3		×8
1.0	3.3		×10
2.0	6.6		×100

Figure 9.30 Neutral density filters

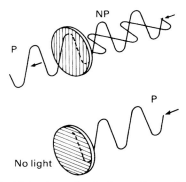

Figure 9.31 Polarized light. Top: Unpolarized light, shown vibrating in two of many directions at right angles to its path of travel, becomes restricted to one plane when passed through a polarizing filter. (It would be polarized this same way if reflected off a shiny non-metallic vertical surface.) Bottom: Polarized light stopped by a polarizing filter turned 90° to the light's plane of polarization

'Black' filters

Infrared-sensitive materials are usually used with a 'black' filter which appears to be opaque but in fact only allows the non-visible wavelengths to pass through it, giving the most extreme effects possible with the film. On SLR cameras the picture needs to be composed and focused before fitting the filter.

Polarizer

A polarizing filter also looks grey, and can be used as an ND filter, but has unusual extra properties which give it several applications. As Figure 9.31 shows, normal light waves vibrate in all planes at once at right angles to their direction of travel. Plane polarized light is restricted to one direction. Unlike some creatures, our eyes cannot tell the difference between polarized and unpolarized light, but polarized light exists around us – in light from parts of blue sky at right angles to sunlight, for example, or light reflected off any shiny non-metallic surface at a low

angle (about 33° to the surface). When using a polarizer to darken the sky, remember that the strongest effect is at right angles to the sun, and the effect may not be uniform if you use a wide-angle lens.

A polarizing filter has a special molecular structure. Think of its effect on light waves as like an egg slicer or narrow parallel railings: when its 'lines' are parallel to the plane in which polarized light is vibrating, light is transmitted, but when they are at right angles the polarized light cannot pass. In practice you look through the filter, rotating it until an unwanted reflection disappears, or the sky darkens, and so on.

Whole lake surfaces or every window of an office block can be cleared of reflected skylight if you have the right viewpoint. Blue sky can be darkened in colour as well as in black and white photography, making clouds prominent. The colour of glossy objects such as glazed ceramic or shiny plastic becomes more intense when the sheen they reflect from surroundings is removed, see Figures 9.33 to 9.36. If you are copying subjects like paintings behind glass, a polarizing sheet over each light plus another on the lens allows specular reflections off any surface, and at any angle, to be controlled (Figure 9.32).

Circular polarizers. Regular linear polarizing filters work fine on most cameras; however, on some SLR cameras they can upset the exposure-reading or focus-sensing mechanisms. If this happens you must use a circularly polarized filter instead (they have a similar effect on the image). Circular polarizers are more expensive so check your camera handbook for more information on whether your camera requires one.

Special-effects filters and attachments

There are dozens of different colour filters for special effects. Some are so strong and assertive that for many they are little more than novelty items which can distract from the picture rather than improve it, but others are more widely useful. 'Graduated' filters have a tint which fades off into clear glass halfway across the surface. They allow you to tint just the sky (or ground) in landscapes (see Figure 9.23). Graduates that are almost colourless or grey are the most useful for reducing light from the sky and so allow bright cloud detail to record at the same exposure needed for the foreground.

Always check the effect through-the-lens at your chosen *f*-number, because the aperture setting affects whether the change of colour will be very graduated or more abrupt. (Such filters cannot be used precisely with direct viewfinder cameras.)

Use fast film with deep-coloured effects filters. They cut down light considerably and you will want a choice of apertures for different results. Suitable subjects include relatively colourless scenes – clouded seascapes or open landscapes (particularly under snow), stone buildings, sand dunes, silhouettes and stark shapes against fairly plain backgrounds. Take care that objects such as trees or chimneys projecting into the sky don't get over-filtered and look unnaturally dark or coloured.

Attachments (Figure 9.38). Colourless special-effects optical attachments (they do not strictly filter anything out) include multi-image refractors, diffusers, and 'starbursts'. None of them calls for increase in exposure. Multi-image units are simply faceted glass discs which form an overlapping repeat pattern of part of the normal image formed by your camera lens. The number of images depends on the number of facets – typically 3, 4 or 5. The longer your lens focal length

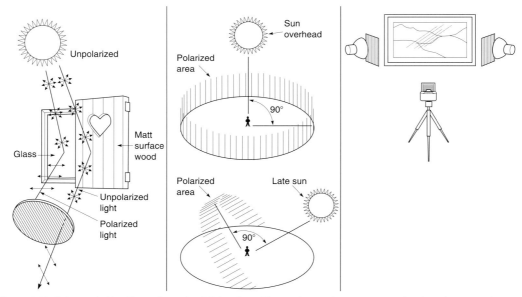

Figure 9.32 Using a polarizing filter. Left: To absorb light reflected from a glass window – most strongly polarized at 33° to the surface. Light scattered from the matt-surfaced wood remains unpolarized, and passes through the camera filter. Centre: Rotating the polarizing filter darkens parts of blue sky at right angles to the sun's direction. Right: All reflections removed from glass by polarizing the light from the lamps and fitting another filter (turned 90°) over the camera lens

Figure 9.33 Suppressing reflections with a polarizer. Left: Pattern of tables on a roof terrace with shiny brick flooring, no filter. Right: The same view, using a polarizing filter rotated to the position giving maximum effect

the farther apart these images are spaced. Such attachments must be deeply hooded from stray light, or image contrast will suffer.

Diffusers spread light parts of the image into dark parts, diluting shadow tones and colours, lowering contrast and helping to give an atmospheric, often high-key effect, like faint mist. 'Starbursts' have a grid of finely etched lines which turn brilliant highlights into radiating spokes of light like a star. The number of 'rays' depends upon the number and angle of the lines. Diffraction sometimes adds a slight colour effect too.

Figure 9.34 The effect of a polarizer on blue skies. Left: No filter. Right: With polarizer rotated to give the maximum darkening effect. Note how only the sky is affected

Figure 9.35 The effect of a polarizer on glass. Left: No filter. Right: With polarizer rotated to give the maximum reduction of reflection in the glass

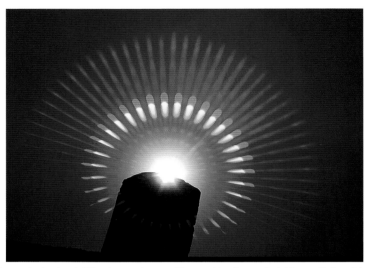

Figure 9.36 A rainbow or '*colourburst*' diffraction attachment adds a graphic effect to the brilliant spill of sunlight topping a simple post. (Take great care not to dazzle your eye looking through an *SLR* eyepiece unless the lens is fully stopped down.) An intense highlight in relatively dark surroundings is ideal for giving brilliant spectral patterns, but can be used in a variety of ways

Other lens attachments have finely etched lines to create 'rainbow' effects around brilliant highlights by diffraction of light (Figure 9.38). It is vital to have one or more really intense point light sources in the picture – the sun, spotlights, or speckled reflections from water – otherwise these attachments just give a slightly diffused low-contrast image.

Effects attachments are helpful for enlivening dull product shots or giving a dynamic edge to music photography, etc. But be careful not to overuse them. Like the effects menus offered in digital manipulation software programs (Chapter 14), they should be used with care. It might be worth asking yourself if an image needs such effects to enliven it; is it good photography in the first place!

Filter kits

The most useful filters are also the most versatile – for example a polarizing filter and a UV or skylight/haze type, both of which are best in glass form. For colour work you should carry appropriate colour balance conversion filters, plus a few CC types. Medium red (or orange), deep yellow, and green filters in either gelatin or glass are the most useful for black and white, although warmer colour-conversion filters may do double service for some of these. The most versatile 'effects' filters could be a couple of different strength graduates in either pale grey or brownish tint, to reduce sky over-exposure and warm up grey clouded landscapes.

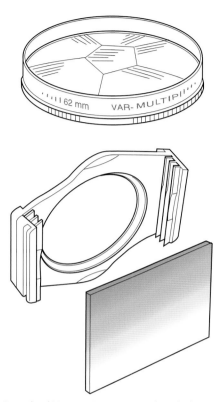

Figure 9.37 Effects attachments. Top: Faceted multi-image unit. Bottom: Graduated tobacco tinted filter, for skies in landscapes, etc. The holder for the square filter allows adjustment of its positioning up or down, to suit the placing of the horizon (see Figure 9.23)

■ Camera films have silver halides, plus gelatin and other additives, forming a light-sensitive emulsion coated on a plastic base. The manufacturers form emulsion 'recipes' giving different levels of grain size, resolution, speed and contrast (all inter-related), and the material is sensitized to chosen bands of the spectrum.

■ Exposure in the camera forms a *latent* image. Later this is amplified by chemical processing to give a visible, permanent result.

■ Light sensitivity or 'speed' is mostly quoted as an ISO rating – containing one figure which *doubles* with the doubling of speed, and another (with degree sign) which *increases by three.* The speed can be varied from the given figure by altering processing times.

■ Most black and white films have full-spectrum panchromatic sensitivity. Ortho materials are insensitive to red wavelengths.

■ Slow films have finer grain, better resolution, and slightly more contrast than fast types. Line and lith films give extreme contrast, when appropriately developed. Some monochrome films which produce a final negative image in dye rather than black silver are processed in the same chemicals (C-41) as colour negatives. You can also shoot 35 mm black and white slides by special processing of monochrome negatives – and larger-format instant prints and negatives. Infrared and SFX films give dream-like landscapes and strange portraits.

■ Colour film emulsion layers are effectively sensitive to blue, green and red light. Colour negative film contains couplers, forming negative images in complementary yellow, magenta and cyan dye during chromogenic developing. Slide and transparency colour films first form black and white negatives, then the remaining emulsion is processed into Y, M, C dye images, finally creating a positive result.

■ Colour film emulsions are balanced to suit set light sources. The two main types are for daylight/flash, and for 3200 K tungsten lamps.

Use each type for other white light sources with a colour conversion filter over the lens or light source. Negative materials allow you farther adjustment during printing.

■ Many faster colour and monochrome films can be exposed at a higher ISO rating, then push-processed to give the effect of even higher sensitivity.

■ Instant-picture materials include colour or monochrome prints (integral or peel apart) and monochrome negatives.

■ 'Professional' films are more finely adjusted in performance than amateur types; often marketed in *natural* and *vivid* colour image strengths, geared to subject and aesthetic preference.

■ Slide and transparency ('reversal') colour films are less tolerant of exposure error, and give more contrasty images than colour negatives. Daylight type film needs a bluish (80A) filter in tungsten lighting.

■ Colour filters (gelatin, glass or acetate) *lighten* the tone of subjects their own colour, and *darken* complementaries when used with black and white film. The richer the colour of the filter and subject, the stronger this effect.

■ Colour correction filters are used with colour films to convert the colour temperature of the subject lighting to suit the colour balance of the film.

■ Colour compensating (CC) filters allow you fine adjustment of colour balance for correction or mood. Graduated, split, colour spot, diffraction and other tinted lens attachments give special colour effects.

■ UV, neutral density and polarizing filters, and many colourless effects attachments such as multi-image, diffusers, and starbursts, are usable for both black and white and colour work. Polarizers can darken polarized light from a blue sky, or reflections off shiny (non-metallic) surfaces. The effect varies according to the direction of your subject lighting and the angle you rotate the filter to on the lens.

■ Get really familiar with the practical performance of a selected range of films.

Establish a technique which makes the most of your materials. Remember you can check your equipment, technique and composition as you shoot, via instant prints.

■ When you choose your film for a job it should match up to type of subject, lighting, and the size and form of the final image required.

■ Protect all film from excess humidity, chemical fumes and X-radiation. Refrigeration reduces the deterioration process, allowing films to be stored for long periods, but allow films to warm up slowly to avoid condensation problems. Note that although airports claim their X-ray machines will not harm film, it is preferable to opt for a hand search if possible.

1 Test the effects of different films. As a starting point try a slow (ISO 100 or less) monochrome film and a fast one (ISO 400 or more) and photograph a similar range of subjects. Try a similar pair of different speed colour films, perhaps from two different manufacturers. To experiment farther, try pushing films to a higher speed or try infrared or other specialist types.

2 Check the visual effects of colour filters. Set up a slide projector in a darkened room and either use its light to illuminate a colourful poster, or simply project a slide containing many strong colours. Use a series of deep colour filters (see Project 3) in turn in front of the lens and notice which parts of the poster or slide image darken/lighten in tone.

3 Check colour casts. Using a *daylight* slide film, shoot subjects (1) in daylight, (2) in tungsten light with and without an 80A filter, (3) in fluorescent light with and without a correction filter for the film (see Figure 9.29); also (4) in daylight with an 85B filter. Using the same subjects, try shooting the same sequence again on a *tungsten* light film. Compare processed results – examine the distorted colours given by mismatching, and consider them for creative effects.

4 Explore the effects of a polarizer. A lot can be explored by simply viewing things through the filter, but also shoot pictures with and without the effect for comparison.

PROJECTS

This chapter looks at what 'correct' exposure means and what we should aim for using different films. It discusses equipment for measuring and setting exposure, their different modes of use, and how to avoid mistakes with problem subjects. Shooting with flash brings in its own exposure features, discussed towards the chapter end. Although film is featured throughout, most of these exposure topics apply equally to digital cameras too.

Films or digital image chips need to receive just the right amount of light to record an image. If insufficient light reaches them they record nothing, or a dark, partial picture. Similarly, too much exposure results in a bleached, washed-out image or just a white blank. Strictly speaking, 'giving the right exposure' means capturing the correct amount of image light (photons). In practice it is much more than this. Exposure can be used to give emphasis, by deliberately over- or under-exposing parts of the scene such as backgrounds to draw the eye towards the main subject or particular areas and therefore affect composition. Exposure control is also the key to getting fine tonal qualities in your final pictures, whether prints or slides. Finally the actual way you give exposure, via chosen permutations of lens aperture and shutter speed, has important side-effects on the image. As shown in earlier chapters, these strongly influence the appearance of things at different distances and the way that movement is recorded.

The exposure measuring and setting help provided by the camera itself varies considerably. At one extreme, a fully automatic compact will measure the light and instantly set controls according to a built-in program, without even telling you what is going on. Total automation ensures a high percentage of accurate exposures with 'average' subjects, but takes many creative decisions out of your hands.

At the other extreme most large format cameras offer no light-measuring facilities, leaving you to make all the decisions on shutter and aperture settings by measuring the light with a separate hand-held meter. The middle ground is catered for by cameras with in-built metres but manual (or semi-automatic) controls.

Factors that determine what exposure to give

The main factors that should be taken into account when measuring light and setting exposure are:

1 *Lighting.* The intensity and distance of the light source, including any light loss due to diffusers, acetates, etc., or atmospheric conditions between source and subject. The range of brightnesses (contrast) needs to be within the film's tolerance range if full detail is to be recorded.

2 *Subject properties.* How much your subject reflects the light – its tone, colour, surface, from a black cat in a coalstore to a milk bottle in the snow. The meter cannot tell what the subject is and so its readings need to be interpreted so light and dark subjects such as these are recorded well.

3 *Film speed.* The ISO speed rating used, together with any alterations necessary due to film colour sensitivity relative to subject light source (p. 202) or if using extremely long exposure times; see reciprocity failure (Appendix C).

4 *Unusual imaging conditions.* Light absorption due to lens filters and attachments, or an image made dimmer by extending the lens forward to focus close-ups (see p. 249).

On top of these come important interpretative or subjective considerations. For example, would it improve the picture to expose wholly for the brightest parts of the scene and make darker parts black; or expose for shadows and let light parts 'burn out'? These judgements can only be made by you, and are carried out by over-riding the camera's settings.

The chosen exposure is delivered to the film by a combination of:

• *Intensity (image brightness):* controlled by the lens aperture. Bear in mind that this choice will affect depth of field, and to some extent definition.

• *Time:* controlled by the shutter speed. This influences the way any movement of subject or camera will reproduce, and the spontaneity of expression or action.

Putting into context the information on 'aperture and *f*-numbers' in Chapter 3 (p. 50) and the 'shutter' in Chapter 4 (p. 68), one of the most important things to remember about setting exposure is the relationship between the two. As Figure 10.1 shows, intensity and time – aperture and shutter – interrelate. Within limits (Appendix C), halving the intensity (*f*-stop) and doubling the time (shutter speed) maintains the same total of photons of light energy reaching

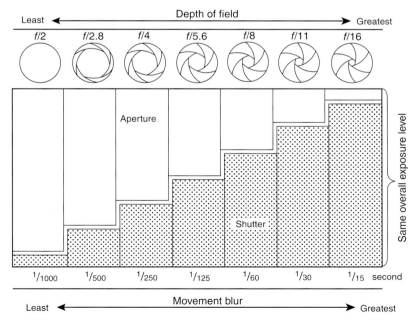

Figure 10.1 Aperture/shutter speed relationships. Identical exposure can be given through a range of intensity/time settings. For example, each combination here will give the same light effect to the film. With a manually set camera you can choose between them, paying attention to depth of field and blur effects

the film (the same amount of light/exposure hitting the film/CCD), as would twice the intensity and half the time. If we put Figure 10.1 into practice we can see the result that these ranges of settings have on two very different situations. The same overall exposure level occurs and therefore we can say that they are all the 'correct exposure'.

In Figure 10.2 we have a static subject, a still life photograph the camera is fixed on a tripod to reduce the possibility of camera shake at slow shutter speeds. For this image the priority is depth of field and how much of the subject is required to appear in focus in the final photograph. In the second set of images (Figure 10.3) the priority is shutter speed because we are dealing with a moving subject. The subject is running in a flat plane across the camera lens, although depth of field will play a role, on the whole, with this image the figure should be in focus across the range of settings we use. For this test the camera is again fixed on a tripod to reduce camera shake at slow shutter speeds; however, the effect of these different shutter speeds, unlike is for the still life image, made apparent in the final photograph. The faster shutter speeds manage to freeze frame the action in mid flow, while the slower shutter speeds mean that the subject appears as a blur. In your normal day-to-day photography it is unlikely that you will always have to deal with such extreme subjects but you will have to decide on a balance between time and intensity, making a decision as to whether depth of field or movement is the key concern.

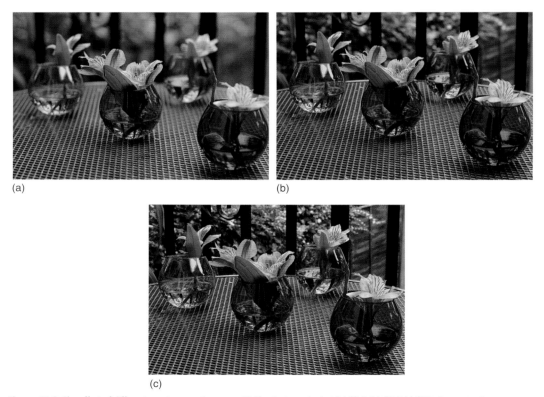

(a) (b)

(c)

Figure 10.2 The effect of different apertures on the same still life photographed at (a) f/3.2 (b) f/9.0 (c) f/22, demonstrating an increase in the depth of field – how much of the image is in focus, in particular look at how the background has become sharper

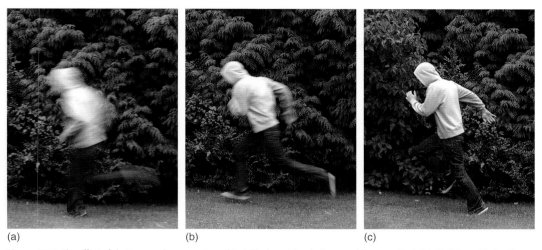

(a) (b) (c)

Figure 10.3 The effect of shutter speed on a moving subject. The lower the shutter speed the more likely it is that the subject will become blurred, and the faster the shutter speed the sharper the subject appears (a) 1/15, (b) 1/60 and (c) 1/125 s

Exposing different film types

Film manufacturers aim for a product which gives you: good image quality and wide tolerance (to exposure errors, wrong colour lighting, etc.) and records the picture in such a way that it is easy to successfully print onto paper. But the requirements for best exposure vary according to film type – monochrome or colour, negative or slide.

Black and white negatives

The more exposure this film is given, the denser the image tones in the processed negative become, until all the image silver is retained and it becomes completely black. Figure 10.4 shows how progressive increases in exposure makes all tones grow darker. Subject highlights such as skies and bright reflections are the first to become solid and lose their details. Then this quickly spreads to mid-tones and finally to shadows. You often find too that, when enlarged, grain is more apparent in overexposed negatives and general light spread throughout the emulsion reduces sharpness.

Going the other way, under-exposure makes subject shadows reproduce so 'thin' they lose their detail, becoming indistinguishable from the clear film edge ('rebate'). Then the same fate occurs to mid-tones, and finally to subject highlights too.

Results like these can be shown on a graph called a 'characteristic curve' for the film (see Figure 10.5 and Appendix D) with image light intensity values from shadows to highlights along the bottom axis ('Log relative exposure') and final tonal density from palest up to darkest parts of the negative along the other. 'Correct' exposure should place all the image light intensities as densities on the lower part of the curve, yet not below the point where it flattens out, showing that densities are no longer separable and detail disappears.

The more contrasty your scene, the more accurate the given exposure must be – for it will then take less over-exposure error to bring highlights into the state of being too dense, and less under-exposure to make shadows too thin (see Figure 10.6). These conditions are said to offer least exposure latitude.

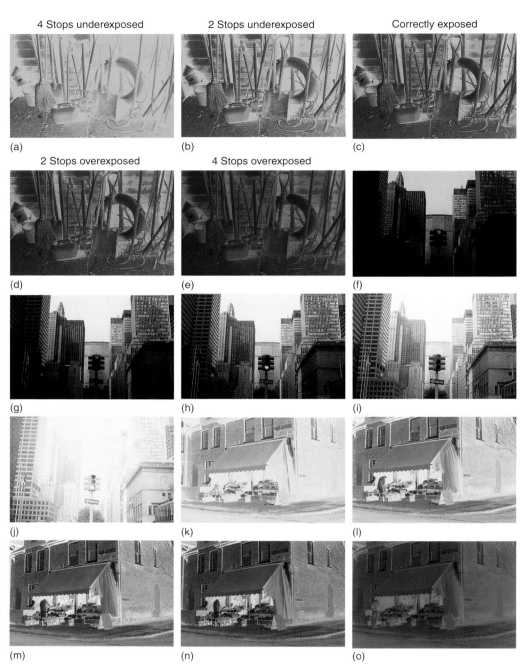

4 Stops underexposed (a) 2 Stops underexposed (b) Correctly exposed (c)

2 Stops overexposed (d) 4 Stops overexposed (e) (f)

(g) (h) (i)

(j) (k) (l)

(m) (n) (o)

Figure 10.4 How exposure affects image appearance. In these three strips each image was given four times the exposure of the one to its immediate left. (a) is grossly underexposed and (e) is grossly overexposed. The subject is correctly exposed in (c). Top row: Colour negatives. Notice how shadow details become indistinguishable from clear film ('off the toe of the curve') in (a). In (e) highlight detail and colours are choked. Middle row: Colour slide film. Being a reversal material under-exposure (f) gives dark, detail-less shadows which also lack colour. Overexposure (j) bleaches all but the subject's darkest shadows. Bottom row: Monochrome negatives. Like the colour negative subject shadow details in (k) are missing – these areas will print as flat grey. Overexposed (o) has flattened contrast, mid-tones and highlights too dense

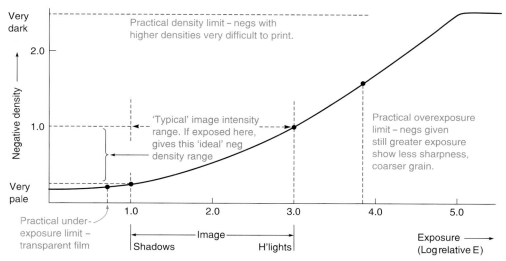

Figure 10.5 Characteristic curve of a monochrome negative film. Every image is a *range* of light intensities, so highlights are shown farther right than shadows on the exposure scale here. When an image is *overexposed*, its shadows-to-highlights values all shift right and so record as denser on the negative, although shadows may still just fall within the ideal range. When it is *underexposed*, values shift left, showing resulting densities are too weak, although highlights may still be acceptable. Compare with Figure 10.4

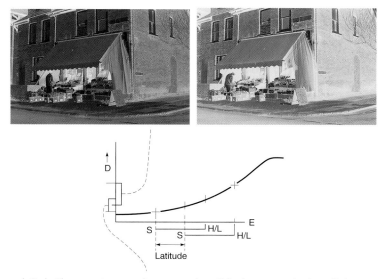

Figure 10.6 Exposure latitude. The amount you can alter exposure but still (just) get a negative that will give an acceptable print. The more extreme the difference between shadows (S) and highlights (H/L) in your image, the less latitude you have in exposing without exceeding ideal limits

Colour negatives

A correctly exposed colour negative should meet requirements broadly similar to those for a black and white negative. However, if anything it is even more important to avoid under-exposure – as thin negatives are difficult to print, empty shadows often print with a different

colour cast, and since there is limited choice of contrast grade with colour paper (see *Advanced Photography*) it is difficult to prevent thin negatives printing grey and flat. Processed colour negatives are also deceptive in appearance. The presence of the overall orange mask tint makes you think the image is denser than it really is. It may help if you assess negatives holding a piece of processed, unexposed film (as at the start of a film) close to your eye as a filter.

Published data for colour negatives shows three colour negative characteristic curves (Appendix C), one for each of the blue, green and red responding layers. If the film were to be exposed to light of the wrong colour balance without a correction filter one emulsion would become effectively faster than another. Within limits this may be corrected by filters during colour printing. However, with a wide-tone-range (contrasty) scene, shot at incorrect colour temperature, it may even be possible for one of the emulsions to have underexposed, low-contrast shadows while at the same time another has overexposed highlights. Printing will not correct the distortion this gives. So bear in mind that colour negative films when shot in lighting of the wrong colour have less exposure latitude than black and white negative films. Colour films are relatively tolerant of over-exposure, many photographers exploiting this deliberately to improve colour saturation, but care should be taken with subjects with bright highlights such as pale skies or they will 'burn out' (see Figure. 10.4).

Slides and transparencies – colour or black and white

Positive images on film are much easier to judge for exposure, as the picture does not need the second interpretive step of printing. You can also make a direct comparison with what you remember of the original scene. As Figure 10.4 shows, the more exposure you give these reversal-processed films, the *lighter* your result – with highlights especially becoming bleached of colour and tone. Under-exposure has a darkening effect, particularly of subject shadows where colours eventually become engulfed in black. Of the two, overexposure is generally more objectionable than under-exposure. This is partly because we tend to 'read' pictures by their light parts and accept dark shadows more readily than burnt-out highlights. Again, a dense transparency is more acceptable for colour printing or scanning into digital form for printed reproduction than one where light parts of the image are literally missing.

The published characteristic curves of reversal materials (Appendix C) slope the opposite way to negative films, and have a steeper angle. In practical terms this means they are more contrasty, desirable in images that must look bright and rich in tone when projected as slides or displayed with back-lighting. However, such a characteristic means you have less room for exposure mistakes. Overexposure very quickly bleaches your image's highlights and pale areas into detail-less clear film; under-exposure brings its shadows down to impenetrable black. Slides and transparency materials therefore demand more accuracy in measuring exposure – they offer less exposure latitude than regular colour or black and white negative films. And as with all films, this shrinks still farther when the picture you are recording contains strong contrasty lighting.

Digital CCDs

Digital camera CCD chips are sensitive to light over a wider range of intensities than are film. All but the most basic digital cameras have settings which allow the sensitivity to be set, typically in the range of ISO 100–800 or more (see Chapter 6). Slight over and underexposure is therefore

less problematic, particularly if shooting RAW images, but note that image colour, contrast and 'noise' all deteriorate with incorrect exposure.

'Bracketing' and clip tests

The simplest insurance against error, if circumstances permit, is to make several 'bracketed' exposures. With black and white film take one picture using the settings you expect to be correct, and then shoot others one stop either side, giving half and twice this exposure. With colour negative film, bracket using closer increments, and shoot one frame a half stop under-exposed, plus frames half a stop and one stop overexposed. For slides and transparencies, bracket at half stops too, but erring more towards under-exposure than over-exposure. If your camera has an exposure compensation dial (p. 247) the quickest way to bracket is by turning this to the required + or – settings. Better still for difficult scenes, several advanced 35 mm and digital SLRs offer 'auto-bracketing'. In this mode one press on the release exposes a burst of 3 or 5 frames in quick succession, each at a different exposure setting. You preset the increments ranging from one third to twice the measured 'correct' exposure.

Farther modify your bracketing routine according to the exposure latitude. For example, a contrasty image (strong lighting and/or a subject with strong inherent contrast) will give absolutely minimal latitude. You should therefore take more bracketed exposures with smaller differences between each. Reverse this approach if exposure latitude is exceptionally wide.

With most materials you can gain farther protection by planning out all or part of one film as test exposures, to be processed and examined first. Use an extra 120 magazine back, a separate 35 mm body or marked sheet-film holders to accumulate one extra anticipated 'correct' exposure of every subject you shoot during a day's location work, additional to your main run of exposures. Process this test set of shots normally and check them to decide which, if any, films will need adjusted processing (p. 282). Alternatively, make sure you include three bracketed exposures at the start of a 35 mm film or end of a 120 roll. These are then easily clipped off and test processed (a service offered by most professional labs) to decide any changes required for the remainder of your film.

Measuring exposure (continuous light)

The normal way of finding correct subject exposure is by measuring with a hand meter or some form of light meter inside the camera. Learning how a hand meter is used will help you understand the built-in meter as they both work along similar lines.

Tables and guides. Don't overlook that simple table of recommended exposure settings packed with your film (see Figure 10.7). Some day your meter or camera may not be working. Another emergency routine to remember is the following:

> *Use one divided by the film's ISO (arithmetic) speed as your nearest shutter speed. Then set f/16 for bright sun, or f/8 for cloudy-bright conditions or their equivalent, e.g. with ISO 100 film use 1/100 or 1/125 s at f/16 for a sunny day, opening up to f/8 for cloud. This is sometimes known as the 'Sunny 16 rule'*

The trouble with tables and guides is that they deal with subjects and situations only in the broadest terms. Tables that try to be more comprehensive often end up becoming

Bright or hazy frontal sunlight, pale sand or snow surroundings	$^1/_{125}$	f/16
Outdoor open setting, cloudy bright (no shadows)	$^1/_{125}$	f/8
As above but heavily overcast	$^1/_{125}$	f/5.6
Outdoors, open shade	$^1/_{125}$	f/5.6
Indoors, domestic interior by existing (hazy) daylight	$^1/_{125}$	f/4
Shop interior, fluorescent tubes	$^1/_{30}$	f/2.8
Indoors, domestic incandescent lamps	$^1/_{15}$	f/2
Light trails from traffic at night, fairgrounds	10 sec	f/11
Floodlit sports arena	$^1/_{60}$	f/2
Portraits by street lighting	$^1/_{30}$	f/2
Landscape lit by full moon	30 sec	f/2.8

Figure 10.7 Simple exposure guide – for an ISO 100/21° film

incomprehensible. Once you are familiar with your camera and get to know the film you use most regularly it can become easier to make your own judgements on exposure if necessary.

Using built-in metres – how they work

An exposure meter built into the camera has a tiny electronic light-sensitive cell measuring your subject, or the image itself, and is able to transfer its readout direct to aperture and shutter settings. In most compact cameras the cell faces the subject from behind a window alongside the lens or viewfinder (Figure 10.8). SLR cameras measure image light directly through-the-lens (TTL), so taking into account the effects of close working, filters, etc., as well as metering exactly the area of the scene framed.

Figure 10.8 The light-measuring cell of the meter built into a basic compact camera. This gives a direct, overall reading of your subject. (Take care not to obstruct it with your finger or the camera will over-expose)

Several cell positions can be used within an SLR body. One or more cells may view the image on the focusing screen (from above the pentaprism eyepiece, for example) while another below the mirror looks up towards the film. The 'off the film' (OTF) cell views the image as it appears on a reflective pattern on the front of the shutter blind, and on the emulsion itself after the mirror has risen and during exposure. This allows it to measure and control the period of a time exposure as it actually takes place, as well as flash exposures (p. 255).

In the commonest design, light passing through a semi-silvered part of the main mirror is reflected downwards to light sensors located in the base of the camera (Figure 10.9). Advanced cameras have here a honeycomb or 'matrix' of several cells arranged to measure different parts of the image area, giving them different priorities – more in the centre than the corners for example. And by selecting 'spot' metering mode only the very centre cells sample light, so you can measure from a small chosen area (Figure 10.10).

Usually you switch on the meter with a half pressure of the shutter release (it switches itself off later after a timed period). Some compact cameras have a lens and viewfinder shield you

Figure 10.9 Various light-measuring cell locations designed for through-the-lens metering in SLR cameras. (A) Viewing most of the image from above the SLR eyepiece or pentaprism. (B) Reading through a semi-silvered part of the mirror. (C) Reading light reflected off the shutter blind or film once the mirror has risen

slide open to switch on the meter and unlock the shutter release. Output from the light-sensing cells feeds to an internal microchip central processing unit. This also receives information from other parts of the camera, namely the ISO speed either set manually or read off the film cassette, any exposure compensation setting you may have given, the *f*-number set on the aperture ring, and/or the shutter speed chosen. The CPU computes this information and typically sends control signals to aperture and/or shutter, as well as displaying the required settings alongside the internal focusing screen and on top of the camera body (see Figure 10.11).

To make full use of built-in metering it's helpful to understand (a) the area of your picture being measured, and (b) the effect of different 'modes' your camera offers to translate light readings into shutter and aperture exposure settings.

Measuring area

Most metres built into compact cameras take a 'centre-weighted' averaging light measurement of your subject. This means that the reading is influenced more by central areas and least by the corners of the picture. Precise layout of this 'sensitivity map' (Figure 10.12) varies in different SLR cameras – some pay more attention to the bottom of the (horizontal) frame to reduce sky influence in landscapes. Overdone though, this creates problems in other, upright, pictures. Centre-weighted measurement is surprisingly successful, but you must still remember that largest areas of tone in your picture have greater influence than smaller areas. Learn to recognize your composition's key tone, such as face skin tone in a portrait. Then if necessary make it fill up more of the frame just while the reading is taken (see p. 245).

Advanced SLR systems measure by multi-segment ('matrix') metering (Figure 10.13). The various outputs from different parts of the frame are then compared against an in-built computer program based on thousands of sample images from manufacturers' field trials. 'Fuzzy logic' fills in gaps in the sampling process, essentially guessing what sort of picture you are taking. For example a dark object in the middle of the frame with much brighter areas above and

Figure 10.10 Spot reading. In this mode you must carefully choose and align one or more subject areas you wish to read – in this case skin tones and shoulder highlights within the marker on the focusing screen

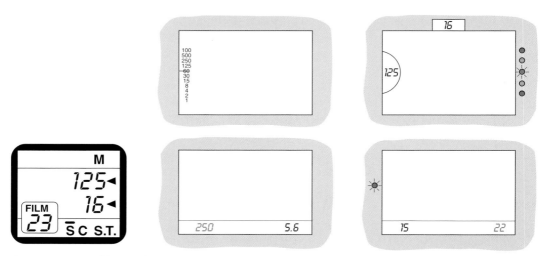

Figure 10.11 Some of the ways the settings made by a light reading are signalled in the viewfinder (or LCD body top panel, above) of different SLR cameras. Top row: Camera in aperture priority (Av) mode – the meter needle shows what shutter speed it has set. Right: Manual mode – you alter either shutter speed or aperture, until OK signal (green diode) lights up. Below, centre: Alternative way of displaying (in green) the meter's setting in Av mode. Below, right: The same display when in shutter priority (Tv) mode. You set shutter speed and the camera now sets aperture. The red signal here warns of the risk of camera shake at 1/15 s

Figure 10.12 Exposure meter measurement area. 'Contour lines' show the relative distribution of light sensitivity across the picture format. Here the system is centre-weighted – most influenced by subjects composed centrally

Figure 10.13 A multi-sensor chip located in the base of an advanced SLR. This evaluates image brightness based on 21 sampling areas. According to the mode you pick light measuring ranges from overall averaging to centre spot reading

either side is likely to be interpreted as a back-lit portrait. The meter software therefore biases the exposure more towards the centre of the frame as it thinks this is the most important subject area. Some cameras additionally offer you the option of spot metering, which measures only within the small area shown by a circle or rectangle in the centre of the focusing screen. You can then align this spot and get the camera to hold this reading. Or take separate readings of darkest and lightest key elements (Figure 10.10) and the metering system averages between the two. (See also Spot metres, p. 248.)

Exposure setting modes

Fed by the light measurements and the other exposure information it needs, the camera's central processing unit (CPU) makes its choice of settings in various ways, according to 'mode'. Some cameras offer only one (typically auto-program) mode, others a choice of four or five that you select according to shooting needs and personal choice. Each offers its own advantages.

So-called *manual mode* is the most basic and flexible arrangement. You turn the camera aperture and/or shutter speed controls, and the meter signals when a combination will give correct exposure. For instance, you can set the shutter to 1/125 second (for hand-holding) and then change

apertures until a signal – such as a green light beside the focusing screen – lights up. Or you could set f/16 for depth of field and then change shutter speeds until the same OK signal is given. Importantly, manual mode allows you to over- or under-expose the shot you are taking as much as you like. The meter will advise what it thinks is correct exposure, flashing red or amber lights, or + or – signs if it disagrees with your choice, but the camera will always fire on your settings as you are in charge (see Figure 10.11).

Aperture priority (Av) goes a step farther – saving time if you must work at a particular aperture, perhaps after having checked depth of field with the lens preview button depressed. In this mode you set the aperture and the camera automatically sets the shutter speed required for correct exposure. The arrangement can be very helpful for close-ups, where depth of field is critical, and also for night-shot time exposures (most cameras can set up to 30 seconds or so). This mode will also handle a very wide range of light-intensity conditions, since cameras offer far more potential shutter settings than f-numbers. However, you may easily discover that you are hand-holding the camera at a slow shutter speed, resulting in blur.

Shutter priority (Tv) mode works the other way around. You set shutter speed and the camera selects the lens aperture to be used when you take the picture. (As with most modes, a signal warns if the exposure required is over or under the setting range available to the camera, in which case you should set a different shutter speed.) Shutter priority is useful for sports work and any action or interpretative photography where you must maintain control over the appearance of movement. Or it may be just that you prefer to shoot a hand-held series at a safe 1/125 second, or 1/250 second with a longer lens, and accept whatever depth of field lighting conditions permit.

Programmed modes allow the camera to take over both shutter and aperture settings, running through an intelligent program – from shortest time/smallest aperture, to longest time/widest aperture, according to inputs of light reading and film speed (shown in Figure 10.14 as exposure values). The chart illustrates a typical standard lens program in which there is a progression of both shutter and aperture changes until, with decreasing light, the lens's widest aperture is reached (in this instance f/1.4). From here onwards exposure time only increases, usually accompanied by a camera shake warning light at speeds slower than 1/30 second (Figure 10.15).

Programs like this are often built into compact cameras as hidden systems which do not reveal to the user any technical information other than giving 'shake' and 'out of range' warnings. They are sufficiently effective for most general photography subject conditions.

On SLR cameras, however, having one standard program may not be suitable when you use telephoto or wide-angle lenses. Some cameras therefore offer two additional programs – 'tele' and 'wide'. As Figure 10.14 shows, on tele the camera reacts to decreasing light by maintaining fast shutter speeds as long as possible, to counteract the ever-present risk of image blur with long-focal-length lenses. When wide is selected the camera makes equal alternating changes of aperture and shutter speed, bearing in mind that camera shake is less likely. This choice of program is either left to the user, or may be selected automatically when you fit on a telephoto or wide-angle lens.

Other modes (often indicated by little icons of people, mountains, athletes, etc.) offer bias for portraits (hold the aperture as wide as possible to blur backgrounds), landscapes (meter reads off the whole scene, shutter speed range biased for a static subject) and sports (fastest shutter speeds held for as long as possible to freeze action), etc.

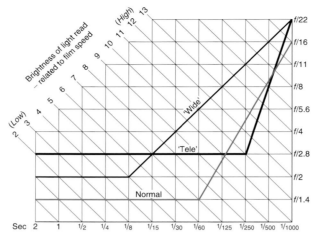

Figure 10.14 Typical exposure auto-program for a camera with *f*/1.4 standard lens. Working from top to bottom of the green graph line, as scene brightness drops (the exposure needed increases) the program progressively widens the aperture and slows the shutter speed. Note speeds safest for hand-holding are retained until *f*/1.4 is reached. Camera may signal 'shake' or 'use flash' at 1/30 second and slower. If you select '*Tele*' program instead (shown here for a lens of *f*/2.8 maximum aperture) shutter speeds of 1/250 second or faster are held as long as possible. '*Wide*' program (*f*/2 lens) pays equal attention to aperture and shutter changes

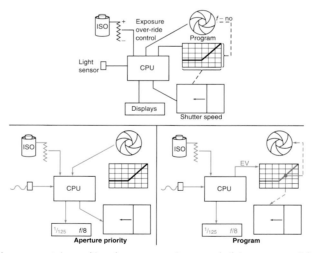

Figure 10.15 Top: The main components in a multi-mode exposure setting system built into a camera. Below left: Set to 'aperture priority' mode. Light reading, film speed and your chosen *f*-number are input, and the CPU translates this data into the correct shutter setting. Your aperture and the camera's chosen shutter speed are also displayed. Below right: Set to 'program'. The CPU inputs light and ISO data, and outputs a figure to a program (see Figure 10.14), which then sets the most suitable shutter/aperture combination

In practice, having a multimode AF camera will probably mean that you rarely use more than two or three of these options. The most popular modes tend to be manual and aperture priority. A fully auto-program is handy for rush situations, while shutter priority is preferable if you do much action-freezing photography or use telephotos hand-held. In all modes it's helpful if the camera displays what lens and shutter settings are made, to allow you to pre-visualize and if necessary over-ride the effect of aperture and shutter on picture appearance.

TTL metres that are built into 120 rollfilm cameras or form add-on accessories to view cameras are less comprehensive than 35 mm types. Most medium format SLRs, for example, offer a system providing centre-weighted measurement and a choice of either manual or aperture-priority setting modes. A TTL meter for view cameras (Figure 10.16) uses a probe you move around the image plane to make spot readings. However, for the most part medium- and large format cameras are still used in conjunction with a separate, hand-held exposure meter.

Using a hand-held exposure meter

Although most commonly used by professionals working with large- or medium format cameras, hand-held metres are simple to use and can be very useful for achieving accurate exposures from images with complex lighting. They also allow you to take reflective and incident readings. Many give readings for a continuous light source (what is generally meant by a hand-held meter) as well as being designed to work with electronic flash (generally known as a flash meter, see p. 257). With most models (Figure 10.35) you feed in either the f-number or the shutter speed you want to use and the film ISO speed, and then a digital display on the meter shows the appropriate shutter speed or f-number with which they should be paired.

A traditional basic meter (Figure 10.17) is a self-contained unit with a small light-responsive cell behind a lens-shaped window. This sensor forms part of a circuit including a battery and current-measuring device. Essentially you program the meter with the ISO speed of your film or CCD, point it towards the subject, and read off the exposure required. To do this last part you note the number picked out by a needle moving over a scale, and set this against a pointer on a large dial. The dial lines up a complete series of f-numbers against a series of shutter speeds. Each combination will give correct exposure – you are left to choose any of these paired settings according to depth of field and image movement considerations.

Figure 10.16 An add-on meter for a 5 × 4 inch view camera. This is carried on an open frame the same size as a film holder. The movable probe then allows selective 'spot' readings from any chosen parts of the picture area

Reading the light

There are several ways to take readings with a hand meter, according to working conditions and personal preference. These are: (1) a general or 'integrated' reading of the subject, (2) two or more 'brightness-range' readings of the subject, (3) a grey-card reading, or (4) an incident-light reading of the light source. (Methods 1–3, which all measure reflected light, can also be carried out with a TTL camera meter.)

1 *For a general reading*, you just point the meter from the camera position towards your subject. The meter's angle of view usually approximates that of a standard lens, so it 'sees' a similar area of the scene. The meter takes an average from all the various light values from the brightest areas to the deepest shadows. It then gives an exposure reading that would place this single imaginary 'average brightness' about midway between under- and over-exposure on the characteristic curve.

Figure 10.17 Hand meter. Top: A light-sensitive cell behind a circular window in the centre of the front end gives general, reflected light readings. The white plastic dome slides over this window for making incident-light readings. Bottom: The large calculator dial must be programmed for film ISO speed. The numbered light reading shown by the needle is next set in the 'SCALE' window. You can then read off shutter settings against f-numbers at top of dial. Note that some models also measure flash and/or have digital displays. See Figure 10.35

Like using a compact camera with an overall reading meter, the trouble with a general reading is that the most important element in your picture is not always the largest. The face in a portrait may occupy less than 50 percent of the picture area, the rest being background (Figure 10.18). In one version you might use a dark background and in another a much lighter one, without any change to the illumination on the face. Yet the meter, taking over 50 percent of its reading from the background in each case, will give low reading for the first shot and so over-expose face skin tones, and a high reading for the second version making the face underexposed.

A general reading is therefore only satisfactory if your shot has a fairly equal distribution of light and dark areas in which you want detail: subjects like Figure 10.19 (left), for example. It often works with softly lit landscapes (tilt the meter down slightly to read less sky and more land, if this is where details are more important). Another problem is that zooming or changing to a different focal length lens can make camera and meter have very dissimilar angles of view. Used from the camera position the meter then reads a larger or smaller area than is included in your picture.

2 *For a brightness-range reading*, you first decide which is the lightest and which is the darkest part of the scene where detail must still just record. Take separate readings of both, bringing the meter sufficiently close in each case to exclude everything else. (Don't cast a shadow onto what you are measuring, however.) You next split the difference between these light measurements to set an exposure midway between the two extremes.

Brightness-range readings therefore make the best possible exposure compromise between subject extremes, and also remind you how much contrast is present. If shadows require over six stops more exposure

(a) (b) (c)

(d) (e)

Figure 10.18 Conditions which often fool a general or 'centre-weighted' exposure reading. Although the figure in all these pictures received the same lighting, in (a) the large area of dark background causes the meter to give a low reading and so make settings which over-expose the face. Coming in close (b) and reading only off the face ensures correct portrait exposure (c). Similarly (d) a bright background leads to under-exposure of the face unless you take a close-up reading to get result (e). Working with an auto-exposure camera AE lock must be applied; see text

Figure 10.19 Left: This sort of subject – with more or less even distribution of light, dark and mid-tone areas – is ideal for exposure reading by either general or centre-weighted measurement. Right: In this shot the most important element is the distorted reflection, occupying only about 25 percent of the frame. A general reading here would under-expose the reflection. It is better to take a spot reading off the reflected building, or briefly recompose it to completely fill the frame while taking a general or centre-weighted reading. (If necessary set Exposure Lock to stop the camera reverting to a faulty measurement when you finally recompose to shoot)

than highlights consider reducing lighting contrast by adding a reflector or flash, or wait for changing conditions, or alter your viewpoint. As a last resort, be prepared to accept loss of detail at one or other end of the scale, and pick which is least objectionable. The trouble is that two readings take longer than one and you may not be able to approach parts of the subject close enough (but see substitute readings, p. 250).

3 *For a grey-card reading* you measure from a mid-grey card, held so that it receives the same light as your subject. (Kodak makes a standard 18 percent reflectance card for the purpose.) Exposure given according to this one reading should coincide with the average of darkest and lightest areas. You must use a card large enough to fill the meter's field of view (Figure 10.22), and avoid casting a shadow on it when reading. Carrying a card is not very practical on location, although it may suit studio work, particularly copying (see Figure 10.21).

Figure 10.20 Exposure compensation dial, on camera body. As shown here all pictures will receive half the exposure the camera would normally set. A reduction of one stop

Figure 10.21 Using a grey card to read exposure when copying drawings. (1) Covering the whole subject imaged by the camera. If the original is larger than your card, move your camera closer (2) until the card fills the frame. But don't refocus, or cast shadows. (3) Finally, keep to the exposure settings made, remove the card, and copy the whole drawing

4 *For an incident-light reading*, the hand meter has a white plastic diffusing dome which covers its measuring window. Then you hold the meter in the same lighting conditions as for the subject, pointing towards the camera. It therefore takes into account all the (scrambled) light reaching the subject, rather than the subject's reflective properties. The plastic dome transmits 18 percent of the light, so you end up with much the same situation as a grey-card reading, but in a more convenient form. Enthusiasts for incident-light metering point out it is simpler than most other techniques, being used extensively in studios, especially for portraits where a quick lighting check can be taken whenever a light has been moved.

Spot metres

A spot meter (Figure 10.23) is a narrow-angle version of a reflected-light meter. It has an eyepiece for aiming the meter from the camera position, through which you see a magnified view of part of the subject, with a small measuring area outlined. The meter's angle of view over this area is typically only 2–3°. Having set your film's ISO speed, you press a trigger-like button to get a reading, and the exposure settings are displayed inside and/or outside the meter. Spot metres are extremely convenient for taking brightness-range readings if you cannot easily approach your subject, and when shooting close-ups. Spot metres should be used with care, as their readings need to be interpreted rather than simply followed. They are ideal when using the zone system (see *Advanced Photography*).

Conditions hand metres do not consider

All the above methods of meter-reading exposure for a subject should give you the same result, if used properly. Bear in mind though that a hand meter does not take into account:

• *Close-up focusing conditions.* Increasing the lens-to-image distance to focus sharply a close subject makes the image darker. Inside the camera, this is like moving a projector farther away from a screen (the film). The projected image grows bigger but less bright, following the rule that twice the distance gives twice the image size and one-quarter the light over the film area. You must therefore increase the exposure the hand meter suggests, as near as possible by the factor shown in Figure 10.24. (Increases here are based on the formula shown in Appendix A.)

• *Use of filters.* Most filters used over the lens cut down the light, so increase the exposure shown on the hand meter by the factor printed on the filter rim or quoted by the manufacturer. Remember with colour filters that this factor may alter with the colour of your subject lighting together with the film's colour response. Read the data

Figure 10.22 Alternative methods of using a hand meter: (a) Direct, general reading from the camera. (b) Close separate measurements of lightest and darkest important areas, then averaging the two light readings. (c) Reading off a mid-grey card receiving the same lighting as your subject. (d) Incident-light reading through the meter's diffusing dome. Meter here points from subject towards camera

Figure 10.23 A spot meter. The eyepiece shows you part of your subject magnified, a small centre circle marking the light measuring zone. Having programmed ISO film speed the meter displays the exposure either on the side or within the viewfinder

Magnification (Subject height divided into the height of its image)	Increase exposure by
0.3	×1.7
0.5	×2.3
0.7	×2.9
0.8	×3.2
0.9	×3.6
1.0	**×4**
1.3	×5.3
1.5	×6.3
1.7	×7.3

Figure 10.24 Close-ups shot using a camera without TTL metering need additional exposure. See table, right. To measure magnification, have a ruler alongside your subject. Divide this into its image size shown on the focusing screen

sheet included with your film. An unknown filter factor may be checked by comparing readings with and without the filter in front of the meter. With strong colour filters, however, the response of some measuring cells slightly mismatches film colour sensitivity and so creates variations.

- *The effects of exceptionally long or short exposure times.* As with internal metres, hand metres don't take account of reduced film sensitivity when long exposure times are given. See reciprocity failure, Appendix C.
- *The subject matter.* It is easy to overlook the fact that no meter made can know what kind of picture you are making. If you are photographing unusually light or dark objects such as the milk bottle or black cat already described then you need either to interpret a reflected reading or use the grey card or incident light dome methods. Also you may want to deliberately over-expose the whole image to give a so-called high key effect or reduce a distracting background to a clean black void. Understanding how metres work gives you the confidence to over-ride them when you need to for creative control.

Practical exposure tips

Point-and-shoot cameras apart, an exposure measuring system (built-in or hand-held) allows you choices and control at three main points: (1) the ISO speed set for the film, (2) the parts of the subject you actually measure, and (3) the alternative ways of dividing exposure between lens and shutter.

If you must get more sensitivity out of the film in dim light, or subject contrast is very flat and needs a boost, try up-rating ('pushing') the film. This means raising the ISO film-speed figure (or using a 'minus' setting on the exposure compensation dial [Figure 10.20] on auto-setting cameras). In both cases you then follow this up with extra development. Take care to use a film the makers describe as suitable for up-rating treatment (see pp. 276 and 280).

Down-rating ('pulling') or use of 'plus' compensation helps to reduce contrast and grain when followed up by reduced development. This applies principally to monochrome films; it is unwise to down-rate and hold back colour films beyond one stop (see p. 282).

Using the 'plus' compensation is also a handy way of compensating for subjects measured by general reading against the light or with large bright backgrounds, which you know will otherwise result in settings which make them underexposed (Figure 10.25). Or you might use it to allow for a film's anticipated reciprocity failure when given a long time exposure (Appendix C). Consider the plus or minus settings on the exposure compensation dial as a lighten/darken device for purely creative purposes too, like the controls on many instant-picture cameras.

Always think carefully about what area(s) of the subject you measure. The meter sees the world as an average 18 percent grey (the reflectance of grey card) and as such you, as the photographer, are responsible where you point the camera. Decide the priorities between various tones of your picture. If there is only one really key tone, and the camera does not have spot reading, try to make it fill up the whole frame. With a close-up you can do this by just moving forward (don't refocus – extra extension may change the reading). If your key subject is inaccessible, take a substitute reading from something convenient that matches it in tone. The eye is good at judging comparisons. A grey card has already been suggested, but you can read off your hand, lining it up and turning it at angles in the light to match a far subject tone (Figure 10.26), or find some part of the ground or sky with the right-looking tone. Some cameras have an 'auto-exposure lock' (AE-L) button but if yours does not, keeping the shutter button half-pressed

(a) (b)

(c) (d)

Figure 10.25 Images of one predominant or single tone can be difficult to correctly exposure as the camera can only read the world as an average 18 percent reflectance. Picture (a) shows the result of exposing for the meter reading, which on a mainly dark toned picture creates an overexposed grey, (b) shows correct print with decrease in exposure by two stops, (c) shows the same principle with a mainly light image that is underexposed and (d) shows an increase in exposure by two stops

will hold this exposure setting when you pull back and recompose the picture, or use manual exposure mode (see above).

Photographing flat objects such as line drawings, photographs, paintings, etc., often brings problems over how best to take a reading. Areas of dark and light are unlikely to be equal. Sometimes you can 'home in' on a midtone of sufficient size in a photograph or painting, but the best approach is to read off a grey card (or take an incident-light reading). You can see how important it is when using a built-in metering system, in that it allows you to take a reading and then retain the settings unchanged after reframing the picture, removing the grey card, and so

Subject

Figure 10.26 Making a substitute reading off your hand, for a distant face. Both must be in the same lighting and similar skin tone. By turning your hand you can match both lightest and darkest parts, and so make brightness-range readings

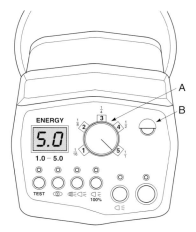

Figure 10.27 The control panel on the back of a small monobloc type studio flash-head. (A) Flash power control. Allows full (250 Ws) or four fractional levels of flash down to 1/16 power. (B) IR/light sensor which acts as a slave trigger

on. You will have to activate the auto-exposure lock or use manual exposure mode, otherwise the meter goes on taking new measurements.

A more specialist problem concerns exposure reading when using a moving light source to 'paint with light' an architectural interior or still life, spreading the light and forming a softer, more even source (p. 149). Provided the lamp is moved in an arc maintaining the same subject distance throughout the exposure, you can accurately read the light when it is still.

Whatever your technique for measuring the light, deciding the best way to deliver the exposure by means of aperture and shutter controls is always something of a balancing act. Each shot has to be considered on its depth versus movement merits. Occasionally, requirements and conditions work together to give plenty of options, as with a scenic landscape with all its elements static and distant, in strong sunlight. At other times, they all conspire against you, as in a dimly-lit shot of moving objects at different distances which must all record in detail. In this instance you must think how to improve conditions – perhaps by adding supplementary lighting, altering camera viewpoint to reduce the range of distances, or up-rating or changing to faster film but still keeping within grain and sharpness tolerances.

Measuring exposure for flash

Getting exposure correct when you light by electronic flash (p. 142) differs in several ways from continuous light source techniques. Electronic flash goes off instantly when fired, its light duration ranging from about 1/500 to 1/30,000 second according to type and conditions of use (see Figure 10.27). So provided your shutter is synchronized to have the image reach the film at this moment, it is primarily the flash that determines exposure time, rather than the shutter itself (Figure 10.28).

If the shutter is built into the lens, as on many large- and medium format cameras, you can use flash at any shutter speed. Most 35 mm cameras, however, use *focal plane* shutters that operate just in front of the film itself, which present potential problems. The shutter blades do not move fast enough on the fastest settings, meaning that the closing blade follows behind the opening one, effectively giving exposure through a moving slot. This is no problem with continuous light but when used with flash the blinds

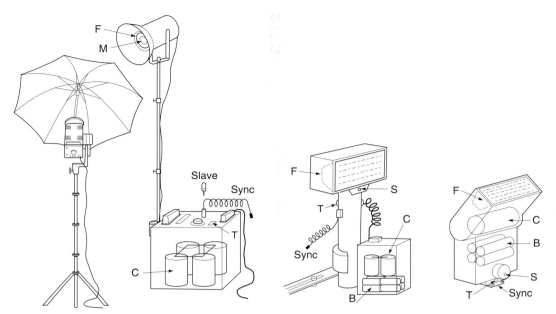

Figure 10.28 Flash equipment. Studio units and add-on portables, showing light sensor and synchronized firing controls. Power comes from batteries (B) or (studio units) household supply which charges capacitors (C). These discharge through flash tube (F) when the circuit is closed by camera synchronizing connections, test button (T) or light-sensitive slave. M: tungsten modelling lamp. S: sensor, measuring the light off the subject and self-regulating the duration of flash

or blades block out part of the picture at high speeds (Figure 4.11). This is why the shutter's fastest 'safe' speed often has a different colour on the setting scale, or is marked (⁴⁄) or X. On programmed cameras this speed (or a slower one) is automatically set when you switch on the dedicated flash unit.

Some older shutters, such as between-lens types on view cameras, have an 'X/M' selector switch near the flash synchronization lead connection. This must be set to X. ('M' is for old-style single use flashbulbs and is virtually obsolete.)

With any camera you can always use an 'open flash' firing routine too, provided your subject and camera are static, and any ambient light around is quite weak. Open flash involves holding open the shutter on 'B' and firing the flash by its test button. Several repeated flashes can be given this way if your flash equipment is not powerful enough for the aperture you need to use. It is also a technique used to light up a very large subject such as working outdoors at night, to give even light coverage or it can be used to give multiply images on the same piece of film (Figure 10.29). If you black out the studio and have a model walk across the face of the camera, by repeatedly firing a very directed flash with the lens open on B setting the model will be illuminated separately on each occasion while the background stays dark; see Figure 10.39.

Working from guide numbers

The most basic way to estimate flash exposure is to use the guide number, GN (or 'flash factor') quoted for the unit. The GN is the distance between flash and subject, multiplied by the *f*-number required, when using film of a given ISO speed. Unless otherwise stated, figures are always

Figure 10.29 Single frame of film with 3 different shots taken in the studio using flash before the film is wound on

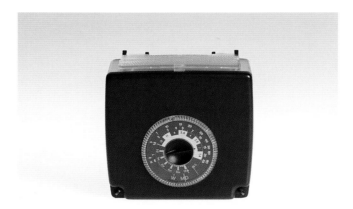

Figure 10.30 Simple exposure calculator dial based on distance × f-number, for a flashgun with a guide number of 36 (metres)

quoted for ISO 100/21° film, and for distances in metres. So using a flash with a guide number of 36 you set f/8 for a subject 4.5 m (15 ft) from the flash, or f/11 for 3.3 m (12 ft), using ISO 100/21° film. This might be built into a calculator dial like that shown Figure 10.30, which can also include other film speeds and the use of the flash at fractions of full power, if this is possible. Self-regulating flashguns set to 'manual' work with a similar kind of calculator or table. Guide numbers are also quoted to compare the output of different flash units.

The much greater power output of studio flash units is more frequently quoted in 'watt-seconds' (5 joules). The guide number of a typical 1500 Ws power pack unit is 160 (metres) using the head with a bare tube and reflector. This ratio varies with the head design, GN often being reduced to one-fifth when the same head is set behind the diffusing material of a softbox, for example (see Figure 7.19). Studio flash working from a generator (power pack) can also feed several heads, in which case output is divided by the number of equal power heads.

Disadvantages. In practice guide numbers alone do not take sufficient account of the reflective properties of your particular subject and its surroundings, and whether flash is direct,

bounced, diffused by a softbox or colour-filtered. Also the manufacturer-quoted number tends to apply to favourable conditions, such as direct lighting of a pale-skinned person in a small room with pale-toned walls.

Example guide number calculations for flash (ISO 100):

Guide number	Flash 2 metres from subject	Flash 3 metres from subject	Flash 4 metres from subject	Flash 6 metres from subject
12	f/5/6	f/4	f/2.8	f/2
24	f/11	f/8	f/5.6	f/4
32	f/16	f/11	f/8	f/5.6
48	f/22	f/16	f/11	f/8

Guide no. divided by distance = f/stop. Note that some values have been 'rounded up' to the nearest aperture number for clarity.

Using a self-regulating flash

Battery flash units – add-ons or built into the camera – mostly incorporate their own exposure reading system. In an add-on gun, this typically consists of a fast-acting sensor set behind a small window on the main body of the unit, facing your subject. The sensor has an angle of view of about 20°, and so reads the flash illumination reflected back from everything within the central area of your picture. The flashgun has to be set for the ISO film speed and the f-number you intend to use.

In the case of a compact camera with built-in flash the camera's own next-to-lens light sensor may act as the flash sensor, and is already fed with ISO speed and aperture information (Figure 10.32). (Alternatively, autofocus cameras set aperture based on subject distance measured by the AF system, simply working to a guide number.)

According to the light received back from the subject, the unit instantly regulates flash duration during the exposure. For example, it might clip flash to 1/30,000 second if the subject is close or bright and therefore gives a strong light reading, or extend it to full (typically 1/500 second) duration with a distant or dark subject. Most units have a 'test' button, allowing you to fire the flash manually. If the built-in sensor receives enough light to regulate the exposure, an 'OK' light comes on briefly to confirm that the system is working and the subject is within range.

The range of subject distances over which a self-regulating flash will maintain correct exposure is reasonably deep but, as Figure 10.31 shows, the wider the lens aperture set, the farther the working range moves away from the camera. Distances double for every two stops' change of aperture, as with guide numbers. Most of the time a setting

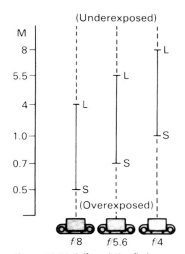

Figure 10.31 Self-regulating flash. Distance S to L shows the self-regulating working range of a typical small flashgun (set for ISO 100/21°) at various apertures. S: shortest flash duration. L: longest duration

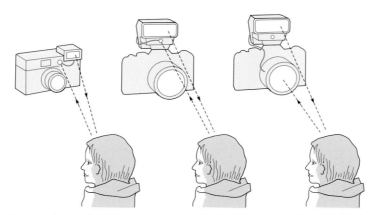

Figure 10.32 Three forms of self-regulating flash exposure control. Left: A compact camera's light sensor beside the lens measures and controls the duration of its built-in flash. Centre: Similar sensor system within a clip-on gun (must be programmed for ISO and aperture set). Right: The same gun, if dedicated to the particular SLR, uses the camera's 'off-the-film' exposure reading circuit instead

Type	Guide no.		Duration		Recycle time (seconds)		Col. temp.
	m	ft	@Max. power	@Min. power	@Max. power	@Min. power	
	20	66	$\frac{1}{2000}$	$\frac{1}{40,000}$	10*	0.6*	5600 K
	36	119	$\frac{1}{3000}$	$\frac{1}{30,000}$	8*	0.4*	5600 K
1500 Ws	60	197	$\frac{1}{200}$	$\frac{1}{20,000}$	5*	0.3*	5600 K
	196	640	$\frac{1}{400}$	$\frac{1}{600}^{\dagger}$	3	0.8^{\dagger}	5500 K
6000 Ws	390	1280	$\frac{1}{200}$	$\frac{1}{300}$	7	2	5500 K

† Quarter power. *Relates to non-rechargeable batteries.

Figure 10.33 Comparing light output and performance. A cross-section of commercial flash units, from a small unit built into a compact camera, to powerful, generator-type studio equipment

about midway in the *f*-number scale gives a good working range unless you are shooting from very close or far away. With the exception of smallest units, electrical energy is returned to storage when shorter flashes are used. The shorter the flash, the less time you have to wait for it to recharge (Figure 10.33).

Disadvantages. Although a self-regulating unit is a quick, convenient way to control exposure, its method of measuring light reflected from your subject is fairly crude. It is over-influenced by the relative areas of light and dark objects within your picture, like any other general reading meter. Also the constant angle of view measures a larger or smaller proportion of your picture area if you use tele or wide-angle camera lenses. When shooting close-ups, no account is taken of light loss in the camera system owing to close focusing conditions (p. 250).

SLR dedicated flash systems

A 'dedicated' flash takes self-regulation one important stage farther for SLR cameras. Multi-circuits between a suitable add-on flashgun and camera allow them to communicate with each other. As long as the camera has TTL exposure measurement 'off the film', this internal

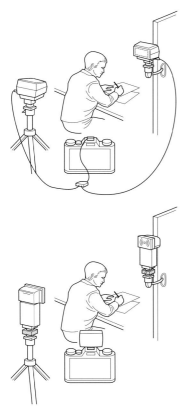

Figure 10.34 Using several heads at once. Top: Two dedicated flashguns controlled from their 'off the film' metering camera by direct wiring. Bottom: Set-up using self-regulating guns set to manual, the two off-camera units being triggered by light slaves fitted below their heads. These respond to light from a small flash used on camera. (IR triggering could be used instead if you don't want the direct frontal lighting the central flash would produce)

metering takes over the role of the flash unit's sensor, with the bonus of automatically taking into account *f*-number, ISO speed, close-up imaging, filters, etc. You also have use of the camera's exposure compensation dial to cope with difficult subject conditions. The SLR camera's focusing screen of course shows how much subject is being measured, whatever the lens focal length. The flashgun may, in return, communicate data such as 'charge ready' and 'exposed within range' confirmation signals directly into the display you see alongside the focusing screen.

Disadvantages. You cannot use any choice of add-on flashgun and camera – they must be matched to each other, the camera having off the film (OTF) metering. Extra flash-heads must all be connected to the camera using matching data cables or infrared triggering systems, which adds to the cost (Figure 10.34).

Flash metres

A flash meter, (see Figure 10.35), is used in a similar way to a hand-held incident-light exposure meter. In fact many models have dual functions, acting as continuous light source exposure metres too. These are the most versatile, not only because you only need to carry one meter but because they can take ambient light into consideration if using slow shutter speeds.

You set it for film speed and point it at the subject, a grey card, or back at the camera using the incident light dome, as with continuous light metres (Figure 10.22). Metres are generally used with a 'synch' (synchronization) cord: a long cable linking meter and flash unit so that you press a button on the meter to fire the flash. Alternatively you can get an assistant to push the test firing button on the flash if it is beyond arm's length. Some advanced systems use wireless or infrared triggering systems. Most metres are extremely accurate, being able to distinguish brightness differences of as little as one-tenth of a stop. These models allow you to either have an incident light reading that calculates the exposure required from the amount of light falling on the subject or a reflective reading that calculates the exposure from the amount of light being reflected from the subject.

Disadvantages. A separate flash meter is really only practical where time and conditions permit you to take a trial flash reading before shooting – it is ideal in the studio, for example. Metres are also rather costly, and you have to remember that they do not automatically take into account camera filters or close-up focusing conditions which affect exposure in the camera.

Figure 10.35 Typical hand-held flash metres. Some models will also measure continuous light sources. All these metres are normally used as here in incident light-reading mode, at the subject facing back at the camera

Practical flash exposure tips

Bounced flash

As discussed in Chapter 7, bouncing flash off a ceiling, wall or similar large surface area is a convenient way of softening lighting quality and improving evenness. However, you greatly reduce its intensity. When working by guide numbers the rule for a white bounce surface is: (1) halve the regular flash guide number, and (2) divide this new number by the total flash distance (i.e. flash to surface to subject) to discover your *f*-number. Flash metres, and dedicated flash, will take bounce light conditions into account in measuring exposure. It's very important with a self-regulating flashgun that the sensor faces the subject when the flash is directed upwards or sideways onto a bounce surface. This is usually taken care of in gun design, where the part containing the flash tube pivots and twists but the sensor remains facing towards the subject (Figure 10.36).

Figure 10.36 'Bouncing' flash. The light sensor must continue to face the subject direct. Illuminate the ceiling above the camera, not subject – otherwise you risk shadowed eyes

Figure 10.37 Fill-in flash. Left: Existing light only, no flash, 1/60 second at f/11. Right: Same exposure with the addition of flash from the camera set to one-quarter correct power for this subject distance. You need a powerful flashgun for fill-in flash outdoors beyond about 2.5 m, unless shooting early or late in the day

Fill-in flash

Flash on the camera is a good way to lower subject contrast in side-, top- or back-lit ambient lighting situations. Of course, you cannot expect to fill in whole buildings this way, but it is useful for portraits and average-size room interiors (Figure 10.37). (Make sure, when shooting in colour, that flash and ambient lighting are the same colour temperature – in unalterable tungsten light conditions fit an orange 85B filter over the flash tube and shoot on tungsten film, unless you want to use the difference between the light sources as part of your design for the image.) Diffuse and direct the flash from close to the lens to avoid casting additional shadows, and arrange to under-expose the flash, aiming for a flash/existing-light ratio of about 1:4 (colour negatives).

Advanced compacts and SLRs often offer a 'fill-flash' mode by which settings are made for the existing light but the camera's built-in flash also fires, at around one-quarter power.

Using more than one flash head

As with any other controlled lighting, there will be times when you want to use two or more flash sources from different positions, especially in the studio (Figure 10.38).

Figure 10.38 Some two flash-head set-ups in the studio. Left: A pair of monoheads. The one shown on the left here is triggered when its slave sensor (S; see Centre) reacts to light from the unit sync wired to camera. Centre: Two more powerful generator type flash units, each wired to its own power pack. Alternatively (right) using two heads from a single generator. Maximum power light output is then split. In each case one unit is synchronized to the camera via a cable, the second unit being fired from the slave

Figure 10.39 Multiple flashes on one frame of film. A sequence of six flashes fired from a hand flashgun in a darkened room, from one side of the model. The camera shutter was locked open on B throughout. This flashgun was totally separate from the camera, and fired manually using the test button. Notice how the almost stationary trunk and legs build up exposure, while hands and fingers receive only one flash each. Set an f-number for halfway between these extremes

One arrangement is to use a number of completely separate units, either battery powered or connected to the mains supply. One head is connected to the camera by the synchronizing lead so it fires when the shutter opens. The other units each have a light-sensitive 'slave' trigger either built in or plugged onto the synchronizing lead socket. This ensures that the additional flashes fire in instant response to the one linked to your camera. Other systems involve using a small infrared or radio pulse transmitter mounted in the camera's hot shoe.

These 'slaved units' can then be moved around in the studio with the freedom of tungsten lighting. Each can be turned down to half or quarter flash power; its modelling lamp dims pro rata to show you the effect of having sources at different intensities. Another, cheaper arrangement is to have just one generator, plug several heads into it and place them in different positions. This means more leads to trip over, but only one link from the pack is needed to your camera. Remember, though, that power output from the pack is then split (for example, a 1500 watt-second unit gives 750 Ws each to two heads).

The best way to measure exposure when using several heads is by flash meter. But if you use a guide number system instead, work according to the GN and distance of your main light flash source only, ignoring the others. A flash meter allows you to exactly measure the lighting

ratio between main and fill-in units. First, turn on the main flash source only, and fire it with the meter near your subject, facing the light. Secondly, turn on the fill-light only instead, and read this facing its light. The difference between the two shows the light ratio. To avoid excessive contrast it's best not to go beyond 4 stops difference for slide films, 5 for colour negatives.

With smaller battery-operated flashguns (Figure 10.34), you will need several complete units on stands wired or slaved to the camera. If guns are dedicated, you must have each one wired back to the camera with the correct cable to control their output. Then exposure measurement is simple – you just use the camera's TTL meter for flash as normal.

Speedy recycling

The faster your flash unit will recharge (recycle), the more rapidly you will be able to take pictures. This is important in most action and press photography, where any delay waiting for the flash to come up to power could lose you an unrepeatable image. And it is vital if you are shooting a sequence by motor drive.

One way of working is to use a powerful flash unit turned down to a fraction of its full output. For example, one such unit allows you to select 1/100th of full power, and then recycles in 0.25 second, giving an extremely brief flash.

Regular studio flash units on full power take around 1–3 seconds to recycle (see table, Figure 10.33). They easily overheat if you try to make them fire and recycle in continuous sequence. Special models are therefore made with rapid-firing facility, but give a fraction of normal output.

■ Exposure level alters image tonal and colour qualities; it can be used to give emphasis and help interpretation.

■ The exposure needed depends on lighting, subject characteristics, film sensitivity and imaging conditions. It is given to the film through the combined effects of the *intensity* of the image light, and the *time* it acts on the emulsion. Exposure can be quoted in *f*-numbers and shutter speeds.

■ With negative films, avoid under-exposure, which produces empty flat shadows. Slight over-exposure is less of a problem. Severe over-exposure gives grainier, less sharp results and loss of highlight detail. If you are shooting on reversal materials – slides and transparencies – exposure is much more critical, especially with contrasty scenes which allow you least exposure latitude. Over-exposure is more of a problem than under-exposure. Where possible, intelligently bracket your exposures as insurance.

■ The response to light by a film is published as a performance graph or 'characteristic curve'(Appendix C). Where the graph flattens out (tones merge) at bottom and top represents under and overexposure zones.

■ A camera meter located behind the lens may read light directly off the film surface during time exposures, and for flash. Here it takes into account changes in focal length, close-up focusing and filters. Reading patterns range from centre-weighted averaging, to spot.

■ Camera settings may be made by the meter direct, working through a program, or you can choose from manual, aperture priority, and shutter priority modes. A fully programmed AE system gives a high number of correctly exposed pictures – but not necessarily with the visual qualities you had in mind.

■ Your three main exposure decisions are the ISO rating you set for your film, the subject parts you measure (emphasis), and how exposure is distributed between shutter and aperture (movement and depth of field effects).

■ Substitute readings, and recomposing different areas of subject within the frame just while you measure exposure, often improves accuracy.

■ Since view cameras (and many 120 rollfilm cameras) have no built-in meter, you will need to use a hand-held meter. Remember then to increase exposure for extreme close-ups and for any filter used.

■ General, overall readings are quick and convenient, but inaccurate when important areas are relatively small. Grey-card or incident-light readings measure exposure independently of the subject. Averaged brightness-range readings (ideally taken by spot metering) take longer but reveal scene contrast, too.

■ Flash exposure can be based on *guide numbers* (*f*-number × distance), measured by *flash meter* (most practical with studio units), or a *sensor* on a self-regulating flashgun, or the camera's *TTL system* in circuit with a dedicated gun.

■ Electronic flash synchronization (X sync) suits between-lens shutters at all speeds. Focal plane shutters often impose a limiting top speed.

■ Self-regulating flash units, independent or dedicated, give shortened flash (and faster recycling) when there is a strong reflected-light measurement from the subject.

■ When you bounce flash, *halve* its guide number at least; remember to measure the *total* light-path distance. Avoid coloured ceilings/walls.

■ With multi-unit set-ups, synchronize one studio flash to the camera and 'slave' the rest. Set self-regulating units to manual; have them wired or slaved to the camera. Check exposure (and lighting contrast) by flash meter, or work with the GN for the key light only. If you have dedicated flash units, wire them all to the camera, and then use the TTL camera meter.

■ Fast-recycling flash is essential for rapid sequence work. Use a powerful gun at frac-tional setting, or a specially designed flash unit.

■ To fill in and reduce the contrast of ambient lighting, use on-camera flash set to fill-flash mode. If this is not offered, make the camera settings correct for existing light and reduce the flash to 25 percent correct output.

1 Test the effects of under and overexposing on colour print, slide and black and white film to compare how much latitude you have with different types of film to achieve an acceptable picture.

2 Set up a number of difficult lighting situations such as white on white, black on black, or a person inside a room in front of a bright window. Try the various methods of taking a reading shown in Figure 10.22 and compare the results.

3 In the studio, or at night create multiple images on one negative by holding the lens open continuously (B setting on some cameras) and, using flash, fire off 3 or 4 flashes at a moving subject before closing the shutter.

4 Buy a photographic grey card and alternate between taking a reading from the grey card using your camera's built-in light meter, or a handheld one and taking a reading straight from the subject. Make sure you write down which images were taken with the different methods to compare when the film is processed.

PROJECTS

11 Film processing

Processing film is relatively simple but it requires a consistent, controlled routine. The gelatin of the emulsion absorbs liquid chemicals, which react with those within the film, differentiating between exposed and unexposed parts of the image. Essentially the 'latent image' formed by the action of light on the emulsion while in the camera is developed, changing its chemical make-up into something more permanent, and then fixed and washed to make it no longer light-sensitive and to remove the chemical by-products.

The most accurate processing is given by automatic machinery, which gives very consistent results but is expensive to set up and really only justified for busy photographic departments and laboratories which have a high throughput. This chapter therefore concentrates on the processing of different kinds of film in small quantities, by one person.

Colour processing can be quite tricky to do by hand as it requires very accurate time and temperature controls and often requires many solutions. Most professionals therefore use a local laboratory, especially as colour film processing is very standardized, chemical costs are quite high, and the keeping qualities of most solutions are limited. Black and white, on the other hand, lends itself to much wider personal choice of developer/film combinations and manipulation of developer and development, and is generally less rigorous in terms of temperature control. With care you can expect to achieve professional standards in black and white processing at home.

For all forms of film processing you can use light-tight tanks. Provided these are loaded with film in total darkness, permanent darkroom facilities are not essential. Consistency must be maintained over timing, temperature and solution agitation to give good results. You can also vary the amount of development – usually by adjusting timing to alter the characteristics of the final image. These changes mostly affect density, contrast and grain. Processing itself is often mundane, but requires concentration and care over detail. You must avoid contaminating one chemical with another, and be sure to wash by-products out of the emulsion thoroughly. Times and temperatures have to be closely monitored. Wet film is very soft and vulnerable to scratches, kinks and dust which, when enlarged, may ruin final results or call for hours of retouching. In short, although processing is not difficult, it remains that a few moments' carelessness can mean the loss of dozens of unrepeatable pictures.

This chapter begins by discussing the equipment and general preparations needed before processing any kind of film. It then looks at the routines, choices and controls over results when processing black and white negatives, colour negatives, and slides.

Equipment and general preparations

Before you start you will need some essential items of equipment, chemicals which may require mixing or diluting for use, and a suitable place to work. Your chief item of equipment is a processing tank. It would be useful if it can hold 120 or 35 mm films in open coils (Figure 11.1)

Figure 11.1 A selection of hand processing equipment. Back: Plastic multi-reel tank for up to six 35 mm or four 120 films. Rear left: Film holder and square plastic tank for up to six sheets of 5 × 4 film. Rear right: Universal tanks in plastic and stainless steel for 35 mm or 120 film. Front: Single-reel stainless 35 mm tank, plastic and stainless steel film spirals. See also Figures 11.6 and 11.7

or sheet films suitably separated (see Figure 11.2). Chemicals or wash water can then circulate over the emulsion surfaces to affect them evenly. You also require a photographic-grade thermometer and various graduated measures ('graduates') for measuring and mixing solutions, as well as a plastic mixing rod. For small tanks in particular you require chemical storage bottles, a funnel (to return solutions to containers), a hose for washing, and photographic clips for hanging up films to dry. You can time processing from any watch or clock, but the ideal is an electronic timer you can program for the complete sequence of stages, including agitation periods. Figure 11.3 shows some of the darkroom equipment you will need for processing film. Also you need to have some means of maintaining solution temperature during processing, and if possible a drying cabinet.

Solution preparation

Whenever you are preparing chemical solutions take care over health and safety. It is always advisable to wear latex or plastic gloves to protect your hands from direct contact with liquid or powder chemicals.

When dissolving dry chemicals or diluting concentrated solutions, do this near a ventilator or open window, and avoid inhaling vapour. Figure 11.4 shows a list of some common photographic solutions which require care in this respect. Always pour the chemicals into

Figure 11.2 Deep tanks. Sheet films are clipped in individual hangers, which hang in solution within tanks. For processing larger quantities, racks hold many hangers, or films in reels. Films must be moved (in darkness) between separate tanks of developer, stop bath and fixer. Tanks are best housed in a flat-bottomed PVC sink, which can also act as a water jacket. See Figure 11.10

Figure 11.3 Left to right: Thermometer dial type, protective latex gloves, minutes/seconds timer, graduate and mixing rod for mixing and diluting, clip for hanging up film, solution storage containers, thermometer (electronic digital), funnel.

the water when making solutions. The reverse way can cause dangerous splashes. Read the warnings on labels, and keep all solutions away from your eyes and mouth as well as from cuts or grazes. Never have food or drink near chemical preparation areas. And make sure all your storage bottles are correctly labelled and cannot be mistaken for something else. (For farther advice see Appendix E.)

Take care not to allow accidental contamination of chemicals. Contamination will often make expensive solutions useless and, worse still, ruin films – especially colour films. To begin with, make sure all items that come into direct contact with photochemical solutions are made from appropriate inert materials such as PVC plastic, stainless steel or glass. Copper, bronze, galvanized iron, chrome or silver-plated materials, zinc, tin or aluminium are all unsuitable, because they react with chemicals and fog film. Absorbent materials such as wood or polyurethane soak up solutions and then contaminate the next thing they touch. Only a drop or

**AVOID skin contact or
inhaling fumes from:**
Chromium intensifier
Selenium toner/powder
Formalin/formaldehyde
Dish cleaner
Iodine bleacher
Lith developer
Hydroquinone
Sepia (sulphide) toner
Blue toner
Stabilizer
Acids of all kinds

**Do NOT store chemicals or
solutions in a refrigerator.**

Figure 11.4 Safety precautions
with processing chemicals. See
also Appendices D and E

so of some chemicals can totally neutralize others. Be careful not to contaminate accidentally through poorly rinsed graduates or storage containers, by solution carried over on a glove, thermometer or mixing rod, or by mixed-up bottle caps.

Processing chemicals are bought either as complete kits containing all stages (as for colour film processing) or as individual items (such as black and white chemicals). In both instances, they may be concentrated liquids or premixed powders which need dissolving. Occasionally, with unusual solutions, you might have to weigh out and mix raw chemicals according to a published formula (see Appendix D). Most often they are pre-packed, in which case follow the instructions supplied meticulously with regard to the order in which the contents of any sub-packets are to be dissolved, and the temperature of the water. Failure to do so may either oxidise your solution or make the powder impossible to dissolve.

Often concentrated liquid chemicals must be diluted by part, for example 'one part stock solution to eight parts water' or 1+8. Parts may mean any unit of volume, as long as you use the same unit for concentrate and water. 1 fl oz with 8 fl oz water (total 9 fl oz) or 1 US pint with 8 US pints (total 9 US pints) are both 1+8 solutions. It is also useful to know how much concentrate you need for a set volume of working solution. The formula is:

$$\text{Parts concentrated solution} = \frac{\text{Final working volume}}{\text{Parts water} + 1}$$

In other words, the amount of concentrated developer to prepare a 12 litre tankful of one part stock to five parts water is 12 divided by 6 = 2 litres. Occasionally you have to use a percentage solution (handy when a chemical is used in different amounts in various solutions). The 'percentage' of a solution means the ratio of chemical to the final quantity of its solution in water. For example, a '5 percent solution' is five parts of chemical made up to a total 100 parts with water. In the case of solid chemicals, this is worked as weight per volume. So both 5 grams of solid chemical made up to 100 ml with water (total 100 ml), and 5 ml of liquid chemical made up to 100 ml (total 100 ml) are 5 percent solutions.

Processing tanks (35mm and 120)

Hand-processing tanks and reels are made of either plastic or stainless steel. Reels have open ends with a spiral channel for the film (Figure 11.5). The stainless steel types are more expensive, but quicker to dry between processing runs, and easier to keep clean. They are quicker to load once you are practised, but unlike some plastic types are not adjustable to accept film of different widths. Having cut off the shaped leading end of the film cleanly, open the 35mm cassette in darkness (using a special opening tool or a bottle opener), see Figure 11.6 to remove your spool of film. With 120 film, unroll backing paper until you reach the film itself. Plastic reels are mostly loaded from the outer rim, steel reels always from the centre outwards, keeping the film slightly bowed across its width. You must not kink the film, which will form dark crescent-shaped marks, or buckle it so one part of the coil touches another, leaving unprocessed patches. A loading aid makes it easier to fill centre-loading reels in the dark. Tank bodies hold single reels, or you can buy various taller versions

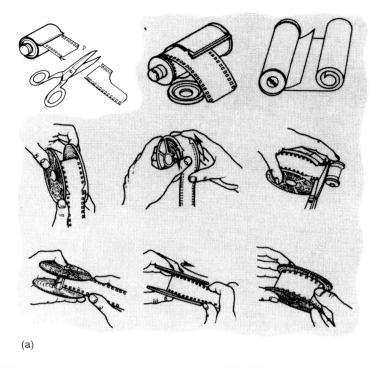

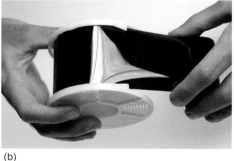
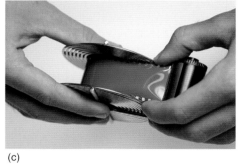

Figure 11.5 (a) Loading reels. Top: Cut off the 35 mm film leader. If your film has wound in completely use a film retriever (Figure 11.6) to pull out the end. Next remove the spool of film from its cassette in the dark. (Top right: When loading 120 rollfilm unwind the backing paper in the dark until you reach the end of the film.) Centre: A plastic 35 mm reel is loaded from the rim towards the centre. Swivelling the flanges in opposite directions draws the film in fully. Cut off and tuck the end in. Bottom: Loading a stainless steel 35 mm reel, clip the film to the centre core and then gently turn the whole reel to wind it in, bowing the film gently between your fingers. Again cut and push the end into its groove. (b) Loading a plastic reel from the edge, set for 120 rollfilm this time. The film does not need to be bowed but enters the spiral virtually flat. Pinching the film too hard will result in kink marks on the negatives. (c) Loading a 35 mm stainless steel reel from the centre. Note the film is very slightly bowed between the fingers

taking multiple reels. Once each film is on a reel, placed inside the tank body and sealed from light by the lid, you work entirely in normal lighting, pouring solutions in and out in turn through a light trapped opening in the lid (Figure 11.7). Note that many popular daylight tanks use a central spindle which is vital as it forms part of the light trap. Ensure you have all the tank's components with you before you start to load film. Once the cassette is opened there is no going back.

Processing tanks (sheet film)

The most common way of hand-processing sheet film is in a series of 15 litre PVC 'deep tanks' (Figure 11.2), one for each stage of processing. An extra floating lid rests on the surface of solutions, such as developer, which are prone to oxidation with the air; remove these before you start processing and replace them immediately afterwards.

Each tank has a main lid which is loose-fitting but generally light-tight, so that you can switch on white light to check time, etc., once films are in the solution. You remove each sheet film from its holder in darkness or special film-type safelighting (p. 305) and clip it into a stainless steel hanger. You can lower hangers individually into the first tank of solution, where they are supported by a ledge near the top. If processing more than two or three sheets together the hangers can be slotted into a rack, which makes them much easier to agitate and greatly reduces the risk of scratching the film.

Similarly several standard reels containing roll or 35 mm film can be placed in a stainless steel basket for batch handling in the same way. Most people carry out the whole process in full darkness, otherwise you must switch off the white light and open the tank lid each time you agitate films or transfer them to the next tank.

Figure 11.6 35 mm tools. Left: Film retriever, inserted into a 35 mm cassette in daylight, pulls out the tip of exposed film which has been wound in. Right: Opener to remove the end of the cassette, in darkness. (Note: a standard bottle opener can work just as well)

Sheet films can also be processed in special 'daylight' tanks. In the first type they are curved and fitted within a horizontal PVC drum, which fits on a motorized cradle like a colour print drum processor (Figure 11.8). This is economical, as the rotating tank needs only a small volume of each solution to be inserted and drained in turn through a light trapped entry funnel. Agitation is continuous. Alternatively, the films may be fitted into slots within a small rectangular developing tank. This has a lid with a light trapped inlet and outlet, so you can pour processing solutions, wash water, etc., in and out of the closed tank in normal lighting. Agitation of these tanks is like that for the rollfilm types; by inversion.

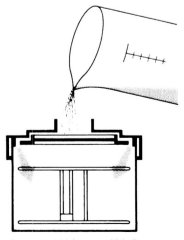

Figure 11.7 Light trapped lid allows solutions to be poured into and out of a hand tank in normal lighting (stainless steel type shown here)

Agitation

Giving the film and solutions the correct agitation is of great importance. Too little, and by-products from the emulsion gradually diffuse and slide down the film towards the tank bottom producing streaks. Excessive, over-energetic agitation creates currents from hanger clips or film perforations which give uneven flow marks; it can also increase the contrast of the film. Most small tank development times are based on 'intermittent' agitation – typically a period of 5 seconds every 1 minute (Figure 11.9). This is given by inverting the film tank or rotating the reel,

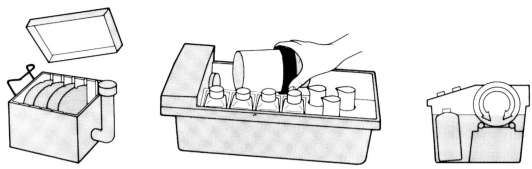

Figure 11.8 Small-volume sheet film processing in (left) stainless steel daylight tank, or (centre) rotary drum. The latter maintains both film drum and chemical containers in a temperature-controlled water bath; see side view (right)

or lifting and tilting sheet films. It is vital that you adopt a consistent agitation routine, or the processing will vary unpredictably; a lack of agitation can reduce the development and increased agitation over develop the film. In motorized processing the action of drum rotation, or continuous passage of the film through solutions between moving rollers, provides the agitation.

Temperature control

You should have developer(s) ready at just the right temperature and maintain this within tolerances for the solution while they act on the film. (Temperature latitude is as little as ±0.25°C with some colour developers, but much wider for fixers, etc.) The best way to hold temperature with a small tank is to have a 'tempering unit' (Figure 11.10). This is an enclosed jacket containing electrically heated air or water, thermostatically controlled within narrow limits. Alternatively stand your tank, and graduates of chemicals, in a bowl or deep tray filled with water of the required temperature.

Larger volumes of chemical in deep tanks hold their temperature more readily. To alter temperature use a thermostatic immersion heater, or a tempering coil through which you pass and discharge to waste warm or cold water. Make sure your thermometer will cope with the higher temperatures (e.g. around 38°C) required for some colour processing.

Working layout

Keep your 'dry' working area – where you will load your rollfilm tank or hangers away from the 'wet' chemical preparation and processing areas. If necessary, small tanks can be loaded in any (clean) light-tight cupboard or even a changing bag (Figure 11.11), then moved somewhere else for processing itself. Deep tanks, however, need to be in a completely blacked-out room (p. 289). Both large and small tanks will have to stand in an empty sink for washing stages. Note that fixer is generally heavier than water and will therefore just sit at the bottom of a tank with inadequate water flow. Just standing a tank under the tap is no good.

Some small tanks are designed to be used with a hose from the water supply attached to the inlet. The water is forced over the film from below, exiting at the top. Specially designed wash tanks (Figure 11.12) follow the same principle; water enters at the bottom via inlet jets and exits at the top, carrying the chemicals with it.

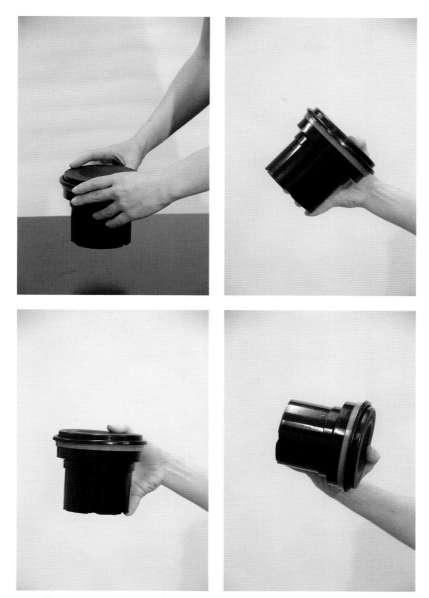

Figure 11.9 Agitating film during processing with a daylight 35mm or 120 hand tank. First tap it gently on a hard surface to dislodge air bells at the start of development then use inversion technique at regular, specified intervals throughout processing

Note also that clean water is a must. The plumbing in many buildings can carry grit, rust from pipes and other impurities which can stick to the film. Small filters are available which fit over the tap to deal with this problem. With an efficient washing system, most black and white films are done in 30 minutes to an hour at 20°C. Hot wash water (above 30°C) can soften the emulsion enough to cause damage. Similarly very cold water (below about 13°C) causes the gelatin to harden and is less effective, requiring extended wash times.

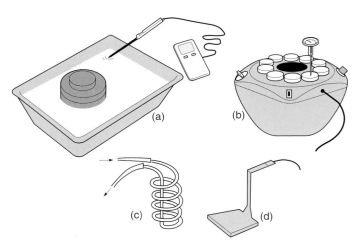

Figure 11.10 Temperature control. (a) Simple water jacket for the film tank. (b) Commercial tempering unit using warmed air (hand tank fits in centre). For deep tanks use (c) stainless steel tempering coil connected to the warm water supply, or (d) electric immersion heater

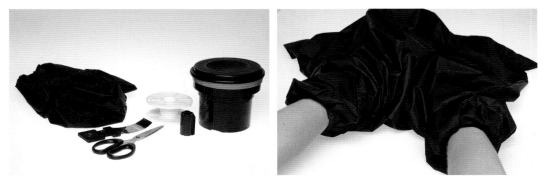

Figure 11.11 Left: Changing bag made of light-proof material, with elasticized armbands. Right: Tank, film, scissors, etc., are placed inside through zip opening before starting to load film, far right. Make sure that everything needed (including the tank lid) is in the bag before you start loading the film. Bag can also be used for loading sheet film holders

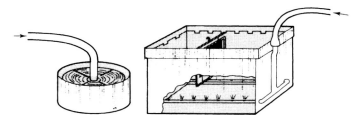

Figure 11.12 Film washing. Simple use of hose pushed fully into the opened reel tank (left), and wash tank for sheet films (right) ensures an even flow of water

The quickest and safest way to dry film is in a drying cabinet (Figure 11.13). Carefully remove rollfilms from their spirals, attach clips or plastic clothes pegs at each end and hang them vertically. A clip on the bottom to weight the film prevents it coiling up as it dries. Sheet film can remain in hangers. (See also wetting agent, p. 278.) Film is best dried at room temperature, which will take several hours. If you are in a hurry, the built-in air heater of a

drying cabinet will dry them in 10 minutes or so but do not run it too hot. Temperatures of over 40°C can damage films.

Never change from one rate to the other part way through drying, or you may create drying marks. You must, of course, dry films well away from dust, fluff, grit or chemicals – which could settle on the delicate emulsion surface. If you intend to re-use reels or hangers immediately for farther processing, first make sure they are absolutely dry. Metal spirals can be dried quickly using hot air (such as from a hairdryer) but this can distort or melt the plastic type.

Figure 11.13 Film drying cabinet, glass fronted type. Accepts 35 mm, roll or sheet film, in mixed sizes. Often heated

Processing black and white (silver image) negatives

What happens

The first processing solution is a developer, containing developing agents (such as metol, phenidone, hydroquinone) and supportive ingredients including an alkali, preservative and restrainer chemicals (see Appendix D). During development, electrons become attached to the film's light-struck silver halide grains. This leads to the formation of vastly more silver atoms until the 'latent' but invisible image the film carries grows visible in black metallic silver. At the same time, the emulsion discharges potassium bromide plus exhausted developing chemicals. As these by-products accumulate they gradually weaken and slow the action of the developer.

Inside the tank during development the image of your subject's highlights appears first, then the mid-tones and finally the shadows. The density (darkness of tone) of highlights builds up faster than shadows so that image contrast steadily increases with development. However, developing does have some effect on unexposed grains, resulting in a grey veil of 'fog' to shadows and clear edges of the film if development is continued for too long.

Once development is complete, the action is halted by rinsing the film in water, or ideally treating it briefly with an acidic 'stop bath' which neutralizes any carried-over developer. The stop bath also prepares the film for the action of the final chemical which is the fixer.

Sometimes known as 'hypo', fixer is a solution of acidified ammonium or sodium thiosulphate which converts all the remaining undeveloped silver halides into soluble compounds which can be washed away. These areas will form the clear parts of the negative in the shadows, edge rebates, etc. The undeveloped silver halides are still light-sensitive and creamy in appearance until fixed. Therefore if your negatives still have a milky appearance when they emerge from the fixer into the light, return them immediately to the dark and fix for longer.

Usually fixer contains a gelatin-hardening agent too, which strengthens the processed emulsion and hastens drying. Fixers are generally acidic and therefore all trace of them must be washed from the film to prevent long-term stability problems.

Degree of development

A properly exposed film requires a matching amount of development to ensure a good, printable negative. The degree of development received depends on four factors:

1　*Type of developer*, its dilution, and general condition (e.g. how many films have already passed through it, how oxidised or 'stale' it has become, etc.). You have dozens of negative developers to choose from. Some are general-purpose fine-grain types like D76 or ID11; others are speed-enhancing (primarily for fast emulsions), or high-acutance (for medium or slow materials), or high contrast (for line films); see Figure 11.14. Their keeping properties vary according to type of formula. Diluting a developer reduces the contrast it gives (even if you extend time). Dilution is also necessary if processing time must be increased to avoid unevenness. However, this adding of water farther shortens solution-keeping properties because more oxygen reaches its chemical contents.

2　*Solution temperature.* The higher the temperature, the faster the development. As you'll see from Figure 11.15, a 1°C change in temperature has a significant effect on the action of a typical developer. Most manufacturers supply graphs like this to allow you to compensate for different solution temperatures but they generally only work well over a fairly small range – about 18–24°C. Outside of this range each component of a developer may react differently. At low temperatures some of the developing agents become inert. At high temperatures you risk over-softening the emulsion gelatin, and development times become too short for even action. Wherever possible, adjust the solution temperature to exactly the makers' recommendations.

3　*Timing.* Within limits imposed by the type of developer and film, the longer your development time the greater the image contrast and density (highlights develop more rapidly than shadows). Grain and fog level tend to increase too. Change of timing is the most practical way of controlling the amount of development you give (see 'pushing', p. 275). But avoid times less than about 4 minutes when tank processing, as it is difficult to get an even effect. Unless you start each film with fresh chemistry, the timing must be increased each time a solution is re-used. See the manufacturers' guidelines.

4　*Agitation.* The more a film is agitated in the solution, the greater the action of the developer; however, the effect is uneven and unpredictable and so just enough agitation to ensure even processing is ideal. Always stick to a standardized method, as discussed on p. 269.

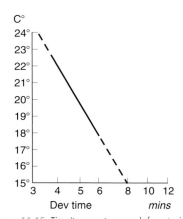

Figure 11.15 Time/temperature graph for a typical normal contrast developer (dilution and agitation specified). Temperatures below 18°C cannot be fully compensated for by increased time, and much above 22°C here, times become too short for tank processing to be even

Kodak D76 Ilford ID11 Kodak HC110	Normal contrast fine-grain; good compromise between fine-grain and full emulsion speed
Microphen	Speed-enhancing (up to 3 times ISO)
Perceptol	Finer grain at the expense of speed
XTOL	High-acutance, low max. density
Celer Stellar, Speedibrew 422	Low contrast
Kodak D19	High contrast (regular and line films)
Speedilitho	High contrast (lith films)

Figure 11.14 Some black and white film developers

Developer:	D76 (1 : 1)	Perceptol (stock)	HC110 (1 : 15)	ID11 (1 : 1)	XTOL (1 : 1)	Microphen (1 : 1)	T-Max (1 : 4)
Film							
Fuji Neopan 100 Acros	7	12.5	4.5	7	8	NR	5.5
Fuji Neopan 400	9.5	10	4	14	10	6.5	6
Fuji Neopan 1600	9	3	3	9	7.5	10	4.5
Ilford FP4 plus	8	9	3	8	10	7	6
Ilford HP5 plus	11	11	4.5	13	12	12	6.5
Ilford Delta 100 Pro	12	15	NR	10	10.5	9	6
Ilford Delta 400 Pro	14	13	7.5	14	12	11	6.5
Ilford Delta 3200	NR	18	NR	NR	NR	NR	8.5
Kodak Plus-X	8.5	8	3.5	8.5	8.5	NR	6
Kodak T-Max 100	12	13	4	12	9.5	11	8
Kodak T-Max 400	12.5	11	3	12.5	9	10	7
Kodak T-Max 3200	NR	NR	5	NR	16.5	18	8
Kodak Tri-X	10	10	5	11	9	11	6

Figure 11.16 Suggested 35 mm film normal development times (20°C). NR = Not recommended

Choosing developer

You need to find the developer(s) which best suit the film, the shooting conditions, and the type of negative you prefer. Another factor is whether to use 'one-shot' (dilute from stock, use once, and throw away) or a long-life re-usable solution (increasing your times gradually with each film batch and replenishing when necessary with some fresh chemicals). The latter type is essential for deep tank use because of the large volume of solution. One-shot is ideal for small tank processing because it is less fuss and ensures consistency, although it may cost more. Extremely energetic developers (two bath lithographic developer for example) have such a short life at working strength they are best used 'one-shot', so you will probably have to tray-process line sheet films (Figure 11.16).

Start by using one of the developers recommended on the film's packing slip. A re-usable fine-grain developer like D76 (diluted 1 + 1) or HC110 (1 + 15) is remarkably versatile, suitable for most continuous-tone films and subjects, given appropriate timing (Figure 11.17). If you are going to re-use your developer it should be appropriately stored to avoid oxidisation, see Figure 11.20. Alternatively, an 'acutance' developer such as Rodinal gives high edge-sharpness with slow films and has some 'compensating' effect, restricting maximum density yet giving a good range of other tones.

Processings	Timing
1–2	Normal
3–4	Normal + 6%
5–6	Normal + 12%
. . .then discard	

Figure 11.17 Development time increases with successive use of the same solution (D76, single reel tank)

'Pushing' and 'pulling' and x-pro

Fast films such as ISO 400/27° are most suited to extra development (push-processing) to enhance speed, because they are less likely than slow films to become excessively contrasty (Figure 11.18). ISO 400/27° film can easily be rated at ISO 1250/32°, for example, if processed in

Kodak T-Max 400

Film rated as:		Mins in T-Max Dev (1 : 4)	Temp (°C)
ISO	400	7	20
	800	7	20
	1600	10	20
	3200	9.5	24

Figure 11.18 Push-processing. Extending the developing time or raising temperature increases effective film speed, but taken beyond two stops (ISO 1600 here) graininess and contrast increase, and shadow detail becomes lost

speed-enhancing developer, or shot at ISO 800/30° and given ×1.6 normal time in regular D76. Certain films are purposely designed for push-processing and will give good results at speeds of ISO 3200/36° or more! Very high speed films may be necessary for dim-light documentary photography, or you push-process simply when you know you have accidentally underexposed. Don't expect miracles if the subject is contrasty because the increased development will farther reduce the detail in the mid-tones and remember it's better to use faster film in the first place unless you are after a high contrast, grainy effect. Remember too that the extra grain will reduce detail.

Slightly extended development helps to improve negatives of very low contrast images, preferably shot on slow film to avoid excessive grain.

Reduced development (holding back or more popularly known as pulling) is less common, but will help when you have accidentally overexposed or want to record a subject with a wide contrast range. The best approach here is to use a superfine-grain, speed-losing developer such as Perceptol, or D76 diluted 1+3. This holds back most films to half their normal ISO rating. You may still find a problem if the negative holds detail throughout an extreme-contrast subject but is too flat and grey to give a satisfactory print, although scanning may come to the rescue with its very wide range.

Note: chromogenic films (which use colour chemistry to produce a black and white negative) such as the Ilford XP2 Super are also useful here, although the same printing problems may emerge.

Developer effect can be shown by changes in the film's characteristic curve (Figure 10.5). As you give more development time the shape of the curve steepens, giving increasing contrast. There is an old adage in photography to 'expose for the shadows and develop for the highlights'. In other words, make sure you give enough exposure to record sufficient shadow detail, then control development to get sufficient (but not too much) density in highlights. Degree of development is given a 'contrast index' (CI) figure. A CI of 0.45 produces a negative of an 'average' subject (say 100 : 1 tone range) which prints on normal-contrast paper using a condenser enlarger (see Figure 11.19). Work to 0.56 for a diffuser enlarger (p. 295). Once you have perfected these film processing techniques it would be useful to look at the Zone System formulated by Ansel Adams and Fred Archer in the 1940s to help determine optimal film exposure and development.

X-pro (more traditionally known as cross processing) is most common in putting colour slide film through C-41 process chemicals. Some commercial photography/darkroom labs will perform this developing process. However, cross processing can take place in many other forms, such as colour negative film and/or colour slide film in a black and white developer. Colour cross processed photographs are often characterized by unnatural colors and high contrast. The results of cross processing differ from case to case, as the results are determined by many factors such as the make and type of the film used, the amount of light exposed onto the film and the chemical used to develop the film. For best results films are normally overexposed by two stops but it is good to bracket exposures.

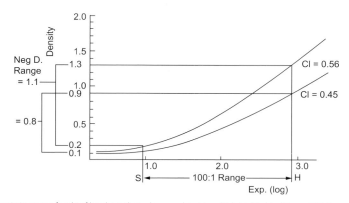

Figure 11.19 Characteristic curves for this film show that when a subject in which highlights (H) are 100 times brighter than shadows (S) is correctly exposed (see Exp. axis) and developed to a CI of 0.45 the resulting negative has a density range of 0.8. Developed longer, to CI 0.56, the negative is more contrasty and has a 1.1 density range. Relate these ranges to printing papers, Figure 12.21

Processing stages following development

As soon as the development time is up, pour out the developer and refill with stop bath (stop bath can be just water). After agitating throughout the 30–60 seconds or so required here (check the stop bath instructions), the next stage is to treat the film with acid fixer solution which will render the undeveloped silver halides soluble and make the film no longer light-sensitive. After a few minutes' fixing it is safe to look at the film in normal light although this is not recommended. It is safer to follow the manufacturer's recommended times. If the film appears creamy at the end of the fixing period, it may be that the fixer is partially exhausted. In this case it may take a little longer for the fixer to make all creaminess disappear from the emulsion and twice this period for film to be fully fixed. Agitate at the beginning of fixing and then once every minute. Both stop bath and fixer are long-lasting and can be re-used, if stored properly (see Figure 11.20), many times (see Figure 11.21). All these chemicals are highly toxic and should be disposed off safely at chemical disposal dumps, not thrown down the sink. In some countries this is against the law.

Figure 11.20 Half-full concertina storage container which can be compressed (left) to minimize air left in contact with solution. This extends the life of developers, stop bath and fixers by reducing oxidation

Solution	Processing capacity (35 mm films per litre)	Keeping properties without use	
		Stock in full container	Working sol. in deep tank
Developer			
D76	5 × 36 exp.	6 months	1 month
Lith	use once only	6 months*	–
Stop bath (typical)	12 × 36 exp.	indefinitely	1 month
Fixer			
Regular and rapid	30 × 36 exp.	2 months	1 month

*Separate A and B solutions.

Figure 11.21 Working life of typical black and white film processing solutions. Figures for processing capacity assume that times are appropriately increased with each re-use

Effective washing time is about 15–20 minutes, less if the emulsion was unhardened, but wash for longer if in doubt - do not leave to wash for an extended length of time as this can soften the emulsion. For best results rinse the film (still on the spiral) to remove the surface fixer before placing it in the washer and ensure the wash water is no colder than about 15°C. (See Appendix D for residual silver permanence test.) Finally, add a few drops of wetting agent to the last of the wash water, to reduce surface tension and so encourage even drying. Surface water can be removed with a special rubber squeegee (ensure it is completely clean or it may scratch), a piece of sponge or chamois leather or even running the film between two fingers, but if the wetting agent is correctly diluted this is unnecessary. The important thing is to avoid water lying on the film in droplets as it dries, as this will cause marks which may be impossible to remove. Carefully hang up the films to dry in a dust-free atmosphere and do not disturb them while drying (see Figure 11.13).

Assessing results

As a general guide, a correctly exposed and developed continuous-tone negative should represent the detail in deepest subject shadows as just perceptibly visible over the clear, unexposed film rebate. Tones representing the subject's brightest important details must not be so dense as to be unprintable and certainly not as dark as the fogged leader of the film.

Figures 11.22 and 11.23 show some common negative faults. It is important to distinguish exposure errors from development errors, and faults originating in the camera from those caused while processing. Unsharp images are not caused by processing, whereas uneven patches of density usually are. Dark, light-fog marks limited to picture areas alone often mean a camera fault; fog across the rebates as well may be either a camera or a processing mishap.

Processing chromogenic (colour and black and white) negatives

What happens

Colour negative films, and black and white dye-image (chromogenic) negative films, can both be processed in the same C-41 process chemical kit. In the first solution (colour developer) the developing agents form a black silver image, but this time exhausted agents react with dye

Figure 11.22 Effects of exposure and development on a normal contrast, silver image monochrome film. (a) Underexposed and under-developed. (b) Underexposed and standard development. (c) Underexposed and over-developed. (d) Correct exposure and development. (e) Overexposed and under-developed. (f) Overexposed and standard development. (g) Overexposed and over-developed. Under-exposure combined with over-development gives highest contrast ('pushing' technique). Over-exposure with underdevelopment ('holding back/pulling') produces lowest contrast

couplers to simultaneously form a different coloured dye image in each emulsion layer. The reaction is known as chromogenic development. In the next solution (a bleach), development is stopped and the black silver is turned into silver halide so that it can be fixed out together with all the remaining unprocessed halides. The fixer may be incorporated in the same solution (then called 'bleach/fix'), or be a separate stage following a brief wash. You are now left with dye images only (see p. 212). The film is washed to remove fixer and all soluble by-products, and then finally, according to the chemicals used, may require a rinse in stabilizer to improve dye stability and harden the emulsion before hanging up to dry. Some C-41 chemical kits do double duty by allowing you to process (RA-4) colour paper as well. As these chemicals too can be toxic they should also be disposed off safely at chemical disposal dumps, not thrown down the sink as mentioned above, in some countries this is against the law.

(a) (b) (c)

(d) (e) (f)

Figure 11.23 Some monochrome silver image processing faults. (a) Partial fogging to light before processing – typically reel loading in an unsafe darkroom. (b) Partly fogged towards the end of development. (c) Extremely uneven development because the tank contained insufficient solution. (d) Rollfilm showing black crescent-shaped kink marks, and clear patches where coils have touched during development. (e) General abrasion and crease marks due to rough handling in reel loading. (f) Circular uneven drying marks, due to splashes or droplets clinging to the emulsion when drying after processing

Processing tolerances

All this takes place at a higher temperature than with silver negative processing. The higher the temperature, the more accurately it must be held, so it is essential that you use an efficient tempering unit such as a water bath, drum processor, etc. (Figure 11.24)

Development is the really critical stage. Colour negative films only tolerate very limited development changes because colour is affected along with density and contrast. All chromogenic black and white and some colour negative films designed for the purpose allow greater adjustment of developing times. These you can 'push' or 'hold back' to compensate for shooting at a higher ISO rating or for (slightly) over-exposing. Overdone, the resulting colour negatives may show colour casts that are different in shadows and highlights. Pushed film has a high fog level and grain, while held-back film gives negatives too flat to suit any colour paper. Therefore it is not advisable to try these techniques purely to compensate for image contrast, as it is in black and white work.

C-41. For colour and chromogenic black and white negatives

Stages	Kodak 37.8°C (100°F)	Paterson 38°C	Temp (°C) tolerance
	min	min	
Colour dev	3½	3	±0.25
Bleach	6½	–	24–41
Wash	3¼	–	24–41
Fix	6½	–	24–41
Bleach/fix	–	3	24–41
Wash	3¼	5	24–41
Stabilize	1½	½	24–41

Figure 11.24 Processing stages for four, or three bath C-41 kits. (These are occasionally updated, and so should be taken only as a guide.) Times differ slightly according to whether you are processing in deep tanks, a small hand tank, or a drum processor

As a rough guide, increase development time for colour negative film by 30 percent for one stop under-exposure, or reduce normal time 30 percent for one stop over-exposure. All other steps remain the same. Whenever you judge processed dye-image films, both colour and monochrome, bear in mind that results appear partly opalescent and 'unfixed' until completely dry.

Processing colour slides and transparencies

Apart from a very few process-paid films such as Kodachrome, etc., all general-purpose colour slide and transparency films require the use of an E-6 process chemical kit. Like colour negatives there is no choice of developer – only complete kits (Figure 11.25). Some kits cut down on time and the number of stages by combining solutions, but give equivalent results which barely differ in sequence or effect.

What happens

The first solution, a form of high-activity black and white developer, forms black silver negatives in each of the emulsion layers. Next, the film is washed to halt the action and remove developer. The remaining halides are then 'chemically fogged' to give an effect similar to exposure by light. This is achieved either by a reversal bath or by chemicals contained in the next solution, colour developer.

E-6. For colour slides

Stages	Kodak 38°C (104°F)	Tetenal 38°C	Temp (°C) tolerance
	min	min	
1st dev	7	6.25	±0.3
Wash	2	2.5	±1
Reversal bath	2	–	±1
Colour dev	4	6*	±1
Wash	–	2.5	20–40
Pre-bleach	2	–	20–40
Bleach	6	–	33–40
Fix	4	–	33–40
Bleach/fix	–	8	33–40
Wash	3	6	33–40
Stabilizer	–	1	30–40

* Includes fogging agent.

Figure 11.25 Reversal processing stages for colour slide and transparency films, using six and four bath kits. As with C-41 processing these times will differ slightly according to your processing equipment

The colour developer has a similar (chromogenic) function to developer used for colour negatives. The silver halides fogged by the previous solution are developed to metallic silver in each layer. At the same time special exhausted developing agents that are formed react with dye couplers attached to the halides undergoing change. The result is yellow, magenta and cyan positive dye images, although at this point they are masked by the presence of both negative and positive silver images. Finally the image goes through bleaching, fixing and washing to remove all the silver, leaving the positive dye images alone.

Warning: In reversal processing contamination of the first developer with the smallest traces of colour developer – even fumes alone – can give results with grey blacks generally off-colour.

Processing tolerances

As with C-41, solution temperatures are higher than in regular black and white processing. The critical solutions are first developer (60.3°C) and colour developer (61.0°C), with the others 20–40°C or 33–40°C, in kits for processing at 38°C. Most brands of reversal colour material can be successfully 'pushed' or 'held back', which you do by altering the first development time (Figures 11.26 and 11.27). All other times remain constant. Regard one stop either way (i.e. doubling or halving ISO speed) as the normal limits, with pushing up to two stops as more of an emergency treatment or for grainy effects.

In general, pushed processing increases graininess and contrast, and leads to shadows with less detail. But in moderation it can improve shots of low-contrast subjects and help when you must have maximum emulsion speed. Held-back ('pulled') processing reduces contrast, which can be useful such as when copying slides or when the original subject contrast is too high. The precise effect of altered processing on final image colours varies with different brands and types of film. Fast films survive push-processing far better than slow ones. Usually pushing gives coarser hues, and holding back produces less brilliant colours and warmer highlights. Any slight

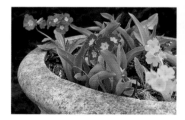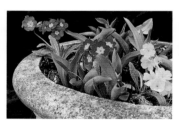

Figure 11.26 Results of adjusting the timing of the first developer stage of E-6 slide film processing (Ektachrome). Left: Over-exposing one stop and holding back. Centre: Correct exposure and normal processing. Right: Under-exposing two stops and giving appropriate push-processing (when enlarged, grain is very apparent)

For camera exposure:	Or meter ISO setting:	Typically alter 1st developer time by:
2 stops under	×4	+90%
1 stop under	×2	+30%
Correct	Normal	
1 stop over	×0.5	−30%

Figure 11.27 Modified E-6 processing to 'push' or 'hold back' slides and transparencies

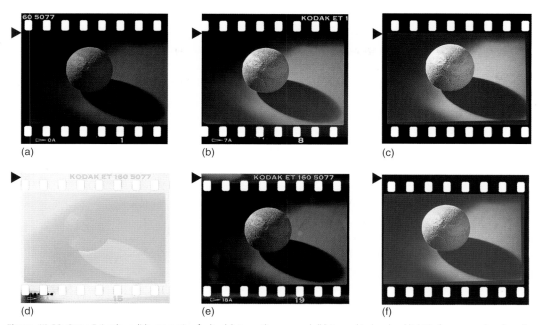

Figure 11.28 Some E-6 colour slide processing faults. (a) Correctly processed. (b) Fogged to low-level light before processing. (c and d) Fogged during processing. (e) Contamination of first developer with fixer (including fix spots). (f) Colour developer contaminated with bleach

colour cast (due to lighting conditions or subject surroundings, for example) seems to become exaggerated. Note that some films are specifically designed to work well when pushed, and these should be chosen when you need very high film speeds.

Most professional photo laboratories offer a push or pull-processing service (sometimes at extra cost). Many photographers will have test rolls or even a small piece clipped from a sample film processed first before judging the exposure and having the rest of the job processed accordingly. Modern automated labs should be able to push or pull-process to an accuracy of a quarter stop with no problem.

Some of the most common reversal processing faults are shown in Figure 11.28.

Processing other film materials

Black and white slides from conventional film

You can reversal-process some black and white negative films to produce direct black and white slides. It is best to use slow film (ISO 100 or less), which you shoot at 2.5 times its official ISO rating. Unsuitable films give flat slides, often with a greenish tinge to blacks.

Processing involves similar steps to colour film reversal-processing – producing first a black and white negative, and then bleaching, fogging, and re-developing in black and white developer to get positive images. Commercial kits such as the Kodak T-Max reversal kit cover the five chemical stages.

Processing by machine

Automatic machines for processing conventional films range from small rotary drum units to dip-and-dunk and roller-transport machines. Given sufficient tanks and appropriate temperature/time programming they can all tackle C-41, E-6 or conventional black and white processing.

Drum units (Figure 11.8) are the least expensive machines and simply mechanize what you would otherwise do by hand. In automatic versions the film drum is filled from chemical reservoirs, rotary-agitated, emptied, washed through, etc. Chemicals are usually 'one-shot' and so discarded after use, but some (bleach/fix for instance) are stored for farther use. The best ones have a thermostatically controlled water bath which keeps the tank and solutions at the right temperature, ensuring more consistent results.

Equipment used by commercial labs

Dip-and-dunk machines work by physically tracking and lifting batches of sheet film in hangers and 120 or 35 mm films suspended on clips, from one tank to another, in a large room-size unit. Transport is at a steady speed, but by having tanks longer or shorter, different periods in each solution are made possible. Many of these are computer controlled, making push and pull processing easy. Finally films are lifted and passed through a drying compartment.

Roller-transport machines also use a sequence of tanks but these are filled with many motor-drive roller units (Figure 11.29) which pass sheets and lengths of film up and down through the tanks and finally through an air-jet drying unit. An emulsion area monitoring system replenishes tanks with fresh processing chemicals automatically as they are required. Push and pull processing is generally achieved by computer control of the roller speed to vary first developer time.

Commercial photo labs almost always sign up to a process monitoring system run by the machine or chemistry supplier, Figure 11.30 shows a typical mini-lab set-up. In addition to running their own tests, the lab will regularly process pre-exposed test films which they submit to an external process auditor for analysis. This provides an independent quality control system, guaranteeing that they meet minimum standards of exposure and colour accuracy.

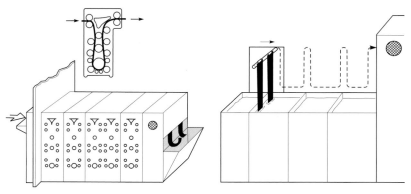

Figure 11.29 Large-volume film processing machines. Roller-transport type, left, contains racks of rollers (see detail) which turn continuously; with this unit you insert individual films in the darkroom end, and they appear from the drier into a normally lit room. 'Dip-and-dunk' machine, far right, processes film in batches. Tanks are open, so developing stages must take place in a darkroom

Figure 11.30 A mini-lab printing unit for 35 mm and APS films

Since both dip-and-dunk and roller machines need large tankfuls of expensive chemical solutions, they are only viable for regular, high-volume film processing. Few commercial laboratories now have sufficient demand to justify running machines for conventional black and white processing. If you want to use a lab for your monochrome work it will be easiest to shoot on a chromogenic-type 35 mm film (p. 206), which any lab can put through their C-41 line; see also *Advanced Photography*.

Mini-lab roller-transport machines provide film processing, printing and paper processing all linked up as either one or two stand-alone units. As mini-labs are designed for full operation in daylight, they are ideal for installations in retail shops, and while generally not run to the same quality standards as professional labs they will produce consistent results much more easily and cheaply than the C-41 kits which are really designed for press use where commercial lab facilities are unavailable.

Permanence of processed results

Correctly processed film images should remain stable for many years. Anticipated life without any perceptible change for dye images, kept in the dark and stored at 21–24°C and 40 percent relative humidity, is 10–20 years for fast films and 40–100 years for slow films. Black and white silver images similarly stored should last 40–100 years. Two ways to ensure maximum permanence with black and white films are: (a) use two fixing baths, giving 50 percent of the fixing time in each. Then, when the first is exhausted (Figure 11.21), replace it with the second and make up a new second bath from fresh solution; (b) rinse films after fixing and treat in hypo-clearing agent prior to washing. This also allows washing time to be reduced by 75 percent. As with black and white film chemicals most colour film chemicals have a limited lifespan (Figure 11.31). If you over-use chemicals permance of the negative will be affected.

Store negatives in sleeved ring-file sheets, made for the purpose from inert material such as polyester. Slides can be mounted in plastic or glass mounts (avoid the card ones as they contain glues, etc. which can attack the image), 'spotted' to show correct image orientation for projection (Figure 11.32) and stored in archival quality pocketed plastic sheets to help ensure longevity which hang in a filing cabinet. Give each image a reference number. (Use the frame number near the edge of 120 and 35 mm negatives as part of this reference when film is stored in strips.)

Take some time to work out a suitable filing system which suits the way you work. A good way to maintain a film file index is to hold it on computer disk, using an image-based software program. Here it is also easily cross-indexed for date, subject, client, invoice number, etc. If you scan in your work (Chapter 14) the computer can display 'thumbnails' a dozen or so at a time based on a selective listing for any permutation of headings you choose, to locate particular pictures. This can also be linked into email and internet transmission of your pictures for sales or reference (see also Figure 15.9).

Solution	35 mm films (36 exp) per l	Working sol. in full container
E-6 slides		
First developer	9*	2 months
Reversal bath/ pre-bleach	20	2 months
Colour developer	20	3 months
Bleach and fix	20	3 months
C-41 negatives		
Colour developer	8†	6 weeks
Bleach	16	indefinitely
Fix and stabilizer	16	3 months

*Extend time after 6 films by 8%.
†Extend time after 4 films by 8%.

Figure 11.31 Working capacity and keeping properties of colour reversal and colour negative processing solutions. This is updated from time to time, as chemical compositions change

Figure 11.32 Storing negatives and transparencies. Top left: Slides are mounted and 'spotted' top right when the image is inverted but right way round. Placed in the projector this way, your picture appears correctly on screen. Drawing a diagonal line across the top edge of a set of slides quickly shows up any missing or disordered ones. Centre: Negative file for rollfilm negatives. Right: Suspension file system. Slides are stored in transparent sheets with pockets holding 20–24 at a time

SUMMARY

■ Key skills in film processing are: (1) preparing solutions accurately and safely, (2) loading the spirals, racks and tanks, in darkness, (3) ensuring correct temperature, timing and agitation, and (4) drying the wet film without damage.

■ Protect yourself from inhaling or touching chemicals. Always add chemicals *to* water. Avoid solution contamination through contact with unsuitable materials or other processing solutions, particularly colour chemicals. Dispose of chemicals safely.

■ Concentrated chemicals may need dilution by *part* (e.g. 1+8) or be used as a *percentage solution* (e.g. percentage of chemical to final solution volume).

■ 35 mm and 120 tanks accept film in single or multiple reels, have a light trapped inlet/waste for solutions to act on the film in sequence. Drum processors work similarly but are motor-driven and use small volumes of mostly one-shot chemicals. Sheet films may be processed in small tanks like rollfilm or, more often, in a sequence of deep tanks – films being transferred between each solution in the dark.

■ Use a tempering unit, tempering coil or thermostatic immersion heater to maintain the temperature of solutions and tank. Agitation during processing must be consistent, not under or over-done.

■ Black and white negatives should be exposed for shadows, and developed for highlights. Development increases contrast, density, graininess and fog level. The degree of development a film receives depends on solution type, condition and dilution; temperature; agitation; and timing.

■ Black and white developers are general-purpose or specialized (high-acutance, contrast, speed-enhancing, etc.), 'one-shot' or re-usable (regularly extending times, or replenishing). Normal processing temperature 20°C (68°F).

■ 'Push' black and white film by extending time or using high-energy developer. 'Hold back' ('pull') by diluting developer, reducing time, or using speed-reducing superfine-grain formula. Watch out for the effects these changes have on image contrast, grain. Black and white negative contrast indices of 0.45 and 0.56 suit condenser and diffuser enlargers respectively.

■ When assessing results clear and featureless subject *shadows* are a sign of negative under-exposure; low contrast and grey *highlights* a sign of underdevelopment.

■ Colour (and monochrome dye image) negatives need C-41 chemistry processing. E-6 chemistry is used for most forms of reversal slide and transparency films. Temperatures are higher than for black and white, latitude much less. Invest in an accurate, preferably digital thermometer. Main chemical stages for negatives: colour developer, bleach/fix, stabilize. For slides: first-developer, reversal (some kits), colour developer, bleach/fix.

■ Suitable negative or reversal type films can be 'pushed' or 'held back' one stop or more by adjusting the timing of the first (development) stage.

■ Processing machines – drum units, dip-and-dunk, roller-transport – offer semi or complete automation. Rotary processing drum apart, their cost in hardware and chemicals is unjustified for small-volume workloads. Virtually every lab is mechanized to offer fast, reliable, straight processing of C-41 films. Cost is less than the chemical kit you must buy when small batches of film are user-processed. Most labs handle E-6 too. Black and white films (unless chromogenic) are best user-processed – then you can make your own choice of developer.

■ For maximum black and white image permanence use two-bath fixing, treat film with hypo-clearing agent at the wash stage, and store carefully.

■ Remember health and safety when using and disposing of chemicals; Appendix E.

1 Compare film/developer combinations for your favourite monochrome films. By practical experiment discover the times needed for different developers to give negatives which best suit your printing set-up. Try pairing up slow films with fine grain developers such as Perceptol, and fast films with speed enhancers like Microphen. Compare with the more all-purpose ID11 or XTOL.

2 Test out the image quality effects of up-rating and then push-processing. Shoot both contrasty and low-contrast subjects on ISO 400 black and white film with correct exposure and development. Then repeat, pushing film speed to ISO 800, 1600 and 3200.

Make the best possible enlargements from each. Try the same with colour slide film. This time, use two projectors to compare pairs of results.

3 Test the effect on pulling (holding back) films during process. Overexpose a film by 1 stop from ISO 100 to ISO 50 and pull process appropriately. Compare with a film exposed and processed looking at the result on grain and contrast. Repeat with an ISO 400 rated film.

4 Experiment with cross processing films: colour slide film through C-41 chemicals and colour negative film in E-6 chemicals, remembering to overexpose the film by two stops.

This chapter is concerned with darkroom organisation, enlargers and other equipment to enable you to set up your own darkroom. It looks at the choice of printing materials, and then discusses basic print-processing chemicals and procedures. With well-organised facilities and a basic understanding of darkroom materials and procedures you will be able to get down to printing your work as outlined in the next chapter.

Darkroom organisation

While it is possible to make successful prints in a temporary darkroom by blacking out a bathroom or a spare room it would be better for printing on a professional basis to establish a permanent darkroom set-up.

There are four basic requirements for a darkroom: (1) it must be light-tight; (2) it needs electricity and water supplies, and a waste outlet and care must be taken in how waste chemicals are environmentally friendly disposed of; (3) the room must have adequate ventilation, and a controllable air temperature; and (4) layout should be planned to allow safe working in a logical sequence, including easy access in and out. Requirements (3) and (4) are just as important as the other, more obvious, facilities. After all, you should be able to work comfortably for long periods, so shutting out light must not also mean shutting out air. If others are using the darkroom too, it is helpful if people can come and go without disrupting production but care must also be taken to restrict dust entering the room.

General layout

Darkroom size depends naturally upon how many people use the room at one time, how long they need to be there, and the work being done. The following should give some idea of what is needed for an ideal darkroom. An 'all day' printing room for one person might be 20 cubic metres (706 cubic feet), e.g. $2.5 \times 3.2 \times 2.5$ m high, plus $4 \, m^2$ of floor space per additional user (Figure 12.1). The best entrance arrangement is a light trap or labyrinth (Figure 12.2). This will prevent entry of light, provided it is properly designed and finished in matt black paint. It allows you free passage without having to open doors or pull aside curtains (both can become contaminated and sources of chemical dust and fluff). Equally important, the light trap will freely pass air for ventilation. Rotating 'shell' doors (Figure 12.2) are available commercially and provide 100 percent light-proofing at the expense of ventilation. If you use an ordinary door, make sure there is a light trapped air grille within it or somewhere in the wall nearby. Elsewhere in the room you should have a light-proof air extractor fan, or better still, an air conditioner. Ideally, aim for a steady inside air temperature of 20°C (68°F).

Figure 12.1 A one-person general black and white darkroom, for small format developing and printing. Note clear separation of 'wet' and 'dry' areas. Film and print drying take place elsewhere. D: Developer. S: Stop bath. F: Fixer. W: Wash

(a)

(b)

(c)

Figure 12.2 Various light trapped darkroom entrances. (a) and (b) layouts are often the easiest way to adapt an existing doorway. (c) is a commercially made revolving shell you step into, then rotate it around you. Unlike the others, it does not promote ventilation. All labyrinths must have an internal matt black finish

Inside, clearly divide your space into 'wet' and 'dry' areas. The ideal wet area should contain a PVC flat-bottomed photographic sink about 6 inch deep with integral splashback, large enough to hold at least three of your largest print trays. Have one water outlet fed through a hot and cold mixer unit, and positioned sufficiently high for you to fill a bucket or tall container. This, and one or more cold-water outlets, can be threaded to firmly accept a hose coupling to a wash tank or tray. Often the incoming water supply contains small particles of grit or rust from pipework which can stick to films or prints, causing unsightly marks. If this is a problem, commercial water filters with disposable cartridges can be plumbed into the supply. As Figure 12.1 shows, you need storage areas for trays and sufficient area for mixing and storing chemicals.

Ideally the 'dry' area should be a bench on the opposite side of the room, far enough away to avoid splashes and big enough to accommodate the enlarger as well as having sufficient space for timers, paper boxes, paper trimmer, negative files and notebooks, etc. The bench should be secure as it is vital that the enlarger shouldn't wobble at all. Have ample power points at bench height along this side for your equipment, plus a sealed outlet higher on the wall near the wet bench for an immersion heater or tempering unit. The latter should be controlled by ceiling-mounted pull switches – you must not be able to operate switches with wet hands. Paper and film should ideally not be stored in the same room as 'chemistry', but if this is unavoidable, keep it in closed storage cupboards rather than on open shelves. Spare chemistry should also be stored away in a metal cabinet and is always advisable, especially if sharing a darkroom, that you have the appropriate health and safety information for each chemical you are using.

Depending on the room size, you will need one or more safelights. Position these so as to give good working illumination everywhere but ensure that none is closer than its recommended distance (p. 305). You need enough safelighting so as to find your way around and also to see clocks, timers and other equipment. It is preferable to have minimal safelighting around the enlarger itself so as to be able to see its projected image more easily.

For white light, use a ceiling light bulb (not a fluorescent tube, which may continue to glow faintly in the dark). This should be operated by a pull cord as used in bathrooms, etc., for safety.

Choose a wall and ceiling finish inside the darkroom that is as pale as possible, preferably matt white. Provided your room is properly blacked out, generally reflective surroundings are helpful. Your safelight illumination will be more even, and working conditions less oppressive. But paint the wall around your enlarger matt black to prevent possible fogging problems from stray white light.

Dry benches can be topped with pale-toned laminate. 50 mm thick kitchen worktop material is ideal as it is durable, easily cleaned and heavy enough to support any enlarger rigidly. The floor should not be carpeted as it generates dust and harbours chemical spills. Do your drying of pictures (film drying cabinet, print dryer) and the dissolving of any dry chemicals, plus all image-toning processes, out of the darkroom in some separate well-ventilated area.

Items for the 'dry' bench

For consistent work, an enlarger timer, wired between the lamp and supply, is essential. A variety of models are available which allow a wide range of timed exposures, plus a switch to keep the enlarger on for focusing. Some models have the facility to set multiple times for dodging, burning-in, etc. and can be controlled by a foot-switch. Ensure that the timer is capable of controlling the power (wattage) of the enlarger; high-power models may need a relay to

prevent damage. You will also need a masking frame (or 'easel') for the enlarger baseboard, with metal masks adjustable to the print size you need. The frame provides a white surface on which to focus the image, and a means of positioning and holding the paper flat during exposure, with edges protected from the light to form white borders. Suction boards are also available for large scale printing. You will also need a focusing magnifier (or 'grain magnifier'). This allows a small part of the projected image to be reflected onto an internal focusing screen which you check through a magnifier, making focusing considerably easier (Figure 12.14). Remember that if you plan to use variable contrast paper with an enlarger not possessing a dial-in head, you will also need a set of filters. Other important accessories include tools for shading (p. 319), a glass-top contact printing frame (p. 314), and a can of compressed air or blower brush for removing any dust or hairs from film and glass surfaces. Some printers use an enlarging exposure meter to help in assessing exposure and contrast although this is by no means an essential when starting out (see p. 316).

Items for the 'wet' bench

You will need sufficient trays for developer, stop bath, and preferably two fixing baths. Good-quality plastic trays are often sold in sets of three, colour coded for identification but the most durable are made in stainless steel. You will also want a wash tray or vertical-slot tank suitable for the papers you are using (resin-coated or fibre base). Ideally use trays at least one size larger than the paper you are using to allow the chemicals to circulate freely. If the developer working temperature is significantly warmer than that of the room, either use a larger tray to enclose your tray of developer and act as a water jacket, or use a dish heater (Figure 12.15). Have a large mixing graduate and containers of concentrated print developer, stop bath, and fixer. It is also recommended that you use disposable gloves when mixing chemicals as well as eye protection wear. Some people may have an allergic reaction to the chemicals and will need to wear gloves whilst printing.

A dish thermometer is essential (preferably alcohol-type, for easy darkroom reading), as well as a wall-mounted clock with clear minute and second hands. Two pairs of plastic or stainless steel print tongs – kept separate for developer and fixer trays – will help keep your hands out of chemical solutions. Finally, don't forget a roller towel, and a waste bin for discarded prints. Empty it daily to avoid darkroom contamination from chemicals drying out. See processing procedure, p. 306.

Equipment: the enlarger

The enlarger and more importantly the lens are your most important pieces of printing equipment. The enlarger is designed like a vertically mounted, low-power projector. A lamphouse at the top evenly illuminates the negative which is held flat in a slide-in carrier. A lens mounted below the negative focuses a magnified image on to the baseboard, where the printing paper is usually held flat in an easel or masking frame. Sliding the whole enlarger head (Figure 12.3) up or down the supporting column alters the *size* of the image on the baseboard. Adjusting the distance between lens and negative alters *focus* (needed for every change of size), and changing lens aperture by *f*-stop intervals alters *image brightness*, just as it does in the camera.

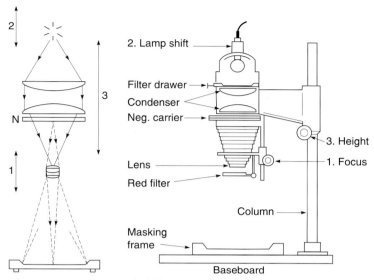

Figure 12.3 Enlarger: basic condenser type. Arrowed solid lines show the path of light through condensers and negative (N), directed into the lens. Dotted lines denote light refracted by lens. Adjustment 1 shifts lens, to focus the image. Adjustment 2 raises/lowers lamp relative to lens position, adjusting for evenness when needed. 3, Movement of the whole enlarger head alters image size

When choosing an enlarger the things you should consider are: (1) the range of negative sizes it should accept, (2) the most appropriate lens, (3) the type of negative illumination, (4) the largest print size you will want to make, and (5) whether you may want to use it for colour as well as black and white printing.

Negative size

A 35 mm-only enlarger is smaller and cheaper than one of similar quality accommodating several negative sizes (Figure 12.4). If you also use medium format cameras or are likely to do so, get an enlarger for the biggest format, as it will comfortably take smaller negatives. As well as negative carriers for each format you will need lenses of suitable focal lengths to get a useful range of print sizes off each format (see Figure 4.15 for example of film sizes).

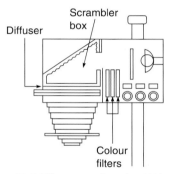

Figure 12.4 Diffuser type enlarger head (this one is also suitable for colour printing). Dials raise filters into the light beam. Light scrambler box scatters and diffuses the illumination to give even light and colour. Reflex layout makes it easier to cool the high-intensity lamp, and reduces headroom

Enlargers for 4 × 5 inch or larger negatives are often much more substantial. Most printers use a separate enlarger for these large formats. They will adapt down for smaller films, but you may find it awkward to keep changing fitments when a mixture of negative sizes is being printed.

Lens

Enlargers normally come without a lens fitted, as you must choose from a variety of focal lengths and prices (Figure 12.5). Unlike camera lenses which work best at infinity, an enlarger lens is designed to give its maximum resolution at very close working distances, although both types of lenses work in

Figure 12.5 Enlarger lens, *f*/2.8. A large aperture scale and 'click' stops make it easy to adjust in the darkroom. Your lens must be of high quality, otherwise all your work is affected. Most lenses up to about 105 mm have a standard 39 mm thread fitting. Larger ones are usually mounted in plates for easy fitting

the same way in that they have a range of apertures to control the amount of light passing through, see Figure 3.6. Typical focal lengths are 50 mm for 35 mm format negatives, 80 mm or 105 mm for medium format sizes, and 150 mm for 4×5 inch However, the lens works in the same way in that it has a number of aperture settings to control the amount of light passing through; see Figure 3.6.

In effect, focal length is a compromise. If it is too long you will not start to get sufficient-size enlargements until the enlarger head is near the top of the column. Too short, and the lens has insufficient covering power (p. 94), resulting in prints with distorted or even cut-off corners, especially at large magnifications. You will also find it is difficult to position the lens close enough to the negative; and when making small prints there is insufficient space below the lens to shade or print in (see p. 317).

The wider the maximum aperture, often *f*/2.8 or *f*/4 for a 50 mm lens, the easier it will be to see and focus the image. However, prints will very rarely be *exposed* at this setting because exposure time is then inconveniently short (see p. 316). Aperture settings are boldly marked for reading under darkroom conditions, and easily felt by 'click' settings at half stop intervals. Always buy the best enlarger lens you can afford. False economy here can undo the fine image qualities achieved by your camera lens. Take care not to put fingermarks onto the lens surface and occasionally check the back, upper surface for any accumulated dust.

Illumination

The negative, held in the enlarger by its carrier, must be evenly illuminated. Light from the lamp either passes through a *condenser or* a *diffuser* system to achieve this. Many older enlargers have a system consisting of a lamphouse which contains one or more simple but large condenser lenses (larger than the negative) to gather diverging light from an opal tungsten lamp and direct it through the negative to focus into the enlarging lens itself. This gives strong, hard illumination which has the effect of making projected images slightly more contrasty than a diffuser system. This can give the impression of greater sharpness but it also shows up scratches and any other surface blemishes on the film. You may have to move the lamp or one of the condenser

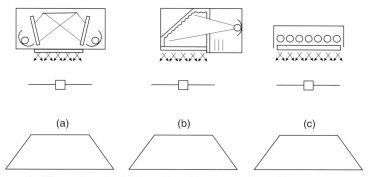

Figure 12.6 Interchangeable diffuser enlarger head designs. (a) Dual-lamp system for variable contrast paper. Lamps are filtered yellow and magenta by adjustable amounts. (Relate to Figure 12.11.) (b) Colour head, also suitable for VC paper. (c) Cold light head. This contains one or more fluorescent tubes and gives excellent brightness with little heat

lenses whenever you change lens focal length or when making an extreme change of print size. Condenser enlargers are capable of very bright illumination, which is useful for large prints but they generate quite a lot of heat which can cause problems with negatives curling and 'popping' out of focus.

A third kind of illumination is offered by cold cathode or 'cold light' enlargers. In reality a type of diffuser, these use one or more fluorescent tubes as a light source. Many experienced printers favour this type as it offers very even illumination with minimal heat. The colour temperature of the tubes can be set so as to offer contrast control similar to that of a filtering head. Cold light units produce light over a much narrower part of the spectrum, meaning chromatic aberrations in the enlarging lens are less of a problem and images look sharper and most true to the negative (see Chapter 13). Many enlargers can be converted to cold cathode by adding lamp units made by specialist suppliers such as Aristo, although they may need additional specialist electronic control units or relays to work with timers.

Whichever type you choose, as discussed on p. 275 it is best to process negatives to a contrast index which suits your particular enlarger by 'pushing' or 'pulling' your film during processing. Then you can make fullest use of printing paper to adjust contrast up or down to 'fine tune' individual pictures (Figure 12.9).

Diffuser enlargers use a lamp head which makes the negative appear as though lit by a miniature lightbox (Figure 12.6). Most enlargers use a small bright, quartz-iodide light source, which is directed through a white plastic diffuser located a short distance above the film. This soft light design lends itself to built-in colour filtering systems, so heads with dial-in filters for controlling variable contrast paper (p. 304) or for colour printing are mainly of this type. Despite the very hot-running QI lamp, diffuser types generally run cooler than condensers. The image projected is usually less bright though, requiring longer exposure times or wider apertures. The diffused light source is much 'kinder' to damaged negatives, with scratches, etc., being less pronounced on final prints.

Figure 12.7 Some enlargers have tilting heads, to correct images with unwanted converging lines

Focal length	Distance negative to lens	Magnification	Distance lens to paper
50 mm	6.6 cm	×3.0	20 cm
	5.5 cm	×10	55 cm
	5.25 cm	×20	105 cm
80 mm	12 cm	×2.0	24 cm
	10.4 cm	×3.0	32 cm
	8.8 cm	×10	88 cm

Figure 12.8 The 'throws' necessary for a 35 mm enlarger (50 mm lens) and 120 film enlarger (80 mm) to achieve various image magnifications. Most 35 mm standard column enlargers allow the lens to be raised at least 60–70 cm above baseboard

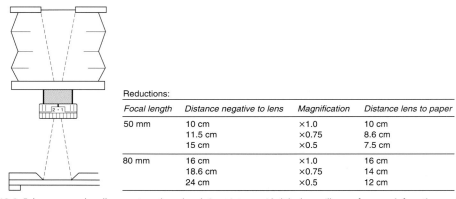

Reductions:

Focal length	Distance negative to lens	Magnification	Distance lens to paper
50 mm	10 cm	×1.0	10 cm
	11.5 cm	×0.75	8.6 cm
	15 cm	×0.5	7.5 cm
80 mm	16 cm	×1.0	16 cm
	18.6 cm	×0.75	14 cm
	24 cm	×0.5	12 cm

Figure 12.9 Enlargers may also allow you to make reduced size prints, provided the lens will move far enough from the negative. If bellows are too short add a camera extension tube. Check that the image remains evenly illuminated

Print size – largest and smallest

Enlargers, as their name implies, allow you to make prints bigger than the negative, but you can make reduced size 'thumbnail' prints too. The maximum size magnification you can get from a negative depends on the enlarger lens focal length, and the lens-to-paper distance, controlled by the height the column will allow. More precisely, magnification is:

lens-to-paper distance divided by focal length, minus one

For example, if your enlarger column can raise the lens 600 mm above the baseboard, you can make a 300 × 450 mm enlargement from a 60 × 90 mm negative (magnification of ×5) using a 100 mm lens (600 ÷ 100 = 6 − 1 = 5.5 × 60 × 90 mm = 300 × 450). The taller the column, the bigger the enlargement possible (assuming the enlarger head doesn't hit the ceiling first!). For even bigger enlargements the enlarger head may be designed to rotate through 90° so that it projects the image horizontally onto a distant wall. Some bench models turn to work vertically downwards onto the floor (see Figure 12.10).

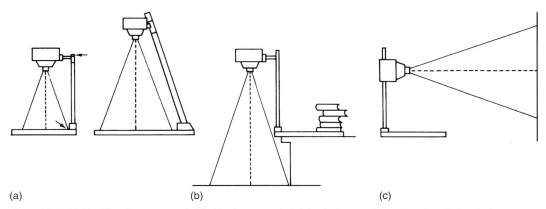

Figure 12.10 Making big enlargements: typical limiting factors are the height of column, and the column base fouling the image area (left). Solutions include: (a) angled, extended column and larger baseboard; (b) turning the enlarger head to project from bench down on to the floor (notebooks, etc. used as counterweights for stability); or (c) rotating the head to project onto a distant wall

Note that there are special enlarging lenses available that have extra-short focal lengths while still covering the negative format in use. For example, a 'normal' 50 mm lens will not cover a 60 × 70 mm negative but a special 'wide-throw' 50 mm one will, allowing much larger prints to be made at maximum column height (Figure 12.8).

At the other extreme, for prints smaller than the negative dimensions, you need to be able to lower the enlarger head and position the lens sufficiently far away from the negative (see Figure 12.9). If the bellows will not stretch this far, try fitting a camera-type lens extension ring. Focusing is frequently difficult at these very close distances unless you remember to keep the lens–paper distance constant while moving the lamphouse up and down.

Contrast control filters

In order to alter the contrast of variable contrast printing papers (p. 304), most black and white enlargers offer some way of adjusting the image colour (Figure 12.11). In many older enlargers there is a simple filter drawer in the lamphouse between the light and the negative. You buy a set of six or more 'above-the-lens' acetate filters (Figure 12.12) to use in the drawer one at a time.

Figure 12.11 Alternative ways to control variable contrast printing paper. (a) Drawer for (acetate) filters between lamp and negative. (b) Holder on lens for (gelatin) filters. (c) Lamphouse with internal dial-in VC filtration system. (d) Colour printing lamphouse (see Figure 12.22)

Figure 12.12 A simple set of acetate filters for a variable contrast paper, marked with contrast grade numbers. Low contrast filters are yellow; higher contrast are magenta

Figure 12.13 Some bigger enlargers have their controls for focusing and raising/lowering located under the baseboard. This is especially useful with column extension units that allow the baseboard down to floor level. The enlarger column is bolted to the wall for added stability

Alternatively you can clamp a special holder below the lens and use a set of smaller filters. (Filters must be the more expensive gelatin type, otherwise their use below the lens will upset image definition. You must keep these filters completely free of fingermarks too.)

Far more convenient, a variable contrast lamphouse unit allows you to vary filtration *continuously*, just by turning a numbered dial which moves built-in filters in or out of the light beam above the negative. If you plan later to make colour prints, a colour lamphouse unit (with yellow, magenta and cyan dial-in filters) will also serve variable contrast monochrome paper, although you may then have to adjust exposure time with each change of filtration (p. 305).

Other features

Red filter. It is very useful to have a swing-across red filter below the enlarger lens (see Figure 12.3). This will allow you to see the image projected on to the actual light-sensitive paper without actually exposing it – helpful when preparing to shade, print in, or make a black edge line (p. 323).

Negative carrier. Most negative carriers are 'glassless' – holding the film flat between metal frames. You may occasionally need a glass carrier when enlarging a sandwich of two films, which might otherwise sag in the middle. However, sandwiching between glass creates problems because: (a) you have four more surfaces to keep clean, and (b) when glass and film are not in perfectly even contact, light-interference causes a faint pattern of concentric lines, called Newton's rings, to appear over the image. Other optional features include metal sliding masks within the negative carrier to block light from any rebate or part of the image you are cropping off (reduces potential flare).

Remote controls for head shift and focusing positioned at baseboard level are a convenience on very large models; and an angled column (Figure 12.10) will avoid the column base fouling images when you make big prints (Figure 12.13). Enlarger movements (a pivoting head and lens panel) are helpful when you must alter image shape without losing all-over sharp focus (Figure 12.7). This will allow you to give some compensation for unwanted converging verticals due to shooting with a camera pointing slightly upwards. See also digital adjustment of perspective, p. 367.

Figure 12.14 Accessories for the 'dry' bench. 1: Focusing magnifier. 2: Compressed air to remove any dust from film. 3: Adjustable masking frame. 4: Enlarger timer. 5: 'Dodgers' for shading. 6: Card with choice of various shaped apertures for 'printing-in'. 7: Set of mounted gelatin lens filters for VC paper

Enlarger care

- Make sure that your enlarger does not shift its focus or head position, once set.
- The head must not wobble when at the top of its column, nor the lamphouse and negative overheat because of poor ventilation or use of the wrong voltage lamp.
- Regularly check that no debris has accumulated on top surfaces of condenser lenses or diffusing panel. (Both add shadowy patches to negative illumination, becoming more prominent in the projected image when you stop down the enlarging lens.)
- Dust, grease or scratches on enlarging lens surfaces, however slight, scatter light and degrade the tonal range of your prints. This shows mostly as dulled subject highlights, and shadows which print smudged and spread.
- Covering your enlarger with a plastic dust sheet when not in use is a good idea, as is keeping a cap over the lens, especially when chemicals are kept in the darkroom. The surface of the glass can actually be attacked by chemical vapours.

Printing papers

There is a range of black and white printing papers, with different types of base, surface finish, size, image 'colour', and emulsion contrast. This, together with a variety of different print developers, offers you an enormous range of subtly different permutations.

Base type

There are two main kinds of paper base – *resin-coated* and *fibre*. This difference is more than cosmetic, because their processing and washing times, drying and mounting procedures are different. Resin-coated materials (known as 'RC', 'plastic' or 'PE') consist of paper, sealed front and back with waterproof polyethylene, then face-coated with emulsion and protective supercoat (see Figure 12.16). Because the core absorbs almost none of the solution, RC prints wash and dry in about one quarter the time required for fibre papers. When dry, prints do not

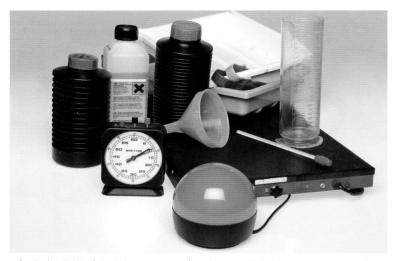

Figure 12.15 Items for the 'wet' side of the darkroom. 1: Trays for solutions, including larger tray as water jacket. 2: Graduate, and funnel. 3: Plastic tongs to hold a corner of your print when agitating or removing it. 4: Chemicals. 5: Dish thermometer. 6: Hose connector to tap, to dish wash prints (see also Figure 12.29). 7: Clock timer. 8: Heated panel, alternative to water jacket. 9: Safelight for shelf above sink. 8 and 9 must be designed for safe use in wet surroundings

curl, and have good dimensional stability. Like colour papers, which are all RC-based, they are also well suited to machine processing (p. 311).

The more traditional type of paper has an all-fibre base. It is first surface-coated with a foundation of baryta (barium sulphate) as a whitening agent, followed by an emulsion layer and gelatin supercoat. It can be trickier to work with as it responds more quickly to changes of exposure and requires careful judgement of tests as it dries noticeably darker than its appearance when wet. The total processing cycle for fibre papers is much longer, typically an hour or more, and a glazer is necessary if you want to give

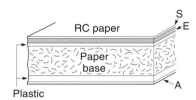

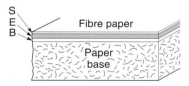

Figure 12.16 Cross-sections of RC and (single weight) fibre bromide papers. S: Supercoat of clear gelatin. E: Emulsion. B: Whitening baryta coating. A: Anti-static layer

glossy paper a really highly glazed finish (Figure 12.30). However, final prints are much more stable and less prone to deteriorate, especially when displayed over long periods. Fibre prints are also easier to tone, hand-colour, mount and retouch.

In practice, the vast majority of amateur enlargements and commercial prints, especially long runs, are made on RC papers. RC is also convenient for contact prints. For archival prints and exhibition-quality images, fibre paper is still the preferred choice of photographers. The finest silver-enriched thick emulsion papers, made only with fibre base, are capable of a better tonal range than are RC.

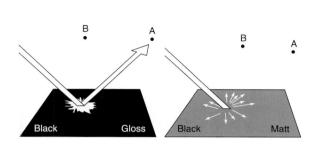

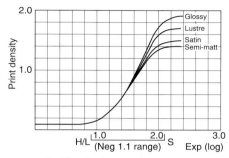

Figure 12.17 How paper surface affects the appearance of maximum black in a print. Left: Although when seen from position A, gloss paper reflects a glare spot, from B and other positions black appears intense. Centre: Matt paper scatters a little light in *all* directions – black looks less rich from every viewpoint. Right: Paper characteristic curves show the surface effect on maximum possible print density. A typical negative prints with its subject shadow detail more compressed on matt than glossy

Thickness and tint

The standard thickness for fibre-base papers is double weight and a few are available as triple or premium-weight (300 gsm) art paper similar to postcard. Many papers had previously been manufactured as single weight but these are hard to find now. RC paper is mostly made in so-called medium weight, just slightly thinner than double weight.

A limited range of papers can be bought with a cream or an ivory tinted base instead of white, but with the exception of products such as Foma Chamois or Kentmere Fineprint VC, these have tended to go out of favour because they limit the tone range of image highlights. In fact, many RC white bases often incorporate 'optical brighteners' which glow slightly under fluorescent or daylight illumination and so farther extend image tone range. (See also lith printing, p. 328 and toning, p. 332.)

Surface finish, size

There is a choice of surface finishes ranging from dead matt, through what are variously called semi-matt, satin, lustre or pearl, to glossy. Simple warm air drying gives RC glossy paper a shiny finish whereas fibre-base 'glossy' dries with a less shiny surface unless it is put through a glazer after washing.

The combination of base brilliance and surface texture has great influence on the maximum white and black the paper offers you. As Figure 12.17 shows, glossy finish produces richest blacks, when lit correctly. Matt papers cannot give much beyond a dark grey, which can suit certain subjects but may look dull and flat in more graphic images. Both papers, however, appear with similarly deep blacks when they are compared wet, so be prepared for changes when prints made on matt paper are dried. Photographs for reproduction should be made on white glossy paper (glazed or unglazed), not on anything with a strong surface texture which can interfere with scanning and copying processes as well as the mechanical screen used in ink printing processes (see *Advanced Photography*).

Figure 12.18 shows the most common printing paper cut sizes. As you can see, some larger sheets can be cut down to give exact numbers of a smaller standard size – one reason for keeping a trimmer in your darkroom. Paper is generally marketed in 10 or 25 sheet packets and boxes of 50 or 100. The cost per sheet is much lower if you buy in the larger quantities.

5 × 7 inch	12.7 ×17.8 cm
7 × 9.5 inch	17.8 × 24 cm
8 × 10 inch	20.3 × 25.4 cm
8.25 ×11.75 inch	20 × 29.6 cm
9.5 × 12 inch	24.0 × 30.5 cm
11 × 14 inch[*]	27.9 × 35.6 cm
12 × 16 inch	30.5 × 40.6 cm
16 × 20 inch[†]	40.6 × 50.8 cm
20 × 24 inch[‡]	50.8 × 61 cm

[*]Gives four 5 × 7 inch
[†]Gives four 8 × 10 inch
[‡]Gives six 8 × 10 inch

Figure 12.18 Standard dimensions of black and white printing paper

Image 'colour'

Most printing papers have an emulsion containing a mixture of silver bromide and silver chloride light-sensitive halides that provide a colour or tone to the image. Those with a high silver bromide content (*bromide* papers) give 'cold' tones, neutral black in colour, in the recommended developer. Papers with more silver chloride than bromide (*chlorobromide*) and/or use crystal structuring give a 'warmer', slightly browner, black. The warmth of tone is responsive to your choice of print developer (see p. 306). The silver chloride content is slower in speed than bromide, and also develops slightly faster – so your chosen length of development makes a big difference to 'colour' too.

Choosing between bromide or chlorobromide paper depends mostly on subject and personal preference. The warmer tones of chlorobromide (Figure 12.19) are often used for landscapes and portraits intended for exhibition. But it is less suitable in pictures for regular monochrome reproduction, because printers' standard black ink will lose the subtleties of warm tone unless printed by four-colour.

Figure 12.19 Monochrome image 'colour'. Top: A print on bromide paper. Bottom: The same negative printed on warm-tone (chlorobromide) paper and processed in warm-tone print developer

Figure 12.20 Contrast. The same (normal contrast) negative printed on four different contrast grades of the same paper. Clockwise from top left: Grade 1 (soft), grade 2 (normal), grade 3 (hard) and grade 4 (extra hard). Hardest paper gives fewest grey tones between white and maximum black. Grade 1 does not reach maximum black before whites begin to grey with this image – it suits much more contrasty negatives. Variable contrast paper gives similar results by change of colour filters

Contrast

You can control the contrast of your prints by purchasing different boxes of *graded* papers – grade 1 (soft), grade 2 (normal), grade 3 (hard), etc., or as is more common use just one box of *variable contrast* paper and achieve similar changes by filtering the colour of your enlarger light. As Figures 12.20 and 12.21 show, soft grades form a relatively gentle 'staircase' of tones between these extremes, whereas hard grades rise more steeply and give a harsher and more abrupt range of greys. All the paper grades are capable of producing essentially the same maximum black and white tones (albeit requiring different levels of exposure) and so you can't tell the contrast grade of a print just by looking at it, but bear in mind that the degree of contrast related to grade number – 1, 2, 3, etc. – is not absolutely consistent between one manufacturer and another. Basically, this choice of contrast allows you to compensate for contrast, or

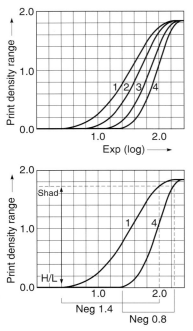

flat negatives. For example, a fairly harsh continuous-tone (contrasty) negative gives results printed on grade 1 similar to a softer (flat) negative printed on grade 4. In practice, choice of grade depends on many factors – type of subject, enlarger illumination, the visual effect you want to achieve, how the picture will be used, and so on. Often by exaggerating contrast beyond how your subject actually looked, you can strengthen a bold design.

Variable contrast papers. These are known as Multigrade or just VC, according to brand. Variable contrast papers carry no grade number. They work by having a mixture of two emulsions. One is contrasty and sensitive only to blue light. The other is low-contrast and sensitized towards the green region of the spectrum. So you can use one of a range of filters from deep yellow (giving grade 00) to deep magenta (grade 5) in the enlarger light-path to achieve the contrast you want. If you use no filter at all the paper prints as around grade 2. If the enlarger has a colour printing head, you can dial in appropriate filters here. (See settings,

Figure 12.21 Top: The response of four grades of one manufacturer's bromide paper expressed as characteristic curves. Bottom: A relatively contrasty negative (1.4 density range) printed by diffuser enlarger on grade 1 paper gives a similar result to a lower contrast 0.8 negative on grade 4

Figure 12.22.) With enlargers fitted with special heads for variable contrast paper you select grade numbers on a dial or baseboard keypad to adjust filtered light beams automatically.

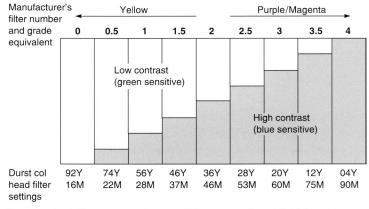

Figure 12.22 How filters control variable contrast printing paper. Different proportions of the high- and low-contrast emulsions present in VC paper are used according to your chosen colour filtration. Increasingly strong magenta filters absorb more of the green content of the light and so make the paper become more contrasty. Increasing yellow suppresses blue and gives the opposite effect. See Figure 12.12. Durst numbers suggest settings when using a colour head enlarger – combining two filters here keeps the overall density the same so that the exposure time remains constant

Figure 12.23 Panchromatic printing paper. The colour negative (centre) shown as printed on regular black and white bromide paper (left) and on pan bromide paper (right). The panchromatic bromide paper gives a more accurate grey-tone representation of colours. (For a colour print of the image see Figure 9.14)

Variable contrast paper offers you the advantage of not needing to keep an expensive stock of grades as well as different sizes. With a good filtering system you can get the equivalent of five different grades (plus half-grades). Uniquely too, it also allows you to vary contrast across a print, by exposing one area of the image at one grade setting and the rest at a different setting. (See double printing, p. 326.)

Choosing a printing paper

All these combinations of features – resin or fibre base; surface; contrast; image colour – are confusing at first but not all papers are available in all forms. Most papers are made with a white base, glossy or pearl (semi-matt) surface and give a predominantly neutral colour image. If you are a newcomer to monochrome printing it is easiest to learn first with a variable contrast resin-coated type, and then explore fibre-based papers as your skills improve (Figure 12.23).

Safelighting and printing paper sensitivity

Darkroom safelighting should be as visually bright and easy to work under as possible, without of course fogging the paper. The colour filter screening the light bulb or fluorescent tube must pass only wavelengths to which the material is insensitive (Figure 12.24). However, no filter dyes are perfect, and if the safelight is too close, or contains a light source too bright, or is allowed to shine on the emulsion too long, fogging will still occur. (See testing project, p. 313.) Follow the distance, wattage, and maximum safe duration recommendations for your particular safelight unit.

Regular bromide, chlorobromide and multigrade papers are safe under a 'light amber' safelight, such as Kodak OC. Some materials such as lith paper have orthochromatic sensitivity

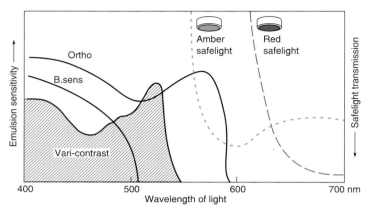

Figure 12.24 Safelight filters. The diagram combines emulsion colour sensitivity curves and filter colour transmission curves. It shows that regular (blue-sensitive) and variable contrast printing papers are safely handled under 'light amber' safelighting. But notice from curve overlap that ortho printing materials, such as lith paper or film, would fog to amber, so they require deep red safelighting instead. Red is also safe for the other two materials, but unnecessarily dark

however, to improve otherwise extremely slow speed. They therefore need deep red coloured safelighting as required for ortho films. As Figure 12.24 shows, you can use the same deep red safelight for regular papers, but not the reverse. Always check the label on any unfamiliar photographic paper for the safelight colour you must use, the recommended minimum distance and the specified lamp wattage.

Processing procedure

Processing black and white paper follows the sequence develop-stop-fix-wash similar to processing film, but with two important differences. Firstly, because you are using open dishes under safelighting you can watch the image gradually developing up on the paper. This is a fascinating, truly magical, aspect of photography. Secondly, each chemical stage of processing is briefer than the time needed for film; see Figure 12.28.

Developing prints

The most commonly used print developers are Phenidone-based (e.g. Ilford PQ) similar to regular film developer (p. 274), although in a more concentrated form. (Some 'universal' developers serve both film and paper functions, given different dilutions.) Unlike the development of negatives, however, it is important to produce an acceptable image colour, along with good tone values, rich black and clean white. Graininess is not a consideration – paper is so slow and fine-grained that any graininess seen in prints is the enlarged structure of the negative, although often emphasized if printed on contrasty glossy paper.

Developers formulated for use with *bromide* papers tend to be energetic, and give a good neutral black given sufficient processing time. A range of 'restrained' developers is made for chlorobromide papers, giving different degrees of warm tone according to formula (see Figure 12.25). It is important that you fully develop prints for a consistent time at correct temperature. Aim to standardize this aspect of printing – having chosen the paper and developer, do all your controls through exposure manipulation and (variable contrast materials) filtration of the enlarger.

	Image colour	On chlorobromide	On bromide
Warm ↑	Brown-black	Agfa Neutol WA, Tetenal Variospeed W	
	Neutral brown	Neutraltyp, Neutol NE	
↓	Neutral black	Kodak Dektol, Neutol BL	Dektol, Ilford PQ Universal
Cold	Blue-black		Neutol BL, Ilfospeed

Figure 12.25 Final image colour depends on your choice of print developer as well as type of paper

Dev. Dektol (1 : 2)	Stop bath with indicator	Fixer regular 1 + 7 or rapid
Throughput: 30*	Until colour change	26*
Keeping properties without use: (full container, stock) 10 months	indefinitely	2 months
(working sol. in dish) 24 hours	3 days	7 days

*Number of 10 × 8 inch sheets per litre.

Figure 12.26 Typical working life of some black and white print processing solutions

Dilute an ample amount of developer from stock solution for your printing session and discard it at the end. Take care not to exceed the maximum number of prints your volume of developer or fixer can handle (Figure 12.26). Work with a tray of developer preferably at least one size larger than your paper size, and first slide the exposed print under the solution emulsion side up. Commence rocking the tray gently – for example, by raising each side in turn about 1 cm and lowering it smoothly. Continue this throughout the development period (typically for 1–3 minutes as directed by the paper and/or developer instructions), then lift the sheet, drain for 2–3 seconds and transfer it to the next solution.

If you want to develop several sheets at once, first ensure you have enough volume of each solution to circulate around all the prints. Immerse prints by sliding in at regular intervals, then draw out the sheet at the bottom of the stack and place it on top. Continue this, leafing through the pile continuously (this substitutes for rocking) until development time is up. Then transfer them in the same order to the next bath. To avoid contamination, pick them from the developer with one hand and immerse them in the next tray with the other. Note that processing several sheets together in this way involves a lot of extra handling of the paper and that the solution circulation may not be as effective. It is therefore not recommended for highest quality results.

Stop bath and fixing

The solution filling the second tray should be stop bath or, at the very least, running water. It has the same development-halting function as with films. If possible use a stop bath containing indicator dye – this changes the solution colour to warn you when it is nearing exhaustion. Stop

Figure 12.27 Example of a badly fixed print which hasn't been washed properly

bath times are generally short, between 10 and 30 seconds for most papers. Next, the paper must be fixed to make remaining halides soluble and so form a permanent image. Unlike film fixing you cannot easily see the creamy halides disappearing from the white paper base, so it is important to adopt an efficient routine. Use a good quality fixer, either normal (containing sodium thiosulphate) or rapid (ammonium thiosulphate), diluted to print strength. This can be a single bath which you monitor and discard after, say, 25 prints of 10×8 inch size per litre (see the manufacturer's instructions). Better still, use two-bath fixing, giving half the recommended fixing time in each. The second bath, which should be fresh solution, is used successively to replace the first bath each time this becomes exhausted and is discarded.

Make sure your prints are agitated from time to time in the fixer. Don't let them float to the surface. It also helps fixing if you keep the paper face down. Acceptable limits for accumulation of silver salts in the fixer are much lower for papers than for films. So avoid solution that has been used for film fixing – it may still work on films and seem to fix prints too, but has such a concentration of silver complexes that compounds are formed in the paper emulsion that cannot be removed during washing. Don't overfix, either. Rapid fixer, in particular, can begin to bleach image highlight detail, and with fibre papers sulphur by-products can soak in and bond themselves into the base. From here they will not wash out, and start to attack the silver image perhaps months or years later (Figure 12.27).

Time and temperature

Typical times and temperature tolerances for dish processing are shown in Figure 12.28. Notice the timing difference between RC and fibre papers. Most RC papers incorporate developing agent in the emulsion that is activated when placed in the regular developer solution. Here it is immediately able to start acting on exposed halides, so this arrangement shortens the period needed for development to about 45–60 seconds, making such papers suitable for machine processing (p. 311). With all RC papers, the stages following development are shorter too. The emulsion absorbs new solutions quickly as the plastic base carries over very little of the previous chemical.

	Developer (20°C)	Stop bath (18–21°C)	Fix (1) (18–24°C)	Fix (2) (18–24°C)	Optional holding bath	Hypo-clear (18–24 °C)	Wash (1) (Not below 10°C)	Wash (2) (Not below 10°C)	Total
RC	1 min	5 seconds	1 min	1 min	As needed		2 min	2 min	7–8 min
Fibre	1½ min	5 seconds	4 min	4 min	As needed		15 min (40 min D/W)	15 min	40–50 min
					or	2 min	5 min (12 min D/W)	5 min	22–24 min

Figure 12.28 Processing sequence for prints using trays. The times given are typical, but you should refer to detailed instructions for each processing solution. The 'holding bath' is a rinse tray, used to accumulate prints during a printing session into batches for washing. Times for fibre papers assume single weight unless shown D/W

It is tempting to develop images 'by inspection', pulling prints from the developer early or extending development to make corrections for exposure. This is difficult to do without experience and will only really work over a range of about ±30 percent at most. Insufficient development gives you grey, degraded blacks; over-development also begins to lower contrast with papers incorporating developing agent. So it is in your best interests to try to work strictly to the recommended time and temperature and use only the enlarger filters and timer to control the image.

Washing prints

RC paper needs a relatively short period of washing, provided it is efficient. The important thing is to keep a flow of water over the emulsion surface. A shallow flow tray, or a wash tank fitted with a print rack (Figure 12.29), will complete washing in about 3 minutes. If prints are just left in running water in an ordinary tray or sink for 3–4 minutes make sure they are agitated, and not allowed to clump together.

When washing fibre paper, however, you must allow time to let by-products soak out of the porous base as well. It will help greatly if you first place prints in hypo-clearing agent (typically 2 minutes' treatment) prior to washing. This agent causes an 'ion exchange', helping to displace the fixer more readily from all layers of the material. The best wash arrangements are either soak-and-dump, using a siphon to completely empty a dish or sink at regular intervals, some form of cascade system, or a vertical slot type print washer (see Figure 12.29). Typical wash time is at least 30 minutes for single weight, 40 minutes for double weight. This can be reduced to one-third or less if hypo-clearing has been used. See also archival print processing, p. 337.

Wash water temperature is not critical, preferably 10–30°C for RC paper, and 18–24°C for fibre types, but effectiveness drops sharply with very cold water and warmer temperatures can cause buckling or other damage. Excessive soaking – say several hours at 24°C, or overnight at any temperature – may cause emulsion to start parting company with the base. It may even initiate gelatin disintegration, especially if you used a non-hardening fixer.

Drying

Your print drying method is important because it has to give a flat, unbuckled finish; it can also affect print surface. The simplest but slowest technique is ambient air drying. You must first remove surplus water from back and front print surfaces with a clean rubber squeegee. Then leave prints on absorbent material such as cheesecloth or photographic blotting paper, face up

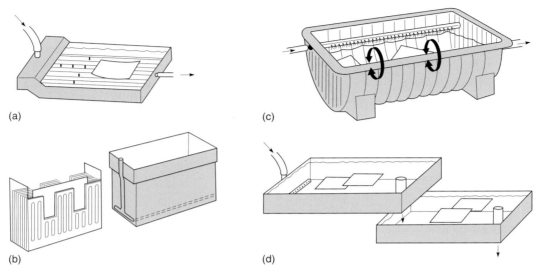

Figure 12.29 Print washing equipment. (a) Small volume tray washer designed for RC papers. (b) Plastic rack and wash tank for RC. (c) Tank for fibre base papers. This uses water flow to keep prints apart. (d) Cascade system. Newly processed prints go into the lower sink, and are later transferred to the upper sink for the second half of their wash period. The tube pushed into each waste outlet maintains solution level. (c) and (d) suit both types of paper

Figure 12.30 Print drying. (a) Fan-assisted warm air dryer, for up to two RC prints at a time. (b) Fast, hot-air dryer for RC paper only; print must be inserted covered by a film of water, direct from tray. (c) Ambient air drying, using fine mesh racks or (d) line pegging. (e) Flat bed heated dryer, with glazing sheet for fibre base glossy paper

for RC paper, face down (to reduce curl) for hardener-treated fibre prints. Drying racks made of frames covered in plastic-coated fibreglass mesh are available or you can make your own, using the fine meshed material sold for insect screen doors, etc. Alternatively you can peg the prints on a line with plastic clothes pegs at top and bottom – fibre prints in pairs back-to-back, RC prints singly. Drying may take several hours at room temperature.

To speed up the drying of RC prints, use a heated air drying unit (Figure 12.30),or blow them over with a hairdryer (temperature not exceeding 85°C). Busy darkrooms use a

roller-transport hot-air RC dryer, designed to deliver dry prints in about 10 seconds, but it is unsuitable for use with fibre papers which would curl and jam the rollers.

For fast drying of fibre prints, have a flat-bed glazer/dryer, which uses tensioned canvas to press the paper against a heated metal surface. Placing the back of the print towards the heat gives a final picture surface similar to air drying. To get a truly shiny finish with glossy fibre paper, you squeegee it face down on to a polished chrome glazing sheet, so the gelatin supercoat sets with a matching glass-like finish when dry. Unless this is done, glossy fibre papers will dry with a surface similar to 'lustre' or 'semi-gloss' RC papers. You can, at any time, remove the glaze from fibre paper by thoroughly resoaking the print and then drying it faced the other way. (Avoid hot-glazing other

Figure 12.31 Black and white print processing machine. A roller-transport unit that delivers washed, dried RC prints. Exposed prints are fed in at the front, and delivered back onto top of machine. This unit is located wholly in the darkroom

fibre paper surfaces, and RC prints of any kind. The former take on ugly patches of semi-gloss; the latter will melt at 90°C or over and adhere firmly to the metal and canvas.)

Manufacturers of premium fine-art fibre papers recommend air drying unless you are glazing glossy. The fact is, anything touching the emulsion during drying is a potential source of damage. There is always a risk, when using a glazer for other fibre paper surfaces, that the canvas will either mark the final emulsion finish, or chemicals previously absorbed from drying insufficiently washed prints will transfer into your print. However, this is still the best drying method for thin-base prints, which tend to curl badly if air-dried instead.

Machine processing

Resin-coated papers lend themselves to automatic machine processing. Units are often bench or floor standing within the darkroom (Figure 12.31). The exposed prints are fed in through motorized rollers and the equipment transports them through tanks of regular developer, rinse, fixer, and wash; then passes them directly through an RC paper dryer. Such machines are expensive but produce a fully processed dry print in about 2 minutes – or up to 450 prints, 10×8 inch size, every hour.

A processing machine can be economically justified when there are several people working on enlargers in a constantly used darkroom – it effectively does away with the wet bench. Without sufficient throughput, however, the transport system and stored chemicals may deteriorate, resulting in faulty prints. There are also concerns about print longevity as the process is not as archivally stable as conventional hand processing.

■ A printing darkroom must be of adequate size, light-tight but ventilated, stable in temperature, away from dust and pollution, allowing easy access, and serviced by electricity and hot and cold water.

■ Divide darkroom layout into wet and dry areas. Consider chemical and electrical safety carefully; Appendix E. Have the room well illuminated by safelighting, with walls mostly light-toned.

■ Enlarger choice factors: negative size(s), type of illumination, lens, and maximum print size. Condenser illumination enhances image contrast, grain and detail, but picks out any negative blemishes. Diffuser and cold light types offer more subtlety in printing and are more forgiving of scratches, etc. Process negatives to best suit your enlarger's illumination system.

■ To calculate the image magnification an enlarger will give, divide the lens-to-paper distance by focal length, then subtract one.

■ RC and fibre papers differ in the times required for processing, washing, drying; also in drying treatment, dimensional stability and archival permanence. RC papers are easier to work with but fibre offers ultimately greater quality.

■ Other printing paper variables: tint, surface, size, neutral or warm-tone emulsion, contrast (graded or variable).

■ Safelights must be appropriate colour, wattage and distance. Even then, don't exceed maximum safe exposure time.

■ Choose a developer for a required image colour – particularly with chlorobromide papers. Aim to standardize the development time and temperature. Use a stop bath, then fresh fixer. Don't use exhausted fix or fixer used for negatives. Avoid overfixing too.

■ Have a wash system that efficiently removes soluble salts. Fibre papers are helped by a hypo-clearing stage. Dry RC prints by heated air dryer, or natural air. For fibre prints either heat-dry (essential if glazing), or hang up thicker papers to air-dry.

1 Find out the range of print sizes you can make. Physically check the upper and lower limits of image magnification your lens(es) and enlarger design allow, while still maintaining an evenly illuminated negative. Remember the use of extension tubes.

2 Test your darkroom safelight. Switch off the safelight(s) and with no negative in the enlarger, expose a piece of paper so as to produce a pale grey tone (make a test strip to determine a suitable exposure). Take this pre-exposed paper and place it emulsion side up at the closest point it would normally come to the safelight, say on the bench immediately below the lamp. Place a small coin on one end of the paper, switch on the safelight and start your timer.

After one minute, place another coin next to the first one. Every minute add another coin until you have a line of 10 coins sitting on the paper. After you place the last coin down, leave the safelight on for a farther minute and then turn it off.

Process the paper normally, working in the dark until it has been fully fixed; then fully wash and dry it as any normal print. If your safelight is completely safe you will have a perfectly even grey print. However, as no safelight is perfect it is likely you will be able to see the shadows of some of the coins. Note the number of visible coin outlines; counting back from 10 will give you the maximum safe exposure time in your darkroom; for example if you can see 3 outlines, paper should not be exposed to the safelighting for more than 7 minutes.

If you can see 8 or more outlines, this means that the safe time is less than 2 minutes, which is insufficient. Move the safelight farther away, use a lower powered bulb or partially mask it off to reduce the light output and re-test. If it is still unsafe, check for white light leaks and if necessary change the safelight filter.

PROJECTS

13

Black and white printing: techniques

This chapter concentrates on the basic controls possible in making prints from black and white films. It also looks at some chemical methods of altering your final result. Having a good negative is always an advantage, but it is the final print which people see. While it is difficult to make good prints from poor negatives it is all too easy to make poor prints from good ones if you lack the basic skills.

By practising your printing techniques you will be able to distinguish really good print quality from the adequate, and develop skills to control your results fully. Other requirements, such as speed and economy, will come with experience – without setting yourself a good print quality to strive for and the knowledge of how to achieve that, you will not get the best from your negative. Many professional photographers use printing labs for their work but have learnt to print first in the darkroom so that they can understand how to advise the printer to achieve the best quality print.

Making contact prints

Most photographers make contact prints – small prints made direct from the film held flat against the paper – from all their negatives as soon as they are processed. This is a good idea as it allows you to preview all your exposures as positive prints, making it easier to pick and choose which shots to enlarge, mark up possible cropping, etc. It also aids filing as it makes images much easier to locate in the future.

To make contact prints, use an enlarger and timer as described in Chapter 12, plus a contact-printing frame (Figure 13.1) or at least a 10×8 inch sheet of clear plate glass. Some negative bags are completely transparent and it is possible to simply lay one on top of the paper with a sheet of clear glass on top to hold the negatives flat. Set up the enlarger so it projects an even patch of light on the baseboard slightly larger than your paper. Reduce the lens aperture two or three stops from its widest (brightest) setting. If your enlarger has a red filter below the lens you can swing this in place to allow the paper to be positioned without fogging it; alternatively mark up the baseboard with tape, etc. to show where the light will fall.

Figure 13.1 Contact-printing equipment. Top and centre: Contact print units for 35 mm and 120 rollfilm strips of negatives. Strips slip into thin transparent guides on the underside of the glass. Bottom: Basic arrangement using plate glass

Switch off white room lights. Place a sheet of grade 1 or 2 paper, or variable-contrast equivalent, emulsion upwards on the baseboard. Lay out your negatives emulsion-downwards (glossy side up), on the paper, and cover them with the glass. The glass presses the negatives down flat so they are in complete contact with the paper. If you use a special contact frame, you can first slip negatives into thin transparent guides on the underside of the glass. This makes things easier when printing more than one contact sheet of a film.

Exposure varies according to the intensity of your light patch, and negative densities. As a guide, having switched off the enlarger and swung back the filter, use your timer to bracket trial exposures in a test strip. Set the timer to 5 seconds and expose the whole sheet for that time. Now cover up part of the paper with a piece of opaque card and expose the remainder for another 5 seconds. Cover a little more of the paper and reset the timer to 10 seconds before giving the rest an exposure for this time as shown in Figure 13.2. Remove and process the paper (Develop–Stop–Fix) waiting until fixing is complete before you view the results in white light.

Rinse the contact sheet and hold it out of the solution; prints look deceptively pale under water. They also darken slightly when dried. The print will have clear bands of exposure, each darker than the last across it, representing 5, 10 and 20 seconds' exposure. The darkest band of density on your print received the longest exposure time. This method follows

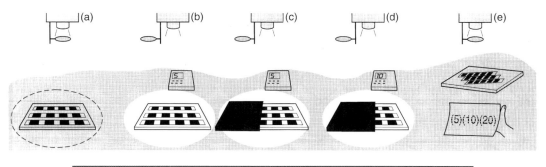

Figure 13.2 Test-exposing a contact sheet. (a) Use the red filter to help pre-position glass and paper within the light patch. By covering one third of the paper after 5 seconds (c), then two-thirds after a farther 5 seconds (d), and giving a final 10 seconds, bands receive 5, 10 and 20 seconds' exposure

Figure 13.3 The final sheet of contact prints. This one was given 10 seconds overall

the logic of the camera's exposure controls in that each step is double the exposure of the previous one, equivalent to increasing exposure by one *f*-stop on your lens each time; this is known as the *f*-stop method. You can use various multiples, for example, 2, 4, 8, 16, 32, etc. The trick to remember is that you expose all of the paper at the start, and then cover up a small part of the paper and repeat the first exposure time; from then on in you start doubling the times. If the first exposure was 5 seconds, by covering up part of the paper the bit now hidden from the light has received only 5 seconds of light; by exposing the rest of the paper again by 5 seconds the paper has received 5 + 5 = 10 seconds of exposure. You continue this by covering up more of the paper so that the bits hidden have received 5 and 10 seconds of light respectively; and now give the paper 10 seconds of exposure so that the last piece would have received 5 + 5 + 10 = 20 seconds. This can go on until you run out of paper to cover up; the next exposure would be 20 seconds, so that it is 5 + 5 + 10 + 20 = 40; the next exposure would be 40 seconds and after that 80 seconds and so on. If none of the steps looks right, with everything either too dark or too light, a farther bracketed test may be required. Open or close the aperture or make the exposure times longer or shorter. Once you have a reasonable looking test strip, you can decide from the most promising band of density what exposure will be correct. Set this exposure on the timer and make a single exposure of the whole sheet, see Figure 13.3.

Of course, if the set of negatives you are printing varies greatly in density, the correct contact-sheet exposure will have to be a compromise between darkest and lightest frames. Variations will be less if you use soft rather than hard contrast paper. It is important that contacts show the detailed picture content of every frame, even if their print quality has to look rather flat at this stage. Contact sheets of 35 mm films do produce fairly small images so you will probably need a magnifying glass or a *loupe* (Figure 13.4) to see the detail. It is also advisable to make a small test, called a work print of the images you know you might want to print up properly later. Once dry you can keep the contact sheet in a negative file with the negatives so mark it with your film's reference number, date and any other information you may need.

'Straight' enlarging

Spend some time with your contact sheets, examining every frame, ideally with a magnifier, to decide the shots you want to enlarge. It is rare to print every frame from the roll and often you will find things in some pictures you didn't notice when taking the photograph. If there are several near-identical frames refer to the original negatives, again with a magnifier, to decide from the technical quality of each one which negative will print best. Check sharpness, and look especially to see that there is sufficient detail present in important highlight and shadow areas. Many photographers mark their contact sheets, drawing around frames with a felt pen or wax pencil to identify them.

Once you have selected a negative, ensure that both surfaces of the film are free of marks or dust before inserting it into the negative carrier, emulsion downwards. The most common way of ensuring dust free negatives is to use a can of compressed air, available from most good photographic suppliers and a dust free cloth. Adjust the masking frame to your paper size, allowing for any white borders. Then switch off the darkroom's white lighting, switch the enlarger on and open the lens to full aperture. Raise or lower the enlarger head until the projected image fills the masking frame area, focusing the image and if necessary readjusting height until composition is correct. You can of course just print from part of the negative if it improves the composition. (Never focus with a thick red filter over the lens – it will alter the focus setting, and when removed the image may be unsharp.) Use a focusing magnifier (p. 299) if possible to make sure the image is truly sharp.

Next, stop down the lens two or three *f*-settings – more if the negative is rather thin. The reasons for stopping down are: (1) to give a conveniently long exposure time (10–20 seconds or so, for example) that gives you enough time to do any shading of the image – (see below), (2) to ensure accuracy (timings tend to be less consistent on exposures of less than 5 seconds due to timer designs and bulbs heating and cooling), (3) to get peak image performance from the lens, and (4) to compensate for any slight focusing error, by extending depth of focus.

Look carefully at the image on the easel, and decide the most likely paper grade. This gets easier with experience but as a starting point choose a middle grade such as grade 2 or 2.5. If you have an enlarging meter (Figure 13.5) this can give you information on likely contrast grade and exposure but a great many printers never use them, as you quickly get to know your enlarger and will have a good idea of the likely exposure time. Use the metered or estimated time as the centre point of a range of exposures to be made on a test strip as before. For example, if you estimate the time needed to be 20 seconds, make test steps at 5, 10, 20, 40 and 80 seconds on a test strip of paper of the required contrast grade (Figure 13.6).

Think carefully how to position these strips – for greatest information, each one should include both darkest and lightest parts of the image. For this reason it is best to make good-sized

Figure 13.4 A loupe is a small magnifying glass especially designed for looking at contact sheets

test strip (Figure 13.7); anything much smaller than a third of a sheet is unlikely to contain enough of the image and you will most likely end up making multiple strips, which wastes time and money. After exposure and processing, judge the best strip, looking especially at key areas such as flesh tone in a portrait, and checking how much detail (present in the negative) has printed in shadows and highlights.

Figure 13.5 Spot measurement of exposure from an area chosen to print mid-grey, using an enlarging meter with a probe. The meter will have been calibrated from previous tests using your equipment and materials

Figure 13.6 Test-exposing an enlargement. By holding an opaque card stationary in the light beam, different areas of a half sheet of printing paper can be given a range of exposure times

The *f*-stop method described above has the advantage of covering a wide range of exposures on one piece of paper but you may find the steps too far apart, with one step too light, while the next is too dark. In this case it is possible to estimate correct exposure and set a time between the two, or you can make a new strip which 'fine tunes' the value. If your first test shows the right time to be between say, 10 and 20 seconds, make a second test with steps of 10, 12, 14, 18 and 20 seconds. An old

Figure 13.7 Always position exposure test bands across an enlargement so that each one includes both light and dark parts of the image, as here. If these three bands had been run vertically instead, two would have shown information about sky and foreground only

saying is that printing without test strips is like driving without a map – you may eventually get to your destination but have gone around the houses to do so. Unless you are a very experienced printer who has fine tuned their film processing and developed consistent working methods you are likely to waste a lot of paper by not using test strips to navigate you towards the best exposure.

You are judging two variables, exposure and contrast, which influence each other and can make judgement difficult unless you follow this method: first choose the exposure step that shows the best highlights (palest areas such as skies, palest skin tones). Now assess the shadows (darkest areas) on the same exposure step. If these are also well rendered, looking strong without being too featureless, then the contrast grade is correct and you can make a print at the exposure represented by the step. If, however, the shadows are too weak and grey you need to increase the contrast grade and make a new test. Shadows that are overly dense and lacking detail require a lower grade of contrast so as to bring the best out of the negative.

Should exposure time now become awkwardly short or long, alter the lens aperture: opening it one stop allows time to be halved; closing it one stop allows it to be doubled. (Aperture has no effect on contrast.) Finally, take a full sheet of paper, position it under the enlarging easel masks, and give the exposure time you consider correct.

Controls during enlarging

Local control of exposure

A single 'straight' printing exposure often fails to suit every part of the picture. The reason may be that the negative density range, while well matched to the paper for most subject tones, exceeds it at one extreme or the other. Perhaps a patch of shadow becomes solid black or highlight detail looks 'burnt out', when mid-tones are correct for density and contrast. Perhaps subject lighting was uneven, or you simply wanted to darken and merge some parts of a composition in order to emphasize others. Most printers would agree that the majority of prints can be improved in some way during printing by locally reducing exposure (known as 'shading', 'holding back' or 'dodging') or extending it ('printing-in', or 'burning-in').

To *lighten* part of the picture (also known as dodging) insert your hand, or red acetate or opaque card, into the light beam during part of the exposure. Hold your shading/dodging device about halfway between lens and paper to soften the shadow edge and keep it slightly on the move during the exposure. To *darken* a chosen area, follow up the main exposure with an additional period when you print-in using a hole in a card, or the gap between your cupped hands (see Figure 13.8), where you let light through onto a selected part of the print to darken it. Feather the edge of your exposure-controlled area in the same way, as for shading you need to keep your hands or card constantly moving so as to get soft edges. Note that a soft edge to the shadow is essential in both cases to make the exposure change invisible, otherwise you will have an unnatural looking print with odd light or dark patches. It may be possible to use a more distinct cut-off on a harder edge such as a wall edge or a horizon but it is seldom necessary to be this precise; it is also much more difficult to control.

(a) (b) (c) (d)

Figure 13.8 Shading and printing-in. Large areas at one side of the picture are conveniently shaded with the edge of your hand (a). To make isolated 'island' areas lighter, shade with a 'dodger' (b) made from card and attached to thin wire. To darken isolated areas, print-in through a hole in opaque card (c) or form a shape between cupped hands (d)

To decide how long to shade or print-in, make the best possible straight print first. Then, place pieces of printing paper across excessively dark or light image areas and make test strip exposures at shorter and longer exposure times respectively (Figure 13.9). If necessary sketch out a shading 'map' (Figure 13.10). This will remind you where and by how much you must shade during your main exposure, and the same for extra exposure afterwards. The harder the contrast of your paper, the greater these exposure differences will have to be.

Sometimes an area being heavily printed-in to black contains some small highlights which still appear as grey shapes, no matter how much additional exposure you seem to give. The best solution then may be to fog over these parts. Either print-in with the enlarger turned out of focus, or fog using a small battery torch fitted with a narrow cowl of black paper (Figure 13.11). Keep the enlarger on, red-filtered, to show you the exact image areas you are treating with white torchlight.

Local control of contrast

By controlling the exposure locally on a print you can change the contrast of the image; note that this can also change the composition of your image as our eyes are naturally drawn to areas of strong contrast. Shading and printing-in are like retouching: if done well, no one should know they have taken place. But when they are overdone you will find that shadows look unnaturally flat or grey, and burnt-in highlights veil over, again with a lost of contrast. The image might look flat because parts of the subject were exposed on the tone-merging 'toe' of the film's performance curve (Figure 10.5), or near the top end where irradiation again destroys tone separation. Perhaps the cause is general under-exposure or over-exposure respectively, or just subject range beyond the capabilities of your film.

Either way, these tone-flattened areas need extra contrast, which you can best achieve with variable contrast paper using selective filtration. Imagine, for example, that you need to shade and contrast-boost a simple patch of shadow in a picture which otherwise prints with grade 2 filtration. You: (a) shade this shadow throughout the *entire* period while the rest of the picture is being printed, then (b) change to grade 4 or 5 filtration, and (c) carefully print the shadow area back in, to the level of exposure it would have received if shaded normally.

Another rule is not to try to force the print against its natural tones. This means making your basic exposure and contrast settings do as much of the work as possible, leaving you only to lighten a highlight or darken a shadow area slightly. If you find you are trying to lighten

Figure 13.9 Print shading. Top: A 'straight' print given 22 seconds shows pale sky, and dark detail at top and right side of memorial. Middle: Test pieces for sky (given 35 seconds) and memorial (10 seconds). Bottom: Working from the test information this print was exposed for 22 seconds, during which memorial areas were shaded for 4 and 5 seconds – see the shading plan below. Then the sky was printed-in for an extra 14 seconds

Overall = 22

−4 and −5

+ 14

Figure 13.10 A rough sketch made as a reminder of the different exposures needed for various areas of the picture, right

shadows and darken highlights you are working against the negative's natural direction.

Overall reduction of contrast

Sometimes, perhaps due to an emergency situation, you have to print a negative which is too contrasty for your softest filtration or graded paper. Three techniques are then worth trying, either singly or all together:

Figure 13.11 Local fogging-in with a battery torch darkens small unwanted light parts, which then blend with dark areas. Alternatively print-in normally, but defocus the lens

1 Make the enlarger illumination less hard. If you have a condenser enlarger, place a piece of tracing paper on top of the condenser or in the lamphouse filter drawer. Light output will probably be quartered, so widen the lens aperture and increase exposure. Negative contrast will be reduced by about one grade.

2 Reduce paper contrast by 'pre-flashing'. This is a tiny amount of controlled fogging of light to the paper – not enough to make the paper look grey, but sufficient to overcome 'inertia' and raise the image exposure received in highlight areas to a developable state, with very little change to darker tones. To do this, first find the correct exposure for your print. Then you need to make a test strip for the flashing. To do this you ideally need a second enlarger but it can be done by raising the enlarger head to its highest point and stopping down the lens as far as it will go so that you have the faintest amount of light for your test strips. Next make a test strip of 1 second intervals. You must gauge the right amount of flashing by making accurate test strips of just the flash exposure. Once the test strip has been developed you need to view it in good daylight as the differences between each step will be very subtle. Much of the paper may still look white but what you are looking for is the first point at which the paper shows a grey strip; select the time just before that. The best way is to keep an accurate record of the total exposure you gave the paper and count backwards. For example if you gave the test strip a total of 12 seconds exposure you count backwards where the steps are visible until it just becomes white, so if from 7 seconds to 1 second the paper is white but at 8 seconds there is a grey step you set your timer to 7 seconds and pre-flash the paper so that it is pre-treated before printing in the usual way. If the paper pre-flashed, in this case at 7 seconds, was immediately developed it would just look white but if you use this pre-treated piece of paper to print your image on it will bring up detail in the highlight area.

3 Change to a low-contrast print developer, which still gives a good black but a more graduated range of greys. See Beer's developer (Appendix D); also contrast masking in *Advanced Photography*.

Overall increase of contrast

An excessively flat negative, provided it still contains sufficient shadow and highlight detail, will usually print on a grade 5 paper. However, other worthwhile techniques to boost contrast include:

1 Chromium-intensifying the negative, Appendix D (only suitable for silver image film).
2 Developing your printing paper in a line developer.
3 Printing on lith paper using lith developer, p. 328.
4 Changing from a diffuser enlarger to a condenser enlarger, or from a condenser to a point-source enlarger.

Figure 13.12 Vignetting. To fade out picture edges hold a card with a large cut-out shape and move it slightly but constantly throughout exposure to get a soft edge

Variations

Vignetting away edges

To avoid clear-cut borders completely, you can use a nineteenth-century printing style – the vignette – where the picture fades out to white paper, as in Figure 13.13. Cut a suitably sized hole – usually round or oval in a sheet of opaque card. Too small a hole will result in the card having to be held close to the lens and can result in uneven exposure with the image looking too dark in the centre. Have this held ready at the correct height before starting the timer. Move the card slightly during the exposure to ensure smooth, soft edges (Figure 13.12).

Adding edge lines

You sometimes have one or more dark subjects against a light background, shapes which become cropped awkwardly first by framing in the camera and then by white print borders. Figure 13.14 shows one example. To lessen the isolation of the background and foreground of the image it helps to add a thin black line as a border. You can do this by felt pen as an after-treatment, but for permanence and neatness of finish, photographic fogging gives best results. Use thin black card cleanly cut to a size a few millimetres smaller than the picture area set on your masking frame (Figure 13.15). Expose a print in the usual way, but, without removing it from the easel, cover the emulsion with the card, weighted down with a few coins. Use red-filtered enlarger light to check that a small gap is left *evenly* all around the edge. Then remove the negative from the carrier and fog the paper to unfiltered enlarger light, giving the same exposure time used before when the negative was in place. Another method is to

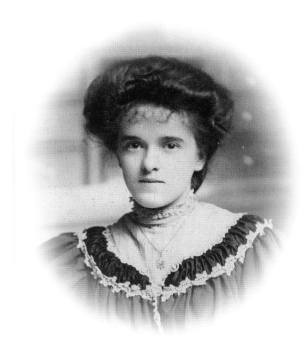

Figure 13.13 Typical vignetted result. Having the card fairly close to the paper avoids the vignette printing dark and 'dirty' near the centre

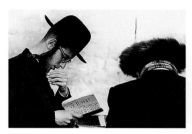

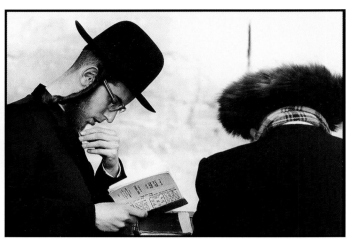

Figure 13.14 The picture above contains strong shapes cut through by edges of the frame. Printing-in a black edge line (right) helps to pull the main elements of the image together

use a negative carrier slightly larger than the image area (some photographers carefully file the carrier edges) so a small amount of negative rebate (border) is projected all round. Similarly you can use a glass negative carrier larger than your negative which holds the negative flat but also provides a gap around the negative to create a border. It is possible to create borders of any shape and size; your images do not always have to be printed rectangular or square. By having a hole cut in a piece of card – a good framing shop will be able to do this for you – you can create a circular frame. Instead of using the print easel you lay the card down on the baseboard, tape it from one side and slot your paper underneath when ready to print; the image will of course only be printed through the shape in the card. In much the same way it is also possible to have two or more holes cut in the board and print multiple images on to one piece of photographic paper.

Figure 13.15 Arrangement for fogging in a black edge line to the picture area. The narrow gap must be even all round

Photograms

A photogram allows you to make a 'photograph' without a negative, by placing an object between the paper and a light source. An opaque object blocks the light from the paper, casting a negative shadow so that when the print is developed the shape of the object appears white while the rest of the paper that is exposed to the light will darken to black depending on the length and strength of exposure. By using transparent or semi-transparent items, for example

Figure 13.16 Create the simplest of photograms by placing your hand on or just above the paper (made more graphic with the jewellery); also note how light has penetrated the finger nails

Figure 13.17 Photogram by exposing an enlargement of a cityscape through a piece of coarse fabric, creating a screen and almost 3D effect

Figure 13.18 Here a torn sheet of cloth has been used to represent smoke, creating a strong graphic image with limited props

a glass bowl or clear plastic ruler, a degree of light will penetrate the object, resulting in grey tones. The list of possible objects you could use is endless, from using your body to feathers, flowers and fabric (Figures 13.16–13.18), to creating your own cardboard cut outs.

In the darkroom ensure that your enlarger (free of any negatives) forms an even patch of light larger than the sheet of paper. Then stop down and using a strip of normal grade paper discover the exposure time which just results in a full black when processed. Do a test photogram with this as your main exposure, but also explore shifting or removing some objects after half or three quarters of this time to produce a range of grey tones.

Prints from prints

This follows the same principle as making a photogram; in this case an existing print is placed face down, emulsion to emulsion, on top of a fresh unexposed piece of photographic paper – similarly to making a contact sheet. Figure 13.19, for example, was produced by face-to-face contact printing a print. Although in this example a fibre-based paper was used it is best to use resin-coated paper as fibre base can sometimes show a fibrous pattern when exposed. Printing this way results in the picture appearing as a negative; the blacks will now be white and vice versa, the picture becoming laterally reversed – any text, for example, will read backwards. This can be overcome by making your original enlargement with the negative inverted, emulsion side up, in the carrier.

Figure 13.19 Split-toning. Left: Printed on warm-toned chlorobromide paper with a warm-toned developer, once fixed and washed the print was emerged in a bath of diluted (1:39) selenium toner. Contrast has increased and the shadow areas intensified. Right: Print from print, a reversed (negative) image has been made by making a contact print from the first image, and then split-toned in the same way

Double printing

It is possible to print from more than one negative onto a single sheet of paper before developing. This can result in a random superimposition similar to an accidental double exposure in the camera without control and consideration of the placement of the two negatives – the shadows and darker tones of one image showing up mostly in highlights and paler tones of the other. But by shading part of the first image, and then printing this area of the paper back with the second image, one scene can be made to merge into the other – often with interesting surreal effect (see Figure 13.20).

This effect is commonly used when a picture has little or no detail in the sky and a second negative is used to superimpose a more dramatic sky for added impact. Variable contrast paper is ideal for this work because you can adjust filters to compensate for any contrast differences between negatives. It also helps to have two enlargers, each set up with a negative so that you only shift the paper from one baseboard to the other. You can even carefully cut card shapes and tape-hinge these to the easel as flaps, to help mask out unwanted parts of one and then the other image along a sharp-edged boundary. As you become more experienced at this technique, you might want to try using more than one negative.

Figure 13.20 Double printing. The sky area of the landscape photograph has been carefully shaded during printing, and then the second negative of the studio portrait has been exposed while shading the bottom half to create a surreal, dream-like image

Negative sandwich

This is another example of using more than one negative to make a picture. Negative sandwich gives you control over the selection and placement of different negatives by sandwiching them together in the carrier. The difference in this case is that the darker an area appears in the print, the more transparent it is in the negative, therefore allowing light to transmit through the second negative (see Figure 13.21).

Sabattier effect

Also known as pseudo-solarization, film or paper is re-exposed to light during development, achieving an unusual tone reversal. Initially discovered by accident, this technique was much exploited by Man Ray the surrealist artist (see Figure 13.22). When using this technique during printing the dark areas of the print, with most of the silver halides already converted to

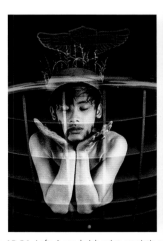

Figure 13.21 Left: A sandwich print consisting of two negatives: a shot of a car grille and studio portrait shot against a black backdrop have been placed in the negative carrier together and given one exposure. Centre: Sabattier effect: the print received an additional 5 second exposure during development from a pure light source. Notice the grey/silver tone of the body and white lines forming between dark and light tonal areas. Right: This print received a longer, second exposure of 15 seconds, creating a more dramatic reversal of tones

metallic silver, are affected little by this re-exposure. However, the bright areas still contain under-developed silver halides, which remain light-sensitive. Through additional exposure and farther development, these can be converted to metallic silver. The result is a light to dark grey tone depending on the second exposure time. The mid greys in the original print also appear lighter as a result of this effect. The most dramatic action, though, happens between the light and dark tonal areas where light, often white, lines now appear; this is the result of chemical by-products remaining from the first development, which hinder final development (see Figure 13.21). Man Ray would use the technique during film processing rather than printing which would result in black lines as opposed to white lines appearing (Figure 13.22).

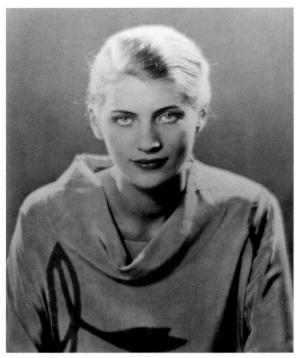

Figure 13.22 In Man Ray's image of the photographer Lee Miller the film was exposed to light during developing time, a technique known as solarization or the sabattier effect where the image is wholly or partially reversed in tone

Prepare an enlargement in the normal way to obtain the correct exposure time (a negative of higher contrast than average works best), and then pull the print from the developer as the image starts to appear. Rinse the print in water to stop farther development and squeegee to remove excess liquid. With an empty enlarger and the lens stopped down, re-expose the print to light. For greater control do a test strip for different exposure times, and then continue to re-develop until conclusion, and fix and wash in the normal way. Make sure the enlarger baseboard is clean and dry before next print.

Lith prints

By controlling exposure and development of certain papers in lith developers – such as Champion Novolith, Kodalith or Fotospeed – you can achieve prints with a range of tones, from brown-black to yellow (see Figure 13.23). The most suitable papers to use are those with a chlorobromide (see the printing papers section in Chapter 12) such as Foma Fomatone FB.

Handle lith material under deep red safelight. The developer comes in A and B solutions, which deteriorate quickly when mixed together; however, to achieve the warm tones place your paper in diluted used developer. Lith developer will increase contrast so choose an image rich in texture or pattern that is sharp. First make test strips based on the exposure you would give with normal bromide paper but bracketed with only about 20 percent differences of time. Process

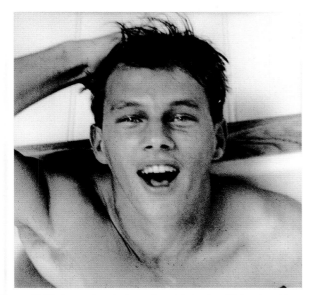

Figure 13.23 A normal contrast negative printed onto a lith-type bromide paper, processed in a lith developer. The print now has a rich black, contrast image with warm, yellow mid-tones, reproducing only a small part of the negative tonal range. The greater the over-exposure and underdevelopment the 'warmer' the mid-tones and lower the contrast will appear

fully in lith developer (typically 2 minutes) followed by regular stop bath and fixer. Decide what you consider correct exposure, ignoring the extreme contrast.

Now make a full print giving four times this exposure time, or opening up the lens two stops. Greatly dilute some of your previous working-strength developer, 1 part developer and 5 parts water, and develop this print purely by inspection, removing it quickly from the developer at whatever stage the image looks best. Development is initially slow, taking up to 10 minutes but accelerates rapidly towards the end, so timing is critical. When you view your fixed print in white light it will show a mixture of black shadows and tinted mid-tones, with generally normal contrast. Increasing exposure by large amounts and reducing development still farther produces more colour and lower contrast. Do any shading or printing-in as normal.

Liquid emulsion

It is possible to print photographs onto almost any surface by coating it with a layer of light-sensitive emulsion, and then expose the treated material under the enlarger and process with normal print chemicals (see Figure 13.24). Mixing your own emulsion can be time-consuming and it can be difficult to obtain consistent results, so a commercially available product such as SE1 Emulsion from Silverprint is recommended.

Liquid emulsion does not have a long shelf-life and should be used within one month of purchase although it is claimed it can last for six months if stored in the fridge. The container of emulsion needs to be heated to 35–40°C first so that it forms a creamy consistency that can be spread over the surface in safelight conditions. You will need to have sample material of the intended surface so that you can make test exposures before the final print.

Most papers, cloth and unprimed canvas, can be coated directly with the emulsion. Non-porous surfaces like fired ceramic, china, enamel, glass, rocks, eggs or shells need to be prepared by scrubbing with a hot solution of sodium carbonate and then covered with a subbing layer, available with SE1 or Black Magic emulsions. For highly porous material, such as unfired ceramic, brick, plaster, most metals and plastics, apply a thin coating of phenol varnish diluted 1:1 with naphtha or benzene. Allow to dry, between 1 and 12 hours; repeat to get an even coat if necessary.

Common print faults

Always check any unexpected faults on your print first of all against the corresponding image on the negative. Assuming that the negative itself is free of blemishes, the most common faults in printing and their causes are:

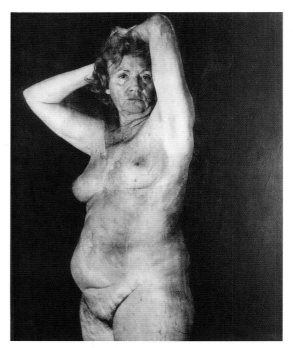

Figure 13.24 Liquid emulsion painted onto canvas has produced this 'painterly' photograph by Melanie Manchot of her mother

- White specks and hair shapes, due to debris temporarily lying on the paper surface, the negative or any carrier glass. If marks are very unsharp the dirt may be on a condenser or diffuser surface between negative and lamp.
- Uneven patches of density, which may be quite large, caused by not submerging the print quickly and evenly in the developer. Perhaps development time was impracticably short.
- Small whitish patches with distinct edges, caused by water or wet finger marks on the emulsion before processing.
- A purple patch, or purple all over. Print insufficiently fixed, and therefore reacting to white light.
- Fine black lines, often short and in parallel groups, caused by physical abrasions of the (dry) emulsion, perhaps from dropping the paper on the floor or slipping it roughly under the masking frame masks.
- One or two short, thick black marks fairly close to a print edge. Caused by over-energetic gripping by print tongs in the developer.
- Only part of the image being sharp (e.g. centre but not edges; one side but not the other). The negative is bowed, or at an angle to the paper.
- Part of the picture showing an offset, double image. Probably caused by the masking frame, lens or negative being jogged between your main and printing-in exposures.
- Grey, muddy image, with smudged shadow detail and sometimes veiled highlights. Caused by grease, dust, or temporary condensation (from moist hands during shading?) on the lens.
- A slight fog-like dark band close to the print's white border, due to light spread from the rebate of the negative.
- Contact prints unsharp. Insufficient pressure between cover glass and paper.
- (RC papers only.) Collapsed blisters in the emulsion surface, where it has separated from the base. The print was not fully covered by a film of water when passed through a roller RC heat dryer.
- White areas, including borders, veiled with grey. Extreme over-development, or fogging by your darkroom safelight (see safelight testing, p. 305).

Chemical afterwork

Once the darkroom side of black and white printing is over, you can still make radical changes to a picture by various chemical processes workable in normal light. These include bleaching, toning and colour tinting.

Image reduction and bleach-out

The two most useful forms of print reducer are Farmer's, which you use to progressively lighten the image, and iodine bleach, which completely removes parts of the image down to white paper. Formulae for each appear in Appendix D, and you can also buy them pre-packaged. Remember health and safety in handling these chemicals; Appendix E.

Farmer's reducer

This is also known as ferricyanide reducer or 'ferri'. Basically it is a combination of potassium ferricyanide, which changes the print's black silver image back to silver halide, and hypo (sodium thiosulphate, fixer) which makes the halides soluble so that they can be washed from the paper. Farmer's reducer can be used as a sequence of two separate solutions, but it is much easier to see the reduction effect with both chemicals present, even though the mixture does not then keep and must be used 'one-shot'.

Use Farmer's reducer to lighten just those areas of the picture you have been unable to shade sufficiently (Figure 13.25). Alternatively, applied to the whole print, it will 'clear' veiled highlights and give extra sparkle to light tones – which it reduces more quickly than darker tones.

The print you want to work on should be fully fixed, rinsed and squeegeed onto a clean flat surface. Dilute the Farmer's reducer with water until tests on a scrap print show that its

Figure 13.25 Changing local tone values with reducer. Left: Straight print from negative. Right: This print had nearly twice as much exposure. Then after processing, the fallen branch was lightened back by repeatedly applying dilute Farmer's reducer on a large watercolour brush

13

Figure 13.26 Bleaching out background. Left: A straight print shows a moss-covered tree stump with confusing background. Right: By carefully applying iodine bleacher with a swab and brush, and finally refixing, unwanted parts of the image are reduced to white paper

image-lightening action is fairly slow, and therefore controllable. Then apply it to your main print using a cotton-wool swab. Keep stopping the action by hosing over the print surface with water (remembering that if you go too far, reduction cannot be reversed). When the image has altered to the visual result you require, give the print normal fixing, washing and drying.

Iodine bleach

This is the best bleacher for giving a 'clean' complete erasure of the image. It is a dark brown solution containing iodine and potassium iodide, which combine with the silver to form a silver halide. This in turn is fixed and washed out. Use the bleacher to convert small black spots into white spots, for subsequent spotting-in with dye or watercolour (see p. 335). It is also excellent for 'shaping-out' subjects from their backgrounds.

Thoroughly blot off the fixed, rinsed print you want to bleach, and apply the undiluted solution with a brush or (for large areas) a swab. A deep brown stain immediately appears, but you can see the black image fading away beneath it. When this bleaching is complete, soak the print in a tray containing some fresh fixer for 5–10 minutes until the treated areas are completely stain-free and white. Then wash and dry the print normally. Discard the fixer because of the iodide by-products it now contains.

When 'shaping out' a very complex subject (Figure 13.26), you can first dry your print, paint over or cover parts you do not want to bleach with a waterproof resist, and then place the whole sheet in a tray of the bleacher. Afterwards peel off the resist at the refixing stage.

Toning

Toning changes the black image into a colour, by either coating the silver or converting it into another, coloured chemical or dye (see Figure 13.27). The paper base remains unchanged. Some toned images (sepia, red) are at least as permanent as the original silver. Others (blue, green) are not.

You may want to tone your print to subtly improve tonal richness and increase its permanence, using selenium (this chemical is carcinogenic and must be used in a well-ventilated area) or perhaps gold. Or you might sepia-tone, either to create an antique-looking image, or as a preliminary to tinting (see below).

Two of the most common colours, sepia and blue, are sold as prepared chemicals, or can be made up (see Appendix D). You can also buy ready-to-use comprehensive kits such as 'Fotospeed Pallette Toner' or a selection of package chemicals from 'Speedibrews', offering a whole range of colours. By mixing these chemicals in different proportions, different toning colours are formed. Stronger toning colours should be used with restraint, unless you need a gaudy effect.

Some toners require two stages, e.g. sepia. First, you bleach the area you want to tone in a ferricyanide solution (without fixer), and then you redevelop this bleached image as a coloured chemical image in the toner. Redevelopment can take place in normal room lighting because only halides representing the image are present; so fogging is impossible.

Others are single solution toners and gradually displace or form an amalgam with the black silver, starting with palest tones first. Yet others (typically those in kits) use *dye-coupled development*, in which the existing image is first bleached, then redeveloped in a developer plus a chosen colour coupler, and finally bleached again to remove the black silver simultaneously reformed during the redeveloping stage. This leaves an image in dye alone. Notice the similarity with colour film processing.

Whichever toning formula or kit you use, you can choose to change the whole image to a coloured form or, perhaps by means of a paint-on resist, tone just selected areas only. Unaffected parts which remain as black silver can next be toned a farther colour (see Figure 13.28). Another way of working is to duotone, meaning that shadows and dark tone values in your picture remain black while mid-tones and paler parts take on colour.

The way you achieve this two-tone effect will depend on the formula and colour (Figure 13.19). With sepia toner, for example, you dilute the bleach bath, which then allows you time to remove your print before silver from the darkest shadow areas has been affected.

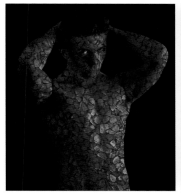 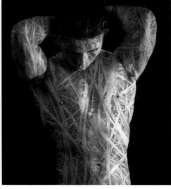 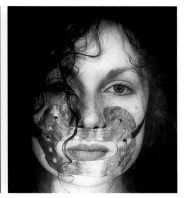

Figure 13.27 Chemical toning. Left: This sandwich negative print has been blue toned (often gives a patchy effect if the print is over-washed) to provide an emotionally cold image to enhance the idea of a man made from stones. Centre: After bleaching and full sepia toning to give a warmer feel to a man made from straw. Right: A copper/red single-solution toner has been applied first and then the lips have been highlighted by hand, tinting them with a pink dye

Then in the toner, only paler, bleached tones become fully sepia. In single-bath toner you treat the print just long enough to start affecting the lighter tones.

Prints for toning should be fully developed in the first instance. Toners such as sepia slightly lighten the image, and others such as blue slightly intensify it, so anticipate this when making the original print. You will also find that final colours differ somewhat according to whether the print is on a bromide, chlorobromide or lith emulsion paper.

Tinting

Tinting means hand-colouring your print with watercolours, dyes or oil paints. Oils are applied by brush – other paints by brush, spot-pen or airbrush. The main advantage of tinting over colour photography is that you can choose the colour of every single element

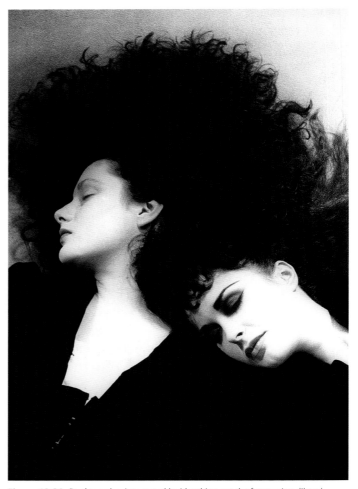

Figure 13.28 Dual toned: print created by bleaching out the faces using diluted bleach and a cotton wool bud, and then placing in a sepia bath. The sepia only works on areas that have been bleached. Once washed the print was placed in a bath of single-solution blue toner, which dyed the remaining black/silver halide areas

in your picture – restrict colour to something you want to emphasise or show in an interpretative way (see Figure 13.27).

If you colour over a normal black and white image, its black silver will mute most of your hues. Instead, work with a print which is warm in image tone and slightly pale. You might sepia-tone the print for example, or make it in the first instance on chlorobromide paper processed in warm-tone developer. Remember that tinting, unlike toning, colours both the image and clear parts of the paper. In fact colours show as stronger and more pure in highlight areas.

Water-based colours, dyes

These are applied to the print while it is still damp. Blot off the print surface and with a swab add a wash of colour to largest areas first. Build up sufficient density of colour gradually. Work down to the smaller areas using a brush, always blotting off the print after each colour

application. When only tiny coloured details remain to be done add these final tints using a small brush or, if you are working with dyes, a fibre-tipped pen. See the following section on retouching.

Oil-based colours

Here you must work on a dry, mounted print. Squeeze artists' oil colour onto a palette and pick up and apply small amounts at a time, using a fine brush moistened in turpentine. Again work from the largest to smallest areas. Progress is slow because a coloured surface must dry for about 24 hours before you can add other coloured details on top. Oils also alter the surface texture of your paper. However, colours can be erased or changed more readily than with water-based tints, by means of a cotton bud dipped in turpentine.

Airbrushing

Colouring of prints can also be handled with a miniature paint spray known as an airbrush. This is powered by compressed air from a can or an electric pump and compressor unit, and projects a fine spread of spirit- or water-based dye or pigment. Control is by a single button – pressing it down controls air flow, and pushing it forward or back allows paint to flow in a narrow or broad spray from a small internal reservoir. Airbrushing is a good way to create smooth, graduated areas of colour or tone, but takes a lot of practice. Colourists today increasingly turn to digital methods of altering prints, as described in Chapter 14.

Retouching

It is always best to ensure your enlarger and negatives are as clean as possible so as to minimise the problem of unwanted marks on the finished print. Some scratches, dirt and other defects cannot be removed, however, and need to be dealt with by hand work after processing. Large areas of damage may only be treatable by digital means (see Chapter 14) but small defects can be rectified fairly easily with a little practice, although resin coated and glossy papers are more difficult than matt and fibre-based papers to retouch. Retouching both in digital and analogue can be a specialised craft and attract high fees if undertaken commercially.

Spotting

This is the use of dyes or inks to touch in small white specks on the print caused by dust or other debris on the negative. Retouching dyes are available from photographic companies and take the form of small bottles of pigment (Diaphoto provide single bottles and packs of 3 or 6 tones) or dry cakes rather like watercolour paints, or even ultra-fine pointed felt-tipped pens, although the latter tend to be less useful for high-quality work. Available in both black and white and colour, the important factor is that the pigments used are designed for photographic materials. This means that they are readily absorbed by the print rather than just sitting on its surface so the paper finish, gloss, lustre or matt isn't altered.

To spot a print, place it on a flat surface in good light (ideally natural daylight) and mix a suitable colour from the dye set, diluted with water. Note that even black and white materials need careful matching as print tone varies considerably with paper types and developers. Use a very fine (No. 0 or 00 or smaller) brush, bought from an artist's supply store, and practise on a spare piece of photo paper until the colour and intensity of the tone match the area you are about to retouch. Since the materials used are dyes, you can build up the tone with repeated applications, so if in doubt make the tone diluted. It might also be advisable to add black to colour dyes to tone them down otherwise they can appear too intense on the final print. Aim to mimic the grain structure of the image by working with a stippling motion to produce a series of very tiny dots. If you overdo the effect, immediately dab the area with a slightly damp cloth, which should draw out the dye. On longer marks such as scratches and hairs, don't paint along the line but blend it into its surroundings with a succession of dots. Work slowly and carefully, taking frequent breaks to rest your eyes and view the print from a normal distance to see the effect of your work. Retouching is a skill that takes a little time to master but makes a huge difference to the overall appearance of your finished work.

Etching

Dark marks on a print, caused by dirt on the negative while still in the camera or processing defects, are harder to remove. You need a very sharp blade to scrape away tiny amounts of the print emulsion. Surgical scalpels are sold in good artists' suppliers and come with a wide variety of extremely sharp blades. A No. 11 blade tapers to a very fine point and can be good for very small spots, while a No. 15 has a curved edge which allows gentle shaving of the emulsion without tending to gouge the surface. Support the print on a flat surface in good light as before and gently scrape over the spot with light strokes. It will take quite a few strokes to scrape away the surface coating on gloss prints, before starting to erode the emulsion below. Once the spot has been scraped away you may find the surrounding area needs blending into its surroundings by spotting with dyes. If this is the case apply them cautiously as the scraped area absorbs the colours more quickly.

An alternative to etching for black and white prints is to bleach the dark areas either using Farmer's reducer (see p. 331) or a specialist spotting bleach solution such as 'Spot Off'. Use a separate brush for such solutions to avoid contamination and re-wash the print after bleaching.

Permanence and archiving

Photography is not intended to be an ephemeral medium, but care needs to be taken if images are to last. It is important to understand what factors make films and papers deteriorate so we can guard against them.

High-quality processing is most important. A poorly processed print can start to show visible deterioration in a matter of days but some problems can take years to appear. Some early photographs have survived for well over 100 years while others have decayed noticeably in a much shorter time. Much of this difference can be traced to how thoroughly the images have been fixed, washed and stored.

Many things combine to make images self-destruct:

- 'Fugitive' colour dyes which fade over time.
- Silver image grains which oxidise and decay.
- Residual chemicals from processing, or chemical composition of film or paper structure that attack the image from within.
- Damage from heat and humidity.
- Airborne contaminants, pollution and chemical compounds in mounting or storage materials.
- Light (this is one of the biggest dangers as it aggravates all the other damaging influences).

Film

Early film stock was nitrate-based, which is possibly the least archivally sound photographic material ever devised – film stocks could literally burst into flames on contact with air! Modern materials are polyester-based 'safety film', which is much more inert chemically. The emulsion coating absorbs water and, therefore, chemicals, which need to be thoroughly washed out after processing. Automated processes, particularly in colour, use stabilizer solutions to reduce washing times and heat drying. For very important work, consider re-washing films and drying them slowly at room temperature. Black and white films should be adequately fixed (but not over-fixed), and washed in running water at 15–25°C (too hot and the emulsion will be damaged, too cold and the wash effectiveness is reduced) for at least 15–20 minutes in an effective washer. Chemical kits are available which allow you to test for the presence of residual fixer if you doubt the efficiency of the washer.

Black and white prints

Resin-coated prints can be made to last decades but they are inherently less stable than fibre-based prints, which have the potential to last centuries. As with film, it is processing which is the key to making prints last as long as possible.

RC papers absorb less of the processing chemicals so wash times are short, but the very thin emulsion layer means that the image is fairly fragile. They can contain chemical brighteners to make the paper base seem whiter and these can attack the image over time.

Fibre-based papers are much more stable but they absorb a lot of the processing chemicals so they need much longer wash times. In both cases, the key to print longevity is to give just the right amount of fixing to dissolve the unused silver compounds but no more than necessary to avoid the acidic fixer solution soaking into the paper base where it is harder to wash out. Once it has done its job, all traces of fixer must be rinsed away by effective washing.

A suggested archival processing sequence for fibre-based black and white papers (all steps carried out at 20°C):

1. Develop the paper fully. Follow the manufacturer's recommended times and temperatures.
2. Use a good-quality fresh stop bath, again for exactly the recommended time.
3. Fix prints using two baths of non-hardening fixer. Follow the instructions but as a guide treat the prints for 5 minutes in each bath for sodium thiosulphate fixers (most powder fixers) and 2 minutes in each bath for ammonium thiosulphate fixers (most liquid fixers) at standard dilution. Agitate the prints in the trays continuously and don't allow prints to stack up on top of each other. The first bath can be old fixer (up to a week or so old) but the second should be freshly made. Don't exhaust the baths by fixing too many prints. The instructions on the pack will tell you the capacity.

4 Wash thoroughly for 20 minutes.

5 Tone in Kodak Rapid Selenium Toner at 1:15 dilution. (This is optional as it alters the image tone slightly. The toner is also highly toxic so take great care when using it.)

6 Apply second wash of 5 minutes.

7 Treat with hypo-clearing agent as recommended by manufacturer. This causes the emulsion to swell, making it easier for the chemicals to wash out of the print.

8 Finally wash for 30–60 minutes in an efficient print washing system.

After washing: make sure your hands are completely clean, using soap and water to remove any traces of fixer so you don't re-contaminate prints. Make sure all surfaces, trays, etc., are spotless before letting a clean print touch them.

Heat can cause damage to prints so the safest method is to air-dry everything. Either peg the prints on a line or place them on mesh racks (p. 310).

Colour prints

Almost all colour print processing is automated. Manufacturers make different claims for longevity of papers but Fuji Crystal Archive is a professional preference. Ilfochrome/ Cibachrome product has an extremely good reputation for colour fidelity and long life but is very expensive. Re-washing final prints as if they were black and white may help remove any residual chemicals.

Digital prints

Commercial printers can offer great quality and permanence with refined processes such as Giclée (formerly known as Iris) prints (giclée is simply French for squirt). Longer-lasting inks and suitable papers have come onto the market, from companies like Lyson and PermaJet, that allow archival prints to be made on your home printer; plus there are other commercially available print processes such as Lambda and Lightjet, which should be as permanent as traditional colour prints since they are produced on the same RA4 machinery. Dye sublimation prints have a very good reputation for longevity.

Mounting and display

Apart from contamination from processing chemicals, acids in mount boards, fixing tapes and glues plus pollutants in the atmosphere and strong light will all attack a print. Use acid-free 'conservation', 'museum' or 'archival' grade materials, seal frames with tape so air can't get in, and don't hang prints in direct sunlight.

Avoid aerosol-type glues or anything with strong solvents. Museum curators and others who deal with old or valuable photographs prefer mounting methods that are reversible, so any glue which is water-soluble is a good bet. The print can then be soaked off its mount if need be at some time. Dry mounting is not considered to be archival even though good-quality mount tissue should not attack the print and presents a barrier to chemicals leaching out of the mount board. It also increases the physical durability of a print, making it harder to crease or dent. The conservators don't like it, as it is not reversible. They consider museum acid-free board with archival photo corners – nothing is permanently attached to the print so that it can be removed and re-mounted if necessary – to be the only true archival method. Dry mounting if done properly does, however, result in a perfectly flat print – something

difficult to achieve otherwise with fibre papers – but bad mounting can give a print the surface look of an orange peel.

Negatives should be stored in 'archival' grade polyester sleeves away from the light, ideally in acid-free boxes. Any prints not for display should be stored in similar archival boxes, laid flat and away from pollutants and extremes of heat or cold.

■ Contact prints are an important way of proofing/filing all your film images. Expose carefully and choose a relatively low contrast grade for maximum information of picture content in every frame.

■ Select and clean negatives for enlarging; remember to stop the lens down, and give a series of test strip exposures, each strip spanning shadows and highlights.

■ Make local density changes by shading/ dodging and printing/burning-in; make local contrast changes by altered filtration (variable contrast paper).

■ To reduce printing contrast, use softer grade paper or a lower number filter with VC paper, diffuse the enlarger illumination, 'pre-flash' expose the paper or change to softer-working developer.

■ To increase contrast, use harder grade paper or VC filtration, consider negative intensification, line developer, and lith materials, or change to a condenser or point-source enlarger.

■ Check print faults against your negative. Most white marks are caused by light obstruction such as dust on the negative, black marks by fog or rough handling, patchiness by careless processing.

■ Materials and methods worth exploring: lith paper, tinted bromide papers (with bleach stage), adding edge lines, vignetting, and double printing.

■ Photograms can give unexpected, unique images. Try removing objects part way through exposure, combining object shapes with an image projected through the enlarger, and printing from prints.

■ Dilute Farmer's reducer will lighten print density and brighten highlights. Halt its effect at any point with water. Stronger-acting iodine bleach will remove chosen image parts altogether. Follow both by re-fixing and washing.

■ Toning chemically changes a black silver image into a colour one. Use it for special effects; to enrich print tone values; to increase permanence (selenium or gold toning); or (sepia) as a preliminary to hand tinting. Some toners reduce image permanence. Make sure health and safety procedures are always followed.

■ Toners may work as single solutions. Others require the print to be bleached, then toned during a redevelopment stage. Yet others use bleaching and dye-coupled development (wide choice of couplers), followed by optional silver bleach. Prints can be toned overall or just a selected area, or only image mid-tones and highlights (duotone effect).

■ Tinting, by applying water or oil colours, allows total control of colouring and is often best used subjectively. Work from largest to smallest areas. Graduated tone or colour can be applied by airbrushing.

SUMMARY

1 Make a 'ring-around'. Pick an interesting negative and make a wide-ranging set of prints:

 (a) on various contrast grades of paper

 (b) on different types and makes of paper

 (c) using different developers.

Mount these on a card for reference.

2 Make strong linear and tonal designs by means of photograms. Try:

 (a) Numerous opaque objects – paper clips, beans, etc. – which you shift around the paper or partly remove after one-quarter, half or three quarters of the full black exposure.

 (b) Positioning some objects on a glass sheet a few inches above the paper, others in surface contact. Hold tracing paper just below the enlarging lens to make the raised objects form soft-edged shadow shapes. The others remain sharp and are therefore emphasized.

 (c) Placing a few larger objects on the paper. Expose these with a moving torch following each circumference – like a paint spray around a stencil.

3 Similarly to project 1, make multiple prints of one image and then try a variety of toning products such as sepia, red and blue. Evaluate how these different colours may enhance or alter the mood of the photograph. Secondly, pick images that you think will be most appropriate for the different colours; for example a cityscape with lots of glass and metal might look preferable with the cold tone of blue.

4 Select an appropriate image to hand tint; experiment with different colours and dilution of dyes to build up the appropriate density of colour on the print; use a range of paper bases and surface finishes including glossy and matt.

5 Try creating differently shaped frames for your print from square to circular as well as creating prints with and without black borders.

14

The digital image: post-production

This chapter is an introduction to the essentials of digital post-production, from hardware to software and from input to output. It is not based around a certain computer platform or software package, but is, rather, a general overview of what can be accomplished regardless of hardware or program specificities.

One of the benefits arising from the popularity and availability of digital cameras and printers is that almost all of them are supplied with some sort of software, enabling you to get started right out of the box. For photographers, computers and digital imaging software have created exciting ways to manipulate, retouch, process and generally improve on an original image without the need for potentially damaging chemicals and big, cumbersome darkroom facilities. Now you can do all these things at your desk or on your laptop. You can connect your computer to a scanner and printer, enabling you to output and input excellent colour and black and white images from almost any of your camera-shot material, regardless of source, analogue or digital.

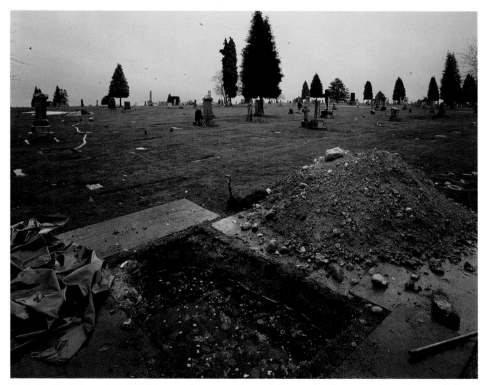

Figure 14.1 *The flooded grave* by Jeff Wall is a seamless merge of several photographs. The graveyard was photographed on location in Vancouver and a cast of the grave was made. Wall then used the cast to create an actual living reef at the bottom of it in his studio and the two were merged together in post-production to create one seamless photograph

As with any new equipment or technology it is important that you don't lose track of your overall aim. It is easy to be seduced by the sheer effortlessness it takes to make dramatic changes to an image, such as the application of striking artistic filters. Having said that, experimentation can be a good way to explore your choice of image editing application. A good starting point, if you already have darkroom experience, is to imitate the techniques you know. Start with the basics, learn them well and then you can move on to more advanced techniques.

Overview

Digital imaging allows you to mimic almost all conventional (chemical-based) photographic tasks such as burning and dodging, spotting and retouching, and colour correction. Results can be seen on screen instantly as most of them occur in real-time (or without any noticeable delay), enabling you to continually adjust your actions accordingly without the need to print out your image.

You can insert motion blur where there is no motion; you can repair areas of an image that would otherwise be unsalvageable in a conventional darkroom environment; you can realistically merge several images into one, either by taking elements from different images into another image (Figure 14.1) or by joining a sequence of images together to construct a seamless panoramic landscape; you can restore a 60-year-old damaged and faded photograph by removing its many creases and revitalizing its faded appearance.

Some of these techniques are very difficult, if not impossible, to achieve perfectly using conventional darkrooms techniques. With the help of a computer and the appropriate software these and many other modifications are but a few steps away.

There are a few things to be aware of when you first start to work with digital photography:

- It is easy to overdo an image. As you are discovering these remarkable possibilities it can be tempting to apply too many needless effects to an already good image in an attempt to improve it.
- Most importantly, perhaps, is that digital imaging is not easy if you are a beginner. As with any new skill, it requires time and patience, but once you have picked up a basic skills set, it is then easier to build on those and try out more sophisticated techniques. You will often find yourself discovering new and better ways at doing the same thing.
- Just because it's straightforward to, for instance, correct a crooked horizon or remove an element in post-production, doesn't mean you shouldn't be taking the same care with your image-taking as you would had you been photographing and working in an analogue environment, where these things would be very difficult to correct.

Hardware

The computer

The computer market is a very competitive industry, which means that you have the choice of computing platforms. Realistically, however, there are two platforms to choose between: the Apple Mac and the Microsoft Windows based PC. Both come in all shapes and sizes and contain

Figure 14.2 Layout of a digital workshop for the manipulation and production of monochrome and colour prints up to A3 size. (A) Computer tower with CD/DVD drive and USB/firewire ports in front for easy access. You can also find additional ports in the back of the computer. (B) A 19 inch flat screen. LCD screens take up considerably less space and produce less heat than an equivalent CRT monitor. (C) A4 flatbed scanner capable of scanning both colour and monochrome reflective material. (D) A designated 35 mm negative scanner capable of scanning colour, black and white negatives and transparencies. (E) An external hard drive, which is useful for backing up your work and if you work between multiple computers. (F) An A3 inkjet printer capable of outputting high-quality monochrome and colour prints on a variety of paper material. (G) A USB memory stick, which can be used to move scanned images from one computer to another. (H) CD-R or DVD-R for backups purposes. (I) Photographs are downloaded directly from the camera to the computer with a USB cable. (J) A nice comfortable chair with adjustable height

the same key components (Figure 14.2). When purchasing a computer for image post-production use have a look out for the following:

- The CPU (Central Processing Unit) is the brain of the computer. The faster it is, the more calculations it is capable of processing. A system with around 2–3 GHz is plenty to start with and most of today's top processors have a dual-core setup, which is two processors squeezed together on the same piece of silicon, offering twice the speed in some applications.
- RAM (Random Access Memory) is the working memory of the computer. The more RAM you have, the smoother (and in most cases faster) your computer will run. Current machines are supplied with at least 2 GB of RAM, which is enough to handle large image files. You can always upgrade later should it be required.
- The hard disk (or hard drive) is the storage space of your computer. On it you store everything from the operating system to your digital image files. If you work with a lot of images you need a lot of hard drive space; hard drives are available in a variety of sizes. A minimum of 200 GB is recommended. You can always add additional hard drives to an existing computer later on should it be necessary.

- A graphic card is important for proper colour reproduction. Almost any graphic card is capable of running today's digital imaging software, so it doesn't really matter which brand you go for. There should, however, be at least 128 MB of RAM on the card.
- A CD and DVD writer or burner is essential to back up your work (which you should do regularly) or if you need to burn CDs/DVDs with images thereon for a client. CD-Rs and DVD-Rs can only be written to once but are recommended over CD-RWs (read-write) or DVD-RWs for long-term storage. It is very important that you store your burned CDs and DVDs properly (and also label them appropriately) as any scratch can render them permanently unreadable. Making multiple copies and storing them in separate locations is also recommended.
- Other forms of storage systems include external drives such as USB memory sticks that can hold up to several gigabytes or external hard drives connected over USB or firewire that can hold in excess of 1 terabyte (1024 gigabytes).

Most of the above components can be upgraded later (possibly with the exception of the CPU) provided that there is enough room inside your computer. Other important accessories are plugged into the computer (Figures 14.3 and 14.4).

Figure 14.3 Mouse. Moving the mouse moves the cursor anywhere on screen. Single or double clicking a button calls up whatever tool, command bar icon, etc., the cursor has been positioned over. A Mac mouse has only one mouse button and a PC has a two-button mouse

Figure 14.4 Graphics palette. Together with a cordless pen this serves the same functions as the mouse. The pen makes it easier to trace around a complicated shape or draw freehand. The pen is also pressure-sensitive, making it the ideal tool for retouching. A small switch on the pen provides the equivalent of mouse clicks

Peripherals

- *Monitor.* You will be looking into a screen for hours on end, which is why it is crucial to purchase a good one – and one that fits your needs. If you are working with a lot of photographs a 17 inch monitor is a minimum, unless you are getting a laptop, in which case you can make do with a 15 inch model. If you can afford, and have room for, one, a bigger screen is always recommended. You should be able to operate your monitor at a minimum resolution of 1024 × 768 pixels with a bit depth (the amount of colours the screen can display) of 24 bit (32 bit is preferred). There are two types of monitor available: LCDs (Liquid Crystal Displays) and CRTs (Cathode Ray Tubes). LCDs or 'flat screens' are brighter than their CRTs counterparts and produce less heat and take up far less space. It is also possible to purchase LCD screens that have either a matt or glossy surface finish. If you are operating a CRT monitor you need to ensure that it is running at an appropriate refresh rate. If your refresh rate is too low, 60 hertz or below, you will notice the screen flickering ever so slightly (as if the image is not quite stable) and this side-effect will tire your eyes over time. It is therefore crucial that your CRT screen is capable of running at 70 hertz or higher to enjoy a flicker-free working environment.
- *Mouse, keyboard and palette.* You need a good mouse. A wireless mouse is recommended as it frees up your working area. It is your main tool when you are working with images. There are other types of mouse device available such as the trackball, which is a stationary mouse with a ball in its casing that you manipulate with your fingers,

unlike a traditional mouse that you operate by moving your arm. The palette enables you to move the mouse cursor with a pen instead of a mouse, making it easier to make minute changes to an image. It is recommended that you try them all out and then decide what type of mouse device you find most comfortable to work with. If you are doing a lot of retouching a tablet can prove invaluable.

- *Flatbed scanner.* A flatbed scanner is a glass top box, containing a tracking light source and scan bar, that converts monochrome and colour prints into digital files. You can use a flatbed scanner to scan any reflective material, such as printed photograph, books, and newspaper clippings. Some flatbed scanners come with an attachment that enables them to scan film material in different formats up to 5 × 4 inches.
- *Film scanner.* A film scanner is a dedicated scanner for transparency and negative film material. It comes in a variety of shapes and sizes and at many different prices. For an entry-level model, you mount your film in a plastic frame that is then inserted into the scanner. Within the scanner software you can pick the frame you want to scan.
- *Card reader.* Some of today's newer computer systems have a built-in card reader that enables you to insert your memory card directly into the computer without the hassle of an external device. Other external card readers are capable of reading a range of different card types (a combo of SD and compact flash is very common). You can also use your camera as the card reader by connecting it directly to the computer with a USB or firewire cable.
- *Modem.* Many computers have a built-in modem, enabling you to connect to the internet over the telephone system. If you want to have a faster internet connection (broadband) a dedicated high-speed modem is required, which can be connected to your computer via USB or network cable (Ethernet).
- *Printer.* A good printer is absolutely essential if you want to output any of your images. See the printer section later in this chapter (p. 375) for more details.

Software

As mentioned earlier, when you purchase a digital camera and/or printer it sometimes comes with a DVD full of free or trial software. Your computer might have sufficient pre-installed software that will allow you to do anything that you require. Figures 14.5–14.9 show the most commonly used software for digital imaging. Featured are the bigger digital imaging software packages available. There is also a whole range of plug-ins that give additional capabilities to each of these programs, such as advanced noise reduction filters, image re-sampling techniques and more specialized effect filters.

Organising your work

Due to the sheer amount of photographs you are bound to take over time it is important to consider early on how you are going to archive and organise your work. You will most likely end up having thousands upon thousands of pictures, the original RAW files, JPEGs for use on online, TIFFS for print jobs, etc. Software programs such as Adobe Lightroom and Bridge, Apple Aperture and iPhoto make this job a lot more straightforward than it used to be.

These programs also take full advantage of the embedded metadata found in Raw files, such as camera type, date of exposure, where the photograph was taken and much more (Figure 14.10). This allows you to sort your files accordingly and group them together.

Figure 14.5 Adobe Photoshop is by far the best known and most popular image editing application. It is now in its 14th version also dubbed CS4. Available for both Mac and Windows it offers an amazing range of features, way too many to even list. It is without a doubt the industry standard and available in a variety of versions: Photoshop, Photoshop Extended and Photoshop Elements. The aforementioned version is a boiled down, more consumer oriented package without some of the more advanced features. Photoshop is most commonly purchased as part of Adobe's Creative Suite, which is a bundle that comes with other software programs such as Indesign, Illustrator, and Dreamweaver, but it can also be bought as a stand-alone program

Figure 14.6 Apple Aperture: This software package is drastically different in both architecture and layout to Photoshop and other more traditional image editing programs. It was built from the ground up to offer a better workflow for photographers shooting in RAW. It is in some ways two programs in one. One part deals with downloading and the organisation of your images; the second part deals with image editing and output. It doesn't have many of the advanced features found in Photoshop (such as layers), but offers plenty of its own. The key feature is its ability to edit RAW files non-destructively. This means in practice that you don't have to worry about saving your file as you go along. Aperture will save all changes to your file as you work on it and any change can be undone even after closing and reopening the program. The program is not a direct competitor to Photoshop but is meant to co-exist alongside it

Figure 14.7 Adobe Lightroom is a direct competitor to Aperture, with most of the same features. The key difference between the two is that Lightroom offers tighter integration with Photoshop, otherwise it is really up to individual preference which one you should pick. You can download trial versions of both before you decide

Figure 14.8 Apple iPhoto: If you are a Mac user, iPhoto is probably your first choice for image management and simple image editing. It comes as part of iLife, an inexpensive add-on to OS X containing a variety of programs. iPhoto has a host of features that makes it easy to download images from your camera. You can organise your photos in sets, upload them to a website, create slideshows; email your best shots to your friends and family directly from within the program and much, much more

Figure 14.9 Gimp (GNU Image Manipulation Program) is a freely distributed program. You can download it from www.gimp.org and it is available for the Macintosh, Windows and Unix platforms. Gimp doesn't have nearly the same feature set as Photoshop or similar programs, but has a lot of the same functionality. Unfortunately, downloading and installing Gimp is not as straightforward and leaves a lot to be desired. Gimp is also in constant development and new versions are immediately available for download from the website. (a) The main toolbar with access to all tools and the ability to adjust brush sizes, etc. (b) Unlike Photoshop, each image that you have open in Gimp comes with its own pop-down menus

Saving your digital file

From your digital camera

When you download files from a digital camera they have already been given a designated file name. Normally these make little sense, but consist of a numbering system as not to overwrite any previous image, such as p1020147.raw (this numbering system is normally sequential so you can always tell how many photographs you have taken with your camera. You can also reset it).

When you start to work on an image and arrive at the stage where you want to save your changes, do not overwrite the existing file but, rather, give the image file a new name that makes sense to you. There is one very important reason for this: it allows you to always go back to the original untouched image file and start from scratch. You may have inadvertently made an alteration to the image that you regret and if you have saved the changes on top of the original file (overwritten it) you cannot undo it.

When you decide on a file name it is considered good practice that it should never contain any foreign characters or spaces. Instead, separate the file name using dashes or underscores such as *man_cycling.tif* or *man-cycling.tif*. If you have several versions of the same image that you want to save, add a number to the end of the file name such as *man_cycling1.tif* or *man_cycling2.tif*. If you have a set of images you can apply batch renaming to them – a function that can be found in Adobe Bridge and other programs.

From your scanner

If you are acquiring your digital image files from a scanner you have to name the file either after or before you commence the scan depending on the type of scanner and software used. Some scanning software runs as independent programs, while others operate as plug-ins to your existing digital imaging program. Labelling your image files properly is incredibly important as you can easily lose track of what image has what file name, and as your library of images grows it is increasingly important to keep track of all your images.

File formats

When you want to save your image do so by using the 'save as' function. This allows you to type in the name of your file and browse to where you want to save it. The next step is to pick the correct file format (Figure 14.11). If you are working with high-quality archival images that are several megabytes in size you would probably not want to compromise image quality by using a compressed file format such as JPEG. For more information

Figure 14.10 The metadata menu in Adobe Lightroom with a wealth of information about your file. Dimensions, Exposure, Focal Length, ISO, Camera, etc. You can also add additional data yourself such as where the image was taken

on the JPEG file format, see Chapter 6, p. 123. For any archival and long-term storage purposes the most widely used image file formats are TIFF (tif), PSD and DNG (digital negative). These file formats are uncompressed – though TIFF files have the option to be compressed. The TIFF format is widely regarded as the industry standard and you can open and work on a TIFF file in all digital imaging software. Photoshop has its own native file format, the PSD. The PSD is unique in many ways in that it saves all the layers (layers are non-destructive adjustments that you have made to your image) you may have added to the image as you have worked on it, enabling you to close it down and open it up at a later point and continue working on it where you left off. The only problem with PSD is that once you start adding layers to an image, the file size gets much larger; how much depends on the bit depth you are using and the use of adjustment layers.

A library of uncompressed files could easily turn out to be several gigabytes in size – so it is very important that you schedule regular backups of all your work. Hard disks can fail; CDs and DVDs can be scratched, rendering them unreadable.

Photoshop
BMP
CompuServe GIF
Dicom
Photoshop EPS
JPEG
Large Document Format
PCX
Photoshop PDF
Photoshop 2.0
Photoshop Raw
PICT File
PICT Resource
Pixar
✓ PNG
Portable Bit Map
Scitex CT
Targa
TIFF
Photoshop DCS 1.0
Photoshop DCS 2.0

Figure 14.11 Some of file formats available in Adobe Photoshop, showing a wealth of possibilities

After you have typed in a file name and chosen a location to save your file in, click the save button. You can now go ahead and close the image down and continue working on another image should you wish to do so.

Basic editing

Navigating the image

With an image loaded into your software program you can now have a look at it in much greater detail. How much of the image is displayed on your screen depends entirely on the size of your monitor and the size of the image. If you look at the title bar of the image it will indicate a percentage value after the name of the file. If it says 20% it simply means that the screen is not running at a high enough resolution to fully display the totality of your image, but only a part of it. It is important to remember that monitors operate at 72 ppi (pixels per inch) versus approximately 300 ppi for print medium, which means that the information on screen is spread over a much bigger area – it's less dense, hence the reason you have to zoom in. To look at the image in greater detail use the zoom tool. You can zoom into an image by clicking on the magnifying icon in the toolbar. When you're zoomed into an image you can navigate it either by dragging the menu bars at the bottom or on the right side of the image or by holding the space bar down and moving your mouse (Figure 14.12).

Undo/Redo/History

As you work on your image you may at times want to undo an action, perhaps because something went wrong. Most imaging software has an undo function that enables you to easily go one step back. You can also redo an action if you then regret undoing it (Figure 14.13).

Photoshop has something slightly more advanced, aptly named History (View History), which gives you an overview of your last 20 actions (this is the default setting, but can be adjusted to list up to 99 actions), enabling you to carefully go back one step at a time, or in multiple steps (Figure 14.14).

Crop, Rotate

You may want to rotate your image or crop it to remove unwanted elements. With the crop tool selected you simply click and drag across the image and adjust the selection accordingly. This allows you to carefully adjust your crop to be exactly what you want it to be. When you use the

Figure 14.12 (a) Full image shown at 16.7% of its size. (b) The same image when zoomed in at 100%, centring on a particular detail. At 100% you are seeing the maximum amount of detail in your image. (c) At 500% zoom you can clearly see pixels

Figure 14.13 All digital imaging programs (except those that don't need them, Aperture and Lightroom) have an undo function that allows you to trace your steps back

crop tool it usually darkens the area around the cropped area (the area you are cropping away), making it easy to adjust and execute the desired crop (Figure 14.15).

You can also rotate the image in any direction. The rotate function gives you the ability to rotate the image clockwise (CW), counter-clockwise (CCW) or by a degree that you specify. Some digital imaging programs allow you to use free-transform, which enables you to rotate the image by eye rather than by numbers, thus for instance allowing you to straighten up a crooked horizon.

Figure 14.14 Adobe Photoshop has a history function that lists the last 20 actions you have made. You can use it to trace your steps back, with more than one step at a time

(a)

(b)

Figure 14.15 Example of a simple crop of an image, before (a) and after (b)

Brightness & Contrast

To add or reduce image brightness or contrast you can use the brightness/contrast function. You adjust the brightness and contrast by moving the two sliders either positively or negatively. As you try to achieve your desired effect the program will continuously give you a 'live' preview of what those changes will do. For better control it is highly recommended that you work with levels or curves to adjust the brightness/contrast in an image, as the default Brightness/Contrast function can remove details in your shadow and highlight area. The Brightness/Contrast method works on the averages of pixels, unlike curves or levels which work on a pixel by pixel basis; thus with them you retain much greater control over the final outcome (Figure 14.16).

Colour adjustments (Colour balance)

You can use the colour adjustment (Color Balance) tool to correct colour casts. The tool has three sliders that can be adjusted individually, one for each colour channel: R for red, G for green, and B for blue (or for C, M, Y & K if you are working in that colour mode). You can drag the sliders either way – to add or subtract one of those colours. In Photoshop, for instance, you can also adjust the colour balance individually for highlights, mid-tones and shadows (Figure 14.17).

(a) (b)

Figure 14.16 You adjust the brightness and contrast of your image by dragging the sliders in either direction. As you move the sliders you will instantly see the changes you are making to your image and adjust accordingly. When you are satisfied click OK. (a) Before any adjustment were made and (b) the final image with increased contrast

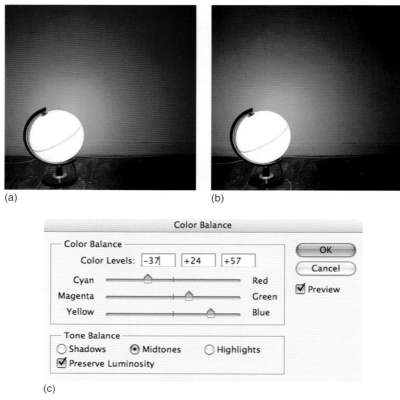

(a) (b)

(c)

Figure 14.17 An example of a colour balance adjustment to an image. (a) Shot on daylight-balanced film under tungsten light. (b) Colour balance correction to simulate daylight. (c) Example of Color Balance tool found in Photoshop showing how the colour levels have been changed; either reduction or addition from a starting point of 0 to produce the effect

Hue/saturation

If you find that your image lacks a bit of colour or impact because it is rather flat you can add some saturation by using the Hue/Saturation function. It allows you to change the overall hue and saturation of your image, while also giving you the option to adjust its lightness, perhaps to change the mood of the photograph. In an extreme case you can reduce the saturation by taking all or selected colours out of the image (Figure 14.18).

Dodge/Burn

Dodge and burn mimics what can be accomplished in a conventional darkroom (see Chapter 13, p. 319). You can dodge certain areas to lighten them up and to bring out additional detail, or burn them to make them darker (Figure 14.19). First select the appropriate tool and adjust your brush size accordingly. The size of the brush dictates the size of the area you will be affecting with each mouse click and the size is measured in pixels. You also need to adjust the edge harshness of your Dodge and Burn tool. The harshness dictates how soft the edge of your dodge/burn brush is. If your brush is very hard the transition between the affected area (the area you are working on) and the rest of the picture will be clearly visible. If you want to burn in a very small area you select a smaller brush or if it is a bigger area, you choose a larger brush.

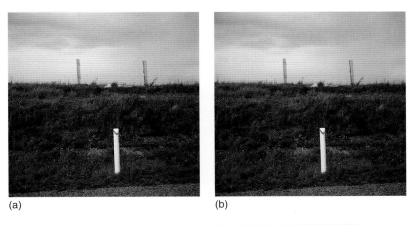

(a) (b)

Figure 14.18 To make the colours in this image more vital the saturation was increased. If you adjust the Hue you add a layer of colour on top of your original image. Lightness allows you to adjust the overall 'brightness' of the image. (a) Before any changes were made. (b) The final image

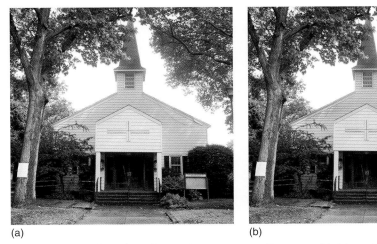

(a) (b)

Figure 14.19 When you use the Dodge and Burn tool set your exposure (the amount of dodging and burning you are doing) to less than 10%, otherwise it can be very easy to overdo. (a) The raw untouched image; in (b) dodge and burn was used to darken or lighten certain areas of the image to bring brighten up some details to give it a more harmonious feel. You simply paint those changes onto the image with your mouse. The adjustments were done carefully by experimenting with various levels of exposure. You can also dodge and burn highlights, mid-tones and shadows separately, allowing you much greater control than you would have had in a darkroom

You can also adjust the intensity of the dodge and burn in percentage. It is recommended that you stay to values below 10 percent, as anything above can be difficult to control. Work your dodge or burn progressively into the image, by using your mouse to 'paint' it in. It is very easy to overdo your dodge/burn, which is why it is recommended that you back up the original file before you commence, or create a dodge/burn layer. This layer is simply a blank layer that resides on top of the original image. Select it and use the Dodge and Burn tool with the Use All Layers option ticked. The dodge/burn effect is then applied on the new layer instead of on the actual image. This allows you to easily undo any mistake you may have made later on.

Cloning & Retouching

Cloning is mostly used as a retouching tool, either to repair scratches or marks in an image or to add or take away elements. When you want to repair a scratch in an image you must first select the Clone Stamp tool, and then adjust your brush size to the size of the area you're attempting to repair. Next, hold down the ALT/OPTION key to select a source area. The source area will be placed (copied) on top of the damaged area, making it disappear. For this to work seamlessly (leaving no trace of there ever being a scratch) and become invisible you must choose your source area very carefully; i.e. the area has to have the same texture and brightness as the area you are attempting to repair.

If it doesn't it will look fake and you will leave artefacts of your repair job behind. Your repaired area will stand out instead of blending in. Photoshop has a more advanced tool for retouching called the Healing Brush. Unlike the Clone Stamp tool, the Healing Brush does not simply copy one element on top of another. It looks at the source area and compares its texture and brightness/contrast to that of the damaged area and automatically attempts to blend the two together without leaving any artefacts behind. At a basic level these tools can be used to retouch areas that have defects, such as dust and scratches, but at a more advanced level they can be used to create interesting and stimulating images, similar to those seen in Figure 14.20).

Removing an element in an image

You can use this same method to remove an object completely from an existing photograph. To remove the airplane from the sky in Figure 14.21 the Clone Stamp tool was used to make sure that the final image appeared to have a clear blue sky. With the sky as the background it is a fairly simple job to fill it in by using a large brush without leaving any artefacts behind. As the plane was progressively removed it was necessary to zoom in and change the brush size to remove a part of the wing hiding among the trees. If the large brush had continued to be used it would have made it very difficult to work on such a small detail. It is therefore essential that you always adjust the size of your brush to the size of the object you are trying to remove. If the brush is too big you can very easily take something away that you wanted to keep. If your brush size is too small you will be giving yourself a lot of unnecessary work. In Photoshop you can adjust the size of your brush either by right clicking (Windows) or control-clicking (OS X) on the image (a little menu will pop up allowing you to change the size by adjusting a small slider).

Image size, interpolation and resampling

The size of your image depends on where it was acquired from. If you are working with an image that you shot using a digital camera, its size depends on how many megapixels

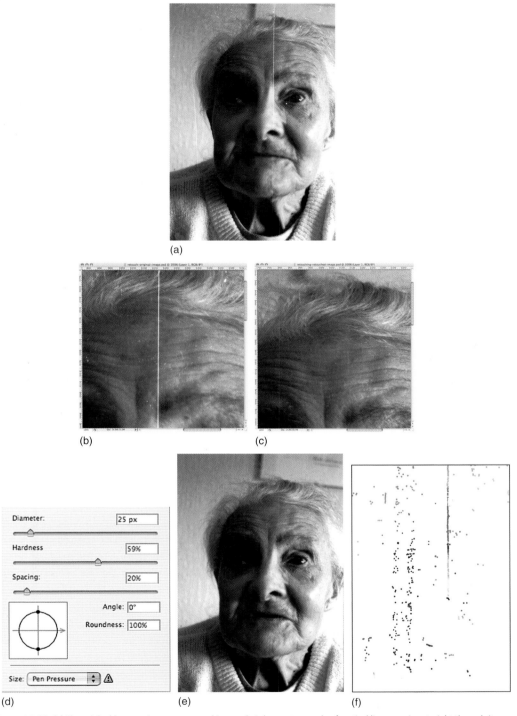

Figure 14.20 (a) The original image prior to any retouching work. It has got a couple of vertical lines running straight through it and many other dust marks throughout. (b) A 100% zoom on a damaged area. (d) Before we start retouching we must select the appropriate brush size. The brush size should be bit bigger than the area we are trying to repair. Select your source area first and then click on the damaged area. (c) Almost done here; most of the dust marks and scratches have been successfully removed. (e) The complete retouched image, now without any trace of the scratches and dust marks. (f) These are all the changes made to the image while retouching separated from the final image. It gives you an idea of just how much work this sometimes requires and what can be accomplished without ever leaving any traces behind

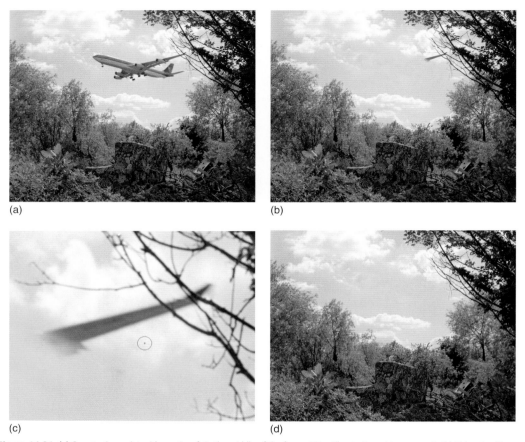

(a) (b)

(c) (d)

Figure 14.21 (a) Our starting point with an aircraft in the middle of the frame. We will not attempt to remove it. (b) Using the Clone Stamp tool and sampling the surrounding sky it is progressively removed. (c) A little bit of wing is still left. (d) For small details it is necessary to zoom in to ensure we remove everything

your camera has. If your image was scanned with a flatbed scanner, the size depends on the resolution that you set in the scanner software and the physical dimensions of the original image.

A 10×8 inch scanned photograph is bigger than a 6×7 inch if they have both been scanned at the same resolution. However, if you increase the resolution of your scan by increasing the pixels per square inch (ppi) it is possible to make the 6×7 inch file bigger than the 10×8 inch file and therefore print a bigger digital image from it. If you've scanned in a negative or a transparency, the size of the image again depends on what resolution you scanned it at. To enable you to figure out exactly how big your image is, not only in pixels, but also how big it will appear in print, all programs have an image size function. It indicates the width and height of your image in pixels and its corresponding document size (print size) in cm or whichever unit of measurement your program has been configured to (Figure 14.22).

Interpolation

Interpolation is a method by which one can increase the apparent resolution of a digital image by averaging out nearby pixel densities and generating a new pixel in between. This

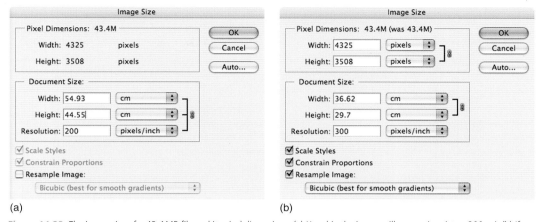

(a) (b)

Figure 14.22 The image size of a 43.4 MB file and its pixel dimensions. (a) How big the image will appear in print at 300 ppi. (b) If we change the output resolution to 200 ppi we see that the print size is now much larger; the available pixels (i.e. the details in the image) are being spread across a larger area. When we do this we are not physically making any changes to the image – its pixel dimensions remain the same as in (a)

functionality cannot add additional detail to an image as interpolation only works with the detail that is available. The resulting image can, depending on the method used, be muddy or slightly blurry or very pixelated; however, interpolation is useful if you are trying to print out images found on the internet that are at a low resolution (Figure 14.23).

Advanced editing

One of the more powerful features found in most digital imaging software are levels and curves. They may at first glance appear a bit overwhelming and complicated, but once you understand their function they have the ability of doing all the adjustments you learned in the basic section but with much greater control.

Histogram/Levels

The histogram (also referred to as levels) displays the tonal distribution in an image as a graph, i.e. how much detail you have in your highlights, mid-tones and shadows. Upon first glance it resembles a mountain range with canyons and peaks. If it peaks in the mid-tones, it simply means that you have a lot of detail in that area: the higher the peak the more detail. From studying the histogram you can pinpoint the amount of detail you have in each area (Figures 14.24 and 14.25).

Curves

Curves when used properly is an incredible powerful tool and represents the content of your image as a graph. When the image is unaltered the curve runs 45° diagonally in a straight line from the bottom left to the top right. The bottom left represents the shadow area in your image, the middle of the curve the mid-tones and the top right the highlights. By manipulating the graph (simply click and drag on the curve, either up or down) you can control the overall lightness or darkness of an image. If you reverse the diagonal line you shift the values in your

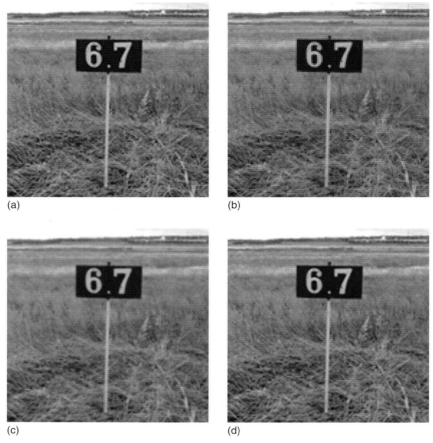

(a) (b)

(c) (d)

Figure 14.23 (a) The original measuring 140 × 140 pixels. Due to its low resolution is it not very usable for print size. (b) The same image but now interpolated 500% using the nearest neighbour function, which in effect simply makes the existing pixels bigger. (c) Same measure of interpolation but done with the bilinear method. This is generally better than nearest neighbour as it causes the edge to be softer. The side-effect is that your image may appear somewhat muddy. (d) Bicubic interpolation, which creates a smoother transition between new and existing pixels in the image. There are different versions of bicubic, such as Bicubic Smoother and Bicubic Sharper

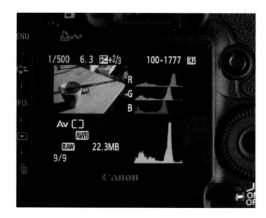

Figure 14.24 Almost every digital camera, whether compact or digital SLR, has the ability to display a histogram on-the-go, which is a handy way of quickly reviewing whether your photograph has been properly exposed. You can review it either as you are photographing or afterwards. Some models project the histogram onto the LCD giving you immediate feedback as you frame your picture

image around. This inverts your image. If you pull the bottom left of the curve slightly down and the top right slightly up, you're adding contrast to your image, as you are darkening the dark area and lightening the highlights. You can adjust the curves individually for each colour channel, making it one of the most powerful features for correcting colour casts and for adding contrast/brightness to a particular area (Figure 14.26).

Selection tools

Selections are used when you want to make an adjustment to a specific area and not the whole picture, or if you want to cut something out and use it in another image. There are a host of tools available to make the selection procedure easier and below are just a few of them.

Magic wand

In this example the sky will be selected. How much of the sky is selected depends on the tonal range of the sky and the tolerance setting of the Magic Wand tool. The higher the tolerance value, the more pixels will automatically be included when you select the sky. Instead of adjusting your tolerance to achieve the desired selection you can add and take away from an existing selection by holding down SHIFT (for adding) or ALT (for subtracting) while you select

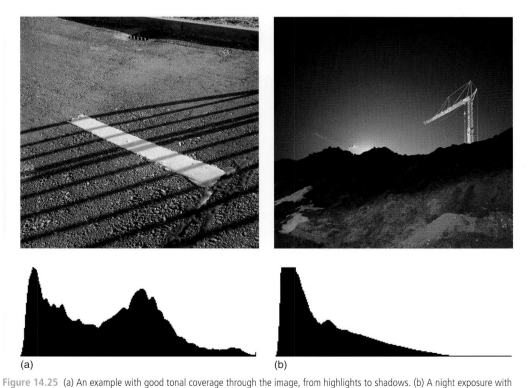

(a) (b)

Figure 14.25 (a) An example with good tonal coverage through the image, from highlights to shadows. (b) A night exposure with very little detail in the highlight area (but still some) and most details reside in the shadows. The top of the shadow is 'clipped' (the range hits the upper ceiling), which means that this image was slightly overexposed. (c) An example with good detail in the shadow and highlight areas but very little in the mid-tones. (d) An example of an image with great detail throughout the image. (e & f). (e) The original image prior to any adjustments. (f) The image after some adjustments have been done resulting in a rather severe loss of detail. The white gaps in the histogram illustrate the tones that have been lost

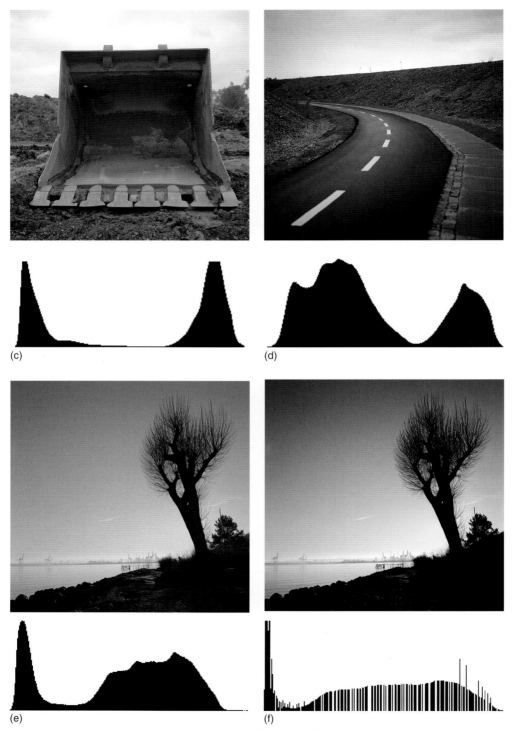

(c)

(d)

(e)

(f)

Figure 14.25—cont'd

the area. The Magic Wand tool is especially good for areas that have the same tonal range such as skies or shapes with the same colour and/or texture (Figure 14.27).

Marquee tools

If you want to select a shape within your image, it is sometimes easier to do so with the Marquee tool. You can make rectangular or elliptical selections with the Marquee tool depending on the shape that you wish to select. The tool can be used in conjunction with the Magic Wand tool.

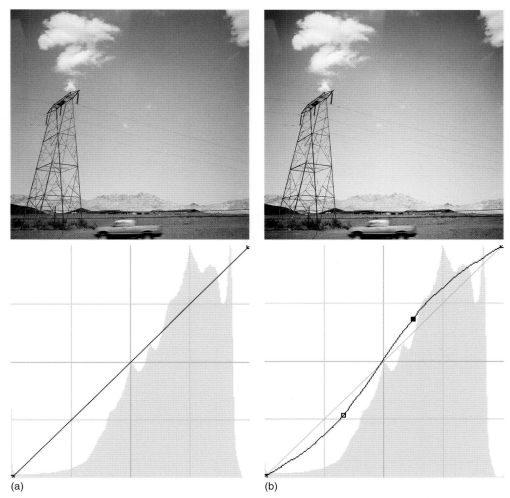

(a)　　　　　　　　　　(b)

Figure 14.26 (a) An unadjusted image and an untouched curve. You can see the histogram below the image for reference. You can clearly see that the majority of detail in this image resides in the mid-tones and highlights. (b) In this example a smooth S curve has been drawn, pushing the highlights down (making those brighter), and the shadows up (making those darker), thus increasing the contrast in the image without losing any details. If you'd made a steep S curve you would have run the risk of clipping your shadows or highlights, i.e. some detail may have been lost. (c) If you shift the curve up and down in a waveform you end up with a polarised image. (d) Here the tonal values of the image have been turned upside down by reversing the curve. The highlights now reside in the shadows and the shadows reside in the highlights area

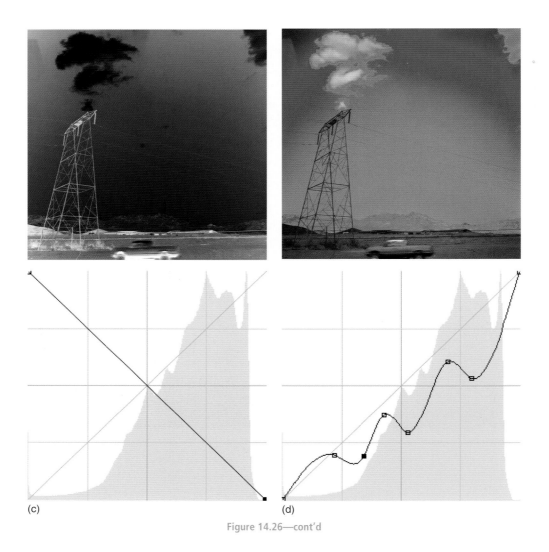

(c) (d)

Figure 14.26—cont'd

You can start your selection with the Magic Wand tool and continue to expand or contract it with the Marquee tool, thus making it easier for yourself to select a desired area (Figure 14.28).

Lasso/freehand tool

Instead of basing your selection on shapes or tonal ranges you can also draw your selection by using the Lasso tool. The Lasso tool can be somewhat tricky to control as you are manually drawing your selection on the image without any constraints (Figure 14.29).

Quick Mask

Quick Mask is another, perhaps simpler and more intuitive way of making a selection. When you enter the Quick Mask mode you simply draw using the Brush tool (which also means that you

(a)

(b)

Figure 14.27 In example (a) the tolerance value was set to 15 and in (b) to 50. Notice the difference in the area that was initially selected

(a)

(b)

Figure 14.28 In example (a) the globe was selected using the elliptical Marquee tool, carefully making the circle as big as the globe. In (b) the frame of the door was selected with the rectangular Marquee tool

(a)

(b)

Figure 14.29 (a) The freehand Lasso selection tool was used to selection the eyebrows. The Lasso tool allows you to select anything within the image simply by drawing freehand. (b) The same selection done with the Polygon Selection tool, whereby you draw straight lines around the area you wish to select. In this case it is not appropriate

(a) (b)

Figure 14.30 Here the shape of the eye was first 'drawn' with the Brush tool, carefully adjusting the area that will eventually be My Selection

can use the Eraser tool to correct the selection). The red area will be turned into your selected area when you exit Quick Mask mode (Figure 14.30).

Feathering/anti-aliasing

Feathering/aliasing applies to many different tools from the use of brushes to the use of selections. Without anti-aliasing/feathering the edge of a selection would have a jagged saw (staircase)-like appearance. To get around this problem you can anti-alias an edge. The program fills the jagged edge with in-between tonal values. If you want to farther soften a selection you can add feathering to it. With any kind of photographic montage work, it is important to work with anti-aliasing/feathering to ensure that the different elements blend together. If the edge of a particular image element is hard it is very easy to see that it has been inserted in post-production (Figure 14.31).

Noise reduction

A photograph taken with any digital camera contains noise no matter what. Noise is best compared to film grain. The higher the ISO the more noise/grain you are likely to get. Thankfully

(a) (b)

Figure 14.31 (a) A selection of the sky without any aliasing, separating the sky from the foreground. If you would go ahead and adjust the content of the selection now there would be no transition between sky and foreground so we need to add some feathering to our selection. (b) The same selection with an edge feathering radius of 20 pixels

(a) (b)

Figure 14.32 A crop of an image shot at ISO 1600. (a) The image prior to any noise reduction. (b) Here the image has had noise reduction applied and it has meant some minor loss of detail

camera and software manufacturers are well aware of this 'side-effect' and there is a whole range of plug-ins that can tackle noise and reduce it considerably (Figure 14.32). Noise-Ninja is one such plug-in, with which you can either auto-analyse your image and reduce the noise based on its own analysis or you can set up and create your own profile. With any kind of anti-noise feature it important to apply just the right amount. If you apply too much anti-noise it can soften the image and result in a loss of detail.

Sharpening/Unsharp Mask

Sharpening can be applied to both scanned photographs and digital camera files. It increases the contrast of edge areas ever so slightly, thus giving the optical impression that the image is crisp and in focus. Many cameras and scanners apply a certain amount of sharpening by default to an image. It is recommended that if you want to retain complete control over all aspects of your image in post-production, to leave such settings at a minimum if possible. Sharpening has the following settings:

Amount: Controls the strength of the sharpening.
Radius: Controls the width of the sharpening.
Threshold: Controls which pixels are to be affected by the sharpening.

Be aware that the settings used for print or Web output vary considerably and that you should always leave unsharp mask as the last process you apply to the image. If you are applying unsharp mask on an image for print, judge the final print not what you see on the screen. If you apply too much unsharp mask to an image it will leave aliased artefacts behind and edges will pixelate due to oversharpening (Figure 14.33).

Perspective, lens distortion and vignetting

The quality of the lens with some digital cameras is sometimes a bit dubious. This is especially visible when the lenses are used at their widest angle. Straight lines are often slightly curved, which often makes architectural images look odd. As a result more and more programs now offer functions that are aimed at removing lens distortions. In Photoshop (Filter Distort Lens distortion)

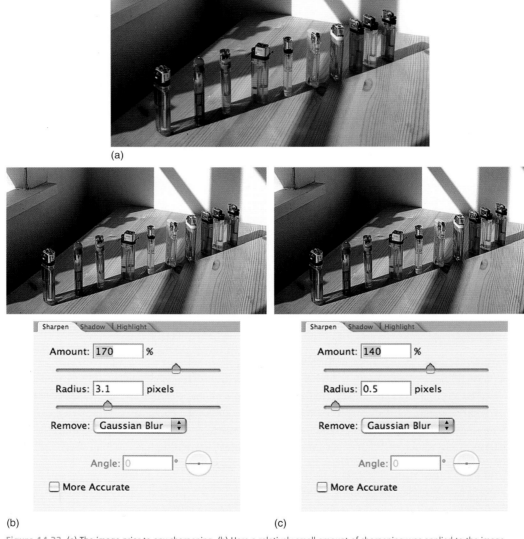

Figure 14.33 (a) The image prior to any sharpening. (b) Here a relatively small amount of sharpening was applied to the image. (c) This is what happens when you apply too much sharpening resulting in an image where every edge has been exaggerated

you can distort an image in any direction to remove lens distortion. The filter inserts a grid in front of your image to help you adjust the uneven lines in your picture. To successfully remove any trace of lens distortion takes a bit of practice and a lot of minor adjustments. Manipulation programs can offer a number of different ways of distorting image shapes. One side of your subject can be made to look smaller and the other side larger. This changes a flat-on shot of, say, a line of washing into a perspective view tapering away into the distance. The chief value of shape control though, is its ability to correct converging verticals. You don't have to use camera movements or a shift lens to get the top of a tall building in and keep its sides looking parallel (Figure 14.34).

Figure 14.34 Shows how Photoshop brings up lines framing your original picture. Dragging the corners or sides, you can then compress the bottom and expand the top. When applied, this distortion redraws the vertical lines of the building parallel. However, to maintain a final rectangular picture, the program has to crop off some of the left- and right-hand picture content towards the top. The height of the building also appears slightly elongated but is corrected by slightly expanding the overall width of your picture relative to its height

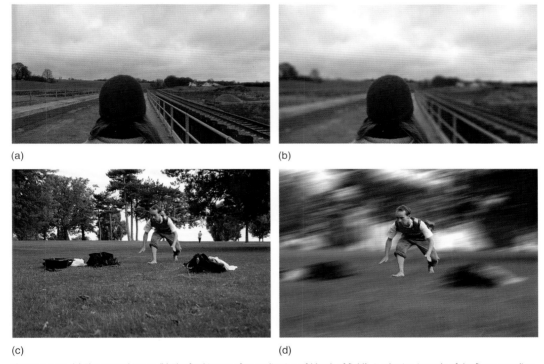

(a)

(b)

(c)

(d)

Figure 14.35 (a) The original image (b) The final image after application of 'depth of field'. A selection is made of the figure standing with its back to the camera with quite a bit of feathering around the person to ensure a smooth transition between the 'focused' plane and everything else that is about to blur. (c) An image that is sharp throughout. (d) A selection is made around the figure and a motion blur is added to give the impression that he's running very fast and that the camera was panning

Depth of field and blur

Starting off with a picture that is sharp throughout, it is possible to reduce depth of field by digital means (Figure 14.35). First you draw around the areas you pick for de-focusing. There are a number of different kinds of blur available, depending on what program you are working in. Photoshop have introduced Lens Blur, which mimics the blur that you can achieve with a shallow depth of field in-camera. Other kinds of blur available include Motion Blur to give the

impression of motion when there is none, and Gaussian Blur, which quickly blurs a selection by an adjustable amount.

Working in monochrome and duotone

Monochrome

It is perfectly possible to work in monochrome in a digital environment. If you are shooting exclusively with a digital camera it is recommended that you do not convert your image to monochrome by using the camera setting because you can never undo it, although some cameras do automatically save a colour version as well. Instead, opt to make any conversion in post-production, as it gives you much greater control over it. In most programs you can simply convert a colour image to greyscale by changing its mode to greyscale. With this type of conversion you lose all the colour information in the image. This type of straight colour to greyscale conversion often results in a rather flat image. In Photoshop one good method is to apply a channel mixer layer and enable greyscale mode, which doesn't convert it per se, but, rather, sits on top of the image, enabling you to control each colour channel separately. Please note this is but one of many, many different methods that can be used to convert an image into black and white. Programs such as Adobe's Lightroom have sophisticated greyscale conversion methods that allow you to control all aspects of the conversion, while retaining the original image's brightness and contrast (Figure 14.36).

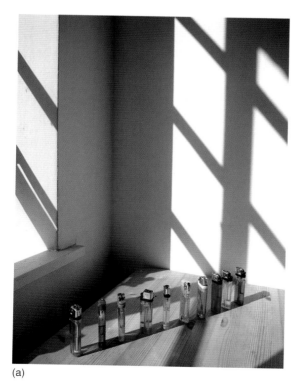

(a)

Figure 14.36 (a) The original image. (b) A straight black and white conversion. This type of conversion leaves the original image untouched, which allows you to adjust the way you want to represent each colour in black and white. (c) Here the way red is insinuated

Duotones

With a conventional photograph you can add a tint of colour to a black and white image by toning it. In most digital imaging programs you can mimic this effect by using the duotone function. It allows you to blend in another colour with your black and white image ever so subtly (depending on the colour you choose to add). In Photoshop you can add another colour to your image by first converting your image to black and white (if it isn't already) and then use the Image Mode Duotone. Here you can add another colour to the image apart from black. You can also do a tritone (three colours) and quadtone (four colours). The Photoshop Duotone Options dialogue box allows you to program up to four different inks, including black.

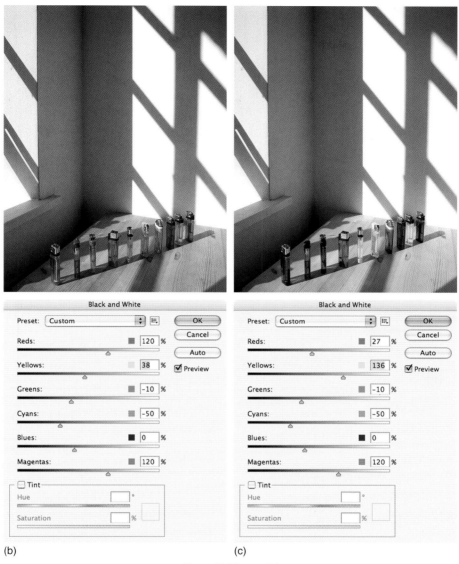

(b) (c)

Figure 14.36—cont'd

Each ink has a curve box to adjust the tones its colour will affect; however, it is best not to change the top box, the black, from the original 45° too much to ensure that your image has a basic structure and shadows have sufficient 'body'. Clicking on Ink 2 makes a palette of colours appear, from which to make your pick. Pull the ink's curve around until it differs in shape or position to the black ink and is generally less strong. Most results are best left here in duotone, but you can add shades of farther colours with increasingly unusual results. Muted colours work best, and it is important not to let any colour overweigh your picture's black content (Figure 14.37).

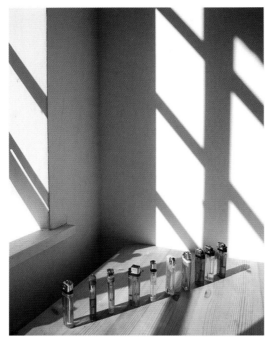

Figure 14.37 The original monochrome version has here been converted to the duotone. A second colour has been added and adjusted to give the necessary effect

Digital photograms

Digital equipment offers an interesting range of opportunities for making pictures without the use of a camera (Figure 14.38). A 35 mm film scanner will accept tiny flat objects sandwiched between glass in a transparency mount. Flower petals (see Figure 14.39), translucent woven fabric, or grass seeds can all be scanned directly to digital files this way; similarly slides or negatives can be sandwiched together in the same mount to form composite images. You can also use a flatbed scanner with the lid removed. This is much more versatile owing to its large A4 or A3 size and the freedom with which you can lay out items on top, the flatbed scanner operating like a camera. This method also allows you to scan in many other objects and textures that can be used as background or elements in other photographs, such as scanning in a Polaroid to use a frame for other photographs.

Inevitably you have to work within the limitations of flatbed technology. Lighting for example is flat and frontal, although this can be modified somewhat using mirrors at the side or allowing your subjects to cast shadows upwards onto a surface held a few inches above. Depth of field is quite shallow too and cannot be altered. It extends for little more than half an inch above the glass top surface, but on some high-end flatbed scanners you can adjust the focusing ever so slightly. Three-dimensional subjects fade away into soft focus and darkness because of the extremely narrow depth of field available (see Figure 14.40).

The blacks generated by flatbed scanner can also be very rich. Remember of course that your picture is scanned in from beneath the glass so everything must be laid out upside down. A test scan will show you on the monitor how things will look and what adjustments of positioning are necessary. Another factor is that a flatbed slowly scans what lies on it, taking many seconds to travel from one end of the glass to the other. This means that if you move anything during the scanning it will appear jaggedly in the final image, but it is certainly something worth exploring, as the effect generated is unique to this method as seen in the work of Pedro Vicente (see Figure 14.38).

Figure 14.38 SC23-280205: A digital photogram by Pedro Vicente. He used a flatbed scanner with the lid off to scan his own upper body. The distortion is caused by the body moving as it was scanned

Figure 14.39 Flower image created by petals sandwiched between glass in a transparency mount and scanned as if a piece of film through a film scanner

Montaging several shots

If you want to combine elements from several photographs (Figure 14.41) the most important thing to consider is the direction of the light and the brightness and contrast of the various image elements that you wish to combine. If they are too different from each other the combined elements will stand out and be recognized as inserted in post-production. You can adjust the lighting, brightness and contrast to make them blend together better, but if you start with good material the potential for them to come together in the end is far better; see Figures 14.42 and 14.43 for exhibition quality digital images. It is also important to consider the size of the different elements in relationship to each other and the angle from which they were photographed.

Figure 14.40 This digital photogram was created by the artist, Suzanne Pollen, placing her face over the flatbed scanner with a flower in her mouth that was touching the glass screen

Figure 14.41 Each photograph for this simple montage was taken at the same location and under the same lighting conditions, making the job of combining them simpler. (a) This photograph has the girl walking towards the camera and in another (b) she is walking away. To combine the two, (a) is the base, and on (a) a careful selection is made around her. It can be somewhat tricky to get the hang of working with selections when you are first starting out, but don't despair. If something goes wrong, use the Undo function, or if the part you are trying to select doesn't look as good as you were hoping for, start again. A good selection is usually achieved by using a combination of selection tools. You might start with the Magic Wand tool, and then use the Lasso tool to manually add something to the existing selection. Adding and subtracting bits to and from a selection is easily done. Hold down the SHIFT button on the keyboard while working with the selection tool to add or ALT/OPTION to subtract. If you are having difficulties selecting a particular object, it may be easier to select everything around it and then invert the selection. With the selection complete (c) a bit of feathering is added to ensure that we have a nice smooth edge around the girl. If we didn't add this, we would end up with a harsh transition between the original image and the imported new element. To merge the two together copy everything within the new selection and move it across to (a), the base image. Do this by copying (Edit Copy) and pasting (Edit Paste) the selection across to (a). When a new element is pasted onto an existing image it is inserted as a new layer, which can be manipulated independently from the image below it. (d) The final image

Printing your work

There is nothing quite like seeing your hard work as a final print; no screen can at the moment simulate the quality and level of detail that is possible with a high quality printer. New printers appear regularly from a variety of manufacturers in an assortment of sizes. It is crucial that you

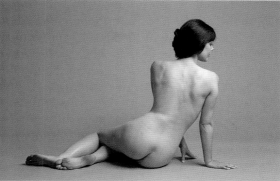
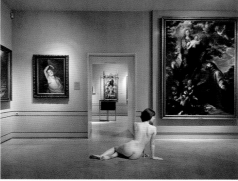

Figure 14.42 Karen Knorr uses digital montage to startling effect. Here the different elements that comprised the final picture have been separated out to show the construction of the image

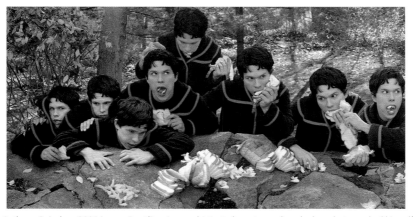

Figure 14.43 Anthony Goicoleas 2001 image *Feastlings* is a sophisticated montage where he has photographed himself acting all the roles in this one scene

choose the right printer to output your work. However, it doesn't stop there. You also need to consider what kind of paper you want to print on as it to a certain extent dictates what kind of printer you should buy. Your photograph will appear very different on matt, gloss, textured or more traditional photographic paper. Some paper types are also far better suited for black and white printing than others.

The first choice to make is the kind of printer you want.

Inkjet printers

An inkjet printer is the most affordable digital printing solution at the moment. It works by carefully spraying liquid ink onto coated inkjet paper through a series of tiny nozzles. If you try to use conventional photographic paper in an inkjet printer you will see that the paper cannot absorb the ink and it floats on its surface. You achieve the best results by using coated inkjet paper or normal matt paper. You can purchase an inkjet printer in sizes that range from A4 to A0 and anything in between. The bigger the printer, the more expensive it is, and each manufacturer has its own ink system.

With PPICT-enabled printers you can insert your memory card directly into a memory card slot and output your photographs without the need for a computer. Canon, HP and Epson all produce printers capable of outputting photographs that are comparable to a conventional photo print.

Inkjet printers are generally reasonably cheap to purchase but expensive to run as ink and paper can be costly. Ink for an Epson printer is incompatible with a Canon printer and vice versa. Before you purchase a printer it is wise to check the price of ink. All manufacturers have their own ink systems and configuration and the accompanying software is also very different. Printers also require some maintenance as the print nozzle will occasionally clog, requiring you to run a cleaning program and you may also have to realign the print head. Some top of the range printers come with up to eight different inks, including: magenta, cyan, yellow, light magenta, light cyan, light black, photo black, and some with a different type of black ink for matt or glossy paper. You can also purchase a specialized ink set made specifically for high-quality black and white printing. This can be rather expensive and it is recommended to use it with a dedicated printer.

Inkjet printers are still relatively slow, but what makes them stand apart from any other digital printing solution is the choice of paper available. You can purchase paper in thickness from 40 gsm to 450 gsm or more with a variety of surfaces from canvas to super glossy including double-sided paper, which lends itself to the printing of portfolios and limited edition books. It is very important that you pick the right type of paper. Just as in a conventional darkroom, it is of utmost importance to make the right choice between, glossy, semi-gloss, matt, etc. Your printed photograph will look very different on each of these surfaces. A good starting point is to perform a series of test prints on a variety of paper stock. You can purchase cheap test packets from paper manufacturers such as Epson, Letraset, Permajet, and Hahnemühle. Inkjet printers are the best choice for hobby/semi-professional use and are also by far the most versatile printer type. To ensure that what you see on screen resembles what comes out of the printer it is crucial that you configure both your software and printer to work together, otherwise the results may be vastly different between screen and output. Please refer to the colour management section of your software and printer for more details.

Laser printers

Colour laser printers are now reasonably affordable. They lend themselves to a slightly different type of photographic work than inkjet prints since the resulting prints have a different aesthetic. Ink for a laser printer can be quite expensive. Before you make any investment it is a good idea to make some calculations and see some sample prints. Any high-street digital photo outlet or printer shop will have samples that they can show you.

Dye sub printers

Dye sub printing has been around for quite a while and is relatively expensive: the cost per print is also higher than for both laser and inkjet. Dye sub printing operates by transferring liquid hot ink onto specialised photographic paper. It takes only half a minute or so to print from start to finish and the quality is comparable to a conventional photo print. A dye sub printer is a reasonably sized device, which means you could have it with you and print directly from a laptop on location. Paper choice is quite limited and double-sided printing is not available.

Lambda/lightjet printers

These two printer types are quite expensive and generally reserved for professional photographic printers. They use a machine connected to a computer that rests on top of a conventional RA4 developing machine. Your digital file is exposed with laser (R, G, B) onto light-sensitive C-type photographic paper. This particular kind of printing lends itself especially nicely to big prints or to a context wherein you are mixing conventional prints with digital prints, as a Lambda or Lightjet print appears indistinguishable from a traditional chemical print. The final print will therefore also have the same life expectancy as a traditional C-type print.

■ Working with a computer you can create movement blur, clone other bits of a picture to change its content, change image depth of field, or cover defects, plus mimic most conventional darkroom techniques.

■ You need patience and ample time at first to master the chains of command and understand new technical terms, but it all becomes easier as you grow more experienced.

■ In specifying your computer hardware make sure that its hard disk, processor and RAM memory all offer sufficient capacity and speed to handle the large digital files photographs create. Have drives for CD/DVD and removable hard disks built-in. You can always start with a minimum specification computer and upgrade its various components later.

■ Essential peripherals include a high resolution monitor of sufficient size, mouse, keyboard and printer. For a full kit include flatbed and film scanners, digital camera card reader, graphics palette and a broadband internet connection.

■ Photo-manipulation software ranges from entry-level programs up to highly comprehensive packages such as Adobe Photoshop. If you are a beginner work your way up gradually, or start with a high-end program but explore each part of it slowly. Make many notes, as these will come in handy later. Write your own little manuals.

■ Typical programs display your picture surrounded by a command bar, toolbar and scrolling controls. Clicking symbols on the bar in turn releases fly-outs such as dialogue boxes for you to make settings.

■ Image changes made by computer that copy what you are used to achieving in the darkroom are often the easiest to learn first. The 'Help' command brings up explanations and advice on screen, more accessible than an elaborate manual.

■ Key manipulation controls – Brightness/Contrast; Levels and Curves; Color Balance; Rotate/Crop; Clone; Undo.

■ Using tools you can change colours; dodge and burn; move elements in your picture to new positions; montage parts of different pictures together; and much more. It's also possible to reduce depth of field and introduce movement blur, either overall or just over selected areas, but don't overdo the special effects.

■ Before montaging several images together make sure they match in lighting, perspective and (preferably) colour balance.

■ Levels (histograms) and curves offer a sophisticated way of altering the distribution of image tone values and colours.

■ Using tools you can change colour photographs into monochrome, and even duotone or tritone. With a flatbed scanner you can make images without film or camera.

■ By applying distortion a 'flat-on' shot can be reshaped into an image with pseudoperspective. Converging verticals can also be corrected this way.

■ Be sure to save all your finished work onto the computer's hard disk, and if possible, duplicate files on a removable disk as backup. Saving as a TIFF or PSD file will retain maximum resolution, but is demanding on disk space. JPEG compresses information, saves disk space and is suitable for email, and can be uploaded to a website where work will only be viewed small size on a computer screen.

1 On your computer or external hard drive create a series of folders for your work. These will contain the files you are working on and those that you have completed. You could establish this structure either by year or by project, or along those lines; it's entirely up to you, but set up a working practice sooner rather than later.

2 Find an old family snapshot, preferably well creased and/or scratched. Scan the image in at around 600 ppi (twice the size of the original) if it's a print. For a negative you may have to scan it at even higher resolution. In your imaging software try to salvage the photo by retouching it as carefully as you can. You may have to start over again a couple of times until you get it right. When you retouch ensure that you see the image at 100 percent otherwise you might not see all the scratches and dust marks. When you are done print it out and compare it with the original image.

3 Experiment with adjusting the same image using Brightness & Contrast, Color Balance and Hue/Saturation.

4 Locate an image with an element in it that you want to remove and using the retouching functionality carefully erase it bit by bit. When you are done print the original and the manipulated image out and compare the two to see if you can spot your handiwork.

5 With a flatbed scanner try to scan a range of household items. A flatbed scanner has an incredibly narrow depth of field which can be used to your advantage. See what happens if you attempt to scan say a milk carton without flattening it.

6 Take a series of photographs in the same location with a model appearing in different areas of the same frame. Use one photograph as your base and select the outline of it and place the selection on your master image so it appears that he or she is appearing multiple times in the same photograph.

PROJECTS

This final chapter is about completing your work and presenting it to other people in the most effective way. Finishing off means mounting, spotting if necessary, and deciding how pictures might be brought to the attention of potential clients and/or audiences. You might be taking a portfolio around to editors, art directors and/or designers, or you may be trying to get work exhibited or published in a book, or you may want to publicise your talent on the internet. In all these forms of presentation, communication skills are important: you will need to be able to select images to show and be able to back them up with verbal or written information.

The permanence of prints

Image stability is a vital element in professional photography. Clients and commissioners have a right to expect the work they have purchased to last a reasonable time – either as many years as possible, or at least sufficient for its intended purpose. Over time a great deal has been learnt about the permanence of prints on silver halide papers. The products of some methods of printing, both analogue and digital, are not long lasting; in other words they will fade within a relatively short period of time. Less is known about the permanence of digital prints, inkjet or dye based type prints claim to be archival and it is clear that for any degree of permanence archival inks must be used at the printing stage.

Conventional silver halide prints

In chemical processing you can either aim to get prints of average stability for normal commercial use and storage conditions, or you can work to the highest possible life expectancy. The latter is essential when selling a print as a work of art to a museum/collector, or producing records that will be filed away in archives and so must survive unchanged for the longest possible period. A long-lasting print is one that is as free as possible of residual thiosulphate (fixer) and silver by-products, and has extra protection from chemical reactions with air pollutants. One form of protecting the silver image is to coat it or convert it to a more stable material by toning. Present thinking suggests the following as the best printing routine for permanence. Choose a fibre-based printing paper, preferably a silver-enriched premium weight type. Make sure you develop fully. Follow this by effective stop bath treatment but don't use the solution at greater than the recommended concentration. Fix in rapid fixer with hardener, using a two-bath system and remembering to agitate regularly. Historically there have been two choices: either rinse and treat in hypo-clearing agent, or tone the image using selenium toner* made up in working

Selenium toner is highly poisonous and is now not permitted for use inside educational institutions. If you decide to use it make sure you understand the dangers and take appropriate precautions as recommended by the manufacturers.

strength hypo-clearing agent. In both cases agitate continuously. Finally, wash prints for 60 minutes in an effective print-wash system, and then squeegee and air-dry them. (However, mixing selenium with hypo clear is now regarded as a bad idea. It is recommended in the Ansel Adams books – and therefore taken as read – but it's an error. The sequence should be rinse, hypo clear, then 60 min wash. Then selenium tone and re-wash if desired.)

Digital prints

Digital printing has developed enormously over the last decade and manufacturers now claim that, provided archival inks are used and certain conditions are maintained, a digital inkjet print can have a life expectancy of anything between 34 and 300 years, depending on: paper type; whether or not the print is constantly exposed to light; and whether it is protected by glass (UV filter in the glass allows longer life). The longest life can be expected if the print is kept in a file or album in a cool room. This is obviously all speculative (as digital prints have not been around for that long) and has only been estimated through simulated tests.

Dye inks (used in some older inkjet printers) will fade more quickly than the newer pigment type inks that are more permanent. Lightjet and Lambda prints are created differently using light as opposed to ink and these kinds of print have the same estimated life span as C-type colour prints (prints made chemically from colour negative film), as they use the same machinery for processing.

Just how long your finished print will last depends on many factors outside your control – adverse temperature or humidity, display under excessive UV-rich radiation, effects of atmospheric pollution, or contact with non-archival packing, mounting or framing materials.

Mounting methods and framing

Mounting is an important stage in presenting professional-looking work. In addition it can help to protect the photographic image from chemical deterioration and handling damage.

Dry mounting

Provided you have access to a heated, thermostatically controlled press, dry mounting is an excellent means of attaching a print to a board, or other flat surface, with a smart, professional-looking finish. It is also good in terms of permanence as it helps keep the print in the best condition. A print can be dry-mounted to several different types of material (many of which are most successfully handled by a professional dry mounter) such as aluminium, foam board or MDF (medium density fibreboard). If you are doing it yourself, Figure 15.1 shows how to do it: you first attach a thin sheet of heat-sensitive material to the back of your (untrimmed) print. Then you trim the print plus heat-sensitive material together, and position them accurately on a suitable acid-free board, preferably museum board (MB is free from chemicals that can damage prints).

You next protect the print surface with a sheet of silicon non-stick release paper. Board, print and silicon cover sheet must all be absolutely dry. The whole sandwich then goes face-up into the top-heated press, which melts the adhesive layer into both print and mount within a few seconds. Press temperature is especially critical with resin-coated prints, and above 99°C (210°F)

(a) (b) (c) (d)

Figure 15.1 Dry mounting. (a) Attach the centre of the mounting tissue to the back of the print, using a heated tacking iron. (b) Trim off borders plus excess tissue. (c) Tack corners to your mount. (d) Cover the print with silicon release paper and place it in the heated mounting press

blisters may occur. If your print was made by inkjet printer or any other digital output, check the paper maker's recommendations. Most dry mounting materials are designed for temperatures between 66°C and 95°C, according to type.

The most common dry mounting faults are: (1) tiny pits or protrusions in the print surface due to grit caught between print and press, or print and mount, respectively; (2) unmounted patches due to uneven heat or pressure; (3) adhesive sheet firmly mounted to the print but not to the mount, owing to insufficient heat; (4) adhesive stuck to the mount but the print detached (and blistered if RC) because of excessive heat. Work slowly and carefully, cleaning all surrounding surfaces and mounting materials to ensure a perfect finish. Dry mounting is irreversible so if selling to a gallery/museum it is best to check if they are happy with this. Dry mounting is not yet available in some countries; however, as the art market for photography expands it is likely to come into more use.

Bonding

Prints can also be mounted (for exhibition purposes) by bonding them to plastic (usually Perspex). The print will first be dry-mounted, usually to aluminium, and then bonded using special glue face down to the Perspex. The Perspex can be of various thicknesses and the thicker it is, the more three-dimensional the print looks. However, large-scale prints mounted in this way are very heavy and some smaller galleries will not be able to hang them securely, neither are they archival.

Adhesive tape

Double-sided adhesive tape is not a good way of mounting any kind of print; prints mounted this way will tend to buckle, particularly when there are changes in humidity levels (this can happen all the time especially if carrying work from one place to another). The most successful way of mounting with tape is to use single-sided linen tape to tack one side of the untrimmed print to mounting board. (One-sided attachment allows for differences in expansion.) Then the print is held down flat with a window matte cut from similar or thicker high-quality board (see Figure 15.2). The matte also protects the print surface from sticking against glass if the work is framed, and allows air circulation. If you want your print to maintain its life expectancy then the best method of attaching a print to a window matte is with photo-corners. These can be made out of folded archival paper, for best permanence, and are then taped to a piece of board so that the print will slip into all four corners (similarly to ordinary photo-corners used in older-style photo

Figure 15.2 Window matte mount construction, using thin linen tape to tack the untrimmed print in place and hinge the top board over it. The cut-out area looks best given bevelled edges, which can be done using a proper mount-cutting rule with attached blade

albums). A window matte can then be overlaid and joined with tape to the bottom board so that the whole thing opens like an easel; this type of mounting was traditionally used to protect the artwork or photograph from touching the glass and any humidity prevent from damaging it.

Liquid adhesives

Liquid adhesives are generally highly unsuitable for mounting any type of photographic print. Sometimes wallpaper paste can be used to mount lightweight prints directly onto walls; this is suitable for silver halide prints and Lightjet prints but not inkjet prints as the water in the paste can make the ink run (usually only on the cheapest kind of inkjet prints).

Mounting directly to the wall

Clear or semi-clear tape ('magic tape' used mainly by designers) can be used very simply over the corners of prints to tape them directly onto the wall – this should be done very neatly if it is to be effective. 'Blue-Tack' can be used on small prints and sticky fixers or 'Velcro' on larger prints. 'Velcro' is good because you can lift the prints on and off should they buckle at all. (Sticky fixers and the back of 'Velcro' are both notoriously difficult to remove from walls at the end of exhibitions.) Another smart way of attaching prints to walls is with simple pins: you can buy all sorts of pins with interesting heads in good-quality stationery or art shops. Mounting directly to the wall like this is a relatively recent phenomenon and has been made popular by a number of contemporary artists. It is smart, simple and ultimately inexpensive; however, you have to be careful in busy spaces as prints that are not protected by glass can be easily damaged.

Commercial mounting

Mounting can be done commercially, which is more expensive than doing it yourself but frequently far more successful. Commercial mounting organisations can mount your prints onto a wide range of materials from aluminium to foam board or even bond it to plastic. It is best to look at mounting in exhibitions and decide what would best suit your work. When exhibiting work it is vital to

consider the mounting as an integral part of the work; when mounting work for a folio there are fewer options and really the finish should be as simple as possible. Often for a folio it is unnecessary to mount work as the prints will simply slip inside the sleeves of the folio or book. However, if your folio is a box then it can be a good idea to dry-mount prints to board before putting them inside transparent sleeves, as this gives them more weight and has a professional appearance.

Framing

Framing photographs is a very personal choice; framers are everywhere and vary enormously pricewise. There are some excellent framers who frame and mount to a high standard for a very reasonable price and are particularly good with work that needs to be archivally protected. Otherwise you can find smaller or larger framers everywhere or even shops that sell frames that you can make up for yourself. Some department stores and art shops also sell reasonably priced simple frames. Framing photographs for exhibition is an important part of finishing the work. Generally, photographers tend to keep to a fairly simple, small frame that does not overpower the image; however, there are exceptions to this when the artist/photographer may want the frame to have a particular meaning in relation to what the work is trying to say. In the 1970s and 1980s black frames were very popular in the UK, Today framing is far more varied: the white frames in fig … were made by Tony Rae for an exhibition at Impressions Gallery in Bradford and you can see in this image that the photographs have been mounted with no matte on top of them. There are numerous ways of framing and mounting work; you can look at framing and note frames that you particularly like by looking closely at exhibitions.

Filing and archiving prints and negatives

It is vital to store your work well if you want it to stand the test of time. Negative sleeves should be archival and stored in archival boxes in a cool, dark place lacking in humidity. Archival prints should be handled with gloves only and should be stored in archival boxes with archival tissue in between each print to prevent scratching; prints are also best kept cool and dark. A photograph exhibited or displayed on a mantelpiece in direct sunlight will fade relatively quickly. Many exhibitions will show photographs in very low light and with a high level of humidity control, particularly old photographs which are far less stable than their modern counterparts. Digital images should be backed up on portable hard drives and CDs or DVDs (the hard drives being more secure); do not leave your digital files simply on your main computer or desktop. A lab can also store your digital images or scans so that when you want to print you have the image ready to go when you call.

Spotting

Silver halide materials. Often prints have a few white spots that you will (in most cases) want to 'spot in'. Use diluted dye or watercolour – either black or the appropriate tint – and apply it with an almost dry, fine-tipped brush. By patiently adding tiny specks (not a *wash*) of matching tone, pale defects can be merged with adjacent image grain (see Figure 15.3). As an alternative to a conventional brush, 'brush tip' pens which each contain their own shade of dye are sold in sets of ten. A set for monochrome spotting, for example, provides a grey scale ranging from a very pale grey pen to one giving deep black.

Figure 15.3 Spotting-in white specks and a hair mark by hand on the surface of a mounted bromide print. Use an almost dry 0 size watercolour brush with a good point. Right: The patient stippling-in of tone is half completed. A hair-line like this is best broken in two or more parts first, and then each section matched into surrounding tone. Work with a tone that is lighter than the surrounding area and build up depth through a series of dots. Do not be tempted to actually 'paint' in the white mark as this will show

Spotting is easiest with a grainy image on matt or semi-matt paper. Glazed glossy prints are almost impossible to spot without leaving some evidence of retouching on their mirror-like surface. However, gum arabic (e.g. from the glue flap of an envelope) mixed in with the watercolour helps it to dry with some form of matching glaze.

Dark spots are best tackled earlier – turned into white by spotting the negative, or by touching the print with a brush tip loaded with iodine bleach (p. 332). Then they are spotted like any other white defects. However, on matt prints you can also try direct print spotting with white pigment.

Digital prints should not need retouching as they will be retouched on screen as digital files. Image defects are very easily eliminated using your manipulation software before the picture goes to your printer. Files should be opened at *actual pixel size* for digital retouching so that all the faults can be seen properly although many photographers would consider this overdone – since the output print is always smaller than actual pixels, retouching at 100 percent (actual pixel size) will reveal dust and scratches that will not be seen in the print but will take considerably more time to retouch. Retouching can be done satisfactorily at print size plus a 10 percent increase and this will deal adequately with most flaws. The cloning tool and healing brush can be used almost in the same manner as a brush to fill in the white spots; this kind of retouching takes a long time and is tiring on the eyes (commercial labs are very efficient at it). See digital retouching in Chapter 14.

Getting your work noticed

The world of photography is very competitive, so at the earliest opportunity it is important to start to get yourself known. For example, enter as many photographic competitions as possible – even if you don't win they can provide you with good sources of project themes, and get you used to working to deadlines. Try to have some pictures published, together with a credit line. Look up *European Photography Guide* (also available in a US and Japanese version); these guides give you comprehensive information about getting work out into the world. Even

Figure 15.4 Some basic forms of presentation. (a) Book folio with very clear sleeves. (b) Framed behind glass. (c) Fold-open box for loose mounted prints – pictures are transferred to the other half of the box as viewed and can be dry-mounted to card before going into the sleeves to give them extra weight

something in a local newspaper or a trade magazine will mean you can put a photocopy or tear-sheet in the back of your portfolio, helping to prove that other people have confidence in you. Seek out cafes, bars, etc., willing for you to put up a display. And check out how to create a website to show your work (see p. 390).

Figure 15.5 A 24 × 20 inch weatherproof, zip-up portfolio. Having individual prints in plastic sleeves protects the work, and allows you to change prints or alter their order. However, these ring binder portfolios have poor-quality sleeves which are difficult to view prints through and the pages do not turn easily so a folio book is far better quality (though usually more expensive)

Portfolios. Taking around a battered parcel of prints of all sizes to show people makes you seem amateurish, or just arrogant. At least have work mounted on thin boards matching in size, which are shown in a box or a book-style portfolio (Figure 15.4). You can also buy ring binder portfolios (Figure 15.5) but the plastic sleeves in these folios are much thicker than in the book-style portfolios and so tend to make your prints appear flatter and less detailed than they really are. Book-style portfolios are undoubtedly more professional looking, though all plastic sleeves are reflective and need to be looked at away from bright light sources. A portfolio makes it simple to change your selection and the order of pictures to suit the occasion (20–25 pictures is about the right number). Many professional photographers will have more than one portfolio, each containing different images for different clients.

As much as possible, take your portfolio around to art directors, gallery curators and other potential clients. Their comments are always worth hearing, even though you may not always agree. Think ahead too in terms of how to give intelligent answers to the sorts of question you could be asked by a curator or gallery director – it is worth writing a statement in support of your work and your interests. For a documentary project it is essential that you provide some kind of introduction to the theme or subject of the work. You should be prepared to talk about why you made the work, what were you trying to convey, what prior experience led you to develop the project, which images stand out for you: be prepared to openly express your thought process – it will help to prove that the work has direction and cohesion. You should also be able to discuss the work of other photographers, seen in books or on the internet, or in exhibitions – photographers who might have influenced the direction you have taken in your work.

Exhibitions. If you are lucky enough to be offered some form of exhibition, both the standard and method of presentation become even more important – in fact the presentation really becomes a part of the work. (Once the pictures are on the wall you will not be there all the time to speak for them.) Take care over the lighting. The same tone range degradation effect caused by viewing prints through portfolio acetate applies to photographs framed behind glass. You may be able to control this by careful positioning of spotlighting (Figure 15.6). In locations with many surrounding reflective surfaces, or having only flat frontal lighting, it may even be best to remove glass from the frames. Museum glass is reflection-free: you may only be able to find it in large city framers and it is very expensive, though beautiful to look through.

There are many different ways of producing photographs to exhibit, from traditional framing with card mattes to flush mounting on board or aluminium, or even simple pinning directly to the wall. You should think carefully about the kind of presentation that will be most effective in relation to the work you are exhibiting as well as the character of the exhibition space itself and what is affordable.

Figure 15.6 For prints exhibited behind glass, position lighting from a high, oblique angle. Specular reflections will then be directed downwards on to the floor, not towards the viewer. However, have the light source as distant as possible, to minimize unevenness between top and bottom

Framed photographs do not always need mattes: a framer can put a small (or large depending on the depth of the frame) fillet between the frame and the print (depth of frame), so a print could sit away from the glass as well as the frame coming right up to the edge of the image (no white borders). Make sure that you have considered the *tone* and *width* of any surround to your photograph. A strongly coloured window matte is likely to overwhelm any photograph and a bright white matte or border can deaden the whites in your prints; off-white is the most neutral colour to use.

Borders and image size can have a huge impact on the impression an image makes: a life size image with no border can almost seem to engulf the viewer, whereas a small print with large border/matte becomes intricate and fascinatingly intimate.

With any exhibition space, the size and tone density of your pictures, and the form of presentation, should be related to the physical conditions in which they will be seen. The intensity and evenness of the lighting is one factor; the height and layout of the exhibition walls is another. Corners offer natural breaks in a picture sequence and alcoves provide intimate enclaves, whereas a long unbroken surface and tall ceiling can suit a run of large prints or a grid. Do not be afraid of leaving space between images or of painting walls particular colours: the most exciting exhibitions have had curators thinking about all of these aspects; they have not necessarily used the space exactly as it has been left by the last exhibitor (of course in some spaces alterations like changing wall colour might not be possible and certainly any changes you make to an exhibition space need to be put back when your show comes down). Think too of likely spectator viewing distance relative to the perspective of your photographs being hung from floor to ceiling (rather than in horizontal lines), in grids or even chaotically spread (see Figure 15.7 for examples). Take time to plan your show, draw plans of what is possible or, if you have time, make a small model of the space in which you can try out scaled-down versions of your images.

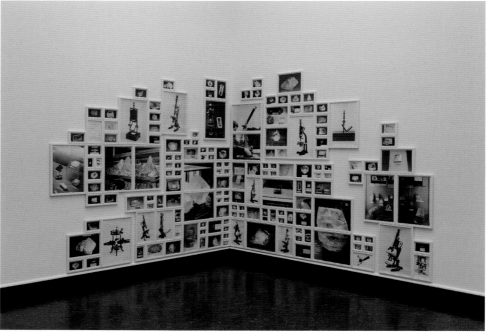

(a)

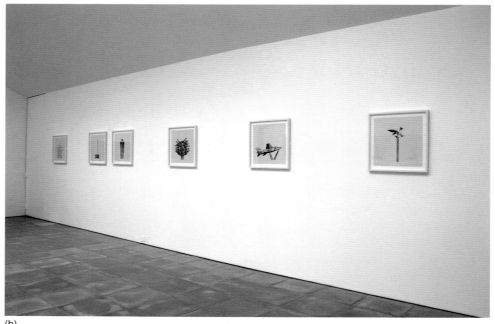

(b)

Figure 15.7 Four examples of exhibition design. When hanging pictures in a straight line, work to a common middle line using tensioned horizontal cord set by spirit level as a hanging guide. Try different ways of hanging work by making sketches or models, or simply lay the work out first on the floor as a guide. (a) Toril Johannessen, *In search of Iceland Spar,* exhibited as part of the Victor Hasseblad Fellowship at the Hasselblad Centre in Gothenburg 2009. (b) Benjamin Becker's work hanging in a formal arrangement at Artsway in Hampshire, UK. (c) Photographs can be hung well in a grid pattern. (d) Anna Fox's photographs from the series *Zwarte Piet* were propped on stands in the cloister of a church (the walls could not be nailed into as it was a listed building) at Le Printemps de Septembre in Toulouse – curated by Val Williams

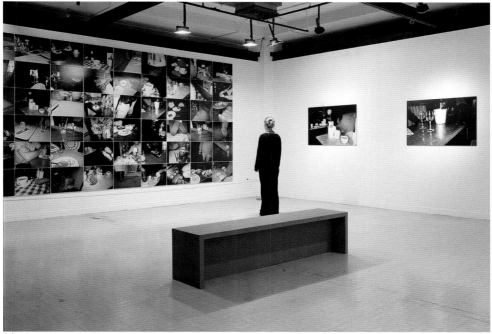

(c)

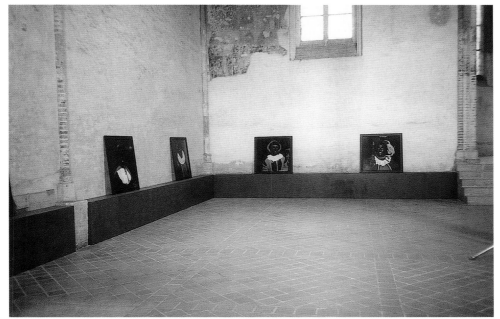

(d)

Figure 15.7, cont'd

An exhibition is an exciting way of exploring space and scale. Some artists build installations, which does not simply mean creating something to hang work inside – this is an art in itself and should not be taken on board without serious thought and prior knowledge of installation type practice (as well as having building skills!). Preparing work for an exhibition needs a lot of consideration; curation (the art of exhibition design and installation) is an art in its own right (which you can now study as a degree) and so sometimes it is better to hand over responsibility for the selection and hanging of an exhibition to a curator. You can submit work to open exhibitions, which tend to take place in many galleries on an annual basis. This is a good way to get your work noticed and to know what people think of it: work has to be chosen by a selection panel and so there is a sense of achievement gained when your work is accepted to exhibit. In the UK you can learn more about exhibiting work from the *Artists Newsletter* website www.a-n.co.uk.

Publications are well suited to promoting photographs.

Pictures on the World Wide Web

The World Wide Web is a hugely popular medium for displaying and sharing photographs. Displaying your photographs on a website enables you to show your work to a whole range of people who would otherwise never encounter your work, as it's accessible to everyone with an internet connection. Like the email system it runs over the internet, the worldwide network of computers that are linked together via high traffic internet cables, satellites and telephone lines providing a rich interactive information resource. The Web is made up of millions of websites spread across the world, stored on servers that are connected to the internet 24 hours (unlike your home computer which is only on when you're using it). A website is made up of web pages that contain images and text. When you type in an internet address in the browser – a piece of software which is provided free of charge with most computers – a request is sent to the server where the website is stored whereupon the content is downloaded to your computer.

To have an online presence of some sort is almost as, if not more, important as having a print portfolio these days. You can show you work on the Web in a variety of ways:

Building your own site

You can build and maintain your own website portfolio, in which you control all aspects of the site design, from your choice of domain name to how the navigation is set up – carefully controlling how your visitors experience your work.

Most portfolio sites are constructed in a very straightforward manner. They display a list of projects or themes together with contact and other details (see Figure 15.8). To display photographs some websites use a series of thumbnails of each image whereupon you can click on a thumbnail to see the whole picture. Others guide you from one image to the next using arrows or buttons, in a traditional slideshow manner. One must, however, realize that the amount of detail in an image is far less on a website than it is on print. Most screens operate at 72 ppi (pixels per inch) versus an average of 300 ppi for print. This is fortunately improving as

Figure 15.8 Christian Nolle's website employs a strong, simple design with a short description of each project and a thumbnail image. It is easy to use and gives a good idea of the range of the photographer's work

screen sizes are getting bigger and brighter. When you share your images on a website there are several things to take into consideration:

1 Images that rely on tiny details might not work at all. This is particularly true for large-scale landscape photographs.
2 Images have to be resized down to a size that fits most monitors but without compromising the overall image. It must be big enough to give a good impression of its content.
3 Almost all photographs on the Web are JPEG (Joint Photographic Expert Group) – a compressed file format. An image in a JPEG format can be compressed to varying degrees. The higher the quality, the more detail is retained in the image but the file size is larger and therefore takes longer to download. A compromise between file size and file quality has to be made.

Constructing your own website can be quite a big technical undertaking as it means you have to use a range of different technologies than you might not normally use as a photographer, but it is also a very gratifying thing to do as you will have built it all yourself.

To make it easier there is a range of software to help you build your own site such as Adobe Dreamweaver, which allows you to assemble web pages visually. The key to building and maintaining your own site is to keep things simple and to ask yourself; what is the site for? Is it a showcase with no particular target audience, a way of just sharing your work? Does it have a particular audience? Would this audience be family and friends so that they can view your photographs easily or potential clients? If a professional website is for potential clients to view, is there a particular market that you are interested in that your site needs to be targeting, for

example, weddings, editorial, portraits or fashion? With that in mind put it together accordingly. Avoid as much as you can superfluous effects and design elements for the sake of design, but don't avoid experimenting.

You can set out to construct your own website in either Adobe Flash (an embedded file format, which is widely used for online video) or as a straight HTML/CSS site (HTML is the structural semantic formatting language that all web pages are written in; CSS controls the layout). They both have their pros and cons: an HTML based site is easily indexed by search engines, easier to update and maintain and can be integrated with a Content Management System, which allows you to add pictures, take others away and adjust almost all aspects of the site without having to open specialised software as all of these functions can be accomplished through a web browser. Flash, on the hand, works quite differently. It allows you to program very sophisticated effects, embed music and video and it looks and behaves the same in every browser as long as they have the Flash plug-in installed, which most people have.

Alternatively, if you want your own website but do not have the skills to build it or the time, you can have it designed by someone else or there are also a couple of online systems that allow you to choose between a selection of templates. This allows you to simply drop your photographs in to an existing design (most of these services are not free).

Figure 15.9 The website of Flickr, a photo-sharing website. Photographers can join different areas of photographic interest

If you don't want your own website there are other ways to share your photographs online. You can sign up to a photo-sharing site; one such is *Flickr* (Figure 15.9), which enables anyone with an internet connection to share their photographs with a community of like-minded individuals. You can add captions to your pictures and tags, which enables other users to more easily locate them. These websites also enable you to leave comments about other people's photographs. Their services are mostly free and you can do it without any prior knowledge about web design. All you need is the ability to save your images as JPEGs and this can be learned quite simply using the help section of your software program.

As the Web becomes more and more popular, it is also becoming more complex to find what you want. It is therefore incredibly important to structure your content wisely and make room for future expansion. Organising your work as projects, series, or under specific categories is a very good idea, as you can always add to it at a later date. Contact and other details are essential if you want anyone to contact you either to purchase work or to offer you some. It is also important to label your images properly with a name and a description, as it enables people using search engines to find your work. They can either type in your name in a search engine or even just the name of an image to find what they are looking for.

How to get connected

Apart from a computer, which can be quite basic for Web access purposes, you will need:

1 A modem to link the computer to your phone line or cable connection (ADSL – Asynchronous Digital Subscriber Line, cable).
2 With a fast connection the waiting time is cut down considerably and highly recommended if you intend to use the Web for looking at images or sharing them.
3 An account with an ISP (Internet Service Provider). This is a very competitive industry. Some ISPs offer unlimited access to the internet, charging a monthly rent. Others offer pay-as-you-go contracts where you pay a very limited monthly fee but then you pay extra depending on how much you download. These are especially popular with ADSL providers. Their start-up package includes all software needed for connection, plus your user name and password.
4 A web browser, which is supplied with the computer's operating system. On the PC platform, browsers such as Firefox and internet Explorer are the most widely used. On the Macintosh platform you can use either Apple's own Safari or Firefox, both of which are free.

It is easy to design your own website. You can use a WYSIWYG (What You See Is What You Get) authoring tool, which hides the underlying code, enabling you to work on the design without having to deal with the underlying technicalities. These programs sometimes come bundled with photo-manipulation software.

Even if you're not interested in designing and maintaining your own website, the Web offers an incredibly rich resource of photographic imagery. Most search engines even offer specific image search features where one can search for images based on user input. Galleries, museums and image databases can all be accessed for free and here you can browse a huge variety of images.

■ Image permanence in prints is very important for all photography sold professionally – especially fine art prints. A long-lasting silver halide print should be on fibre-based paper, as free as possible of fixer and silver by-products, and given some protection from air pollutants through selenium toning (see previous note about hazards of selenium toner). The long-term permanence of digital inkjet prints has improved massively in recent years. Intensive research on inks suggests that life span for this new medium can be up to 300 years depending on the ink and paper types.

■ However carefully a print is made, image fading and other changes are just as often due to the way it is later displayed and stored. Excessive UV-rich lighting, damp, chemical pollution from packaging or atmospheric conditions all take their toll.

■ Mount your silver halide prints by dry mounting or by sandwiching behind a window matte. Look at different materials to use when dry mounting. Prints mounted on board can be trimmed flush without borders, or left with print or mount borders. Be wary of strong- or bright-coloured mounts.

■ Retouch white spots on silver halide prints using dye or watercolour on a fine brush, gradually blending in with surrounding tone. Alternatively apply spotting dye from a range of brush tip pens. Retouch digital prints using the clone tools and healing brush in your software package.

■ Get your work noticed. Enter competitions; get some pictures published; find good places where you can put work on show. Perhaps you can set up or share somebody's website?

■ Good work doesn't deserve to be presented in a scruffy portfolio or box. Take care picking your pictures (20–25) and deciding their order, bearing in mind the individual who will be looking at them.

■ Get out to see art directors, gallery curators and others, with your portfolio. Think how you will present it. Be ready to answer questions articulately on your approach and the intended meanings in your pictures. Have a view on the work of some leading photographers, past and present.

■ When planning an exhibition, fully exploit the physical environment wherein your show is taking place – use its features to create natural breaks, give points of emphasis. Think about what can be done with sequences and what narratives unfold when one image follows another on the wall.

■ Lighting the work effectively is very important. Prevent reflections, which dilute the richness of image tones and colours.

■ The World Wide Web provides an important showcase for photographers. You can display thumbnail versions of prints viewable 24 hours a day from almost every country in the world. People browsing the Web on their computers can visit your work, buy pictures, and decide to commission you for jobs.

■ Connection to the Web calls for a modem, browser software, and the services of an internet service provider. You can design your own website using tools within most modern image manipulation software programs.

■ Browsing the Web yourself gives you an enormous source of visual information on what other photographers are currently doing, especially in other countries.

SUMMARY

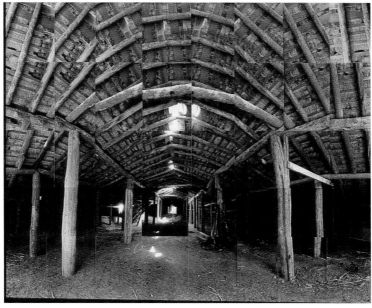

Figure 15.10 Joiners are not intended as accurate depictions of space. If you want to make the joins invisible then you can do this digitally. This image, created using multiple photographs, by Masumi Hayashi is of the *Minidoka Relocation Camp, Root Cellar* 1992 (one of the relocation camps used to house the Japanese in the USA during WWII). Hayashi used joiner image techniques for her series *American Relocation Camps* to explore her own personal relationship to the spaces where she had been interned as a child with her family

1 Examining a series of small, hand-size prints in a set order is an intimate one-person experience, very different to looking at a wall of big pictures in a public exhibition. You have to think about the narrative, text and typography that you might use and design layout. Make yourself a 6 × 4 inch book of 12–15 pages that you are going to put 20 photographs into. The theme could be a story (real or imaginary), or a particular memory, a diary of a simple event, or visual recollections of a place. Think carefully about your approach to shooting, print qualities and the order in which each picture is to be viewed. Also think about which images are going to have separate pages and why and where you are going to place the images on the page. Title each photograph or use more text if you like.

2 Mock up a website that displays up to 20 of your pictures, plus brief text material to explain how you can be contacted and your curriculum vitae. Scan in the work so that it fills your monitor screen.

3 Shoot a panorama, or a 'joiner'. For the panorama shoot from one position with a normal or long focal length lens, panning the camera between shots. The subject content of each frame should overlap that of the next by at least 30 percent – do not use a digital camera to do this. A joiner (Figure 15.10) can be more loosely structured, varying the viewpoint slightly to give more an impression than a record. Make a series of prints matched in tone and size, and mount to give one composite picture – you can also try to do this digitally by scanning the negatives and joining them in a suitable software program. Make a test print of the digital image as well.

PROJECTS

Appendices

Appendix A: **Optical calculations**

Pinholes

The best size pinhole for forming images has to be a compromise. It must be small enough to form quite tiny circles of confusion, so that as much subject detail as possible can be resolved. But the smaller the hole, the more diffraction increases, so that eventually detail no longer improves and rapidly becomes worse.

> **Optimum pinhole diameter = √distance from film/25**

So for a pinhole placed 50 mm from the film, best diameter is the square root of 50 divided by 25 = 0.3 mm. To make the pinhole, flatten a piece of thin metallic kitchen foil on a pad of paper. Pierce the foil gently with the tip of a dressmaker's pin. Check with a magnifying glass that the hole is a true circle and free of ragged edges. By placing the millimetre scale of a ruler next to the hole and examining both through the magnifier it is just possible to measure diametres down to about 0.2 mm.

In the example above the relative aperture is f/150. However, a modern SLR camera set to aperture priority (Av) mode should be sufficiently sensitive to measure exposure from the image itself. You may need to adjust your film's ISO setting to compensate for long exposure reciprocity failure (see p. 406).

Image size, object and image distances from lens

Codings:

F = focal length
M = magnification
I = image height
O = object height (neg height when enlarging)
V = lens to image distance*
U = lens to object distance* (to neg or slide when enlarging or projecting)

*See warning note on p. 397.

Magnification formulae:

$M = I/O$
$M = V/U$
$M = (V/F) - 1$
$I = O \times M$
$O = I/M$

Object/image distance formulae:

$$V = F (M + 1)$$
$$U = F ((1/M) + 1)$$
$$V = (F \times U)/(U - F)$$

Close-up exposure increase when not using TTL metering

This is important when you are using a camera which does not measure light directly through the camera lens. Extra exposure (by means of aperture or time) has to be given when you are working close up. The increase becomes significant when the subject is closer than about 4.5 times the focal length of your lens, or to put it another way, when the image size is greater than one-sixth of the size of the subject. Under these conditions and assuming that you would be measuring exposure with a separate hand meter, the exposure that the meter reads out has to be multiplied by:

[i] $(M + 1)^2$
[ii] V^2/F^2 or
[iii] $U/(U - F)^2$

For example, you might be using a 120 rollfilm camera with an 80 mm lens to photograph a small 100 mm high product 50 mm high on film. The hand-held meter reads 1/2 s at f/16. Following formula (i) above, magnification is 0.5, so exposure needs multiplying by 2.25 times. The closest setting available is therefore likely to be 1 s at f/16.

Warning note on telephoto and inverted telephoto lens designs. The above formulae are sufficiently accurate for most large-format camera lenses, enlarging lenses, and normal focal length lenses for rollfilm and 35 mm cameras. However, expect some discrepancy if using any formula containing V or U for lenses of either telephoto or inverted-telephoto construction. This is because it is difficult to know from where to make simple measurements with a ruler alongside such a lens. In these circumstances you can still calculate close-up exposure increase accurately using the formula based on M rather than V or U.

Appendix B: Camera movements

The term 'camera movements' refers to the group of features offered on some cameras by which the lens and/or film plane shifts sideways or pivots. The advantage of a camera with movements is that it can get you out of all kinds of difficulties, particularly in architectural or still life studio photography. Using movements you can increase depth of field, adjust the apparent shape of subjects, even photograph square-on views of reflective surfaces without your reflection showing.

The most comprehensive range of movements is to be found on large format cameras, but some are offered by medium format professional cameras too. Special lenses allowing movements are made for 35 mm SLRs. See Figure B.1 and Figure 4.16 on p. 75.

In a normal camera the plane of the lens is parallel to the film, the lens centre is aligned with the dead centre of the picture format, and a line between the two (the lens axis) is parallel to the camera base. In a camera offering movements this arrangement is said to be 'neutral'. From here there are shift movements (known as rising, drop and cross front or back) and pivoting movements (swing front or back); see Figure B.2.

Shift movements

Rising front means upward shift of the lens, remaining parallel to the film surface.

Drop front means shifting the lens downwards, again parallel to the film, placing the lens axis below the centre of the picture format.

Cross front involves shifting left or right, parallel to the film, placing the lens axis to one side of the picture centre.

These three shift movements are achieved on a view camera by undoing locks on the front (lens) standard and sliding it a few centimetres up, down or sideways. On a monorail view camera front and back standards are identically engineered, so you can double the effect by moving them in opposite directions – for example shifting the back of the camera downwards when you use rising front. Standard length bellows may not be flexible enough to allow much shift movement, especially when using shorter focal length lenses. With a view camera you can work more easily by changing to bag bellows instead (Figure 5.9). One or two rollfilm cameras (wide-angle shift cameras) offer shift movements by not having bellows at all. Instead (Figure B.1), two sliding plates are used and the lens has its own focusing mount.

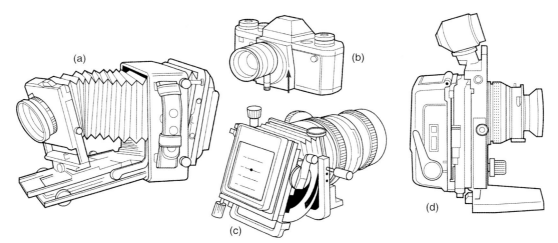

Figure B.1 The range of ways in which large-, medium- and some small format cameras allow you to shift or tilt the lens or back to provide 'camera movements'. (a) Baseboard view camera. (b) 35 mm shift lens, racked upwards to give rising front. (Lens mount rotates, allowing you to also turn this into a cross front movement.) (c) Bellows unit replacing Hasselblad body. Accepts regular lens and rollfilm magazine but uses a direct focusing screen. (d) A 'shift camera' with rollfilm back set to give rising front. The linked direct viewfinder pivots to adjust framing

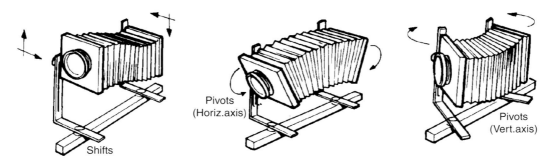

Figure B.2 A monorail camera offers the greatest variety and range of shift and pivot movements, which can be used simultaneously

On small- or medium format SLR cameras the body as such may not offer movements. Instead you fit a 'shift' or 'perspective control' (PC) lens. This has a special mount allowing the whole lens to slide a few millimetres or so off-centre in one direction. The mount itself rotates, to allow you to make this off-setting give either upward, downward or sideways shifts.

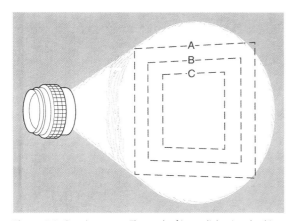

Figure B.3 Covering power. The patch of image light given by this lens is insufficient to cover film format A. Format B is sufficiently covered provided it remains centrally aligned with the lens. Only film format C is suitable if you intend to use this lens off-centre (essential for most camera movements). See also Figure 5.3

Note on lens coverage

Shift movements (or lens pivoting) tend to move the lens axis away from the centre of the *picture format*. You should only do this if your lens has sufficient covering power (Figure B.3) to continue to illuminate the entire picture area. Otherwise the corners and edges of the format farthest from the lens axis will show blur and darkening. Most good lenses for view cameras are designed with these movements in mind and have generous covering power.

The usual range of lenses for medium- and small format cameras cover little more than the picture area for which they are designed. Shift lenses are exceptional. Optically they must cover a much larger image patch. Mechanically too the back of the lens must be far enough forward to allow off-setting and pivoting without fouling the sides of the mount. Most shift lenses are wide-angle, typically 75 mm for 6 × 4.5 cm or 35 mm or 28 mm for 35 mm format.

Using rising front

Effect. As you raise the lens the image shifts vertically too. The lowest parts of the subject no longer appear but you gain an equivalent extra strip at the top of the picture. Raising the lens say 1 cm, raises the image 1 cm. But in most situations the image is much smaller than the subject, so this small shift alters the subject matter contained in your picture by several metres – far greater than if you raised the whole camera by 1 cm.

Practical purpose. Rising front allows you to include more of the tops of subjects (losing an equivalent strip at the bottom) *without tilting the camera upwards*. The objection to tilting the whole camera is that vertical lines seem to converge. Tall buildings shot from street level or cylindrical containers photographed from low level in the studio begin to look tapered as the film is no longer parallel with the subject. You can argue that this is exactly how they appear when you look up at a tall subject. However, the stereoscopic effect of seeing with two eyes plus the physical act of looking up helps you to accept converging uprights as a perspective effect – the top of the subject is experienced as more distant than the base. On a two-dimensional photograph though, results can be interpreted as something with non-parallel sides, particularly when they are just slightly out of true. (The same problem occurs when you must record a painting fixed too high to allow a centred camera viewpoint, or have to shoot an interior showing more ceiling detail than floor, without walls appearing to converge; Figure B.4.)

To use rising front for, say, the tall building assignment, choose the best viewpoint for perspective and subject inclusion, and position the camera *with its back absolutely vertical* (see Figure B.5). This is vital if vertical lines in the structure are to reproduce parallel. The top of the building will now be out of the picture and too much is included at the bottom. Focus the image; then raise the camera front or shift lens until the image of the top of the building moves on to the focusing screen. If in doing this you lose too much at the bottom of the scene, either move back (and accept slightly flatter perspective) or change to a wider-angle lens.

Overdone, any shift movement can produce two ill effects. These are 'cut-off' (image darkening) and shape elongation. Both are likely to show in that part of the picture you have just moved onto the screen. Watch out for darkening towards the two corners here, and remember that cut-off has a much more obvious edge when the lens is stopped down. This kind of trouble occurs most often with the extensive shift movement offered by a view camera.

Secondly, beware of subject shapes within the area shifted into your picture looking stretched and elongated. This is because they are well off the lens axis, so that light strikes the film more obliquely here. Disguise distortion by keeping such areas plain or free of recognizable elements, especially in the corners (see Figure B.5).

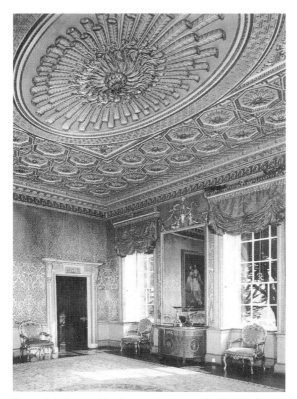

Figure B.4 Extreme rising front used with a good wide-angle lens may not give 'cut-off', but stretches recognizable shapes and details near the top part of the picture (farthest from the lens centre). Results in this area are like an extreme wide-angle (see Figure 5.8). However, in cramped locations this may be unavoidable

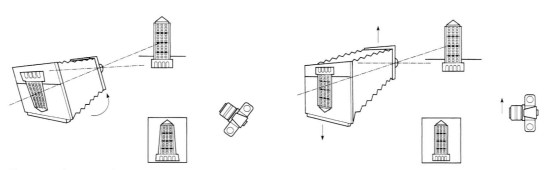

Figure B.5 Shooting a subject well above camera height, when you cannot move back or change to a wider angle lens. Left: Tilting the camera results in converging vertical lines. But (right) camera movements allow you to keep the camera back vertical and raise the lens to include the top of the subject without convergence. See also Figure 14.34

Using drop front

Effect. Shifting the lens downwards, making the lens axis lower than the centre of your picture, includes more at the bottom of your subject and less at the top.

Practical purpose. You can use a camera viewpoint looking slightly down, yet avoid vertical parallel lines in the subject appearing to converge downwards. In architectural photography, for example, your only camera position may be high up, perhaps to avoid traffic obstructions. In the studio you may want to show something of the top surfaces of upright objects such as boxes and packs. In all cases keep your camera back parallel to the vertical surface you do not want to taper, and then shift the lens downwards to get the lower subject parts into your picture. There are the same risks of cut-off and image elongation as described with rising front, but this time they will appear in the *lowest* parts of the scene.

Using cross front

Effect. Shifting the lens left- or right-of-centre means that more is included on one side of the picture, and less on the other.

Practical purpose. Cross front allows you to shoot an apparently 'square on' image of a subject from a slightly oblique viewpoint. For example, you may need a flat-on record photograph of a shop window, or an interior shot directly facing a mirror. Instead of setting up the camera opposite the centre of the glass where its reflection will be seen, you can position it farther to the left, keeping its back parallel to the subject. Then you cross the front to your right so that the whole image of the window or mirror shifts sideways until it is centre frame.

Similarly, when a pillar or other obstruction prevents a square-on view of some wall feature you can set up the camera right next to the obstruction (Figure B.6), its back parallel to the subject. Then cross the front to move the feature into frame. (This often gives less distortion than the alternative – fitting the camera in between obstruction and subject and changing to a wider-angle lens.) If cross front is overdone, your image may show signs of cut-off and elongation along the side and corners of the frame farthest from the shifted lens axis.

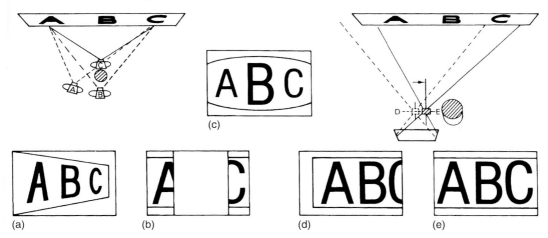

(c)

(a)　(b)　(d)　(e)

Figure B.6 Using cross front for a square-on image, despite obstruction. Without movements viewpoint (a) gives convergence, (b) is blocked and (c), because you are forced to use an extreme wide-angle lens, gives distortion. In (d) the camera is next to the obstruction, back parallel to poster and movements neutral. (e) is the same camera position as (d) but with the cross front shifted to the right. (For easier comparison all lens images are shown right way up)

Pivoting movements

Swing front means pivoting the lens so that it tilts upwards or downwards about a horizontal axis, or sideways about a vertical axis, both at right angles to the lens axis itself (Figure B.2). Front swings on view cameras are achieved by releasing a lock on the side of, or below, the lens standard, pivoting it several degrees and then relocking. Some medium format SLR cameras, such as Hasselblad, allow you to replace the reflex body with a very flexible bellows system. This provides a full range of swings, but you must then compose and focus on a rear screen, like a view camera. One or two shift lenses for 35 mm SLRs also contain a pivoting mechanism. Using this in conjunction with its rotating mount, you can make the lens swing about a vertical or horizontal axis, or anywhere in between.

Practical purposes. Pivoting the lens: (i) alters effective coverage because it moves the point where the lens axis meets the film format, and (ii) tilts the plane over which the subject is sharply imaged. The latter effect is explained as follows. A subject at right angles to the lens axis is normally sharply focused as an image on film also at right angles to the axis. This is typical, say, of copying a flat surface – subject plane, lens surfaces and film are all parallel. But when you swing the lens it views the subject obliquely (Figure B.7). One part of the subject, now effectively

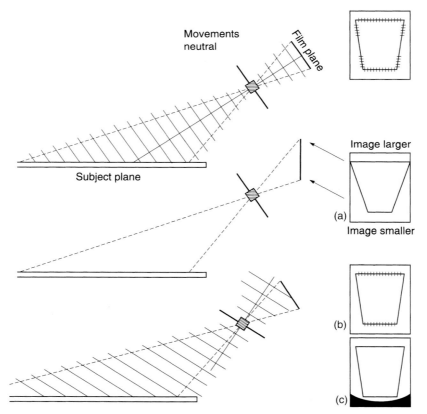

Figure B.7 Top: Even with the lens fully stopped down this obliquely angled subject is not sharp overall. (a) shows the result of using swing back alone. Since near parts of the subject come to focus farther from the lens, pivoting the film into the (more upright) plane of sharp focus increases depth of field but exaggerates shape. (b) is the result of using swing front alone. This slight horizontal pivoting of the lens gives a better compromise between subject and film planes. Depth of field improves without shape distortion. However, a lens with poor covering power will give 'cut-off' (result (c))

closer, is brought to focus slightly farther from the lens. In fact the whole plane on which the subject is sharply focused is pivoted to become much *less parallel* to the subject.

You can swing front to achieve effect (i) above, in which case (ii) usually forms the drawback. Or you can use it for (ii) but find yourself limited by (a). Here are examples of each kind of situation.

Photographing a tall structure, you use rising front to avoid tilting the camera and making vertical lines appear to converge. However, there is darkening and other tell-tale signs of image 'cut-off' in corners around the top of the subject. By unlocking the horizontal axis swing movement, you can pivot the lens to point upwards very slightly. This makes the lens axis less off-centre on the film; effective coverage is improved and cut-off miraculously disappears.

However, your lens, in viewing the subject obliquely, sharply images it on a plane at an angle to the back of the camera. It is probably impossible now to render the top and bottom of your subject sharp at the same time; the best thing to do is focus for the centre and stop down.

As another example, you have to photograph an expanse of mosaic floor extending into the distance. The camera views the floor obliquely, and even at smallest aperture there is insufficient depth of field. By pivoting the lens slightly downwards about a horizontal axis it views the floor less obliquely, giving a better compromise between planes of floor and film. This adjustment of swing front is critical, but you will find depth of field greatly improves across the floor surface.

This time the drawback is that your lens axis is now much higher than the centre of the film. A lens with only adequate covering power may produce signs of cut-off around corners of the picture where the farthest parts of the floor are imaged.

Although these examples feature swings about a horizontal axis, the same principles apply to vertical-axis swings. Their use in equivalent circumstances would be to improve coverage with extreme cross front, or increase depth of field over an obliquely photographed *vertical* surface, such as a long wall.

Using swing back

Swing back means pivoting the back of the camera about a horizontal or vertical axis across the film surface, usually at right angles to the lens axis (Figure B.2). On a monorail view camera you achieve this movement by mechanically adjusting the back standard in the same way as you would alter the front standard for swing front. Baseboard view cameras offer much less swing back because of their box-like structure. Notice how swing back does not itself move the lens axis off the centre of the picture format. Therefore the lens you use need not have exceptional covering power, unlike lenses used with shift or swing front movements.

Practical purpose. Pivoting the camera back: (i) swings the film into (or out of) the plane of sharp focus for a subject, and (ii) alters image shape. Once again you can use this movement primarily for (i) and suffer (ii), or the reverse. For example, you have to photograph, from one end, a long table laid out with cutlery and mats. The table must taper away into the distance, its oblique top surface sharp from front to back. Unfortunately there is insufficient depth of field for you to do this, even at smallest aperture. When you think about the problem (see Figure B.7), light from the closest part of the table actually comes to focus some way behind the lens, while the farthest part comes to focus nearer the lens. So by swinging the back of the camera until that part of the film recording near subjects becomes farther from the lens and the part recording far subjects becomes closer, you have angled the film into the plane of sharp focus. Depth of field is greatly extended – and may even be sufficient to shoot at a wider aperture.

The drawback is that the part of your image now recorded farther back from the lens is considerably larger than the image recorded near the lens. Front parts of the table will reproduce larger than they appear to the eye, and distant parts appear narrower. Perspective appears steeper, although *only along the plane of the table,* which may give it a noticeably elongated shape. (Sometimes of course you can choose just this kind of distortion for dynamic effect.)

As another example, the new wing of a building must be shown obliquely, to taper away at one side to a feature at the far end. But it is surrounded by other buildings, and the only available viewpoint is opposite the centre of the wing. From this square-on position it appears rectangular. However, you can set up the camera to include the whole wing, then swing the back about a vertical axis to bring the right-hand side of the film closer to the lens, and the left-hand side farther away. In this way, the image at the left end is made bigger and at the right end becomes smaller – the building appears tapered.

The drawback is that the camera back no longer corresponds with the plane of sharp focus for the building (which, because it is square on, is at right angles to the lens axis). Both ends will look unsharp; you must stop down fully and if necessary reduce the amount of swing to get the whole image in focus.

Combined use of movements

Combinations of movements are useful either to gain extra collective effect or to create a movement the camera itself does not directly offer. Most importantly, you can often produce the result you want and minimize problems by combining a *little* of each of two movements which have a common effect but different drawbacks.

For instance, in tackling the mosaic floor (example; p. 403) you could create your extra depth of field by using a little of each of front *and* back swings. The back is swung (horizontal axis) just enough to start to improve depth of field, without noticeable shape distortion. Then the front is swung (horizontal axis) just enough to extend depth of field to the whole floor at your chosen aperture, without noticeable cut-off due to poor coverage. You will notice that in doing this the subject plane (the floor), the film plane (camera back) and the lens plane (glass surfaces) all point towards one imaginary point below the camera. The less front swing you set, the more back swing is needed, and vice versa. This meeting of planes, giving best compromise position of front and back to maximize depth of field over an oblique subject plane, is known as the Scheimpflug principle, as shown in Figure B.8. Remember it as a guide.

The great thing about camera movements is to understand and control them, but use them with restraint. Decide whether it

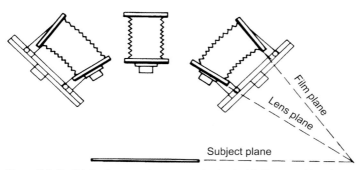

Figure B.8 The Scheimpflug correction, to maximize depth of field over a subject plane imaged obliquely. Note how the subject, lens and film planes all meet at one point. This uses some swing of both front and back, minimizing the side effects of each movement (see Figure B.9). Note that when all three planes are parallel as in the centre position the lines meet theoretically at infinity

Film plane

Lens plane

Subject plane

Figure B.9 Camera movements used to improve depth of field. Left: No movements, fully stopped-down lens. Centre: Swinging the back more vertical gives the depth of field needed, but distorts shape unacceptably. Right: Combined use of some front and back swings (Scheimpflug) achieves the overall sharpness needed, with minimum side-effects

is necessary to show the verticals in a building or studio still life as truly vertical, or whether a slight tapering will give a stronger impression of height, more striking composition, etc. Bear in mind too that several of the image shape changes previously achieved by camera movements can now be carried out later using the computer (p. 371).

Appendix C: **Expressing film response**

Film response to light is often presented in manufacturers' technical data in graph and in table form. Both allow you to make comparisons between different products, show a film's performance under differing conditions, etc. It is therefore worth making yourself familiar with how certain technical information is expressed, and what this means in practice.

Response to colour

A graph such as that in Figure C.1 (top) shows how a particular black and white film responds to the colours of the visual spectrum, on the final print. This film records deep blues and purples, and to a lesser extent reds, as lighter in tone than they appear to the eye. On the other hand it responds to greens as if darker than the eye's impression. Where such differences are important a green or yellow filter over the lens will bring them more into line.

The same pan film colour response curve can be compared against film (or paper) which is only blue sensitive or orthochromatic (Figure C.1, centre). The graph shows how shooting on a blue-sensitive emulsion would result in a print in which green, yellow and red objects reproduce black or very dark and unnatural in tone. Ortho film responds better by encompassing green, but makes reds black (see Figure 9.14). This film can be handled safely under red lighting.

The three emulsions present together in the colour film (Figure C.1, bottom) collectively respond to the whole spectrum. Where individual response 'dips' in the greeny-blue and orange bands, this receives some correction by the fact that *two* emulsions overlap their sensitivity here. This slide film is a daylight-balanced type – had it been exposed/tested to an image lit by

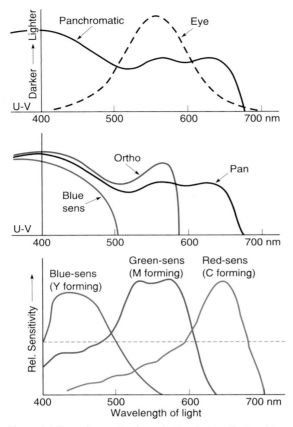

Figure C.1 Top and centre: Tonal reproduction of colours (final print) by panchromatic, ortho, and blue-sensitive black and white materials, relative to eye response. All emulsions respond to ultraviolet down to about 250 nm – still shorter wavelengths are absorbed by the gelatin. Bottom: Relative response curves for the blue, green and red colour-sensitive emulsions used in typical daylight-balanced slide film. Only response *above* the broken line is significant. Y, M and C stand for yellow, magenta or cyan dye finally formed in each emulsion to give a full coloured image

red-rich tungsten illumination instead, the blue-sensitive and green-sensitive curve would be lower than the red curve. After processing, the final picture would have a shortage of cyan dye. The dominant yellow and magenta combine to give the slide a reddish cast.

Response to length of exposure ('reciprocity failure')

Exposure is a function of brightness multiplied by time. Giving a film or printing paper a long exposure time to a dim image should have the same effect as short exposure to a bright image. After all, this *reciprocal* relationship forms the whole basis of controlling exposure using aperture and shutter settings. However, this relationship breaks down when using very long exposures of 1 second or more or extremely short times such as 1/10,000th second or less. In these extreme exposure times the film behaves as if it is less sensitive and requires more exposure than metered or calculated. This *reciprocity failure* is mainly an issue in long exposures such as when shooting at night or in other dim lighting conditions. Since RF can also affect the various emulsion layers in colour films by different amounts, a correction filter is sometimes needed for slide films. As Figure C.2 shows, it is best to allow for reciprocity failure by widening the lens aperture (intensity) if possible rather than farther extending time. Films launched in recent years suffer no reciprocity failure for the most commonly used shutter speeds and manufacturers publish data for ISO adjustments when using times outside the normal range. Follow these when available and if you are bracketing exposures around what the TTL or hand meter reads as 1 second or over then always give a series of *longer rather than shorter* exposures or adjust the aperture to give a faster corresponding shutter speed.

Characteristic curves

A characteristic curve is a performance graph showing how a particular film or paper responds to both exposure and processing. To produce the characteristic curve of a black and white film (Figure C.3) the material is first given a series of tightly controlled 'light dosages'. This is done in

Indicated exposure time (s) ▶	$\frac{1}{10,000}$	$\frac{1}{1,000}$	$\frac{1}{100}$	$\frac{1}{10}$	1	10	100
B & W negative	$+\frac{1}{2}$ stop	none	none	none	+1 stop	+2 stops[†]	$+3\frac{1}{2}$ stops[†]
Colour negative	none	none	none	none	$+\frac{1}{2}$ stop	+1 stop	+2 stops
Colour slide* (daylight)	$+\frac{1}{2}$ stop	none	none	none	+1 stop 15B	$+1\frac{1}{2}$ stop 20B	Not fully correctable
Colour slide* (tungsten)	none	none	none	none	$+1\frac{1}{2}$ stop 10R	+1 stop 15R	Not fully correctable

*Colour correction filters vary with brand.
[†]Reduce development time by 20–30%.

Figure C.2 Reciprocity failure. Typical exposure/filter compensation required

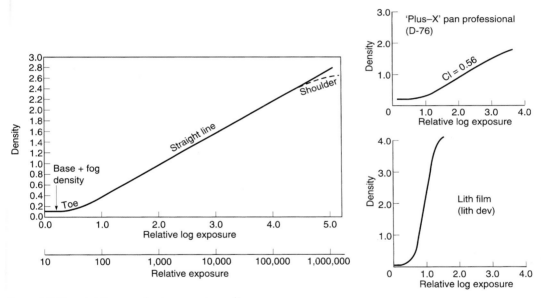

Figure C.3 Characteristic curves of various monochrome films

an instrument called a sensitometer, which exposes the emulsion to a series of light intensities a small patch at a time, giving the same short exposure for each. This is rather like exposing an image in the camera, except that: (i) it gives a much wider range of intensities than you are likely to find in any one actual scene. Also (ii) the amount each separate patch or step differs in exposure from the preceding one is an exact regular factor, normally 2.

The exposed sample film is next developed under strictly controlled conditions. The processed result is a series of tone patches, from clear film to something quite dark. The exact darkness of these results is measured with a densitometer instrument, which reads out the values as density figures. (Density is the \log_{10} of opacity, which is incident light divided by light transmitted by the film. When half the incident light passes through the sample, opacity is 2.0 and the density reading is 0.3.)

Figure C.4 Colour film characteristic curves. Left: A colour negative film exposed to an image in light for which it is colour balanced. (Emulsion responses to R, G and B are plotted individually.) Centre: If this film is used with light of reduced red content (colour temperature too high) the red sensitive layer reacts as if relatively slow. Its curve has shifted right, which shows that the red density and contrast now differ between the image highlights and shadows. This may not be correctable in printing. Right: A colour slide film, exposed to light of the correct colour balance. Compared against lower contrast materials, such films allow much less exposure latitude

The exposure to light can now be plotted against the resulting series of density readings. To prepare a characteristic curve graph, the vertical axis is scaled in density values and the horizontal axis is scaled in log exposure (or relative log exposure) values. The use of a \log_{10} scale here is to avoid an otherwise unmanageably long range of figures; the axis also becomes compatible with the \log_{10} sequence used for density. An increase of 0.3 on the log E axis means doubling of exposure.

The resulting graph for almost all photographic materials is not a straight line, but escalator-shaped.

Significance of curve shape. Most characteristic curves can be divided into three distinct regions: the toe; the straight-line portion; and the shoulder. Remember that both density and exposure axes cover a very wide range of conditions for maximum information. In practice most actual images you expose on film have a brightness range of around 100:1, which spans just 2.0 on the log E axis. This means that, like selecting a group of notes from a long piano keyboard, you have options. Slight under- or over-exposure of most normal subjects can be tolerated as the tone range still fits onto the main part of the curve. If this 'exposure latitude' is exceeded, however, parts of the image may stray into the toe or shoulder regions, where the line flattens out, resulting in lower contrast and a loss of detail.

In this way the characteristic curve shows the total performance of a film under given processing. And the part that relates to a particular shot depends on your image brightness range (a low contrast scene spans a much shorter length of the log E axis than one that is very contrasty), as well as whether you under-, over- or correctly expose it.

The toe. The very bottom of the characteristic curve becomes a horizontal straight line. Here the film has received too little light to respond at all. The very slight density value present is due to the film base itself, plus normal fog density. As log E values increase, the graph begins to rise gently, meaning that density values are increasing too. However, the image tones are very compressed – shadow parts of the subject are still difficult to pick out (any density less than about 0.1 above fog usually prints indistinguishably from black). Look at Figure 10.4 on p. 23.

Gradually, with more exposure, the upper region of the toe merges into the straight line. The actual length of the toe varies with different films – for example it is longer with Tri-X than with Plus-X.

The straight line. In the straight-line part of the graph image tones are still compressed as the material translates them into negative densities, but now the log exposure/density relationship is more constant: tones are compressed evenly. You might assume from this that getting your image to fall entirely on the straight-line portion would be the most 'correct' exposure. But to maximize film speed, and to avoid image highlights becoming so dense that sharpness suffers and graininess is increased, 'correct exposure' is regarded as using the upper part of the toe plus only as much as is necessary of the lower part of the straight line (see Figure 10.5). Printing paper characteristics are designed to suit negatives exposed in this way, and reproduce mid-tones to shadows with contrast slightly greater than mid-tones to highlights.

The steepness of the film's straight-line portion also shows you what contrast to expect. The extremely steep line shown for lith film (Figure C.3) indicates that the particular combination of emulsion and development gives a much more contrasty negative (for the same brightness-range image) than material with a lower pitched slope, such as Plus-X.

The shoulder. At the top of the characteristic curve the graph begins to flatten out again. Increasing exposure now gives less and less increase in density. The material is approaching its maximum black under these development conditions.

With most usable exposures the shoulder is never reached because of the poor image quality produced, as mentioned above. The shoulder of the curve is often not included in data published for general-purpose films as manufacturers assume exposures in this area as outside the useful range of the material.

Theory into practice. Exposure metres are so calibrated that a single overall (or centre-weighted) reading, which is assumed equivalent to a mid-grey in the scene, is 'placed' on the average film's characteristic curve at about the lowest part of the straight-line portion. Given an 'average' 100:1 range camera image this means that shadows will fall on the toe, but not beyond the lowest useful part. Highlights fall farther up the straight-line portion, but nowhere near the definition-destroying upper part or shoulder. You can see from this that a lot of assumptions have to be made.

For tighter control it is better to use a spot or local reading, provided you know what you are doing. This way you can choose your own midtone in the scene to place on the curve.

By taking two spot readings – darkest important shadow, brightest important highlight – you measure your image contrast range. If this greatly exceeds the 'average' it will also remind you that for better results you can slightly over-expose and under-develop. The development change will reduce the slope of the whole characteristic curve and so avoid an excessively contrasty negative. The reverse is true if your two camera readings show the image is much flatter than average (see Figure 11.19). Of course, this kind of adjustment is more difficult if you have a whole mixture of subjects exposed on one film. A magazine-type camera back is then especially useful for critical work; you can expose all your most contrasty subjects on the same film, earmarking this for reduced development. Sheet films can of course be given individual processing to suit each negative.

Appendix D: Chemical formulae

Most proprietary forms of developer (Xtol, T-Max, etc.) do not have published formulae. They are only sold as ready-mixed concentrated solutions or occasionally as powders. However, the table below gives some well-established developers you can prepare yourself at relatively low cost from their constituent chemicals. († = handle with special care.)

Developers (all weights of solids in grams)

Chemical	Gen-purpose fine-grain		Soft-working D23	Contrasty D19	Line D11	Prints D72	Vari-contrast (Beers)		Function*
	D76/ID11	DK50					A	B	
Metol ('Elon') cryst	2	2.5	7.5	2	1	3	8		Dev agent, soft-working
Sod sulphite anhyd	100	30	100	90	75	45	23	23	Preservative
Hydroquinone cryst	5	2.5		8	9	12		8	Dev agent, contrasty
†Pot/sod hydroxide		1.5							Extreme alkali
Sod carbonate anhyd				45	25.5	67.5			Alkali or accelerator
Pot carbonate anhyd							20	27	Alkali or accelerator
Borax cryst	2	7							Alkali or accelerator
Pot bromide cryst		0.5		5	5	2	1.1	2.2	Restrainer
Make up to	1 litre	1 litre	1 litre	1 litre	1 litre	1 litre	1 litre	1 litre	
Working sol, if different from above (stock + water)	1 + 1	1 + 1				1 + 2	See chart, page 411		
†Typical dev time (min) at 20°C (68°F)	7–12	4–7	5–9	5–14	4	$\frac{3}{4}$–2	2–2$\frac{1}{2}$		

*For terms see Glossary. †Times apply to formulae here but may differ from pre-packed versions.

Substitutions

Chemical	When formula quotes weight for	And the only available form is	Multiply weight by
Sodium carbonate	Anhydrous or desiccated	Monohydrate or H_2O	1.2
Sodium carbonate	Anhydrous or desiccated	Crystalline or decahydrate ($10H_2O$)	2.7
Sodium sulphite	Anhydrous or desiccated	Crystalline/heptahydrate ($7H_2O$)	2
Sodium thiosulphate	Crystalline/pentahydrate	Anhydrous/desiccated	0.6
Sodium thiosulphate	Anhydrous/desiccated ($5H_2O$)	Crystalline/pentahydrate	1.7
Borax	Crystalline/decahydrate ($10H_2O$)	$5H_2O$	0.8

Beers print developer: proportions and contrast

	Lowest						Highest
Sol A	8	7	6	5	4	3	2
Sol B	0	1	2	3	4	5	14
+Water	8	8	8	8	8	8	0

Stop baths

	SB-5 (for films)	SB-1 (for paper)
Water	500 ml	750 ml
†Acetic acid (80%)	11 ml	17 ml
or †Acetic acid (glacial)	9 ml	13.5 ml
Sod sulphite anhyd	45 g	
Water up to	1 litre	1 litre
Treat for	30 seconds	5–10 seconds

Some bromocresol purple can be added to SB-1 to form an indicator stop bath. The solution then appears yellow when fresh, turns orange in use, and becomes purple when the stop bath is exhausted and must be replaced.

Fixers

	F-24 Non-hardening*	F-5 Hardening acid fix	F-7 Rapid hardening acid fix‡
Water (at about 50°C)	600 ml	600 ml	600 ml
Sod thiosulphate (hypo) cryst	240 g	240 g	360 g
Ammonium chloride			50 g
Sod sulphite anhyd	10 g	15 g	15 g
Sod metabisulphite	25 g		
†Acetic acid (80% sol)		17 ml	17 ml
Boric acid cryst		7.5 g	7.5 g
Pot alum			15 g
Water up to	1 litre	1 litre	1 litre

*As required when selenium toning, etc.
‡Prolonged fixing time may bleach image.

Residual fixer test HT-2

Water	350 ml
†Acetic acid (80% sol)	22 ml
†Silver nitrate cryst	3.75 g
Water to	500 ml

Store solution away from light, in a labelled brown screw-top bottle. To test a washed print or film, cut off a small strip of rebate and wipe off surface water. Place a drop of HT-2 on the emulsion surface and allow it to stand for 2–3 minutes. Rinse off. There should be little or no staining. Prints can be compared against a Kodak hypo estimator colour chart.

Negative intensifier: chromium IN-4

Bleacher stock solution:	
Water	500 ml
†Potassium dichromate	90 g
†Hydrochloric acid (conc)	64 ml
Water to	1 litre
Use 1 + 10 parts water	

Film, which should be hardened, is bleached until yellow-buff right through, washed 5 minutes, then darkened in a regular print developer. Rinse, fix and finally wash 5 minutes. Can be repeated for greater effect.

Sulphide toner T-7a (sepia)

Bleacher working solution (reusable):	
Water	700 ml
Potassium ferricyanide	30 g
Potassium bromide	10 g
Sodium carbonate	16 g
Water to	1 litre
Toner stock solution:	
Water	300 ml
Sodium sulphide anhyd	50 g
Water to	500 ml
Dilute stock 1 + 9 parts water for use	

Fully bleach the black image to pale straw colour (about 5 minutes). Then rinse 1 minute, and tone for 4–5 minutes. Finally wash thoroughly, separately from other prints.

Blue toner IT-6

Sol A	Water	700 ml
	†Sulphuric acid (conc)	4 ml
	Potassium ferricyanide cryst	2 g
	Water up to	1 litre
Sol B	Water	700 ml
	†Sulphuric acid (conc)	4 ml
	Ferric ammonium citrate	2 g
	Water up to	1 litre

Use one part A plus one part B. This toner has an intensifying action, so start with a *pale* black and white print. Immerse prints until the required tone is reached, and then wash gently until the whites no longer have a yellow stain. Over-washing begins to bleach the blue – this is reduced by adding salt to the wash water.

Gold toner GP-I (blue-black or red). For red tones, sepia-tone the print first.

Water	700 ml
Gold chloride, 1% stock solution*	10 ml
Sodium thiocyanate	10 g
Water up to	1 litre

Make up just before use. Treat for 10 minutes, then wash 10 minutes.
*1 g of sodium chloro-aurate in 100 ml water.

Bleachers

Farmer's reducer R-4a		
Sol A	Water	250 ml
	Potassium ferricyanide	37.5 g
	Water up to	500 ml
Sol B	Warm water	1 litre
	Sodium thiosulphate cryst	480 g
	Water up to	2 litres

Mix one part A, plus 8 parts B, and 50 parts water, just before use. For faster reduction of density, double the quantity of solution A.

Iodine IR-4
Recommended for locally bleaching out the print image completely, leaving white paper.

Warm water	750 ml
Potassium iodide	16 g
†Iodine	4 g
Water up to	1 litre

Keeps well. For bleach-out, apply neat with brush or cotton wool to the damp (blotted) print. Finally rinse and treat in a small quantity of regular print fixing bath (5–10 minutes) to completely remove deep brown stain. Discard this fixer. Wash fully.

Conversions: metric, UK and US units

Use the information below in conjunction with a pocket calculator.

To convert length and area

Millimetres to inches	Multiply by 0.039
Metres to feet	Multiply by 3.28
Inches to millimetres	Multiply by 25.4
Feet to metres	Multiply by 0.305
Sq centimetres to sq inches	Multiply by 0.155
Sq inches to sq centimetres	Multiply by 6.45

To convert volume and weight

Millilitres to UK fl oz	Multiply by 0.035
Millilitres to US fl oz	Multiply by 0.034
UK fl oz to millilitres	Multiply by 28.4
US fl oz to millilitres	Multiply by 29.6
US fl oz to UK fl oz	Multiply by 1.04

Litres to UK fl oz	Multiply by 35
Litres to UK gallons	Multiply by 0.22
Litres to US gallons	Multiply by 0.264
UK gallons to litres	Multiply by 4.55
US gallons to litres	Multiply by 3.79
US gallons to UK gallons	Multiply by 0.833
Grams to ounces	Multiply by 0.035
Ounces to grams	Multiply by 28.35
Kilograms to pounds	Multiply by 2.20
Pounds to kilograms	Multiply by 0.454

To convert temperature

°Celsius into °Fahrenheit	Multiply by 1.8 then add 32
°Fahrenheit into °Celsius	Subtract 32 then multiply by 0.56

Other chemicals in this appendix have a long history but are still listed because they remain of practical value, although some are difficult to track down in a ready-prepared form. The component chemicals you need are stocked by a few specialist suppliers (such as Silverprint or Creative Monochrome in the UK). Chemicals marked † should be handled with special care. Be sure to read over the appropriate advice in Appendix E before you begin.

Preparing solutions from bulk chemicals. First weigh out all the dry chemicals listed in your formula, using clean paper on the scales for each one. The quantities shown in formulae below are in metric units (for conversion, see above) and relate to dry chemical in anhydrous or crystalline form.

Start with about three quarters of the final volume of water, and fairly hot (typically 50°C). Tap water is satisfactory unless distilled water is specified. Always dissolve chemicals one at a time and in the order given. Tip powder gradually into the water, stirring continuously. Wait until as much as possible has been dissolved into solution before starting to add the next chemical. Measure and pour in liquid chemicals in the same way, taking special care over strong acids; see notes on safety. Finally, add cold water to make up the full amount and if possible leave the solution some hours to farther dissolve and cool to room temperature. If your formula contains metol and sodium sulphite it is best to dissolve a pinch of weighed-out sulphite first – to help prevent the metol oxidizing (turning yellowish brown) during mixing. Then dissolve the remaining sodium sulphite after the metol, as listed in the formula.

Alternative forms of chemical. Many photographic chemicals come in anhydrous form (also known as 'desiccated'). Weight for weight this is much more concentrated than the same chemical in crystalline form. A few chemicals are marketed in 'monohydrate' (H_2O) form, which in terms of concentration falls between the other two. When a formula quotes the weight for one form of the chemical and you can only obtain it in another, make adjustments by the amounts shown in the Substitutions table.

Appendix E: **Health and safety concerns**

Preparation and use of chemicals. Most common chemicals used in photography are no more dangerous to handle than the compounds – cleaners, insect repellents, adhesives – used every day around the home. However, several of the more special-purpose photographic solutions such as bleachers, toners and intensifiers do contain acids or irritant chemicals which must be handled with care. (These are listed in Figure 11.4 and also picked out in the formulae given in Appendix D.)

Your response to direct contact with chemicals may vary from finger staining to direct irritation such as inflammation and itching of hand or eyes, or a skin burning or general allergic reaction which may not appear until several days later. A small minority of photographers are particularly sensitive to chemicals present in developers. Metol, also known as Rhodol or Elon, can be troublesome to such people. Changing to a developer of different make-up such as those containing Phenidone instead of Metol (i.e. PQ developers) may solve the problem.

The following guidelines apply to all photographic chemical processes:

- *Avoid direct skin contact with all chemicals,* especially liquid concentrates or dry powders. Do this by wearing thin rubber or plastic gloves, and using print tongs when lifting or manipulating prints during processes in trays (p. 306).
- *Avoid breathing-in chemical dust or fumes.* When weighing or dissolving dry powders work in a well-ventilated (but not draughty) area. Don't lean over what you are doing, and if possible wear a simple respiratory mask (the disposable types sold in DIY stores are ideal).
- *Be careful about your eyes.* When mixing up chemicals wear eyeshields, preferably the kind you can wear over existing spectacles. (Remember not to rub an eye with a chemically contaminated gloved hand during processing.) If you do splash or rub an irritant into your eye wash it with plenty of warm water immediately – it is always good practice to have a bottle of eye-wash somewhere close to where you are working.
- *Keep things clean.* Liquid chemical splashes left to dry out turn into powder which you can breathe in or get on your hands or clothes, as well as damaging films and equipment. Similarly, don't leave rejected test prints, saturated in chemical, to dry out in an open waste bin close to where you are working. To prevent chemicals getting on to your clothes wear a PVC or disposable polythene-type apron.
- *Labels are important.* Carefully read the warnings and procedure the chemical manufacturer has printed on the label or packaging, especially if you have not previously used this product. Clearly label the storage containers for chemicals and stock solutions you have made up yourself. Never, ever, leave photographic chemicals in a bottle or container still carrying a food or drink label. Conversely don't put food in empty chemical containers.
- *Keep chemicals and food and drink well separated.* Even when properly labelled keep all your chemicals well out of the reach of children – and never store them in or near the larder. Avoid eating in the darkroom or processing in the kitchen or wherever food is prepared.
- *Chemical procedure.* Where a formula contains an acid which you must dilute from a concentrated stock solution, always slowly add the acid to the water (adding water to acid may cause splattering). Don't tip one tray of chemical solution into another of a different kind, as when clearing up – cross-reaction can produce toxic fumes.
- *Dispose of used chemicals safely.* Most photographic chemicals can safely be poured down the sink as they can be dealt with by ordinary water treatment works if flushed away with plenty of water. However, read manufacturers' warnings and store especially dangerous chemicals safely until they can be disposed of by specialists if need be. If in doubt consult your local authority.
- *Spray adhesives.* These are particularly hazardous if inhaled. Take special care to ensure ample ventilation when working with aerosol sprays of this kind. Their contents could cause nerve damage if you subject yourself to prolonged exposure in a confined space when mounting prints this way.

Electrical hazards

Many of the safety precautions you need to take are also common to domestic and simple workshop situations. For example:

- *Circuit protection.* Make sure that all your equipment – enlarger, lamps, heaters – are effectively earthed ('grounded') via three-core cable. Plugs should contain fuses which are appropriate to the equipment they serve. This is more than a question of not drawing more power than the fuse will handle (p. 148). A 13 amp fuse for instance is quite suitable for equipment drawing 10 amps, but used with something taking only 4 amps means that you are underprotected – before this fuse blows the cabling could heat up considerably. A circuit-breaker at the mains fuse box is a good protective measure for the whole system. When lighting subjects at locations you have not used before check that the circuit is sufficiently powerful and in good condition to supply your gear. (To light a large area it may be best to hire a generator.)
- *Cables.* Check all your equipment cables regularly for signs of cracked or worn installation, or loose connections. Don't roll lighting stands over cables on the floor. Never pull out a plug by means of tugging on its cable. Don't power a lighting unit through a long cable still coiled on a drum – the current can heat the coiled-up cable until it melts or starts smouldering. Make sure your main cable is of a suitable gauge to carry all the power you need and will not heat up due to overloading, especially when it feeds several pieces of equipment through adaptors or splitter boxes. Avoid cable runs which come into contact with moisture (condensation as well as water) unless fully protected in a waterproof sheath. Damp grass, wet bench areas of darkrooms, bathrooms and saunas are all hazardous.
- *Flash.* Studio equipment and even small battery powered flash units should not be opened to make your own repairs – residual charge held in internal power-storage components may give you a severe or even fatal electric shock.

Appendix F: **Digital notebook**

When you are first learning to use digital editing software it is extremely useful to compile your own notes. These can be simple reminders of the sequence of steps you have discovered you have to take to achieve a particular image change. After all, if you are forgetful and make one wrong selection this often breaks the whole chain and brings you to a frustrating halt. On the other hand image editing may often be achieved by more than one command route, and as you progress you will discover which seems the fastest or easiest to remember, but most importantly, which one gives you the best end-result.

The listings below are practical notes on command sequences for ten different image changes, in a choice of two photo-manipulation programs. Bear in mind too that programs are reissued in revised editions at frequent intervals, so some of these sequences may now differ in current software. They appear here to simply show how you might set out your own quick check notebook.

Image adjustment	Adobe Photoshop (includes all versions of Photoshop)	Paint Shop Pro
Zoom image magnification on screen	Click on the magnifying glass icon. To zoom into the image simply click on it with the zoom tool selected. If you want to zoom out hold down the ALT/OPTION key. Alternatively, keep keyboard CTRL (control) key pressed and use + or – keys. If you want to zoom in on a particular part of your picture, click and drag a square around it.	Select the Zoom tool in the toolbar. Click on the image to zoom in. If you can also manually enter the amount of zoom you want. To zoom out, click on the Zoom Out icon and click on the image. If you want to zoom in to a particular object in your picture, click and drag a square around the object.

Image adjustment	Adobe Photoshop (includes all versions of Photoshop)	Paint Shop Pro
Overall brightness, and contrast	Image > Adjustments > Brightness/Contrast and move the slider as you see fit. For better and more accurate control use Levels and Curves. To add contrast/brightness use Curves and add two points in the middle. Adjust them so they make a very soft S curve.	The interface is different from that Photoshop but the method is the same.
Shading or burning-in small areas	Select the Dodge and Burn tool. Adjust the size of your brush by right clicking on the PC or control clicking on the Mac: set the size of your brush and the hardness. Keep the exposure below 10% for greater control.	Select the Lighten/Darken brush. At the top you are given a whole range of menu options that allow you to adjust the 'lighten' or 'darken' action carefully.
Cloning	Select the Clone Stamp tool. Adjust the size and the hardness of your brush (its feathering). Zoom in for a close-up of the area you want to repair. Look around for a good source area and sample it by holding down the ALT/OPTION to sample the area. Next click on the damaged area.	Select the Clone Brush. Right click on your mouse to sample your source area and click on top of the damaged bit.
Straightening a horizon	Open your image via File > Open. Use the Measure tool (shortcut I) to trace the horizon (or the line in the image you wish to be straight). Go Edit > Rotate Canvas > Arbitrary and click OK. The picture will now be slightly turned and your horizon will be straight. To cut away bits of the image that you don't want use the Crop tool.	Open your image via File > Open. Use the Straighten tool to drag a line along the line you want to level. When you have done so, click the green Apply button on the top menu bar. Use the Crop tool to crop away unwanted elements.
Overall colour balance correction	Edit > Adjustments > Color Balance. You can adjust the colour balance for each colour channel separately or all of them together.	Adjust > Color > Red/Green/Blue.
Sharpening	Filter > Sharpen > Unsharp Mask. Apply this just before you print or export your file as JPEG. Keep the amount between 50 and 100, radius below 1 and threshold at 1.	Adjust > Sharpen > Unsharp Mask.
Soften or motion blur over chosen areas	Select Edit Photo. Then with Freehand selection tool mark out the area to become blurred. Soften the marked out image by selecting Touch Up & Transform > Touch Up > Soften. Set the intensity slider below the picture. Apply.	Click on Lasso tool and draw around the area to be blurred. Either command Filter > Blur > Radial, and on fly-out set the centre of rotation and click OK. (Or on the Filter > Blur > Motion). Then on fly-out set the direction and amount of straight streaky blur. Click OK.
Changing from colour to monochrome	Image > Greyscale Layer > New Adjustment Layer > Channel Mixer. Tick the monochrome, change the blending mode to colour. This is but two methods out of many possible combinations.	Image > Greyscale Image > Adjustment Layer > Channel mixer (tick the monochrome button) Image > Adjustment Layer > Hue/Saturation/ Lightness and desaturate the image.
Saving for Web or email	Open your image File > Open. Go File > Image Size and change the resolution under Document size to 72 dpi. Click OK. Apply some unsharp mask (see above). Go File > Save-for-Web. Pick a JPEG quality between 60 and 80.	Open your image File > Open. Go Image > Resize (control + x). Tick the box at the bottom labelled Resample using smart size. Change the resolution to 72 dpi and click OK. Go File > Export > JPG Optimizer. Set the compression value to between 60 and 80.

In some programs 'Help' information refers to the key marked Ctrl on many keyboards as 'Command'; also Alt is referred to as the 'Option' key.

Appendix G: Photography timeline

	Image Technologies & Processes	Photography & Art	Culture & Current Affairs
Circa 400BC	Chinese and Greek philosophers describe the basic principles of optics and the *camera obscura*	Ancient Greek Art and Architecture (c. 1000BC–1AD)	Beginning of Greek philosophy. Socrates teaches ethics and a method of philosophical enquiry based on discourse. Plato develops Socrates' work and Plato's pupil, Aristotle, establishes an empirical approach to science
c. 1–500AD		Roman Art	Roman Empire
c. 700	Wood block printing in China	Byzantine Art (c. 300AD – c. 1400)	Moors conquer Spain (711)
c. 1000	Paper first manufactured in Europe Principle of the *camera obscura* described in detail	Romanesque Art (800AD–1100AD) Bayeux Tapestry	Norman conquest of Britain (1066) Crusades begin in Europe (1096)
c. 1250		Gothic Art	
c. 1325–50	Beginnings of linear perspective system for representing figures and space in pictures	Giotto and others pioneer perspective pictures	The Renaissance begins in Italy Black Death in Europe
c. 1370	Woodblock printing of pictures in Europe		Chaucer active: the start of English Literature
c. 1410	Brunelleschi demonstrates linear perspective		
c. 1430	Tempera paint, used since ancient times, gradually replaced by oil paint	Van Eyck pioneers the use of oil paint	
c. 1460	Drypoint engraving invented in Germany		Johannes Gutenberg invents a printing press with movable type – printed books start to become widespread
c. 1500	Canvas first used to paint on	Leonardo da Vinci, Michelangelo, Raphael and Dürer all active	Moors driven out of Spain. Columbus reaches the Americas. Vasco da Gama sails around Africa and discovers a sea route to India. Magellan's expedition circumnavigates the globe

(Continued)

	Image Technologies & Processes	Photography & Art	Culture & Current Affairs
c. 1520	Etching invented		Martin Luther begins the Protestant Reformation
c. 1550	First published reference to *camera obscura* with a lens	Titian and Bruegel active. Art dealing in its modern form begins	Counter-Reformation
c. 1600		Caravaggio makes first pictures with 'photographic' detail and lighting. Rubens, Rembrandt and Velazquez all active	Galileo pioneers the use of telescopes in astronomy and Kepler describes how the planets orbit the sun. Shakespeare active
c. 1650	Vermeer and other Dutch artists experiment with *camera obscuras* to aid painting		The 'Enlightenment' or 'Age of Reason' begins – philosophical, scientific and rational attitudes spread in Europe
1666	Newton describes how light is made up of different colours		
c. 1700		Hogarth active	First steam engine produced (1712), improved by Watt in 1765. Industrial Revolution begins
1727	Schulze describes light sensitivity of silver salts		
c. 1780	*Camera obscura* use for drawing becomes widespread		Steam engines in use Mozart active American independence (1783)
1789			French Revolution
c. 1800	Thomas Wedgwood and Humphry Davy make photograms on sensitized leather, but cannot 'fix' them (Britain)	Goya, Ingres and Turner active	'Modernity' begins: industrialization and urbanization accelerate Britain and USA abolish the slave trade First electric light invented by Davy (1809)
c. 1820		Dioramas and Panoramas popular	Faraday explains electromagnetism Beethoven active Brazil declares independence (1822)
c. 1826	JN Niepce produces first photograph from nature (France)		Height of Romantic movement in Europe

			
1829			Beginning of rail travel. First typewriters
c. 1830	Stereoscopes invented		Charles Babbage invents 'Analytical Engine' – a mechanical calculator and the precursor to computers
1835	WHF Talbot produces first negative photograph		
1839	Official invention of photography – Louis Daguerre's photographic process publicly announced (France) Talbot then announces his negative–positive process (Britain)		
1840	Petzval portrait lens manufactured (Germany) Wolcott patents mirror portrait camera (USA)	Decline in painted miniatures as photography begins to spread	
1841	Talbot patents Calotype process (Britain)	Beard opens first European portrait studio (Britain)	
1843		Hill and Adamson collaborate to produce Calotype portraits	
1844		Talbot publishes *The Pencil of Nature* (Britain)	
1846	Carl Zeiss optical factory opens, Jena (Germany)		
1847	Albumen on glass negatives introduced (France)		
1848		First use of photographs by Police departments	Paris revolution. New France republic proclaimed
1850	Albumen on paper for prints introduced (France)		
1851	Archer suggests collodion process (Britain) First albumen photo-print factory (France)	Great Exhibition (Britain) includes photography	Isaac Singer invents a sewing machine
1853		Photographic Society founded (London): RPS from 1894 onwards (Britain)	
1854	Ambrotype version of collodion process (Britain)	Disderi introduces carte-de-visites (France)	Crimean War (1854–56)
1855		Fenton photographs Crimean War	
1856	Smith patents tintypes (USA)		
1857		Rejlander's *The Two Ways of Life* exhibited (Britain)	

(Continued)

	Image Technologies & Processes	Photography & Art	Culture & Current Affairs
1859			Charles Darwin publishes *On The Origin of Species by Means of Natural Selection*
1860	Tintypes (Ferrotypes) introduced	Frith photographs in Egypt and Jerusalem. Boom in stereo-photographs, sold in most stores	
c.1860		Manet produces first 'Modern Art'	
1861	Maxwell demonstrates 3-colour theory (Britain)	Brady and his photographers (inc. O'Sullivan) begin photographing US Civil War	American Civil War (1861–65)
1864	Carbon transfer process introduced	Cameron begins portraits of famous men (Britain)	
1866	Woodburytype reproduction process invented	Carte-de-visite craze comes to an end	First trans-Atlantic telegraph cable is laid. Germany unified (1866–71)
1867		Watkins and O'Sullivan photographs on US geological surveys	Marx publishes first volume of *Das Kapital*
1869		HP Robinson's book *Pictorial Effects in Photography* published	
1871	Maddox suggests gelatine emulsion (Britain)		
1873	Gelatin–Bromide paper / Vogel discovers ortho sensitization (Germany)	WH Jackson photographs Western territories (USA)	First use of electricity to drive machinery (USA)
1874		Impressionism, the first Modern Art movement, begins in France	
1876	First manufactured dry plate (Britain)		AG Bell patents the electric telephone (USA)
1877	First electric light studio (Britain)	Thomson's pictures of London street life published	
1878	Platinum printing paper introduced	Muybridge experiments with photography of animal locomotion (USA)	

			
c. 1880–85			First refrigerated cargo ships Storage battery invented Internal combustion engine invented by Daimler (Germany) First petrol driven car developed by Benz (Germany)
1882	First ortho sens. Dry plates manufactured (Britain) First commercially produced halftone blocks	Marey's locomotion photo-experiments 1882–96 (France)	
1883	Large scale production of bromide paper begins		
1884	George Eastman patents paper-strip film (USA)		
1887		Muybridge's locomotion pictures (11 vols) published (USA)	
1888	Kodak produces the first cameras with roll film and processing service (USA)	Riis' photos of NY slums first published (USA)	Eiffel tower completed (France)
1889	Eastman patent application for transparent rollfilm	Emerson's *Naturalistic Photography* published (Britain)	
1890	Hurter and Driffield set down H–D emulsion speeds (Britain)	Riis' *How the Other Half Lives* published (USA)	
c. 1890	Half-tone printing, offset lithography, colour printing and using photographs to make printing plates all begin		First electric tram (Italy)
1891		Vienna camera club founded Growth of 'Art Nouveau' (W. Morris, Britain)	
1892	Edison perfecting movie equipment (USA)		Ellis Island immigrant receiving station opens (USA)
1894	Gum bichromate process developed for 'pictorial' use		
c.1895	Lumiere movie equipment demonstrated and first public showing of a motion picture (France) Roentgen discovers X-rays, radiography (Germany)		Marconi builds the first radio transmitter

(Continued)

	Image Technologies & Processes	Photography & Art	Culture & Current Affairs
1897	Kodak folding pocket rollfilm camera (USA)	Stieglitz edits *Camera Notes* (USA)	
1898		Atget establishes his photographic practice in Paris	
1900	Kodak 'Brownie' $1 box camera (USA)	New American Photography exhibition at RPS Half-tone photos printed on some newspaper power presses (USA)	Freud publishes *The Interpretation of Dreams*
1902	Zeiss Tessar f/3.5 lens designed (Germany)	Photo-Secession founded First issue of *Camera Work* (USA)	
1903	First panchromatic (Perutz) plates (Germany)		Wright brothers invent the first powered aeroplane
1904		Newspapers with half-tone printed photographs	Panama Canal opened
1905		291 Gallery Opens, New York	Einstein proposes his Theory of Relativity
1906	Panchromatic plates introduced in Britain		San Francisco earthquake
1907	Autochrome colour plates introduced (France)	Futurist movement (c. 1907–1914)	
1908	First Soho Reflex SLR plate camera (Britain)	Hine begins child labour documentary using photography (USA) Picasso and Braque pioneer Cubism	Mass production begins in earnest with First Model T Ford Car (USA)
1909	Cellulose acetate 'safety' film base replaces flammable cellulose nitrate (USA)		Modern music: Stravinsky's *Rite of Spring*
1912	Motorized movie cameras invented. Compur bladed shutter invented (Germany)		*Titanic* sinks
1913	First Speed Graphic Press camera (USA)	Duchamp exhibits first 'Readymade' art. Armory exhibition of modern art, New York	
1914	Oscar Barnack develops a camera using the 24 × 36 mm frame and sprocketed 35 mm movie film, the 'Ur-Leica'		World War I (1914–1918)
1915	Aerial plate cameras developed	Growth of Modernist photography ideas Dada Movement begins	

			
1917	Platinum paper discontinued	Coburn 'Vortographs' (Britain) Final issue of *Camera Work*. 291 Gallery closes	Russian Revolution
1919	Tri-colour Carbro process developed (Britain)	Bauhaus design school founded (Germany)	
1921		Man Ray, Moholy Nagy; photogram experiments	First robot built Regular 'wireless' programs broadcast (USA)
1922		Surrealist paintings from about this date	First feature-length all-Technicolor (two strip) Hollywood film, *The Toll of the Sea*, released
1923		Edward Steichen appointed chief photographer of *Vogue*	
1924	Leitz manufacture first Leica camera (Germany)		
1925	Ermanox camera f/1.8 lens manufactured (Germany)		First TV built
1927	Sound movies now universal. Capstaff formulates D-76 developer		'Picture palaces' built everywhere to show movies
1928	First Rolleiflex TLR rollfilm camera (Germany)	Salomon begins political candids (Germany) Renger-Patzsch's *The World is Beautiful* published (Germany)	Picture magazine *Berliner Illustrierte Zeitung* published. Alexander Fleming discovers penicillin
1929	Flashbulbs introduced (Germany)	Film and Foto exhibition (Germany) August Sander publishes *Face of Our Time* (Germany)	New York stock-market crash, start of world-wide depression Soviet agriculture collectivized
1930	First colour print service (professionals only) established in USA		Jet engines invented
1931	First photo-electric meter (USA)	Dr Harold Edgerton invents high-speed stroboscopic photography Group f64 formed by Adams, Weston, Cunningham and others (USA)	
1932	8 mm amateur movie film and equipment (USA) First Technicolor film shot using three-strip camera (USA)		

(Continued)

	Image Technologies & Processes	Photography & Art	Culture & Current Affairs
1933	First panchromatic rollfilms (USA)	Heartfield, photomontagist, flees Nazi Germany Bauhaus (Berlin) closed	Nazis come to power in Germany Roosevelt's New Deal social reform program (USA)
1935	Dufaycolor rollfilm introduced (France)	FSA photo project launched (USA)	
1936	Kodachrome 35 mm films introduced (USA) Dufaycolor roll and sheet film available (UK)	Photo League of NY still photographers formed	First issue of *Life* Magazine
1937	First 35 mm SLR camera – Exakta (Germany)	Edward Weston receives first Guggenheim Award given to a photographer. New Bauhaus opens, Chicago	Photocopier invented
1938	First camera with built-in meter, for rollfilm (USA)	Walker Evans publishes *American Photographs*	First issue *Picture Post* (Britain) and *Paris Match*
1939	Edgerton evolves first electronic flash (USA) German lenses and cameras, and Agfa materials, cut off by war		Second World War (1939–45)
1940		Photo section of Museum of Modern Art opens (USA)	
1941			Orson Welles' film *Citizen Kane* released
1942	Agfa neg/pos colour film and paper (Germany) Kodacolor rollfilm colour negative and printing service (USA)	Irving Penn begins photography while art directing for *New York Vogue*	
1945	Dye-transfer colour print assembly process (USA) introduced – less complex alternative to carbon		Atomic bomb invented and used
1946	Ektachrome sheet film, processable by the photographer (USA)	Abstract Expressionist painting begins	
1947	Polaroid Instant (B&W) film and cameras (USA)	Magnum photo co-operative formed by Cartier-Bresson and others	Cinema-going reaches its peak India and Pakistan become independent
1948	First model, Hasselblad rollfilm SLR		Establishment of the State of Israel First Arab-Israeli war

			
1949	Contax S, first pentaprism finder 35 mm SLR (Germany)		Establishment of the People's Republic of China, after Communist victory in civil war. George Orwell publishes *1984*. George Eastman's House opens as museum (USA)
1951		Photo League ceases (USA)	Popular growth of B&W TV begins
1952		Pop Art begins *The Decisive Moment* by H Cartier Bresson published. First Issue *Aperture* magazine, New York	First pocket size transistor radios (Japan)
1955	Hasselblad 500C model	Family of Man exhibition opens, New York	Berlin Wall built
1957	First Japanese precision 35 mm. SLR (Nikon F) generally available		Last issue of *Picture Post* America passes first Civil Rights Bill European Economic Community established
1958	Kodacolor available in 35 mm. Fujicolor photo materials introduced	Robert Frank's book *The Americans* first published	Alfred Hitchcock's film *Vertigo* released
1962	Growth of studio electronic flash	Andy Warhol produces his first silkscreen paintings	*Sunday Times* publishes first British newspaper colour supplement
1963	Polaroid Instant pictures in colour (USA) Kodak launch 126 (Instamatic) cameras and colour film		Colour TV spreads. President Kennedy assassinated. First successful Beatles record
1964	Expanded range of new optics – 'fish eye' lenses etc.		US involvement in war in Vietnam begins Race riots in major US cities
1965		Conceptual Art begins	
1969	Offset litho gives improved printed page reproduction of colour First Charge-coupled device (CCD) invented (USA)	Witkin Gallery, exclusively photography, opens in New York First photographs taken on moon, using Hasselblads	250,000 demonstrators march in Washington to oppose the Vietnam War
1970		Bernd and Hilla Becher publish *Anonymous Sculpture: A Typology of Technical Buildings*	US Feminists parade – 50th year of women's voting rights. *The Female Eunuch* by G Greer published (UK)

(Continued)

	Image Technologies & Processes	Photography & Art	Culture & Current Affairs
1971		Opening of the Photographers' Gallery, London	
1972	Polaroid SX-70 one-step colour print system introduced (USA) Kodak launch 110 format cameras and films	Stephen Shore publishes *American Surfaces*	*Life* magazine ceases publication
1973	C-41 processing replaces C-22 for colour negs		Cease-fire in Vietnam
1974		International Center of Photography opens in New York	Resignation of US President Nixon following Watergate scandal
1975		New Topographics exhibition, George Eastman House, New York. 'Postmodern' art begins around this time	Steven Spielberg's *Jaws* begins the era of the Hollywood blockbuster
1976	First SLR with TTL flash metering – Olympus OM-2 Inkjet printer invented	William Eggleston becomes the first person to exhibit colour photographs at MoMA, New York	
1977	Majority of Brits now shoot more colour than B&W photos	Susan Sontag publishes *On Photography* Cindy Sherman produces her first *Untitled Film Stills*	
1978	Konica introduces first point-and-shoot, autofocus camera	Jeff Wall produces his first large scale transparencies on lightboxes	
1979			Cellular phones invented
1980	First consumer camcorder	Roland Barthes publishes *Camera Lucida*	
1983	Kodak Disc format cameras and film Auto focus SLRs	Opening of National Museum of Photography, Film and Television, Bradford, UK	
1984	First digital electronic still camera Apple Macintosh computers first appear		
1985	Digital imaging processors introduced Digital image manipulation programmes Digital scanners		Microsoft invents *Windows* computer operating system

			
1986	Fuji produce the first disposable cameras	Nan Goldin publishes *The Ballad of Sexual Dependency*	Chernobyl nuclear power station accident
1987	First 3-D video games		
1989	150 years of photography celebrated		Berlin Wall falls; Eastern bloc disintegrates
1990	Photo CD introduced as a digital image storage medium Adobe Photoshop digital image manipulation program introduced		Germany reunified Hubble telescope launched into space Nelson Mandela freed from prison World Wide Web protocols invented
1992			Official End of the Cold War World Wide Web in use
1996	APS format introduced First digital cameras appear		CCTV becomes widespread in British cities Mad Cow Disease in Britain
1997		*Pathfinder* space probe sends back images of Mars Sensation exhibition of Young British Artists at the Royal Academy of Arts, London	Scientists clone sheep Princess Diana dies in a car crash after being followed by press photographers
1998	First digital compact cameras		
c. 2000	Phone cameras introduced Home negative scanners available Home inkjet printing Laserjet printing		Blogging and online albums begin
2001		Corbis transfers the United States' largest archive of photographs from New York City to a secure and environmentally controlled underground facility in Pennsylvania	Islamist terrorists hijack planes and destroy World Trade Center in New York, seen live on TV around the world. US invasion of Afghanistan follows
2002	Digital cameras outsell film cameras for the first time		Single European currency introduced. Indian-Pakistani crisis over Kashmir

(Continued)

	Image Technologies & Processes	Photography & Art	Culture & Current Affairs
2003	First disposable digital cameras on the market		US led coalition invades Iraq and deposes Saddam Hussein, leading to civil war
2004		NASA robot 'Rovers' send back colour images from Mars	Indian Ocean tsunami hits South East Asia. European Union expands to include 25 member states. Large increase in Islamist terrorism in the Middle East. Madrid bombed by Islamist terrorists
2005		Richard Prince's *Untitled (Cowboy)*, 1989, becomes the first photograph to sell for more than one million US dollars	London bombed by Islamist terrorists. Hurricane Katrina destroys New Orleans
2006	Nikon and others announce that they are discontinuing production of all but a few models of film camera		

Glossary

Aberration Defect in a lens resulting in less than optimum sharpness over part of the image plane. See Chromatic Aberration, Spherical Aberration.

Accessory shoe Fitting on a camera to allow devices such as flashguns to be clipped on. See Hot Shoe.

Accelerator Chemical ingredient of developer to speed up the otherwise slow activity of developing agents. Normally an alkali such as sodium carbonate, borax or (high contrast developers) sodium hydroxide. Also known as 'activator' or 'alkali' component.

Achromatic Lens system corrected to eliminate the effects of chromatic aberration.

Acid Chemical substances with pH below 7. Harmful to skin and eyes. Because acid neutralizes an alkali, acidic solutions are often used to halt development as in stop bath or fixer.

Adaptor ring Narrow threaded ring which fits the front rim of a lens to allow use of filters or accessories of a different ('step-up' or 'step-down') diameter.

ADC Analogue Digital Converter. The piece of electronics which transforms the signal from a digital camera's sensor into a stream of digital information.

AE Automatic exposure The camera adjusts the shutter and/or aperture settings itself, based on readings from a built-in light meter.

AE lock (AE-L) Camera control which allows the user to hold the exposure settings made by an auto exposure program before re-composing the picture.

Aerial perspective Sometimes referred to as Atmospheric perspective. Sense of depth conveyed by atmospheric haze, i.e. changes of tone with distance. Distant hills appear paler and possibly cooler in tone than similar features nearer the camera.

AF Autofocus. The camera adjusts the focus point of the lens itself using sensors to determine maximum sharpness.

AF lock (AF-L) Camera control which allows the user to hold the focus setting made by an auto-focusing lens before re-composing the picture.

Aliasing A rough edge effect ('jaggies') seen most clearly on diagonal or curved lines in an electronic image. Created by low pixel resolution. This staircase appearance is due to the large square pixels present.

Alkali Chemical substances with pH above 7. Harmful to skin and eyes. Solution feels slippery to the touch, can neutralize acid. See also Accelerator.

Ambient light General term covering existing subject lighting, i.e. not specially provided by the photographer.

Analogue Continuously variable. A traditional negative is one example of analogue data having a continuous range of tones in colour or black to white. Often used to mean 'non- digital'.

Angle of view Angle, formed at the lens, between lines from the extreme limits of a (distant) scene just imaged within the diagonal of the picture format. Varies with focal length and format size.

Anhydrous (anhyd) Dehydrated form of a chemical. More concentrated than the same substance in crystalline form.

ANSI American National Standards Institute. Present title of organization once called American Standards Association. See ASA.

Anti-halation Light-absorbing dye present in film to prevent reflection or spread of light within the film base itself giving 'haloes' around bright highlights. Dissolved during processing.

Aperture Circular or hexagonal opening within the lens used to control image brightness and depth of field. Usually variable in diameter and controlled by a diaphragm calibrated in *f*-numbers.

Aperture (Apple Aperture) Software application from Apple Inc. used for organising and manipulating digital images.

Aperture preview SLR camera control to close the lens diaphragm to the actual setting used when exposing. For previewing depth of field effects in the image.

Aperture-Priority See Av.

APS (Advanced Photographic System) System of easy-load cameras and film cartridges about 30 percent smaller than 35 mm, planned and introduced (1996) by a consortium of manufacturers: Canon, Fuji, Kodak, Minolta and Nikon. All but defunct now but see APS-C and APS-H.

APS (Active Pixel Sensor) A type of digital image sensor (see CMOS) where each pixel sensor contains its own amplifier. APS sensors consume less power and are faster than a CSS sensor and are widely used in mobile phone cameras.

APS-C/APS-H Originally terms describing Advanced Photographic System negative formats (see APS). These are now often used to describe the size of digital image sensors. They approximate to the APS dimensions of 25.1 × 16.7 mm; (3:2 aspect ratio) for APS-C ('Classic') and 30.2 × 16.7 mm (16:9 aspect ratio) for APS-H ('High definition').

Archival processing Procedures during processing aiming for the most stable image possible to ensure long life.

Archival inks Inks made for digital printers that have long-lasting permanence.

Array A single row of charge-coupled devices (CCDs), as used in flatbed scanners, etc., to respond to light and convert it to digital information.

Artificial light General term for any man-made light source. Artificial-light film, however, normally refers to tungsten illumination of 3200 K.

ASA American Standards Association, responsible for ASA system of speed rating. Doubling the ASA number denotes twice the light sensitivity. Now replaced by ISO.

Aspect ratio The ratio of the width to the height of an image. 35 mm format has an aspect ratio of 3:2, computer monitor and TV screens 4:3.

Asynchronous Digital Subscriber Line (ADSL) High-speed Internet connection that runs over an exiting phoneline. Consumer ADSL systems are commonly known as 'Broadband'.

Autofocus System by which the lens automatically focuses the image (for a chosen area of subject). See AF.

Av Aperture value. Auto-exposure camera metering mode. You choose the aperture, and the camera's meter sets an appropriate shutter speed. (Also known as aperture priority system.)

B setting See Bulb.

Bag bellows Short, baggy form of bellows used on view cameras when working with a wide-angle lens. Allows camera movements otherwise restricted by standard lens bellows.

Ball and socket Swivelling ball joint between camera and tripod, monopod, etc. Typically allows setting at any angle with a single locking control.

Barndoors Set of folding metal flaps fitted around the front of a spotlight. Controls light spill, or limits beam.

Baryta papers See Fibre-based paper.

Batch number Data printed on film and paper packaging at manufacture. Small production variations occur in speed, contrast and colour but materials from the same batch will be consistent.

Baseboard camera Also known as a Field camera. View camera with fold-open baseboard, which supports lens and bellows.

Bellows Concertina shaped light-tight sleeve used on some cameras and enlargers between lens and film to allow extensive focus adjustment.

Between-lens shutter Bladed (or 'leaf') shutter positioned between elements of a lens, close to the aperture.

Bit (b) A binary digit. Basic digital quantity representing either 1 or 0. The smallest unit of computer information.

Bit depth The number of bits per pixel. Can vary from 1 bit per pixel within a black and white line image, to 32 or 36 bit depth for a colour image (composed of cyan, magenta, yellow and black, each 8 bits per pixel). The greater the bit depth, the better the tonal gradation and colour quality of the digital image.

Bitmap An image made up of pixels.

Bleacher Chemical able to erase or reduce image density.

Blog A regularly updated (normally diary style) website, either with new images or text – or both.

Blonde A tungsten lamp rated at 2 kilowatts (2000 W). Usually yellow-bodied, hence the name.

Blooming (1) In digital photography refers to haloes or streaks recorded around images of bright light sources or other intense highlights.

Blooming (2) On lenses refers to fungal growths on the glass surfaces due to storage in damp conditions. The fungus produces an acid which can etch the glass, leading to degraded image contrast and sharpness.

Blue-sensitive Emulsion sensitive to the blue and UV regions only of the visible spectrum.

Blu-Ray Recording medium physically the same size as a CD or DVD but capable of storing more data – up to 50 GB.

Bokeh A descriptive term for the way out of focus points are rendered. From a Japanese word meaning fuzziness or dizziness.

Buffer memory A built-in memory where the camera can temporarily save images before saving them to the memory card. A buffer allows you to shoot a burst of several shots without having to wait until the images have been written to disk.

Bracket In exposure, to take several versions of a shot giving different levels of exposure, usually either side of the metered value.

Brief See Bulb.

Brightness range See Subject brightness range.

Broadband See ADSL (Asynchronous Digital Subscriber Line).

Bromide paper Printing paper with predominantly silver-bromide emulsion.

Browser Software which permits your computer to transfer information and display multimedia sites on the Internet, e.g. Firefox, Safari, Opera, Internet Explorer.

Buffer Chemical substance(s) used to help maintain the pH (acidity or basicity), and therefore the activity, of a solution such as developer or fixer.

Bulb Also 'brief'. The B setting on a shutter – keeps the shutter open for as long as the release remains pressed.

Bulk film Film sold in long lengths, usually in cans either for reloading into cassettes or for specialist camera backs.

Burning-in See Printing-in.

Byte (B) A (small) measurement of the memory or storage space in a computer. One byte equals 8 bits. One kilobyte represents 1024 bytes. See also megabyte, gigabyte and terabyte.

C-41 process Processing procedure used for the vast majority of colour (and monochrome chromogenic) negative films. Originally developed by Kodak but used by all major manufacturers.

Cable release Remote shutter control via flexible cable or electric cord which attaches to the camera. Allows the shutter to be fired (or held open on 'B') without camera shake.

Cadmium (di)sulphide See CdS.

Capacitor Unit for storing and subsequently releasing a pulse of electricity.

Callier effect A contrast effect caused by the scattering of light through a condenser enlarger. The denser negative highlights scatter more light than the clear shadows, resulting in abnormally high contrast and a lack of highlight detail.

Cassette Light-proof metal or plastic film container with light-tight entry slot. Permits camera loading in normal lighting.

Cast Overall bias towards one colour.

CCD Charge-coupled device. Electronic light-sensitive surface, e.g. modern substitute for film in digital cameras. In simpler form used in AF systems to detect image sharpness.

CC filter Colour Compensating filter used to correct colour bias mainly when printing. Filters are produced in primary and secondary colours plus ND in a range of densities.

CD-R Compact disc, recordable. A CD to which digital data can be written once only, but read many times. Cannot be erased. Typical capacity is 700 MB.

CD-ROM Compact disc with read-only memory. Non-re-writable disc used to provide software programs, etc.

CD-RW Compact disc, read/write. A CD to which data can be read and written many times. (Old data is erased by laser beam.)

CdS Cadmium disulphide; used in the battery powered light sensor cell, commonly utilized in hand-held exposure metres.

Changing bag A bag of opaque fabric with light-proof arm holes, allowing film holders, cameras or tanks to be loaded or unloaded in normal lighting conditions.

Characteristic curve Graph relating exposure to resulting image density, under given development conditions. See p. 276 and Figure 11.19. Also known as an H–D curve.

Chemical processing All developing and printing processes that use chemicals to produce prints/slides from negative and/or transparency film.

Chlorobromide paper Warm-tone printing paper. Uses emulsion containing silver chloride and silver bromide.

Chromatic aberration A lens defect where the lens fails to focus different colours at the same point. Coloured fringes appear around objects, especially at the edges of the frame.

Chromogenic film Films which form a final dye image rather than one of silver, when given appropriate dye-coupled processing (C-41 for example). Includes monochrome film designed to be processed with standard colour film chemistry.

CI See Contrast index.

CIE Commission Internationale de l'Eclairage. Originator of a standard system for precise description of colours.

Circles of confusion Discs of light making up the image formed by a lens, from each point of light in the subject. The smaller these discs the sharper the optical image appears.

Clearing time The time taken in a fixing bath for a film emulsion to lose its milky appearance. As a rule of thumb, most materials are fully fixed when twice the clearing time has elapsed.

Click stops Aperture settings which you can set by physical 'feel' as well as by following a printed scale.

Clip test Processing a small piece of film cut from one end of a roll to determine suitable processing times.

Cloning Digital manipulation process where a small area of an image is copied and then superimposed on another spot.

Close-up lens Additional element added to the main lens, to focus close objects.

CMOS Complementary Metal-Oxide Semiconductor. A type of image sensor widely used in digital cameras. See APS and CCD.

CMYK Cyan, magenta, yellow and key (black). The colour printing model predominantly used for mass produced printing material such as books and magazines. It can also be found in some inkjet and dye sublimation printers.

Coating (1) Transparent material deposited on lens glass to suppress surface reflections, improve image contrast.

Coating (2) Top layer of photographic or ink-jet paper which gives it a texture; matt, lustre or glossy, etc.

Cold-light (cold cathode) enlarger Enlarger using a fluorescent tube grid. Gives bright, diffused illumination without producing a lot of heat.

Colour balance (film) Relates to the lighting under which a colour film is designed to record subject colours accurately. Typically expressed as daylight balance (5500 K) or tungsten light balance (3200 K); see Kelvin.

Colour balance (digital) In most digital cameras the colour balance is set automatically. You can also set it manually by photographing a neutral surface. The camera then calculates the Kelvin degree required.

Colour head An enlarger lamp head with a colour printing filter system built-in.

Colour temperature Way of defining the colour of a (continuous spectrum) light source, usually expressed in Kelvin (K).

Colour wheel Diagram in which the colours of the visual spectrum are shown 'bent' into a circle, with each colour facing its complementary; see Figure 9.24.

Complementary colours Resulting colour (cyan, magenta or yellow) when one of the three primary colours (red, green or blue) is subtracted from white light. Also called 'subtractive primaries', 'secondary colours'.

CompactFlash Type of digital camera removable memory card.

Compound lens One with more than one glass element. Virtually all photographic lenses are compound.

Compression Electronic 'squashing' to reduce file size and therefore its storage needs, and minimize the time taken to transmit it via networks. Greatest compression can be achieved by means of 'lossy' methods such as JPEG, but at the cost of poorer image resolution.

Condenser Simple lens system to concentrate and direct light from a source, e.g. in a spotlight or enlarger.

Contact print Print made with paper exposed in direct contact with negative, therefore matching it in size.

Contrast The difference between extremes: of lighting, of negative or print tone values, of subject reflectance range, etc. The greater the difference between extremes present together, the higher the contrast.

Contrast index A numerical index relating image brightness range to resulting processed density range when 'correctly exposed' on the film's characteristic curve. Therefore relates to development and contrast. (Most general-purpose negatives to be printed on diffuser enlargers are developed to a CI of 0.56.)

Conversion filter Colour filter used to compensate for differences between the colour temperature of the light source and the colour balance of the film, where the two differ.

Converter lens Multi-element lens unit specially designed to (typically) double the focal length of each of a given range of long focal length camera lenses. Fits between prime lens and camera body.

Covering power The area of image of useful quality that a lens will produce. Must exceed camera picture format, generously so if movements are to be used.

CPU Central Processing Unit. Solid-state electronic chip housed within a computer or camera. In the camera it is used to compute exposure, focusing, etc., from data input by other electronic components. In a computer it translates, intercepts and executes instructions received as digital data, communicating with and transferring data between itself and all other internal circuits.

Cropping To trim one or more edges of an image, usually to improve composition.

Cropping tool A tool in image-editing software. Allows you to trim an image as you would mask the borders of an enlargement being made in the darkroom.

Cross front Camera movement. Sideways shift of lens, parallel to film plane.

C-Type A type of colour print made using light to convert a colour negative image into a positive one. Requires chemical processing. See Lambda and RA-4.

Curtin Sync – First Shutter setting which fires the flash at the start of the exposure. The normal setting on most cameras.

Curtin Sync – Second Shutter setting which fires the flash just before the end of the exposure.

Cut-off Term describing the blocking-off of image light ('vignetting') usually at one or more corners of the picture format. May be caused by using the wrong lens on camera or enlarger, accessories such as lens hoods which are too small, or excessive use of certain camera movements.

Cyan Complementary colour to red, composed of blue and green light.

Darkslide Removable plastic or metal sheet fronting a sheet film holder or film magazine. Often used to describe the whole sheet film holder.

Daylight film Colour film balanced for subject lighting of 5400–5500 K.

Daylight tank Film processing container with a light trapped lid allowing development in normal lighting.

DCS (Digital camera system) Prefix used for a number of Kodak camera models.

Dedicated flash Flash unit which fully integrates with camera electronics. Ensures that the shutter speed is correctly set for flash; detects film speed, aperture, light reading, subject distance, etc.

Dense Dark or 'thick', e.g. a negative or slide which transmits little light. Opposite of 'thin'.

Densitometer Electro-optical instrument for reading the densities of a film or paper image.

Density Numerical value for the darkness of a tone on a processed film or paper.

Depth of field Distance between nearest and farthest parts of a subject which can be imaged in acceptably sharp focus at one setting of the lens.

Depth of focus Distance the film (or printing paper) can be positioned either side of true focus whilst maintaining an acceptably sharp image, without refocusing the lens.

Developing agent Chemical ingredient(s) of a developer with the primary function of reducing light-struck silver halides to black metallic silver.

Dialogue box On a computer a special window (often in fly-out form) which may appear on screen as part of a photo-manipulation program. It asks the user for information and/or commands before a task is completed.

Diaphragm Variable diameter hole formed by an overlapping series of blades. See Aperture.

Differential focus Using a small depth of field so only a selected part of the image is in sharp focus.

Diffraction Minute change in the path of light rays when they pass close to an opaque edge. The cause of poorer image quality if a lens is used with an extremely small aperture.

Diffuser Translucent material placed over a light source such as a studio light or enlarger bulb to make the light soft and evenly spread.

Digiscope A device used to clamp a camera to a telescope or microscope so as to photograph the image directly off its eyepiece. Most commonly used with compact or small digital cameras.

Digital camera A camera or camera back in which a CCD chip and supporting electronics replace film.

Digital image An image defined by a stream of digitalized electronic data, typically made visible by display on a computer monitor screen.

Digitalize Process of converting analogue data, which is continuously variable, into digital data represented by a code made up of combinations of only two (binary) digits, 0 and 1. In this binary form pictures can be processed by computer.

Dioptre (or Diopter) A measure of the strength, or light-bending power of a lens. The higher the dioptre, the greater the magnification, and the shorter the focal length.

DIN Deutsche Industrie Normen. German-based system of film speed rating, much used in Europe. An increase of 3 DIN denotes twice the light sensitivity. Now replaced by ISO.

Dodging See Shading.

DPI Dots per inch. A measurement of the resolution of a computer scanner, monitor (72 dpi) or a printer (typically 300 dpi).

Dragging Holding down the computer mouse button while moving it, to reposition items on the monitor screen, etc.

Dreamweaver Software application from Adobe Systems Inc. used for building and managing websites.

Dry mounting Bonding a photograph to a mount by placing dry, heat-sensitive tissue between the two and applying pressure and heat.

Drying mark Uneven patch of density on film emulsion, due to uneven drying. Cannot be rubbed off but can sometimes be reduced by re-soaking.

D-SLR Digital version of an SLR camera. See SLR.

DVD Digital Versatile Disk. Recording medium physically the same size as a CD but capable of storing more data. See also Blu-Ray.

DVD-R Recordable DVD with a capacity of 4.6 GB; see CD-R.

DVD-RW Read/write DVD with a capacity of 4.6 GB; see CD-RW.

DX coding Direct electronic detection of film characteristics (speed, number of exposures, etc.) Read from the chequer board pattern on a 35 mm film cassette by sensors in the camera's film-loading compartment.

Dye-image film See Chromogenic film.

E-6 process Colour reversal processing procedure in widespread international use for most forms of colour slide/transparency film.

Easel See Masking frame.

Edge numbers Frame number, film type information, etc., printed by light along film edges and so visible after processing.

Effective diameter (of lens aperture) Diameter of the light beam entering the lens which fills the diaphragm opening.

Electronic flash General term for common flash units which create light by electrical discharge through a gas-filled tube.

Element A single piece of glass which is combined with others to form a lens of high quality.

Emulsion The coating on film or paper. A mix of light-sensitive silver halides, plus additives, and gelatin.

EV (Exposure value) A system used on some light metres. Each value expresses a series of shutter/aperture combinations all giving the same exposure effect, e.g. an EV of 12 means 1/250 @ f/4, or 1/125 @ f/5.6, or 1/60 @ f/8; EV 13 means 1/500 @ f/4, etc.

EXIF Metadata embedded into a digital RAW file. Contains info such as shutter speed, aperture, etc. See RAW file.

Existing light See Ambient light.

Expiration date The 'use by' date found stamped on the packaging of most light-sensitive materials.

Exposure compensation dial Camera control effectively overriding film speed setting (by up to 1 or 2 stops). Used when reading difficult subjects, or if film is later to be 'pushed' or 'held back' in processing to modify contrast.

Exposure Index (EI) Measure of sensitivity to light for practical use. Expressed as a film speed setting (ISO).

Exposure latitude Variation in exposure level (over or under) which still produces acceptable results.

Extension tube Tube, fitted between lens and camera body, to extend lens-to-film distance and so allow focusing on very close subjects.

Eyepiece projection A method of photographing through optical devices such as telescopes or microscopes. The camera's lens is positioned where the human eye would be, i.e. immediately behind the eyepiece and the image is formed by both devices in series.

f-numbers International sequence of numbers, expressing relative aperture, i.e. lens focal length divided by effective aperture diameter. Each change of f-number halves or doubles image brightness.

f-stops See f-numbers.

Farmer's Reducer An old name for a solution of potassium ferricyanide and hypo, used for bleaching tones on black and white prints and negatives.

Fast Relative term meaning comparatively very light sensitive.

Feathered edge In digital manipulation a command giving a soft (vignetted) edge to the whole image, or the area selected for cutting-out, darkening, etc. Helps avoid an obvious hard edge when printing-in or shading. Allows seamless montaging effects.

Ferrotype sheet Polished metal plate used for glazing glossy fibre-based prints.

Fibre-based paper Traditional type of photographic printing paper with an all-paper base.

Field camera See Baseboard camera.

File The term for a single document (e.g. a camera image) of digital data, as held on a storage device such as the computer's hard disk or some form of removable disk. File format digital images need to be saved in a format that can be read by your software program(s). Typical image file formats are TIFF, JPEG and RAW (all bitmap file formats).

File size The volume of image information forming the contents of a digital file. Becomes larger as the data from a digital image becomes more complex. Measured in kilobytes or megabytes.

Fill-in Illumination that lightens shadows, so reducing contrast.

Film holder Double-sided holder for two sheet films, used with view cameras. See Darkslide.

Film pack Stack of sheet films in a special holder. A tab or lever moves each in turn into the focal plane, e.g. instant-picture peel apart material.

Film plane The position in the back of the camera, in which the film lies during exposure.

Film scanner Device for converting the (analogue) data of images on film into the digital data of image files. Incorporates a CCD array which scans the original.

Film speed Figure expressing relative light sensitivity. See ISO.

Film writer/film recorder Device to convert digital files into analogue images on silver halide photographic film, negative or transparency.

Filter Optical device used on a lens to modify the image by altering its colour by absorbing selected wavelengths.

Filter factor A measure of the amount of light absorbed by a filter, reducing image brightness.

Firewire A common cable protocol (IEEE 1394) for downloading and sending digital data from a variety of external devices such as printers and cameras. A brand name of Apple Inc. Other names include Sony's i.Link and Texas Instruments' Lynx. Faster than USB and so favoured particularly for video.

Fisheye Extreme wide-angle lens, uncorrected for curvilinear distortion.

Fixed focus camera Camera (typically very simple type) with a non focus-adjustable lens. Usually set for its hyperfocal distance.

Fixer Chemical solution which converts silver halides into soluble salts. Used after development and before washing, it removes remaining light-sensitive halides, retaining the developed black silver image.

Flare Unwanted light, scattered or reflected within a lens or camera/enlarger body. Can cause uneven patches in the image, reduce contrast and degrade shadow detail.

Flashing Giving a small extra exposure (to an even source of illumination) before or after image exposure. Lowers the contrast of the photographic material.

Flat A subject or image lacking contrast, having minimal tonal range.

Flatbed scanner Light box with an internal CCD array able to digitally scan-in photographic prints, etc. placed face down on its flat glass upper surface.

Flickr An image-hosting website widely used by people sharing personal photos and video clips online.

Floodlight Powerful artificial light source giving illumination over a wide area.

Focal length Distance between the image and lens when the lens is focused for an infinity subject. More precisely, between the image centre and the lens's rear nodal point.

Focal plane Plane on which a sharp-focus image is formed. Usually at right angles to lens axis.

Fog Unwanted veil of density (or bleached appearance, in reversal materials). Caused by accidental exposure to light or chemical reaction.

Format or 'frame' General term for the picture area given by a camera. See also Aspect ratio, and page 73.

FP-synch Setting or socket for specialist 'focal plane' flashbulbs.

Gamma Tangent of the angle made between the base and straight-line portion of a film's characteristic curve. Used as a measure of contrast.

Gamut The range of colours reproducible by a particular display screen, inkjet printer or other digital imaging device.

Gel Term used to describe large sheets of coloured material which act as filters over lights. Sometimes used to describe flexible acetate or polyester lens filters.

Gelatin Natural protein used to suspend silver halides evenly in an emulsion form on film and paper. Swells to permit entry and removal of chemical solutions.

Giclée Print A type of inkjet print of high quality and good archival stability.

Gigabyte (GB) Unit of computer memory equivalent to 1024 megabytes.

Gimp (GNU Image manipulation Program) A freely distributed software program for working on digital images.

Gobo Shape made from metal or cardboard which is added to the light source to project shadow effects such as window frames, tree branch effects, etc.

Gradation Variation in tone. Tonal range or scale.

Graded papers Printing papers of fixed contrast. You purchase the grade you need as indicated by a number on the packaging. The lower the number, the lower the contrast.

Gradient Digital manipulation term for filling an area with a colour or grey tone which gradually changes in density across the filled zone.

Graduate Calibrated container for measuring liquids.

Grain Clumps of processed silver halides forming the image. Coarse grain reduces fine detail, gives a mealy appearance to even areas of tone.

Grey Card Neutral mid-grey (18 percent reflectance) card used to simulate midpoint of the tones in an average scene for exposure and colour balance measurement.

Greyscale A digital image containing only shades of grey, black or white.

Guide number Number for simple flash exposure calculations, being flashgun distance from subject times the *f*-number required (when using ISO 100/21° film). Normally relates to distances in metres.

Gum Arabic Glue used on the flaps of envelopes to seal them.

Half plate Old glass-plate negative format. See Whole plate.

Halftone Full tone-range photograph broken down into tiny dots of differing sizes, for ink reproduction on the printed page.

Halides Alkali salts such as potassium iodide or potassium bromide, which when combined with silver nitrate form light-sensitive silver halides.

Hard Contrasty – harsh tone values.

Hard disk/Hard drive High capacity magnetic disk, usually held internally in the computer, forming the main storage device for programs and image files.

Hardener Chemical which toughens the emulsion gelatin to reduce the risk of damage from abrasion, etc. while washing.

High Definition Video Any TV or video system with a resolution of higher than the standard of 640 × 480 pixels. Typical HD resolutions are 1280 × 720 or 1920 × 1080 pixels.

High-end Digital equipment capable of capturing, manipulating, or outputting high resolution image files.

High key Scene or picture consisting predominantly of pale, delicate tones and colours.

Highlights The brightest, lightest parts of the subject or print.

Histogram A bar chart graphically representing a digital image's distribution of grey or colour tones.

Holding back Reducing development (often to lower contrast). Usually preceded by increased exposure. Also called 'pulling'. Term is sometimes used to mean shading or dodging when printing.

Home page The opening page of a website. Introduces contents, and offers click-on links to other pages.

Hot shoe Flashgun accessory clipping point built into the camera; it incorporates electrical contacts allowing the shutter and flashgun to synchronize. Generally a standardized design.

HTML Hypertext Markup Language. A series of instructions which tell a web browser how to display website data. The 'language' in which websites are written.

Hue A particular precise gradation of colour.

Hyperfocal distance The closest subject distance which is acceptably sharp while the lens is focused on infinity. Setting the focus point at this distance extends the available depth of field to its maximum. (See Figure 3.16.)

Hypo Abbreviation for sodium hyposulphite, the fixing agent since renamed sodium thiosulphate. Also the common term for all fixing baths.

Icons Small graphic symbols displayed on the computer monitor. These provide 'click-on' positions for your cursor to command applications, open or close files, activate tools, etc. See Thumbnail.

IEEE 1394 See Firewire.

Image stabilization System of motion sensors and moving optics or CCD used to minimize the effects of camera shake.

Incandescent light Illumination produced from an electrically heated source, such as the tungsten-wire filament of a lightbulb.

Incident light Light falling on a subject, surface, etc.

Incident-light reading Using an exposure meter at the subject position, pointed towards the camera, with a diffuser over the light sensor.

InDesign Software application from Adobe Systems Inc. used for book and magazine design and layout.

Infinity A subject so distant that light from it effectively reaches the lens as parallel rays. (In practical terms the far horizon.)

Infra-red (IR) Wavelengths longer than about 720 nm. Invisible to the naked eye and all but specialist films or CCDs.

Inkjet printer Converts digital images into microscopic dots of ink on paper, so creating a final print in colour or monochrome.

Instant-picture material Photographic material with integral processing.

Intensification Chemical treatment of negative materials to increase image density and contrast.

Internet Service Provider (ISP) A company which provides you with access to the Internet.

Interpolation Increasing the apparent resolution of a digital image by averaging out nearby pixel densities and generating a new pixel in-between. (Cannot therefore truly provide additional detail.)

Inverse square law The rule that says light intensity at a surface is inversely proportional to the square of its distance from the source, e.g. half the distance equals four times the intensity.

Inverted telephoto lens A lens with rear nodal point well behind its rear element. It therefore has a short focal length but relatively long lens-to-image distance, allowing space for an SLR mirror system.

iPhoto An image cataloguing and manipulation program from Apple Inc. Simpler and more basic than Aperture. Only available for the Mac platform.

IR focus setting Red line sometimes located to one side of the lens focus-setting mark, used when taking pictures on IR film.

Iris See Diaphragm.

ISO International Standards Organization. Responsible for ISO film speed system. Combines previous ASA and DIN figures, e.g. ISO 400/27°.

JCII Japan Camera Inspection & Testing Institute. Quality monitoring organization for Japanese optical equipment.

Joule See Watt-second.

JPEG Joint Photographic Experts Group. The name of a widely used image file format able to give a very high level of compression (e.g. to one-hundredth its original size). As a 'lossy' system it inevitably degrades some image quality.

Kelvin (K) Measurement unit of colour. Equals the temperature, absolute scale, to which a metal black body radiator would have to be heated to match the colour of the source. Named after the scientist Lord Kelvin.

Keylight Main light source, usually casting the predominant shadows.

Kilobyte (KB) A measurement of digital file size, computer storage or memory space. One KB is 1024 bytes of information.

Kilowatt Unit of (usually electrical) power. One thousand watts.

Lambda A type of print made using lasers or LED systems to expose a digital image onto C-type or other analogue colour material.

Large format General term for cameras taking pictures larger than about 6 × 9 cm.

Latent image Exposed but still invisible image before processing.

Latitude Permissible variation. Can apply to focusing, exposure, development, temperature, etc.

LCD See Liquid Crystal Display.

Leaf shutter See Between-lens shutter.

LED Light-emitting diode. Tiny lamp used on equipment for light signalling – camera viewfinder information, battery check, etc.

Lens hood, or shade Shield surrounding lens (just outside image field of view) to intercept side-light, prevent flare.

LightJet See Lambda.

Light meter Device for measuring light and converting this into exposure settings.

Lightroom Software application from Adobe Systems Inc. used for organising and manipulating digital images.

Light trap Usually some form of baffle to stop entry of light yet allow passage of air, solution, objects, according to application.

Lighting contrast ratio The ratio between deepest shadow and brightest lit areas of a scene. Assumes that in both instances the tone of the actual subject remains the same (grey card in each area for example).

Line image Very high contrast black/white image with no mid-tones at all, as needed for copies of line diagrams or drawings.

Linear perspective Impression of depth in a picture given by apparent convergence of parallel lines, and changes of scale between foreground and background elements.

Liquid crystal display (LCD) Electronically energized panel used in film cameras to display settings, and in digital cameras to show the picture before and after exposure.

Lith (lithographic) film Highest-contrast film able to yield negatives with very intense blacks. For making line images.

Live View Feature on some digital SLR cameras which allows you to use the LCD screen as a viewfinder.

Location photography Photography away from the studio.

Long focus lens A lens of longer focal length than normal for the format. See Telephoto.

Long-peaking flash Electronic flash utilizing a fast stroboscopic principle to give an effectively long and even peak of light. This 'long burn' allows a focal plane shutter slit to cross and evenly expose the full picture format, at fastest speeds.

Lossless compression A non-destructive method of reducing the size of digital files. Avoids loss of quality relative to the original file when decompressed. TIFF is one such example.

Lossy compression Method of greatly reducing digital file size by discarding data. Induces loss of quality of image when decompressed. JPEG is one such example.

Low key Scene or picture consisting predominantly of dark tones, sombre colours.

Lumen Unit of illumination or light output.

Lux See Lumen.

Macro lens Lens specially corrected to give optimum definition at close subject distances.

Macro setting A special, close focusing setting offered on some lenses (typically zooms).

Macro zoom Macro lens which can also be varied in its focal length.

Macrophotography See Photomacrography.

Magenta Complementary colour to green, composed of blue and red light.

Magnification In photography, means linear magnification (height of object divided into height of its image).

Manual mode Selectable option on a multi-mode camera whereby you choose and make all the exposure settings.

Marquee tool A computer image manipulation selection tool used to outline an area of an image with a broken line showing where changes are to be made.

Masking frame Adjustable frame which holds printing paper flat during exposure under the enlarger. Also covers edges of the paper to form white borders.

Mat, or overmat Cardboard rectangle with cut-out opening, placed over the print to isolate the finished picture.

Maximum aperture The widest opening (lowest *f*-number) a lens offers.

Medium density fibreboard (MDF) A solid board available in various thicknesses made from wood fibres bonded together with synthetic resin adhesive. It is useful for mounting prints.

Medium format camera Camera taking pictures larger than 35 mm but smaller than sheet film sizes. A 120 rollfilm camera, for example.

Megabyte (MB) A measurement of digital file size, computer storage or memory space. One MB is 1024 kilobytes of information.

Meta-data Information recorded along with the image in some digital formats. See EXIF.

Microphotography Production of extremely small photographic images, e.g. in microfilming of documents.

Mid-tone A tone about mid-way between highlight and shadow values in a scene.

Mirror lens Also 'Catadioptric' lens. Lens using mirrors as well as glass elements. The design makes long focal length lenses more compact, less weighty, but more squat.

Mode One of a series of settings on camera equipment which define how exposure or other settings are made. See Av, Tv and Program.

Modelling light Continuous light source, positioned close to a flash tube, used to preview exact lighting effects before shooting with the flash itself.

Modem Device to convert digital data from a computer into analogue form capable of being carried (as sound) over regular telephone lines. Also acts in reverse converting incoming analogue data back into digital data.

Monochrome Single colour. Also general term for all forms of black and white photography.

Monorail camera Metal-framed camera, built on a rail allowing a wide range of camera movements.

Motor drive Motor which winds on film after each exposure.

M-synch Flash setting for old type flashbulbs which delays the shutter opening to allow the bulb to reach its peak brightness.

MTF Modulation Transfer Function. A comparative measure of the contrast of an image of a test chart with the original. Used in assessing lens performance.

Multigrade See Variable contrast paper.

Multicoating Microscopically thin layer on lens elements which reduces flare.

Museum board A cardboard (used to make window mattes) which is free from chemicals that may reduce permanence of prints. Essentially it is acid-free board that has long-lasting permanence.

ND See Neutral density filter.

Negative Image on film in which tones are reversed relative to the original subject.

Negative sandwich Two or more negatives placed in the enlarger at the same time to produce a print.

Neutral density filter Colourless grey filter which simply dims the image by a known amount.

Noise Defect by which shadows and other dark areas of a digital image contain pixels of the wrong colour, randomly distributed. Most often occurs in digital camera pictures which have been under exposed.

Normal lens See Standard lens.

Notch code Notches on one edge of sheet film, shape-coded to identify film type.

Object The thing photographed. The same as Subject.

One-shot processing Processing in fresh solution, which is then discarded rather than used again.

On-the-fly A term used when referring to digital procedures that happen in real-time.

Opacity Incident light divided by light transmitted (or reflected, if tone is on a non-transparent base).

Opaque Impervious to light.

Open flash Firing flash manually while the camera shutter remains open.

'Opening up' Changing to a wider lens aperture.

Optical axis An imaginary line through the exact centre of a lens system.

Optical resolution In digital cameras the true maximum resolution possible is a product of CCD resolution and lens quality without resort to interpolation.

Optimum aperture Lens *f*-stop setting which results in the highest image quality.

Ortho (Orthochromatic) Selective sensitivity to colours. An example of an ortho material is black and white printing paper, which is sensitive to the blue end of the spectrum, but does not react to red safe lighting.

OTF Off the film. Light measurement of the image whilst on the film surface during exposure – essential for through-the-lens reading of flash exposures.

P See Program.

Pan and tilt head Tripod head allowing smooth horizontal and vertical pivoting of the camera, usually with independent controls.

Pan film See Panchromatic.

Panchromatic Material equally sensitive to all parts of the visible spectrum.

Panning Pivoting the camera to follow movement of the subject.

Panorama camera Camera giving a long, narrow image covering a very wide horizontal angle of view. Specialist models can rotate to give up to 360°.

Parallax Difference in viewpoint which occurs when a camera's viewfinding system is in a position separate from the taking lens, as in compact and TLR cameras.

PC lens Perspective control lens. A lens of wide covering power on a shift (and sometimes also pivoting) mount. See Shift lens.

PCMCIA card Personal Computer Memory Card International Association card. (Also known as a PC card.) These removable cards include types I, II and III, and are used to store images or add extra functions to computers. In digital cameras they have been largely replaced by lesser capacity but smaller cards such as SmartMedia.

PE European code for resin-coated paper. See RC paper.

Pentaprism Multi-sided silvered glass prism. Converts the laterally reversed image on the focusing screen of an SLR camera to right-reading, as well as reflecting it to the eyepiece.

Perspective The relationship of size, position and shape of three-dimensional objects as represented in two dimensions, i.e. a flat picture.

pH Acid/basic scale. Spanning 0–14, based on the hydrogen ion concentration in a solution. 7.0 is neutral, e.g. distilled water. Chemical solutions with higher pH ratings are increasingly alkaline, lower ones acid.

Photo etching A method of printmaking in which a metal plate has been coated with a light-sensitive material and exposed to light; the resulting image is then cut into the surface using an acid. Ink is then rubbed into the 'cuts' and transferred to paper.

Photoflood Bright tungsten studio-lamp bulb. Usually 3400 K colour temperature.

Photogram Image recorded by placing an object directly between sensitive film (or paper) and a light source. Similarly, objects placed on the top glass surface of a flatbed digital scanner.

Photomacrography Preferred term for extreme close-up photography giving magnification of ×1 or larger, without use of a microscope.

Photomicrography Photography carried out through a microscope.

Photoshop Software application from Adobe Systems Inc. used for manipulating digital images.

Pictbridge enabled printer A printer with a built-in digital card reader which enables you to bypass the computer when printing out your photographs.

Pinhole camera One which uses a very small hole in place of the lens. Images are typically less sharp and much dimmer than those made by a lens.

Pixel PICture ELement. The smallest element making up a visual digital image.

Pixellated A digital image which has been enlarged to the point where the pixels are clearly visible as individual blocks of colour or tone.

Polarized light Light waves restricted to vibrate in one plane at right angles to their path of direction.

Polarizing filter Grey-looking filter; allows light waves vibrating in only one plane to pass through.

Polaroid. Instant picture company which made 'self-processing' pictures from 1947 to 2009. The term is still often used to mean any instant picture film.

Polaroid back Camera magazine or film holder accepting instant-picture material.

Positive Image with tone values similar to those of the original subject.

PQ Developer using phenidone and hydroquinone as developing agents.

Preservative Chemical ingredient of a processing solution. Maintains its activity by reducing oxidation effects over time.

Press focus Lever on most large-format camera shutters. Locks open the shutter blades to allow image focusing.

Primary colours Of light: red, green and blue.

Printing-in (also known as Burning-in) Giving additional exposure time to some chosen area, during printing.

Program, programme, or P Setting mode for fully automatic exposure control. The camera sets both aperture and shutter settings based on its own built-in program(s).

Pulling See Holding back.

Push-processing Increasing development, usually to improve speed or increase contrast.

Q-Lab An auditing service for professional processing labs run by Kodak to ensure quality standards.

Quarter plate See Whole plate.

Quartz iodine (QI) Compact tungsten filament lamp. Gives high light output for its wattage and maintains colour temperature and intensity throughout its life.

RA-4 The commonest chemical process used to process colour print materials such as C-type. Usually automated.

RAM Random access memory. Temporary memory used within a computer when it is switched on. Large amounts of RAM are required by a manipulation program in order to run its many image changes.

Rangefinder Optical device for assessing subject distance, by comparison from two separate viewpoints.

Rapid fixer Fast-acting fixing bath using ammonium thiosulphate or thiocyanate as the fixing agent.

RAW file The untouched digital file straight from the camera CCD without any adjustment by built-in camera software.

RC paper See Resin-coated paper.

Rebate The unexposed edge of a negative, often printed with frame numbers, etc.

Reciprocity law Exposure equals intensity multiplied by time. This relationship breaks down at extremely long (and short) exposure times, known as Reciprocity failure.

Redhead A tungsten lamp rated at 800 watts. The name comes from the red housing.

Reducer Chemical able to lower the density of a processed image. (Paradoxically the term 'reducing agent' is also applied to developing agents.)

Reflected-light reading Measuring exposure (often from the camera position) with the light sensor pointing towards the subject.

Reflector Surface used to bounce light.

Reflex camera Camera using one or more mirrors in its viewfinder system.

Refraction Change in the direction of light as it passes obliquely from one transparent medium into another of different refractive index, e.g. from air to water.

Relative aperture See *f*-numbers.

Remote control Alternative to a cable or electric cord release on newer cameras using infra-red signals to fire the shutter.

Removable (external) hard disk Storage medium for digital data which you can physically transport and connect to another computer to download its information.

Replenisher Solution of chemicals (mostly developing agents) designed to be added in controlled amounts to a particular developer, to maintain its activity and compensate for repeated use.

Resin-coated paper Printing paper which differs from the fibre-based type by the addition of a clear resin (plastic) coating which reduces the amount of chemistry absorbed, reducing processing times.

Resolution (1) Digital image quality as measured by multiplying the number of horizontal and vertical pixels. Results in a figure for resolution in pixels per inch.

Resolution (2) Ability of a lens to record fine detail, sometimes referred to as resolving power, expressed in lines per mm.

Resolving power See Resolution (2).

Restrainer Chemical component of developer which restrains it from acting on unexposed halides.

Reticulation A 'wrinkly' overall pattern created in an emulsion during processing, due to extreme changes of temperature or pH. More common in older films.

Retouching The process of manually altering an image to add or remove details. Often used interchangeably with 'Spotting' though that is restricted to eliminating defects such as dust marks.

Reversal system Combination of emulsion and processing which produces a direct image of similar tonal values to those of the picture exposed on to the material. A typical example is a colour transparency (slide).

RGB Red, Green and Blue. The colour mode used on all screens and most inkjet printers. Each colour reproduced is a mixture of red, green and blue.

Ring flash Circular electronic flash tube, fitted around the camera lens yielding even, almost shadowless illumination.

Rising front Camera design feature which allows the lens to be raised, parallel to the film plane.

Rollfilm Any film larger than 35 mm which comes as a roll. Typically 120, 220 or 620 film formats.

Rollfilm back Adaptor back allowing rollfilm to be used in a larger-format camera.

ROM Read-only memory. A type of computer memory able to store data which can be read later but cannot be subsequently amended. Used to contain the basic code that allows the central processing unit to work. See CD-ROM.

Sabattier effect The result of re-exposing film or a print to light before development is complete, sometimes known as pseudo-solarization.

Safelight A darkroom working light of the correct colour and intensity not to affect the light-sensitive material in use, e.g. red/orange for regular blue-sensitive bromide paper.

Saturated colour A strong, pure hue – undiluted by white, grey or other colours.

Scanning back A device which operates much like a flatbed scanner. Mounted at the back of a 5 × 4 in. camera, it slowly scans the scene in front of it. Mostly used in a controlled studio environment and for archival purposes such as museums.

Scanner Device for converting existing (analogue) images – photographic prints, negatives, slides, etc. – into digital form.

Scrim Metal or glass fibre mesh attachment to the front of a lighting unit which reduces intensity without altering lighting quality or colour.

Search engine A website through which one can search for content on other websites by inputting keywords.

Secondary colours See Complementary colours.

Secure digital A fast digital storage card available in sizes up to 32 GB and used predominantly in compact digital cameras.

Selective focusing Precise focus setting and shallow depth of field, used to isolate a chosen part of a scene.

Self-timer Delayed-action shutter release.

Sensitometry Scientific analysis of the behaviour of photographic materials in their response to exposure and development.

Sepia A colour ranging from reddish brown to chocolate, as formed in toning processes by different combinations of toner and silver halide emulsion. Also an option in some digital image processing software.

Shading Blocking off light from part of the picture during some or all of the exposure, usually in printing.

Shadows In exposure or sensitometric terms, the darkest tones in the subject.

Sharp In-focus and not blurred.

Sheet film Light-sensitive film in the form of single sheets.

Shift camera General term for a bellowless, wide-angle lens architectural camera with movements limited to up/down/sideways shift of the lens panel. No pivots or swings.

Shift lens Wide-covering-power lens in a mount permitting it to be shifted off-centre relative to the optical axis. Useful in cameras lacking movements. Some models allow the lens to be tilted in relation to the image plane too.

Shutter Mechanical device used to control the time of exposure in the camera.

Shutter-priority mode See Tv.

Silhouette An image showing the subject as a solid black shape against white background.

Silicone release paper Heatproof non-stick sheet used in dry mounting to prevent the print adhering to the press.

Silver halides Light-sensitive compounds of silver and alkali salts of halogen chemicals, such as bromine, chlorine and iodine.

Single-use camera Simple, ready-loaded camera, broken open and disposed of by the lab when processing your exposed film.

Slave unit Electronic device which reacts to light from another flash and fires a second unit simultaneously.

SLR Single-lens reflex.

SmartMedia A PC card which fits into a digital camera or (typically through an adaptor) into a computer or printer to allow storage or transfer of data.

Snoot Conical black tube fitting over a spotlight or small floodlight. Restricts lighting to an even, circular patch.

Soft (1) Low contrast.

Soft (2) Slightly unsharp or blurred.

Solarization Reversal (either partially or totally) of the tones in a photograph caused by massive over-exposure, often during processing. Now an effect in some digital image manipulation programs.

Spectrum Radiant energy arranged by wavelength. The visible spectrum, experienced as light, spans 400–700 nm.

Specular reflection Light which is perfectly reflected, as by a highly shiny surface such as a mirror, glass, smooth water etc.

Speed (of emulsion) A material's relative sensitivity to light.

Spherical aberration Lens defect which causes the image to be formed in a partially curved instead of flat plane resulting in poor image definition over the whole area. Effects can be reduced by using a small aperture to increase depth of focus.

Spill kill Small reflector/light control ring which stops the spread of light in all directions. Often used in conjunction with an umbrella reflector.

Spot meter Hand meter, with aiming viewfinder able to pick out small areas of (often distant) subjects and so make precise exposure readings.

Spot mode A TTL metering mode option which allows a narrow-angle exposure reading of the subject. The small area measured is outlined on the camera's focusing screen.

Spotting Retouching-in small, mainly white specks or hairs – generally on prints – using water-colour, dye or pencil. Can also be performed digitally using image manipulation programs.

Squeegee Rubber blade or roller device used to remove water from the surface of prints, etc.

Stabilization Chemical process used either instead of or in addition to fixing. Undeveloped halides are converted to more stable compounds either to reduce washing times or to increase material longevity.

Standard lens The lens most regularly supplied for the camera size; typically has a focal length equal to the diagonal of the picture format. Covers a field of view roughly the same as the human eye.

Still-life General term for an inanimate object, set up and arranged in or out of the studio.

Stock solution Chemical stored in concentrated liquid form which is then diluted for use.

Stop Correctly used means aperture but commonly used to mean an increment of half or twice the exposure value. See *f*-numbers.

Stop bath Acidic solution which halts development, and reduces fixer contamination by the alkaline developer.

Stopping down Changing to a smaller aperture (higher *f*-number).

Strobe Old, mainly US general term for electronic flash. (Was a trade name for a manufacturer of studio flash equipment.) Strictly it means a fast-repeating stroboscopic lamp or flash which may fire many times a second.

Subject The thing being photographed. Term used interchangeably with object, although more relevant to a person, scene or situation.

Subject brightness range The ratio between the most brightly lit reflective part, and the most dimly lit dark toned part of the subject appearing in your picture.

Supplementary lens See Close-up lens.

Sync lead Cable connecting flashgun to camera shutter, for synchronized flash firing.

Synchro-sun Flash from the camera used to 'fill-in' shadows cast by sunlight.

T Setting 'Time' setting available on some large-format camera shutters. The release is pressed once to lock the shutter open, and then pressed again to close it.

Technical camera See View camera.

Tele-converter See Converter lens.

Telephoto Long focal length lens with shorter back focus, allowing it to be relatively compact.

Tempering bath Large tank or deep tray, containing temperature-controlled air or water. Accepts drums, tanks, bottles or trays to maintain their solution temperature before and during processing.

Terabyte 1024 gigabytes.

Test strip Full or part sheet of photographic paper given a number of different exposures to help determine the correct print setting.

'Thick' image Dense, dark result on film.

'Thin' image Pale, ghost-like film, lacking density.

Thumbnail Small version of a larger digital image used a visual reference for locating and identifying image files on a computer or printed reference sheet. See Icons.

Thyristor flash Automatic sensor on a flashgun which measures the light reflected from the subject during exposure and cuts off the power when exposure is deemed correct.

TIFF Tagged Image Format File. Extensively used file format for high-resolution digital images.

Tilt and Shift lens See Shift lens.

Tinting Applying colour (oils, dye, watercolours) to a print by hand.

TLR Twin-lens reflex.

Toning Converting a black silver image into a coloured compound or dye. The base remains unaffected.

Transparency Positive image on film. Includes both 35 mm slides and larger formats.

TTL Through-the-lens camera reading, e.g. of exposure.

Tungsten-light film Colour film balanced to suit tungsten light sources of 3200 K.

Tv Time value. Auto-exposure camera metering mode. You choose the shutter speed; the meter sets the aperture. (Also known as shutter priority system.)

Ultraviolet Wide band of wavelengths less than about 390 nm. Invisible to the human eye.

Undo A digital manipulation program command which reverses the last editing command you applied to an image. Programs offering multiple Undo allow you to work backwards over a number of commands.

'Universal' developer A developer designed for both films and prints (at different dilutions).

Unsharp masking (digital) Selective sharpening of the image in areas of high contrast, with little effect on areas of solid tone or colour. An effective method of improving the visual appearance of sharpness and detail.

Uprating Increasing the film's speed setting (or selecting a minus setting on the exposure compensation dial) to suit difficult shooting conditions. Followed up with extended development.

USB Universal Serial Bus. A very common cable protocol for downloading and sending digital data from a variety of external devices such as printers and cameras.

UV filter Filter absorbing ultraviolet light only. Appears colourless.

Vanishing point The point on the horizon where parallel lines seem to meet in a two-dimensional image.

Variable contrast paper Monochrome printing paper which changes its contrast characteristics with the colour of the exposing light. Controlled by filters. Multigrade; Polygrade; Varigrade and Polymax are all trade names for variable contrast papers.

VGA Video Graphics Array. The established standard term for digital resolution of 640 × 480 pixels. Found in low-end cameras used as computer peripherals.

View camera Camera (usually large format) in which the image is viewed and focused on a screen in the film plane, later replaced by a film holder. View cameras are primarily used on a stand or tripod.

Viewpoint The position from which the camera views the subject.

Vignetting Fading off the sides of a picture into plain black or white, instead of having abrupt edges.

Warm tone A brownish black and white silver image.

Watt Unit of power, usually in electrical devices.

Watt-second Light output given by one watt burning for one second. Used to quantify and compare the power output of electronic flash (but ignores the influence of flash-head reflector or diffuser on exposure).

Wetting agent Detergent-type additive, used in minute quantity to lower the surface tension of water. Assists even action of most non-acid solutions, and of drying.

White balance Automatic or manual adjustment to a digital camera's CCD colour response. Ensures correct colour balance in images shot under lighting of various colour temperatures.

White light Illumination containing a mixture of all wavelengths of the visible spectrum.

Whole plate An obsolete film and paper format measuring 6.5 × 8.5 in. Half-plate and quarter-plate sizes were also manufactured.

Wide-angle lens Short focal length lens of extreme covering power, used to give a wide angle of view.

Wide-carriage printers Inkjet printers capable of outputting poster-size colour prints, e.g. over a metre wide and of unlimited length.

Window matte Cardboard surround used to frame photographic images when behind glass.

Working solution Liquid chemical at the dilution strength actually needed for use.

WWW World Wide Web. That part of the Internet which involves servers to be able to communicate with other computers on global telecommunication networks. Provides an infinite web of links to information stored in hundreds of thousands of servers all over the world. Makes possible electronic publishing.

X-synch Setting or socket for electronic flash.

Zone system Method of controlling final print tone range, starting with your light readings of the original subject. Pictures are previsualized as having up to nine tone zones, adjusted by exposure and development. Propounded by photographers Ansel Adams and Minor White.

Zoom lens Lens continuously variable over a range of focal lengths, while maintaining the same focus setting.

Zoom range The relationship of longest to shortest focal lengths offered by a zoom lens, e.g. ×2, ×3, etc. See Figure 5.15.

Zooming Altering the focal length of a zoom lens.

Index